American Art

Ilene Susan Fort *Michael Quick*

American Art

LOS ANGELES COUNTY MUSEUM OF ART

A Catalogue

of the

Los Angeles County

Museum of Art

Collection

Published by the
Los Angeles County Museum of Art
5905 Wilshire Boulevard
Los Angeles, California 90036

Distributed by
University of Washington Press
P.O. Box 50096
Seattle, Washington 98145-5096

This catalogue was made possible by a generous
grant from the Luce Fund for Scholarship in Ameri-
can Art, a program of the Henry Luce Foundation.
It was supported in part by funds provided by the
Andrew W. Mellon Foundation Publications Fund.

Edited by Joseph N. Newland and
Kathleen Preciado
Designed by Lilli Cristin
Photography of the collection and the museum
by the department of Photographic Services,
Los Angeles County Museum of Art
Set in Kennerley by Andresen Typographics,
Tucson, Arizona
Printed by Dai Nippon, Tokyo, Japan

PHOTOGRAPH CREDITS
All works not in the museum's collection are
reproduced courtesy of their owners and with mate-
rial provided by them except the comparative
illustrations on the following pages:
Chisolm, Rich, and Associates, 181
Conservation Center, Los Angeles County Museum
of Art, 193
Helga Photo Studio, 159, 241, 266
Kennedy Galleries, 114
Los Angeles County Museum of Natural History,
16, 18, 20
National Archives, Washington, D.C., 353
Miriam and Ira D. Wallach Division of Art, Prints,
and Photographs, New York Public Library, Astor,
Lenox, and Tilden Foundations: Art Collection,
225; Print Collection, 338
Reunion des Musées Nationaux, Paris, 147
Joseph Szaszfai, 99
Taylor & Dull, 114

Jacket: John White Alexander, *Portrait of Mrs. John
White Alexander,* 1902, see page 220.

Library of Congress Cataloging-in-Publication Data

Los Angeles County Museum of Art.
 American art : a catalogue of the Los Angeles County Museum of Art
collection / Ilene Susan Fort, Michael Quick.
 p. cm.
 Includes bibliographical references and indexes.
 ISBN 0-87587-155-0 -- ISBN 0-295-97027-8 (Univ. of
Washington Press)
 1. Art, American--Catalogs. 2. Art--California--Los Angeles-
-Catalogs. 3. Los Angeles County Museum of Art—Catalogs.
I. Fort, Ilene Susan. II. Quick, Michael. III. Title.
N6505.L6 1991
759.13 ' 074 ' 79494--dc20
 90-13570
 CIP

ISBN 0-87587-155-0 [LACMA]
ISBN 0-295-97027-8 [Univ. Wash.]

Contents

Foreword

Earl A. Powell III
Director

*T*his is the first publication devoted to the collection of historical American art in the Los Angeles County Museum of Art and one in a series of scholarly catalogues raisonnés that the museum has undertaken to document its varied and far-ranging holdings. Because of the museum's distance from Eastern centers of art production and collection, its American holdings are not as well known to scholars and the general public as are those of its Eastern counterparts. This volume aims to rectify that situation.

Since 1913, when the fledgling Los Angeles Museum of History, Science, and Art opened its newly completed building, American art has played a role central to the museum's identity and development. From its earliest days an active schedule of changing exhibitions was devoted to contemporary American art, and for many decades American art constituted the core of the museum's collection, which until recently was the largest of its kind on the West Coast. In 1916 the museum purchased its first American painting, George Bellows's *Cliff Dwellers*, a work now considered one of the icons of American art. Through the generosity of its first major patron, William Preston Harrison, the museum continued through the 1920s and 1930s to acquire the finest examples of contemporary American paintings and watercolors by nationally renowned artists. Paintings by Southern California artists, many of them award-winners in exhibitions held at the museum, also entered the collection. A number of patrons have donated historically significant works over the years, and after the art department separated from the history and science sections of the museum to form the Los Angeles County Museum of Art in 1965, the American art collection became an independent department with its own curator and the museum made a commitment to building a representative collection spanning Colonial times to 1940. As a result, the museum now has over three hundred paintings, sculptures, and watercolors, constituting a survey of the major developments in American art up until World War II as well as a representative sampling of the best of early California art.

In the past quarter-century scholarship in the field of American art history has come of age. During the past decade various public institutions began to document and publish their American art holdings. Many such collection catalogues were encouraged by the support of the Henry Luce Foundation. In late 1980 the foundation established the Luce Fund for Scholarship in American Art to assist museums with significant collections of American art. Two years later the Los Angeles County Museum of Art became one of those to benefit from the Luce Foundation's generosity, and this volume is the result. On behalf of the trustees of the museum I would like to express our appreciation to the Henry Luce Foundation for its support. The beauty and usefulness of the volume has been greatly enhanced by additional color plates generously underwritten by the museum's American Art Council and color plates of California works of art funded by contributors led by James Ries, who are listed in the authors' acknowledgments. The dedication of editor Joseph N. Newland deserves special recognition.

The catalogue was written by Ilene Susan Fort, associate curator of American art, and Michael Quick, curator of American art, both established scholars in their field. I would like to commend them for their diligent research and thoughtful text.

Preface and Acknowledgments

Ilene Susan Fort
Michael Quick

This catalogue documents the paintings, sculptures, and watercolors in the Los Angeles County Museum of Art's collection of historical American art. Works included date from before 1940 with two exceptions: representational works created after 1940 by artists who came to prominence in the preceding years and prizewinning watercolors by members of the California Water Color Society from the period 1930 to 1954. The latter is the only such collection in a public institution. Some artists included here are also represented in the museum's collection by later works or works in different media; pastels, drawings, and prints are omitted as are works made by immigrant artists before they came to the United States. No works that entered the collection after December 31, 1987, have been included.

The introduction provides a general history of the museum's collection of American art, and the special nature of the watercolor holdings is explained in a brief note preceding that section of the catalogue. Owing to the strength of the museum's holdings in works by Southern California artists and by visitors to the area, more detailed biographical information is provided for the regional artists, and the visitors' associations with Southern California are pointed out. Unfortunately documentation on these artists was hampered somewhat by recent major fires in two local archives with unique holdings, the Hollywood and Los Angeles Central Public Libraries.

Entries are divided into paintings, sculptures, and watercolors. Brief biographies of the artists and suggestions for further reading are provided for the general reader and as a background to the discussion of the individual works. The entries open up central questions in the interpretation of each work, providing biographical and historical context and/or iconographic and stylistic analysis. The listings of previous owners, exhibitions, and references to art-related literature aim toward completeness.

A generous grant from the Luce Fund for Scholarship in American Art, a program of the Henry Luce Foundation, awarded in 1982 enabled the American Art department to undertake a thorough and systematic study of the collection and partially underwrote this publication. We would like to express our appreciation to the Luce Foundation for the initial funding of the project. We would like also to thank the museum's American Art Council for underwriting the cost of additional color plates, and thank James Ries, who was instrumental in raising funds for color reproductions of California works of art; these were made possible by donations from Buck Fine Arts, Daniel Hansman/Marcel Binh, William A. Karges Fine Art, Jack Kenefick, Orr's Gallery and Group, Petersen Galleries, Millard Sheets Designs, Stary-Sheets Gallery, George Stern Fine Arts, and James and Linda Ries.

The cataloging of the collection was begun with the encouragement of Earl A. Powell III, himself a scholar in the field of American art. We would like to thank him as well as the museum's board of trustees for their support. The research and the beginnings of a catalogue were started by assistant curator of American art Nancy D. W. Moure before she left the museum in 1983. The project was continued by Ilene Susan Fort, who became assistant curator in 1983 and is now associate curator. She researched the collection and oversaw additional staff who conducted primary research and checked the accuracy of the final text. The contribution of research assistant Dana Sebrée was essential, and we would like to express our heartfelt gratitude for her thoroughness and conscientiousness. Thanks also are due Philip Armstrong, Trudi Casamassima,

Mary-Alice Cline, and Gregory A. Dobie for their assistance. The secretaries in the American Art department who worked on the catalogue in different stages were Ondine Jarl, Jennifer McNeil, Lisa Murphy, Lisa Weber, and Sheila White. The final text was written by Ilene Susan Fort and Michael Quick, curator.

Documenting a museum's collection requires years of extensive research and cannot be accomplished by any one department. We would like to express our appreciation to our colleagues Leslie Greene Bowman, curator of decorative arts; Susan L. Caroselli, associate editor and formerly associate curator of decorative arts; Edward Maeder, curator of costumes and textiles; Constantina Oldknow, former associate curator of ancient and Islamic art; Scott Schaefer, former curator of European paintings; Robert T. Singer, curator of Japanese art; and Nancy Thomas, associate curator of ancient and Islamic art, for sharing their expertise in their respective fields, and to Stephanie Barron, curator of twentieth-century art, and Bruce Davis, curator of prints and drawings, for reading drafts of portions of the text. Thanks also go to Pieter Meyers, head of the Conservation Center, and William Leisher, former head; to paintings conservators Joseph Froenek and the late David Kolch and their staff; to paper conservator Victoria Blyth-Hill; and to Paul Hernandez and his coworkers in the Technical Services department for assistance in examining each work of art and ascertaining its materials. We are indebted to the museum's registrar, Renee S. Montgomery, and her staff, in particular Anne Smith, for clarifying many details on the history of the collection, and Eleanor Hartman and the staff of the Art Research Library, especially Anne Diederick, for obtaining copies of countless hard-to-find journal articles, books, and ephemeral materials.

Over the years many individuals and institutions assisted in our research. A number of the artists and members of their families were able to provide us with remembrances about their lives and specific works of art in the museum's collection. We would like to thank the following artists for their cooperation: Ben Abril, Standish Backus, Rex Brandt, the late Nick Brigante, Paul Cadmus, the late Phil Dike, Neil Fujita, the late Robert Gwathmey, Bendor Mark, J. Jay McVicker, Richards Ruben, the late Millard Sheets, and the late Jan Stussy. The late Nancy Hale Bowers, the late Conrad Buff III, Jacques Davidson, and David Soyer furnished much appreciated information about their respective fathers, Helen Lundeberg on her husband, Lorser Feitelson, Velma Hay-Messick on her husband, Ben Messick, Wesley Halpert on Samuel Halpert, Janet J. Le Clair on Robert Henri, and Louis Ritman's family on him.

We are indebted to several divisions of the Smithsonian Institution. The resources of the Archives of American Art are essential to any research in the field. The staffs of the main office and the various branches offered advice, assistance, and answers to our many questions. A special note of gratitude must go to Stella Paul, former director of the Southern California branch of the Archives in San Marino, and her staff, Margaret Nelson and Barbara Wilson, for facilitating our research on numerous occasions. The staff of the Inventory of American Paintings was also most cooperative.

Vital too was the help of our sister institution, the Los Angeles County Museum of Natural History, whose registrar, Lella F. Smith, delved into their files to answer our questions. The assistance of Gretchen Sibley, the archivist of the Museum of Natural History, who almost single-handedly ensured that documents on the early years of the Los Angeles Museum of History, Science, and Art would be saved, was invaluable. She made known to us the existence of wonderful scrapbooks containing newspaper reviews that document each of the museum's exhibitions from its opening in 1913 through the years of the Great Depression. Without these scrapbooks documentation on the paintings acquired during the early years would not have been as thorough. Her friendliness and many anecdotes made research at our sister museum all the more enjoyable.

Much of the detailed information in this catalogue was derived from registrars' records, catalogues, and archival and library materials available only in other institutions. It is not possible to acknowledge individually all the people in those museums, libraries, historical societies, and associations who provided information, but among those who came to our aid, many on repeated occasions, were: Albright-Knox Art Gallery, Buffalo, Laura Catalano, Marjorie J. Huston, Annette Masling; American Academy and Institute of Arts and Letters, New York, Nancy Johnson; Amon Carter Museum, Fort Worth, Tex., Carol Clark; Architectural League, New York, Alison Zucrow; Art Gallery of Hamilton, Ont., Canada, Lorna Somers; Art Gallery of Ontario, Toronto, Catherine Li Spence; Art Gallery, Vassar College, Poughkeepsie, N.Y., Sandra S. Phillips; Art Institute of Chicago, Courtney Connel, Althea H. Huber, Mary McIsaac, Mary Mulher; Art Students League of New York; Aurora (Ill.) Historical Society, John J. Jaros; Baltimore Museum of Art, Frances Klapthore Andrews; Bayerische Staatsbibliothek, Munich, Dr. Junginger;

Belmont, Gari Melchers Memorial Gallery, Falmouth, Va., Richard S. Reid; Berkshire Athenaeum Public Library, Pittsfield, Mass., Ruth T. Degenhardt; Berkshire Museum, Pittsfield, Mass., Debra Balken; Bethesda (Md.) Art Gallery, Betty Minor Duffy; Boston Public Library, Janice H. Chadbourne; Brandywine River Museum, Chadds Ford, Pa., Gene E. Harris; Brooklyn Museum, Sarah Faunce, Barbara Dayer Gallati, Thea K. Hunter; Brown University Library, Providence, R.I., Mrs. Kenneth A. Lynch; Buffalo and Erie County (N.Y.) Historical Society, Yvonne M. Foote; Butler Institute of American Art, Youngstown, Ohio, Ed Amatore; California Historical Society, San Francisco, Pamela Seager, Judy Sheldon, Gerald D. Wright, and in the Los Angeles branch, Daniel Hoye; California Institute of the Arts, Valencia, Evy White Horigan, John M. Orders; B. Gerald Cantor Art Foundation, New York, Michele Fraser Labozzetta; Century Association, New York, Andrew Zaremba; Chaffey Community Art Association, Ontario, Calif.; Chicago Historical Society; Cincinnati Art Museum, Mona L. Chapin; City University of New York, Graduate School and University Center, William H. Gerdts, Marlene Park, H. Barbara Weinberg; Cleveland Museum of Art, Jean Addison, Linda Jackson; Colby College, Miller Library, Waterville, Maine, Patience-Ann M. Leuk; Collins Art Gallery, North Falmouth, Mass., Douglas B. Collins; Columbia University, New York, Janet Parks, Allen Staley; Columbus (Ohio) Museum of Art, Maureen Alvim, Christy Putman; Corcoran Gallery of Art, Washington, D.C., Katherine M. Kovacs, Rebecca Tiger; Dartmouth College Library, Hanover, N.H., Philip N. Cronenwett; Delaware Art Museum, Wilmington, Rowland Elzea; Denver Public Library, Eleanor M. Gehres; Des Moines Art Center, Phemie Conner; Detroit Institute of Arts, Nancy Rivard Shaw, Maureen A. Siler; Episcopal Church Center, New York, Avis E. Harvey; Everson Museum of Art, Syracuse, N.Y., Karin Lee; Lyman Field and United Missouri Bank of Kansas City, n.a., cotrustees of Thomas Hart and Rita P. Benton Testamentary Trusts, Kansas City, Mo., Stephen J. Campbell; Frick Art Reference Library, New York, Paula L. Pumplin, Helen Sanger; Friends of the Royal Society of Painters in Water Colours, Bankside Gallery, London; Galleries of the Claremont (Calif.) Colleges, Marjorie Harth Beebe, Kay Koeninger; Gallery of Art, Washington University, Saint Louis, Joseph D. Ketner II; J. Paul Getty Museum, Malibu, Calif.; Haggin Museum, Stockton, Calif., Joanne Avante; Hirshhorn Museum and Sculpture Garden, Smithsonian Institution, Washington, D.C., James W. Mahoney, Rebecca Zurier; Historical Sites, Southwestern Nova Scotia, Annapolis Royal, N.S., Canada, F. G. McGill; Historical Society of Pennsylvania, Philadelphia, Carol Hevner, Louise T. Jones; Holland Society of New York, Linda Rolufs; Grace Hudson Museum, Ukiah, Calif.; Herbert F. Johnson Museum of Art, Cornell University, Ithaca, N.Y., Margaret Anne Tockarshewsky; Jonathan Club, Los Angeles, Sally R. Guthrie; Joslyn Art Museum, Omaha, Mrs. Kenneth A. Anderson; La Farge Catalogue Raisonné, Henry A. La Farge, James L. Yarnall; La Jolla (Calif.) Museum of Contemporary Art, Erika Torri; Lake Tahoe Historical Society, South Lake Tahoe, Calif., Linda Mendizabal; Maier Museum of Art, Randolph-Macon Woman's College, Lynchburg, Va., Ellen Schall; Mariner's Museum, Newport News, Va., Charlotte Valentine; Massachusetts College of Art, Boston, John Baker; Massachusetts Historical Society, Boston, Ross Uruquhart; Mattatuck Museum, Waterbury, Conn., Verna A. Gilson; Memorial Gallery of the University of Rochester, N.Y., Sandra Markham; Metropolitan Museum of Art, New York, Doreen Bolger, Donna Hassler, Joan Mertens, Jennifer Roundy, Lewis I. Sharp; Milwaukee Art Museum, Diane Driessen; Minneapolis Institute of Arts, Marilyn Bjorkland, Moira Harris; Monroe County Historical Society, Stroudsburg, Pa., James Crawford; Munson-Williams-Proctor Institute, Utica, N.Y., Sarah Clark-Langager; Musée national d'art moderne, Centre Georges Pompidou, Paris, Messody Zrihenj; Museum and Library of Maryland History, Baltimore, Stiles T. Colwill; Museum of Art, Rhode Island School of Design, Providence, R.I., Luann M. Skorupa; Museum of Fine Arts, Boston, Edward S. Cooke, Jr., Erica E. Hirschler; Museum of Fine Arts, Springfield, Mass., Martha J. Hoppin, Nancy L. Swallow; Museum of Modern Art, New York, Barbara C. Matilsky, Clive Phillpot; Museum of the City of New York, Jan Seidler Ramirez; National Academy of Design, New York, Abigail Booth Gerdts, Barbara S. Krulik; National Archives, Public Building Service, Office of Design and Construction, Washington, D.C., William R. Lawson, the late Karel Yasko; National Maritime Museum, Greenwich, England, Richard Ormond; National Museum of American Art, Smithsonian Institution, Washington, D.C., the late Adelyn Breeskin, Elizabeth Broun, George Gurney, Christine Hennesey; National Portrait Gallery, Smithsonian Institution, Washington, D.C., Lillian Miller, Robert G. Stewart; Newberry Library, Chicago, Diana Haskell; New England Historical Genealogical Society, Boston, Pauline King; New Orleans

Museum of Art, Vallerie Loupe Olsen; Newport Harbor Art Museum, Newport Beach, Calif., Cora Lee Gibbs; New-York Historical Society, Mary Carey; New York Public Library; Norton Gallery and School of Art, West Palm Beach, Fla., Esther Grapes, Bruce Weber; Norton Simon Museum, Pasadena, Calif., Andrea Clark, Judy Anderson Mowinckel, Helene L. Ratski; Oakland Museum, Mary Bisbee, Barbara Bowman, Christine Doran; Occidental College, Los Angeles, Robert Hansen; Old Dominion University, Norfolk, Va., Betsy Fahlman; Onondaga Historical Association, Syracuse, N.Y., Richard N. Wright; Parrish Art Museum, Southampton, N.Y., Norman Loehner; Pennsylvania Academy of the Fine Arts, Philadelphia, Frank H. Goodyear, Jr., Cheryl Leibold; Philadelphia Maritime Museum, Ann Wilcox; Phillips Collection, Washington, D.C., Martha Carey, Grayson L. Harris; Portland (Ore.) Art Museum, Jack Rutland; Prendergast Catalogue Raisonné Project, Williams College Museum of Art, Williamstown, Mass., Gwendolyn Owens; Queens College of the City University of New York, L. M. Chisolm; Rochester (N.Y.) Institute of Technology, Gladys Taylor; Roman Bronze Works, New York, Phillip Schiavo; Royal Academy of Arts, London; Saint Louis Art Museum, Patricia L. Adams, Doris C. Sturzenberger; San Diego (Calif.) Historical Society, Bruce Kamerling; United Methodist Church, General Commission on Archives and History, Madison, N.J., Gregory Strong; United States Department of the Interior, National Park Service, Yellowstone National Park, Barbara Beroza, Timothy R. Manns; Unity Church, North Easton, Mass., Richard C. Meyers; University of California, Berkeley, Bancroft Library, Annegret Ogden; University of California, Los Angeles, Robert Brown; University of California, Redlands, Art department; University of Delaware, Newark, John Sloan Archives; University of King's College, Halifax, N.S., Canada, Jane Trimble; University of Massachusetts, Amherst, Martha Clark, Martha J. Hoppin; University of Michigan Museum of Art, Ann Arbor, Hilarie Faberman; University of Minnesota, Minneapolis, Karal Ann Marling; University of New Mexico, Albuquerque, Teresa A. Prater; University of Rochester, N.Y., Sandra Markham; University of Texas, Austin, Harry Ransom Humanities Research Center, Cathy Henderson; Virginia Museum of Fine Arts, Richmond, Lisa Hummel Hancock; Wadsworth Atheneum, Hartford, Conn., Muriel A. Thompson; Western Heritage Museum, Omaha, Jane G. Murry; Woodstock (N.Y.) Artists Association, Woodstock, Sam Klein; Worcester (Mass.) Art Museum, Kathy Berg, Sally R. Freitag, Susan Strickler; and Yale University Library, New Haven, Conn., Judith A. Schiff.

Many of the works of art in the museum's collection came to Los Angeles directly from the artists or their dealers, while others have been handled by various galleries. The following commercial art galleries and dealers were most helpful, especially in shedding light on the provenances of specific works: ACA Galleries, New York, Meredith Sutton, Amy J. Wolf; H. V. Allison Galleries, Inc., New York, Glenn C. Peck; Babcock Galleries, New York, Michael St. Clair; Berry-Hill Galleries, New York, Bruce Chambers; John Burrows, London; Child's Gallery, Boston, Galena Gorokhoff; Coe Kerr Galleries, Inc., New York, Warren Adelson; Conner-Rosenkranz, New York, Janis Conner; Graham Gallery, New York, Wendy Weaver; Grand Central Art Galleries, New York, Edith Roach; Hammer Galleries, New York, Patrick O'Connor; Hirschl & Adler Galleries, Inc., New York, Kathleen Burnside, M. P. Naud; Kennedy Galleries, New York; M. Knoedler & Co., New York, Nancy Little; Kraushaar Galleries, New York, Katherine Kaplan, Antoinette M. Kraushaar, Carole Pesner; Meredith Long & Company, Houston, Tex.; James Maroney, Inc., New York; Midtown Galleries, Inc., New York, Bridget L. Moore; Toby C. Moss Gallery, Los Angeles; Steve Newman Fine Arts, Stamford, Conn., Daniele Delouya-Newman; The Old Print Shop, Inc., New York, Kenneth M. Newman; Old West Publishing Co., Denver, Stephen L. Good; Frank Perls Archives, Pasadena, Calif., Joan Q. Hazlitt; Rowe Fine Arts, Inc., Chicago, Ill., Harold M. Rowe; Marvin Sadik, Falmouth, Maine; Schoelkopf Gallery, New York, Robert Schoelkopf; M. R. Schweitzer Gallery, New York; Valley House Gallery, Inc., Dallas, Cheryl S. Vogel; Vose Galleries of Boston; Carol Walker Aten, Robert C. Vose, Jr.; and Zabriskie Gallery, New York, Pamela Dickson, Virginia Zabriskie.

We would like to express our appreciation to a number of scholars and other individuals who shared their knowledge and expertise on individual artists: Mildred Albronda, Mrs. Merrill P. Brooks, Sarah Burns, Taylor Coffman, Mrs. Raymond G. Crawford, Michael B. Croyden, Stanley L. Cuba, David B. Dearinger, Elizabeth Waldo-Dentzel, William Dick, Fredrick S. Dickson, Lord and Lady Eccles, Julian Ganz, Jr., Doris Harris, Mrs. Robert Hays, Jr., Daniel S. Hodgson, Edward Sprague Jones, Ronald M. Lawrence, Rae Alexander-Minter, Ronald G. Pisano, Henry M. Reed, Mrs. Berny Shulman, Will South, Ila Weiss, and Anthony R. White.

The realization of this publication was

made possible only through the assistance of many people at the Los Angeles County Museum of Art, beginning with Mitch Tuchman, managing editor, and Deenie Yudell, head designer. The skill of Peter Brenner and his staff of photographers ensured the accuracy of all the reproductions. Nancy Carcione ably assisted in preparing the manuscript. Kathleen Preciado and Joseph Newland edited the text; the authors appreciate their expertise, dedication, cooperation, and good humor. Joseph Newland took over the editing in mid-course, a difficult task for any editor, and his close involvement and devotion to the project assured that the catalogue would be realized. And Lilli Cristin created a book design that handsomely satisfies the special needs of a collection catalogue.

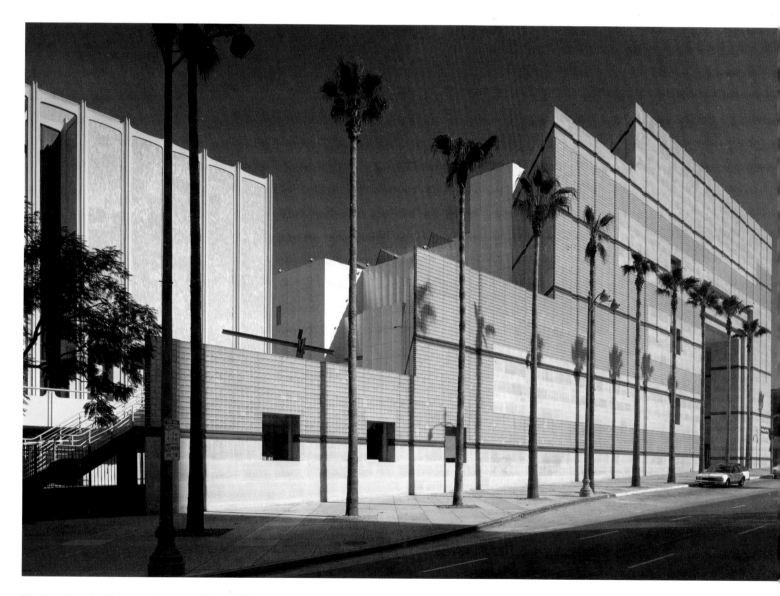

The Los Angeles County Museum of Art, 1989.
The facade along Wilshire Boulevard is that of the
Anderson Building, opened in 1986, Hardy Holzman
Pfeiffer, architects. Visible on the left is the
Ahmanson Building, 1965, in which the American
art collection is housed.

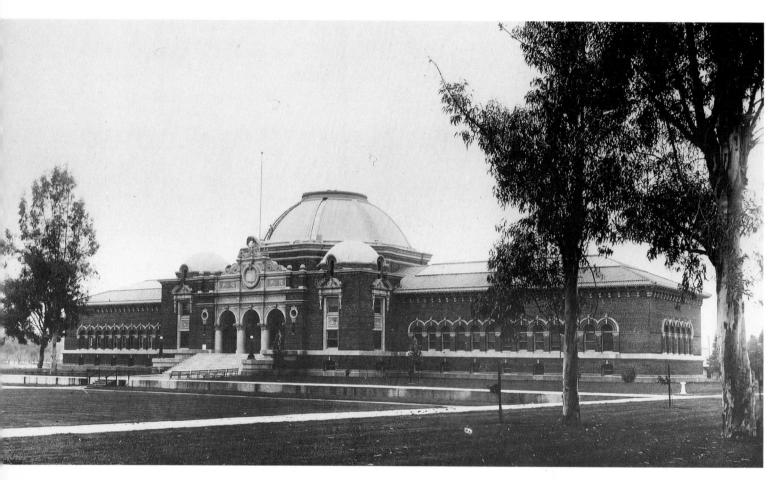

The Los Angeles Museum of History, Science, and Art, Howard and Munsell, architects, in May 1914. The Mr. and Mrs. William Preston Harrison Collection of American Art originally was hung in the rotunda. (Historical photographs courtesy Los Angeles County Museum of Natural History.)

Introduction

*T*he American art collection catalogued herein is the oldest of the museum's collections and the one most central to its historical identity.

Joint plans of the state, city, and county for the development of a cultural center and park in the area of the city's current Exposition Park gave rise to the founding of the Los Angeles Museum of History, Science, and Art in 1910. Ground was broken there that year for its building, which officially opened on November 6, 1913. That organization was the parent of the present Los Angeles County Museum of Art, which, as an independent museum, opened its own building in the city's Hancock Park in April 1965. Unlike some museums that are founded with the gift of a major collection, the Los Angeles Museum of History, Science, and Art was created without any collection in its Art division. The museum's founding can be understood as an expression of pride in the rapidly growing metropolis: the museum's grand opening in 1913 was part of the celebration of the completion of the Owens River aqueduct, which assured the city's expansion. Moreover, it can be seen as a competitive gesture in the emerging rivalry among the leading cities along the West Coast, part of the same cultural self-assertion that generated the Panama-Pacific International Exposition in San Francisco in 1915 and the Panama-California Exposition in San Diego the following year. (It would be 1925 before Los Angeles would be able to respond to these challenges with its own *Pan-American Exhibition*.) However, organized art activity had been available in Los Angeles for some years through the artists' clubs and the influential women's clubs. The Fine Arts League, an offshoot of the Federation of Women's Clubs, was placed in charge of the programs of the Art division of the new museum. The Art division opened with a loan exhibition of contemporary and older paintings from local collections. It was followed by a kaleidoscope of rapidly changing exhibitions, primarily of contemporary American paintings.

Given the division's very limited budget, it is not surprising that the artists of Los Angeles dominated the exhibition schedule. Through the 1940s there were few significant artists of Los Angeles who did not have at least one solo show at the museum. In 1914 it became host to the regular exhibitions of the California Art Club and in 1921 to those of the California Water Color Society, organizations primarily of regional artists despite their names. Gifts and purchases of paintings and works on paper by the city's artists, beginning at an early date and continuing to the present, have added up to the most important institutional holding of the art of Southern California. Particularly in the 1930s special efforts were made to build this collection.

There is nevertheless considerable evidence that, from its beginning, the Art division saw a major part of its mission to be to bring contemporary American art from other parts of the country to Los Angeles. Besides group exhibitions of artists from elsewhere it held exhibitions of the work of Robert Henri in 1914 and of George Bellows, Louis Kronberg, and George Inness in 1915, and a calendar of future exhibitions printed in 1914 announced (unrealized) plans for exhibitions of the work of Gardner Symons, William Glackens, John Sloan, Ernest Lawson, George Luks, Maurice Prendergast, Guy Pène du Bois, Karl Anderson, and Allen Tucker, among others. The young Art division also announced ambitious plans for an annual, juried, competitive exhibition of contemporary American painters, with several purchase prizes. The first and only exhibition in the projected series was held from June 15 to September 30, 1916, and the museum purchased from it paintings by Daniel Garber, Richard Miller, and William Wendt. (Its first

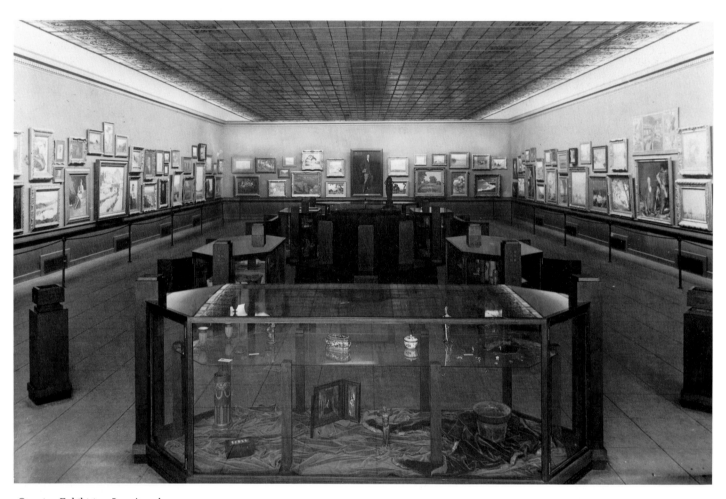

Opening Exhibition, Los Angeles
Museum of History, Science, and
Art, November 1913.

purchase of a painting, on September 6, 1916, had been George Bellows's *Cliff Dwellers,* painted in 1913.) Another early purchase was *Boy with a Cod* by the Northern California painter Armin Hansen, acquired in 1919 from the *Exhibition of Paintings by a Group of Artists of San Francisco and Vicinity.* Although the museum's plans for exhibitions and acquisitions of paintings by leading eastern artists were not realized because of the disruptions of the First World War and continuing financial constraints, it should not be thought that Los

George Bellows's *Cliff Dwellers,* 1913, was the first painting purchased by the museum.

Angeles was isolated from trends in eastern art. The city was visited before 1920 by leading artists such as Robert Henri, George Bellows, and Childe Hassam and in the following decades by a surprising number of the artists included in this catalogue, some of whom worked in this active art center, among them Thomas Hart Benton, Robert Philipp, Norman Rockwell, and Morgan Russell.

The museum's early interest in the national scope of American art was given new impetus in 1918 by the magnificent gift of the collection of Mr. and Mrs. William Preston Harrison, whose names appear frequently in this catalogue. The museum's collection essentially began with the Harrisons. Writing in 1930, Harrison recalled, "Twelve years ago, in a city of half a million, we were confronted with an unheard of opportunity—a new

museum, the proud possessor of precisely four permanent pictures. . . . This constituted the start of a really remarkable instance of building up a public art gallery, with the eyes of the world focused on the gradual development of a growing collection. . . ." As its first and for a long time its only major donor, as a supporter of the programs of the Art division during difficult decades, and as more or less the founder of the Museum Associates, the museum's major support group since 1938, Harrison easily could be said to have been the museum's greatest benefactor. He stated repeatedly that only the collection of a museum matters in the end, not the endless round of exhibitions. He was the first one to work toward building the museum's collection into something of national significance.

William Preston Harrison was the son of a mayor of Chicago and the brother of another that formed a collection of French paintings that he presented to the Art Institute of Chicago. At the time of his initial donation in 1918 and for several years after that William Preston Harrison indicated that he was legally a resident of Chicago and considered himself to be so, but he and his wife had been spending increasing amounts of time in Los Angeles and by 1920 were spending most of their time here. The original gift of twenty-eight paintings simply had been the collection they had formed for their own enjoyment in their home. Even while giving it, Harrison realized that not all the paintings were worthy of the museum, and he made provision for later substitutions of superior works by the same artists, or in other cases, even works by other artists judged to be more important. His concept was to choose for the museum's collection only "art that will last," meaning art that would stand the test of time and the judgment of future generations. Because he considered any individual's judgment to be imperfect in the area of contemporary art, Harrison established for himself the method of watching which artists were acquired for the collections of the older, established museums and which artists received prizes at the major annual and biennial exhibitions. He also limited himself at first to acquiring only the work of artists who were either members or associate members of the National Academy of Design. With the exception of William Wendt, who had strong Chicago ties and was a member of the National Academy, Harrison did not collect the work of local artists, and he even weeded out most of what had been a strong group of works by Taos artists among his original, Chicago-influenced collection. Hedging his bets in this way, Harrison hardly could avoid ending up with a very conservative collection for his day, representing the

William Preston Harrison, c. 1920s. His portrait painted by Wayman Adams may be found on page 301.

established artists and those working in a fashionable style. Still, to judge from the merciless and unceasing criticism he received from both public and press for his avant-garde collection of unknown artists, he seems to have been ahead of taste in Los Angeles.

Harrison threw himself into building the collection. He followed art events closely, knew the artists, visited them in New York City, Woodstock, and elsewhere, and liked to buy works directly from them when he could. He worked hard at making the collection as good as he could because, he often said, he knew it would be his monument. He was deeply interested in the collection and the welfare of the museum. The Harrisons made additional gifts at frequent intervals and lent other works, and William Preston Harrison made so many exchanges for the purpose of upgrading given examples that it is impossible to summarize the evolution of the collection. Although he stated in 1930 that he would not buy artists like Andrew Dasburg, Charles Burchfield, and Edward Hopper, he had lent his support to Stanton Macdonald-Wright and the Los Angeles modernists already in 1920. It would appear that his taste did evolve toward modernism judging from the composition of the collection of American watercolors he put together for the museum beginning in the late 1920s.

The years 1925 and 1926 were a turning point in Harrison's collecting for the museum. The Harrison paintings originally had hung in the main rotunda of the building in Exposition Park, with the understanding that, if an addition were built, one of the rooms was to be named permanently the Mr. and Mrs. William Preston Harrison Gallery of Contemporary American Art. (Reflecting his changing perceptions of the collection, in 1925 Harrison requested that the term *contemporary* be dropped from the name.) Harrison eagerly followed the planning and construction of the new wing, which began in 1919, and to celebrate its completion, he helped organize the *First Pan-American Exhibition of Oil Paintings,* which ran from November 27, 1925, to February 28, 1926. It turned out to be an important event for the art world of Los Angeles and also for the museum's collection, to which were added not only the purchase prize paintings—William Wendt's *Where Nature's God Hath Wrought,* John Carroll's *Parthenope,* Andrew Dasburg's *Tulips,* Guy Pène du Bois's *Shops,* and Diego Rivera's *Flower Day*—but also Bernard Karfiol's *Seated Figure* and Eugene Savage's *Recessional.* In 1926 Harrison gave ten more American paintings for the new gallery and then went to Europe, where he became interested in French art and sent back a group of forty-eight School of Paris water-

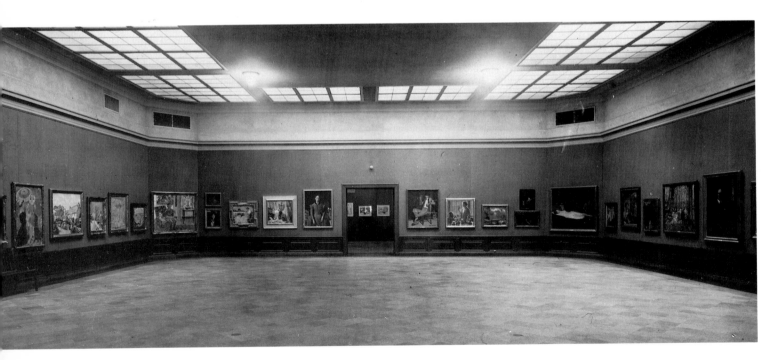

The Mr. and Mrs. William Preston Harrison Gallery of American Art, c. late 1920s. Visible on the walls are key works presently in the collection as well as works subsequently exchanged according to the Harrisons' wishes.

Worthington Whittredge's *A Home by the Seaside,* c. 1872, one of a large group of works from the William Randolph Hearst Collection now in the museum.

Mr. and Mrs. Allan Balch donated Frederick Freiseke's *In the Boudoir,* painted by 1914, a prizewinning painting at the Panama-Pacific International Exposition of 1915.

colors that he bought to form a new collection for the museum. He wrote from Europe that he felt that he had finished his collection of American art, unless possibly for a water-color room or a Childe Hassam room. He did assemble an impressive group of American watercolors for the museum and over time purchased a few more American paintings that were given or bequeathed, but after 1926 his resources went into French paintings and watercolors. Like the French works, the American watercolors he acquired during these years were strikingly more modernist than his collection of American paintings. Harrison's interest in the museum remained just as strong after 1926, as is witnessed by the crucial financial support he gave the Art division during the Great Depression.

With the receipt of the remainder of the collection following Mrs. Harrison's death in 1947, the final number of artworks contributed by the Harrisons, after all the deletions and substitutions, came to two hundred sixty-seven, including sixty-six American paintings and forty-eight American watercolors, thirty-four French paintings and eighty French watercolors, two paintings and one watercolor from other European countries, and a number of prints and drawings. Although Harrison worked hard to make his collection an ideal one, he provided in his deed of gift for the collection to be reviewed, beginning in 1956 and every ten years thereafter, by a jury of cura-tors from five specified museums who would vote for the elimination of inferior works, with the director of the Los Angeles Museum retaining the right to accept or reject their recommendations. Proceeds of all sales were to be reinvested in works for the Harrison collection. Harrison believed that this process

of winnowing over time must go forward, even though he foresaw the possibility that the collection would be so much reduced that it would fit into a much smaller gallery, even onto only certain walls of the gallery, or that just a few individual examples would remain. As a matter of fact the judgment of posterity has been much kinder than Harrison may have feared. Twenty-six of the original sixty-six American paintings and nineteen of the origi-nal forty-eight American watercolors remain. Among them are some of the museum's most highly prized works. Among the distinguished works purchased with proceeds from the sale of Harrison paintings are such paintings as Marsden Hartley's *The Lost Felice* and Rembrandt Peale's portraits of Mr. and Mrs. Jacob Koch.

However, the judgment of experts and the museum's staff immediately following Mrs. Harrison's death in 1947 was extremely unfavorable. The collection had fallen into dis-repute. The American collection (but not the French collection) was then judged to consist of paintings by artists who had no reputation at that time and of paintings of inferior quality by the few good artists. Just a small selection of it was moved to a modest second-floor gal-lery, and the original Harrison Gallery was used for special exhibitions—an ironic turn for the collection that had been intended to displace the centrality of special exhibitions in the museum's program.

The move of the Harrison paintings was announced as part of a reorganization of the American collection into a historical pro-gression from the eighteenth century to the present that was begun in 1948 and completed in early 1951. The museum that had been dom-inated by the Harrison collection during the

Winslow Homer's *Moonlight on the Water,* early 1890s/c. 1906, was in the important early gift of the Los Angeles collector and patron Paul Rodman Mabury (see page 308).

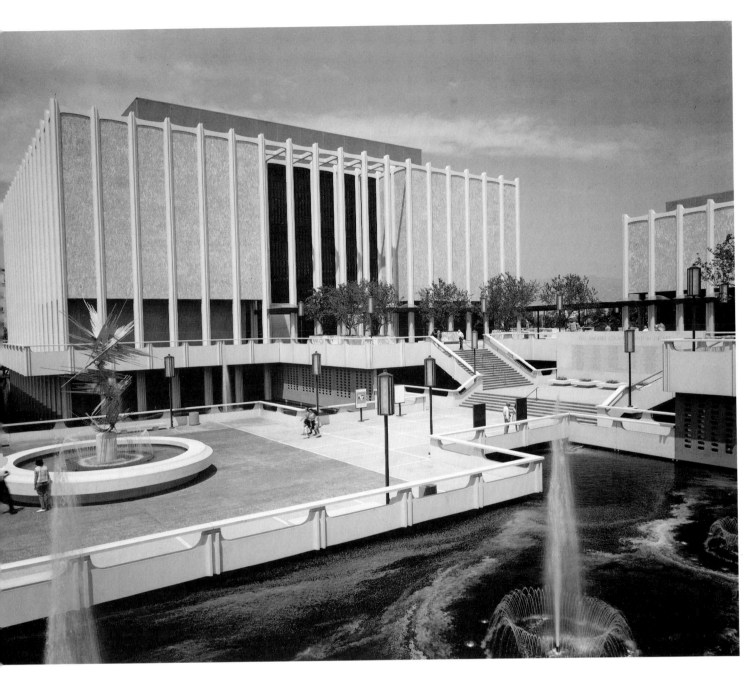

The Los Angeles County Museum of Art,
William L. Pereira & Associates, architects,
as it appeared when the art museum moved
into its own building complex in April 1965.

1920s and early 1930s had grown considerably and changed. By 1948 the Harrisons' founding gifts were a smaller part of a museum that saw itself as presenting a comprehensive permanent collection representing the entire history of art. From its earliest years, actually, the vast majority of accessions, mainly gifts to the collection, had been examples of the decorative arts, oriental art, and prints and photographs. Bequests in the late 1930s and early 1940s brought to the museum large groups of decorative arts and distinguished old masters. The numerous gifts during the late 1940s and early 1950s from the William Randolph Hearst collection were of decisive importance to the self-image of the museum by greatly expanding its coverage of ancient art, medieval and Renaissance decorative arts, and old master paintings. By the late 1940s the museum was organizing special exhibitions of old master paintings and had on its staff a curator of prints and drawings, a curator of decorative arts, and a curator of oriental art in addition to the curator of modern art, who also handled American art. These collections were displayed in a new wing in a series of galleries presenting the art of every nation and of every era from ancient times to the present.

The paintings of the Harrison collection and the early purchases of the museum now fit into this series of galleries and their historical perspective. They had undergone the perceptual change from being contemporary art to being historical art. Although by no means all phases of the history of American art were represented, it was easier to fit the American collection into a historical sequence because of its growth during the 1940s and its expansion beyond the boundaries of the Harrison collection, which was limited essentially to the period of about 1915 to 1925. The first important additions to that collection came in the bequest in 1939 of Paul Rodman Mabury, which, in addition to choice examples of the decorative arts and fine old master paintings, included nine American paintings, watercolors, and sculptures, among them George Inness's *October* and Winslow Homer's *Moonlight on the Water,* as well as Homer's outstanding watercolor *After the Hunt.* The collection of Mary D. Keeler, which came to the museum in 1940, included late nineteenth-century American paintings such as John S. Sargent's *Man Wearing Laurels,* William M. Chase's *Pablo de Sarasate: Portrait of a Violinist,* and George Fuller's *Sprite.* Among the large collection of Dr. Dorothea Moore, bequeathed in 1943, were Arthur B. Davies's *Pastoral Dells and Peaks* and Robert Henri's *Edna.* The bequest of Mr. and Mrs. Allan C. Balch, which so enriched the museum's collection in

other areas, included Frederick Carl Frieseke's *In the Boudoir.* Similarly, the William Randolph Hearst collection, among its other treasures given between about 1946 and 1952, added to the museum's American art collection Childe Hassam's *The Spanish Stairs,* Gari Melchers's *Writing,* Worthington Whittredge's *A Home by the Sea Side,* Frederic Remington sculptures, and a group of ship portraits. In 1946 works by Phillip Evergood and Robert Gwathmey were purchased with funds from the sale of artworks left to the museum by Mira Hershey. With the revival of interest in nineteenth-century American art some Hudson River school landscapes began to be given in the late 1940s and the 1950s.

The annual reports during these years lament the utter lack of acquisition funds aside from a few annual purchase awards. The collection was almost entirely shaped by collectors such as those named and by the donors who from time to time gave extremely important individual works, such as Mrs. Fred Hathaway Bixby's bequest in 1962 of Mary Cassatt's *Mother about to Wash Her Sleepy Child.* Valuable gifts and bequests have come from all parts of the community, not the least of them a wide range of gifts from the members of the entertainment community, including Billy Wilder, Clifton Webb, Ira Gershwin, Irving Mills, Merle Oberon, Ozzie and Harriet Nelson, Burt Lancaster, and Steve Martin.

A turning point in the development of the American collection came with the opening of the new buildings for the newly separated Los Angeles County Museum of Art in 1965. Early American art was identified at that time as one of the areas of greatest need and one that the trustees would endeavor to build. In an initial effort the museum purchased George Caleb Bingham's *A View of a Lake in the Mountains,* John S. Copley's *Portrait of Hugh Montgomerie, Later Twelfth Earl of Eglinton,* Gilbert Stuart's *Portrait of Richard Barrington, Later Fourth Viscount Barrington,* and John S. Sargent's *Portrait of Mrs. Edward L. Davis and Her Son, Livingston Davis.* An advocate of an expanded role for American art, Larry Curry became active with that collection while it still was at Exposition Park and organized exhibitions of American art in the new facility while still associate curator of modern art. He then became the museum's first curator of American art and served until 1971, Donelson Hoopes from 1972 to 1975, and Michael Quick since 1976. Nancy D. W. Moure was curatorial aide from 1968 to 1972 and then assistant curator of American art from 1972 to 1983; Ilene Susan Fort served as assistant curator from 1983 to 1987 and has been associate curator of American art since 1987.

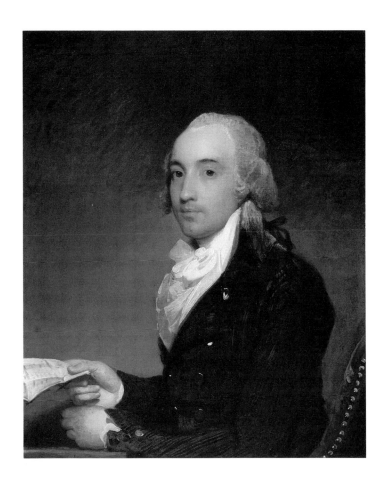

Among the earlier paintings bought by the art museum after it moved into its own quarters were Gilbert Stuart's *Portrait of Richard Barrington, Later Fourth Viscount Barrington*, c. 1793–94, and George Caleb Bingham's *A View of a Lake in the Mountains*, c. 1856–59.

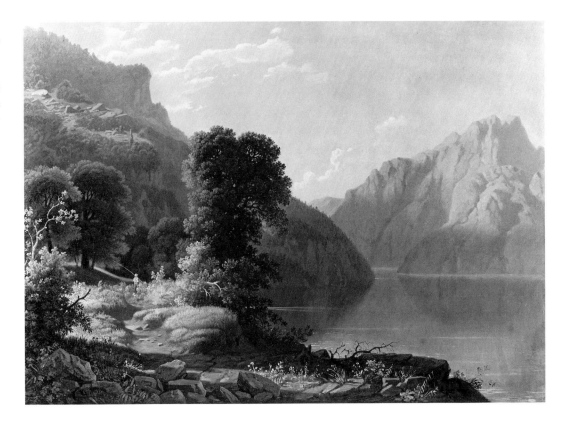

The paintings and sculptures purchased by the museum since 1965 form the backbone of its collection of eighteenth- and nineteenth-century American art. The collection assembled by gifts, bequests, and infrequent purchases before 1965 was strong in conservative painting from the first third of this century and in the regional school. The challenge facing curators since then has been to achieve for the collection a greater range and balance. In 1970 the collection's first large Hudson River school landscape was purchased, Jasper F. Cropsey's *Sidney Plains with the Union of the Susquehanna and Unadilla Rivers;* it was followed by Thomas Cole's *L'Allegro* in 1974, Sanford R. Gifford's *October in the Catskills* in 1977, and Cole's *Il Penseroso* in 1980 (reuniting Cole's long-separated pair of landscapes). The historical range of the collection was greatly extended by the purchases in 1968 of the Copley and Stuart already mentioned, portraits by John Smibert and Rembrandt Peale in 1978, a portrait by Henry Inman and a second, American-period Copley portrait in 1985, and a portrait by John Hesselius in 1986. New artists and types of painting were added with the purchase of a history painting by Emanuel Leutze in 1976 and another by Benjamin West in 1982 and the purchase of an early genre painting by Allen Smith, Jr., in 1981. An effort has been made to extend a limited group of sculptures with the purchase of early works by John Quincy Adams Ward in 1977, William Wetmore Story and Randolph Rogers in 1978, Arthur Putnam in 1984, Thomas Ball and Frederick MacMonnies in 1986, and Charles Henry Niehaus in 1987.

These acquisitions, so central to the present collection, were made possible by an exceptional level of individual generosity, in particular by the support of Mr. and Mrs. Fred A. Bartman, Jr., Mr. and Mrs. Willard G. Clark, Mr. and Mrs. Julian Ganz, Jr., Mr. and Mrs. Alan D. Levy, Mr. and Mrs. John M. Liebes, Dr. and Mrs. Matthew S. Mickiewicz, Mr. and Mrs. Charles C. Shoemaker, and Mr. and Mrs. J. Douglas Pardee. The support groups of the museum also have made important acquisitions possible. The Art Museum Council purchased John S. Sargent's watercolor *Rose-Marie Ormond Reading in a Cashmere Shawl* in 1972 and contributed toward the purchase of Thomas Cole's *L'Allegro* in 1974 and of John S. Copley's *Portrait of a Lady* in 1985. Since its founding in 1973 the American Art Council, the official support group of the American art department, has made possible the purchase of Elihu Vedder's *Japanese Still Life,* Allen Smith, Jr.'s *The Young Mechanic,* Reginald Marsh's *Third Avenue El,* Henry Inman's *Portrait of Mrs. James W. Wallack, Sr.,* and Frederick Mac-Monnies's *Young Faun and Heron,* and also was the largest contributor toward the acquisition of Copley's *Portrait of a Lady.* In the case of the most important acquisitions, an extraordinary group effort was necessary. Mr. Edward W. Carter recognized the exceptional importance of Winslow Homer's *The Cotton Pickers* and led the heroic effort to acquire it in 1977, himself contributing and also enlisting the aid of fourteen of his fellow trustees. Mr. Julian Ganz, Jr., likewise contributed to and led the effort in 1984 and 1985 to acquire another of the museum's most outstanding masterpieces, John S. Copley's *Portrait of a Lady.*

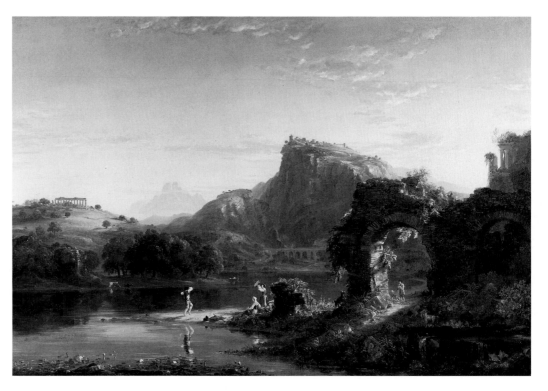

Thomas Cole's *L'Allegro,* 1845, was the first of a pair of paintings to enter the museum's collection; it was followed six years later by its pendant, *Il Penseroso,* 1845, from which it had been separated since 1918.

Another significant source of funds for the purchases of the late 1970s and early 1980s was the sale of objects from the collection. The first large sale was in 1965, in connection with the move to the new museum building. The largest of the sales was in 1977 and another significant group of paintings was sold in 1985, with additional items sold in 1982, 1985, and 1986. The collection that had been accumulated at the museum from gifts and bequests over so many years contained inauthentic paintings, duplicate material, small or decorative paintings more suitable for a home than for a museum, and serious imbalances of coverage and quality. The deaccession sales were meant to eliminate works that were not of museum quality and to use the proceeds of the sales to acquire other works in areas not represented in the collection. Important works indeed have been added to the collection through this process, which, after such large-scale selling, certainly has run its course.

Unfortunately, one can see in retrospect that the collection at the same time has suffered certain irreplaceable losses, particularly in the area of Southern California painting, a school now so much better understood and more highly valued.

Along with the purchases, important gifts continued to add to the collection's depth and stature. The collectors who were most generous with gifts to the collection during the late 1960s and into the mid-1970s were Mr. and Mrs. Will Richeson, Jr., with gifts such as Daniel Huntington's *Philosophy and Christian Art,* David Neal's *After the Hunt,* and Ralph Albert Blakelock's *Landscape with Trees,* among numerous others, and Mr. and Mrs. Julian Ganz, Jr., with gifts such as George Baker's *Portrait of Children,* Edmund Tarbell's *Mrs. George Putnam and Her Daughters,* and Emil Carlsen's *Still Life: Brass Bowl, Ducks, Bottles,* among others. Individual gifts of great distinction were received throughout the period from other collectors and valued friends, among them, Mr. and Mrs. Sidney Avery, Mr. B. Gerald Cantor, Mr. Richard W. Foster and his family, Mr. and Mrs. Herbert M. Gelfand, Mr. and Mrs. Robert B. Honeyman, Jr., Dr. and Mrs. Ronald M. Lawrence, Dr. and Mrs. Matthew S. Mickiewicz, Mr. and Mrs. Hoyt S. Pardee, and Dr. and Mrs. Herbert B. Sussman.

The collection continues to grow, but even as catalogued here it represents a major holding in the area of American art. In spite of the effort to build up its earlier sections with important examples, it remains primarily a collection of conservative, early twentieth-century art. Its single greatest point of distinction is its collection of Southern California artists, who are represented by their masterpieces as painters and watercolorists.

The future of the collection still rests in the hands of private collectors. Even as the museum has purchased more American art than ever in its past, the number and quality of the community's private collections of American art have grown even faster. Formally and informally promised to the museum are collections of Hudson River school paintings, American impressionism, Ash Can school paintings, Southern California paintings, and other important individual works. When these gifts and bequests eventually come to the museum, its American art collection truly can be said to be among the country's most important.

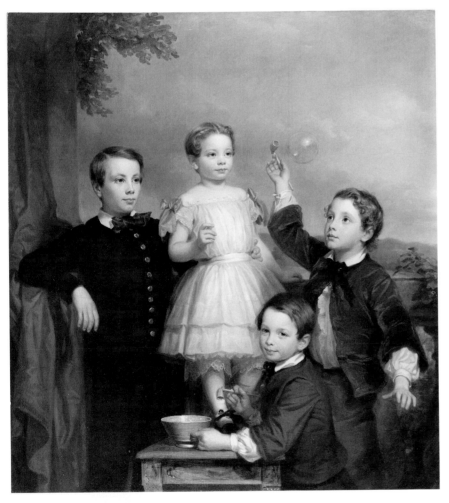

George Baker's *Portrait of Children,* 1853, the gift of Jo Ann and Julian Ganz, Jr., reflects the interest in historical American art that began to increase among collectors in Los Angeles during the 1970s.

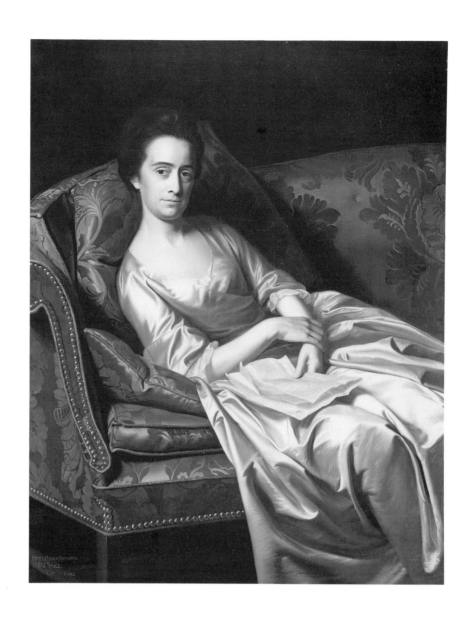

John S. Copley's *Portrait of a Lady*, 1771, and Winslow Homer's *The Cotton Pickers*, 1876, were two of the most important works to enter the collection during the 1970s and 1980s.

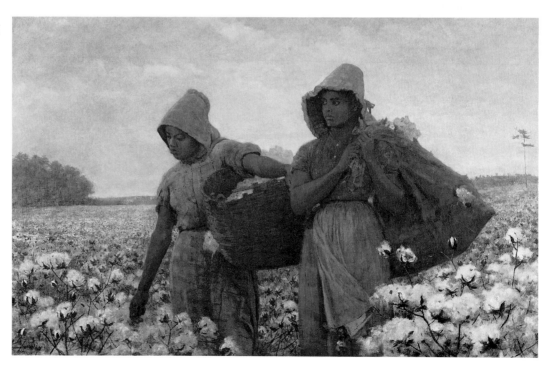

Gallery installation of mid-nineteenth-century
American art, 1990.

Gallery installation of turn-of-the-century American
art, 1990.

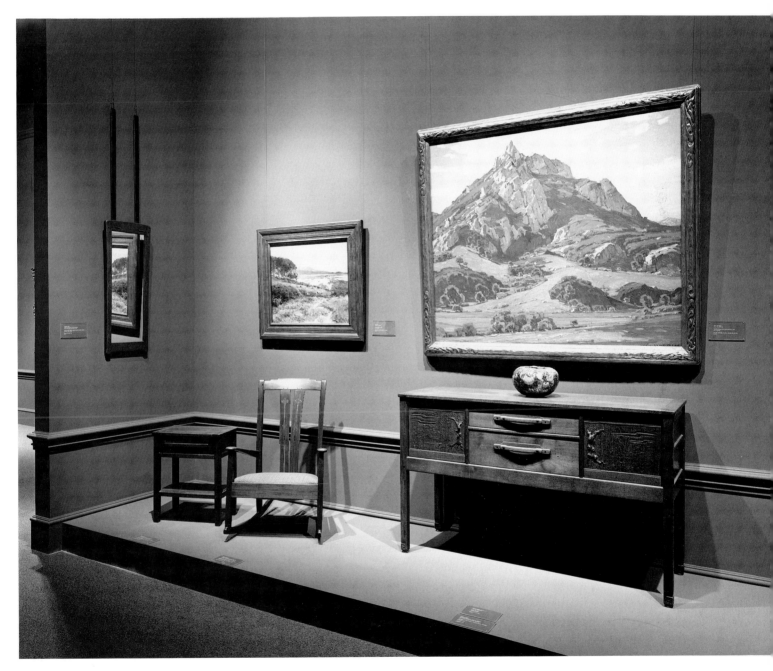

Gallery installation of California works, 1983.

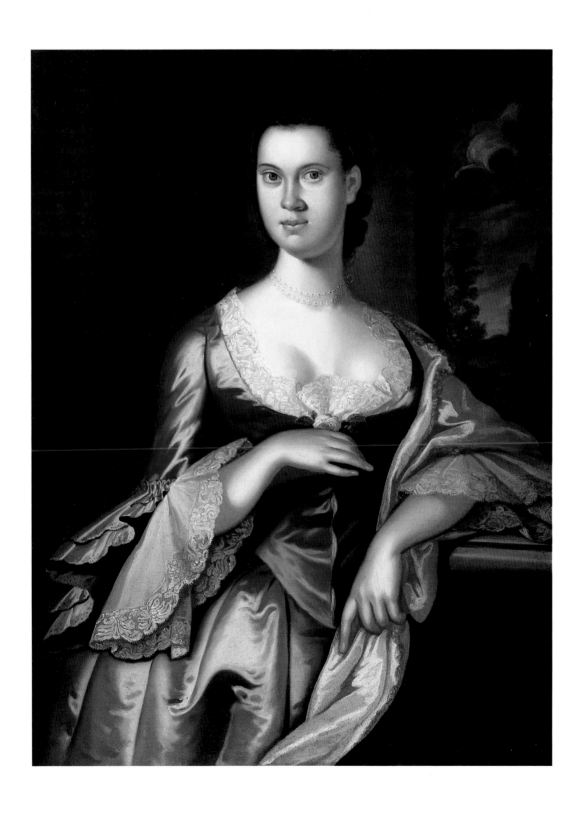

John Hesselius, *Portrait of Elizabeth Chew Smith*, 1762, see page 92.

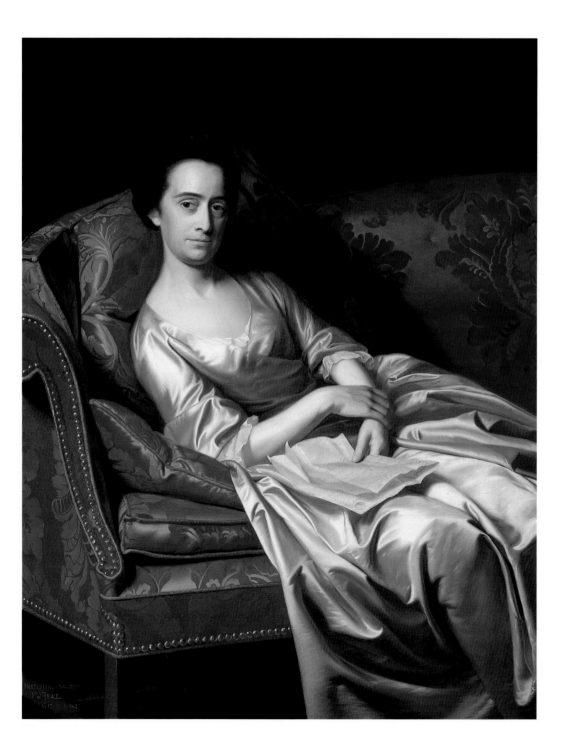

John S. Copley, *Portrait of a Lady*,
1771, see page 94.

Benjamin West, *Cymon and
Iphigenia*, 1773, see page 98.

Rembrandt Peale, *Portrait of Jacob
Gerard Koch*, c. 1817, see page 104.

Thomas Birch, *Loss of the
Schooner "John S. Spence" of
Norfolk, Virginia, 2nd View—
Rescue of the Survivors,* 1833,
see page 108.

Thomas Cole, *Il Penseroso,* 1845,
see page 113.

Emanuel Leutze, *Mrs. Schuyler Burning Her Wheat Fields on the Approach of the British*, 1852, see page 121.

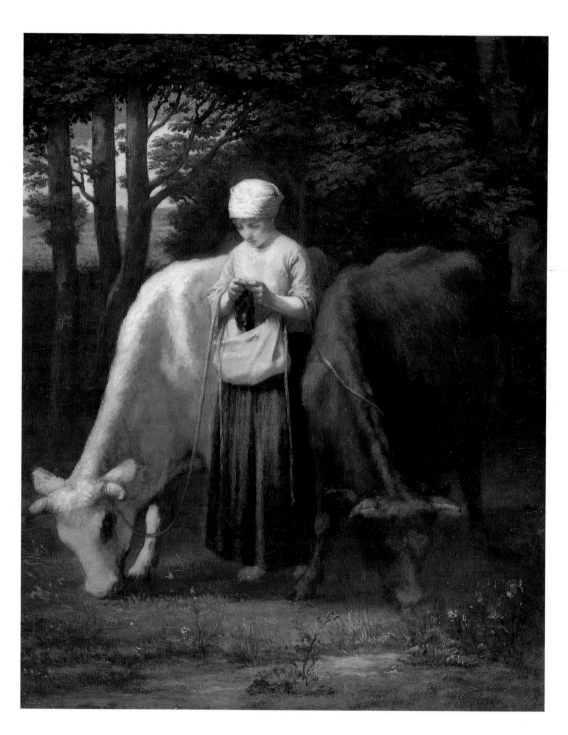

William Morris Hunt, *Girl with Cows,* 1860, see page 128.

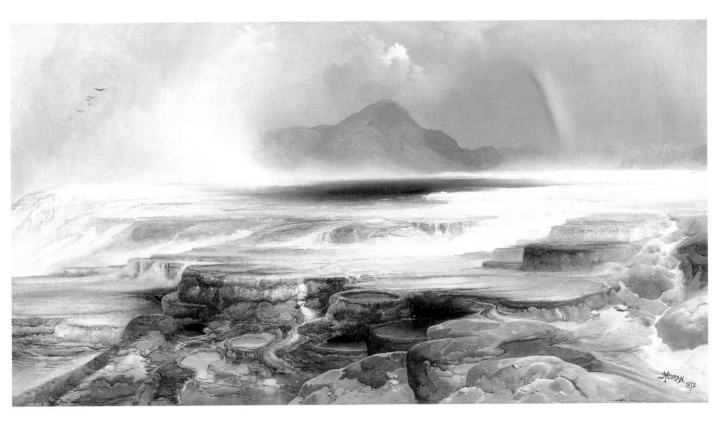

Thomas Moran, *Hot Springs of the
Yellowstone,* 1872, see page 154.

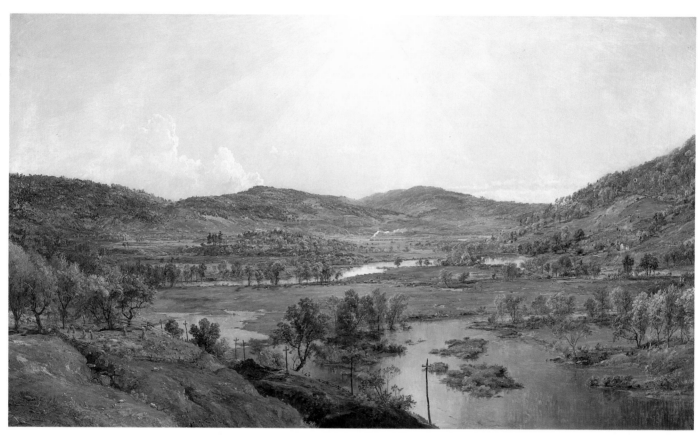

Jasper F. Cropsey, *Sidney Plains
with the Union of the Susquehanna
and Unadilla Rivers*, 1874, see
page 160.

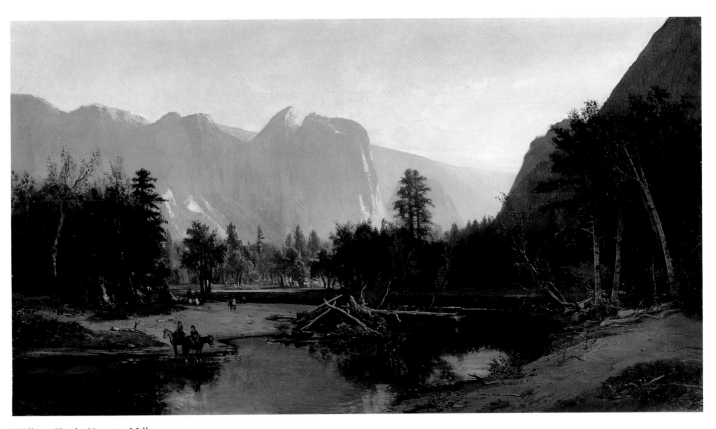

William Keith, *Yosemite Valley,*
1875, see page 167.

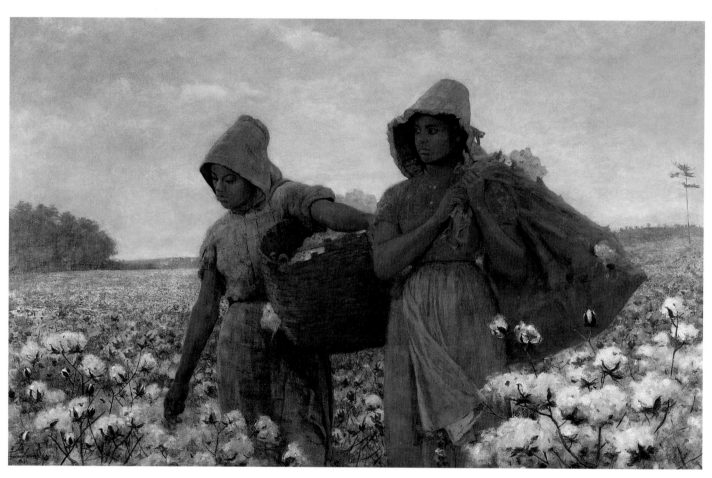

Winslow Homer, *The Cotton Pickers,* 1876, see page 174.

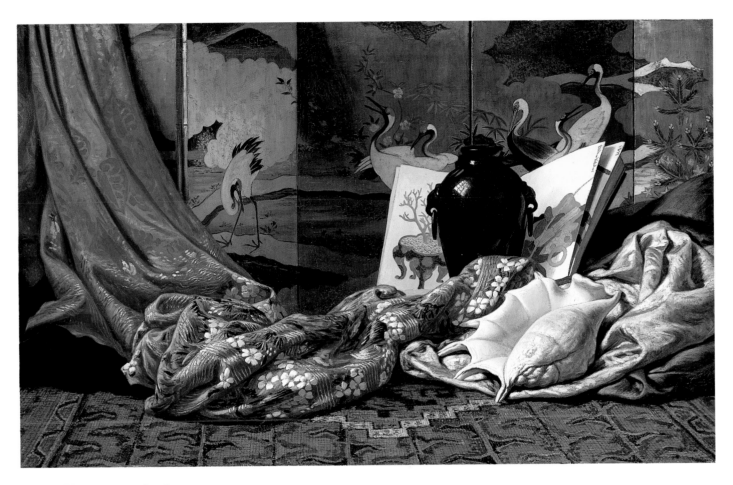

Elihu Vedder, *Japanese Still Life*,
1879, see page 152.

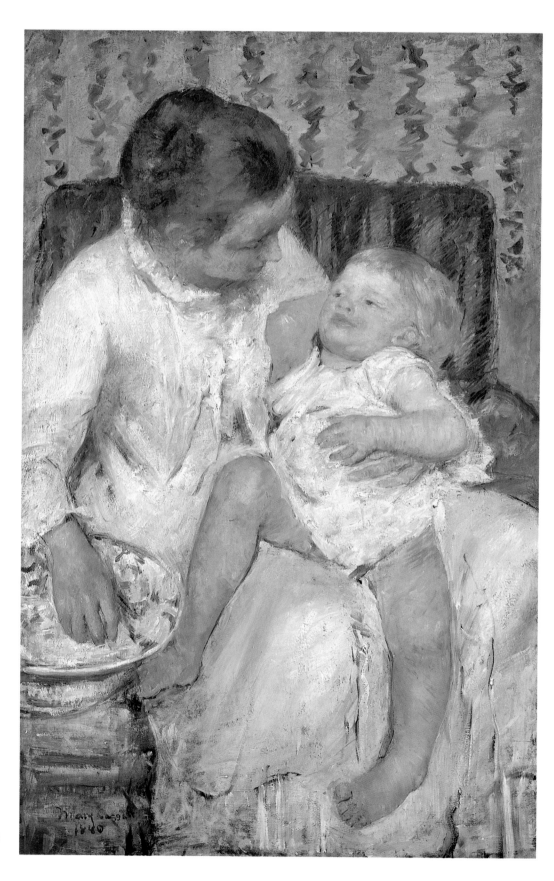

Mary Cassatt, *Mother about to Wash Her Sleepy Child*, 1880, see page 180.

Sanford R. Gifford, *October in the
Catskills,* 1880, see page 182.

George Inness, *October,* 1882 or
1886, see page 184.

John S. Sargent, *Portrait of Mrs. Edward L. Davis and Her Son, Livingston Davis*, 1890, see page 164.

Winslow Homer, *After the Hunt*,
1892, see page 437.

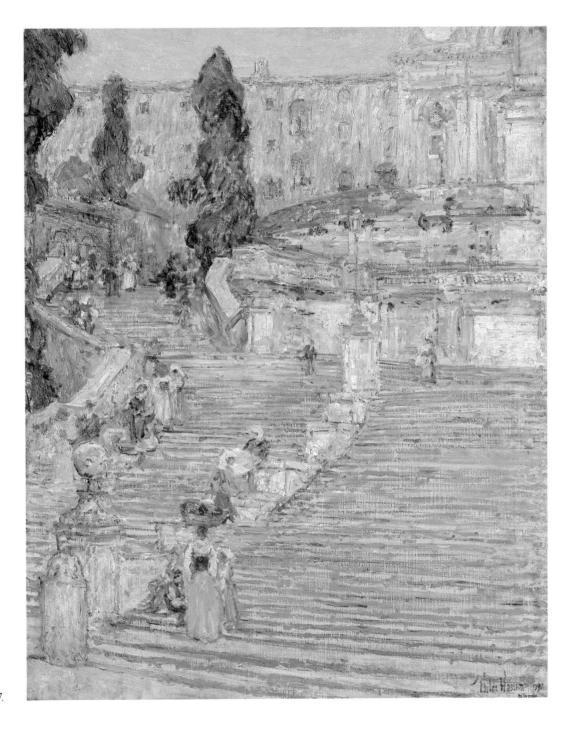

Childe Hassam, *The Spanish Stairs, Rome,* 1897, see page 207.

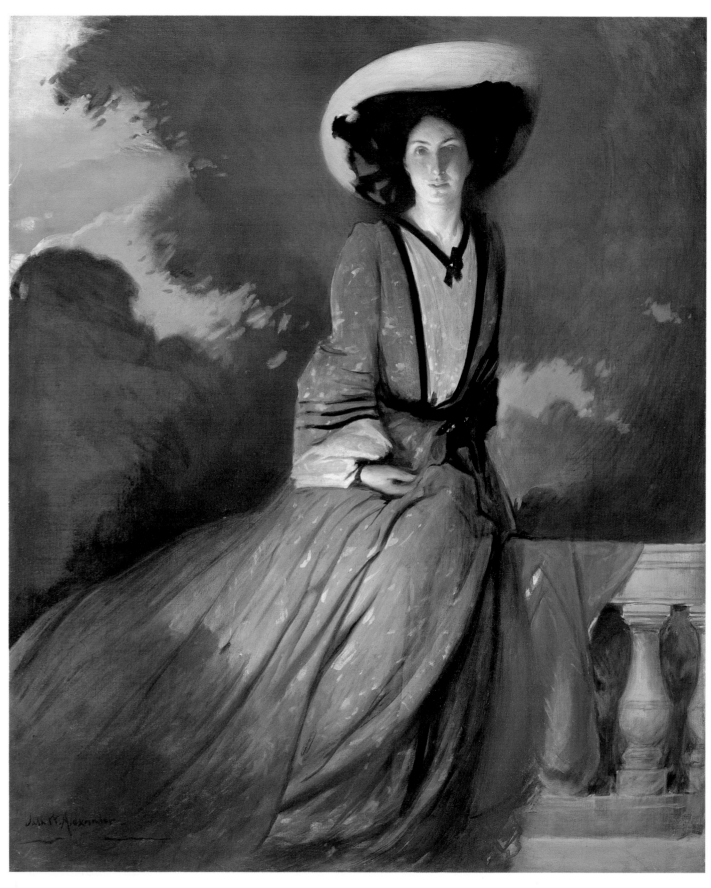

John W. Alexander, *Portrait of
Mrs. John White Alexander*, 1902,
see page 220.

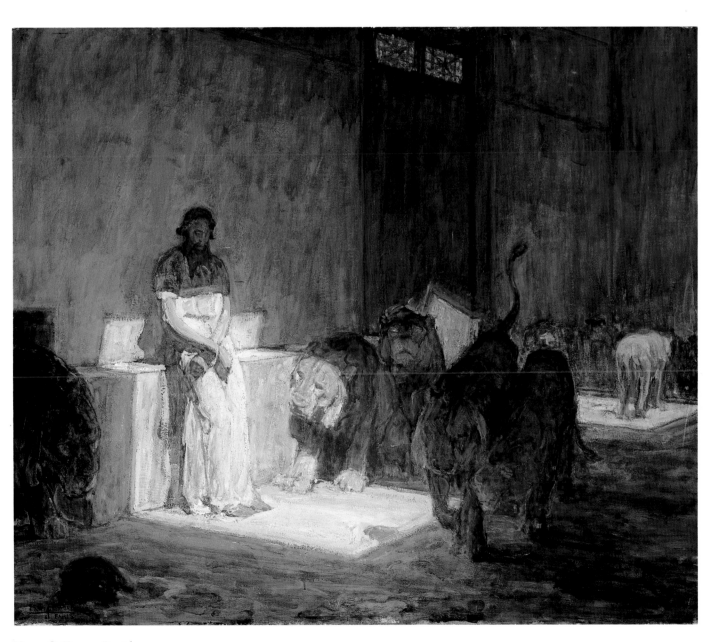

Henry O. Tanner, *Daniel
in the Lions' Den*, c. 1907–18,
see page 225.

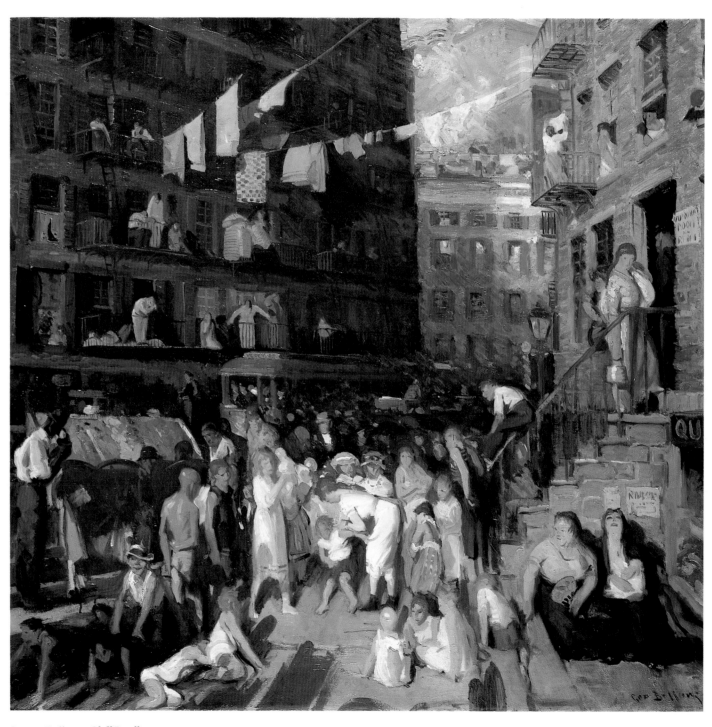

George Bellows, *Cliff Dwellers,*
1913, see page 241.

Morgan Russell, *Sketch for
"Synchromie en bleu-violacé,"*
c. 1913, see page 250.

Childe Hassam, *Point Lobos,
Carmel,* 1914, see page 210.

Maurice Prendergast, *Decorative Composition*, c. 1914, see page 448.

Robert Henri, *Edna*, 1915, see
page 259.

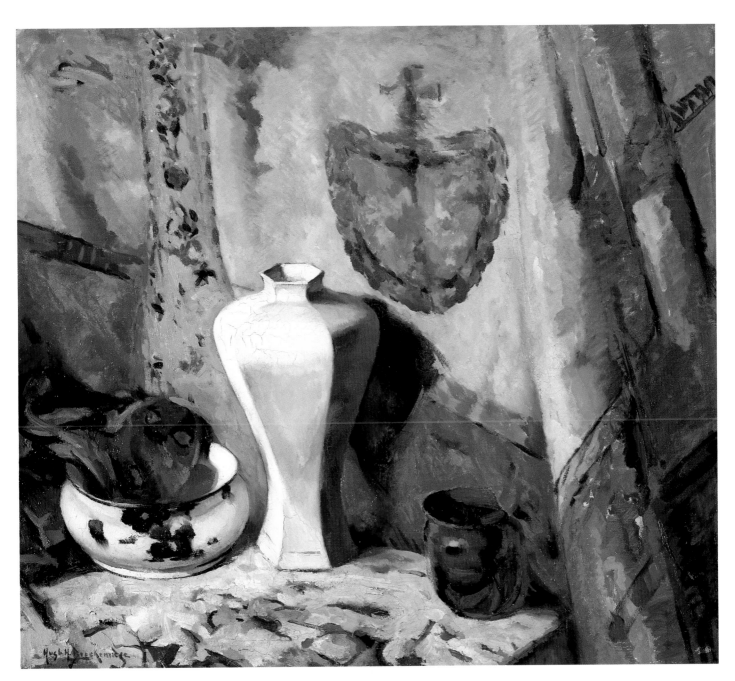

Hugh H. Breckenridge, *The Altar
Cloth,* 1916, see page 264.

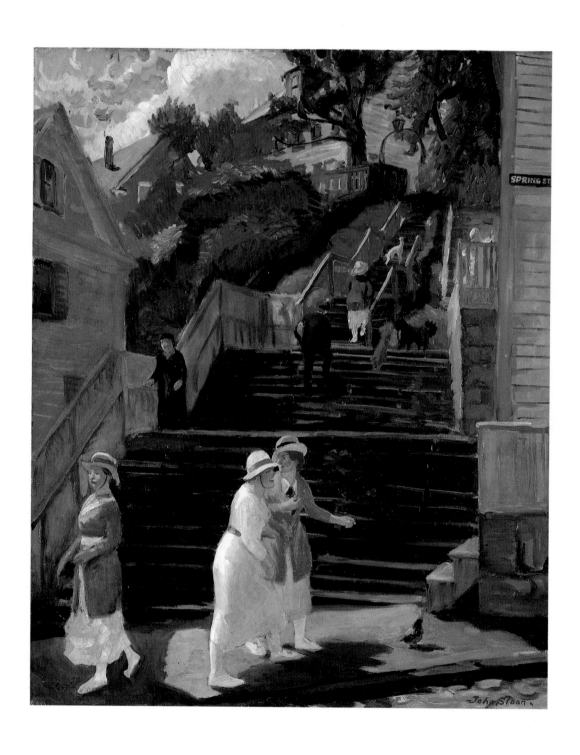

John Sloan, *Town Steps,*
Gloucester, 1916, see page 269.

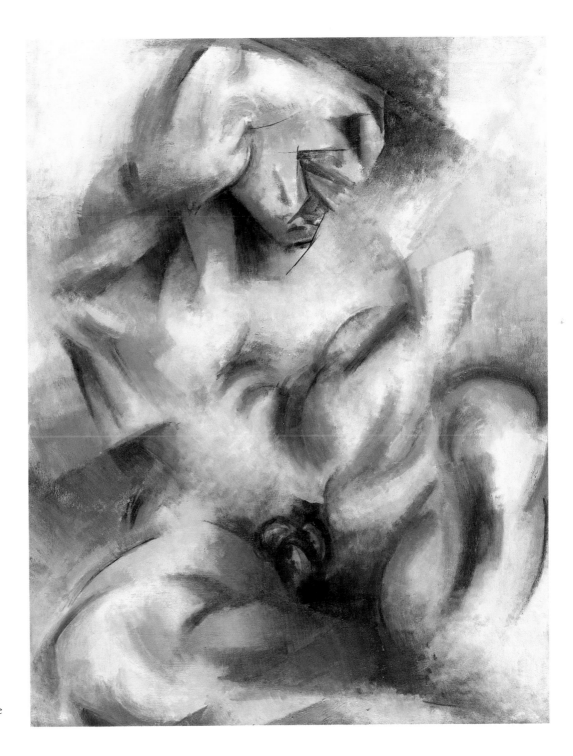

Stanton Macdonald-Wright,
Synchromy in Purple, c. 1917, see
page 275.

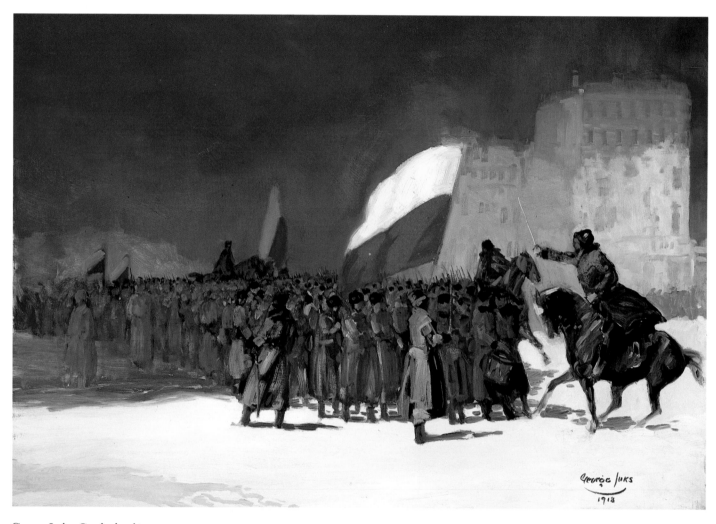

George Luks, *Czechoslovakian Army Entering Vladivostok, Siberia, in 1918*, 1918, see page 278.

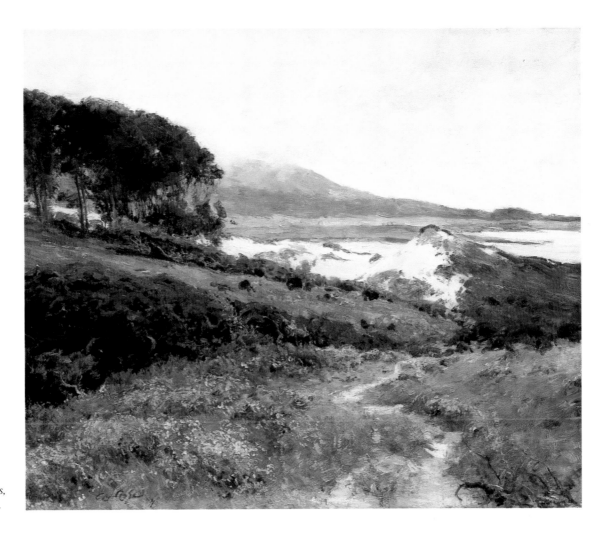

Guy Rose, *Carmel Dunes,*
c. 1918–20, see page 258.

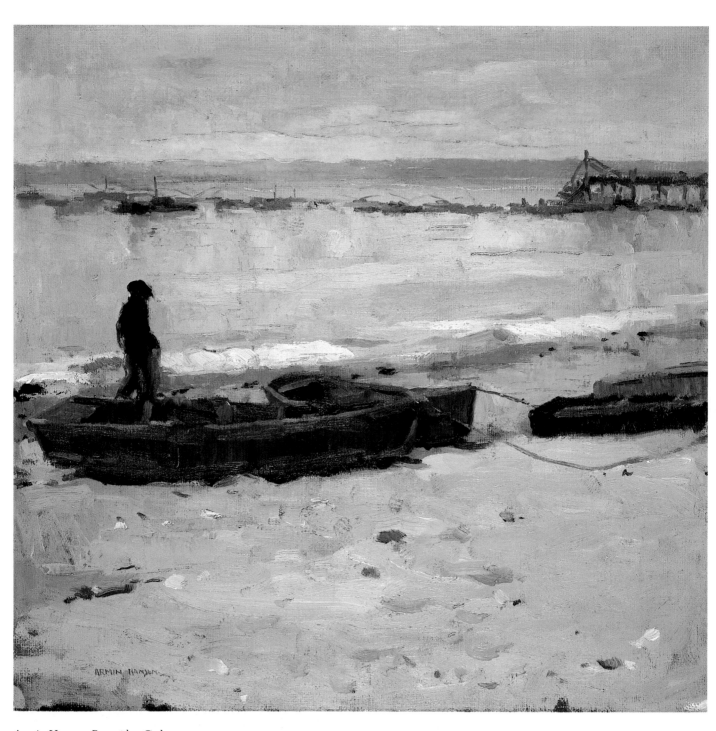

Armin Hansen, *Boy with a Cod,*
by 1919, see page 281.

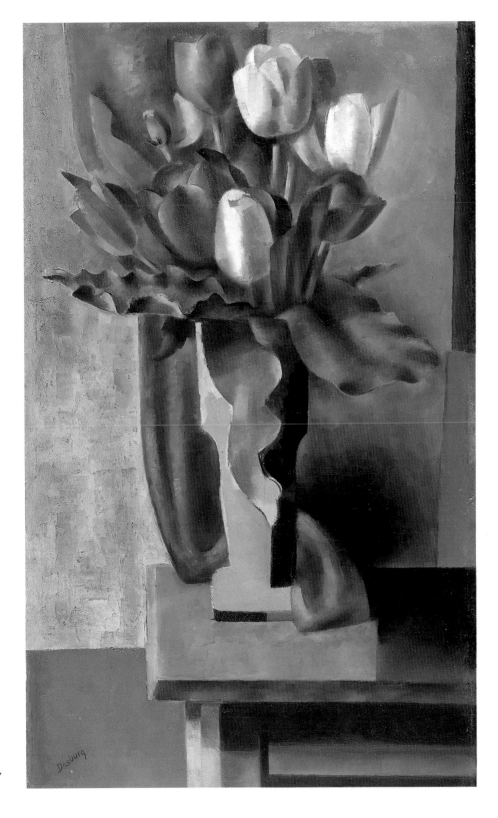

Andrew Dasburg, *Tulips*,
c. 1923–24, see page 297.

John Carroll, *Parthenope,* by 1925,
see page 306.

William Wendt, *Where Nature's
God Hath Wrought*, 1925, see
page 273.

Granville Redmond, *California
Poppy Field*, c. 1926, see page 287.

Eduoard Vysekal, *The Herwigs,*
1928, see page 318.

Karoly Fulop, *The Hymn*,
c. 1929–37, see page 425.

Henry Lee McFee, *Still Life with Carafe,* by 1931, see page 333.

Reginald Marsh, *Third Avenue El,*
1931, see page 337.

Millard Sheets, *Angel's Flight*,
1931, see page 339.

Conrad Buff, *Westward,*
c. 1933–34, see page 343.

Nick Brigante, *Nature and*
Struggling Imperious Man (detail),
1935–37, see page 456.

Marsden Hartley, *The Lost Felice*,
c. 1939, see page 247.

Standish Backus, Jr., *Uninhabited*,
1940, see page 481.

Dan Lutz, *Green Trees and Blue
Lagoon*, 1944, see page 485.

Emil Kosa, Jr., *The First Overcast,*
by 1945, see page 482.

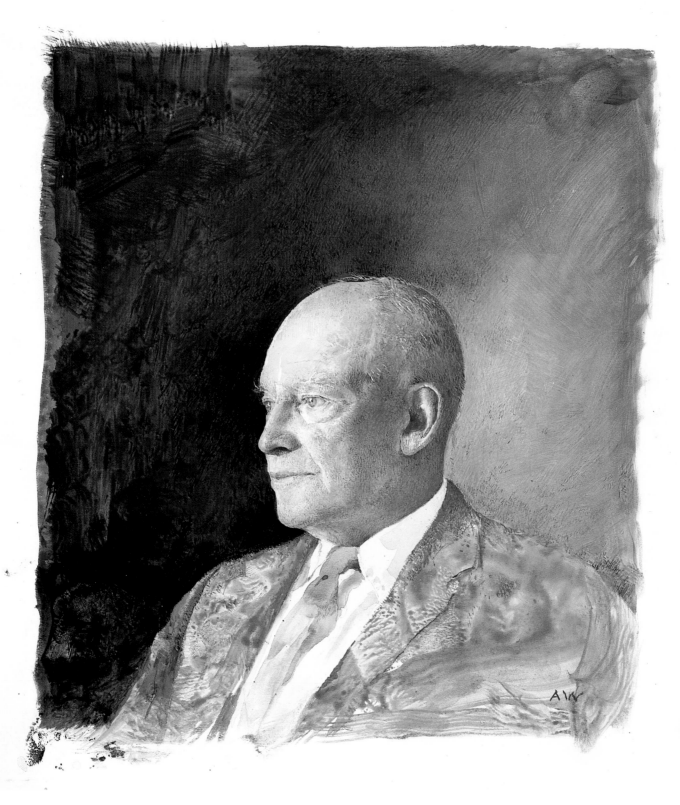

Andrew Wyeth, *Portrait of Dwight Eisenhower*, 1959, see page 502.

Note on the Catalogue

Works are divided into paintings, sculptures, and watercolors. The works of each artist are grouped together and placed in chronological order. Artists are arranged within each section according to the chronological order of the first work by each. Alphabetical order is used for those artists whose earliest work is from the same year and for works from the same year by a given artist. Works for which the date is certain precede those with approximate dates; if a span is given, the earlier date is used, for example, 1890, c. 1890, c. 1890–92, c. 1890–95, c. 1890s.

Every attempt has been made to supply the date and location of works mentioned as well as the dates of artists' lives. When an artist who is represented in the catalogue is mentioned in another entry, his or her name is given in SMALL CAPITALS on its first occurrence. When works in the catalogue are mentioned in other entries, they are referenced with *q.v.*

Sources for quotations and specific information are given parenthetically in the text only if the source is not included in the Exhibitions or Literature section of the work under consideration.

Only selected watercolors have been fully researched, based on whether the artist is highly regarded for his or her watercolors or devoted a significant portion of his or her output to the medium; others have been documented with reproduction and caption only.

BIOGRAPHY

The heading for each entry provides the artist's name and the dates and places of birth and death as well as the year of immigration if the artist was foreign born. The artist is listed by the name used in his or her signature or as known to his or her contemporaries; the full name or a different birth name is given at the beginning of the biographical note. A short, general discussion of the artist's life is provided as background and to help place works in the museum's collection in context. Biographies of lesser-known artists, especially those active in California, are relatively more complete whereas those of the most famous figures are brief since books and articles on them are widely available.

BIBLIOGRAPHY

Five sources deemed most useful for further reading about the artist are listed in chronological order. Published works have been given precedence over unpublished material such as dissertations. Archival material has been included if it is one of the only sources of information or is an especially outstanding source. Papers in the Archives of American Art (Archiv. Am. Art) are on microfilm unless otherwise noted.

TITLE

The title used is that given by the artist, if known, or that used upon the work's first exhibition or publication unless research has led to a reidentification of the subject or another title is so widely known that confusion would result. Alternate titles are given in parentheses and their occurrences indicated in the Exhibitions and Literature citations; they are given in the Provenance if the work was not published under that name while in the possession of that owner and/or to indicate the first occurrence of a title used again later. Verbatim translations in another language have not been noted. Variations in the use of the definite article, variant spellings, and minor variations in punctuation have not been noted.

DATE

For sculptures, the modeling date refers to the artist's first creation of the version of which the museum has an example; a carving or casting date refers specifically to the example in the museum's collection.

MEDIUM AND SUPPORT

Works on paper are on white paper unless otherwise noted.

MEASUREMENTS

Sizes are stated in inches followed by centi-

meters in parentheses. Height precedes width; for three-dimensional objects if only one dimension is given it is that of height. All works were remeasured for this catalogue.

INSCRIPTIONS

Artists' signatures and inscriptions and their locations are stated. The use of cursive is not indicated. Inscriptions in another hand are noted as such when known. Locations of inscriptions on two-dimensional works and sculptural reliefs are given from the viewer's perspective. For the location of those on three-dimensional objects, *right* and *left* should be interpreted from the sculpture's perspective. Stamps, stencils, and stickers on canvas backs are included if informative.

RELATED WORKS

Here are included preliminary studies, replicas by the artist, copies by other artists, prints based on the work of art, or a finished work for which the museum's piece is a study. Although an artist may have portrayed the same subject repeatedly, another example of the same theme is not included unless there is reason to believe that one of the works is based on the other. If a piece is unlocated but an illustration is known, a citation for it is provided.

In the case of sculptures cast or carved in multiples, examples of the same-sized edition or those in other sizes or media are discussed in the text, not listed as Related Works. The word *version* is used by the authors to refer to a visibly different example or edition. A sculpture by the same artist closely related in theme and originally exhibited or sold together with the work under discussion is listed as a Companion Piece.

The listings of Related Works represent the authors' best knowledge at the time of publication and may not be complete. They contain information taken from publications or provided by the owners of the works.

PROVENANCE

This is a list of former owners that can be traced. When information could not be

verified conclusively, the words *probably* or *possibly* precede the name. The term *by descent* indicates that the work remained in the family of the previous owner, whether by lineal or collateral descent or through marriage. The term *with* indicates that the work was consigned to or owned by a dealer. Information on auctions, listed as *(sale . . .)*, is given in parentheses. A lower case *s* in *sale* indicates that the work went to the auction from the owner listed immediately preceding; a § and a capital *S* in *Sale* indicate an intervening owner or agent or the possibility thereof.

The artist is named in the Provenance only if he or she owned the work for a long period, the work was extensively exhibited while in the possession of the artist, or the artist was the only owner prior to the work's entering the museum collection.

ON DEPOSIT

This signifies that a work was placed on long-term loan to an institution or an individual.

CITATIONS

Except as noted below for sculptures, the citations listed under Exhibitions and Literature refer directly to the work under consideration; they are listed in chronological order. Abbreviated citations refer to sources in the individual artist's Bibliography or the list of Abbreviations following this Note. All of the pages on which a work is discussed are listed (captions and checklist entries excluded) and the contents annotated as appropriate, followed by information on reproductions, alternate titles or datings, and prizes and awards. Although in many cases all of the text pages are enumerated before a general annotation on the contents, if, for example, more than one author discusses the work, annotations follow the relevant page number(s), for example, in *p. 13, essay by Donelson Hoopes, p. 211, entry by Nancy D. W. Moure,* the work is mentioned in Hoopes's essay on page 13.

Reproductions are noted with *repro.* or by *fig. 00* or *pl. 00* followed by the requisite page number if paginated and different from an immediately preceding text page: *pp. 22, 29,*

repro. indicates that the work is mentioned in the text on pages 22 and 29 and illustrated on page 29, whereas *p. 22, repro., p. 29* indicates that the work is discussed on page 22 and reproduced on page 29. In such cases the word *unpaginated* functions in the same way as a page number.

The terms *probably* and *possibly* are used when incontrovertible evidence of a work's being the one on exhibit or under discussion could not be found.

Catalogues for exhibitions in which the museum's work under discussion was included are listed under Exhibitions, not Literature.*

EXHIBITIONS
The listings consist of the city and institution(s), title of the exhibition, year(s) of exhibition, exhibit number if known, and any annotations on the relevant content of the exhibition publication if one was issued. (In cases where a catalogue or checklist could not be found, *no cat.* or *no cat. traced* is used.) Exhibitions shown at more than one venue are listed under the first, and more than two venues are noted with the name of the first plus *and others.*

In the early years of the Los Angeles Museum, paintings in the Mr. and Mrs. William Preston Harrison Collection were often on view in the galleries before they were accessioned into the permanent collection. Their exhibition histories, however, do not include such installations; like those for all of the objects catalogued herein, the exhibition histories are restricted to special exhibitions per se.

LITERATURE
If reference to a work is made in an exhibition catalogue but the work was not included in the exhibition, the citation appears in this section. Reproductions in non-art-historical publications, such as secondary-school textbooks, have not been cited.

Archival materials in the museum's possession are listed under the department that holds them. Some of the archives of the art museum's earlier years are at the Los Angeles County Museum of Natural History, which remains in the building of the parent institution of both.

Whereas citations for the paintings and watercolors are restricted to works that discuss or reproduce the specific object under consideration, many of the sculptures are not unique examples and up to five "general" sources on the work are cited in addition to "specific" literature on the museum's cast or carving.

*In recent years it has become increasingly common to publish or copublish books surpassing the scope of traditional exhibition catalogues in conjunction with exhibitions. Due to variations in the publication arrangements of such volumes and in crediting contributions to and inclusions in them, a systematic method of citation has not been attempted, however, those dealing almost exclusively with works in the exhibition and containing an exhibition checklist have generally been treated as exhibition catalogues.

Abbreviations

The name of the museum has changed several times since its founding in 1913. For the sake of consistency in the text it is referred to as "the Los Angeles Museum." In the citations the following abbreviations are used:

LAMHSA
Los Angeles Museum of History, Science, and Art, 1913–1931

LACMHSA
Los Angeles County Museum of History,

Science, and Art, 1931–1961

LACM
Los Angeles County Museum, 1961–1965

LACMNH
Los Angeles County Museum of Natural History, 1965–present

LACMA
Los Angeles County Museum of Art, 1965–present

ABBREVIATED REFERENCES

Archiv. Am. Art
Archives of American Art, Washington, D.C., and elsewhere; on microfilm unless otherwise noted.

Craven 1968
Wayne Craven, *Sculpture in America* (New York: Crowell).

Fort 1986
Ilene Susan Fort, "American Painting and Its Development," in Los Angeles County Museum of Art feature issue, *Apollo* 124 (November 1986): 420–25.

Fullerton 1976
Fullerton, California State University, Art Gallery, *California White Paper Painters, 1930s–1970s,* exh. cat., entries not numbered.

Harrison 1934
[William] Preston Harrison, comp., *A Catalogue of the Mr. and Mrs. William Preston Harrison Galleries of American Art: A Gift to the People* (Los Angeles: Saturday Night Publishing).

Higgins 1963
Winifred Haines Higgins, "Art Collecting in the Los Angeles Area, 1910–1960," Ph.D. diss., University of California, Los Angeles.

Index 20th Cent. Artists
The Index of Twentieth Century Artists, ed. John Shapley and others (New York: Research Institute of the College Art Association, 1933–37; reprint, New York: Arno Press, 1970). Unless otherwise noted, "listed" is in reproductions.

LA 1951
Los Angeles, City Hall Tower Museum, *California Watercolor Society Purchase Awards, 1932–1950,* no cat. traced.

LACMA 1973
LACMA, *California Water Color Society Collection,* exh. cat., with essay by Nancy Dustin Wall Moure.

LACMA 1975
LACMA, *A Decade of Collecting, 1965–1975,* exh. cat., with essay by Kenneth Donahue, entries with provenance, lists of exhibitions and literature.

LACMA 1977
LACMA, *Handbook,* with preface by Kenneth Donahue, entries by curatorial staff.

LACMA 1980
LACMA, *Painting and Sculpture in Los Angeles, 1900–1945,* exh. cat., by Nancy Dustin Wall Moure.

LACMA 1981–82
LACMA and Washington, D.C., Smithsonian
Institution, National Portrait Gallery, *American
Portraiture in the Grand Manner: 1720–1920*,
exh. cat., with essays by Michael Quick,
Marvin Sadik, and William H. Gerdts, entries
by Michael Quick.

LACMA 1988
LACMA, *Masterpieces from the Los Angeles
County Museum of Art Collection*, with text by
Lorna Price.

LACMA Bulletin
Los Angeles County Museum of Art Bulletin
14–28, 1962–84 (continuation of *LA Museum
Art Div. Bull.*).

LACMA Report
LACMA Report [years covered], [year of pub-
lication]. Generally biennial, with fiscal years
running from July 1 to June 30 (published for a
time in *LACMA Bulletin*, volume and issue
numbers for which are noted parenthetically).

LACMHSA 1945
LACMHSA, *California Water Color Society
Twenty-fifth Annual Exhibition*, exh. cat.

Laguna 1958
Laguna Beach (Calif.) Art Association,
*Americans from the Harrison Collection: Fiftieth
Anniversary of the "Ashcan School,"* exh. cat.

Laguna 1979
Laguna Beach (Calif.) Museum of Art, *South-
ern California Artists, 1890–1940*, exh. cat.,
essay by Carl S. Dentzel, biographies and bib-
liographies by Nancy Dustin Wall Moure,
entries not numbered.

LAMHSA 1918
LAMHSA, *Catalogue of Paintings by Contem-
porary American Artists Donated by Mr. and Mrs.
William Preston Harrison*, exh. cat.

LAMHSA 1921
LAMHSA, *Catalogue of Paintings by Contem-
porary American Artists Donated by Mr. and Mrs.*

William Preston Harrison.

LAMHSA 1924
LAMHSA, *Catalogue of Paintings by Contem-
porary American Artists Donated by Mr. and Mrs.
Preston Harrison and Paintings by Contemporary
American Artists Loaned by Mr. and Mrs. Preston
Harrison*, exh. cat.

LAMHSA 1928
LAMHSA, *Paintings from the Permanent Collec-
tion*, exh. cat.

LAMHSA 1930
LAMHSA, *Exhibition of Paintings by Contem-
porary American Artists*, exh. cat.

LA Museum Art Dept. Bull.
*Bulletin of the Los Angeles Museum of History,
Science, and Art, Department of Fine and Applied
Arts, Los Angeles* 1–7, 1919–26.

LA Museum Art Div. Bull.
*Bulletin of the Art Division of the Los Angeles
County Museum* 1–2, 1947–48; *Los Angeles
County Museum Bulletin of the Art Division*
2–13, 1948–62 (continued as *LACMA
Bulletin*).

LA Museum Art News
Los Angeles Museum Art News 1–6, 1931–32.

LA Museum Bulletin
*Quarterly Bulletin of the Los Angeles Museum
of History, Science, and Art* 1, 1936–37; *Bulletin
of the Los Angeles Museum* 2, 1938.

LA Museum Graphic
Los Angeles Museum Graphic 1, 1926–28.

LA Museum Quarterly
Los Angeles County Museum Quarterly 1–18,
1941–1962.

Long Beach 1959–62
Long Beach (Calif.) Museum of Art and
others, organized by Western Association of
Art Museums, *California Water Color Society:
Twenty-five Years of Prizewinners*, no cat. traced.

Los Angeles 1945
Los Angeles, Dalzell Hatfield Galleries, *Christmas Gift Exhibition: 1945 Prize Winners*, exh. cat., entries not numbered.

Moure 1975
Nancy Dustin Wall Moure, *The California Water Color Society: Prize Winners, 1931–1954; Index to Exhibitions, 1921–1954*, Publications in Southern California Art, no. 1 (Los Angeles: Privately printed).

Moure & Moure 1975
Nancy Dustin Wall Moure and Phyllis Moure, *Artists' Clubs and Exhibitions in Los Angeles before 1930*, Publications in Southern California Art, no. 2 (Los Angeles: Privately printed), unpaginated.

Moure with Smith 1975
Nancy Dustin Wall Moure with research assistance by Lyn Wall Smith, *Dictionary of Art and Artists in Southern California before 1930*, Publications in Southern California Art, no. 3 (Los Angeles: Privately printed), with introduction by Carl Schaefer Dentzel.

New York and San Francisco 1940
New York, Riverside Museum, and San Francisco Museum of Art, *Pacific Coast States Water Color Exhibition*, exh. cat.

Pasadena 1948
Pasadena (Calif.) Art Institute, *California Water Color Society Twenty-eighth Annual Exhibition*, exh. cat., entries not numbered except that year's prizewinners.

Pasadena 1957
Pasadena, Calif., California Institute of Technology, Division of Humanities, [exhibition title unknown], no cat. traced.

Pomona 1964
Pomona, Calif., Los Angeles County Fair Association, *American Watercolor Association*, no cat. traced.

San Francisco 1946
San Francisco Museum of Art, *Water Color Society Annual*, no cat. traced.

Sylmar 1978
Sylmar, Calif., County of Los Angeles Veterans Memorial Park, Cultural Arts Center, *California Gold: Fifty Years of Awards of the National Watercolor Society*, exh. cat., entries not numbered.

Taft 1930
Lorado Taft, *The History of American Sculpture* (1903; New York: Macmillan, 2d new ed., 1930).

Tuckerman 1867
Henry T. Tuckerman, *Book of the Artists: American Artist Life; Comprising Biographical and Critical Sketches of American Artists, Preceded by an Historical Account of the Rise and Progress of Art in America* (New York: Putnam).

Westphal 1982
Ruth Lilly Westphal, *Plein Air Painters of California: The Southland* (Irvine, Calif.: Westphal Publishing), with essays by Terry De Lapp, Thomas Kenneth Enman, Nancy Dustin Wall Moure, and others, lists of professional associations, awards, and public collections.

Paintings

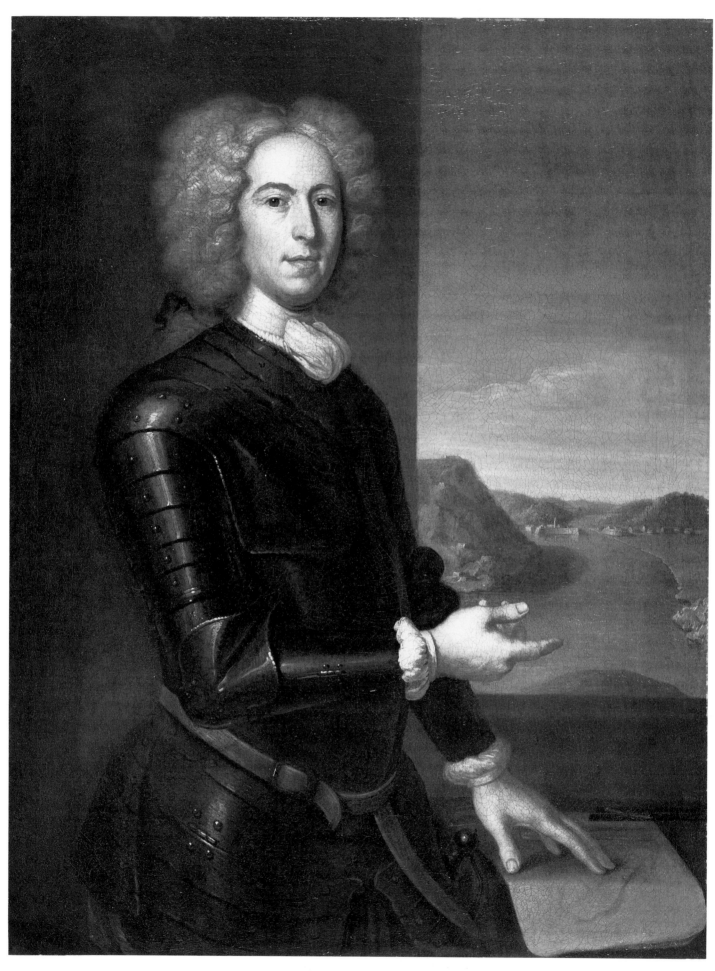

Smibert, *Portrait of Major General Paul Mascarene.*

John Smibert

Born March 24, 1688,
Edinburgh, Scotland
To United States 1728
Died April 2, 1751, Boston,
Massachusetts

John Smibert was the first fully trained artist to settle in the American colonies and as such can be considered the founder of academic painting in this country. At the age of fourteen he was apprenticed as a house painter in Edinburgh. Seven years later he left for London, where he worked as a coach painter and then copying paintings for dealers. In 1713 he attended the short-lived academy organized by Sir Godfrey Kneller (1646–1723), where he would have drawn from prints and casts. In about 1717 he returned to Edinburgh to establish a practice as a portraitist but in 1719 went to Italy in search of further training, copying paintings in Florence and Rome. After about a year he returned to Great Britain, probably to Edinburgh. In 1722 he established a studio in London and achieved a certain reputation and standing, albeit at a low ebb of British painting.

In September 1728 John Smibert set out for America with his friend Dean George Berkeley, who had invited him to serve as professor of art at the college Berkeley was proposing to found in Bermuda. In April 1729, while the party waited in Newport, Rhode Island, for Parliament's appropriation of funds for the college, Smibert went to Boston to paint some portraits and met with such success that he was encouraged to settle there. His work was so superior to anything available that he dominated portraiture until the mid-1740s, when failing eyesight forced him to abandon painting. To supplement his income he opened a shop selling prints and artists' supplies. It continued as an influential factor in New England painting even after his death.

BIBLIOGRAPHY
Alan Burroughs, "Notes on Smibert's Development," *Art in America* 30 (April 1942): 109–21 § Henry Wilder Foote, *John Smibert: Painter* (Cambridge, Mass.: Harvard University Press, 1950), with catalogue of portraits, bibliography § John Smibert, *The Notebook of John Smibert, with Essays by Sir David Evans, John Kerslake, and Andrew Oliver and Notes Relating to Smibert's American Portraits by Andrew Oliver* (Boston: Massachusetts Historical Society, 1969) § Richard H. Saunders III, "John Smibert (1688–1751): Anglo-American Portrait Painter," Ph.D. diss., Yale University, 1979, with catalogue, bibliography § Miles Chappell, "A Note on John Smibert's Italian Sojourn," *Art Bulletin* 64 (March 1982): 132–38.

Portrait of Major General Paul Mascarene, 1729

Oil on canvas
40 9/16 x 31 5/8 in (103.0 x 80.4 cm)
Museum purchase with funds provided by Mr. and Mrs. William Preston Harrison Collection, Charles H. Quinn Bequest, Eli Harvey, and other donors
78.8

In June 1729 Smibert painted a portrait of then-Major Paul Mascarene, his seventh American sitter. The painting recalls his English-period portrait of Lieutenant General Charles Otway, 1724 (Royal Sussex Regiment, Chichester) in its use of the convention of half armor for a military commander. The armor is at least a century earlier in its design, which presumably was taken from Smibert's treasury of drawings and engravings. The armor, a highly unusual feature in Boston portraiture, with its virtuoso highlights and reflections, was a showpiece of Smibert's abilities and could not fail to catch the eye of the poetizing Mather Byles, who mentioned it in the line, "and studious Mascarene asserts his arms."

The portrait also contains a landscape background and a small still life of a map and drafting instruments. The still life refers to Mascarene's coastal survey of Nova Scotia, which could have served as the basis for the fortified harbor seen in the portrait. Smibert was one of the few early colonial artists who sometimes painted specific, actual landscapes

as backgrounds in his portraits. Whether it depicts an actual or proposed fortification, it apparently is not Annapolis Royal, the location with which Mascarene is chiefly associated and for which he attempted to improve the fortifications.

Paul Mascarene was born Jean-Paul Mascarene in France in 1684 or 1685 of a family of Huguenots later forced to leave the country after the revocation of the Edict of Nantes in 1685. He was educated in Geneva and in 1706 began a military career in England. In 1708 he was in Portsmouth, New Hampshire, preparing troops for an expedition against Canada, and in 1710 he was the captain who took possession of Port Royal (renamed Annapolis Royal) in the campaign that won Nova Scotia for Britain. He was thereafter very involved in the military life and civil government of the province, although he spent much time in Boston, where he married Elizabeth Perry, built a large brick house, and raised a family. He was known as a man of considerable learning and taste. In a letter of 1740 he referred to "four large pictures of Mr. Smibert" in his possession. Between 1740 and 1749 he was chief administrator of Nova Scotia during the campaign against Louisbourg. He became a major general in 1758 and died in Boston in 1760.

RELATED WORKS
Copy by Rebeakah T. Furness, n.d., oil, 25 1/2 x 19 1/2 in (64.7 x 49.5 cm). Fort Anne National Historic

Park, Annapolis Royal, Nova Scotia, Canada §
Copy by Thomas Beamish Akins, before 1848, prob-
ably 1840s, oil on canvas, 36 x 29 in (91.4 x 73.7 cm).
Library, University of King's College, Halifax, Nova
Scotia, Canada § Copy by William H. Whitmore,
1871, oil on canvas, 16¹⁵/₁₆ x 13⁷/₈ in (43.0 x 35.2 cm).
Massachusetts Historical Society, Boston.

PROVENANCE
Paul Mascarene, Boston and Canada § John Mas-
carene (by descent), Boston, 175?–79 § Margaret
Holyoke Mascarene (by descent), Boston, 1779–92
§ Foster Hutchinson, Jr. (by descent), Halifax, Nova
Scotia, Canada, 1793 § Abigail Hutchinson (by
descent), Halifax, as of 1838 § W. J. Stirling (by
descent), Halifax; Wiesbaden, Germany; and
London, as of 1869 to 1910 (sale of W. J. Stirling
effects, London, 1910 [?], as by Sir Peter Lely) §
With A. Ellis, London, from 1910 § London (?),
auction, about 1915 § With Alfred M. Lever,
London, as of 1925 or 1926 § Paul Mascarene
Hamlen, Boston, 1926 § Mrs. E. R. Warren (by
descent), Boston, 1928 § Mrs. Paul Mascarene
Hamlen (by descent), Wayland, Mass., as of 1950 §
Mr. and Mrs. Nathaniel Hamlen (by descent), Way-
land § Estate of Nathaniel Hamlen, as of 1973
§ With Hirschl & Adler Galleries, New York,
1975–78.

ON DEPOSIT
Pennsylvania Academy of the Fine Arts, Phila-
delphia, 1978–79.

EXHIBITIONS
Boston, studio of the artist, January 1730, no cat.
traced § Halifax, Nova Scotia, Cochran's Buildings,
Mr. Eagar's Exhibition of Paintings, 1838, no. 20
§ Boston, Museum of Fine Arts, *Loan Exhibition of
One Hundred Colonial Portraits (Massachusetts Bay
Colony Tercentenary)*, 1930, entries not numbered,
repro., p. 55 § New Haven, Conn., Yale University
Art Gallery, *The Smibert Tradition*, 1949 (cat. pub-
lished as *Bulletin of the Associates in Fine Arts, Yale
University* 17, nos. 2–3 [1949]), no. 20 § Boston,
Museum of Fine Arts, *Recent Accessions: Samuel
Sewall*, 1959, no cat., as a comparative exhibit §
LACMA 1981–82, no. 3, p. 16, essay by Michael
Quick, pp. 82, 84, entry by Quick, repro., p. 83.

LITERATURE
London, Public Records Office, Chancery Master's
Exhibits, John Smibert, "Notebook" manuscript,
listed as no. 7 under June 1729 entry in inventory of
paintings executed in Boston § [Mather Byles], "To
Mr. Smibert, on the Sight of His Pictures," *American
Weekly Mercury* (Philadelphia), February 10–19,
1730, p. 2; reprinted in *Daily Courant* (London),
April 14, 1730, pp. 1-2, Byles praises the paintings
in the artist's studio, characterizing studious
Mascarene, who "asserts his arms" § Boston,
Massachusetts Historical Society, Mascarene Family
Papers, Jean Paul Mascarene to Margritt (Peggy)
Mascarene [his daughter], Annapolis Royal,
[December?] 1740, of the "four large Pictures by
Smibert" he mentions as decorating his quarters, one
was probably his own portrait; receipt, dated May
27, 1793, Halifax, by F. Hutchinson, Jr.; Abigail
Hutchinson to John Mascarene, Halifax, September
19, 1837 or 1839, states that she inherited the por-

trait from her mother § R. H. Raymond Smythies,
*Historical Records of the Fortieth (Second Somersetshire)
Regiment, Now First Battalion, the Prince of Wales's
Volunteers . . . from Its Formation, in 1717 to 1893*
(Devonport, England: Privately printed, 1894),
p. 541, appendix by James Mascarene Hubbard
quotes Mascarene's 1740 letter, repro., probably of
copy, facing p. 10 § W. A. Calnek, *History of the
County of Annapolis*, ed. A. W. Savary (Toronto:
William Briggs, 1897), repro., probably of copy, fac-
ing p. 93 § John G. Bourinot, "Builders of Nova
Scotia," *Transactions of the Royal Society of Canada*,
2d ser., 5 (1899): 128, repro., detail, probably of copy,
p. 14, dated to 1725; reprinted as idem, *Builders of
Nova Scotia: A Historical Review* (Toronto: Copp-
Clark, 1900) § National Society of the Colonial
Dames of America, *Register of the Massachusetts
Society of the Colonial Dames of America, 1893–1927*
(Boston: Privately printed, 1927), repro., facing
p. 368 § Annapolis Royal, Nova Scotia, Canada,
Historical Society, "Minutes" (1928), typescript,
pp. 103–11, includes letter from Mrs. E. R. Warren,
June 1928, giving a detailed account of the owner-
ship of the painting within the sitter's family and
its return to the family in 1926 § Frank William
Bayley, *Five Colonial Artists of New England: Joseph
Badger, Joseph Blackburn, John Singleton Copley,
Robert Feke, John Smibert* (Boston: Privately printed,
1929), repro., p. 403 § Theodore Bolton, "John
Smibert: Notes and a Catalogue," *Fine Arts* 20
(August 1933): 42, listed § Works Progress Admin-
istration, Historical Records Survey, *American
Portraits, 1620–1825, Found in Massachusetts* (Boston:
Historical Records Survey, 1939), 2: 260, lists por-
trait as no. 1393, possibly by the artist, owned by
Paul Mascarene Hamlen § Burroughs, "Smibert's
Development," pp. 113–14, erroneously dated to
1730, states that the vigorous execution and blunt
construction of the hands is due to the artist's lack
of time, repro., p. 111 § Foote, *Smibert*, pp. 21, 53, 55,
167–68, quotes Byles's poem, catalogues the paint-
ing with provenance and references, erroneously
dates portrait to November 1729–March 1730,
assuming that the artist did not arrive in Boston
until November 1729 § John Kerslake, "The Date
and Early Provenance of Smibert's *George Berkeley*,"
Art Quarterly 28, no. 3 (1965): 150, contrasts it to
English-period portrait of General Otway, fig. 4,
153 § Smibert, *Notebook*, p. 88, listed, p. 104,
Andrew Oliver corrects the dating of the work in
Foote, *Smibert*, based on information in the painter's
notebook § Stephen T. Riley, "John Smibert and
the Business of Portrait Painting," in *American Paint-
ing to 1776: A Reappraisal*, ed. Ian M. G. Quimby,
Seventeenth Annual Winterthur Conference, 1971
(Charlottesville: University Press of Virginia, 1971),
pp. 170, 171, quotes Byles's poem § Saunders,
"Smibert," 1: 129–30, 137, discusses work in refer-
ence to early Boston portraits of military officers; 2:
pl. 78, p. 81 § "New Acquisition: American Paint-
ing," *LACMA Members' Calendar* 17 (August 1979):
unpaginated, repro. § "American Art," *LACMA
Report 1977–1979* (1980), p. 12, repro., p. 13 § "La
Chronique des arts," *Gazette des Beaux-Arts*, 6th ser.,
95 (March 1980): supp. 35, repro. § Eleanor H.
Gustafson, "Museum Accessions," *Antiques* 117
(June 1980): 1242, repro. § "Face the Nation," *Art
News* 81 (February 1982): 119, repro., 118 § Fort
1986, pp. 20–21 § LACMA 1988, p. 12, repro.

Joseph Badger

Born March 14, 1708,
Charlestown, Massachusetts
Died May 11, 1765, Boston,
Massachusetts

Joseph Badger was an active portraitist in Boston during the middle of the eighteenth century. Having spent his youth in the town of his birth, Joseph Badger was married in Cambridge, Massachusetts, in 1731. Two years later he was recorded as living in Boston. He is thought to have worked almost exclusively in the Boston area. In documents concerning his estate he is identified as a "glazier" and a "painter." He appears to have begun painting portraits about 1740. Where Badger received what training he had is not known, although he lived near the "colour shop" of JOHN SMIBERT, presumably purchased supplies from Smibert, and may have taken some instruction from him. He must be considered a self-trained, primitive artist, but with the retirement of Smibert in 1746 and the departure of John Greenwood (1727–1792) in 1752, Badger ranked as Boston's foremost portraitist until the arrival of Joseph Blackburn (active in North America, 1753–1763) in Boston in 1755. About 150 portraits by Badger survive, including those of some of Boston's leading citizens.

BIBLIOGRAPHY
Lawrence Park, "An Account of Joseph Badger, and a Descriptive List of His Work," *Proceedings of the Massachusetts Historical Society* 51 (December 1917): 158–201 § Frank William Bayley, *Five Colonial Artists of New England: Joseph Badger, Joseph Blackburn, John Singleton Copley, Robert Feke, John Smibert* (Boston: Privately printed, 1929), pp. 1–49 § Richard C. Nylander, "Joseph Badger, American Portrait Painter," Master's thesis, State University of New York at Oneonta, 1972, with catalogue of paintings, bibliography § Phelps Warren, "Badger Family Portraits," *Antiques* 118 (November 1980): 1044–45 § Washington, D.C., Smithsonian Institution, National Portrait Gallery, *American Colonial Portraits, 1700–1776*, exh. cat., 1987, published by Smithsonian Institution Press, with essays by Richard H. Saunders and Ellen G. Miles, bibliography.

Badger, *Portrait of Sarah Larrabee Edes.*

Portrait of Sarah Larrabee Edes, c. 1760
Oil on canvas
48³⁄₈ x 38¹⁄₄ in (122.9 x 97.2 cm)
Gift of Dr. Herbert and Elizabeth Sussman in honor of Saul and Ida Epstein
M.86.310.2

No signed portraits by Badger are known, but on the basis of the style of four documented portraits a large group of paintings similar in style have been attributed to him. The portrait of Sarah Larrabee Edes possesses the characteristics of this style: fairly pastel, chalky colors, outlining of the edges of the linen cuffs and collars, indistinct backgrounds with feathery foliage, and an insufficiency of foreshortening that makes the figures seem to float upon the surface of the painting. Since Badger's portraits also are not dated, the progression of his stylistic development is not clear, making it hard to assign a date to the present painting. It has been dated about 1760 because that approximate date has been assigned to the portrait of the sitter's father, Captain John Larrabee.

Badger's *Captain John Larrabee*, c. 1760 (Worcester [Mass.] Art Museum), is his only full-length adult portrait and easily his finest effort. The subject, born in 1686, was captain-lieutenant, or commanding officer, of Castle William (afterwards Fort Independence) in Boston Harbor for nearly forty years before his death on February 11, 1762. In 1710 he married Elizabeth Jordan, and the couple had three children, a son and two daughters. The younger daughter, Sarah, was born on July 12, 1719. On December 21, 1738, she married Thomas Edes

(1715–1794), a ship-joiner, or carpenter, of Boston. They had ten children. Thomas Edes was one of the executors of Captain Larrabee's will.

An unusual feature of the portrait of Sarah Larrabee Edes is the evidence of significant changes in design, particularly in the position of the hands. Her proper right hand originally was painted as extending further into the lap, and her proper left hand, with its linen sleeve hanging downward, was raised toward her bosom, as though tucking a flower into the neckline, as in Robert Feke's *Mrs. James Bowdoin II*, 1748 (Bowdoin College Museum of Art, Brunswick, Maine).

PROVENANCE
Captain John Larrabee, Boston § Elizabeth Edes (by descent) § Jane Carter Sigourney (by descent) § Elisabeth Burnham (by descent) § Elisabeth S. Clinton (by descent) § With Thomas D. and Constance R. Williams, Litchfield, Conn., 1957 § With David C. Stockwell, Wilmington, Del., 1959 § Mr. V. C. Schwerin, Charleston, S.C., to 1962 § With M. Knoedler & Co., New York, 1962–85 § (Sale, Christie's, New York, *Important American Paintings, Drawings, and Sculpture of the Eighteenth, Nineteenth, and Twentieth Centuries,* May 31, 1985, no. 4, repro.) § Dr. and Mrs. Herbert Sussman, Studio City, Calif., 1985–86.

ON DEPOSIT
LACMA, 1985–86.

EXHIBITIONS
Cincinnati Art Museum, *American Paintings on the Market,* 1966, no. 1 § New York, M. Knoedler & Co., *American Portraits,* 1968, no. 1.

LITERATURE
Advertisement, *Art in America* 45 (Summer 1957): repro., 6 § "Shop Talk," *Antiques* 72 (November 1957): repro., 414 § Advertisement, *Art in America* 47, no. 2 (1959): repro., 14 § Nylander, "Badger," p. 53, listed in catalogue of portraits.

John Hesselius

Born 1728, Philadelphia, Pennsylvania (?)
Died 1778, Anne Arundel County, Maryland

John Hesselius was the leading portraitist of the mid-Atlantic region, especially Maryland, during his most active career, from about 1750 to 1763. He was born in 1728, probably in Philadelphia, the son of Gustavus Hesselius (1682–1755), a Swedish-born painter who was among the first trained artists to work in this country. John Hesselius appears to have begun his portrait-painting career about 1750, to judge from his dated works. He may have traveled that year in the company of the artist Robert Feke (1707–1752). Hesselius lived several years in Philadelphia but often traveled through Virginia and Maryland in search of commissions. He settled in Anne Arundel County, Maryland, about 1759. In early 1763 he married a Mary Woudward, a wealthy widow there. Although he continued to paint in Maryland and Virginia, his duties as manager of a country estate and his religious activities occupied much of his time. The inventory of his estate suggests that he was a wealthy man of numerous gentlemanly accomplishments.

BIBLIOGRAPHY
Theodore Bolton and George C. Groce, Jr., "John Hesselius: An Account of His Life and the First Catalogue of His Portraits," *Art Quarterly* 2 (Winter 1939): 76–91 § Richard K. Doud, "John Hesselius: His Life and Work," Master's thesis, University of Delaware, 1963, with catalogue of signed, attributed, and lost paintings, will of the artist, inventory of his chattels (1778), bibliography § Richard K. Doud, "The Fitzhugh Portraits by John Hesselius," *Virginia Magazine of History and Biography,* 75 (April 1967): 159–73 § Richard K. Doud, "John Hesselius, Maryland Limner," *Winterthur Portfolio* 5 (1969): 129–53, with catalogue of signed attributed portraits of Maryland subjects, reprint of the artist's will, inventory of his possessions in 1778 § Roland E. Fleisher, "Three Recently Discovered Portraits by John Hesselius," *Antiques* 119 (March 1981): 666–68.

Portrait of Elizabeth Chew Smith, 1762
Oil on canvas
38⅞ x 29⁷⁄₁₆ in (98.9 x 74.8 cm)
Inscribed and dated verso, now relined: Elizabeth Smith AEtat 19 / John Hesselius Pixt / 1762
Gift of Cecile and Fred Bartman in memory of Nelly and Bernard Citron
M.86.1
Color plate, page 33

The museum's portrait was painted in 1762, at the peak of the artist's abilities. The previous year Hesselius had obtained the prestigious commission to paint the portraits of the four children of Benedict Calvert, 1761 (Baltimore Museum of Art). Having begun his career under the stylistic influence of Robert Feke, he had by this point come under the influence of John Wollaston (active 1736–1767), who then was working in the mid-Atlantic region.

In his mature work a sculptural feeling for clear forms and volumes recalls the work of Feke. The head, for instance, is isolated as a distinct form, high on a thin neck, its shapes

slightly simplified and clarified. The heavy-lidded, almond eyes betray the example of Wollaston, as do the decorative elaboration of lace and extensive patterning of highlights in the drapery. More his own is Hesselius's use of strong color, in this case a brilliant blue in the dress and bright pink in the shawl, echoed in the high color of the face. The museum's painting is exceptionally well preserved for the work of Hesselius and consequently unusually impressive.

The subject was born in 1742 or 1743, the daughter of Samuel Chew III of Anne Arundel County and his wife Sarah Lock. The museum's painting is one of four portraits of members of the Chew family executed by Hesselius in 1762. One is a portrait of Elizabeth's mother, another is of Elizabeth's brother, Samuel Lloyd Chew (both unlocated), and the fourth is another version of the por-trait of Elizabeth (Brooklyn Museum). The other version is smaller (28³⁄₈ x 25¹⁄₈ inches), and only a bust-length, with Elizabeth Smith wearing a silver dress, with blue bow, and chocolate-colored shawl and holding a sprig of flowers in a slightly different gesture. In 1939 the museum's painting was the only one of this group of four not in the collection of Samuel Claggett Chew of Bryn Mawr, Pennsylvania. The fact that the museum's painting descended through Mrs. Smith's family rather than the Chew family suggests the possibility that it was commissioned separately by Mr. and Mrs. Smith. Since Elizabeth Chew was married on February 11, 1762, it is possible that the present painting was a marriage portrait. Her first hus-band was John Hamilton Smith, a resident and plantation owner of Calvert County; they had two daughters, Elizabeth Chew and Mary. Her half-sister, Mary, married a Dr. Alexander Hamilton Smith in 1767. (There was a promi-nent Scottish physician of the same name living in Annapolis in the 1740s.) Records for Saint James's (Old Herring Creek) Parish show a large family with the name of Smith living there in the early eighteenth century. Elizabeth Chew Smith later married a man named Sprigg. It is not known whether this second marriage produced issue. She died sometime after 1800.

Hesselius, *Portrait of Elizabeth Chew Smith.*

PROVENANCE
Elizabeth Chew Smith, Calvert County, Maryland § Mr. Smith (by descent) § Mrs. Herbert A. Gill (Monica Smith; by descent), Washington, D.C. § Theodore Nicholas Gill (by descent), Washington, D.C. § Mrs. Theodore Nicholas Gill (by descent) § Private collection (by descent), to 1980 § With Hirschl & Adler Galleries, New York, 1980–86.

EXHIBITIONS
New York, Hirschl & Adler Galleries, *American Art from the Gallery's Collection,* 1980, no. 1, repro., p. 7 § New York, Hirschl & Adler Galleries, *American Art from the Colonial and Federal Periods,* 1982, no. 8, repro., p. 16.

LITERATURE
Fort 1986, p. 421, fig. 1, p. 420 § LACMA, Ameri-can Art department files, Gregory R. Weidman to Ilene Susan Fort, February 22, 1989, discusses Chew and Smith families of Anne Arundel County, with genealogy of Chew family by Robert L. Chew; Katherine Bond to Ilene Susan Fort, March 2, 1989, discusses Chancery Court papers regarding John Hamilton Smith's will, names his wife and children.

John S. Copley

Born July 3, 1738, Boston,
Massachusetts
Died September 9, 1815,
London, England

One of this country's greatest artists, John Singleton Copley was a towering figure among American artists of the eighteenth century and rose to prominence as a portraitist and history painter during his subsequent career in England.

After his father's death Copley's mother married the painter-engraver Peter Pelham (1697–1751) in 1748. Although his stepfather died less than four years later, the young Copley grew up in artistic circles and by 1753 was active as a professional mezzotintist and portraitist. He rapidly assimilated influences from other painters and from prints, emerging within five years as the preeminent portraitist of Boston. He achieved wealth and property, as well as a national reputation.

Desiring to study in Italy and England, Copley sailed for London on June 10, 1774. After a period of study on the Continent, he joined his family in London in October 1775. (He had married Susanna Farnham Clark in 1769.) They were never to return to America. In London Copley continued his successful practice as a portraitist but altered his style to current English practices. He had a significant influence on the development of history painting. He was elected to the Royal Academy in 1779 and achieved numerous other honors.

BIBLIOGRAPHY
Augustus Thorndike Perkins, *A Sketch of the Life and a List of Some of the Works of John Singleton Copley*, (Privately printed, 1873), with supplement § *Letters and Papers of John Singleton Copley and Henry Pelham, 1739-1776* (1914; reprint, New York: Kennedy Graphics, Inc., and Da Capo Press, 1970) § Jules David Prown, *John Singleton Copley*, Ailsa Mellon Bruce Studies in American Art, 2 vols. (Cambridge, Mass.: Harvard University Press for National Gallery of Art, Washington, D.C., 1966), with catalogue raisonné, analyses of data on portraits, genealogies, lists of exhibitions and contents of various sales, bibliographies § Ann Uhry Abrams, "Politics, Prints, and John Singleton Copley's *Watson and the Shark*," *Art Bulletin* 61 (June 1979): 265–76 § Trevor J. Fairbrother, "John Singleton Copley's Use of British Mezzotints for His American Portraits: A Reappraisal Prompted by New Discoveries," *Arts* 55 (March 1981): 122–30.

Portrait of a Lady, 1771
(Mrs. Thrale; Unknown Subject, Traditionally Known
As Mrs. Thrale)
Oil on canvas
49¹⁵⁄₁₆ x 39½ in (126.9 x 100.3 cm)
Inscribed on letter: 1771
Inscribed lower left: HESTER LYNCH
SALUSBRY. / MRS THRALE. / Na 17 Ob182
Purchased with funds provided by the American
Art Council, Anna Bing Arnold, F. Patrick Burns
Bequest, Mr. and Mrs. William Preston Harrison
Collection, David M. Koetser, Art Museum Coun-
cil, Jo Ann and Julian Ganz, Jr., The Ahmanson
Foundation, Ray Stark, and other donors
85.2
Color plate, page 34

At the invitation of Captain Stephen Kemble, who had arranged a number of commissions for him, Copley came to New York by June 1771, encountering sufficient demand for his work to keep him there until Christmas of that year. Several circumstances suggest that the museum's *Portrait of a Lady* may have been painted while Copley was in New York: the letter the subject is holding is dated 1771; the placement of the sofa is similar to Copley's New York portrait of Captain Kemble's daughter, Mrs. Thomas Gage, 1771 (Timken Art Gallery, San Diego); the discovery of the portrait in England may reflect the fact that many of his New York sitters were Tories who would have taken their portraits back with them to England during the Revolution.

The closest one can come to the identity of the lady is the earliest known owner of the painting, a granddaughter of Hester Thrale who married the fourth marquis of Lansdowne in 1843. The granddaughter was the last of the descendants of Mrs. Thrale and could have inherited the painting from any of a number of aunts and their relatives by marriage. One would hope that one of these branches could be traced to someone who was in America in 1771. In any case, the source of the inheritance apparently led to the misidentification of the museum's painting as a portrait of Mrs. Thrale, the friend and patron of Dr. Johnson.

The strongest candidate for the identity of the sitter for this painting is a "Miss Johnston" whose name appears on the list of subscribers for portraits prepared by Captain Kemble to induce Copley to come to paint in New York. She is the only subscriber for a fifty-by-forty-inch portrait whose portrait has not been identified and who was the age of the sitter in the museum's portrait. (However, the bottom of Captain Kemble's torn list is missing, and other New Yorkers contracted for fifty-by-forty-inch portraits after Copley's arrival.) Given the fact that Captain Kemble's list reflects his associations with the Tory elite of New York City and New Jersey and the English military, the Miss Johnston on his list probably was Ann Johnston, daughter of Dr. Lewis Johnston, a prominent landholder in Perth Amboy, and his wife Martha Heathcote, daughter of the cele-

Copley, *Portrait of a Lady.*

brated Caleb Heathcote, as has been suggested by Mr. Edward Sprague Jones. She married a Captain (later Lieutenant-Colonel) John Burnet of the Eighth Regiment, British Army. The Johnston family left New Jersey and moved to New York during the Revolution. Afterward, Ann Johnston Burnet and her daughter lived with her father-in-law in Plymouth, England. John Burnet appears in Army lists up to the year 1792, but thereafter no record can be found of him either in War Office records or in the half-pay and pension returns of the Paymaster General. From 1783 to 1831 Ann Johnston Burnet was granted a Loyalist pension. It has not been possible to trace wills for either Captain Burnet or his wife.

In contrast to his more decorative work of the 1760s, Copley's portraits of the early 1770s are sober. As in *Portrait of a Lady,* the subject usually is posed before a vacant, dark background. A strong light partially illuminates the figure, which is otherwise enveloped by shadows. An almost stark simplicity gives the portrait at once a greater sense of sculptural form and a tougher, more forceful realism.

Although the setting of the portrait is simple, it contains a prominent note of luxury and even ostentation, the large camelback sofa upholstered in a plum-colored damask. Upholstered sofas were prohibitively expensive and rare in the American colonies. Of course, the sofa need not have belonged to the subject of

the portrait. Copley sometimes dressed sitters in dresses that appeared in others of his portraits, and he sometimes copied costumes from prints. Often the settings were adapted from prints or were invented. The shape of the sofa and the pattern of the decorative nailing in the museum's portrait are the same as in Copley's portrait of Mrs. Gage, although the color of the upholstery is different. A distinctive feature of the museum's painting is the evidence it alone provides as to the use of cushions on American sofas. The subject of the portrait is depicted reclining upon both a box-edge cushion and a knife-edge cushion. The box-edge cushion may have been either a seat cushion or more likely a back cushion. The knife-edge cushion may have been one of the pillows placed at each end. In the third edition of his *Gentleman and Cabinet-Maker's Director* (1762), Thomas Chippendale advised that sofas "have a bolster and pillow at each end and cushions at the back, which may be laid down occasionally."

The subject wears a white dress of the style seen in portraits of as much as forty years earlier in the works of JOHN SMIBERT, for instance. By the time the museum's portrait was painted this type of dress was no longer worn in public, becoming a kind of formal undress comparable with the turbans and dressing coats in which Copley's men sometimes appear, something to be worn in the presence of family and close friends. The subject wears no jewelry. The relaxed, reclining pose of the subject, unique in Copley's work, enhances this impression of our having been admitted into a private setting.

Another interpretation of the costume would suggest a distinctly different mood within this painting. In contrast to Copley's Boston subjects, who usually wore their best street clothes, his more sophisticated New York sitters were aware of the current fashion in London for portraits in fancy costume. For instance, Mrs. Gage wears what was known as Turkish dress. The simple, crossed-over, loose dress worn by the subject of the museum's painting is similar to the classical costume worn by the subjects of Sir Joshua Reynolds's grand manner portraits employing personification from mythology or ancient history. If it was meant to suggest classical costume, the utterly simple dress in the museum's painting would indicate to the viewer of that period not informal relaxation but sophisticated elegance.

In contrast with Mrs. Gage, who looks away, the subject of the museum's painting gazes directly at the viewer. The art historian Jules Prown remarks upon the exceptional degree to which Copley here concentrates upon the character of his subject: "There is a strong sense of the sitter's personality here, whoever she may be, and a warm rapport is created between the viewer and the subject of the painting."

PROVENANCE
Lady William Osborne (Georgiana Augusta H. Elphinstone Villiers), London, to 1892 § Lansdowne family (by descent), Bowood, Wiltshire, 1892–1952 (sale, Christie, Manson & Woods, London, *Catalogue of Pictures by Old Masters . . . The Properties of His Royal Highness, the Duke of Windsor, K.G., the Most Hon. The Marquess of Lansdowne . . .,* May 16, 1952, no. 61, as *Portrait of Mrs. Thrale* by Nathaniel Dance) § Mr. Robinson, 1952 § Mrs. Donald F. Hyde, Somerville, N.J., mid-1950s–1985 § Viscount Eccles, London, 1985 § With Thomas Agnew & Sons, London, 1985.

EXHIBITION
New York, Hirschl & Adler Galleries, *American Portraits by John Singleton Copley,* 1975–76, no. 38, repro., unpaginated, as *Unknown Subject, Traditionally Known as Mrs. Thrale.*

LITERATURE
Marquis of Lansdowne, ed., *Johnson and Queeny: Letters from Dr. Johnson to Queeny Thrale from the Bowood Papers* (London, 1932), repro., p. 22 overleaf, as *Mrs. Thrale* § James L. Clifford, *Hester Lynch Piozzi (Mrs. Thrale)* (Oxford: Clarendon Press, 1941), repro., frontispiece, as *Mrs. Thrale* by an artist unknown § Charles Merrill Mount, "A Hidden Treasure in Britain, Part 2: John Singleton Copley," *Art Quarterly* 24 (Spring 1961): 43, fig. 4, p. 41, as *Mrs. Thrale* § Prown, *Copley,* 1: 80–81, 232, listed in cat. raisonné under American portraits, discussed as one of the few portraits in which Copley concentrates on the figure's character, discusses identity of sitter, fig. 286, as *Unknown Subject, Traditionally Known as Mrs. Thrale* § Sylvia Hochfield, "John Singleton Copley's America," *Art News* 75 (February 1976): 84, repro., as *Unknown Subject, Traditionally Known as Mrs. Thrale* § LACMA, American Art department files, Lord Eccles to Ilene Susan Fort, October 25, 1985, suggests that the figure might be Mrs. Gage's stepmother; Lady Eccles (formerly Mrs. Donald F. Hyde), to curator of American painting, March 17, 1986, discusses provenance and problems of attribution § "Recent Acquisition: *Portrait of a Lady,*" *LACMA Members' Calendar* 23 (November 1985): 2, repros., cover, 2 § "American Art," *LACMA Report 1983–1985* (1985), p. 16, repro., p. 3 § Brock Jobe, "The Boston Upholstery Trade, 1700–1775," in *Upholstery in America and Europe from the Seventeenth Century to World War I,* ed. Edward S. Cooke, Jr. (New York: W. W. Norton, 1987), p. 65, quotes Chippendale on sofa pillows, fig. 39, p. 64 § LACMA, American Art department files, Edward S. Cooke, Jr., to Michael Quick, July 28, 1988, discusses the kinds of sofa cushions in the portrait § Edward Sprague Jones, telephone conversation with Michael Quick, October 1988, suggested that the "Miss Johnston" on Kemble's list might be Ann Johnston of Perth Amboy § Fort 1986, p. 421, pl. x, p. 423 § Jules David Prown, "John Singleton Copley in New York," *Walpole Society Note Book* 1986: 36–37, discusses his discovery of the painting, repro., following p. 34 § LACMA 1988, p. 13, repro.

Copley, *Portrait of Hugh Montgomerie, Later Twelfth Earl of Eglinton*.

Portrait of Hugh Montgomerie, Later Twelfth Earl of Eglinton, 1780
(*Portrait of an Highland Officer*)
Oil on canvas
94½ x 59¾ in (240.0 x 151.7 cm)
Signed and dated lower right: J S Copley / 1780
Gift of Andrew Norman Foundation and Museum
Acquisition Fund
M.68.74

Hugh Montgomerie was born in 1739, the son
of Alexander Montgomerie of Coilsfield,
Ayrshire, Scotland. He entered the army in
1756 and was a lieutenant when the Seventy-
seventh Regiment, or Montgomerie's High-
landers, was raised and commissioned by his
kinsman Archibald Montgomerie (later elev-

enth earl of Eglinton). The regiment saw
action in the French and Indian War at Fort
Duquesne, Ticonderoga, and other places and
in 1760 and 1761 against the Cherokees, defeat-
ing them in battles at Etchocy and War-
Women's Creek. Hugh Montgomerie had risen
to the rank of major by 1780, when Copley
painted his portrait, and had been elected
member of Parliament for Ayrshire. He suc-
ceeded to the title of twelfth earl of Eglinton
in 1796.

In 1780 Montgomerie's bright political
career yet lay before him. He was still active in
the army, rising to the rank of colonel in 1793,
so it would have been natural for him to have
himself portrayed as a soldier. The decision to
paint him leading a battle fought twenty years
earlier probably was the artist's. The portrait
belongs to the tradition of grand-manner por-
traiture, as promulgated by Sir Joshua Reynolds
(1723–1792), president of the Royal Academy.
The concept was to raise the artistic value of a
portrait by ennobling mere representation with
elements of higher art. Copley's portrait meets
these objectives by incorporating elements of
history painting, considered to be the highest
genre. It has a color and drama not to be found
in simple portraiture, depicting the subject as a
man of energy and importance. Another elevat-
ing feature, which serves to further flatter the
subject, results from Copley's decision to fol-
low Reynolds's example by posing Mont-
gomerie in the striding stance of the *Apollo
Belvedere* (Vatican Museum, Rome), then con-
sidered the greatest ancient sculpture.

Comparison with the museum's *Portrait of
a Lady* shows how quickly after his arrival in
England Copley had mastered the heightened
palette and bravura technique of the best of the
English school.

RELATED WORKS
Study for Figure of Montgomerie, c. 1779–80, black
and white chalk on pink-buff paper, 12 x 17 in (30.5
x 43.1 cm). Mr. and Mrs. Herbert C. Lee, Belmont,
Mass., as of 1966 § *Study for Figure of Montgomerie,*
c. 1779–80, black and white chalk on blue-gray
paper, 12 x 23⅜ in (30.5 x 59.3 cm). University of
Virginia Art Museum, Charlottesville, as of 1966
§ Copy, n.d., oil on canvas, 87 x 56½ in (220.9 x
143.5 cm). National Portrait Gallery of Scotland, Edin-
burgh § Copy by Henry Raeburn, 1821, oil on
canvas, dimensions unknown, Town Hall, Ayr,
Ayrshire, Scotland § Copy attributed to Angelica
Kauffmann, n.d., location unknown.

PROVENANCE
Hugh Montgomerie, Coilsfield, Ayrshire, Scotland,
to 1819 § Mrs. Edward Archibald Hamilton (Lady
Jane Montgomerie; by descent), Rozelle, Ayrshire,
to 1860 § Lt. Commander John Hamilton, R.N.
(by descent), to 1967 (sale, Christie's, London, *Impor-
tant English Pictures,* July 7, 1967, no. 109, repro.,
p. 44 overleaf) § M. Knoedler & Co., New York,
1967–68.

ON DEPOSIT
National Gallery of Art, Washington, D.C., 1969.

EXHIBITIONS
London, Royal Academy of Arts, *Twelfth Exhibition*, 1780, no. 172, as *Portrait of an Highland Officer* § Washington, D.C., Smithsonian Institution, National Collection of Fine Arts, *Survey of American Art*, 1968, entries not numbered, p. 7 § Oakland Museum, *Art Treasures in California*, 1969, entries not numbered, repro., unpaginated § LACMA 1975, no. 116, pp. 215–16, entry by Donelson Hoopes and Nancy D. W. Moure, repro., p. 120.

LITERATURE
"An Artist," *A Candid Review of the Exhibition (Being the Twelfth) of the Royal Academy*, 2d ed. (London: H. Reynell and T. Evans, 1780), no. CLXXII, p. 26, describes Montgomerie's attire § Frank William Bayley, *The Life and Works of John Singleton Copley* (Boston: Taylor Press, 1915), p. 179 § Prown, *Copley*, 2: 275–76, 328, 387, 427, listed in cat. raisonné under English portraits with location unknown, fig. 389 of National Gallery of Scotland copy as "After Copley," fig. 390 of preparatory study dated 1779–80, fig. 390a of undated preparatory study § *LACMA Members' Calendar* (November 1969): opposite 1, repros., detail as cover, opposite 1 § "Permanent Collections," *LACMA Report 1968–69* (as *LACMA Bulletin* 19, no. 1 [1969]), pp. 15–16, repro., p. 16 § "La Chronique des arts," *Gazette des Beaux-Arts*, 6th ser., 75 (February 1970): repro., supp. 75 § Mahonri Sharp Young, "A Decade of Collecting," *Apollo* 101 (March 1975): 225, fig. 13, p. 223 § Sarah B. Sherrill, "Current and Coming," *Antiques* 107 (April 1975): repro., 576 § LACMA 1977, p. 132–33, repro., p. 133 § William Wilson, *The Los Angeles Times Book of California Museums* (New York: Harry N. Abrams, 1984), p. 149, fig. 133, p. 153 § "American Art," *LACMA Report 1983–1985* (1985), p. 16 § Fort 1986, p. 421.

Benjamin West

Born October 10, 1738, Springfield Township (now Swarthmore), Pennsylvania
Died March 11, 1820, London, England

One of the most prominent artists of his era, Benjamin West helped to shape both the neoclassical and the romantic styles in England. Because of his help to a generation of young American artists, he was considered during the nineteenth century to have been the father of American painting.

He showed artistic ability at a very early age. He received some instruction from the English portrait painter William Williams (1721–1791) and by the time he was eighteen years old had established himself as a professional portraitist in Philadelphia. The support of patrons enabled him in 1760 to study in Italy, where he absorbed the spirit and emerging style of the neoclassical movement. In 1763 he went to England, where he was to remain for the rest of his life. West met with great success with the neoclassical style he introduced to England and further developed there. In 1772 he was appointed historical painter to King George III. During the 1780s West was an important figure influencing the emergence of the romantic style in England. A charter member of the Royal Academy, he was elected its second president in 1792, remaining in that position, with a brief interruption, until his death in 1820. Already a prominent figure in London in the 1760s, West continued to be celebrated and influential throughout his life. His example attracted a generation of American artists to study with him.

BIBLIOGRAPHY
John Galt, *The Life, Studies, and Works of Benjamin West, Esq.* (London: T. Cadell and W. Davies, 1820), with catalogue § Grose Evans, *Benjamin West and the Taste of His Times* (Carbondale: Southern Illinois University Press, 1959), with bibliography § John Dillenberger, *Benjamin West: The Context of His Life's Work with Particular Attention to Paintings with Religious Subject Matter* (San Antonio: Trinity University Press, 1977), with correlated version of early nineteenth-century lists of West's paintings, exhibitions, sales, checklist of religious paintings, bibliography § Robert C. Alberts, *Benjamin West: A Biography* (Boston: Houghton Mifflin, 1978), with bibliography § Helmut von Erffa and Allen Staley, *The Paintings of Benjamin West* (New Haven, Conn.: Yale University Press, 1986), with catalogue raisonné.

Cymon and Iphigenia, 1773
(*Rinaldo and Armida*)
Oil on canvas
50 x 63⅛ in (127.0 x 160.3 cm)
Signed and dated lower left: B. West / 1773
Purchased with funds provided by Mr. and Mrs. Reese Llewellyn Milner, Mr. and Mrs. Byron E. Vandergrift, George C. Zachary, Jo Ann and Julian Ganz, Jr., and Joseph T. Mendelson
M.82.91
Color plate, page 35

When this painting was first exhibited and in early lists of West's works, the subject was given as Rinaldo and Armida, from a scene in Torquato Tasso's *Gerusalemme Liberata* (1575), in which Rinaldo is most often represented holding a mirror to Armida's face, as in West's version of 1766 (Rutgers University Art Gallery, New Brunswick, N.J.). Few details of the painting support that identification, however, whereas many coincide with the story of Cymon and Iphigenia, which West may have

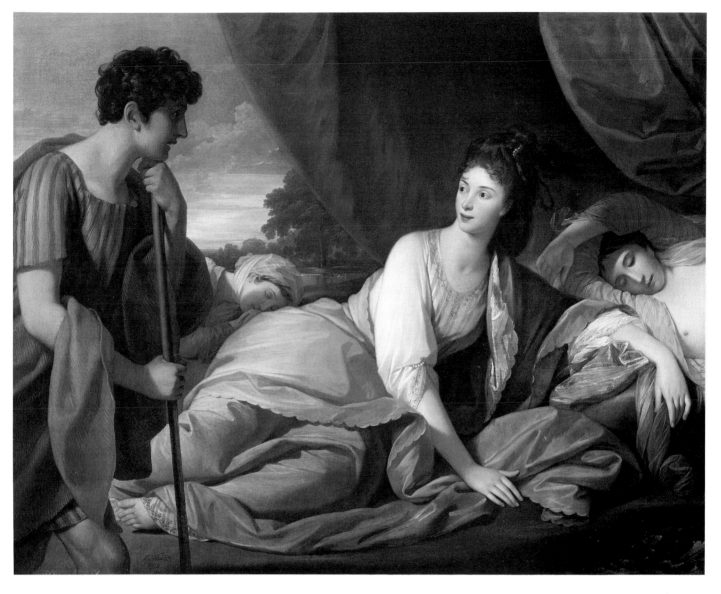

West, *Cymon and Iphigenia.*

West, *Isaac's Servant Tying the Bracelet on Rebecca's Arm,* 1775, oil on canvas, 49¾ x 63³/₁₆ in (126.4 x 160.5 cm), Yale Center for British Art, Paul Mellon Collection.

known either from the original tale by Boccaccio in *The Decameron* (1353) or from the version by John Dryden (1700). Cymon was the handsome son of a nobleman of Cypress who was so crude and stupid that he was sent to work on the land. One morning he happened on the camp where Iphigenia (not the daughter of Agamemnon) was sleeping among her slaves. Transfixed by her beauty, he remained leaning on his staff. When she awoke and spoke, he continued to stare at her. His love for Iphigenia fired Cymon with such desire for learning that he quickly advanced to become an exemplary young man and after some military adventures, won her. All the elements in this painting correspond to the story, with the exception that Iphigenia is here clothed, whereas in most representations she is sleeping nearly nude, with her breasts uncovered. A reference to this detail is made by the partial dress of the sleeping slave on the right.

The museum's picture and West's *Isaac's Servant Tying the Bracelet on Rebecca's Arm,* 1775 (Yale Center for British Art, New Haven, Conn.; see illustration), dated two years later

and of identical size, were painted for John Hobart, the second earl of Buckinghamshire, and exhibited at the Royal Academy in 1776. The theme shared by these otherwise dissimilar subjects is the finding of the ideal wife. It would have been entirely characteristic of West to have painted these pictures, with their similar central female figures, as allegorical portraits, in this case of Lord Buckinghamshire's second wife, whom he had married in 1770. The fact that they were inherited by the daughter from this marriage would seem to support this conjecture. If Iphigenia is a portrait of the countess, perhaps this explains her modestly covered bosom.

In his well-known works of the mid-1760s West continued to develop his somewhat dry and stiff neoclassical style. By the early 1770s he had arrived at a truly grand style: the forms are simpler and larger, colors richer, technique more expert and elegant. The large forms, heavy drapery, and slow rhythms recall the classicism of the Italian seventeenth-century artists Guercino (1591–1666) and Guido Reni (1575–1642).

PROVENANCE

John Hobart, second earl of Buckinghamshire, 1773–93 § Amelia Anne, viscountess Castlereagh (by descent), London, 1793 § Lady Mairi Bury (by descent), Newtownards, County Down, Northern Ireland, 1962–77 § With Thomas Agnew & Sons, London, 1977–79 § With Coe Kerr Gallery, New York, 1980–82.

EXHIBITIONS

London, Royal Academy, *Eighth Exhibition*, 1776, no. 320, as *Rinaldo and Armida* § Baltimore Museum of Art, *Benjamin West: American Painter at the English Court*, 1989, no. 19, pp. 38, 51, text by Allen Staley, repro., p. 50.

LITERATURE

"A Correct Catalogue of the Works of Mr. West," *Public Characters of 1805* (London) 7 (1804–5): 564, as *Rinaldo and Armida* § "A Correct List of the Works of Mr. West," *Universal Magazine* 3 (1805): 529, as *Rinaldo and Armida* § "A Correct Catalogue of the Works of Benjamin West, Esq." *La Belle Assemblée* (known as *Bell's Court and Fashionable Magazine*) 4 (July 1808): supp. 16, as in collection of the late Lord Buckinghamshire, as *Rinaldo and Armida* § "A Correct Catalogue of the Works of Benjamin West, Esq.," *Port Folio* n.s. 3 (December 1811): 548, as *Rinaldo and Armida* § Galt, *West*, part 2: 225, listed in appendix of works done for the late Lord Buckinghamshire, as *Rinaldo and Armida* § Dillenberger, *West*, pp. 163, 192, as *Rinaldo and Armida* § LACMA, American Art department files, Allen Staley to Michael Quick, December 9, 1981, discusses title and suggests its relationship to *Isaac's Servant . . .* as allegorical portraits for Lord Buckinghamshire § "American Art," *LACMA Members' Calendar* 21 (July 1983): unpaginated, repro. § "American Art," *LACMA Report 1981–1983* (1984), p. 20, repro., p. 22 § Von Erffa and Staley, *Paintings of West*, pp. 284, 292, listed as no. 228 in cat. raisonné, discussed in relationship to *Isaac's Servant . . .*, repro., p. 78, as *Rinaldo and Armida* § Fort 1986, p. 421 § LACMA 1988, p. 14, repro. § William L. Pressly, "Exhibition Reviews: Baltimore, Baltimore Museum of Art, Benjamin West," *Burlington Magazine* 131 (August 1989): 589-90, mentions Staley's acceptance of reidentification of subject.

Gilbert Stuart

Born December 3, 1755, North Kingston, Rhode Island
Died July 9, 1828, Boston, Massachusetts

By far the country's best portraitist following the Revolutionary War, Gilbert Stuart considerably influenced the development of portraiture in America. He is best known for his portraits of George Washington, which have become the standard image of the country's first president.

Having received some training at an early age by an itinerant Scottish portraitist, Cosmo Alexander (c. 1724–1772), Stuart traveled to Edinburgh with Alexander and then returned to work as a portraitist in Newport, Rhode Island. In September 1775 he left for London, where the inadequacies of the primitive style he had practiced brought him close to starvation. Writing in 1777 to BENJAMIN WEST, he received a warm welcome and spent the next five years in the home of his countryman. By the time he set up his own studio in 1782, he was a stylish portraitist and master of a fluent technique. In 1782 he married Charlotte Coates. Although he was in great demand as one of London's most fashionable portraitists, Stuart's extravagant living led to his move to Ireland in 1787 to escape his debtors. Stuart enjoyed even greater success in Dublin but again fell heavily into debt, leaving for America in early 1793. He worked first in New York and then moved in late 1794 to Philadelphia, where he had the opportunity to paint a portrait of George Washington. He moved to Washington, D.C., in 1803 and in 1805 to Boston, where he lived until his death in 1828.

BIBLIOGRAPHY

George C. Mason, *The Life and Works of Gilbert Stuart* (New York: Scribner's, copyright 1879, 1894), with catalogue of works § Lawrence Park, comp., *Gilbert Stuart: An Illustrated Descriptive List of His Works, Compiled by Lawrence Park, with an Account of His Life by John Hill Morgan and an Appreciation by Royal Cortissoz*, 4 vols. (New York: William Edwin Rudge, 1926), with lists of owners § John Hill Morgan, *Gilbert Stuart and His Pupils* (1939; reprint, New York: Kennedy Galleries and Da Capo Press, 1969), with notes on painting by Matthew H. Jouett from conversations with the artist § Charles Merrill Mount, *Gilbert Stuart: A Biography* (New York: W. W. Norton, 1964), with lists of sitters and works § Washington, D.C., National Gallery of Art, and Providence, Rhode Island School of Design, Museum of Art, *Gilbert Stuart: Portraitist of the Young Republic, 1755–1828*, exh. cat., 1967, with essay by Edgar P. Richardson, chronology, catalogue by Mary E. Burnet and others.

Portrait of Richard Barrington, Later Fourth Viscount Barrington, c. 1793–94

Oil on canvas
30⁵/₁₆ x 25¹/₈ in (76.9 x 63.9 cm)
Los Angeles County Fund
68.2

Little is known about Richard Barrington (died 1814 in Valenciennes), who became the fourth viscount Barrington in 1801. He married Susannah Budden (1761–1830) of Philadelphia, daughter of Captain William and Louisa Cuzzins Budden, in 1783. Although the Barrington family belonged to the peerage of

Ireland, their principal residence was listed in 1783 as Becket House, Shrivenham, England. In 1785 Stuart painted a portrait in London of Richard Barrington's uncle, Admiral Samuel Barrington. It is possible that Captain William Budden's family moved to England after the Revolution.

The subject was associated with London, Dublin, and Philadelphia, the cities where Stuart spent three of his most important periods, but the style of the painting appears to be that found in the portraits Stuart painted in New York immediately after his return to this country in 1793. As in those portraits, Barrington's figure is drawn as though immediately against the picture plane, a silhouette estab-lished from the indefinite background. The seriousness and direct gaze of the subjects of these portraits contribute to a feeling of sensitive realism, enhanced by skillfully differentiated textures.

PROVENANCE
Richard, fourth viscount Barrington, to 1814 § George, fifth viscount Barrington (by descent), to 1829 § William Keppel, sixth viscount Barrington (by descent), to 1867 § George William, seventh viscount Barrington (by descent), to 1886 § Percy, eighth viscount Barrington (by descent), to 1901 § Walter Buckley, ninth viscount Barrington (by descent), to 1935 § Sir C. B. Barrington, Fairthorne Manor, near Southhampton, England, 1956 § With F. Kleinberger & Co., Inc., New York, 1956(?)–68.

Stuart, *Portrait of Richard Barrington, Later Fourth Viscount Barrington.*

EXHIBITION
LACMA 1975, no. 117, pp. 216–17, entry by
Donelson Hoopes and Nancy D. W. Moure, repro.,
p. 121.

LITERATURE
"Permanent Collections," LACMA Report 1968–
1969 (as LACMA Bulletin 19, no. 1 [1969]), p. 17,
repro. § "La Chronique des arts," Gazette des
Beaux-Arts, 6th ser., 75 (February 1970): supp. 76,
fig. 344 § LACMA 1977, pp. 135–36, repro., p. 135
§ LACMA, American Art department files,
Marvin Sadik to Michael Quick, July 19, 1988,
suggests date of c. 1794.

Attributed to John Wesley Jarvis

Born 1781, England (baptized
South Shields, Durham,
July 1, 1781)
To United States c. 1785
Died January 12, 1840, New
York, New York

John Wesley Jarvis was considered the foremost portraitist of his time in New York and
also enjoyed a national reputation. He was born in England to an American father of the
same name and an English mother related to the Methodist, John Wesley, whose name
John Jarvis later added to his own. In about 1785 the family followed the father to Phila-
delphia, where the children were raised. About 1793 the young John was apprenticed to
the engraver Edward Savage (1761–1817), with whom he moved to New York. The fol-
lowing year Jarvis opened his own studio as an engraver and painter. By 1803 he was in
partnership with the miniaturist Joseph Wood (c. 1778–1830). His skills steadily improved
over the next five years, until, with the departure of John Trumbull (1756–1843) for
England in 1808, his practice as a portraitist greatly expanded. He married in about 1809.
In 1810 he set off for Baltimore, beginning a series of winter trips to seek commissions in
Southern cities. The success of several important commissions from the City of New
York for portraits of heroes of the War of 1812 established him in about 1814 as the city's
leading portraitist. That year he took as his apprentice and assistant HENRY INMAN, who
came to eclipse his master in about 1825. Jarvis married for a second time in 1819. A
stroke in 1834 ended his career.

BIBLIOGRAPHY
William Dunlap, History of the Rise and Progress of the Arts of Design in the United States, (1834; 3d ed., rev. and
enl., New York: Benjamin Blom, 1965) 2: 208–28 § Harold Edward Dickson, John Wesley Jarvis: American
Painter, 1780–1840, with a Checklist of His Works (New York: New-York Historical Society, 1949), with bibli-
ography and list of owners § Joseph J. Arpad, "John Wesley Jarvis, James Kirke Paulding, and Colonel
Nimrod Wildfire," New York Folklore Quarterly 21 (June 1965): 92–106 § Ernest Rohdenburg, "The Mis-
reported Quidor Court Case," American Art Journal 2 (Spring 1970): 74–80 § Leah Lipton, "William
Dunlap, Samuel F. B. Morse, John Wesley Jarvis, and Chester Harding: Their Careers as Itinerant Portrait
Painters," American Art Journal 13 (Summer 1981): 34–50.

Attrib. Jarvis, Portrait of Isaac
Van der Beek.

Attrib. Jarvis, Portrait of Rachel
Van der Beek.

Portrait of Isaac Van der Beek,
c. 1807–12
Oil on wood panel
34⅛ x 26¹³/₁₆ in (86.7 x 68.1 cm)
Gift of Mr. and Mrs. Arnold S. Kirkeby
56.60.3

Portrait of Rachel Van der Beek,
c. 1807–12
Oil on wood panel
34⅛ x 26¹³/₁₆ in (86.7 x 68.1 cm)
Gift of Mr. and Mrs. Arnold S. Kirkeby
56.60.4

The sitters both descended from very old Dutch families of New Jersey. Isaack Van der Beek (by 1805 he spelled his name Isaac Vanderbeck) was born in Hackensack on October 29, 1743, and died in New York on May 27, 1833. On November 27, 1767, he married Rachel Ryerson of Saddle River. She was born on May 13, 1751, and died in New York on February 23, 1825. Their only child was a daughter, Ann.

Isaac Van der Beek was active in the patriot militia during the Revolutionary War. In 1791 he was an elder of the Dutch Church in Hackensack and in 1805 president of the town's board of trustees. The couple is listed in the New York census of 1810 but not the census of 1820, although their wills, hers in 1823 and his in 1833, describe them as residents of New York. Their estates consisted primarily of real estate in New York and Newburgh, New Jersey.

The portraits have been attributed to several different artists. They were originally sold in 1918 and in the 1920s as by GILBERT STUART, with a statement of authenticity from Jonce I. McGurck. Lawrence Park felt they were by John Vanderlyn (1775–1852). William Sawitzky attributed them to James Frothingham (1786–1864). The staff of the Frick Art Reference Library and also Harold E. Dickson felt they were by John Wesley Jarvis. This last attribution seems to be the correct one, judging especially from the clarity of the spirited likenesses and the summary fashion in which the arms and hands are painted. According to family tradition, they were painted in 1807, which would have been about the time the couple moved to New York, but a relative

fluency of technique suggests that Jarvis may have painted them as much as five years later.

PROVENANCE
Mr. and Mrs. Isaac Van der Beek, New York § Elizabeth Fowler (by descent), New York, to 1917 § With Ehrich Galleries, New York, 1917 § (Sale, Anderson Galleries, New York, *Rare Italian Primitives . . . together with . . . the Property of Mr. Arthur M. Hammerschlag of New York City and others,* 1923, *Isaac Van der Beek,* no. 138, repro., facing p. 34; *Rachel Van der Beek,* no. 139; as by Gilbert Stuart) § William J. Ralston, New York, to 1926 (sale, American Art Association, New York, *Important Paintings of the English, American, Flemish, Dutch, and French Barbizon Schools, From the Estate of the Late Lieut. William J. Ralston,* 1926, *Isaac Van der Beek,* no. 56, repro., unpaginated; *Rachel Van der Beek,* no. 57, repro., unpaginated; as by Gilbert Stuart) § With Arthur U. Newton, New York, 1926–still in 1930 § With John Levy Gallery, New York, c. 1943 § Mr. and Mrs. Arnold S. Kirkeby, Los Angeles, to 1956.

ON DEPOSIT
Buffalo, Albright Art Gallery, 1929–30.

EXHIBITIONS
New York, Ehrich Galleries, *Portraits by Stuart and Sully,* 1917, no cat. traced § New York, J. Leger and Son, Inc., *Exhibition of American Paintings of the Eighteenth and Nineteenth Centuries,* 1930, pair as no. 15, as by Vanderlyn.

LITERATURE
"Stuarts and Sullys at Ehrich's Galleries," *American Art News* 16 (November 17, 1917): 3, states that "the eight Stuarts shown . . . [include] the half lengths of the ruddy faced genial Mr. and Mrs. Isaac Van der Beck, who show so unmistakably their Dutch ancestry, . . . [and] are all worthy examples of the artist's American period—those of Mr. and Mrs. Van der Beck—exceptionally fine ones" § New York, Ehrich Galleries, *One Hundred Early American Paintings,* 1918, *Isaac Van der Beek,* repro., p. 110; *Rachel Van der Beek,* repro., p. 111; as by Gilbert Stuart § Lawrence Park, comp., *Gilbert Stuart* (New York: Rudge, 1926), 2: 904, listed under "Portraits Attributed to Gilbert Stuart"; suggests that they may be by Vanderlyn § "Eight Thousand for a Whistler Paid at Ralston Sale," *New York Times,* March 13, 1926, p. 12, says Van Der Beek of Paterson, New Jersey, and New York § LACMA, American Art department files, Hannah Howell, Frick Art Reference Library, to Richard F. Brown, April 10, 1957, suggests attribution to Jarvis; Harold E. Dickson to Nancy Dustin Wall Moure, May 13, 1971, attributes them to Jarvis.

Rembrandt Peale

Born February 22, 1778, Bucks County, Pennsylvania
Died October 3, 1860, Philadelphia, Pennsylvania

Rembrandt Peale was the preeminent American portraitist working in the neoclassical style. His father, Charles Willson Peale (1741–1827), was at the time of Rembrandt's birth the best-trained artist in the country, since JOHN S. COPLEY had left Boston for Europe. Rembrandt learned to draw at the age of eight and at thirteen painted his first self-portrait. At sixteen he became a professional portraitist. In 1795 he had his first portrait sitting with President George Washington, which was the beginning of a lifelong interest in an ideal image of the great man, culminating in his often-replicated *Patriae Pater* portrait of about 1824 (Pennsylvania Academy of the Fine Arts, Philadelphia). He painted in South Carolina in 1795 and then in Baltimore and again in Philadelphia. In 1798 he married Eleanora Mary Short.

In 1801 he accompanied his father to Newburg, New York, where he assisted with the exhumation and reconstruction of two mastodon skeletons. He exhibited one of these in 1802 in London, where he also studied briefly with BENJAMIN WEST in 1803. In 1808 and again in 1809 he visited Paris; here his mature style began to coalesce under the influence of French neoclassicism. After his return to Philadelphia in 1810, he attempted to establish himself as a history painter with his large work, *The Roman Daughter,* 1811 (National Museum of American Art, Smithsonian Institution, Washington, D.C.). In 1814 he opened in Baltimore a museum of painting and natural history and in 1816 helped to found the Gas Light Company of Baltimore. In 1822 he sold the museum to his brother Rubens and returned to painting full time. In the following years he traveled to New York, where he became a founding member of the National Academy of Design, and to Boston, where he experimented with lithography. In 1828 he traveled in Europe, principally in Italy, returning to New York in 1830. The following year he published his *Notes on Italy.* In 1832 he was again in Europe, painting portraits in London. Returning to New York in 1834, he published a drawing manual, *Graphics,* that was reprinted nineteen times and was an important high-school textbook throughout the latter half of the nineteenth century. In 1836 he became president of the American Academy of Fine Arts. In 1846 he was again in Philadelphia, where he published *Portfolio of an Artist.* In the late 1850s he published his "Reminiscences" in *The Crayon* and frequently lectured on his portraits of Washington.

BIBLIOGRAPHY

Philadelphia, American Philosophical Society, Peale-Sellers Papers § C. Edwards Lester, *The Artists of America: A Series of Biographical Sketches of American Artists* (1846; reprint, New York: Kennedy Galleries and Da Capo Press, 1970), pp. 199–231, with Peale's autobiography and Lester's comments on *The Court of Death,* 1820 (Detroit Institute of Arts) § Eleanor McSherry Fowble, "Rembrandt Peale in Baltimore," Master's thesis, University of Delaware, 1965, with bibliography, appendixes of reprinted letters § Lillian B. Miller, ed., *The Collected Papers of Charles Willson Peale and His Family* (Millwood, N.Y.: Kraus Microform for National Portrait Gallery, Smithsonian Institution, 1980) § Philadelphia, Historical Society of Pennsylvania, *Rembrandt Peale, 1778–1860: A Life in the Arts,* exh. cat., 1985, with essays by Carol Eaton Hevner and Lillian B. Miller, catalogue by Hevner and Carrie H. Scheflow, bibliography.

Portrait of Jacob Gerard Koch, c. 1817
Oil on canvas
34¹/₁₆ x 29 in (86.5 x 73.7 cm)
Inscribed on letter: SHIP 6 / [Ja]cob Gerard Koch / Philadelphia
Purchased with funds provided by Mr. and Mrs. William Preston Harrison Collection, Mary D. Keeler Bequest, and Dr. Dorothea Moore
78.5.1
Color plate, page 36

Portrait of Jane Griffith Koch, c. 1817
Oil on canvas
34 x 29¹/₁₆ in (86.4 x 73.8 cm)
Purchased with funds provided by Mr. and Mrs. William Preston Harrison Collection, Mary D. Keeler Bequest, and Dr. Dorothea Moore
78.5.2

The letter that the male sitter has apparently just pulled from his correspondence folder is addressed to [Ja]cob Gerard Koch (1761–1830), a prosperous merchant and prominent citizen of Philadelphia. Born in Holland, Koch emigrated to America before 1778. His business as an importer and merchant of "German" linens made him wealthy enough to purchase a country estate, Fountain Green, at the Falls of the Schuylkill in about 1801 and leave an immense estate in 1830 of more than a million dollars. A conspicuous patriot during the War of 1812, he contributed five thousand dollars toward the building of a frigate. Contemporaries remarked upon his exceptional corpulence; he weighed more than three hundred pounds. The letter bears a postal hand stamp "SHIP" and a manu-

script rate marking "6." Although the six-cent rate was in use for a long time (1794–1861), the earliest known use of the "SHIP" hand stamp was in 1817, which suggests to historian Frederick S. Dickson that the paintings should be dated between 1817 and 1820, when Koch retired from business and moved to Paris. At that time he was married to his second wife, Jane Griffith (born in Ireland about 1772), whom he had married in Philadelphia in 1801. She survived her husband and lived in Paris until 1848.

sky painted in the romantic tradition. As was his custom, Peale carried out the wife's portrait in an even more romantic manner, with flowing lines, softer modeling, and a less direct gaze. While the male and female types are dissimilar, the unified architectural space between the portraits leaves little doubt that they are a pair. This background is among the most elaborate and impressive that Rembrandt Peale painted. Together with the richness and high quality of the figure painting, it marks the pair as among the artist's finest works.

Peale, *Portrait of Jacob Gerard Koch.*

Peale, *Portrait of Jane Griffith Koch.*

In 1833 Mrs. Koch wrote to her brother-in-law Matthew Huizinga Messchert in Philadelphia to order a copy of the portraits from THOMAS SULLY, who referred to them in his journal as by "R. Peale," confirming the stylistic evidence that points to an attribution of the original portraits to Rembrandt Peale. Closely comparable with the Koch portrait, for instance, would be Rembrandt Peale's portrait of General Samuel Smith from the period of about 1817–18, in Baltimore's Peale Museum, and his portrait of Isaac McKim of the same period at the Maryland Historical Society.

Peale frequently posed his male subjects with one arm over a chair back to create a pyramidal composition, as in the portrait of Koch. Together with a general simplification and geometrizing of form, this most stable of compositions contributes to the neoclassical order of the portrait, which, however, is balanced by the strong contrasts and turbulent

RELATED WORKS
Copies by Thomas Sully, 1833–34, oil, each, 29 x 36 in (73.7 x 91.4 cm). Formerly collection Jane Griffith Koch, Paris.

PROVENANCE
Mr. and Mrs. Jacob Gerard Koch, Philadelphia, to 1820 § Mr. and Mrs. Matthew Huizinga Messchert (by descent), Philadelphia, 1820–33 § Mary Griffith Messchert (by descent), as of 1833 § Harold H. Lefft, Pottstown, Pa., and New York, as of 1966 to 1971, as by unknown artist § Estate of Harold H. Lefft, 1971–78 § With Victor Spark, New York, 1978.

ON DEPOSIT
Metropolitan Museum of Art, New York, 1966–68 § Brooklyn Museum of Art, 1978 § Minneapolis Institute of Arts, 1978.

EXHIBITION
LACMA 1981–82, nos. 32, 33, pp. 44–45, essay by William H. Gerdts, p. 134, entry by Michael Quick;

Jacob Gerard Koch, repro., p. 136; *Jane Griffith Koch,* repro., p. 137.

LITERATURE
Collection Frederick S. Dickson, Jane Koch to the Messcherts, October 12, 1833–September 6, 1834, discusses commission for Sully copies § Edward Biddle and Mantle Fielding, *The Life and Works of Thomas Sully (1783–1872),* (1921; reprint, Charleston, S.C.: Garnier, 1969), p. 201, nos. 999 and 1,000 in Sully's register of paintings are Sully's copies of Peale's portraits, with notes from the artist's journal § "New Acquisitions: American Art," *LACMA Members' Calendar* 17 (January 1979): unpaginated, *Jane Griffith Koch,* repro., cover; *Jacob Gerard Koch,* repro., frontispiece § Eleanor H.

Gustafson, "Museum Accessions," *Antiques* 116 (November 1979): 1074, repro., *Jane Griffith Koch* § "La Chronique des arts," *Gazette des Beaux-Arts* 6th ser., 95 (March 1980): supp. 40, repro., *Jane Griffith Koch* § Frederick S. Dickson, "Painted Postal Markings," *American Philatelist* 96 (October 1982): 933–34, dates *Jacob Gerard Koch* based on postal marking; *Jacob Gerard Koch,* fig. 1, 933; *Jane Griffith Koch,* fig. 2, 934; fig. 3, detail of letter, 934. § LACMA, American Art department files, Carol Hevner to Ilene Susan Fort, July 23, 1985, dates portraits c. 1815 based on style § "Rembrandt Peale" issue, *Pennsylvania Magazine of History and Biography* 110 (January 1986): *Jacob Gerard Koch,* fig. 28, p. 60; *Jane Griffith Koch,* fig. 29, p. 61.

Henry Inman

Born October 28, 1801, Utica, New York
Died January 17, 1846, New York, New York

Henry Inman was the foremost portraitist in New York during the romantic period. He moved with his family to New York City in 1812. In 1814 he entered into a seven-year apprenticeship with JOHN WESLEY JARVIS, at that time New York's leading portraitist. In 1822 he married and established his own studio. From 1826 to 1828 he was in partnership with Thomas S. Cummings (1804–1894) as a portraitist and miniaturist. He assumed a leading role in the organization of the National Academy of Design and was elected its first vice-president. By 1829 he had attained the position of the city's most prominent portraitist. From 1831 to 1834 he was active in Philadelphia as a portraitist and a partner in the lithographic firm of Childs and Inman. Late in 1834 he returned to New York, where he remained for the rest of his career, except for a visit to England during 1844–45. He was honored with a memorial exhibition of his works at the National Academy of Design in 1846.

BIBLIOGRAPHY
C. Edwards Lester, *The Artists of America: A Series of Biographical Sketches of American Artists* (1846; reprint, New York: Kennedy Galleries and Da Capo Press, 1970), pp. 34–64, with list of paintings shown in Inman memorial exhibition § Theodore Bolton, "Henry Inman: An Account of His Life and Work," *Art Quarterly* 3 (Autumn 1940): 353–75, supplement, 401–18, with catalogue of paintings § William H. Gerdts, "Henry Inman in New Jersey," *Proceedings of the New Jersey Historical Society,* 78 (July 1960): 178–87 § William H. Gerdts, "The Henry Inman Memorial Exhibition of 1846," *Archiv. Am. Art Journal* 14, no. 2 (1974): 2–6 § Washington, D.C., Smithsonian Institution, National Portrait Gallery, *The Art of Henry Inman,* exh. cat., 1987, with essay by William H. Gerdts, entries by Carrie Rebora, bibliography.

Inman, *Portrait of Mrs. James W. Wallack.*

Portrait of Mrs. James W. Wallack, c. 1828
Oil on canvas
30¼ x 25⅛ in (76.8 x 63.7)
Gift of the members of the American Art Council's 1985 spring trip
M.85.33

In 1817 James William Wallack, actor and theatrical producer, married actress Susan Johnstone, who was daughter of John Henry Johnstone (known as Irish Johnstone, a singer, comedian, and member of the circle of the Prince of Wales). She enjoyed successful comic roles using her maiden name. In 1818 and frequently after that she came to New York with her husband. Of their four sons, the eldest, John Johnstone Wallack, known as Lester Wallack, was also an actor, as was his second son, Arthur. Mrs. Wallack died in 1851.

Like his contemporary THOMAS SULLY, Henry Inman painted several portraits of theatrical figures. Sully exhibited a *Portrait of Mrs. Wallack* at the Pennsylvania Academy of the Fine Arts in 1819. Inman painted a full-length-in-small of James William Wallack (unlocated), portraits of Mr. and Mrs. Wallack (both unlocated) that he exhibited at the National Academy of Design in 1828, and yet another portrait of Mrs. Wallack, n.d. (Museum of the City of New York). Hair and costume styles indicate that the museum's portrait was painted about 1828 and the portrait in the collection of the Museum of the City of New York much later. In both portraits of Mrs. Wallack one can see the full romantic style that won for Inman the title "the American Lawrence."

PROVENANCE
Mrs. McCormick, Washington, D.C., 1920s § Mrs. Ernest Graham, Chicago, as of 1967 § James Wylie, Glendale, Calif., to 1985.

EXHIBITION
Possibly New York, National Academy of Design, *The Exhibition of the National Academy of Design, The Third,* 1828, no. 8.

LITERATURE
LACMA, American Art department files, James Wylie to Michael Quick, September 5, 1984, gives previous ownership § "American Art," *LACMA Report 1983–1985* (1985), p. 16.

Thomas Birch

Born June 26, 1779, London, England
To United States 1794
Died January 13, 1851, Philadelphia, Pennsylvania

Active during the first half of the nineteenth century, Thomas Birch was one of the earliest and foremost marine painters in America. The son of the English engraver and miniature painter William Russell Birch (1775–1834), Thomas emigrated with his family to Philadelphia in 1794. He began his artistic career around 1798, assisting his father in the preparation of an album of engraved topographical views, *The City of Philadelphia . . . as It Appeared in 1800* (1800). Then he established an independent career as a portrait and miniature painter based in Philadelphia. Around 1806 he painted his first marine, and he began to advertise himself as a landscape painter by 1811. That year Birch participated in one of the earliest full-scale public exhibitions held in Philadelphia, sponsored by the Pennsylvania Academy of the Fine Arts and the Society of Artists in the United States, by exhibiting twelve works, none of which was a portrait. This display was indicative of his prolific output and the active role he would play in a variety of early art organizations, such as the Philadelphia Artists' Fund Society, throughout his career. Birch produced over five hundred paintings, including landscapes, snow scenes, harbor and river views, ship portraits, and marines. His finest work was in a dramatic vein: storm-tossed seas, shipwrecks, and naval encounters. He first gained a reputation for his depictions of the sea battles of the War of 1812, some of which were published as prints. His work in marine portraiture helped establish the tradition of this type of painting in American art. In the more dramatic seascapes he combined the accuracy of a topographical artist in the descriptions of the ships with a strong degree of romanticism, pitting man against the awesome forces of nature. Despite the variety of his output Birch seems to have rarely ventured far from Philadelphia in search of subject matter.

BIBLIOGRAPHY
Bryn Mawr, Pennsylvania, Collection of Mrs. Joseph Garson, William Birch, "The Life of William Russell Birch, Enamel Painter, Written by Himself," c. 1829, manuscript (typed copies of varying completeness in Philadelphia, Pennsylvania Historical Society, Library Company of Philadelphia, and New York Public Library) § William Dunlap, *History of the Rise and Progress of the Arts of Design in the United States* (1834; 3d ed., rev. and enl., New York: Benjamin Blom, 1965) 3: 25–26 § Doris Jean Creer, "Thomas Birch: A Study of the Condition of Painting and the Artist's Position in Federal America," Master's thesis, University of Delaware, 1958, with bibliography, catalogue of known works and prints after, appendixes about George Birch, William Birch, and members of early nineteenth-century Philadelphia art organizations § Philadelphia Maritime Museum, *Thomas Birch, 1779–1851, Paintings and Drawings,* exh. cat., 1966, with essay by William H. Gerdts, bibliography § John Wilmerding, *A History of American Marine Painting* (Salem, Mass., and Boston: Peabody Museum and Little, Brown, and Co., 1968), pp. 103–18; rev. ed., *American Marine Painting* (New York: Harry N. Abrams, 1987), pp. 75–82.

Loss of the Schooner "John S. Spence" of Norfolk, Virginia, 2d View—Rescue of the Survivors, 1833
Oil on canvas
26¼ x 35¾ in (66.7 x 90.2 cm)
Signed and dated lower right: Tho Birch 1833
Gift of Dr. and Mrs. Ronald M. Lawrence
M.86.308.2
Color plate, page 37

Although he achieved success with his ship portraits, Birch's distinctive contribution to

the passengers on the schooner during its last voyage. At the age of nineteen Pelz, desirous of adventure, left his home in Washington, D.C., and on August 19, 1827, set sail from Norfolk, Virginia, on the "Spence" in the company of a childhood friend, intending to travel to Mexico to join the company of the former U.S. commodore David Porter. Six days later the schooner was wrecked in a storm on the open sea, its bowsprit and taffrail broken, and its masts transformed into a confusion of ropes and broken wood. Five survivors, including Pelz—but not his friend—were rescued a

Birch, *Loss of the Schooner "John S. Spence" of Norfolk, Virginia, 2d View—Rescue of the Survivors.*

American art was his more romantic renderings of ships in storms, such as *Loss of the Schooner "John S. Spence"* In his cool palette, evocative sky, and turbulent sea Birch reveals the influence of Joseph Vernet (1714–1789), a French marine painter whose imaginative works were available to the artist in Philadelphia. Although Birch was actually depicting the aftermath of the storm, he still conveyed its power through the vigorous waves, overcast sky, brisk wind, and the narrative element of the destroyed ship.

Although some of Birch's stormy marines were fictional, at least two, the museum's painting and *The Loss of the New York Packet Ship "Albion,"* exhibited 1824 (unlocated), were based on actual events. The schooner "John S. Spence" was lost at sea not long after it had left the port of Norfolk, Virginia, bound for Havana, Cuba. The museum's painting was commissioned by Alexander M. Pelz, one of

week after the wreck by a New England captain, Isaac Staples of the brig "Cobosse Contee," but only three lived to reach New York.

Pelz originally intended to give the painting to Captain Staples, his rescuer. Staples was lost at sea before the painting was completed, however, so it remained in Pelz's family until 1982. Shortly before his death Pelz wrote an account of the voyage, disaster, and struggle to survive without food and water. Birch no doubt based much of his rendering on Pelz's oral account, for the written account demonstrates that he vividly recalled the details of the disaster.

When the painting was exhibited in 1834 at the Pennsylvania Academy of the Fine Arts it was listed as a "second view." Another painting of a shipwreck dating from 1833, *Ship at Sea (Shipwreck)* (New York art market as of 1989), shares several of the same elements and may

have been the first view. Birch used the inci-
dent as the basis for an engraving that appeared
in the 1836 volume of *The Token*; however, this
drawn *The Wreck at Sea* is a close-up view from
on board the "Spence" rather than from the
distant perspective, and it depicts only four
men being rescued.

RELATED WORK
Ship at Sea (Shipwreck), 1833, oil on canvas, 20 ⅛ x
30 ⅛ in (51.1 x 76.2 cm). New York art market as of
1989.

PROVENANCE
Alexander M. Pelz, Washington, D.C., 1833–38 §
Mr. and Mrs. M. Alexander Laverty (by descent),
1982 (sale, Sotheby-Parke-Bernet, New York, *Ameri-
can Eighteenth, Nineteenth Century, and Western
Paintings, Drawings, and Sculpture*, April 23, 1982, no.
18, repro.) § Dr. and Mrs. Ronald M. Lawrence,
Malibu, Calif., 1982–86.

EXHIBITIONS
Philadelphia, Pennsylvania Academy of the Fine
Arts, *Twenty-third Annual Exhibition*, 1834, no. 20 §
Philadelphia Maritime Museum, *Birch*, no. 18, p. 15,
Gerdts's essay discusses in context of scenes of ships
in storms, repro., p. 27.

LITERATURE
LACMA, American Art department files, "This
Copy of the Ship Wreck of Alexander M. Pelz typed
for Maris Alexander Laverty 1941," typed copy of
manuscript by Alexander M. Pelz, c. 1836–37, with
postscript (1890) by his daughter, Elizabeth M. P.
Kennedy, gives personal account of the voyage and
disaster of the schooner at sea § Creer, "Birch,"
p. 65, listed in cat. as no. 78, with location
unknown § William H. Gerdts, "Thomas Birch:
America's First Marine Artist," *Antiques* 89 (April
1966): repro., p. 531 § New York, Berry-Hill
Galleries, *American Paintings IV*, 1986, p. 10, entry
for *Ship at Sea* suggests relationship to *Loss of the
"Spence."*

Thomas Sully

Born June 19, 1783,
Horncastle, England
To United States 1792
Died November 5, 1872,
Philadelphia, Pennsylvania

Thomas Sully dominated the field of portraiture in Philadelphia during the romantic
period. In 1792 he came with his parents, who were actors, to this country, where they
eventually settled in Charleston, South Carolina. Showing artistic abilities at a very early
age, Sully received instruction from his brother-in-law, a French miniature painter, Jean
Belzons (active eighteenth century), and in Norfolk, Virginia, from his brother Lawrence
Sully (1769–1804), also a miniature painter.

Thomas Sully opened his own studio in Richmond in 1803. He married his brother's
widow in 1806. In 1807 he visited GILBERT STUART in Boston and received some advice.
Between 1804 and 1808 he painted in a number of cities before settling in Philadelphia,
which would become his permanent home, although he continued to travel to other cities
to execute portraits. In 1809 he went to London, where he spent nine months studying
with BENJAMIN WEST. When he returned to Philadelphia, he brought back with him a
fully romantic style, with which he dominated portraiture in the city until at least 1850.
Sully's second trip to England in 1837 came at the end of his most important period as a
portraitist, but his long career extended almost to his death in 1872.

BIBLIOGRAPHY
Thomas Sully, "Recollections of an Old Painter," *Hours at Home* 10 (November 1869): 69–74 § Edward
Biddle and Mantle Fielding, *The Life and Works of Thomas Sully (1783–1872)* (1921; reprint, Charleston, S.C.:
Garnier, 1969), with annotated transcription of the artist's register of paintings, letters from the artist §
Philadelphia, Pennsylvania Academy of the Fine Arts, *Catalogue of the Memorial Exhibition of Portraits by
Thomas Sully*, exh. cat., 1922 § Washington, D.C., Smithsonian Institution, National Portrait Gallery, *Mr.
Sully, Portrait Painter: The Works of Thomas Sully (1783–1872)*, exh. cat., 1983, published by Smithsonian Insti-
tution Press, by Monroe H. Fabian, with bibliography and illustrated appendix of signatures § Steven E.
Bronson, "Thomas Sully: Style and Development in Masterworks of Portraiture, 1783–1839," Ph.D. diss.,
University of Delaware, 1986, with bibliography.

The Gypsy Girl, 1839

Oil on canvas
29⅞ x 24⅞ in (75.9 x 62.8 cm)
Signed and dated lower right: TS [monogram] 1839
Inscribed verso lower center: The Gypsy / Designed
in England / finished at Philadelphia / 1839 TS
(monogram)
Canvas stamp verso upper center: [illegible]
CHESTNUT / EARLES' GALLERIES / PHILADELPHIA
Gift of Dr. and Mrs. James K. Weatherly
M.82.161

Sully considered the high point of his life to be
the trip he made to London in 1837 to paint a
full-length portrait of the young Queen Vic-
toria. The artist's journal entry of September
18, 1837, records that Edward Carey, a pub-
lisher and art collector, suggested that Sully
make the trip to England and offered him one
hundred dollars in advance for pictures to be
painted either in England or on the artist's
return to Philadelphia. Sully's "Register of Pic-
tures" indicates that he painted *The Gypsy Girl*

Sully, *The Gypsy Girl*.

of Sir Thomas Lawrence (1769–1830), which Sully would have had a chance to see in London at the Royal Academy of Arts. Known to his admirers as "the American Lawrence," Sully was a great admirer of the English artist, as the dramatic style of his own *The Gypsy Girl* attests, in its dramatic contrasts, flowing lines, and rich, warm color.

RELATED WORK
The Gipsy, engraving after the artist by John Cheney for *The Gift: A Christmas and New Year's Present* (1842): repro., between pp. 150–51.

PROVENANCE
Edward Carey, Philadelphia, 1839–as of 1847 § H. C. Baird (by descent), Philadelphia, as of 1864 § Andrew Howell Halberstadt (by descent), Pottsville, Pa., as of 1921 § Private collection, New York § With Rowe-Pollack Fine Arts, New York § Dr. and Mrs. James K. Weatherly, Houston, Tex., 1982.

ON DEPOSIT
Pennsylvania Academy of the Fine Arts, Philadelphia, as of 1847, no. 155.

EXHIBITIONS
Philadelphia, Pennsylvania Academy of the Fine Arts, *Exhibition of Paintings, Statues, and Casts,* 1847, no. 305 § Philadelphia, Great Central Fair for the United States Sanitary Commission, *Catalogue of Paintings, Drawings, Statuary, Etc. of the Art Department,* 1864, no. 158.

LITERATURE
Unlocated, private collection, "Journal of Thomas Sully's Activities, May 1792–December 1846," January 25, 1839, entry (typed transcript in Archiv. Am. Art and New York Public Library, p. 195 [Archiv. Am. Art microfilm roll N18, fr. 492]), states the artist "began a sketch of a gipsy from Hints obtained in England" § Philadelphia, Historical Society of Pennsylvania, Dreer Collection, the artist's "Register of Paintings," manuscript, February 24, 1839, entry (typed transcript in Archiv. Am. Art and New York Public Library, p. 78 [Archiv. Am. Art microfilm roll N18, fr. 44]), lists as *Gipsy Girl* § Biddle and Fielding, *Sully,* p. 353, listed as no. 2260 in transcript of Sully's register, under subject paintings, with then current location and discussion of dating § "American Art," *LACMA Report 1981–1983* (1984), p. 20, repro., p. 22.

for Carey for a price of three hundred dollars, designing it in England before beginning it in Philadelphia on February 24, 1839, and finishing it there on September 9, 1839. In an apparent contradiction Sully's journal entry for January 25, 1839, indicates that he "began . . . England."

Sully is best known as a portraitist, but of the more than twenty-six hundred paintings he made, nearly six hundred were genre and thematic paintings, what he called "fancy pictures." Of these, more than two dozen were of peasant children like this gypsy girl, a subject that appealed very much to early Victorian taste and the purchasers of the period's elaborately illustrated gift books. *The Gypsy Girl* appeared in the 1842 volume of *The Gift: A Christmas and New Year's Present* as an engraved illustration for Charles West Thomson's poem "The Gipsy's Chaunt."

Sully's register records other paintings of gypsy children, some made as early as 1828, and drawings survive. However, the specific inspiration for Sully's *The Gypsy Girl,* the "Hints obtained in England," may have been *A Gipsy Girl,* 1794 (Royal Academy of Arts, London; see illustration), the diploma picture

Thomas Lawrence, *A Gipsy Girl*, 1794, oil, 35 x 27¾ in (88.9 x 70.5 cm). Royal Academy of Arts, London.

Waldo and Jewett

Samuel Lovett Waldo and William Jewett, who painted portraits as partners, enjoyed extensive patronage in New York. Samuel L. Waldo went to Hartford, Connecticut, at the age of sixteen to study painting with Joseph Steward (1753–1822). At the age of twenty he began to work as a portraitist in Hartford, then Litchfield, Connecticut, and later Charleston, South Carolina. In 1806 he went to London with letters of introduction to BENJAMIN WEST and JOHN S. COPLEY and was befriended by both, becoming one of the last American students of West. He roomed with another of them, Charles Bird King (1785–1862). Waldo studied drawing at the Royal Academy and was able to exhibit a

Samuel L. Waldo
Born April 6, 1783,
Windham, Connecticut
Died February 16, 1861,
New York, New York

William Jewett
Born January 14, 1792,
East Haddam, Connecticut
Died March 24, 1874,
Jersey City, New Jersey

portrait there in 1808. He married before returning to America in January 1809 and taking up permanent residence in New York. Waldo soon assumed a position as a leading portraitist. He was a member of the board of directors of the American Academy of Fine Arts from 1817 to 1828.

In 1812 Waldo took as an apprentice William Jewett, who had purchased his release from an apprenticeship to a coachmaker in New London, Connecticut, in order to go to New York to study with Waldo, who took him into his home, where he remained for eighteen years. While assisting Waldo in routine studio business, he drew from casts, learned from Waldo, and painted landscapes with him along the Hudson. From 1816 to 1819 Jewett exhibited at the American Academy of Fine Arts, mostly still lifes, but also a genre painting, a history painting, and two portraits. In 1818 Waldo took him into partnership, and until 1854 they worked together as the firm of Waldo and Jewett, even becoming associate members of the National Academy of Design under that joint name in 1847. In 1842 Jewett moved to Bergen Hill, New Jersey.

BIBLIOGRAPHY
"Artist Biography: Samuel L. Waldo," *Crayon* 8 (May 1861): 98–100 § *Dictionary of American Biography,* 10: 333–34, Waldo entry by William H. Downes, with bibliography; 5: 72–73, Jewett entry by Agnes B. Brett, with bibliography § Helen C. Nelson, "The Jewetts: William and William S.," *International Studio* 83 (January 1926): 39–42 § Frederic Fairchild Sherman, "Samuel L. Waldo and William Jewett, Portrait Painters," in *Early American Portraiture* (New York: Privately printed, 1930), pp. 15–19, with lists of portraits by the individual artists § New-York Historical Society, *Catalogue of American Portraits in the New-York Historical Society* (New York: New-York Historical Society, 1941), passim.

Waldo and Jewett, *Portrait of Mrs. Sackett.*

Portrait of Mrs. Sackett, 1839
(*Portrait of a Woman*)
Oil on wood panel
48 x 35⅛ in (121.9 x 89.3 cm)
Inscribed verso center: Mrs. Sacket / Painted by / Waldo & Jewett / New York / 1839
Gift of Dr. Herbert and Elizabeth Sussman in honor of Saul and Ida Epstein
M.86.310.1

Because no portraits survive that can be attributed beyond doubt to William Jewett, whereas numerous, accomplished portraits by Waldo are known, it has been thought that Jewett's contributions to their joint efforts were limited to the drapery, accessories, and background. However, Jewett's portrait style may have so resembled that of Waldo, his teacher, that they may have been able to work on the likeness together without the slight difference in their personal styles being apparent in the result. Tuckerman wrote that it was "a puzzle to the uninitiated to assign to either painter his share of a portrait," and so it remains (Tuckerman 1867, p. 67).

If Jewett's principal work was in the drapery and backgrounds, the portrait of Mrs. Sackett, being considerably larger than the firm's usual size of portrait, provided exceptional scope for his abilities. There is considerable space around the figure, who stands in a velvet dress with full lace sleeves, enough space for a table or bracket with a vase of flowers behind her, a table with a large book of engravings atop it in front of her, as well as the distant landscape vista and the vine that softens the transition between the spaces and climbs into the room itself. The imagery is that of an elegant interior somehow joined, through the flowers and landscape, with the natural realm, characterizing Mrs. Sackett in terms of the feminine ideal of the romantic period. The conspicuously free handling in the accessories blends imperceptibly with the firmer, but still softened likeness. It is the "speaking likeness" for which Waldo, and Waldo and Jewett, were known, the impression of an intelligent, friendly personality that looks directly at the viewer in a warm greeting.

It is unfortunate that so little is known about this vividly portrayed personality, this

Mrs., or Miss, Sackett. Without knowing her first name, it is a formidable task to identify her among the very large Sackett family. Descendants indicate that she married a General Steward. The bracelet she wears in the portrait descended with it in the family.

PROVENANCE
Mrs. Sackett, 1839 § Marilyn Lauder (by descent?), Reno, Nev., as of 1978 to 1984 (sale, Butterfield & Butterfield, San Francisco, *American and European Paintings*, July 26, 1984, no. 1849, as *Portrait of a Woman*, not listed in cat.) § Dr. and Mrs. Herbert Sussman, Studio City, Calif., 1984–86.

ON DEPOSIT
LACMA, 1984–86.

Unknown Artist

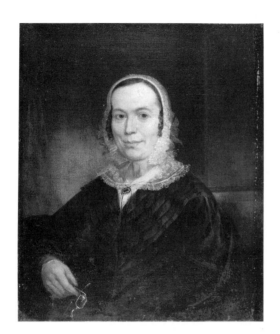

Unknown, *Portrait of an Unknown Lady.*

Portrait of an Unknown Lady, late 1830s
Oil on canvas
30¹/₁₆ x 25¹/₁₆ in (76.3 x 63.6 cm)
Gift of Anna Bing Arnold
M.73.40

The names of the sitter and artist are unknown. The sitter's clothing can be dated to approximately the late 1830s.

PROVENANCE
Anna Bing Arnold, Los Angeles, to 1973.

Unknown Artist

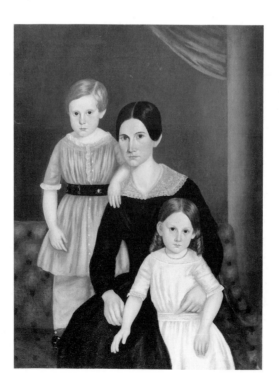

Unknown, *A Family Group.*

A Family Group, late 1840s
Oil on canvas
48⅝ x 36³/₁₆ in (123.5 x 91.9 cm)
Gift of W. L. Adams
45.7

Nothing is known about the identity of the sitters and little is known with certainty about the history of the painting, although the donor stated that it was painted in New York State. The style of the apparel worn by the sitters indicates a date in the late 1840s.

The patrons of the itinerant portraitists of the period insisted on realistic likenesses. The artist of this portrait paid relatively little attention to detail in the softly painted clothing and furniture but concentrated on the strikingly more plastic and fully developed physiognomies. Although a close family resemblance marks the sitters, each is described as a distinct individual.

In most American primitive portraits the subjects are arranged across the picture plane, side by side. The vertical arrangement of this painting is unusual, as is the unconventional position of the boy standing on the sofa. His position is used in an interesting way to achieve a characterization of the psychological relationships within the family. Whereas his sister is enfolded within the protecting arm of the mother, the boy stands independently, higher than the mother and apparently self-sufficient, as he leans comfortably on her shoulder. It is conceivable that the boy's likeness is a memorial portrait.

PROVENANCE
W. L. Adams, Los Angeles, to 1945.

Thomas Cole

Born February 1, 1801,
Bolton-le-Moors, England
To United States 1818
Died February 11, 1848,
Catskill, New York

Thomas Cole was the foremost American landscape painter of the romantic period. He apprenticed as an engraver as early as 1815 in England. At the age of eighteen he came to this country with his family, who settled in Ohio. After learning the rudiments of painting, in about 1820, Cole assisted as a designer in his father's wallpaper and floor-cloth factory. He also worked as an itinerant portraitist. Determined to become an artist, he went to Philadelphia in late 1823, studying at the Pennsylvania Academy of the Fine Arts, when he could. In 1825 he moved to New York and that summer made his first sketching trip up the Hudson River, achieving immediate fame with the resulting landscapes. The following year the National Academy of Design elected him to membership.

Cole regularly summered in Catskill, New York, sketching in New York and New England. He achieved success with both wilderness scenes and ideal landscapes, painting the first of these in 1827. In 1829 he made his first trip abroad, spending most of his time in England and Italy and returning to New York in 1833. After this time he was increasingly occupied with important ideal projects, especially *The Course of Empire,* 1833–36 (New-York Historical Society), and *Voyage of Life,* 1839–40 (Munson-Williams-Proctor Institute, Utica, New York). In 1836 he married and established his permanent residence in Catskill, New York. On a second trip abroad in 1841 he visited London, Paris, Rome, and Sicily.

BIBLIOGRAPHY
Albany, New York State Library, and Detroit Institute of Arts, Thomas Cole Papers (on microfilm, Archiv. Am. Art) § Louis Legrand Noble, *The Life and Works of Thomas Cole,* ed. Elliot S. Vesell (1853; Cambridge, Mass.: Harvard University Press, 1964) with introduction by Vesell § "Studies on Thomas Cole, An American Romanticist," *Baltimore Museum of Art Annual* 2 (1967), with essays by Gertrude Rosenthal and others, reprints of handlist of 1965 Baltimore Museum of Art Cole exhibition, selected Cole–Robert Gilmor, Jr., correspondence from 1826 to 1837, and Cole's list of "Subjects for Pictures, 1827–30" § University of Rochester, N.Y., Memorial Art Gallery, and others, *Thomas Cole,* exh. cat., 1969, with text by Howard S. Merritt § Ellwood C. Parry III, *The Art of Thomas Cole: Ambition and Imagination,* American Arts Series (Newark, Del.: University of Delaware Press, 1989), with reprint of catalogue of 1848 memorial exhibition, chronology, bibliography.

L'Allegro, 1845
(*Classic Landscape; Italian Sunset; Segesta, Sicily; The Temple of Segesta*)
Oil on canvas
32⅛ x 47¹⁵/₁₆ in (81.6 x 121.9 cm)
Signed and dated lower right: T. Cole. / 1845
Gift of the Art Museum Council and Michael J. Connell Foundation
M.74.53

Il Penseroso, 1845
(*The Shrine; View of Lago de Nemi, near Rome*)
Oil on canvas
32⅜ x 48¹/₁₆ in (82.3 x 122.0 cm)
Signed and dated lower right: T. Cole / 1845
Trustees Fund, Corporate Donors, and General Acquisition Fund
M.80.115
Color plate, page 38

Although Cole made his early reputation with his romantic interpretations of the American wilderness, his chief interest was in ideal landscapes rather than realistic depictions of specific locations. He painted his first pair of ideal compositions, *The Garden of Eden,* 1828 (unlocated), and *Expulsion from the Garden of Eden,* 1828 (Museum of Fine Arts, Boston), even before his first trip to Europe in 1829, by which time he already had compiled a long list of ideal subjects; among them the paired titles *L'Allegro* and *Il Penseroso.* Paired and serial paintings were to occupy much of his interest and best efforts over the following years.

A commission from the collector Charles M. Parker permitted Cole to undertake the paintings *L'Allegro* and *Il Penseroso.* On January 8, 1844, Cole wrote to Parker: "I intend to com-

mence two pictures, to be called *L'Allegro* and *Il Penseroso*. In the first picture, I should represent a sunny luxuriant landscape, with figures engaged variously in gay pastimes or pleasant occupation. In the second picture, I would represent some ivy clad ruin in the solemn evening twilight, with a solitary figure musing among the decaying grandeur The subject . . . is one upon which I can work con amore." The paintings are dated 1845 and were exhibited at the annual exhibition of the National Academy of Design in the spring of

pletely ideal and imaginary landscape. The conventionally picturesque composition resembles a sketch now apparently misidentified as a study for the 1838 painting *A Dream of Arcadia* (see illustration). To this framework Cole introduced various architectural elements. The art historian Wayne Craven has pointed out the resemblance of the Doric colonnade in the left distance to the early Greek temples in Italy that Cole had traveled to see and paint in 1832 and 1842. The other ruins are more difficult to identify specifically. The right

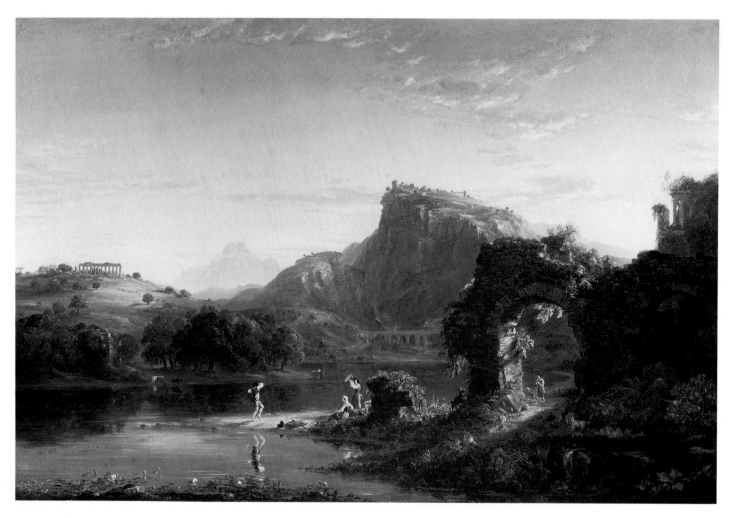

Cole, *L'Allegro.*

Cole, *Italian Landscape: Sketch for "A Dream of Arcadia,"* c. 1844–45, see Related Work for *L'Allegro.*

1846, but with the titles *Italian Sunset* and *View of Lago de Nemi, near Rome.*

Il Penseroso is based fairly closely upon a detailed view of Lake Nemi with the town of Nemi that Cole had drawn in 1832. He drew the shrine on the notebook's facing page (see illustrations), as a repositioned foreground element of the landscape, and transferred its design to the painting with the same degree of fidelity, leading one to conclude that the shrine was an actual structure, possibly at that location. The trees behind the shrine and figure before it are the only major elements not present in the drawing.

In contrast to *Il Penseroso*'s specific and realistic portrayal, *L'Allegro* seems to be a com-

foreground arches, which resume on the other side of the river, could be the remains of a Roman bridge, but they also recall the Claudian aqueduct painted by Cole on several occasions. The brickwork, however, is unlike that in Cole's other depictions of the monument. The softness of Cole's rendering of the circular temple on the extreme right suggests that he did not intend to depict any specific ruin. The hilltop town near the center of the painting likewise has a generalized, ideal quality, unlike the detailed accuracy of Cole's rendering of the town of Nemi in *Il Penseroso*. Whereas *Il Penseroso* is an actual view, *L'Allegro* belongs to the tradition of ideal arcadian landscapes composed by Cole and many others

of his generation and earlier.

The titles *Il Penseroso* and *L'Allegro* refer to a pair of poems by John Milton, one characterizing a cheerful and the other a melancholy outlook. Cole's landscapes contain none of the setting and specific detail of the poems (except, in a general sense, for the dance in *L'Allegro*), but they do present contrasting moods. Rather than illustrating the poems, the paintings translate their overall meaning into the visual language of landscape. The pair represents approximately the same time of day, late after-

In contrast, the encircling walls of Lake Nemi's crater in *Il Penseroso* shut out both light and sky, their shaggy slopes looming ominously. The painting is both darker and cooler than *L'Allegro*. The rough foreground foliage and forested background seem more agitated than the broad expanse of smoothness of *L'Allegro*. Although the foreground of *Il Penseroso* is near the Grove of Diana, off to the left, and the site recalls the pagan past (with some of its most somber associations), the painting is dominated by associations with Italy's Chris-

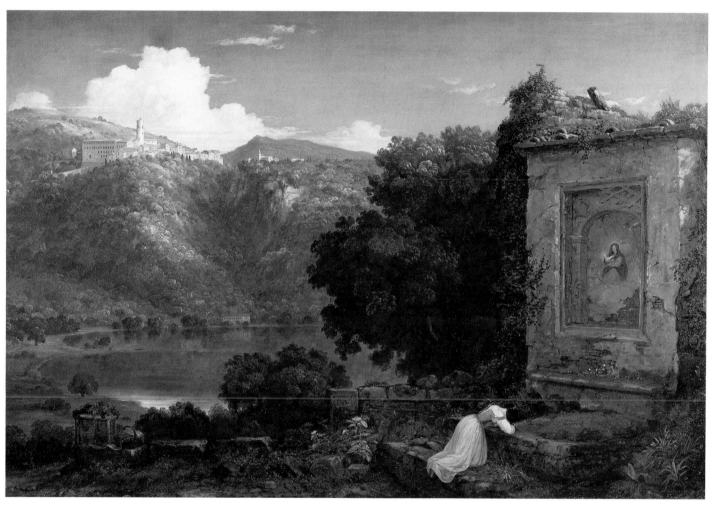

Cole, *Il Penseroso.*

noon, but the degree of brightness and relative warmth of the light differ because of the terrain. The horizon of *L'Allegro* is low, the foreground water reflecting even more of the generous expanse of sky. The distance of the one large hill contributes to the feeling of openness and light. The scene is bathed in the warm Claudian light of contentment. In a landscape filled with references to antiquity, the foreground dancer, his pose modeled after the *Dancing Faun* from the House of the Faun in Pompeii (Museo Nazionale, Naples), suggests the survival of a pagan strain among the peasants of the day, as had Donatello in Hawthorne's *The Marble Faun*. *L'Allegro* evokes the innocent joyfulness of the arcadian ideal.

tian piety: a shrine to the Virgin built upon the medieval fortifications of Nemi. In contrast to the merry peasants of *L'Allegro*, the foreground figure kneels with an abjectness suggesting grief.

The pair of paintings expresses the sense of Milton's poems in terms of highly sophisticated concepts—in the opposition of the conventions of picturesque and sublime landscape and in terms of Italian architectural and intellectual history. As embodied in these paintings, Cole's concept of ideal landscape is so rich with intellectual and poetic content that the two form a complex unit, depending upon each other for their complete meaning.

L'Allegro

RELATED WORK

Italian Landscape: Sketch for "A Dream of Arcadia" [misidentified], c. 1844–45, oil on academy board, 5⅝ x 9 in (14.3 x 22.9 cm). Private collection.

PROVENANCE

Charles M. Parker, New York § James V. Parker, New York (by descent; sale, American Art Association, New York, *Oil Paintings . . . Belonging to the Estate of the Late James V. Parker*, January 4, 1918, no. 101, as *Classic Landscape*) § Thomas Benton, 1918 § William H. Payne, New York (sale, American Art Association, New York, *The Private Collection of American Paintings Formed by the Late William H. Payne*, 1919, no. 77, repro., unpaginated, as *Segesta, Sicily*) § (Sale, Anderson Galleries, New York, *Paintings*, 1925, no. 112, as *The Temple of Segesta*) § Cecelia Ober, New York, 1925–31 § Dr. and Mrs. Samuel Kleinberg, New York, 1931–57 § Private collection, Washington, D.C., 1957–65 § Private collection, New York, 1965–69 § With Hirschl & Adler Galleries, New York, 1969 § Douglas B. Collins, Longmeadow, Mass., 1969–72 § With Vose Galleries, Boston, 1972–74.

ON DEPOSIT

Museum of Fine Arts, Springfield, Mass., 1969–71 § Phoenix Art Museum, 1974.

EXHIBITIONS

New York, National Academy of Design, *Twenty-first Annual Exhibition*, 1846, no. 174, as *Italian Sunset* § New York, American Art-Union, *Exhibition of the Paintings of the Late Thomas Cole*, 1848, no. 50 § New York, Hirschl & Adler Galleries, *The American Scene: A Survey of the Life and Landscape of the Nineteenth Century*, 1969, no. 13, repro., p. 18 § Springfield, Mass., Museum of Fine Arts, *Nineteenth-Century American Landscape Paintings Selected from a Springfield Private Collection*, 1970, no. 9 § LACMA, *American Narrative Painting*, 1974, no. 19, p. 16, essay by Donelson F. Hoopes, p. 53, entry by Nancy Wall Moure, repro., p. 52 § LACMA 1975, no. 119, pp. 218–19, entry by Donelson Hoopes and Nancy D. W. Moure, repro., p. 123.

LITERATURE

Albany, New York State Library, Thomas Cole Papers, "Thomas Cole, N York, 1827," sketchbook, with Cole's list of possible subjects for paintings, including *L'Allegro* and *Il Penseroso*, both listed twice; Thomas Cole to Charles M. Parker, New York, January 8, 1844 (Archiv. Am. Art microfilm roll ALC1, no fr. number), suggests theme for the two paintings § "Editor's Table," *The Knickerbocker* 27 (May 1846): 463 § Charles Lanman, "The Epic Paintings of Thomas Cole," *Southern Literary Messenger* 15 (June 1849): 355 § Noble, *Cole*, p. 266, reproduces, with slight alterations, the artist's letter to Parker of January 8, 1844, p. 271, Noble calls it "a joyous spirited picture of a rural scene in Italy" § "Thomas Cole," *National Magazine* 4 (April 1854): 319 § E. Anna Lewis, "Art and Artists of America," *Graham's Magazine* 46 (April 1855): 338 § "The Artists of America," *The Crayon* 7 (February 1860): 46 § Tuckerman 1867, p. 231 § Clara

Endicott Sears, *Highlights among the Hudson River Artists* (Boston: Houghton Mifflin, 1947), p. 93 § Hartford, Conn., Wadsworth Atheneum, and New York, Whitney Museum of American Art, *Thomas Cole, 1801–1848: One Hundred Years Later*, exh. cat., 1948–49, p. 11, introduction by Esther Isabel Seaver § Boston, Museum of Fine Arts, *M. and M. Karolik Collection of American Paintings, 1815–1865* (Cambridge, Mass.: Harvard University Press, 1949), p. 196 § Barbara Novak Deutsch, "Cole and Durand: Criticism and Patronage (A Study of American Taste in Landscape, 1825–65)," Ph.D. diss., Radcliffe College, 1957, p. 117 § New York, Kennedy Galleries, *An Exhibition of Paintings by Thomas Cole, N.A., from the Artist's Studio, Catskill, New York*, 1964, p. 23 § "Studies on Thomas Cole," pp. 83, 88, 91 § University of Rochester, *Cole*, p. 18 § *Art Gallery* 13 (November 1969): repro., 20 § Henry A. La Farge, "The Quiet Americans," *Art News* 68 (November 1969): 34, 68 § Ellwood C. Parry III, "Thomas Cole's *The Course of Empire*: A Study in Serial Imagery," Ph.D. diss., Yale University, 1970, 2: fig. 24b § Lee Sheridan, "Cole's Masterpiece Remains at Springfield Arts Museum," *Daily News* (Springfield, Mass.), November 5, 1970, p. 24, repro. § Ellwood C. Parry III, "Thomas Cole's *The Titan's Goblet*: A Reinterpretation," *Metropolitan Museum Journal* 4 (1971): 135 n. 31 § Alan Peter Wallach, "The Ideal American Artist and the Dissenting Tradition: A Study of Thomas Cole's Popular Reputation," Ph.D. diss., Columbia University, 1973, pp. 132, 134 § Advertisement, *Antiques* 103 (February 1973): repro., 229 § James C. Moore, "Thomas Cole's *The Cross and the World*: Recent Findings," *American Art Journal* 5 (November 1973): 53 § "American Narrative Painting," *LACMA Members' Calendar* 12 (October 1974): repro., unpaginated § Martha Hutson, "American Narrative Painting," *American Art Review* 1 (November–December 1974): 98, repro., 101 § "La Chronique des arts: acquisitions des musées," *Gazette des Beaux-Arts*, 6th ser., 85 (March 1975): supp. 42, fig. 152 § LACMA 1977, p. 136, repro. § Wayne Craven, "Thomas Cole and Italy," *Antiques* 114 (November 1978): 1025, pl. x, 1027 § LACMA, American Art department files, Wayne Craven, "Thomas Cole's *L'Allegro* and *Il Penseroso*," unpublished paper, 1981 § Matthew Baigell, *Thomas Cole* (New York: Watson-Guptill, 1981), p. 8 § "New Acquisition: American Art," *LACMA Members' Calendar* 19 (March 1981): repro., unpaginated § David Coombs, "Lost Painting by Thomas Cole," *Antique Collector* (May 1981): 39 § "Acquisitions of American Art (1776–1980) by British and American Museums," *Burlington Magazine* 123 (November 1981): 713 § Ellwood C. Parry III, "Recent Discoveries in the Art of Thomas Cole: New Light on Lost Works," *Antiques* 120 (November 1981): 1161–62 § "American Art," *LACMA Report 1979–1981* (1982), pp. 17–18 § William Wilson, *The Los Angeles Times Book of California Museums* (New York: Harry N. Abrams, 1984), p. 150, fig. 132, p. 152 § *Vose Galleries of Boston, Inc.: A Commemorative Catalogue* (Boston: Vose Galleries, 1987), p. 12, repro. § Fort 1986, p. 424 § LACMA 1988, p. 15, repro. § Parry, *Art of Cole*, pp. 309-10, fig. 250, p. 309.

Cole, *A View of Lake Nemi*, c. 1832, see Related Works for *Il Penseroso*.

Cole, *A Shrine*, c. 1832, see Related Works for *Il Penseroso*.

Il Penseroso

N.B. Short citations in the following may refer to works cited above for *L'Allegro* as well as those in the Bibliography.

RELATED WORKS
A View of Lake Nemi and *A Shrine*, c. 1832, pen and ink over pencil on paper, each, 8¹³/₁₆ x 12⁹/₁₆ in (22.3 x 31.8 cm), sketchbook no. 7, pp. 56, 57. Detroit Institute of Arts, Thomas Cole Papers.

PROVENANCE
Charles M. Parker, New York § James V. Parker, New York (by descent; sale, American Art Association, New York, *Oil Paintings . . . Belonging to the Estate of the Late James V. Parker*, January 4, 1918, no. 100, as *The Shrine*) § F. A. Lawlor, 1918 § (Sale, Chicago, September 1979, as a nineteenth-century English painting) § With Leonard E. Stark Fine Paintings, Bristol, Ill., 1979–80.

EXHIBITIONS
National Academy of Design, *Annual,* 1846, no. 180, as *View of Lago de Nemi, near Rome* § American Art-Union, *Cole,* no. 49.

LITERATURE
Albany, New York State Library, Thomas Cole Papers, 1827 sketchbook; Cole to Parker, January 8, 1844 (Archiv. Am. Art microfilm roll ALC1, no fr. number) § "Editor's Table," p. 463 § Lanman, "Epic Paintings," p. 355 § Noble, *Cole,* p. 266, reproduces, with slight alterations, the artist's letter to Parker of January 8, 1844, p. 271, Noble describes as "expressive of the tender, pensive spirit of the hour, and the pleasing loneliness of shadowy woods and waters" § "Cole," *National Magazine,* p. 319 § Lewis, "Art and Artists," p. 338 § "The Artists of America," *The Crayon,* p. 46 § Tuckerman 1867, p. 231 § Sears, *Hudson River Artists,* p. 93 § Wadsworth Atheneum and Whitney Museum, *Cole,* p. 11 § Kennedy Galleries, *Cole,* p. 23 § "Studies on Thomas Cole," pp. 83, 88, 91 § University of Rochester, *Cole,* p. 18 § Hirschl & Adler Galleries, *American Scene,* p. 18 § Parry, "*The Course of Empire,*" 2: fig. 24b § Sheridan, "Cole's Masterpiece," p. 24 § Parry, "Cole's *Titan's Goblet,*" p. 135 § Wallach, "Ideal American Artist," pp. 132, 134 § Moore, "Cole's *The Cross and the World,*" p. 53 § LACMA, *American Narrative Painting,* exh. cat., 1974, p. 16, essay by Donelson F. Hoopes, p. 53, entry by Nancy Wall Moure § "American Narrative Painting," *LACMA Calendar,* unpaginated § LACMA, *Handbook,* p. 136 § Craven, "Cole and Italy," p. 1025 § LACMA, Craven, "Cole's *L'Allegro* and *Il Penseroso*" § Baigell, *Cole,* p. 8 § "New Acquisition," repro., cover § Coombs, "Lost Painting," p. 39 § "Acquisitions of American Art," p. 713, fig. 134 § Parry, "Recent Discoveries in the Art of Cole," pp. 1161–62, pl. VI, p. 1164 § *LACMA Report 1979–1981,* pp. 17–18, repros., pp. 11, 18 § *Vose Galleries Commemorative Catalogue,* p. 12 § Fort 1986, p. 424 § LACMA 1988, p. 15 § Parry, *Art of Cole,* pp. 309-10, fig. 251, p. 310.

Allen Smith, Jr.

Born July 10, 1810,
Dighton, Massachusetts
Died September 8, 1890,
Concord, Ohio

Allen Smith, Jr., met with considerable success in the Midwest as a portraitist. He studied briefly with William D. Parisen (1800–1832) while attending the antique classes at the American Academy of Fine Arts in New York. Smith also attended the antique class of the National Academy of Design, where he won a prize in 1833. He exhibited at the National Academy of Design intermittently, 1832–42, and was an associate member, 1833–60. In 1835 he moved to Detroit, where his parents were living. In 1838 he was in Cincinnati and then again lived briefly in New York before settling in Cleveland about 1842. In 1882 he retired to the countryside.

BIBLIOGRAPHY
Cleveland Museum of Art, Library, artist's file, newspaper clippings § George C. Groce and David H. Wallace, *The New-York Historical Society's Dictionary of Artists in America, 1564–1860* (New Haven, Conn.: Yale University Press, 1957), p. 586, with bibliography § Arthur H. Gibson, comp., *Artists of Early Michigan: A Biographical Dictionary of Artists Native to or Active in Michigan, 1701–1900* (Detroit: Wayne State University Press, 1975), p. 214.

The Young Mechanic, 1848
(*A Country Conference*)
Oil on canvas
40⁵/₁₆ x 32³/₁₆ in (102.2 x 81.7 cm)
Signed and dated lower left: Paintd by / Allen Smith Jr. / 1848
Gift of the American Art Council and Mr. and Mrs. J. Douglas Pardee
M.81.179

Early in his career Smith exhibited landscape, still-life, and genre paintings in addition to portraits, but he met with such success as a portraitist after moving to the Midwest that he seldom painted any other subject. He appears to have received almost all of the most important portrait commissions in the Midwestern cities where he worked. Nevertheless, he exhibited genre paintings at the National

Smith, *The Young Mechanic.*

trait style during the period. The thorough-going realism is epitomized in the trompe l'oeil feature of the gate that extends forward toward the picture plane and which bears Smith's signature. His attention to detail and textures seems almost obsessive, even in the context of Midwestern taste as displayed in the realism of Cincinnati's Lilly Martin Spenser (1822–1902) and JAMES H. BEARD early in the following decade. Smith's is a frank realism of wear, stains, and clutter, held together by a strong architectural framework. The title, *The Young Mechanic* (the word *mechanic* meaning a skilled person who works with his hands), refers to the boy seated behind the counter of what may be his father's wood-working shop. The working-class boy has been hired by the better-dressed boy in the straw hat to whittle a new mast for his toy boat.

PROVENANCE
William S. Barton, Fredericksburg, Va., 1848 § William Taylor, Maryland (by descent) § With Tillou Galleries, Litchfield, Conn. § With Vose Galleries, Boston, 1981, as *A Country Conference.*

EXHIBITION
New York, American Art-Union, 1848, no. 149.

LITERATURE
"Catalogue, 1848," *American Art-Union Bulletin* 1 (September 25, 1848): 9, listed § "Notices of the Press," *American Art-Union Bulletin* 1 (November 10, 1848): reprints earlier newspaper reviews: 29, "The Art-Union Prizes for the Present Year," *New York Courier and Enquirer,* praises its "commendable observation of nature"; 36, "The Art-Union Gallery," *Evening Post* (New York), praises its truth-fulness § *Transactions of the American Art-Union, for the Year 1848* (New York, 1849): 59, listed as no. 149 under "Distribution" § "Recent Acquisition: American Art," *LACMA Members' Calendar* 20 (January 1982): unpaginated, repro., cover § "American Art," *LACMA Report 1981–1983* (1984), p. 20, repro., p. 21.

Academy of Design in 1842 and with the American Art-Union in 1846 and 1848–49. *The Young Mechanic,* his Art-Union painting for 1848, is the first of these efforts to come to light. Its warm tonality, strong lighting, and detailed realism accord with the artist's por-

Robert S. Duncanson

Born 1821 or 1822,
Seneca County, New York
Died December 21, 1872,
Detroit, Michigan

Robert Scott Duncanson was an eminent Midwestern artist during the mid-nineteenth century and also one of the most successful black artists of the century. Accounts of his early life are contradictory, but by 1842 he was known to be actively painting in Cincinnati, where he came to the attention of the notable art patron Nicholas Longworth. He also worked as an itinerant artist, spending long periods in Detroit. Until 1853, when he went abroad with WILLIAM L. SONNTAG and John Robinson Tait (1834–1909), Duncanson painted portraits and landscapes and worked as a daguerreotypist. The trip, sponsored by the Anti-Slavery League, determined the nature of Duncanson's mature art as he fell under the spell of English landscape painting, particularly that of J. M. W. Turner (1775–1851), and classical Italy. From then on he primarily painted landscapes that can be seen as lyrical versions of the Italianate scenes of THOMAS COLE. Duncan-son's romantic landscapes always evoked a gentle, even poetic mystery, with soft brushwork and delicate atmosphere. His occasional forays into literary landscape—

Land of the Lotos Eaters, 1861 (His Royal Highness, The King of Sweden), and *Uncle Tom and Little Eva,* 1853 (Detroit Institute of Arts)—brought him critical attention. From 1863 to 1865 Duncanson resided in Montreal, then he visited England and Scotland. In his late works he combined realistic details with an elegiac tone.

BIBLIOGRAPHY
James A. Porter, "Robert S. Duncanson: Midwestern Romantic-Realist," *Art in America* 39 (October 1951): 98–154, with checklist of located and unlocated paintings § Cincinnati Art Museum, *Robert S. Duncanson: A Centennial Exhibition,* exh. cat., 1972, with essay by Guy McElroy, entries by Richard J. Boyle § Joseph D. Ketner II, "Robert S. Duncanson (1821–1872): The Late Literary Landscape Paintings," *American Art Journal* 15 (Winter 1983): 35–47 § Washington, D.C., Smithsonian Institution, National Museum of American Art, and others, circulated by Smithsonian Institution Traveling Exhibition Service, *Sharing Traditions: Five Black Artists in Nineteenth-Century America,* exh. cat., 1985, with text by Lynda Roscoe Hartigan, pp. 51–68 § Allan Pringle, "Robert S. Duncanson in Montreal, 1863–1865," *American Art Journal* 17 (Autumn 1985): 28–50.

Duncanson, *Still Life.*

Still Life, 1849

Oil on canvas
16¼ x 20³⁄₁₆ in (41.0 x 51.2 cm)
Signed and dated lower right: R.S Du[n]can[son?] 1849
Gift of Mr. and Mrs. Robert B. Honeyman, Jr.
M.78.98

Still-life paintings are rare in Duncanson's oeuvre. Seven canvases are known today. The decorations Duncanson created from 1848 to 1850 for Belmont, the home of his patron Nicholas Longworth (now the Taft Museum, Cincinnati), may have stimulated his interest in such subject matter. Although painted in a different, more rococo style, the decorative panels included two overdoor designs of fruit and flowers in vases. Longworth was not only a lawyer and a major patron of the arts but one of the finest horticulturists in America. He played a major role in the commercialization of grapes and cultivation of strawberries. However, in none of Duncanson's located still lifes did the artist focus on grapes. Rather, in the fashion of most still-life specialists, he included a variety of food: apples, grapes, oranges, raisins, nuts, pineapples, and honeycombs. The last two items were considered exotic and often were included in Victorian still lifes; in the South the pineapple was a symbol of hospitality.

Still Life is a transitional piece, exhibiting characteristics typical of both early- and mid-nineteenth-century American still-life paintings, due in part to the date of the painting and to the fact that it was painted in a frontier environment, which slightly lagged behind the East in artistic developments. In the tradition of paintings by the Peale family, the fruit and nuts are arranged on a bare, wood table with a dark background and strong lighting. Duncanson's composition is more elaborate than the spare, neoclassical arrangements of Raphaelle Peale (1774–1825) and closer to those by James Peale (1749–1831) and younger Peale children. In fact, Sarah Miriam Peale (1800–1885) extended the Peale influence to the West when she moved to Saint Louis in 1847. The arched format was a later, more Victorian element, however, used by SEVERIN ROESEN and many other artists of the 1850s and 1860s. Two other Duncanson still-life paintings (Detroit Institute of Arts and Corcoran Gallery of Art, Washington, D.C.) have similar compositional treatments and formats. However, in these two, following midcentury fashion, the still-life elements are set on a white tablecloth rather than a bare wooden table. In complexity of arrangement, the museum's still life seems to be midway between the Corcoran Gallery picture, the least complex, and that in the Detroit Institute, the most complex.

Duncanson exhibited his fruit still-life paintings at state fairs and art displays in Detroit, Cincinnati, and New York during the late 1840s and 1850s. While not all the exhibits can be definitely identified with known works,

it is probable that the museum's still life was shown at one time, possibly at the Western Art Union or Detroit Gallery of Fine Arts in Fireman's Hall.

PROVENANCE
With Victor Spark, New York, probably 1940s § Mr. and Mrs. Robert B. Honeyman, Jr., San Juan Capistrano, Calif., to 1978.

LITERATURE
Guy C. McElroy, "Robert Duncanson: A Problem in Romantic Realism in American Art," Master's thesis, University of Cincinnati, 1972, p. 83, pl. 41, p. 124 § Eleanor H. Gustafson, "Museum Accessions," *Antiques* 116 (November 1979): 1074, repro. § "New Acquisition: American Art," *LACMA Members' Calendar* 17 (April 1979): unpaginated, repro. § "American Art," *LACMA Report 1977–1979* (1980), p. 13.

Frederick R. Spencer

Born June 7, 1806,
Lennox, New York
Died April 3, 1875,
Wampsville, New York

Frederick Randolph Spencer was an itinerant portraitist in New York City and upstate New York. In 1822 he entered Middleburg Academy, Genesee County, New York, but around this time became attracted to the work of Ezra Ames (1768–1836) in Albany and William Dunlap (1766–1839) in Utica, New York. He received at least some instruction from Dunlap and in 1825 went to New York City, where for about two years he drew from the casts in the American Academy of Fine Arts and received some instruction from its president, John Trumbull (1756–1843). He painted portraits near his family's home in Canastota, New York, and then for several years in Albany and Utica before settling in New York City about 1831. His portrait practice flourished, and he rose rapidly in the esteem of his fellow artists. He was elected an academician of the American Academy of Fine Arts in 1832 and a member of its board of directors from 1833 to 1835. He was elected an associate member of the National Academy of Design in 1837 and academician in 1846, and served as an officer of the organization in 1849 and 1850. He retired to upstate New York in 1858 but continued to paint until his death in 1875. Although he was primarily a portraitist, Spencer exhibited genre paintings occasionally from 1839 to 1852.

BIBLIOGRAPHY
William Dunlap, *History of the Rise and Progress of the Arts of Design in the United States* (1834; 3d ed., rev. and enl., New York: Benjamin Blom, 1965), 3: 243–44 § Obituary, *Art Journal* (New York) n.s. 1 (May 1875): 160 § Laurence B. Goodrich, "A Little-Noted Aspect of Spencer's Art," *Antiques* 90 (September 1966): 361–63 § Utica, N.Y., Munson-Williams-Proctor Institute (cosponsored by Oneida Historical Society, Fountain Elms), *A Retrospective Exhibition of the Work of Frederick R. Spencer, 1806–1875*, exh. cat., 1969, with biography by Susan C. Crosier, list of signed and attributed works.

Spencer, *Self-Portrait.*

Self-Portrait, 1849
Oil on canvas
30 x 25 in (76.2 x 63.5 cm)
Inscribed verso center right, now relined: F. R. Spencer. / Painted by himself / March 1849
Canvas stamp verso upper right: PREPARED / BY / EDwd DECHAUX / NEW-YORK
Gift of Thomas A. Anderson, in memory of Thomas A. Anderson, Sr.
M.74.71

The inscription on the reverse indicates that this is a self-portrait. It does appear to be a self-portrait to judge from the similarity of the likeness to the portrait of the artist by CHARLES LORING ELLIOTT, c. 1845, in the collection of the National Academy of Design. Its strong lighting and somewhat photographic quality are characteristic of a new degree of realism that was transforming Spencer's formerly romantic manner at this point in his career and

was to dominate his future work, as indeed it would that of Elliott's. On the other hand, Spencer's portrait of himself is more flattering than his likeness by Elliott.

The self-portrait's hard, direct gaze is encountered in numerous other portraits by Spencer. Spencer's wife, who remained in New York City rather than move with her husband to upstate New York in 1858, later charged him with insanity. His letters do not appear to support this charge.

PROVENANCE
The artist § Spencer E. Phelps (by descent), to 1957 § Thomas A. Anderson, Sr., to 1957 § Thomas A. Anderson, Jr. (by descent), Hemet, Calif., to 1974.

EXHIBITION
Munson-Williams-Proctor Institute, *Retrospective Exhibition*, no. 25, repro., frontispiece.

LITERATURE
Goodrich, "A Little-Noted Aspect," repro., p. 361.

Emanuel Leutze

Born May 24, 1816,
Schwäbisch-Gmünd,
Germany
To United States 1825
Died July 16, 1868,
Washington, D.C.

Emanuel Gottlieb Leutze was the foremost American history painter of the mid-nineteenth century. He was born near Stuttgart but came to this country with his family in 1825, settling in Philadelphia. In 1834 he began to copy engravings and drew from casts in classes taught by John Rubens Smith (1775–1849). He worked primarily as a portraitist until his patrons sent him on a European study trip in 1840. He spent the 1840s in Düsseldorf, where his artistic direction and style were shaped. He enrolled in the Düsseldorf Academy in late 1841 and by 1842 was already completing large historical paintings. In 1843 he left the academy to establish an independent studio. He traveled through southern Germany and Italy during 1843–45. In 1845 he married Julianne Lottner.

Leutze was so productive and influential a history painter that he was elected president of the Union of Düsseldorf Artists for Mutual Aid and Support. In 1851 he completed the work for which he is best known, *Washington Crossing the Delaware* (Metropolitan Museum of Art, New York), and returned to the United States for a year for its display. From 1852 to 1858 he again worked in Düsseldorf and elsewhere in Germany, but after 1859, except for a brief trip in 1865, he remained in the United States, primarily in Washington, D.C., and New York. During the 1850s he painted his best historical paintings and portraits. In 1861 he made a trip to the western United States in preparation for a mural commission for the United States Capitol. He continued to work until his death from a stroke.

BIBLIOGRAPHY
Tuckerman 1867, pp. 333–45 § Ann Hawkes Hutton, *Portrait of Patriotism: "Washington Crossing the Delaware"* (Philadelphia: Chilton, 1959) § Raymond L. Stehle, "The Life and Works of Emanuel Leutze," copyright 1972, copies of typescript in LACMA, Research Library; Washington, D.C., Library of Congress; New-York Historical Society; with annotated list of works § Barbara S. Groseclose, *Emanuel Leutze, 1816–1868: Freedom Is the Only King* (Washington, D.C.: Smithsonian Institution Press for the National Collection of Fine Arts, 1975), with catalogue of known works, annotated list of American artists in Düsseldorf, 1840–60, bibliography, published in conjunction with an exhibition at the National Collection of Fine Arts, Smithsonian Institution, Washington, D.C., 1976 § Barbara S. Groseclose, *"Washington Crossing the Delaware*: The Political Context," *American Art Journal* 7 (November 1975): 70-78.

Mrs. Schuyler Burning Her Wheat Fields on the Approach of the British, 1852

(*Lady Schuyler Setting Fire to Her Wheat Field, on the Approach of the British; Mrs. Schuyler Firing Her Wheat Fields; Mrs. Schuyler Firing the Fields*)
Oil on canvas
32 x 40 in (81.3 x 101.6 cm)
Signed and dated lower left: E. Leutze. 1852
Bicentennial gift of Mr. and Mrs. J. M. Schaaf, Mr. and Mrs. William D. Witherspoon, Mr. and Mrs. Charles C. Shoemaker, and Mr. and Mrs. Julian Ganz, Jr.
M.76.91
Color plate, page 39

Leutze returned to this country from Düsseldorf in September 1851 to be present during the exhibition in New York and Washington of his phenomenally successful showpiece *Washington Crossing the Delaware*. By February 1852, working in his New York studio, he had begun *Mrs. Schuyler Burning Her Wheat Fields on the Approach of the British*. It was to be the second of some dozen subjects from the Revolutionary War that he was to paint, capitalizing on the fact that the sensational response to his *Washington Crossing the Delaware* was henceforth to link his name with such subject matter. Patriotic feelings stirred by the Mexican-

American War had already inspired patronage for other artists' efforts on such themes.

Catherine Van Rensselaer Schuyler (1734–1803), wife of General Philip Schuyler, is shown setting fire to her wheat fields to keep them from the enemy, whose imminent arrival is announced by a messenger. The first account of this act of heroism to appear in print was a passage in the chapter on Mrs. Schuyler in Elizabeth F. Ellet's *The Women of the American Revolution* (1848), one of the many anthologies of Revolutionary War feminine heroism popular during the period. It was based on the account of Mrs. Schuyler written in 1846 by Catherine Van Rensselaer Cochrane, Mrs. Schuyler's youngest daughter. Surviving documents do not support this family tradition, however. Although General Schuyler pursued a scorched-earth policy and Mrs. Schuyler traveled twice to the estate to pack furnishings during July 1777, the British under John Burgoyne arrived at Saratoga (now called Schuylerville) on September 13 to find the large plantation virtually intact.

The painting reflects the skillful history-painting tradition of Düsseldorf in its clearly subordinated composition and use of antique sculptural models for two of the figures.

Leutze's freedom in adding genrelike secondary activity of his own invention is balanced by his efforts to obtain an accurate portrayal of Mrs. Schuyler by studying a portrait in the family's possession (probably one now in the

New-York Historical Society). Leutze's reputation as an outstanding colorist is supported by the painting's rich harmonies.

RELATED WORKS
Thomas J. Phillebrown, 1856, engraving, copyrighted by Martin, Johnson, and Co., New York § John B. Lee, engraving (repro., *Proceedings of the New Jersey Historical Society* 80: 285).

PROVENANCE
Charles M. Leupp, New York, by 1856 (sale, National Academy of Design, New York, *Catalogue of Valuable Paintings and Engravings, Being the Entire Gallery of the Late Charles M. Leupp, Esq., . . . to Be Sold at Auction by E. H. Ludlow and Co.,* 1860, no. 23, as *Mrs. Schuyler Firing Her Wheat Fields*) § Francis Lieber Alphonso Thill, New Haven, Conn., as of 1895 § Private collection, Connecticut § With Vose Galleries, Boston, 1976.

EXHIBITION
New York, Metropolitan Museum of Art, *Pictures by Old Masters; Retrospective Exhibition of American Paintings; The Henry G. Marquand Collection,* exh. cat. issued as Handbook no. 6 [1895], no. 181, p. 53, suggests that Leutze based the figure of Mrs. Schuyler on a portrait of her that he had borrowed from the Schuyler family, as *Lady Schuyler Setting Fire to Her Wheat Field, on the Approach of the British.*

LITERATURE
"Fine Arts," *New York Herald,* February 7, 1852, p. 3, notes that Leutze was at work in his studio on a revolutionary history scene of Mrs. Schuyler § "Our Private Collections, No. IV," *The Crayon* 3 (June

Leutze, *Mrs. Schuyler Burning Her Wheat Fields on the Approach of the British.*

1856): 186, mentions that the painting is in the Leupp collection § "Domestic Art Gossip," *The Crayon* 7 (November 1860): 323 § "Sale of Works of Art," *New York Tribune,* November 14, 1860, p. 8, notes that a Mr. Lieber purchased the painting for $385 § "Domestic Art Gossip," *The Crayon* 7 (December 1860): 354 § Thomas S. Cummings, *Historic Annals of the National Academy of Design* (Philadelphia: George W. Childs, 1865), p. 278, mentions the sale of the painting from the Leupp collection § Tuckerman 1867, p. 335 § Philip T. Sandhurst and others, *The Great Centennial Exhibition: Critically Described and Illustrated* (Philadelphia: Ziegler, 1876), p. 52, incorrectly mentions it as one of the paintings with an American subject that Leutze painted while in Germany, discussed in text but not included in exhibition § "Art Notes," *Art Journal* (New York) n.s. 8 (January 1882): 32, notes that the painting was attracting attention in New Haven and that one of the figures in it was supposed to be a portrait of Leutze § Clara Erskine Clement Waters and Laurence Hutton, *Artists of the Nineteenth Century and Their Works* (7th rev. ed., 1894; reprint, New York: Arno Press, 1969), 2: 63–64, incorrectly states that it was painted in Germany § Stehle, "Life and Works," pp. 59, 131 § Groseclose, *Leutze,* no. 75, p. 89, as unlocated, as *Mrs. Schuyler Firing the Fields* § Advertisement, *Antiques* 110 (September 1976): repro., 407 § "New Acquisitions: American Art," *LACMA Members' Calendar* 14 (November 1976): unpaginated, repro. § "Important Museum Acquisitions," *Connoisseur* 194 (January 1977): 55, fig. 7 § Eleanor H. Gustafson, "Museum Accessions," *Antiques* 112 (August 1977): 220, repro. § Michael Quick, "A Bicentennial Gift: *Mrs. Schuyler Burning Her Wheat Fields on the Approach of the British,* by Emanuel Leutze," *LACMA Bulletin* 23 (1977): 26–35, discusses painting in context of the apocryphal story about Mrs. Schuyler and also refers to the Germanic sources for Leutze's imagery, repros., detail as frontispiece, 26 § LACMA 1977, p. 137, repro. § "American Art Department," *LACMA Report 1975–1977* (1978), p. 12, repro., p. 10 § James T. Callow, "American Art in the Collection of Charles M. Leupp," *Antiques* 118 (November 1980): 1003, notes that Leupp met Leutze in Germany in 1845 and that this painting was the only Leutze picture with an American theme in the Leupp collection, pl. VI, 1001 § Fort 1986, p. 421, fig. 2 § Wendy Greenhouse, "The American Portrayal of Tudor and Stuart History, 1835–1865," Ph.D. diss., Yale University, 1989, 1: 297, contrasts heroic image of American womanhood in *Mrs. Schuyler* with images of suffering and doomed womanhood in contemporary paintings of Tudor and Stuart history; fig. 128, 2: 521.

George Baker

Born March 1821,
New York, New York
Died April 2, 1880,
New York, New York

George Augustus Baker, Jr., was a successful portraitist in New York, where he spent most of his life. His father taught him the art of miniature painting, and he began a successful career as a miniature painter when he was only sixteen years old. He also attended classes at the National Academy of Design for seven years. From 1846 to 1848 he traveled in Europe, returning to establish a successful practice as a portraitist in New York. Although Baker painted a few ideal subjects, his subject matter was almost entirely limited to portraiture. In 1851 he was elected a member of the National Academy of Design. After 1866 he divided his time between New York and Darien, Connecticut. From 1867 to 1869 he taught at the National Academy of Design. He continued to exhibit regularly until his death in 1880.

BIBLIOGRAPHY
"Sketchings" column, *The Crayon* 1 (February 28, 1855): 140; 1 (March 21, 1855): 186; 1 (April 18, 1855): 250; 4 (April 1857): 123; 4 (July 1857): 221; 5 (June 1858): 176 § Tuckerman 1867, pp. 489–90 § Henry W. French, *Art and Artists in Connecticut* (1879; reprint, New York: Kennedy Graphics, 1970), pp. 109–10 § Obituary, *American Art Review* 1 (1880): 320–21 § *Dictionary of American Biography,* s.v. "Baker, George Augustus," with bibliography.

Portrait of Children, 1853
(*Blowing Bubbles; Family Portrait; Group of Children*)
Oil on canvas
59¹⁵⁄₁₆ x 53⅞ in (152.3 x 136.8 cm)
Signed and dated lower left: G A Baker 1853
Gift of Jo Ann and Julian Ganz, Jr., in memory of Betty H. and Julian A. Ganz
M.72.49

Although he painted many portraits of men, Baker was most highly regarded for portraits of women and children. This portrait, painted while he was strongly influenced by romanticism, displays the idealization, soft brushwork, and rich color for which Baker was known. Like other artists of the period, he has used the soap bubble to represent the innocent pleasures of childhood but also the transience of youth. Even though the subject required an outdoor setting, Baker introduced a column and curtain on the left as an element of formality.

The identification of the sitters can only be conjectured. The large size of the painting, the number of figures, and the attire all suggest that the portrait was commissioned by someone from the upper middle class, perhaps a prosperous businessman or financier. In 1854, the year after the portrait was painted, Baker exhibited in the National Academy of Design

Baker, *Portrait of Children.*

PROVENANCE
Private collection (sale, Parke-Bernet, New York, *American Paintings,* November 6, 1968, no. 190) § With Hirschl & Adler Galleries, New York, as of 1969 to 1972.

EXHIBITIONS
Possibly New York, National Academy of Design, *Twenty-Ninth Annual Exhibition,* 1854, no. 13, as *Group of Children* § New York, Hirschl & Adler Galleries, *The American Scene: A Survey of the Life and Landscape of the Nineteenth Century,* 1969, no. 3, repro., p. 9, as *Blowing Bubbles* § New York, Whitney Museum of American Art, *Eighteenth- and Nineteenth-Century American Art from Private Collections,* 1972, exhibited but not listed § Detroit Institute of Arts, *The Quest for Unity: American Art between World's Fairs, 1876–1893,* 1983, no. 1, p. 14, essay by David C. Huntington, pp. 47–48, entry by Nancy Rivard Shaw, repro., p. 47.

LITERATURE
Advertisement, *Art Quarterly* 32 (Summer 1969): repro., inside front cover § John Canaday, "Good Art Shows Abound in Museums," *New York Times,* July 14, 1972, repro., p. 16, as *Family Portrait* § "La Chronique des arts," *Gazette des Beaux-Arts,* 6th ser., 81 (February 1973): supp. 140, fig. 510 § "An American Gift," *LACMA Members' Calendar* 11 (February 1973): repro., unpaginated § "Recent Acquisitions, Fall 1969–Spring 1973," *LACMA Bulletin* 19, no. 2 (1973): fig. 23, p. 43 § "Permanent Collection," *LACMA Report 1969–1973* (as *LACMA Bulletin* 20, no. 1 [1974]), p. 19, as *Blowing Bubbles.*

annual a group portrait of children owned by E. B. Sutton. Effingham B. Sutton (1817–1891) was the founder of the Sutton Line, the first clipper shipping service from New York to San Francisco. As Sutton fathered fourteen children, the museum's portrait may be of his three oldest sons and daughter.

George Caleb Bingham

Born March 20, 1811,
Augusta County, Virginia
Died July 7, 1879,
Kansas City, Missouri

George Caleb Bingham was a prominent frontier artist of the mid-nineteenth century. Raised in Missouri, he apprenticed with a cabinetmaker before turning to painting in the early 1830s. Bingham worked as an itinerant portraitist in Missouri until 1838, when he traveled east to become better acquainted with art in Philadelphia and New York. During the first four years of the following decade he worked in Washington, D.C., painting portraits.

Returning to Saint Louis in 1845, he devoted himself to painting genre scenes of frontier life. These classic images of Missouri River boatmen, fur traders, and politicians established his reputation when they were shown at the annual exhibitions of the Apollo Association and its successor, the American Art-Union, and reproduced as prints made after the paintings. From 1856 to the beginning of 1859 he was in Paris and Düsseldorf, where he studied art and completed portraits of George Washington and Thomas Jefferson commissioned for the Missouri State Legislature.

After his return to Missouri Bingham again primarily painted portraits; the only notable multifigure canvas he produced was *Order No. 11,* 1865–68 (Cincinnati Art Museum), his protest of the 1863 order forcing the evacuation of Missouri citizens from the dis-

puted Missouri-Kansas border area. He had more than an aesthetic interest in politics. Bingham actively participated in Whig conventions and held a number of elected and appointed offices, among them Missouri State treasurer, 1862–65.

BIBLIOGRAPHY
"Letters of George Caleb Bingham to James S. Rollins," ed. C. B. Rollins, *Missouri Historical Review* 32 (October 1937–July 1938): 3–34, 164–202, 340–77, 484–522; 33 (October 1938–July 1939): 45–78, 203–29, 349–84, 499–526 § John Francis McDermott, "George Caleb Bingham and the American Art-Union," *New-York Historical Society Quarterly* 42 (January 1958): 60–69 § E. Maurice Bloch, *George Caleb Bingham,* Vol. 1, *The Evolution of An Artist,* Vol. 2, *A Catalogue Raisonné* (Berkeley: University of California Press, 1967), with bibliography, lists of prints after paintings, exhibitions and owners to 1879; idem, *The Paintings of George Caleb Bingham: A Catalogue Raisonné* (Columbia: University of Missouri Press, 1986), a revised version of volume 2 of the 1967 book § Albert Christ-Janer, *George Caleb Bingham: Frontier Painter of Missouri* (New York: Harry N. Abrams, 1975), with preface by Thomas Hart Benton, chronology, bibliography § Barbara S. Groseclose, "Painting, Politics, and George Caleb Bingham," *American Art Journal* 10 (November 1978): 4–19.

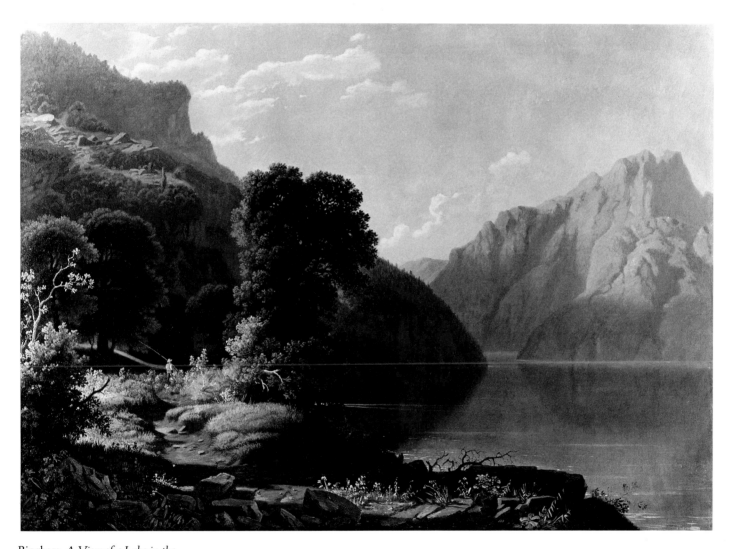

Bingham, *A View of a Lake in the Mountains.*

A View of a Lake in the Mountains, c. 1856–59
(*Landscape: Mountain View; Landscape of the Upper Mississippi*)
Oil on canvas
21¼ x 30⅛ in (53.9 x 76.5 cm)
Signed lower left: G. C. Bingham.
Los Angeles County Fund
65.18

Although Bingham is known primarily for his genre images of the frontier, he also created approximately forty landscapes in which figures are only a minor element or were omitted altogether. Actually the landscapes fit well into his oeuvre, since nearly all of Bingham's narrative scenes were set out-of-doors, in locales often similar to those of his landscapes. Based on formal criteria, most of Bingham's land-

scapes are dated from the late 1840s and early 1850s. *A View of a Lake in the Mountains* has traditionally been considered a work from the years prior to Bingham's study in Düsseldorf, dating either c. 1851 or 1853–56. While *A View of a Lake* has motifs similar to those in *Landscape with Fisherman*, c. 1850 (Missouri Historical Society, Saint Louis)—the tiny figure of the fisherman and the rocky setting near a body of water—it is a much more complex and formal landscape.

One authority has suggested that Bingham painted *A View of a Lake* in the mountains while in Germany; he is known to have done landscapes for his own satisfaction when in Düsseldorf. The landscape displays the sophisticated approach to form and space of the Düsseldorf school. Unlike his earlier landscapes in which numerous passages are amorphous and ill defined, the rocks and foliage in the foreground of *A View of a Lake* are sharply delineated with a crisp drawing technique and clear light. The sunlight on the right forms a pattern of alternating passages of light and shadow, a characteristic typical of Bingham's German-period figure paintings. The rocks and trees in the foreground of the landscapes of the early 1850s frame the scene, while the rocks in this mountain view are placed one behind the other to define spatial recession. In the one known landscape datable to his Düsseldorf period, *Moonlight Scene: Castle on the Rhine*, c. 1857–59 (private collection), Bingham adopted a hard finish and massed lights and darks in a similar manner to emphasize a progression of planes rather than a continuous recession as in his earlier landscapes. The distant rock formations appear more idealized and their stylized shapes are described by a softer, almost opalescent palette. They have been compared with Alpine scenery. Thus, the increased sophistication Bingham demonstrated in this landscape compared with those from the early 1850s suggests that the painting dates from his years in Düsseldorf or from the period immediately following his European visit.

PROVENANCE
William D. Sage, East Lansing, Mich. § With Harry Shaw Newman Gallery (The Old Print Shop), New York, 1946–47 § With Victor D. Spark, New York, 1965.

EXHIBITIONS
Washington, D.C., Smithsonian Institution, National Collection of Fine Arts, and others, *George Caleb Bingham, 1811–1879*, 1967–68, no. 25, p. 54, text by E. Maurice Bloch, repro., p. 55, as *Landscape: Mountain View* § Dallas Museum of Fine Arts, *The Romantic Vision in America*, 1971, no. 35, repro., unpaginated § Spokane, International Exposition on the Environment, *Our Land, Our Sky, Our Water*, 1974, no. 121 § Kunstmuseum Düsseldorf und Kunsthalle Bielefeld, *The Hudson and the Rhine: Die Amerikanische Malerkolonie in Düsseldorf im 19. Jahrhundert*, 1976, no. 22, unpaginated, entry by Rolf Andree and Ute Ricke-Immel, repro., as *Gebirgsee*, about 1856 § Palm Springs (Calif.) Desert Museum, *The West as Art: Changing Perceptions of Western Art in California Collections*, 1982, exh. cat. for *Western American Art in California Collections*, no. 9, p. 14, essay by Patricia J. Trenton, pl. 14.

LITERATURE
Charles D. Chiles, "The Rise of the American Landscape School," *Panorama* 2 (January 1947): 60, repro., cover, as *Landscape of the Upper Mississippi* § John Francis McDermott, *George Caleb Bingham: River Portraitist* (Norman: University of Oklahoma Press, 1959), pp. 117, 418, no. 76 of "Checklist of Works," pl. 51, p. 247 § Bloch, *Bingham*, 1: 180, discussed, pl. 117; 2: 87, listed in cat. raisonné as no. 224, with provenance and references; as *Landscape: Mountain View*, dated "after 1851" § "The Permanent Collection: Recent Acquisitions," *LACMA Report 1965–1967* (as *LACMA Bulletin* 18, nos. 1–2 [1968]), p. 12, repro., p. 11 § Christ-Janer, *Bingham*, pl. 155 § LACMA 1977, p. 138, repro. § Bloch, *Paintings of Bingham*, p. 203, listed in cat. raisonné as no. 271, with provenance, exhibitions, and references, fig. 271, p. 95, dated "after 1853."

William Morris Hunt

Born March 31, 1824, Brattleboro, Vermont
Died September 8, 1879, Appledore, New Hampshire

William Morris Hunt was the earliest and foremost proponent of Barbizon art in America and a popular portrait painter and teacher in Boston. Born into a well-to-do family, Hunt attended Harvard University, but his poor health prompted his family to move to Italy, where Hunt studied sculpture with Henry Kirke Brown (1814–1886). In 1845 he enrolled in the Düsseldorf Academy on the advice of EMANUEL LEUTZE. Dissatisfied with the strict training, he moved to Paris in 1846 and became one of the first Americans to study with Thomas Couture (1815–1879), staying in his atelier for five years. Around 1853 he began a two-year association with Jean-François Millet (1814–1875) at Barbizon. In 1852 he made his debut at the Paris Salon and in 1855 was one of the few Americans to participate in the Universal Exposition in Paris.

In 1855 he returned to New England and settled in Newport, Rhode Island, where he transferred his knowledge and admiration of French painting to a group of artists, among them JOHN LA FARGE, that congregated around him there. In the 1860s he established a

studio in Boston and, with the assistance of the social connections of his wife, Louisa Dumaresq Perkins, became a much sought-after portrait painter of Boston's upper class. He also exhibited paintings of picturesque Europeans, Barbizon-inspired pastorals, and portraits, and became active in other aspects of local art life, helping to form the Allston Club in 1866 to promote modern art. The same year he left for about a year's stay in Europe, living in Italy and France and spending the summer painting landscapes at Dinan, France, with ELIHU VEDDER and Charles Caryl Coleman (1840–1928). During that trip he also began to work increasingly in charcoal. Upon his return home he opened his studio to female students, becoming the most influential teacher in Boston before the establishment of the School of the Museum of Fine Arts. His lectures were compiled and published by one of his students after his death as *Talks on Art*.

In 1873 he visited Magnolia Springs, Florida, and from that time on landscape painting became his dominant concern. The following year he traveled to Cuba and Mexico. In 1878 he was commissioned to decorate the lunettes of the New York State Capitol with allegorical murals of *Anahita* and *Columbus*. Suffering from depression, Hunt visited his writer-friend Celia Thaxter at her home on the Isle of Shoals; there he drowned, whether by suicide or accident.

BIBLIOGRAPHY
Henry C. Angell, *Records of William M. Hunt* (Boston: J. R. Osgood, 1881) § Helen M. Knowlton, comp., *W. M. Hunt's Talks on Art, First Series* (Boston: Houghton Mifflin, [1875]); idem, *W. M. Hunt's Talks on Art, Second Series* (Boston: Houghton Mifflin, 1883) § Helen M. Knowlton, *Art-Life of William Morris Hunt* (Boston: Little Brown, 1900) § Martha A. S. Shannon, *Boston Days of William Morris Hunt* (Boston: Marshall Jones, 1923) § College Park, University of Maryland Art Gallery, and Albany (N.Y.) Institute of History and Art, *The Late Landscapes of William Morris Hunt*, exh. cat., 1976, with introduction by Marchal E. Landgren, chronology and catalogue entries by Sharman Wallace McGurn.

Hunt, *Portrait of Edward Wheelwright.*

Portrait of Edward Wheelwright, 1857
Oil on canvas
21¹³/₁₆ x 18⅛ in (55.4 x 46.0 cm)
Signed and dated center right: W M Hunt. / 1857
Gift of T. Gilbert Brouillette
51.5

Trained as a lawyer and artist, Edward Wheelwright (1824–1900) is known today for his writings on art. He was born into a prestigious Boston family and educated at the finest schools, including Harvard, where he was a classmate of Hunt. Well traveled and erudite, Wheelwright turned to painting, first studying art around 1850 in the Parisian atelier of Eugène Cicéri (1813–1890), a landscape painter. Five years later, inspired by Hunt, he returned to France and persuaded Millet to become his teacher. Their student-teacher association was quite formal, the only one of its kind to be made by an American with Millet. However, Wheelwright never seriously pursued the career of an artist. After his return to the United States, he turned his attention to other aspects of art, becoming a critic for the *Atlantic Monthly* in the late 1870s. He actively promoted the reputation of Millet in this country, through his article "Personal Recollections of Jean-François Millet" of 1876 in the *Atlantic Monthly* and through his assisting the Boston Museum of Fine Arts in raising funds for the purchase of paintings by Millet.

In June 1856 Wheelwright returned home after spending nine months in Barbizon. He

joined Hunt at Newport, becoming part of the intimate circle of artists and writers around Hunt and his family. It was at this time that Hunt painted his portrait. With his return to the United States, Hunt entered the field of portraiture, and Wheelwright's bust is an early example of Hunt's extensive work in that genre. Some of his best portraits were created during his Newport years. Although he received numerous commissions, he often painted his friends.

Hunt's handling of the portrait reveals his French training, in particular the influence of Thomas Couture and Millet. The overall effect is one of softness, in contrast to the harsh clarity typical of mid-nineteenth-century American portraits. Hunt built up Wheelwright's face with light and dark passages of color, including different shades of pinks, roses, and oranges, vigorously applied in small strokes over a warm underdrawing. The head is quite plastic, but its contour is blurred. The warm tonal palette of browns is carried through into the background, although less densely.

PROVENANCE
Edward Wheelwright, Boston § William C. Endicott, Boston § Colonial Society of Massachusetts, Boston, by 1926 to 1942 § Society for the Preservation of New England Antiquities, Boston, 1942–48 § T. Gilbert Brouillette, New York, by 1950 to 1951.

ON DEPOSIT
Museum of Fine Arts, Boston, 1926–42.

LITERATURE
Boston, Massachusetts Historical Society, Matthew Ridley Papers, receipt of payment, November 21, 1857, states Hunt received two hundred dollars for the portrait § Knowlton, Art-Life of Hunt, p. 48 § Martha J. Hoppin, "William Morris Hunt: Aspects of His Work," Ph.D. diss., Harvard University, 1974, p. 288, listed as no. 116 § Memphis, Dixon Gallery and Gardens, An International Episode: Millet, Monet, and Their North American Counterparts, exh. cat., 1982, fig. 15, p. 33.

Hunt, *Girl with Cows*.

Girl with Cows, 1860

(*Girl with Cows, Fountainbleau; Fontainebleau Wood; Woman with Cattle*)
Oil on canvas
31⁷/₁₆ x 25¹/₂ in (79.9 x 64.7 cm)
Signed and dated lower right: WM Hunt. 1860. (WM monogram)
Purchased with funds provided by Joseph T. Mendelson and Mr. and Mrs. Allan C. Balch Fund
M.78.59
Color plate, page 40

After his return to the United States in 1855, Hunt worked in Newport, Rhode Island, continuing to produce figure paintings reflecting the spell of Millet. *Girl with Cows* relates closely to the peasant images Hunt created while in France, in particular his *On the Edge of the Forest*, c. 1853 (Museum of Fine Arts, Boston), in which a woman stands next to a grazing cow in a forest glade. The image of a female peasant quietly involved in knitting or sewing, while tending farm animals, was a common theme in midcentury French art. Millet created several such images, including *Peasant Woman Guarding Her Cow*, 1852 (Museum Boymans-van Beuningen, Rotterdam), while Hunt lived at Barbizon.

Edward Wheelwright, another follower of Millet in the intimate circle around Hunt, may have been instrumental in Hunt's creating this specific image. Wheelwright brought back to America Millet's *The Knitter*, 1856 (Cincinnati Art Museum), which is the closest pictorial source for Hunt's *Girl with Cows*. Unlike *On the Edge of the Forest* but similar to Millet's *The*

Knitter, Girl with Cows depicts a young peasant girl in a secluded forest glade with the thick foliage of trees forming a barrier between her and the distant field seen partially in the distance. Consequently the focus is solely on the figure and cows.

The scene is painted in dark, shadowy tones. Two cows—one brown, the other white—frame the young girl, forming contrasts of light and dark, while picking up the sweet pink and blue colors of her simple peasant garb. The white handkerchief wrapped around her head glows in the reflected yellows and pinks. Indeed, the entire scene is rich with color, even to the warm browns and greens of the darker passages.

RELATED WORKS
Woman with Cow, n.d., charcoal drawing, dimensions unknown. Unlocated (listed Louis J. Bird & Co., Auctioneers, Boston, *Exhibition and Public Sale of the Celebrated Paintings and Charcoal Drawings of the Late William Morris Hunt,* February 24, 1898, no. 59) § *Woman Knitting and Cow,* 1860, oil on panel, 12¼ x 9¼ in (31.1 x 23.5 cm). With Vose Galleries, Boston, as of 1986.

PROVENANCE
Samuel G. Ward, New York, as of 1879 § Frank W. Bayley, Boston (?), as of 1923 § Mr. and Mrs. William C. Endicott, Jr., Boston, as of 1924 § Private collection, Boston, to 1978 § With Vose Galleries, Boston, 1978.

ON DEPOSIT
Museum of Fine Arts, Boston, 1931.

EXHIBITIONS
Probably Boston, Studio Building, 1862–64, as *Fontainebleau Wood,* no cat. traced § Boston, Museum of Fine Arts, *Exhibition of the Works of William Morris Hunt,* 1879, no. 199, as *Girl with Cows, Fontainebleau* § Boston, Museum of Fine Arts, *William Morris Hunt Memorial Exhibition,* 1924, no. 43, as *Girl with Cows, Fontainebleau* § Buffalo, Albright Art Gallery, *Centennial Exhibition of Paintings by William Morris Hunt,* 1924, no. 12 § Memphis, Dixon Gallery and Gardens, *An International Episode: Millet, Monet, and Their North American Counterparts,* 1982–83, no. 16, pp. 39–41, 95, text by Laura L. Meixner, repro., p. 112.

LITERATURE
Shannon, *Boston Days,* repro., facing p. 76, as *Woman with Cattle* § Martha J. Hoppin, "William Morris Hunt: Aspects of His Work," Ph.D. diss., Harvard University, 1974, p. 306, listed as no. 204, as *Girl with Cows, Fontainebleau,* with note that it is probably the lost *Woman with Cattle* § Michael Quick, "Homer in Virginia," *LACMA Bulletin* 24 (1978): 62, fig. 6, p. 64 § "New Acquisition: American Art," *LACMA Members' Calendar* 16 (September 1978): unpaginated, repro. § "La Chronique des arts," *Gazette des Beaux-Arts,* 6th ser., 93 (April 1979): supp. 47, fig. 236 § "American Art," *LACMA Report 1977-1979* (1980), p. 13 § Boston, Vose Galleries, *The Return of William Morris Hunt,* exh. cat., 1986, fig. 6, p. 23.

James H. Beard

Born May 20, 1812,
Buffalo, New York
Died April 4, 1893,
Flushing, New York

James Henry Beard moved with his family to Painesville, Ohio, in 1823. He was active as an itinerant portraitist in the Midwest as early as age seventeen. In 1830 he settled in Cincinnati and married there in 1833, although he continued to travel to find commissions, eventually becoming a leading portraitist of the region. Beard was in New York from 1846 to 1847, served in the Civil War as a captain of the Union forces, and in 1870 moved permanently to New York. He was an honorary member of the National Academy of Design, 1846–60, and was elected to full membership in 1872.

Beard painted portraits and genre pieces during his Cincinnati period and satirical animal pictures while in New York. His four sons and brother William were also well-known artists.

BIBLIOGRAPHY
Washington, D.C., Library of Congress, Daniel C. Beard Papers, include James Henry Beard's autobiography of his early years § Tuckerman 1867, pp. 436–37 § "American Painters: James H. Beard," *Art Journal* (New York) n.s. 1 (December 1875): 366–68 § Leon Mead, "The Apprenticeship of an Academician," *American Magazine* 9 (December 1888): 192–200 § S. Winifred Smith, "James Henry Beard," *Museum Echoes* (Ohio State Archaeological and Historical Society) 27 (April 1954): 27–30.

Portrait, 1859
Oil on canvas
30¹/₁₆ x 25¹/₁₆ in (76.3 x 63.6 cm)
Signed and dated lower left: J-B / 1859
Gift of Lillian Dunn Miller in memory of
Albert T. Miller
M.77.25

The backlighting and strong silhouette of the
unknown subject, the rather frank portrayal
of the face, and the averted, thoughtful gaze
are characteristic of Beard's portraits of the
late 1850s.

PROVENANCE
Lillian Dunn Miller, Los Angeles, to 1977.

Beard, *Portrait.*

John F. Kensett

Born March 22, 1816,
Cheshire, Connecticut
Died December 14, 1872,
New York, New York

John Frederick Kensett was a leading mid-nineteenth-century landscape painter and a major figure in New York art circles. He began his career in New Haven, Connecticut, in the late 1820s as an engraver with the firm of his father, Thomas Kensett (1786–1829), and uncle, Alfred Daggett (1799–1872). He later worked with the firm of Peter Maverick in New York and with the banknote engravers Hall, Packard, and Cushman in Albany.

After deciding to become a painter, Kensett traveled to Europe in the company of Asher B. Durand (1796–1886), John Casilear (1811–1893), and his longtime friend Thomas P. Rossiter (1818–1871). Kensett spent seven years in England, France, and Italy, sketching and also studying old master paintings and contemporary art in public and private collections. Shortly after his return to New York in 1847, he exhibited *The Shrine: A Scene in Italy,* 1847 (Mr. and Mrs. Maurice Katz, Naples, Florida) at the National Academy of Design, obtaining immediate success. Thereafter he received numerous commissions for American landscapes and became a leading exponent of the Hudson River school. Around 1855 his art began to change; his subject matter became coastal scenes instead of mountain views, and he developed a more austere, controlled painting style. With his images of the New England coast Kensett became a major practitioner of the style now known as luminism. He gradually expanded his repertoire of locales, traveling in 1856 to Ireland, Scotland, England, and Wales and in 1870 going as far West as Colorado and the Rocky Mountains with WORTHINGTON WHITTREDGE and SANFORD R. GIFFORD. Daringly abstract seascapes, presumably painted during the last summer of his life, were found in his studio on Contentment Island, in Darien, Connecticut, after his death.

Despite his numerous commissions, Kensett took time from his hectic schedule to aid the cause of the American artist, raising money for the National Academy of Design's new building, serving on the three-member presidential commission to review the decoration of the United States Capitol, chairing in 1864 the artists' committee for the Metropolitan Fair of the Sanitary Commission, and in 1870 sitting on the first board of trustees of the Metropolitan Museum of Art.

BIBLIOGRAPHY
Albany, New York State Library, Edwin D. Morgan Collection, John Frederick Kensett Correspondence § John K. Howat, *John Frederick Kensett,* exh. cat. (New York: American Federation of Arts, 1968) § University Park, Pennsylvania State University, Museum of Art, *John F. Kensett Drawings,* exh. cat., 1978, text by John Paul Driscoll § Mark White Sullivan, "John F. Kensett: American Landscape Painter," Ph.D. diss., Bryn Mawr College, 1981, with bibliography § Worcester (Mass.) Art Museum and others, *John Frederick Kensett: An American Master,* exh. cat., 1985, ed. Susan E. Strickler (copublished with W. W. Norton, New York), with essays by John Paul Driscoll, John K. Howat, Dianne Dwyer, and Oswaldo Rodriguez Roque,

appendix listing pictures in artist's estate and "last summer's work" given Metropolitan Museum of Art, New York, bibliography.

Kensett, *Almy's Pond, Newport.*

Almy's Pond, Newport, c. 1860
(An Inlet of Long Island Sound)
Oil on canvas
12⅝ x 22¹/₁₆ in (32.1 x 56.1 cm)
Signed lower left: JFK (JF in monogram)
Gift of Colonel and Mrs. William Keighley
49.24

This landscape came into the collection with the title *An Inlet of Long Island Sound.* The setting has recently been identified as Almy's Pond, near Newport, Rhode Island. This low-lying area of the Rhode Island coast, with its rolling hills and salt marshes, was a popular site with American artists at midcentury and was painted by Martin Johnson Heade (1819–1904) and William Trost Richards (1833–1905) as well as Kensett. The numerous landscapes of the Newport vicinity listed in the sales catalogue of his estate indicate that Kensett often worked in the area. The museum's painting may be one of the three Almy's Pond scenes of similar size sold at auction in 1873 (New York, Association Hall, *The Collection of Over Five Hundred Paintings and Studies by the Late John F. Kensett,* nos. 366, 454, 559; another painting of the same subject and similar size believed to be one of these three is in the Terra Museum of American Art, Chicago). A very similar landscape painted around 1860 from the same vantage point that recently appeared on the art market (see Related Work) suggests that the museum's canvas was painted about the same time.

In the museum's painting Kensett viewed the pond, which once was an inlet of the Rhode Island Sound, looking toward the nearby sound, indicated by the large sailboats in the distance. The topography well suited Kensett's temperament for serene, open landscapes. The museum's painting typifies the artist's mature luminist images of the 1860s. It is a tranquil view of nature on a sunny day with a clear, almost cloudless sky dominating the horizontal composition. Little activity occurs. The cattle grazing do not disturb the harmony of the composition, allowing the viewer to attain a transcendental unity with nature; even Kensett's thin, smooth brushwork keeps from intruding upon the illusion of contact with nature.

RELATED WORK
Landscape, c. 1860, oil, 10 x 14½ in (25.4 x 36.8 cm). Coe Kerr Gallery, New York, as of 1978.

PROVENANCE
Possibly estate of the artist, to 1873 (sale, New York, Association Hall, *The Collection of Over Five Hundred Paintings and Studies by the Late John F. Kensett,* March 24–29, 1873, no. 559) § Colonel and Mrs. William Keighley, Beverly Hills, Calif., to 1949.

EXHIBITIONS
Seattle, University of Washington, Henry Art Gallery, *The View and the Vision: Landscape Painting in Nineteenth-Century America,* 1968, no. 25, p. 31, as *An Inlet of Long Island Sound* § Bloomington, Indiana University Art Museum, *The American Scene, 1820–1900,* 1970, no. 12, pl. 12, p. 45, as *An Inlet of Long Island Sound,* c. 1865 § Washington, D.C., National Gallery of Art, *American Light: The Luminist Movement, 1850–1875,* 1980, entries not numbered, p. 114, essay by John Wilmerding, fig. 118, as *An Inlet of Long Island Sound,* c. 1865 § Worcester Art Museum and others, *Kensett,* 1985–86, entries not numbered, pl. 39, p. 143, as *An Inlet of Long Island Sound,* c. 1865.

LITERATURE
Vincent Price, *The Vincent Price Treasury of American Art* (Waukesha, Wis.: Country Beautiful, 1972), p. 122, repro., pp. 122–23 § Gerald F. Brommer, *Landscapes* (Worcester: Davis, 1977), p. 70, repro. § LACMA, American Art department files, Richard Grosvenor to Ilene Susan Fort, September 7, 1984, accurately identifies the painting's locale.

John Ferguson Weir

Born August 28, 1841,
West Point, New York
Died April 8, 1926,
Providence, Rhode Island

Following the success of his early career as a painter, John Ferguson Weir became an influential art educator. He grew up at West Point, where his father, ROBERT W. WEIR, was drawing instructor at the United States Military Academy. He received his art training from his father, beginning at an early age, and through his father was introduced to leading artists. He served briefly in the New York Seventh Regiment in 1861. Later that year he took a studio in the Tenth Street Studio Building in New York. His exhibition of *An Artist's Studio*, 1861–64 (LACMA; q.v.), at the National Academy of Design in 1864 secured his election as an associate member of the organization. He obtained full membership in the academy when in 1866 he exhibited *The Gun Foundry*, 1866 (Putnam County Historical Society, Cold Spring, New York), a dramatic representation of an industrial subject. *Forging the Shaft*, 1868 (destroyed; repetition of 1874–77, Metropolitan Museum of Art, New York), another heroic industrial subject, established his reputation as one of the most promising young artists. He married in 1866 and late in 1868 went abroad, where he received an invitation to become director of the Yale School of Fine Arts, a position he assumed in September 1869. Until his retirement in 1913, most of Weir's time and energy was taken up in teaching, the administration of the art school, and expansion of the art collection, most notably in the acquisition of the Jarves collection of early Italian paintings. His major paintings behind him, he painted portraits and landscapes, but also did some sculpture and architectural designs. He wrote on both art and religion. With his younger half-brother J. ALDEN WEIR he made a second trip abroad in 1881. His later landscapes in an impressionist style reflect the influence of J. Alden Weir. After his retirement, he lived in Providence, R.I.

BIBLIOGRAPHY
New Haven, Conn., Yale University, Sterling Memorial Library, John Ferguson Weir Papers § Tuckerman 1867, pp. 487–88 § George W. Sheldon, *American Painters* (New York: Appleton, 1879), pp. 175–77 § John Ferguson Weir, *The Recollections of John Ferguson Weir, Director of the Yale School of the Fine Arts, 1869–1913*, ed. Theodore Sizer (New York and New Haven: New-York Historical Society and Associates in Fine Arts at Yale University, 1957) § Betsy Fahlman, "John Ferguson Weir: Painter of Romantic and Industrial Icons," *Archives of American Art Journal* 20, no. 2 (1980): 2–9.

An Artist's Studio, 1861–64, dated January 1864

(*The Artist's Studio; The Studio*)
Oil on canvas
25½ x 30½ in (64.8 x 77.5 cm)
Signed and dated lower left: J. F. Weir. / January 1864
Gift of Jo Ann and Julian Ganz, Jr.
M.86.307

Weir seems to indicate in his published *Recollections* that he began *An Artist's Studio* in West Point during the summer of 1862 and returned during the summer of 1863 to finish it, but in an early manuscript of the recollections he wrote that he carried the unfinished canvas with him when he moved to New York in 1861 to set up his own studio in the Tenth Street Studio Building. In a manuscript list of some of his works Weir indicated that *An Artist's Studio* was painted in 1863 and 1864.

He intended to exhibit the picture for the first time in the spring exhibition of the National Academy of Design in 1864, but the artist SANFORD R. GIFFORD, a friend and neighbor in the Tenth Street Studio Building, admired it enough to borrow it first for an exhibition and reception at the Athenaeum Club. Its favorable reception at the exhibition of the National Academy of Design was Weir's first great success, causing his election as an associate member of the academy. Even though he raised the price, Weir sold it soon afterward.

Robert Weir had introduced his son to the world of art and to numerous leading artists, so it seems appropriate that a painting of the distinguished artist in his studio at West Point should have been John Ferguson Weir's introduction to the National Academy of Design and the art world of New York. The young Weir had served what he considered an apprenticeship in that studio and wrote of it in the same manuscript draft of the *Recollections*: "Brought up in an artist's studio, surrounded with what was actively related to the practice

of art, with opportunity for gaining such knowledge of the past as the collections and library of the house inspired, it only needed a strong incentive to get from this what was requisite in the way of preparations in following one's bent. At any rate, the results of this experience supplied my equipment when eventually I struck out in the swim and found myself in the Tenth Street Studios." The significance the subject had for the young Weir is reflected in the fact that he painted the studio in other works, *The Artist's Studio,* 1864 (Yale Univer-

Weir, *An Artist's Studio.*

sity Art Gallery, New Haven, Connecticut), *The Studio,* 1864 (art market 1976), and *The Morning Paper,* 1868 (Metropolitan Museum of Art, New York). What apparently is a study for the right side of the museum's painting is preserved in the West Point Museum. An inventory made in 1914 indicates that he still had at that time two paintings and oil sketches of the interior of a studio, as well as two photographs thought to be of the interior of his father's studio (New Haven, Yale University, John Ferguson Weir Papers, "Professor Weir's Portfolio, Case in Lobby to Store-room, March 1914," pp. 4, 5).

An Artist's Studio depicts Robert Weir writing in his studio, surrounded by his own paintings, drawings, and artist's equipment, as well as antique furniture, armor, and other artifacts assembled by him, for he was conscientious about the accuracy of the details of his history paintings. The very size of the studio, a space of two stories open to the roof, recalled his most famous history painting in

that the studio was an addition to his original stone quarters that was built to enable him to paint *The Embarkation of the Pilgrims,* 1843, for the rotunda of the Capitol in Washington. Two studies for that painting can be seen on the left side of the back wall, the upper one a study for the figure of John Robinson, the pastor, and the lower one a study for those of Miles Standish and his wife. His most recent success, *Taking the Veil,* 1863 (Yale University Art Gallery, New Haven), is represented as on the large easel in the center of the room. It had been a critical triumph when exhibited in February 1863 in Goupil's gallery in New York and later, by April of that year, in his son's Tenth Street studio. The other recognizable images depicted are also ones that had special meaning for Robert Weir: the version of his celebrated painting *Saint Nicholas* of 1837 (unlocated; one of numerous replicas or later versions, dated 1838, New-York Historical Society) that can be seen near the upper right-hand corner of *The Artist's Studio,* and the large bust near it, on top of the cabinet, a replica of a bust of 1840 by Shobal Vail Clevenger (1812–1843) of Washington Allston (1779–1843), esteemed as the greatest American artist of the romantic period. Propped up on the cabinet is an oil sketch of what looks like a Deposition, perhaps a study for the painting, *Evening of the Crucifixion,* which Robert Weir exhibited at the National Academy of Design in 1864 (unlocated). The cabinet had been used as a background in the artist's painting, *The Microscope,* 1849 (Yale University Art Gallery, New Haven).

Although surrounded by evidence of his artistic activity and success, Robert Weir is shown writing at his book-lined desk rather than painting. Father and son shared the ideal of the artist as a man of wide reading and a resultingly deep knowledge and rich imagination. An artist of the romantic period thought of himself as a poet, rather than primarily a craftsman, his chief effort being conceptual.

Although the painting's dramatic shadows suggest this lofty realm of the imagination, *An Artist's Studio* was developed in terms of clear spatial progression and firm drawing. Henry T. Tuckerman in 1867 praised Robert Weir's *Taking the Veil* for its architectural truth and correct drawing (Tuckerman 1867, p. 214), but these qualities were developed much further in his son's *An Artist's Studio.* Robert Weir's instruction to the cadets in military draftsmanship must have emphasized perspective drawing and clear rendering of details. The son he trained was exceptionally strong in both these areas. At the same time, the painting's highly detailed quality reflects the taste of the 1860s, as seen in the work of his neighbors in the Tenth Street Studio Building.

The entry for the painting in the catalogue of the National Academy of Design's exhibition included the following poem:

"I well remember how the light, the pale, pure
 north light, fell
On all within that lofty room, and clothed
 with mystic spell
A massive oaken cabinet, and many a curious
 chair—
Bright armor of the olden time, and relics
 quaint and rare.

"I marked them well,—the gathered books, the
 painter's treasures all:
Here was the resting-place of day, whatever
 might befall;
The inner shrine of one whose brow the stamp
 of genius bore,
And who the laurels of his fame with childlike
 meekness wore.

"Oh, many a slowly-waning hour this silent
 room alone
Had seen the dreaming artist sit, like statue
 carved in stone;
Absorbed in patient watchfulness of all that
 Fancy brought,
Gleanings of gladness or of gloom from out the
 fields of thought."

RELATED WORK
Attributed to J. F. Weir, *Studio Scene (View of Robert Weir's Studio with Man Reading),* mid-nineteenth century, oil on paper, 14⅛ x 10 in (36 x 25 cm). West Point Museum, United States Military Academy, West Point, N.Y.

PROVENANCE
Cyrus Butler, New York, 1864 § Mrs. Alice Clark Read, Lexington, Mass. § Mrs. Ruth Read Young (by descent), Bronxville, N.Y. § (Sale, Sotheby Parke Bernet, New York, *American Nineteenth- and Twentieth-Century Paintings, Drawings, Watercolors and Sculpture,* October 27, 1977, no. 19, repro., unpaginated, as *The Artist's Studio*) § Jo Ann and Julian Ganz, Jr., Los Angeles, 1977–86.

EXHIBITIONS
New York, Athenaeum Club, *A Reception Given to Meet the Artists of New York,* 1864, no cat. traced § Brooklyn Art Association, *Catalogue of the Works of Art Exhibited at Brooklyn and Long Island Fair in Aid of the United States Sanitary Commission,* 1864, no. 114, as *The Studio* § New York, National Academy of Design, *Thirty-Ninth Annual Exhibition,* 1864, no. 236, p. 18, listed with poem § New Haven, Conn., Yale College, *Second Annual Exhibition of the Yale School of Fine Arts,* 1870, no. 72 § Possibly Troy, New York, Young Men's Association, *Loan Exhibition of One Hundred and Forty Ancient and Modern Paintings Loaned by the Hon. Thomas B. Carroll,* 1878–79, no. 128, as *The Artist's Studio* § Washington, D.C., National Gallery of Art, and others, *An American Perspective: Nineteenth-Century Art from the Collection of Jo Ann and Julian Ganz, Jr.,* 1981–82, entries not numbered, pp. 58–59, essay by Linda Ayres, pp. 169–70, entry by Stephen Edidin, repros., pp. 64, 170.

LITERATURE
New Haven, Yale University, John Ferguson Weir Papers, notebook with manuscript draft of *Recollections,* unpaginated, "Beside my foundry studies I carried with me to the City a number of unfinished canvases, upon one of which I placed a modest hope, "An Artist's Studio"—an elaborate portrait-study of my father's studio, though not yet completed"; manuscript page, "'An Artist's Studio' canvas. 25 x 30 inches - painted [18]63 & 4," discusses medium and technique; "List of Pictures Painted by John Ferguson Weir," typed, no. 36, "'An Artist's Studio' (R. W. Weir) 25 x 30 Cyrus Butler - New York Mar [1864] [$]800 Miss Alice Cary, Lexington Mass." § Tuckerman 1867, p. 623 § Clara Erskine Clement Waters and Laurence Hutton, *Artists of the Nineteenth Century and their Works,* (7th rev. ed., 1894; reprint, New York: Arno Press, 1969), 2: 343 § Irene Weir, *Robert W. Weir, Artist* (New York: House of Field-Doubleday, 1947), pp. 58–59, 114, 140, as *The Studio* § Weir, *Recollections,* pp. 46–47 § Fahlman, "Weir: Icons," p. 2 § William H. Truettner, "The Art of History: American Exploration and Discovery Scenes, 1840–1860," *American Art Journal* 14 (Winter 1982): 30, fig. 27, p. 29 § Lauretta Dimmick, "Robert Weir's *Saint Nicholas:* A Knickerbocker Icon," *Art Bulletin* 66 (September 1984): 468, 480, lists as no. 9 of "Type 3" in "Catalogue, Paintings of *Saint Nicholas* by Robert Weir, and Copies After Him," figs. 9, 10 § Susan P. Casteras, "Robert W. Weir's *Taking the Veil* and 'The Value of Art as a Handmaid of Religion,'" *Yale University Art Gallery Bulletin* 39 (Winter 1986): 23, fig. 9 § Natalie Spassky and others, *American Paintings in the Metropolitan Museum of Art, Volume 2: A Catalogue of Works by Artists Born Between 1816 and 1845,* ed. Kathleen Luhrs (New York and Princeton, N.J.: Metropolitan Museum of Art in association with Princeton University Press, 1985), p. 566, Doreen Bolger Burke mentions in the context of artist's early interiors.

Severin Roesen

Born 1815 or 1816
To United States
probably 1848
Active 1848–72

Severin Roesen was a still-life specialist in the mid-Victorian period. Much of his biography remains uncertain. He was probably born in Prussia about 1815 or 1816. He may have been the porcelain painter who exhibited a floral still life at an art club in Cologne, Germany, in 1847, and he may have emigrated to the United States in 1848 as one of the large group of German immigrants settling in this country at that time. A variety of contemporary documentary evidence, such as records of his marriage to Wilhelmina Ludwig and the births of their children, place him in New York from 1848 to 1857. During these years he was very active there, judging by the number of his signed paintings and records of his sales to the American Art-Union. Around 1858 he left his family and went to Pennsylvania, spending time in Philadelphia, Harrisburg, and Huntingdon before settling in Williamsport about 1862. The date and place of his death are unknown. The latest date on any of his paintings is 1872, the last year that his name appears in the Williamsport city directory.

BIBLIOGRAPHY
Richard B. Stone, "Not Quite Forgotten: A Study of the Williamsport Painter, S. Roesen," *Lycoming Historical Society Proceedings and Papers*, no. 9 (November 1951): 3–40, with catalogue of known paintings and bibliography § Maurice A. Mook, "Severin Roesen: The Williamsport Painter," *Lycoming College Magazine* 25 (June 1972): 33–41 § Maurice A. Mook, "Severin Roesen: Also the Huntingdon Painter," *Lycoming College Magazine* 26 (June 1973): 13–16, 23–30 § Lois Goldreich Marcus, *Severin Roesen: A Chronology* (Williamsport, Pa.: Lycoming County Historical Society and Museum, [c. 1976]), with bibliography § Judith H. O'Toole, "Search of 1860 Census Reveals Biographical Information on Severin Roesen," *American Art Journal* 16 (Spring 1984): 90–91.

Roesen, *Fruit Still Life in a Landscape.*

Fruit Still Life in a Landscape, c. 1862–72

Oil on canvas
36⁵/₁₆ x 50½ in (92.1 x 128.3 cm)
Signed lower right: S.Roesen (S.R in monogram)
Gift by exchange of Jo Ann and Julian Ganz, Jr., and Mary and Will Richeson, Jr.
M.77.126

The stylistic source for the clarity and sculptural presence of Roesen's fruit still-life compositions easily can be traced to artists in his north German background, but little there anticipates the exuberant energy of his mature American style.

Fruit Still Life in a Landscape was commissioned by Mrs. Alma White of Williamsport, Pennsylvania. Its provenance and similarity to the large painting of fruit, n.d., in the collection of the Lycoming Hotel, Williamsport, firmly date the museum's painting to the period the artist lived in Williamsport. Few of his fruit pieces from the 1860s are dated, and his mature style, once established, did not change much in his fruit still-life compositions until very late. The presence of a landscape background in the *Fruit Still Life with Wine Glass and Coins in a Landscape,* dated 1861 (private collection), suggests a date in the early 1860s for the museum's painting, but a painting with a more similar landscape background bears the date of 1867 (Amon Carter Museum, Fort Worth, Texas). A still life of flowers with a landscape background (private collection) bears the date of 1850, but it appears that Roesen used such backgrounds more often during the 1860s.

The landscape in the museum's painting is an unusual feature that adds a dramatic note. Roesen's adoption of landscape backgrounds is thought to reflect the taste, inspired by the English Pre-Raphaelites, for still-life compositions in a natural setting. Roesen's response is a somewhat artificial compromise, in which he

set his conventional tabletop still life in front of a landscape, with little connection between the two. His landscape compositions almost always conform to the formula of trees and road on the left, clouded sky and distant hills on the right. Numerous other aspects of the museum's painting also employ formulas familiar in Roesen's work, for instance, the corner of a gold-fringed pillow emerging from a fold in a large cloth.

Roesen's central theme is that of abundant fruitfulness. The composition is so crowded that it appears as though a great cornucopia is spilling fruit from one tier to the other and out into the viewer's space. Roesen uses the trompe l'oeil device of having fruits and leaves overhang the edges of the table, but this confuses the sense of space within the painting; the predominant appearance is that of a single wall of fruit, which enhances the painting's decorative character. The color in the museum's painting is exceptionally strong for the artist. The primary colors are announced in the group of lemon peel, cherries, and blue plum on the lower shelf. Elsewhere the colors are more mixed, except in the brilliant red of the strawberries high on the footed milk-glass dish.

PROVENANCE
Mrs. Alma White, Williamsport, Pa. § Lycoming County Bar Association, Williamsport, c. 1900 § Hugh Gilmore, Williamsport, by 1905 § Clarence Gilmore (by descent), Williamsport § Lee A. Cillo, Williamsport, c. 1972 § With Coe Kerr Gallery, New York, 1977.

LITERATURE
Advertisement, *Antiques* 112 (August 1977): repro., 195 § "New Acquisition: American Still Life," *LACMA Members' Calendar* 16 (March 1978): unpaginated, repro. § "La Chronique des arts: principales acquisitions des musées en 1978," *Gazette des Beaux-Arts*, 6th ser., 93 (April 1979): fig. 231, supp. 46 § Eleanor H. Gustafson, "Museum Accessions," *Antiques* 115 (June 1979): repro., 1174 § "American Art," *LACMA Report 1977–1979* (1980), p. 13, repro., p. 14.

Charles Loring Elliott

Born October 12, 1812,
Scipio, New York
Died August 25, 1868,
Albany, New York

At midcentury Charles Loring Elliott was the leading portraitist in New York City. When he was fifteen, Elliott and his family moved to Syracuse, New York. Determined to become a painter, in 1829 he went to New York City with a letter of introduction to John Trumbull (1756–1843), who allowed him to draw from casts at the American Academy of Fine Arts. He also spent about six months in the studio of William Rimmer (1816–1879). Essentially self-taught, Elliott spent about a decade working as an itinerant portraitist in western and central New York State. About 1839 he moved permanently to New York City, steadily gaining in ability, especially after his acquaintance with HENRY INMAN in 1844. The success of one of his portraits at the exhibition of the National Academy of Design in 1845 established Elliott as one of the city's leading portraitists, and after the death of Inman in 1846 he was considered to have succeeded that artist as the foremost portraitist in New York. He was elected an associate of the National Academy in 1845 and an academician the following year. In 1854 he established a residence at West Hoboken, New Jersey, but kept a studio in New York. Until his death Elliott was in great demand as a portraitist and received almost all the most important private and civic commissions.

BIBLIOGRAPHY
E. Anna Lewis, "Art and Artists of America: Charles Loring Elliott, N.A.," *Graham's American Monthly Magazine* 44 (June 1854): 564–68 § Tuckerman 1867, pp. 300–305 § Thomas Bangs Thorpe, "Reminiscences of Charles L. Elliott, Artist," *New York Evening Post*, September 30 and October 1, 1868, reproduced as a pamphlet, n.d. (on microfilm, Archiv. Am. Art, roll N52, frs. 641–46) § Theodore Bolton, "Charles Loring Elliott, an Account of His Life and Work" and "A Catalogue of The Portraits," *Art Quarterly* 5 (Winter 1942): 58–96 § Philip F. Schmidt, "Charles Loring Elliott (1812–1868): American Portrait Painter," Master's thesis, University of Minnesota, 1955.

Elliott, *Portrait of a Gentleman.*

Portrait of a Gentleman, 1863
Oil on canvas
42⅛ x 34 in (107.0 x 86.4 cm)
Signed and dated lower left: C. L. Elliott / 1863
Gift of Sandra and Jacob Y. Terner
M.81.30

Elliott's work progressed through several stylistic phases. He first painted in general imitation of GILBERT STUART. While in New York during the 1840s he sought a rich, romantic style. In the 1850s and 1860s Elliott worked in the style most distinctively his own, one of firm and frank realism to some extent shaped by the development of photographic portraiture.

With its plain background setting and distinct plastic figure, the museum's portrait of an unknown gentleman is characteristic of Elliott's full realist style. Elliott was thought to be best in his portraits of men particularly, as observed by Tuckerman (1867, p. 300), when the sitters have "strong, practical natures," as this one seems to have.

PROVENANCE
With antique dealer, New Jersey, 1960s § With The Old Print Shop, New York, 1960s–1972 § With The Scriptorium, Beverly Hills, Calif., 1972 § Dr. and Mrs. Jacob Y. Terner, Beverly Hills, 1972–81.

LITERATURE
"Reinstallation: American Painting and Sculpture," LACMA *Members' Calendar* 19 (September 1981): unpaginated.

John F. Francis

Born August 13, 1808,
Philadelphia, Pennsylvania
Died November 15, 1886,
Jeffersonville, Pennsylvania

John F. Francis was an active mid-nineteenth-century portrait and still-life painter. He was a reputable Philadelphia portraitist who as early as the mid-1830s had painted Governor Joseph Ritner. In 1851 Francis painted a portrait of James Moore II, the founder of Bucknell University in Lewisburg, Pennsylvania.

Francis's style was somewhat in the manner of THOMAS SULLY but with a greater focus on personality. He painted many portraits of children. Although most associated with Pennsylvania, living there and exhibiting in the annuals sponsored by the Artists Fund of Philadelphia and the Pennsylvania Academy of the Fine Arts, he traveled perhaps as far as Ohio to the west and Tennessee to the south in search of commissions. Although he devoted his attention to portraiture in the 1830s and 1840s, thereafter he turned increasingly to still-life paintings, which constitute the bulk of his known oeuvre. His still-life paintings were always tabletop arrangements, usually assembled to suggest an elegant meal of a middle-class household, either luncheon or dessert. Sometimes he presented fruit tumbling out of a simple straw basket. His paintings were characterized by exceptionally soft brushwork, a pastel palette, and concern for form—all formal elements not typical of the period. His last known painting dates from 1879.

BIBLIOGRAPHY
Alfred Frankenstein, "J. F. Francis," *Antiques* 59 (May 1951): 374–77, 390, with list of portraits § George L. Hersey, ed., "A Catalogue of Paintings by John F. Francis," *Bibliotheca Bucnellensis* 14, no. 1 (1958), served as a catalogue of an exhibition held at Ellen Clarke Bertrand Library, Bucknell University, Lewisburg, Penn. §

William H. Gerdts and Russell Burke, *American Still-Life Painting* (New York: Praeger, 1971), pp. 60–61 § William H. Gerdts, *Painters of the Humble Truth: Masterpieces of American Still Life, 1801–1939* (copublished by Philbrook Art Center, Tulsa, and University of Missouri Press, Columbia, 1981), published in conjunction with an exhibition at the Philbrook Art Center, Tulsa, and others, 1981–82, pp. 89–93 § Lewisburg, Penn., Packwood House Museum, *A Suitable Likeness: The Paintings of John F. Francis, 1832–1879*, exh. cat., 1986, essay by David W. Dunn, with list of portraits by place.

Francis, *Fruit Still Life.*

Fruit Still Life, 1864
Oil on canvas
15³⁄₁₆ x 19¹⁵⁄₁₆ in (38.5 x 50.6 cm)
Signed and dated verso lower right, now relined:
Jno. F. Francis. / Pinxit 1864
Gift of Mr. and Mrs. Floyd E. Yates in loving memory of Dr. and Mrs. Alexander C. G. de Turzanski-Kahanowicz
M.81.252

Francis painted both elaborate still-life paintings, in which fruit was presented along with fancy cakes and drinks in expensive pitchers and goblets, and also simpler arrangements such as this one, in which the fruit and nuts are served as the entire dessert. Gone is the neat, orderly display of food that would be found in the classically perfect world of a still life by Raphaelle Peale (1774–1825). The partially consumed cluster of grapes, empty nutshells, and table in disarray indicate that the meal is over. The fruit is not fresh for it is bruised with age spots, suggesting the passage of time. The table is not aligned with the picture plane but is set on a slight diagonal. While the still life does not appear as methodically arranged as those in Francis's earlier paintings, its seemingly random arrangement is actually a well-balanced and rhythmic placement of color and shapes, for the artist was fascinated with the formal aspects of a painting. The red goblet balances with the foreground orange to form the base of a triangle with the stem of the grapes as the apex and the smaller groupings of nuts, raisins, and grapes the intermediary color notes.

PROVENANCE
Mrs. Alexander C. G. de Turzanski-Kahanowicz, Detroit, by 1940s (?) § Mr. and Mrs. Floyd E. Yates (by descent), Long Beach, Calif., to 1981.

Thomas Hill

Born September 11, 1829,
Birmingham, England
To United States 1844
Died June 30, 1908,
Raymond, California

Thomas Hill is identified with the scenery of California. His family in 1844 immigrated to Taunton, Massachusetts, where he was employed in a cotton mill. He next worked as a decorative painter in Gardner, Massachusetts, and as a carriage painter and decorative painter in Boston. He married in 1851. In 1853 Hill entered the Pennsylvania Academy of the Fine Arts in Philadelphia and attended the life class of Peter Rothermel (1817–1895). During the later 1850s he worked in Massachusetts and painted in the White Mountains with leading Hudson River school artists. Threatened with tuberculosis, he and his family moved to the milder climate of California, settling in San Francisco in 1861. At this time Hill was primarily a portrait painter but also painted California landscapes. In 1866 he studied for six months in Paris with Paul Meyerheim (1842–1915), who advised him to specialize in landscape painting. From 1868 to 1870 he lived in Boston, but his health forced him to return to San Francisco. He prospered during the boom of the 1870s, primarily as a landscape painter. He was awarded a bronze medal at the Centennial Exposition in Philadelphia in 1876 and the Temple Medal of the Pennsylvania Academy of the Fine Arts in 1884. He experienced financial setbacks during the economic depression that struck California beginning in 1879. During the summers of 1880 and 1892 and fall of 1886 he painted in the White Mountains. In the summer of 1886 he established his studio next to the Wawona Hotel in Yosemite, where he sold paintings to tourists. His

winter studio was in San Francisco, but beginning in the early 1890s, he wintered in Raymond, California. Hill continued to travel until about 1896, when his health declined, and he painted very little thereafter.

BIBLIOGRAPHY
Samuel G. W. Benjamin, *Our American Artists* (1881; reprint, New York: Garland, 1977), pp. 22–26 §
California Art Research Project 2 (December 1936): 67–97a, with list of representative works, bibliography
§ Hardy George, "Thomas Hill (1829–1908)," Master's thesis, University of California, Los Angeles, 1963,
with bibliography, reprint of Hill's *History of the "Spike Picture"; and Why It Is Still in My Possession* (1884) §
Hardy George, "Thomas Hill's 'Driving of the Last Spike,' A Painting Commemorating the Completion of
America's Transcontinental Railroad," *Art Quarterly* 27 (Spring 1964): 82–93 § Oakland Museum and
others, *Thomas Hill: The Grand View,* exh. cat., 1980, with text by Marjorie Dakin Arkelian, chronology,
bibliography.

Hill, *Emerald Bay, Lake Tahoe,* 1864.

Emerald Bay, Lake Tahoe, 1864
(*View of Yosemite*)
Oil on canvas
36³/₁₆ x 56³/₈ in (91.9 x 143.2 cm)
Signed and dated lower left: T. Hill / 1864
Canvas stamp verso upper right: JONES, WOOLL &
SUTHERLAND / LOOKING GLASS / PICTURE STORE /
[M]ONT[GOMERY] ST
William Randolph Hearst Collection
53.6

Thomas Hill is so firmly identified with views of Yosemite that this painting was long thought to depict a lake in Yosemite even though no lake of this size is to be found there. The liberties that Hill took with topography make it difficult to identify conclusively the sites of a number of his paintings, but the distinctive double-peaked hill at the left, known as Maggies Peaks, mark this painting as a view of Lake Tahoe, and the waterfall suggests Emerald Bay. The *Daily Alta California* of June 19, 1864, in the year the museum's landscape was painted, mentioned that Hill exhibited a view of Emerald Bay of about the same size and also showing Maggies Peaks and the same sunset effect: "A beautiful bit of Emerald Bay, Lake Tahoe by T. Hill, was placed in the window of Jones, Woll [*sic*] and Sutherland. It is about 3' x 4', a sunset; the twin buttes (Maggies Peaks, at left) and snowy mountains in the distance are lit by the red rays of evening. The light and shade are forcible. . . ." By the mid-1860s, tourists, such as those depicted in this painting, were visiting Emerald Bay.

The museum's painting apparently is the earliest dated California landscape by Hill. The artist is so much identified with California views it is easy to forget that he came west as an accomplished landscape painter who had sketched in the White Mountains of New Hampshire with Benjamin Champney (1817–1907), Asher B. Durand (1796–1886), and GEORGE INNESS, among others identified with the Hudson River school. *Emerald Bay, Lake Tahoe* is very much in the idiom of those artists.

PROVENANCE
Senator James D. Phelan, San Francisco § Possibly with Schussler Brothers, San Francisco, c. 1907–13 § Mr. and Mrs. John F. Merrill, San Francisco, by 1913 § Samuel G. Hooper, North Hollywood, Calif., to 1953, as *View of Yosemite*.

ON DEPOSIT
Los Angeles County Office of the District Attorney, 1960–72.

EXHIBITIONS
Probably San Francisco, Jones, Wooll & Sutherland, 1864, no cat. traced § Probably San Francisco, Mechanics' Institute, *Fourth Industrial Exhibition*, 1864, no. 337 § Oakland Museum and others, *Hill*, 1980–81, entries not numbered, p. 44, fig. 27, as *View of Yosemite*.

LITERATURE
"City Items," *Daily Alta California* (San Francisco), June 19, 1864, p. 1, describes a painting of Emerald Bay, Lake Tahoe § "American Paintings," *LACMA Bulletin* 6, no. 3 supp. (Summer 1954): repro., 13, as *View of Yosemite* § LACMA, American Art department files, William Dick to curator, March 31, 1982, correctly identifies locale.

Hill, *Emerald Bay, Lake Tahoe*, 1883.

Emerald Bay, Lake Tahoe, 1883
(*Lake in High Sierras*)
Oil on canvas
27¼ x 45³/₁₆ in (69.2 x 114.8 cm)
Signed and dated lower left: T. Hill / 1883.
Gift of Mr. and Mrs. Robert B. Honeyman, Jr.
54.77

Painted nearly twenty years later than the museum's other view of the subject, this painting exemplifies the artist's mature style. A characteristic difference is the way Hill has practically eliminated the immediate foreground, moving almost directly into the distance. His brushwork is broader and more formalized, but at the same time more vigorous. More accurately rendered than his earlier landscape, this painting includes an islet that is one of the landmarks of Emerald Bay.

Hill developed more or less standard types of staffage, which he inserted into his landscapes to establish the mood. In the earlier painting the group of tourists draws attention to the picturesque qualities of the landscape; here the presence of Native Americans suggests a wilder, more sublime mode.

PROVENANCE
Mr. and Mrs. Robert B. Honeyman, Jr., Pasadena, Calif., to 1954.

EXHIBITIONS
Los Angeles, Barnsdall Park, Municipal Art Gallery, *The American Scene*, 1956, no cat. traced § LACMA and others, *The American West*, 1972, no. 87, pl. 95, p. 145 § Oakland Museum and others, *Hill*, 1980–81, entries not numbered, p. 3, repro., frontispiece § San Diego Museum of Art, *The Golden Land*, 1986–87, entries not numbered § Galleries of the Claremont (Calif.) Colleges,

Pomona College, Montgomery Gallery, *Myth and Grandeur: California Landscapes, 1864–1900*, 1987, entries not numbered.

LITERATURE
LA Museum Art Div. Bull. 6 (Fall 1954): repro., 20, as *Lake in High Sierras*.

Wesley Vernier

Born c. 1820, Ohio
Active 1850–64

Almost nothing is known of Wesley Vernier, except that he was born in Ohio and painted in New York around 1850 and in California somewhat later.

BIBLIOGRAPHY
George C. Groce and David H. Wallace, *The New-York Historical Society's Dictionary of Artists in America, 1564–1860* (New Haven, Conn.: Yale University Press, 1957), p. 649.

Vernier, *The Great California Pear*.

According to the inscription on the back of the canvas, the large fruit was grown by Charles Nova in Los Angeles in 1864, but efforts to document a farmer with that name as then residing in Los Angeles have proved futile.

The enormous weight of the pear—four pounds—must have caused quite a stir. California was perceived as a garden paradise, and the pear's size demonstrated the richness of the land. In the late 1870s, when the railroad linking the East and Southern California was completed, railroad companies issued posters extolling the fecundity of the land; one lithograph, depicting an array of fruit, referred to California as the "cornucopia of the world."

The Great California Pear, 1864

Oil on canvas
16¹/₁₆ x 12⅛ in (40.8 x 30.7 cm)
Signed and dated lower right: Vernier. / 1864
Inscribed verso center: The great California Pear / Weight, 4 Lbs. / Variety, Duchesse d'Angouleme. / grown by Charles Nova / Los Angeles / 1864
Gift of Mrs. Fred Hathaway Bixby
M.47.5

Although little is known about this painting, it might have been created as a record of the accomplishment of modern horticulture. Such still lifes of specific agricultural products were common in the nineteenth century. Vernier's botanically accurate rendering of the pear skin, stem, and leaves, however, seems unusual in the context of the dramatic lighting, which was used by other American still-life painters of the period.

PROVENANCE
Mrs. Fred Hathaway Bixby, Long Beach, Calif., to 1947.

EXHIBITIONS
La Jolla (Calif.) Museum of Art, *California Landscapes: Then and Now*, 1969, no cat. traced § Pittsburgh, Hunt Institute for Botanical Documentation, Carnegie-Mellon University, *American Cornucopia: Nineteenth-Century Still Lifes and Studies*, 1976, no. 49, p. 8, introduction by William H. Gerdts discusses in context of still-life paintings illustrating specific agricultural products, repro., p. 34.

LITERATURE
James B. Byrnes, "The Great California Pear," *LACM Quarterly* 10 (Fall 1953): 7, calls it an "almost botanical rendering," repro. § William H. Gerdts and Russell Burke, *American Still-Life Painting* (New York: Praeger, 1971), p. 72 § William H. Gerdts, *Painters of the Humble Truth: Masterpieces of American Still Life, 1801–1939*, (copublished by Philbrook Art Center, Tulsa, and University of Missouri Press, Columbia, 1981, in conjunction with an exhibition at the Philbrook Art Center and others, 1981–82), p. 26, fig. 1.3, p. 26.

Alexander Wyant

Born January 11, 1836,
probably Evans Creek, Ohio
Died November 29, 1892,
New York, New York

Alexander Helwig Wyant was one of the country's leading landscape painters in the decades following the Civil War, infusing new life into and broadening the Hudson River school's aesthetic. Wyant's early career was typical of a frontier-born artist. He first worked as a harness maker and sign painter in Ohio. Inspired by the paintings of GEORGE INNESS, which he may have seen in Cincinnati in 1857, Wyant traveled east to visit Inness. This visit in 1859 was instrumental in gaining for Wyant the patronage of the Cincinnati collector Nicholas Longworth.

Wyant led the life of an itinerant painter in Ohio and Kentucky until 1863, when he settled in New York. He first exhibited at the National Academy of Design in 1865. Later that same year he went to Karlsruhe, Germany, studying for about a year with the Düsseldorf-trained, Norwegian landscapist Hans Fredrik Gude (1825–1903). During this trip he also visited England and Ireland and became impressed with the art of John Constable (1776–1837). Back in America, he painted in an early Hudson River school style, which was eventually transformed under the influences of Inness's later style and of Barbizon painting.

Wyant became known for intimate scenes of woodland glades and open, rolling hills. During his later years his paintings were noted for their extremely loose, almost abstract handling of the brush, which traditionally has been explained as due to his painting with his left hand after a stroke in 1873 left his right one paralyzed.

Most of his landscapes were painted in the Adirondack and Catskill mountains in New York, especially after 1889, when he settled in Arkville. He painted as far west as Arizona, which he visited in early 1873 with the Wheeler Survey. In 1862 he helped establish the American Society of Painters in Watercolor and in 1868 was elected an associate member of the National Academy of Design.

BIBLIOGRAPHY
Eliot Clark, *Alexander Wyant* (New York: Privately printed, 1916) § Eliot Clark, *Sixty Paintings by Alexander H. Wyant* (New York: Privately printed, 1920) § John C. Van Dyke, *American Painting and Its Tradition* (New York: Scribner's, 1920), pp. 45–63 § Robert S. Olpin, "Alexander Helwig Wyant (1836–1892) American Landscape Painter," Ph.D. diss., Boston University, 1971, with catalogue raisonné, chronology, bibliographies, lists of exhibitions and collections § Peter Bermingham, "Alexander H. Wyant: Some Letters from Abroad," *Archives of American Art Journal* 12, no. 4 (1972): 1–8.

Landscape, 1865
(*The Mohawk Valley*)
Oil on canvas
17 1/16 x 25 in (43.3 x 63.5 cm)
Signed and dated lower right: AWyant 1865
Gift of Joseph T. Mendelson
M.66.66.2

When this landscape surfaced in the 1940s it bore the title *The Mohawk Valley* because it resembled a landscape by that name in the Metropolitan Museum of Art, New York. Newly found documentary evidence has led to the identification of the Metropolitan Museum's landscape as a painting titled *Tennessee* (see illustration). Although contemporary references do not mention that Wyant was active in Tennessee, he may have visited the state when he was sketching in neighboring Kentucky during the late 1850s and early 1860s. In 1865 the artist traveled to Düsseldorf, and it was there in 1866 that he painted the Metropolitan's painting.

The Los Angeles Museum's *Landscape* resembles the Metropolitan Museum's *Tennessee* in Wyant's general approach to the mountainous landscape: taking an elevated perspective, the artist presented a broad view, delineating the meanderings of a river in the middle distance and placing to one side a single, tall tree that provides a point of entry for the viewer. Both paintings have a similar rocky ledge in the foreground on which the artist stood to view the scene, although in *Tennessee* the ledge is actually the escarpment of a river. Despite the similarities—many of which may have derived from traditional studio landscape devices—there are enough differences to question whether the Los Angeles Museum's painting is of the same scene of the Grand Canyon of Tennessee in the Cumberland Mountains that has been identified as the site depicted in the Metropolitan Museum's painting. The distant mountains in *Landscape* do not have the same configuration as the mountains in *Tennessee*, in which the gorge between Signal and Lookout Mountains formed by the Tennessee River is delineated.

Although the date and size of *Landscape* suggest that Wyant may have intended it to be a study for *Tennessee*, there is no conclusive documentary evidence to prove such a link between the two paintings. Moreover, *Landscape* appears to be more complete in execution than a study might be.

Wyant, *Landscape.*

Wyant, *Tennessee (The Mohawk Valley),* 1866, oil on canvas, 34³⁄₄ x 53³⁄₄ in (88.3 x 136.5 cm). Metropolitan Museum of Art, New York, gift of Mrs. George E. Schanck, in memory of Arthur Hoppock Hearn, 1913.

Landscape is a highly finished, tightly painted work in which a brilliantly clear atmosphere and bright colors dominate. From its earliest days, *Tennessee* was criticized for its subdued colors and its style linked with the Düsseldorf school. *Landscape,* however, demonstrates that the crisp, linear quality of the Metropolitan Museum's painting of 1866 may not have been due solely to the influence of German art. In the Los Angeles painting of the preceding year, Wyant was meticulous in his delineation of the blades of grass and occasional flower. He even conveyed the striations of the foreground rock formations. Such an exacting representation was extolled by John Ruskin and enthusiastically followed by the English critic's American disciples in the late 1850s and early 1860s.

While Düsseldorf-trained artists shared with Ruskin's followers an interest in a heightened technical realism, they did not use a similar palette. English Pre-Raphaelite painters, whom Ruskin held up as exemplifying the best in art, were noted for their brilliant hues. The Düsseldorf painters were usually criticized for their cold, colorless palette. The museum's *Landscape* not only has a more varied and brighter palette than the somber browns and greens of the Metropolitan painting, more

importantly it has the unique lavender-green combination found only in those mid-century American landscape paintings inspired by the English Pre-Raphaelites. Wyant briefly visited New York in 1857, the year of the first major showing of Pre-Raphaelite art in the United States, but it is more likely that he first came into contact with their art after his move to New York in 1863. Although it is not known exactly when in 1865 Wyant painted *Landscape,* most likely it was executed before his trip to Germany.

Due to the lack of early, dated Wyant landscapes, it is difficult to characterize the artist's development before his European studies. If the museum's *Landscape* is typical of the artist's style immediately prior to his European travels, then the differences between the 1865 landscape and the larger 1866 painting demonstrate the alteration in Wyant's approach that occurred as a result of his studies with Gude. The transformation of Wyant's palette was not the only change. In the museum's *Landscape* Wyant depicted a more natural, almost "accidental" view, the type that Ruskin extolled, but in *Tennessee* he adopted a traditional academic approach to landscape painting and presented a grand vista centered around a waterfall in the foreground. The other major

difference between the two paintings is the overall mood the artist established through the meteorological conditions depicted. The sky in *Landscape* is clear and calm while that in *Tennessee* is stormy and overcast. Wyant's emphasis on clarity and factual detail in the 1865 painting suggests an emphasis on accurate transcription, and his veiling of *Tennessee* in clouds and shadows reveals that subsequently, in Germany, he adopted the highly romantic approach of the Düsseldorf school.

PROVENANCE
Mr. Willever, to 1943 (sale, Parke-Bernet Galleries, New York, *Important Paintings,* April 29, 1943, no. 12, as *The Mohawk Valley,* repro.) § With H. E. Russel, Jr. § Sale, Santa Barbara, Calif., c. 1960 § With Terry De Lapp Gallery, Los Angeles, c. 1960–66 § Joseph T. Mendelson, Santa Monica, Calif., 1966.

EXHIBITIONS
Los Angeles, Terry De Lapp Gallery, *A Selection of Nineteenth-Century American Paintings,* 1965, entries not numbered, repro., unpaginated § Los Angeles, Terry De Lapp Gallery, *American Masters, 1800– 1966,* 1966, no. 18, repro., unpaginated, incorrectly dated 1875 § Long Beach (Calif.) Museum of Art, *Nineteenth-Century American Landscape Painting,* 1966, no. 39, repro.

LITERATURE
"French Art Sale," *Art Digest* 17 (April 15, 1943): 22, as *The Mohawk Valley* § Salt Lake City, University of Utah, Utah Museum of Fine Arts, *Alexander Helwig Wyant, 1836–1892,* exh. cat., 1968, unpaginated, listed in "Register of Wyant Paintings in Public Collections" § James C. Kelly, "Landscape and Genre Painting in Tennessee, 1810–1985," *Tennessee Historical Quarterly* 44 (Summer 1985) served as a catalogue of an exhibition held at Nashville, Tennessee State Museum, and others, p. 68, mentioned as related in composition to the Metropolitan painting, as *Mohawk Valley* § Natalie Spassky and others, *American Paintings in the Metropolitan Museum of Art, Volume 2: A Catalogue of Works by Artists Born between 1816 and 1845,* ed. Kathleen Luhrs (New York and Princeton, N.J.: Metropolitan Museum of Art in association with Princeton University Press, 1985), p. 413, Amy L. Walsh discusses in relation to the Metropolitan's painting, as *Mohawk Valley.*

Wyant, *Any Man's Land.*

Any Man's Land, by 1880
(*No Man's Land*)
Oil on canvas
18³/₁₆ x 30 in (46.2 x 76.2 cm)
Signed lower right: A H Wyant
Purchased with funds provided by Mr. and Mrs. Willard G. Clark, Mr. James B. Pick, and Coe Kerr Gallery
M.80.192

Eliot Clark referred to this landscape as "one of the most dramatic and powerful pictures painted by Wyant," expressive of "the unrelenting and irresistible force of nature." Wyant depicted a desolate land, devoid of any human presence, with only one tree sturdy enough to survive, and the painting was mistakenly referred to in 1912 as *No Man's Land.* Storm clouds move quickly over the wild marshy

land, solitary stream, and ragged rocks, which cast threatening, dark shadows. While Wyant was preoccupied with light, atmosphere, and weather, *Any Man's Land* is one of his stormiest landscapes. His earth-toned palette has become even more somber, and his colors—browns, yellow ochers, grays, dark greens, blacks, and white—serve as visual equivalents of nature's ominous mood.

The loose brushwork in the artist's late paintings is usually attributed to the physical disability he suffered after his stroke. *Any Man's Land*, however, demonstrates that Wyant's late painterly handling was not a result of technical inability but was deliberately employed as an expressive element. The forceful strokes in the clouds and sky echo the movement of the threatening storm, and the vigorous scumbling of the rocks and distant terrain express the wildness of the land. Air and earth seem to merge as the wind whips through, and all becomes ethereal. So removed from strict representation had Wyant become that his art verged on abstraction.

Wyant's brushwork and emphasis on mood rather than place would date this as a late work. The art historian Robert S. Olpin places it in the artist's last years, dating it about 1887–92. A painting with the same title was exhibited in the 1880 annual exhibition of the Society of American Artists, however, and the notices the exhibited landscape received in several newspaper reviews accord with the appearance of the museum's painting. *Any Man's Land* therefore was painted much earlier than previously considered and demonstrates that Wyant's turn toward a personal, abstract art began earlier than art historians previously thought.

PROVENANCE
Thomas B. Clarke, New York, by 1893 to 1899 (sale, American Art Association, New York, February 16, 1899, no. 225, for five hundred fifty dollars) § William M. Clausen, New York, 1899 § D. J. Morrison, 1904 § Frederic Bonner, as of 1904 § Estate of Frederic Bonner (sale, Plaza, New York, *Important Paintings Belonging to the Estates of the Late George Crocker, Alice Newcomb, Emily H. Moir, Frederic Bonner*, 1912, no. 66, repro., as *No Man's Land*, for sixty-five hundred dollars) § With M. Knoedler & Co., New York, 1912 § J. William Clarke, New York, 1912 to as of 1920, bought for seventy-five hundred dollars § Margaretta C. Clark (by descent), to 1941 (sale, Parke-Bernet, New York, *European and American Paintings . . . Property of the Estate of Margaretta C. Clark*, 1941, no. 12, as *No Man's Land*, repro.) § George Ainslie, New York and Los Angeles § Mrs. George Ainslie (by descent), Los Angeles, to 1980.

EXHIBITIONS
New York, Society of American Artists, *Third Exhibition*, 1880, no. 76 § New York, Art House, organized by Fifth Avenue Art Galleries, *Catalogue of American Oil Paintings and Water Colors Loaned and for Sale, First Annual Summer Exhibition*, 1893, no. 169 § New York, Fine Arts Building, organized by Society of Art Collectors, *Comparative Exhibition of Native and Foreign Art*, 1904, no. 187 § Los Angeles, Terry De Lapp Gallery, *A Selection of Nineteenth- and Early Twentieth-Century American Paintings*, 1974, entries not numbered, unpaginated, repro., dated c. 1880 § West Palm Beach, Fla., Norton Gallery of Art, and others, *In Nature's Ways: American Landscape Painting of the Late Nineteenth Century*, 1987, no. 77, p. 9, essay by Bruce Weber, repro., p. 72.

LITERATURE
Samuel G. W. Benjamin, "Society of American Artists: Third Exhibition," *American Art Review* 1 (1880): 259, gives mixed praise for the artist's suggestive treatment of land and sky § "Fine Arts: Society of American Artists," *New York Herald*, March 8, 1880, p. 8 § "Fine Arts: Third Annual Exhibition of the Society of American Artists," *New York Herald*, March 16, 1880, p. 6, calls it "brilliant" § "The Society of American Artists," *The Sun* (New York), March 21, 1880, p. 5, praises as one of the strongest landscapes in the exhibition § "Society of American Artists' Exhibition," *Art Interchange* 4 (March 31, 1880): 59, notes its "striking foreground" § "Art for Artists," *Art Amateur* 2 (April 1880): 90, refers to the "heavy-skied landscape" § "The Clarke Collection of American Paintings," *Art Interchange* 42 (March 1899): 65, sold for five hundred fifty dollars § Robert Vonnoh, "Increasing Value in American Paintings," *Arts and Decoration* 2 (May 1912): 256, reprints letter from William T. Evans who notes the rise in value of Wyant's *No Man's Land* and suggests that it would have brought even more money "'if it had a less desolate name'" § "American Picture Prices," *American Art News* 10 (May 4, 1912): 3, quotes May 1912 *Arts and Decoration* article and adds that the title *No Man's Land* is quite appropriate § "Corot Sells for Eighty-five Thousand Dollars," *New-York Tribune*, January 25, 1912, p. 4, lists § New York, M. Knoedler & Co., Library, newspaper clippings pasted in *Important Paintings Belonging to the Estates of the Late George Crocker, Alice Newcomb, Emily H. Moir, Frederic Bonner* (1912, auction cat., Plaza, New York), "Eighty-five Thousand Dollars Paid for Landscape by Corot," *New York Press*, January 25, 1912, listed with sale price and buyer; *Sun* (New York), January 28, 1912, painting attracted much attention during sale preview § "Two Great Artists: Inness and Wyant," *Fine Arts Journal* 27 (October 1912): 675, discusses, as *Any Man's Land* § Clark, *Sixty Paintings*, no. 50, p. 125, declares it to be "one of the most dramatic and powerful pictures" by the artist, repro., p. 124 § *Index 20th Cent. Artists* 4 (October 1936): 330; reprint, p. 630; listed § Olpin, "Wyant," pp. 201–2, 376–77, listed in cat. raisonné as no. 211, discussed in context of Wyant's atmosphere studies of the late 1880s, described, dated 1887–92, as unlocated § H. Barbara Weinberg, "Thomas B. Clarke: Foremost Patron of American Art from 1872 to 1899," *American Art Journal* 8 (May 1976): 83, listed with purchase and disposal date § "Rein-

stallation: American Painting and Sculpture,"
LACMA Members' Calendar 19 (September 1981):
unpaginated § Jennifer Bienenstock, "Formation
and Early Years of the Society of American Artists,
1877–1884," Ph.D. diss., City University of New
York, 1983, p. 402, identifies painting exhibited in
1880, as at De Lapp Gallery § LACMA and others,
George Inness, exh. cat., 1985, p. 51, essay by Michael
Quick discusses in context of Inness's late paintings,
fig. 27, p. 51.

Daniel Huntington

Born October 14, 1816,
New York, New York
Died April 18, 1906,
New York, New York

A respected leader in New York's artistic circles throughout most of the second half of the nineteenth century, Daniel Huntington also was one of the most productive portraitists. He was raised in comfortable circumstances. After private preparatory schools, he attended Yale College in New Haven, Connecticut, for a year before transferring to Hamilton College in Clinton, New York, where the itinerant CHARLES LORING ELLIOTT came to paint portraits. Fascinated, Huntington borrowed some materials, learned what he could from Elliott, and tried to learn to be a portraitist. In 1835 he enrolled in the art department recently established at New York University by Samuel F. B. Morse (1791–1872). He next studied with HENRY INMAN. In 1839 he went to Rome, Florence, and Paris for further study.

Huntington was elected an associate of the National Academy of Design in 1839 and a full member the following year. Returning to New York in 1840, he achieved almost immediate success with the ideal subjects and genre pieces upon which his reputation was to rest. In 1842 he married and returned to Italy for three years. He was accorded the exceptional honor of a retrospective exhibition at the American Art-Union in 1850. He lived in England from 1851 to 1858 and visited Europe for the last time in 1882. In 1862 he was elected president of the National Academy of Design, a position he held longer than anyone else, from 1862 to 1869 and from 1877 to 1891. He served as vice-president of the Metropolitan Museum of Art in New York from 1870 to 1903. He continued to paint almost until the time of his death.

BIBLIOGRAPHY

New York, Art Union Buildings, *Catalogue of Paintings by Daniel Huntington, N.A.,* exh. cat., 1850, with essay by the artist § D[aniel] O'C[onnell] Townley, "Living American Artists: Daniel Huntington, Ex-President N.A.D.," *Scribner's Monthly* 2 (May 1871): 44–49 § "An Artist on Art," *Appletons' Journal* 18 (December 1877): 537–43, interview with the artist § Agnes Gilchrist, "Daniel Huntington: Portrait Painter over Seven Decades," *Antiques* 87 (June 1965): 709–11 § William H. Gerdts, "Daniel Huntington's *Mercy's Dream:* A Pilgrimage through Bunyanesque Imagery," *Winterthur Portfolio* 14 (Summer 1979): 171–94.

Philosophy and Christian Art, 1868
(*Science and Christian Art*)
Oil on canvas
40⅜ x 50⅜ in (102.6 x 128.0 cm)
Signed and dated lower left: D Huntington. 1868
Gift of Will Richeson
M.69.48

Although most of Huntington's long career was taken up in painting more than one thousand portraits, he also painted landscapes and probably thought of himself as a painter of allegories and ideal subjects. His interest in religious and allegorical painting had been kindled by the Raphaelesque Italian and German ideal subjects he had seen in Rome on his first trip to Europe in 1839. By the 1860s his models were the Venetian artists of the High Renaissance, especially Titian (c. 1488–1576), whose example can be seen in the costumes and figure types depicted in *Philosophy and Christian Art.* The model or the type of the old man also appears in Huntington's *Sowing the*

Word, 1868 (New-York Historical Society). The influence of the Venetian school can also be seen in the rounder forms and richer palette of his paintings of this period. Even the half-length format seems to echo Venetian examples. The model for the painting to which the young lady gestures, however, appears to be *The Adoration of the Shepherds,* 1650, by José Ribera (1588–1652) in the Louvre, Paris (see illustration).

The painting is conceived as a conversation between embodiments of opposing, but equally worthy points of view. The wisdom of the aged scholar, reading a book by lamplight, is contrasted with the intuitive perceptions of the young woman who examines a work of art by the daylight signified by the window. Huntington has cast in terms of ideal figures one of the pressing problems of his own times, when scientific findings seemed to challenge the truth and wisdom of religion conveyed by artistic and other nonscientific forms of perception.

Huntington, *Philosophy and Christian Art.*

The richly colored background landscape was larger when the painting was reproduced in 1878. It is not known when the artist reduced the size of the opening, but evidence of the change can be discerned in the painting.

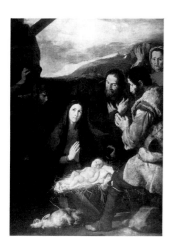

José Ribera, *The Adoration of the Shepherds,* 1650, oil on canvas, 94 x 70½ in (238.0 x 179.0 cm). Musée du Louvre, Paris.

PROVENANCE
Robert Hoe, 1869–82 (sale, Clinton Hall, New York, *Catalogue of Choice Oil Paintings. The Entire Collection of the Hon. Levi P. Morton, and a Portion of the Collection of Mr. Robert Hoe,* March 1, 1882, no. 155) § Charles R. Huntington, New York, 1882 to at least 1908 § Alexis Huntington Bostwick (by descent) § With Terry De Lapp Gallery, Los Angeles, 1960s (?) § Will Richeson, San Marino, Calif., to 1969.

EXHIBITIONS
New York, National Academy of Design, *Forty-fourth Annual Exhibition,* 1869, no. 277, as *Science and Christian Art* § Philadelphia, *Centennial Exhibition,* 1876, no. 490 § Paris, *Exposition universelle internationale de 1878, à Paris. Catalogue officiel, Tome I, Group I, Oeuvres d'art Classes 1 à 5,* 1878, no. 64 § New York, Metropolitan Museum of Art, *Hand-Book No. 6: Loan Collection of Paintings and Sculpture,*

in the West Galleries and the Grand Hall, 1881–82, no. 171 § New York, Century Association, *Memorial Exhibition of Works by the Late Daniel Huntington, N.A.,* 1908, no. 56 § Berkeley, University of California, University Art Museum, and others, *The Hand and the Spirit: Religious Art in America, 1700–1900,* 1972–73, no. 29, p. 80, entry by Jane Dillenberger § LACMA, *American Narrative Painting,* 1974, no. 42, pp. 20–21, essay by Donelson F. Hoopes, p. 95, entry by Nancy Dustin Wall Moure, repro., p. 95 § Detroit Institute of Arts, *The Quest for Unity: American Art between World's Fairs, 1876–1893,* 1983, no. 8, p. 58, entry by Nancy R. Shaw, repro., p. 59.

LITERATURE
Townley, "Daniel Huntington," p. 47 § "Our Steel Engravings," *Art Journal* (New York) n.s. 4 (April 1878): 122, repro., facing 97 § Clara Erskine Clement Waters and Laurence Hutton, *Artists of the Nineteenth Century and their Works* (7th rev. ed., 1894; reprint, New York: Arno Press, 1969), 1: 378, as *Science and Christian Art* § LACMA, American Art department files, Pierre Rosenberg to Scott Schaefer, September 26, 1983, suggests that woman is holding a copy of Ribera's *Adoration of the Magi.*

William L. Sonntag

Born March 2, 1822,
East Liberty, Pennsylvania
Died January 22, 1900,
New York, New York

William Louis Sonntag was a landscape painter associated with Cincinnati, Ohio. In 1823 Sonntag's family moved to Cincinnati, where he grew up. Apparently self-taught, he opened a studio around 1846. Among his early works were ideal subjects, but he soon established a specialty as a landscape painter, drawing his themes from sketching trips in the nearby mountainous areas. He married in 1851, and his son William Louis Sonntag, Jr. (1869–1898) also became a landscape painter. The elder Sonntag traveled to Europe in 1853, probably with ROBERT S. DUNCANSON, and again in 1855, spending a year in Florence. After his return he settled in New York, although he continued to visit Cincinnati and may have again visited Italy sometime during the 1860s. He was elected an associate member of the National Academy of Design in 1860 and an academician in 1861. He was active as a watercolorist during the 1880s.

BIBLIOGRAPHY
"William Louis Sonntag," *Cosmopolitan Art Journal* 3 (December 1858): 26–28 § Boston, Vose Galleries, *William L. Sonntag, 1822–1899, William L. Sonntag, Jr., 1869–1898*, exh. cat., 1970, essay by William Sonntag Miles § New York, Chapellier Galleries, *William L. Soontag* [sic], *N.A., March 2, 1822–January 22, 1900*, exh. cat., 1970 § Nancy Dustin Wall Moure, *William Louis Sonntag: Artist of the Ideal, 1822–1900* (Los Angeles: Goldfield Galleries, 1980), with catalogue raisonné, chronology § New York, Irvin Brenner, Maxwell Circle Galleries, *William L. Sonntag*, exh. cat., 1982.

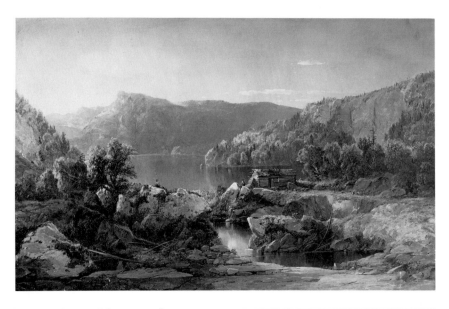

Sonntag, *Autumn Morning on the Potomac.*

Autumn Morning on the Potomac,
c. 1860s
Oil on canvas
36 x 56⅛ in (91.5 x 142.5 cm)
Signed lower left: W. L. Sonntag
Inscribed verso along left: "Autum," [sic] Morning, /
On the Potomac. / W.L Sonntag
Gift of Mr. and Mrs. Yolande B. Markson
M.58.33

Although the directions of all of Sonntag's sketching expeditions are not known, it is recorded that during the summer of 1860 he sketched in West Virginia, presumably the location of this view of the Potomac. It resembles his mature style of the 1860s and, like works in that style, is a highly ideal, conventionalized interpretation. Since few of his paintings are dated, an exact dating cannot be ascertained.

PROVENANCE
Mr. and Mrs. Yolande B. Markson, Beverly Hills, Calif., to 1958.

ON DEPOSIT
Criminal Courts Building, Los Angeles, 1971–73.

LITERATURE
Moure, *Sonntag*, p. 128, listed in cat. raisonné as no. 394, fig. 27, p. 28.

David Neal

Born October 20, 1838,
Lowell, Massachusetts
Died May 2, 1915,
Munich, Germany

David Dalhoff Neal achieved international fame as a history painter working in Munich, Germany. At age fourteen he left his home for New Orleans and subsequently settled in San Francisco, where he worked as a wood engraver. Sent in 1861 to Munich by a patron, he commenced his artistic education by entering the antique class at the Royal Academy. In 1864 he began to study under Professor Max Emmanuel Ainmiller (1808–1879), a painter of architectural interiors, whose daughter Neal had married. Neal also became known for his paintings of church interiors. From 1869 to 1876 Neal studied with Karl von Piloty (1826–1886). At this time he had his first successes with the historical paint-

ings for which he was to become best known. As one of the first Americans to achieve prominence in Munich, Neal was influential as a model and friend to the many who came to study there in the 1870s. For a time he had his own school. Neal was in the United States in 1871–72 and then visited frequently after 1884, for portraiture occupied more of his time in later life.

BIBLIOGRAPHY
Samuel G. W. Benjamin, *Our American Artists* (1879; reprint, New York: Garland, 1977), pp. 51–54 § John R. Tait, "David Neal," *Magazine of Art* 9 (1885–86): 95–101 § Friederich Pecht, *Geschichte der Münchener Kunst im neunzehnten Jahrhundert* (Munich: Verlagsanstalt für Kunst und Wissenschaft, 1888), pp. 386–88 § Dayton Art Institute and others, *American Expatriate Painters of the Late Nineteenth Century,* exh. cat., 1976, text by Michael Quick, pp. 119, 154–55, with bibliography § Sacramento, Calif., E. B. Crocker Art Gallery, *Munich and American Realism in the Nineteenth Century,* exh. cat., 1978, with essays by Michael Quick and Eberhard Ruhmer, bibliography.

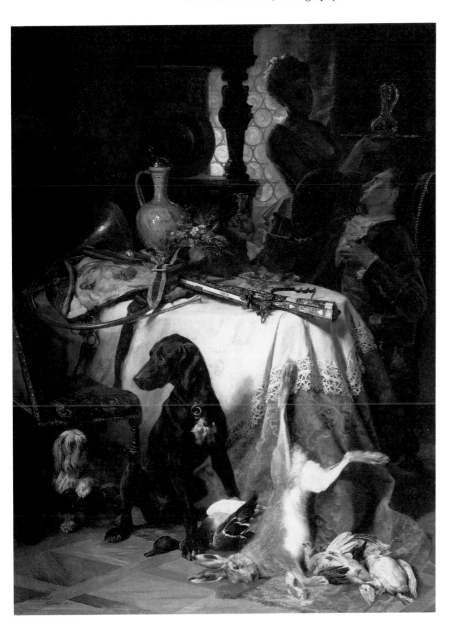

Neal, *After the Hunt.*

After the Hunt, 1870
(After the Chase; Return from the Hunt)
Oil on canvas
62⁵/₁₆ x 46³/₄ in (158.3 x 118.8 cm)
Signed and dated lower left: David Neal / München. 1870.
Gift of Mr. and Mrs. Will Richeson, Jr.
M.72.103.1

After the Hunt, Neal's first great success, was a transitional work between his early architectural paintings and the history paintings that were to win him renown. Although not a history painting, it demonstrates his total mastery of the technique that would make those paintings so successful. Produced while Neal worked in Piloty's atelier, *After the Hunt* exemplifies the style of romantic realism practiced and taught by his professor. During the late 1860s Piloty had transformed the teaching of the Munich academy by introducing an emphasis on skillful painting technique. Although based on the work of the old masters, the style he taught was capable of impressive realism of lighting and textures. It also reflected painstaking research of authentic settings, costumes, and accessories. *After the Hunt,* with its baroque lighting, dramatic contrasts, and rich, warm tonality, strikes the note of romanticism central to the style. The aristocratic hunter and the servant girl dressed in period costume, nominally the subject of the painting, are secondary to the foreground still-life arrangement, in which Neal's virtuosity has persuasively reproduced a wide range of textures.

Still-life compositions are rare in the Munich tradition in contrast to that of Vienna, where this type—the corner of a room with a table piled with bric-a-brac—was known. Two other Americans, WILLIAM M. CHASE and Theodore Wores (1860–1939), also included background figures in the most important still life they produced during their student years in Munich.

Neal's painting originally bore the title *Retour de Chasse* and was reproduced in *Aldine* in 1872 as *After the Chase.*

RELATED WORK
Return from the Hunt, 1877, oil on canvas, 15⁷/₈ x 11⁷/₈ in (40.3 x 30.2 cm). Mount Holyoke College, South Hadley, Mass.

PROVENANCE
Mathias H. Bloodgood, Brooklyn, by 1871 § Mr. and Mrs. Will Richeson, Jr., San Marino, Calif., to 1972.

EXHIBITIONS
Munich Royal Academy, *Works of the Piloty School*, 1871, no cat. traced § New York, National Academy of Design, *Fifth Winter Exhibition*, 1871–72, no. 75, as *Return from the Hunt* § Dayton Art Institute and others, *American Expatriate Painters*, 1976–77, no. 32, p. 119, pl. 17, p. 65 § Crocker Art Gallery, *Munich and American Realism*, no. 51, pp. 23–24, essay by Quick, p. 56, entry by Richard V. West, repro., p. 110.

LITERATURE
"After the Chase," *Aldine* 5 (November 1872): 227, repro., 219, as *After the Chase* § Tait, "Neal," p. 98, describes at length and mentions that the painting was one of the two most attractive works on display in Munich in an exhibition for the benefit of wounded soldiers of the Franco-Prussian War § "Recent Acquisitions, Fall 1969–Spring 1973," *LACMA Bulletin* 19, no. 2 (1973): fig. 24, 44 § "Permanent Collection," *LACMA Report 1969–1973* (as *LACMA Bulletin* 20, no. 1 [1974]), p. 19.

Elihu Vedder

Born February 26, 1836, New York, New York
Died January 29, 1923, Rome, Italy

During the second half of the nineteenth century Elihu Vedder was among the most imaginative and independent of the American expatriate artists. After studying with the genre painter Tompkins H. Matteson (1813–1884) in Sherburne, New York, Vedder traveled to Paris, where in 1856 he drew from casts in the atelier of François-Edouard Picot (1786–1868). In 1857 he moved to Florence to study with Raffaello Bonaiuti (active mid-nineteenth century). While in Florence he also became associated with the Macchiaioli, a group of experimental Italian plein-air painters, and influenced by them, he painted light-filled landscapes and views of rustic towns.

Vedder returned to the United States in 1860 and began to establish a reputation for imaginative literary paintings and book illustrations. He became a member of the Tile Club and the Century Association and an intimate of notable artistic and literary circles in New York. In 1863 he was elected an associate of the National Academy of Design. He visited Brittany with WILLIAM MORRIS HUNT and Charles Caryl Coleman (1840–1928) in 1866 and then settled in Rome, becoming a well-known expatriate figure. In 1869 he visited London, where he established important associations with Pre-Raphaelite artists as a result of his friendship with Frederic Leighton (1830–1896) in Florence. During much of his career he continued to paint Italian landscapes and costumed figure pieces, but by the 1870s he became increasingly philosophical, using personal, symbolic imagery—sometimes derived from literature, religion, or myth—to explore questions of faith and mortality.

In 1881 Vedder won the Prang Christmas card competition, inaugurating his active participation in the field of decorative arts. He soon became a sought-after designer of stained-glass windows, book illustrations, and murals, receiving commissions for murals from major architects and assignments from leading journals. His most important murals were for the home of Collis P. Huntington, 1892–93 (now Yale University Art Gallery, New Haven, Connecticut), the Walker Art Building at Bowdoin College, Brunswick, Maine, 1895–1900, and mosaics for the Library of Congress, Washington, D.C., 1897; his most famous illustrations were for the *Rubáiyát of Omar Khayyám*, 1884.

In the early 1890s he built a villa on the island of Capri, where he resided for the rest of his life, but he continued to make frequent visits to the United States until 1901. After the death of his wife, Carrie Rosekrans, in 1909 he began writing poetry, and some of his writings were published as *Miscellaneous Moods in Verse* (1914) and *Doubt and Other Things* (1923).

BIBLIOGRAPHY
Archiv. Am. Art and New York, American Academy of Arts and Letters, Elihu Vedder Papers, all on microfilm at Archiv. Am. Art § Elihu Vedder, *The Digressions of V.* (Boston: Houghton Mifflin, 1910), with appendix of chronological list of sales § Regina Soria, *Elihu Vedder: American Visionary Artist in Rome (1836–1923)* (Rutherford, N.J.: Fairleigh Dickinson University Press, 1970), with catalogue raisonné, bibliography § Marjorie Reich, "The Imagination of Elihu Vedder As Revealed in His Book Illustrations," *American Art Journal* 6 (May 1974): 39–53 § Washington, D.C., Smithsonian Institution, National Collection of Fine Arts, and Brooklyn Museum, *Perceptions and Evocations: The Art of Elihu Vedder*, exh. cat., 1979, published by Smithsonian Institution Press, with introduction by Regina Soria, essays by Joshua C. Taylor, Jane Dillenberger, and Richard Murray, bibliography.

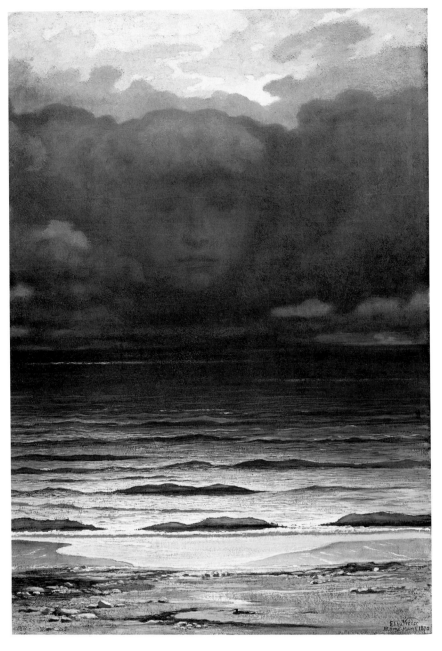

Vedder, *Memory*.

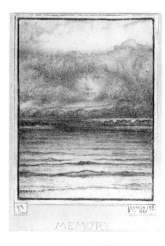

Vedder, *Memory*, 1867, see Related Works.

Memory, 1870

(*Marine*)
Oil on mahogany panel
20⁵/₁₆ x 14³/₄ in (52.2 x 37.5 cm)
Signed and dated lower right: Elihu Vedder / Rome
—March 1870
Mr. and Mrs. William Preston Harrison Collection
33.11.1

Memory is one of Vedder's most symbolic paintings. Although it at first appears to be a straightforward nocturnal view of the beach and ocean, upon close scrutiny one sees a faint human face emerge in the cloudy sky. Similar images of a floating head appear in a group of Vedder's drawings from the late 1860s. Later he would be fascinated by the related classical motif of the head of Medusa. The theme of floating and severed heads was popular with the English Pre-Raphaelites, and at the end of

the century it became a characteristic motif of the symbolists. Artists used such imagery to suggest states of mind and ideas of a personal nature rather than to describe the material world.

The art historian Regina Soria has identified two of the artist's drawings as bases for the museum's painting: *The Face in the Clouds*, 1866 (Wunderlich & Co., New York, as of 1987), which was illustrated in Vedder's autobiography *The Digressions of V.* (p. 287), and a small drawing done the next year with the title *Memory* inscribed on its original mat (LACMA, see illustration). As the 1867 drawing was executed on March 19, the birthday of Carrie Rosekrans, Vedder's fiancée at that time, it has been assumed that the head in the two drawings and the oil painting was that of Carrie. If the drawings were intended to be portraits of Carrie, they would have had to have been done from memory for she was not with Vedder at the times of their execution. Actually, it is difficult to ascertain either the sex or the age of the face in any of the three. The head may be that of a child. When Vedder painted *Memory*, Carrie was pregnant with their first child, and some seven years later he was commissioned by a Mr. and Mrs. J. R. Dumaresq to make a similar painting using the face of their recently deceased son.

Will South has noted that at least one contemporary of Vedder's, English critic William Davies, referred to the head in the drawing *Memory* with the neuter "it" (*Art Pictorial and Industrial: An Illustrated Magazine* 1 [September 1870]: 49). In none of Vedder's own writings does he suggest a particular person or type as the model for the floating head. Perhaps the ambiguity of the sex and age of the head was intentional, for such imagery accords well with the artist's lifelong fascination with imaginative subjects and his enthusiasm for a sense of mystery.

According to the artist's annotation of the 1866 drawing *The Face in the Clouds*, he was inspired to create such a meditative image by Alfred Lord Tennyson's poem, "Break, Break, Break" (published 1842), in which the poet contemplates the sea and broods over the memory of lost ones. In Vedder's painting the insubstantial, miragelike face, in contrast to the sharp reality of the shore and waves, suggests the transitory nature of life and the dreamlike quality of memory. In its quiet, mysterious mood the painting is quite evocative. The mauve palette and spectral quality of the night lighting also place *Memory* within the formal and conceptual tenets of late nineteenth-century symbolism. In fact, *Memory* ranks as one of the earliest symbolist images by an American.

RELATED WORKS
The Face in the Clouds, September 1866, pencil on
paper, 3 x 2⁷⁄₁₆ in (7.6 x 6.2 cm). Wunderlich & Co.,
New York, as of 1987 § *Memory,* dated March 19,
1867, pencil on paper, 3⁷⁄₈ x 2¹⁵⁄₁₆ in (9.8 x 7.5 cm).
LACMA, gift of Jo Ann and Julian Ganz.

PROVENANCE
H. Fargo, Buffalo, 1870 § George Willard Benson,
Buffalo § With C. W. Kraushaar Art Galleries,
New York, to 1933 § Mr. and Mrs. William Preston
Harrison, Los Angeles, 1933.

EXHIBITIONS
LACMA, *American Narrative Painting,* 1974, no. 71,
p. 150, entry by Nancy Dustin Wall Moure discusses
the Tennyson inspiration, repro., p. 151 § New
York, Whitney Museum of American Art, *Seascape
and the American Imagination,* 1975, entries not num-
bered, pp. 112, 137, text by Roger Stein, fig. 124,
p. 116 § LACMA, *Pertaining to the Sea,* 1976,
no. 55, repro., unpaginated § Richmond, Virginia
Museum of Fine Arts, and Newport News, Va.,
Mariners Museum, *American Marine Painting,* 1976,
no. 37, pp. 19, 85, text by John Wilmerding, repro.,
p. 84 § LACMA, *American Expatriate Painters of the
Nineteenth Century,* 1977, exhibited but not listed §
National Collection of Fine Arts and Brooklyn
Museum, *Perceptions and Evocations,* 1978–79, p. 116,
discussed in Dillenberger essay, fig. 139, p. 117 § San
Bernardino, California State College Art Gallery,
*Symbolism: Europe and America at the End of the
Nineteenth Century,* 1980, no. 45, p. 62, entry by
Vicki Younger, repro., p. 63.

LITERATURE
Archiv. Am. Art, Carrie Vedder's Sales Book,
(microfilm roll 528, fr. 618), lists sale under "Roma
1870" as "July London H. Fargo, Buffalo, N.Y. Mem-
ory $300" § Vedder, *Digressions of V.,* p. 470, cites
sale of *Memory* in 1870 § "Harrison Gifts," *Art
Digest* 8 (March 1, 1934): 8, as *Marine* § Harrison
1934, p. 49, as *Marine* § LACMA, Registrar's files,
Regina Soria to James Elliott, May 8, 1962, identifies
Marine as *Memory* and states that "it represents
quite a psychological landmark in this artist's life";
Soria to Larry Curry, January 4, 1970, discusses
related drawings § Higgins 1963, p. 62, no. 128 in
checklist of Mr. and Mrs. William Preston Harrison
collection § Soria, *Vedder,* pp. 79, 303, listed in cat.
raisonné as no. 202, states *Memory* may have been
painted from an 1866 pencil sketch, quotes Mrs.
Vedder: " 'a very characteristic example of my hus-
band's thought,' " illus. 11, between pp. 252 and
253 § New York, Museum of Modern Art, *The
Natural Paradise: Painting in America, 1800–1950,* exh.
cat., 1976, ed. Kynaston McShine, repro., p. 87 §
Sarah Lea Burns, "The Poetic Mode in American
Painting: George Fuller and Thomas Dewing," Ph.D.
diss., University of Illinois at Urbana-Champaign,
1979, p. 38, fig. 1, p. 375 § Grace Glueck, "Art:
Rediscoveries Paired in Brooklyn," *New York Times,*
June 29, 1979, pt. 3, p. 22, calls it one of the "most
arresting" works in Vedder exhibition in Brooklyn
§ Carter Ratcliff, "The Gender of Mystery: Elihu
Vedder," *Art in America* 67 (November 1979): 91,
describes head as "a faintly discernible woman's
face," repro., 86 § LACMA, American Art depart-
ment files, Will South, "Elihu Vedder's *Memory:* An
American Symbolist Painting," unpublished paper,
1989, explores the context of the painting and dem-
onstrates that it is an early example of American
symbolism.

Japanese Still Life, 1879
(*Still Life*)
Oil on canvas
21½ x 34¹³⁄₁₆ in (54.5 x 88.4 cm)
Signed and dated center right: Elihu Vedder / 1879
Gift of the American Art Council
M.74.11
Color plate, page 45

Vedder did few still-life paintings and only
four of Japanese objects. The collecting of
oriental bric-a-brac became very popular in
America among artists and the general public
with the initiating of trade relations between
Japan and the West by Commodore Matthew
C. Perry in 1853 and with the exhibition of
many exotic objects at the 1876 Centennial
Exhibition in Philadelphia. Vedder was par-
ticularly fortunate as a collector, for his brother
Alexander Madison Vedder was a physician
practicing in Japan from 1865 to 1870, first
privately and then as head of the Imperial
Hospital at Kobe. Dr. Vedder was well aware
of the beauty and exoticism of oriental items

and purchased many objects. After Alex-
ander's death in 1870, Vedder received three
trunks containing his brother's effects, includ-
ing his Japanese purchases. The objects in
Vedder's Japanese still-life paintings may have
been among them. This painting depicts
nineteenth-century items: the golden heron
screen in the style of the Kanō school, a shiny,
black Meiji-period vase, an album of paintings
with a *bonsai* on the left page, and a carpet
probably of Japanese manufacture but with a
Western-influenced design.

Despite his awareness of the nature of Jap-
anese aesthetics, and unlike his friend Charles
Caryl Coleman, who used the Japanese aes-
thetic in his still lifes of this period, Vedder
conceived his painting in traditional Western
terms. The arrangement resembles the way in
which Japanese items were displayed at the
1876 Centennial and pictured in various books
commemorating the fair. The manner in which
Vedder luxuriated in the voluminous folds of
the rich drapery reveals his long-standing love
of elegant textiles, seen more often in his

single-figure paintings of the 1870s.

During his lifetime Vedder exhibited still lifes that included oriental objects and were sometimes titled *Japanese Still Life.* It is possible that the museum's example was the one exhibited in Vedder's showings of 1880. However, since the painting was privately owned by then, it is unlikely that the museum's painting was the still life included in Vedder's 1900–1901 traveling exhibition or his exhibitions in New York and Boston in 1912.

Collection of Fine Arts and Brooklyn Museum, *Perceptions and Evocations,* 1978–79, entries not numbered, pp. 106–7, essay by Taylor, fig. 129, p. 109 § Tulsa, Philbrook Art Center, and others, *Painters of the Humble Truth: Masterpieces of American Still Life, 1801–1939,* 1981–82 (related book by William H. Gerdts copublished with University of Missouri Press, Columbia, 1981), pp. 147–48, fig. 7.6, p. 148 § New York, Metropolitan Museum of Art, *In Pursuit of Beauty: Americans and the Aesthetic Movement* 1986-87 (copublished with Rizzoli, New York), entries not numbered, p. 326, essay by Doreen

Vedder, *Japanese Still Life.*

PROVENANCE
The artist § T. W. Hathaway, 1883 § Private collection § With M. Knoedler & Co., New York, by 1969–1974.

ON DEPOSIT
Phoenix Art Museum, 1974.

EXHIBITIONS
Possibly New York, Vedder's studio at 39 Union Square, 1880, no cat. traced § Possibly Boston, Williams and Everett Gallery, *Pictures: Sketches of Pictures and Studies by Elihu Vedder,* 1880, no. 7, as *Still Life* § New York, M. Knoedler & Co., *American Paintings, 1750–1950,* 1969, no. 59, as *Still Life* § New York, M. Knoedler & Co., *Nineteenth- and Twentieth-Century American Paintings from the Gallery Collection,* 1972, no. 28 § Dayton Art Institute and others, *American Expatriate Painters of the Late Nineteenth Century,* 1976–77, no. 52, pp. 139–40, text by Michael Quick, pl. 29, p. 67 § National

Bolger Burke, p. 477, biographical note by Catherine Hoover Vorsanger, fig. 9.16, p. 326.

LITERATURE
Archiv. Am. Art, Elihu Vedder Papers, Carrie Vedder's Sales Book (microfilm roll 528, fr. 630), lists sale under "1883 America Rome" as "Feb. 8th T. W. Hathaway Japanese Still Life $300" § Vedder, *Digressions of V.,* p. 483, lists 1883 sale to Hathaway § "Outstanding Exhibitions," *Apollo* n.s. 90 (September 1969): 261, repro., as *Still Life* § Soria, *Vedder,* p. 327, listed in cat. raisonné as no. 387, dates 1879–83, mentions September 19, 1879, letter by the artist to Samuel Avery in which he describes painting § William H. Gerdts and Russell Burke, *American Still-Life Painting* (New York: Praeger, 1971), pp. 192, 253, repros., p. 189 of detail, p. 253 § "Permanent Collection," *LACMA Report 1969–1973* (as *LACMA Bulletin* 20, no. 1 [1974]), p. 19 § "American Art Council Gift," *LACMA Members' Calendar* 12 (March 1974): repro., unpaginated.

Thomas Moran

Born January 12, 1837,
Bolton-le-Moors, England
To United States 1844
Died August 25, 1926, Santa
Barbara, California

Known as "the American Turner," Thomas Moran, Jr., gained fame for his sublime landscapes of the Yellowstone and the Grand Canyon; he was equally famous for his watercolor and oil paintings. Born into a family of artists, Moran began his career around 1856 in Philadelphia as an etcher and in 1858 exhibited his first important painting at the Pennsylvania Academy of the Fine Arts. In 1861 he traveled with his brother Edward (1829–1901) to England expressly to study the paintings of J. M. W. Turner (1775–1851). Moran also traveled throughout England and Scotland, perfecting his use of the English sketching technique.

On his return to the United States he supported himself by drawing magazine illustrations. An article on the Yellowstone in *Scribner's Monthly,* which he illustrated, piqued his interest in the uncharted West, and in 1871 he participated in an expedition led by Ferdinand Hayden. His watercolors of the area and the large oil painting *The Grand Canyon of the Yellowstone,* 1872 (National Museum of American Art, Smithsonian Institution, Washington, D.C.), brought him national recognition. Moran frequently returned to the West, constantly looking for new scenery and expanding his knowledge of the wilderness. In 1872 he briefly visited Yosemite, in 1873 he participated in Major John Powell's expedition to the Grand Canyon, in 1874 he explored the Colorado area with Hayden's survey, and in 1879 and again in 1894 he and his brother Peter (1841–1914) explored the Teton Mountains in Wyoming. He toured the West four more times between 1900 and 1910. He also revisited England in 1882 to exhibit his *Mountain of the Holy Cross,* 1875 (National Cowboy Hall of Fame, Oklahoma City), and made two trips to Venice, another subject for which he became known. In 1883 he visited Mexico and Cuba.

In 1884 he built a studio in East Hampton, New York. The tranquil landscapes of Long Island that he often painted during his later years are quite different from his forceful scenes of the West and prismatic views of Venice. The serene Long Island flatlands also often served as a subject for his etchings, a technique he became preoccupied with during the early 1880s. In 1924 he settled permanently in Santa Barbara, California.

BIBLIOGRAPHY
James Benjamin Wilson, "The Significance of Thomas Moran as an American Landscape Painter," Ph.D. diss., Ohio State University, 1955, with bibliography, catalogue of paintings § Fritiof Fryxell, ed., *Thomas Moran: Explorer in Search of Beauty* (East Hampton, N.Y.: East Hampton Free Library, 1958), with essays by Fryxell, Ruth B. Moran, A. De Montaigue, and others § Thurman Wilkins, *Thomas Moran: Artist of the Mountains* (Norman: University of Oklahoma Press, 1966), with descriptive catalogue, bibliography § William H. Truettner, "'Scenes of Majesty and Enduring Interest': Thomas Moran Goes West," *Art Bulletin* 58 (June 1976): 241–59 § Carol Clark, *Thomas Moran: Watercolors of the American West* (Austin: University of Texas Press for Amon Carter Museum of Western Art, Fort Worth, Tex., 1980), with catalogue raisonné of watercolors, bibliography, checklist of exhibition held at Amon Carter Museum of Western Art, Fort Worth, and others, 1980–81.

Hot Springs of the Yellowstone, 1872

Oil on canvas
16³/₁₆ x 30¹/₁₆ in (41.1 x 76.2 cm)
Signed and dated lower right: TMoran. / 1872 (TM in monogram)
Inscribed verso along lower edge: Hot Springs of The Yellowstone / TMoran. / 1872 (TM in monogram)
Gift of Herbert M. and Beverly Gelfand
M.84.198
Color plate, page 41

As a guest in 1871 of the official government survey team led by Ferdinand Hayden, Moran explored the headwaters of the Yellowstone River and became the first professional artist to paint the area. While he was out in the field, Moran worked in pencil and watercolor. These watercolor field sketches were used to influence Congress in its decision to declare the Yellowstone area America's first national park.

On his return to Philadelphia at the end of the summer of 1871 Moran produced a series of highly finished watercolors, which became his best-known early images of the Yellowstone. Contemporaneously dated oil paintings of Yellowstone by Moran are rare, and only three from 1872 have been documented: the museum's painting, an unlocated *The Tower Falls,* and *The Grand Canyon of the Yellowstone.* The last is perhaps Moran's best known, having been bought by Congress soon after its exhibition in Washington in 1872.

Hot Springs of the Yellowstone was only recently discovered and did not receive critical attention in either the nineteenth or twentieth century. The exact month in which Moran painted it is not known; it may have been created before or after *The Grand Canyon of the Yellowstone.*

Moran depicted the main terrace of Mammoth Hot Springs in the Wyoming Territory,

just south of what is today the Wyoming-Montana state line. The Hayden group spent three days in late July 1871 exploring the springs, and Moran's watercolors express their enthusiasm for the unusual geology of the area. Hayden noted, "The scenery in the vicinity of these hot springs is varied and beautiful beyond description" ("The Wonders of the West—II," *Scribner's Monthly* 3 [February 1872]: 391).

In the meticulously rendered foreground details Moran showed the hot springs and

be identified as Bunsen Peak, Moran took liberties with its profile. The entire distant area, with its soft opalescent atmosphere and rainbow, is idealized. The romanticized view suggests that Moran intended the painting to be an exhibition piece rather than a highly developed preparatory study.

In many respects *Hot Springs of the Yellowstone* reflects the influence of Turner. In his early paintings the English artist had demonstrated an exactitude to nature which John Ruskin had extolled while in his later canvases

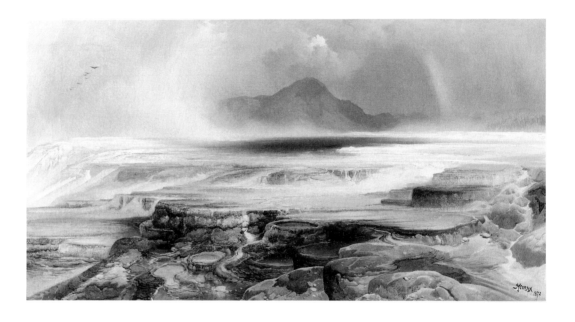

Moran, *Hot Springs of the Yellowstone.*

unusual travertine terraces, geological formations which were not well known in the East. Hot springs tend to be concentrated along drainage basins of lakes and streams, and Moran's delineation of a lake in the broad plain of the middle distance is faithful to geological principles. The streams that feed into the lake eat away at the rock as the water, rich in minerals, filters through limestone crevices. Even his dabbing style of brushwork mirrors the cauliflowerlike appearance of sulfur deposits.

The entire scene is conveyed in the vibrant palette typical of Moran's watercolors: salmon, yellow, sulphur, onyx, and a bit of green. The intense hues, although seemingly exaggerated, realistically present the extraordinary colors that the rocks take on from the sulfur, sodium, and other minerals in the water.

When he originally transcribed this view of the hot springs, Moran was looking south toward what is now known as Bunsen Peak, which rises near the Gardiner River. Although the high mountain visible in the distance can

he evinced a romanticism in his use of a brilliant palette and powerful sense of vortex. Moran's landscape has all these elements.

PROVENANCE
Brian Fawcett (by descent), Colton, Calif., to 1980 § Mr. and Mrs. Herbert Gelfand, Los Angeles, 1980–84.

ON DEPOSIT
LACMA, 1980–84.

LITERATURE
LACMA, American Art department files, Thomas Schnabel, "Analysis of Thomas Moran's Painting *Hot Springs of Yellowstone* (1872)," unpublished paper, 1984, describes geological formations; Timothy R. Manns to Ilene Susan Fort, January 30, 1985, identifies site § Josine Ianco-Starrels, "Proposing Monumental Sculpture," *Los Angeles Times,* February 17, 1985, Calendar, p. 79, announces new acquisition § "Recent Acquisitions," *LACMA Members' Calendar* 23 (April 1985): 5, repro. § "American Art," *LACMA Report 1983–1985* (1985), p. 16, repro., p. 17 § Fort 1986, p. 424, pl. XII, p. 423.

Worthington Whittredge

Born May 22, 1820, near
Springfield, Ohio
Died February 25, 1910,
Summit, New Jersey

Thomas Worthington Whittredge was a highly regarded landscape painter during the third quarter of the nineteenth century. After a brief career in Cincinnati as a daguerreotypist and portrait painter in the early 1840s he turned to landscape painting in 1843. He began exhibiting in New York at the National Academy of Design in 1846 and later at the American Art-Union. With commissions for foreign scenery from Cincinnati patrons, he left for Europe in 1849, sketching in Belgium, France, and Germany before going to Düsseldorf, where he lived with Andreas Achenbach (1815–1910) and became an intimate of the circle around EMANUEL LEUTZE, even posing for several figures in Leutze's *Washington Crossing the Delaware*, 1851 (Metropolitan Museum of Art, New York). In 1856 Whittredge left Germany and toured Switzerland and Italy before meeting ALBERT BIERSTADT and SANFORD R. GIFFORD in Rome and settling there. On his return to the United States four years later, he established a studio in the popular Tenth Street Studio Building in New York and became a highly regarded member of the art community. He was admitted to the National Academy of Design in 1860 and elected its president in 1875, and he was invited to join the Century Association in 1862.

His desire to develop a native landscape style prompted Whittredge to travel extensively throughout the country. In 1866 he made the first of three trips west as a member of General John Pope's expedition to Colorado and New Mexico, and in 1870 he returned to the West in the company of Gifford and JOHN F. KENSETT. Later, during the 1890s, he visited Mexico twice, once in the company of Frederic E. Church (1826–1900). Whittredge became especially known for several types of landscapes: shadowy woodland interiors in the tradition of Asher B. Durand (1796–1886), expansive views of the flat Western plains, often along rivers, and picturesque scenes of the rolling New England hills dotted with rustic buildings. Although Whittredge brought a tight, crisp painting style back with him from Düsseldorf and painted within the Hudson River aesthetic until his first trip to the West, that experience as well as his close friendship with Gifford stimulated him to develop an art more sensitive to light and atmosphere. His later landscapes are characterized by a breadth of vision and quiet luminosity.

BIBLIOGRAPHY

John I. H. Baur, ed., *The Autobiography of Worthington Whittredge* (1942; reprint, New York: Arno Press, 1969) § Sadayoshi Omoto, "Old and Modern Drawings: Berkeley and Whittredge at Newport," *Art Quarterly* 27 (Winter 1964): 42–56 § Utica, N.Y., Munson-Williams-Proctor Institute, and others, *Worthington Whittredge Retrospective*, exh. cat., 1969, with introduction by Edward H. Dwight, chronology § Anthony F. Janson, "The Paintings of Worthington Whittredge," Ph.D. diss., Harvard University, 1975, with bibliography, catalogue of paintings, lists of paintings exhibited at various locations and included in various sales, of completed commissions, and of lost paintings § Washington, D.C., Adams Davidson Galleries, *Quiet Places: The American Landscape of Worthington Whittredge*, exh. cat., 1982, with text by Cheryl A. Cibulka, chronology, bibliography, list of exhibitions.

A Home by the Seaside, c. 1872
(*The House on the Sea; Sea Side Home; Autumn Landscape*)
Oil on canvas
20 x 31¹/₁₆ in (50.8 x 79.0 cm)
Signed lower right: W Whittredge
William Randolph Hearst Collection
46.45.1

The location of this landscape has been identified as Newport, Rhode Island. Whittredge may have first visited the area as early as 1859, immediately following his return to America. He visited it often and even built a summer house there. He became fascinated with the colonial architecture of the area, drawing and painting Bishop George Berkeley's house, Whitehall. Whittredge's first Newport painting dates from 1865, and in the early 1870s he began a series of Newport landscapes in which the focus was a shingled, gambrel-roofed farmhouse near the sea. In most of these landscapes, such as *Home by the Sea*, c. 1872 (Westmoreland County Museum of Art, Greensburg, Pennsylvania), and *Old Homestead by the Sea*, 1883 (Museum of Fine Arts, Boston), the artist assumed an elevated position away from the house to obtain an expansive view of the surrounding countryside and distant ocean.

A Home by the Seaside is the only painting in this series in which Whittredge moved closer to the house, which serves as a framing device leading the viewer into the scene and down the hill to the field below where men are working. The image of hayers was a popular motif, frequently used by Whittredge and other art-

ists of the period to convey the nationalistic pride of a country rich in natural resources and human energy. Although Whittredge explained his attraction to Newport as returning to the land of his forefathers, a land made familiar to him through tales heard as a child, his fascination was also part of a general cultural trend during the late nineteenth century called the colonial revival. The farmhouse in *A Home by the Seaside* has not been specifically identified, but its type and age added a note of native picturesqueness to the scene. Whittredge did

no. 22, repro., p. 45 § Shreveport, La., R. W. Norton Art Gallery, *The Hudson River School: American Landscape Painting from 1821 to 1907*, 1973, no. 59, repro., p. 56 § John and Mable Ringling Museum of Art, Sarasota, Fla., *Worthington Whittredge*, 1989–90, entries not numbered, pp. 11, 14, text by Anthony F. Janson, repro., p. 12.

LITERATURE
"American Painters: Worthington Whittredge, N.A.," *Art Journal* (New York) n.s. 2 (May 1876): 148–49, states that the work was painted for the Artists Fund Society of 1872, repro., p. 148 §

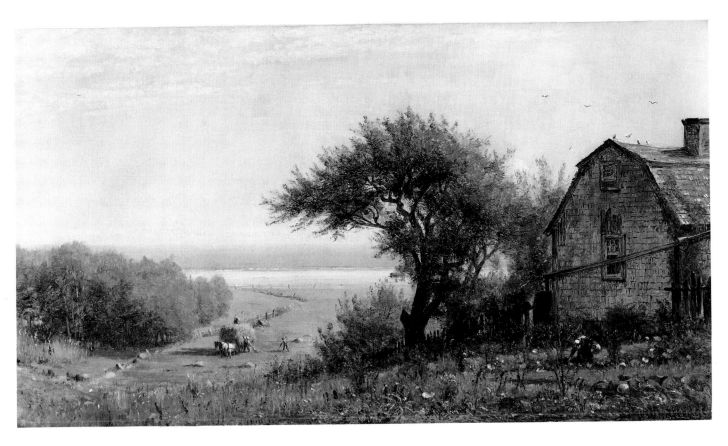

Whittredge, *A Home by the Seaside.*

not depict Newport as the fashionable summer resort of the elite but as the land he had heard about as a child. The soft autumnal haze contributes to the general sentiment of nostalgia.

By the 1870s Whittredge had become known for his serene, sun-filled, open landscapes. When this painting was exhibited, such critics as George Sheldon praised its diffused light and quiet mood.

PROVENANCE
Isaac Henderson, New York, c. 1873 to at least 1879 § A. F. Mondschien (also known as Frederick Mont) [?] § William Randolph Hearst, New York, to 1946.

EXHIBITIONS
New York, Somerville Gallery, Artists Fund Society, *Catalogue of the Thirteenth Annual Sale of Paintings Contributed by Members in Aid of the Fund*, 1873, no. 56, as *Sea Side Home* § Munson-Williams-Proctor Institute and others, *Whittredge*, 1969–70,

George W. Sheldon, *American Painters* (New York: Appleton, 1879), p. 99, discusses effects, repro., p. 100 § J. Denison Champlin & C. Perkins, *Cyclopedia of Painters and Paintings* (1885–87; reprint, New York: Scribner's, 1908) 4: 428 § Baur, *Autobiography of Whittredge*, p. 63, repro., between pp. 50–51 § "Recent Gifts," *LACMA Bulletin* 1 (Spring 1947): 28, repro., as *Autumn Landscape* § Wolfgang Born, *American Landscape Painting: An Interpretation* (New Haven, Conn.: Yale University Press, 1948), fig. 117, p. 177, as *The House on the Sea* § LACMA, American Art department files, Sandra Feldman, "A Technical Analysis of an Oil Painting by Worthington Whittredge, N.A.," 1967, unpublished paper § Edward H. Dwight, "Worthington Whittredge, Artist of the Hudson River School," *Antiques* 96 (October 1969): repro., 585 § Vincent Price, *The Vincent Price Treasury of American Art* (Waukesha, Wis.: Country Beautiful Corp., 1972), pp. 134–5, repro., p. 135 § Janson, "Paintings of Whittredge," pp. 99, 101, 122–23, 240, listed in cat. as no. 4-16 § Anthony F. Janson, "Worthington Whittredge: Two Early Landscapes," *Bulletin of the Detroit Institute of*

Arts 55, no. 4 (1977): p. 206, fig. 9 § Adams Davidson Galleries, *Quiet Places,* no. 23, pp. 25, 58, repro., p. 60 § Anthony F. Janson, "Worthington Whittredge's *Landscape with Washerwoman:* A Notable New Acquisition," *Pharos* (Museum of Fine Arts, Saint Petersburg, Fla.) (1984–85): 9, 11, compares with German landscape and perceives it to be Whittredge's interpretation of America as a "civilized" landscape, fig. 3, p. 10 § Anthony F. Janson, *Worthington Whittredge,* Cambridge Monographs on American Art (New York: Cambridge University Press, 1989), p. 139–40, fig. 105.

Albert Bierstadt

Born January 7, 1830,
Solingen, Germany
To United States 1832
Died February 18, 1902,
New York, New York

During the 1860s Albert Bierstadt was one of America's most celebrated landscape painters. He was born in a town near Düsseldorf, Germany, but his family moved to New Bedford, Massachusetts, when he was two years old. As a self-taught artist he was active as early as 1850, but his mature style was formed at the Düsseldorf Academy, where he studied from 1853 to 1856. He associated there with the American artists EMANUEL LEUTZE and WORTHINGTON WHITTREDGE and was influenced by the work of the German landscape painters Karl-Friedrich Lessing (1808–1880) and Andreas Achenbach (1815–1910). Beginning in the summer of 1856 he traveled through Germany and visited Italy with Whittredge and SANFORD R. GIFFORD. In 1859 and again in 1863 he traveled throughout the American West, achieving immediate success with the spectacular, highly finished, large canvases that introduced eastern audiences to the marvels of this virtually unknown scenery. Bierstadt was thereafter identified with the western landscape.

Capturing the imagination of the public during the 1860s, Bierstadt experienced great demand for his paintings and enjoyed sufficient financial success to build Malkasten, his large home in Irvington-on-Hudson. Based in or near New York, he continued to make frequent trips. From 1867 to 1869 he traveled in Europe and from 1871 to 1873 worked in Northern California, traveling through the region to make oil studies that he combined and worked up into the large finished paintings that he produced in his studio in San Francisco. After the middle of the 1870s his style fell into critical disfavor. He underwent bankruptcy in 1895. Bierstadt spent much of his last years promoting his inventions but continued to travel abroad and to paint.

BIBLIOGRAPHY
"Albert Bierstadt," *California Art Research* 2 (1936): 98–129, with lists of representative works, public collections, exhibitions, awards, and clubs, bibliography § Richard Shafer Trump, "Life and Works of Albert Bierstadt," Ph.D. diss., Ohio State University, 1963, with catalogue of significant works, bibliography § Gordon Hendricks, *Albert Bierstadt: Painter of the American West* (New York: Harry N. Abrams in association with Amon Carter Museum of Western Art, Fort Worth, Tex., 1973), with geographical checklist of paintings in American public collections, chronology, bibliography § Catherine H. Campbell, "Albert Bierstadt and the White Mountains," *Arch. Am. Art Journal* 21, no. 3 (1981): 14–23, with annotated list of White Mountain scenes § Allan Pringle, "Albert Bierstadt in Canada," *American Art Journal* 17 (Winter 1985): 2–27.

Carleton Watkins, *Grizzly Giant, Mariposa Grove, California, no. 110,* c. 1862, albumen print, 20¾ x 15½ in (52.7 x 39.4 cm). Courtesy of the Oakland Museum, History Department.

The Grizzly Giant Sequoia, Mariposa Grove, California, c. 1872–73

(Redwood Trees)
Oil on paper mounted on board
29¹³/₁₆ x 21⁵/₁₆ in (75.7 x 54.2 cm)
Signed lower left: ABierstadt. (AB in monogram)
Purchased with funds provided by Dr. Robert G. Majer
53.30

In May 1863 Bierstadt and the writer Fitz Hugh Ludlow left New York for the artist's second trip through the West. Their principal objective was to capture the beauty of Yosemite Valley, which the photographs of Carleton Watkins (1829–1916) had revealed to astonished New Yorkers in 1862.

In a drawing room in San Francisco in August, on the eve of their departure for the final leg of their journey there, they again gazed at Watkins's photographs. Shortly before reaching Yosemite, they and other artist-companions —Enoch Wood Perry (1831–1915) and Virgil Williams (1830–1886) of San Francisco— paused near Mariposa to sketch the big trees. Although the museum's painting was not executed until about ten years later, it should not be surprising that in it Bierstadt borrowed the subject and vantage point of one of Watkins's early photographs of the Grizzly Giant Sequoia (see illustration).

The size of the museum's painting indicates that it was not one of the oil sketches Bierstadt made that day. All of his sketches from that trip were fourteen by nineteen inches or smaller. Bierstadt did not employ the twenty-two-by-thirty-inch sheet until 1872, and then only for oil sketches painted in the studio.

The museum's painting probably dates from Bierstadt's residence in San Francisco (1871–73). It may be visible in a photograph probably taken in 1873 of the artist's studio, where it hangs on the wall among rows of studio sketches (Hendricks, *Bierstadt*, CL-6).

Bierstadt often painted the big California trees. He exhibited such paintings in 1874 at the National Academy of Design and the Royal Academy. The Grizzly Giant still stands in Mariposa Grove. The huge tree, to the left of center in the painting, was 28 feet wide and 209 feet high. Equally impressive was the giant's age, estimated at twenty-five hundred years, a span of time going back to the kings of the Old Testament.

Bierstadt may have used the museum's painting as a study for his ten-foot-high *California Redwoods*, painted in about 1875 (private collection; see illustration). In that painting he corrected the Grizzly Giant's leaning, noticeable in the oil study. Intended as a record for the artist's later use, these studies have a fresh realism often sacrificed to dramatic effect in the finished exhibition paintings.

PROVENANCE
With Victor H. Spark, New York, to 1953.

EXHIBITIONS
Santa Barbara (Calif.) Museum of Art, *Albert Bierstadt, 1830–1902: A Retrospective Exhibition,* 1964, no. 34, as *Redwood Trees* § Washington, D.C., Smithsonian Institution, National Collection of Fine Arts, and others, *National Parks and the American Landscape,* 1972, published by Smithsonian Institution Press, no. 32, repro., p. 70, as *Redwood Trees* § LACMA, *Western Scene,* 1975, no. 2, as *Redwood Trees* § Fresno (Calif.) Arts Center, *Views of Yosemite: The Last Stance of the Romantic Landscape,* 1982, entries not numbered, repro., p. 13, as *Redwood Trees* § Galleries of the Claremont (Calif.) Colleges, Pomona College, Montgomery Gallery, *Myth and Grandeur: California Landscapes, 1864–1900,* 1987, entries not numbered, as *Redwood Trees.*

LITERATURE
"American Paintings," *LACMA Bulletin* 6, no. 3 supp. (Summer 1954): repro., 14, as *Redwood Trees* § Hendricks, *Bierstadt,* p. 325, no. CL-6, as *Redwood Trees* § J. Gray Sweeney, "The Artist-Explorers of the American West, 1860–1880," Ph.D. diss., Indiana University, 1975, pp. 192–93, 235, fig. 22, p. 191, as *Redwood Trees* § Gerald F. Brommer, *Landscapes* (Worcester, Mass.: Davis, 1977), p. 35, repro., as *Redwood Trees* § Jeanne Van Nostrand, *The First Hundred Years of Painting in California, 1775–1885* (San Francisco: John Howell, 1980), pl. 31, p. 81, as *Redwood Trees* § LACMA, American Art department files, Vern Pascal to Michael Quick, January 26, 1986, discusses title, dating, and possible presence in photograph of San Francisco studio.

Bierstadt, *The Grizzly Giant Sequoia, Mariposa Grove, California.*

Bierstadt, *The Great Trees, Mariposa Grove, California,* c. 1875, oil on canvas, 118⅛ x 59¼ in (300.0 x 150.5 cm). Private collection.

Jasper F. Cropsey

Born February 18, 1823,
Rossville (now Staten Island),
New York
Died June 22, 1900, Hastings-
on-Hudson, New York

Jasper Francis Cropsey was one of the most popular mid-nineteenth-century Hudson River school painters, known particularly for his autumnal views. Trained as an architect, he began painting in the 1840s, achieving membership in the National Academy of Design in 1844 for a painting of Greenwood Lake in an area of New Jersey he often depicted early in his career. From 1847 to 1849 Cropsey traveled throughout England and the Continent, studying and painting with other American artists in Rome, Sicily, and Fontainebleau. He sketched in New England and New York State until 1856, when he settled in London, becoming friends with John Ruskin and other notables of the English art world. The exhibition of *Autumn on the Hudson,* 1860 (National Gallery of Art, Washington, D.C.), in the London International Exposition of 1862 brought him international success. Due to the Civil War, he returned home in 1863.

Cropsey was initially a disciple of THOMAS COLE in his vigorous paint handling and rugged scenes of storm-damaged nature. He abandoned such sublime romanticism for more serene images of nature and made his reputation with brilliantly colored autumn scenes. In the 1850s he also painted several historical landscapes. Late in his career Cropsey turned more to the watercolor medium and helped form the American Water Color Society. His fascination with vivid hues continued throughout his career and contributed, along with his work in watercolors, to the somewhat luminist quality of his late landscapes. He also returned to architecture, designing his own home in Warwick, New York. He wrote a few articles, the most notable being "Up among the Clouds," for *The Crayon.*

BIBLIOGRAPHY
Jasper F. Cropsey, "Up among the Clouds," *The Crayon* 2 (August 8, 1855): 79–80 § College Park, University of Maryland Art Gallery, *Jasper F. Cropsey: A Retrospective View of America's Painter of Autumn,* exh. cat., 1968, with text by Peter Bermingham, bibliography § Washington, D.C., Smithsonian Institution, National Collection of Fine Arts, and others, *Jasper F. Cropsey, 1823–1900,* exh. cat., 1970, published by Smithsonian Institution Press, with text by William S. Talbot, chronology, bibliography § Yonkers, N.Y., Hudson River Museum, *An Unprejudiced Eye: The Drawings of Jasper F. Cropsey,* exh. cat., 1979, with text by Kenneth W. Maddox, bibliography § New-York Historical Society, *Jasper F. Cropsey: Artist and Architect,* exh. cat., 1987, with essays by Ella M. Foshay and Barbara Finney, entries by Mishoe Brennecke, annotated bibliography of Cropsey's library by Stephen J. Zeitz, chronology, bibliography.

Sidney Plains with the Union of the Susquehanna and Unadilla Rivers, 1874

(*Wyoming Valley, Lucerne County, Pennsylvania; Sidney Plains*)
Oil on canvas
42¹/₁₆ x 71⁷/₈ in (106.9 x 182.5 cm)
Signed and dated lower left: J F Cropsey 1874
Jessie R. McMahan Memorial and Museum Acquisition Fund
M.70.2
Color plate, page 42

Sidney Plains is an area in south-central New York State, between Binghamton and Oneonta, that Cropsey visited frequently on his trips to Niagara Falls and the Susquehanna River Valley. In the middle ground, at the extreme right, just below the hill with the white farmhouse flows the Unadilla River. A pencil drawing dated 1873 (see illustration) locates the exact spot Cropsey chose to delineate. In fact, the painting deviates little from the preparatory drawing and consequently takes on the character of a topographical record. It was just such numerous details presented on a large scale that critics such as Henry James found fault with when the painting was exhibited at the annual exhibition of the National Academy of Design in 1875.

During the eleven years following his return from England in 1863, Cropsey added to his growing reputation with a number of large-scale, panoramic landscapes of northeastern American scenery. In *Sidney Plains,* as in the earlier *Valley of Wyoming,* 1865 (Metropolitan Museum of Art, New York), he attempted to epitomize the settling of the wilderness. Cropsey depicted man's encroaching on the wild landscape as he fenced in orchards and grazing fields for cows and sheep. Such expansion was then seen as "progress" and was associated with the advancement of modern technology, here indicated by the presence of telegraph poles and a distant train. The completion of the Erie Railroad line to Binghamton through the Alleghenies in 1848 had made the area more accessible to New York City.

Cropsey's landscape represents a nostalgic image of the settling of the American frontier. The railroad was crucial to the settlement of the American wilderness and in this painting may have had more than iconographic significance. Cropsey may have painted *Sidney Plains* for the railroad magnate John Taylor Johnston. There is conflicting information concerning the name of the original owner: when the landscape was exhibited at the National Academy of Design in 1875, the owner was listed as John

H. Johnston, and literature thereafter referred to the owner as John N. Johnston or John J. Johnston. John T. Johnston was a collector of American painting and the first president of the Metropolitan Museum of Art. If he were the owner, *Sidney Plains* was not sold in 1876 when business circumstances forced him to sell much of his collection. John T. Johnston may have kept the painting or given it to his son, John Herbert Johnston, owner of the Tenth

ON DEPOSIT
Philadelphia Museum of Art, 1970.

EXHIBITIONS
New York, National Academy of Design, *Fiftieth Annual Exhibition,* 1875, no. 375, as *Sidney Plains,* as owned by John H. Johnston § LACMA 1975, no. 121, pp. 219–20, entry by Donelson Hoopes and Nancy D. W. Moure, as first owned by John N. Johnston, repro., p. 125.

Cropsey, *Sidney Plains with the Union of the Susquehanna and Unadilla Rivers.*

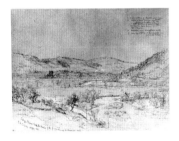

Cropsey, *Sidney Plains—With the Union of the Susquehanna and Unadilla Rivers,* 1873, see Related Work.

Street Studio Building, where many New York artists rented studios. Although John Taylor Johnston did not own the Erie Railroad pictured in Cropsey's landscape, his Lehigh and Susquehanna line provided one of the links from the seaboard to the inland.

Sidney Plains is painted in Cropsey's characteristic autumnal palette, which, according to the color notes written on the preparatory drawing, he found in nature. The sun breaking through the moist haze has the appearance of shafts of light. Although they can be explained as a natural phenomenon, these pearly hued rays imply a divine blessing on the land and its settlement.

RELATED WORK
Sidney Plains—With the Union of the Susquehanna and Unadilla Rivers, 1873, pencil and wash on paper, 9⅝ x 12½ in (24.4 x 31.7 cm). Sheldon Memorial Art Gallery of the University of Nebraska, Lincoln.

PROVENANCE
John H. [?] Johnston, New York, as of 1875 § Kurt E. Baur, New York, to 1969 § With Newhouse Galleries, New York, to 1970, as *The Wyoming Valley, Lucerne County, Pennsylvania.*

LITERATURE
"The National Academy of Design," *Art Journal* (New York) n.s. 1 (May 1875): 158, considers painting a "topographical landscape" and questions its size § Henry James, Jr., "On Some Pictures Lately Exhibited," *The Galaxy* 20 (July 1875): 96 § Clara Erskine Clement Waters and Laurence Hutton, *Artists of the Nineteenth Century and Their Works* (7th rev. ed., 1894; reprint, New York: Arno Press, 1969), 1: 173, painted for John N. Johnston § LACMA, American Art department files, William S. Talbot to Larry Curry, February 2, 1970, identifies the site § *LACMA Members' Calendar* (June 1970): inside front cover, repros., detail on cover, frontispiece § William S. Talbot, "Jasper F. Cropsey, 1823–1900," Ph.D. diss., New York University, 1972, pp. 194–95, 451, listed in cat. raisonné as no. 183, as originally owned by John J. Johnston, fig. 142 § "Recent Acquisitions, Fall 1969–Spring 1973," *LACMA Bulletin* 19, no. 2 (1973): fig. 18, 42 § "Permanent Collection," *LACMA Report 1969–1973* (as *LACMA Bulletin* 20, no. 1 [1974]), p. 19, repro., p. 48 § LACMA 1977, p. 139, repro. § Binghamton, N.Y., Roberson Center for the Arts and Sciences, *Susquehanna: Images of the Settled Landscape,* exh. cat., 1981, pp. 63–64, 67, 71, with text by Roger B. Stein, listed but not included in exhibition, fig. 6, p. 6.

John S. Sargent

Born January 12, 1856,
Florence, Italy, to
American parents
Died April 15, 1925,
London, England

The foremost Anglo-American portrait painter of his time, John Singer Sargent based his career in Paris and London, although he made several extended trips to the United States. In 1874 he entered the atelier of Carolus-Duran (1837–1917) and was admitted to the Ecole des Beaux-Arts. Three years later he began exhibiting at the Paris Salon; in 1878 he received much praise for his *The Oyster Gatherers of Cancale,* 1878 (Corcoran Gallery of Art, Washington, D.C.), and the next year won honorable mention for his portrait of his teacher, Carolus-Duran (Sterling and Francine Clark Art Institute, Williamstown, Mass.). That year he traveled to Holland and Spain to study the portraits of Frans Hals (1580–1666) and Diego Velázquez (1599–1660) and visited North Africa and Venice. Because of the public scandal when his portrait *Madame X,* 1884 (Metropolitan Museum of Art, New York), was shown at the Paris Salon of 1884, he moved to England and began exhibiting with the progressive New English Art Club. He spent several summers during the 1880s at the Anglo-American colony of artists and writers in Broadway in the Cotswolds and at Giverny, France, with Claude Monet (1840–1926). The colorful, light-filled landscapes he painted at both locales reflect the growing influence of impressionism on his art.

Sargent developed a cosmopolitan style of portraiture, depicting his sophisticated, wealthy sitters in harmony with their sumptuous surroundings. In late 1889 he visited New England and New York to fulfill several portrait commissions and while there was selected to paint murals for the Boston Public Library. He then traveled to Egypt to gather material for the murals, to be about the history of Judaism and Christianity. In 1897 he was elected to the Royal Academy. By the early 1900s he had become increasingly bored with portraiture, which in 1907 he all but abandoned, making more modest portrait drawings for his clients while devoting himself increasingly to landscape painting. Watercolor had now become his favorite medium. In London in 1904 he exhibited at the Royal Society of Painters in Water-Colours and in 1907 at the Pastel Society. In 1916, the year he completed the Boston Public Library decorations, he was commissioned to design murals for the Museum of Fine Arts, Boston. The only significant work from his last years was *Gassed,* 1918–19 (Imperial War Museum, London), painted for the British Ministry of Information.

BIBLIOGRAPHY

William Howe Downes, *John S. Sargent: His Life and Work* (Boston: Little, Brown, 1925), with catalogue of oil paintings, watercolors, and drawings, bibliography § Evan Charteris, *John Sargent* (1927; reprint, New York: Benjamin Blom, 1972), with Vernon Lee's "J.S.S.: In Memoriam," catalogue of oil paintings § Stanley Olson, *John Singer Sargent: His Portrait* (New York: St. Martin's, 1986), with genealogies of Sargent family, reprint of Sargent's description of Boston Public Library decorations, bibliography § Robert H. Getscher and Paul G. Marks, *James McNeill Whistler and John Singer Sargent: Two Annotated Bibliographies* (New York: Garland, 1986), the most extensive bibliography on the artist § New York, Whitney Museum of American Art, and Art Institute of Chicago, *John Singer Sargent,* exh. cat., 1986 (copublished with Harry N. Abrams, New York), with text by Patricia Hills and others, chronology, bibliography.

Man Wearing Laurels, c. 1874–80
(*Portrait of a Man; Portrait of a Man Wearing Laurels; Study of a Man Wearing Laurels; The Victor*)
Oil on canvas
17½ x 13³/₁₆ in (44.4 x 33.4 cm)
Stamped on verso, now relined: JSS (encircled)
Mary D. Keeler Bequest
40.12.10

Sargent executed several studies of male nudes, which were probably painted during or soon after his student years at the private atelier of Carolus-Duran. While *Man Wearing Laurels* is a bust-length study, a more elaborate painting of perhaps the same man wearing laurels, *A Male Model Standing before a Stove,* late 1870s (Metropolitan Museum of Art, New York), indicates that the figure is a professional model posing in a studio. French academic training extolled the human form as the major vehicle of expression. Usually the student was forced to develop his draftsmanship through meticulous drawings. Only after gaining a command of the human figure was the student permitted to use paint. Carolus-Duran was considered a radical in his methods because he encouraged his students to merge drawing with painting. He emphasized tonal painting as the means to construct form and stated, "Search for the values. . . . Establish the half tints (*la demi-teinte*) as a basis, then a few accents and the lights" (quoted in Boston, Museum of Fine Arts, *Catalogue of the Memorial Exhibition of the Works of the Late John Singer Sargent,* exh. cat., 1925, text by J. Templeman Coolidge, p. IX). Following these tenets, Sargent built up the model's face by applying lights and darks to convey the sense of three-dimensionality, re-

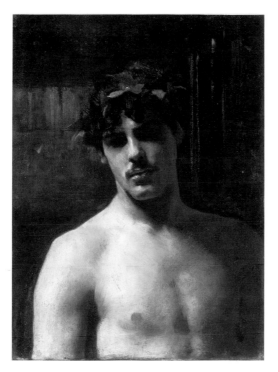

Sargent, *Man Wearing Laurels.*

boldly contrasts the model's chest and face but softens the image.

PROVENANCE
The artist (sale, Christie, Manson, & Woods, London, *Catalogue of Pictures and Water Colour Drawings by J. S. Sargent and Works of Other Artists,* 1925, no. 237, as *Portrait of a Man Wearing Laurels*) § With M. Knoedler & Co., New York, 1925 § Mary D. Keeler, Los Angeles, to 1938 § Estate of Mary D. Keeler, 1938–40.

EXHIBITIONS
Los Angeles, Municipal Art Gallery, *The American Scene,* 1956, no cat. traced § New York Cultural Center and others, *Three Centuries of the American Nude,* 1975, no. 31, as *Portrait of a Man.*

LITERATURE
"Almost a Million at Sargent's Sale," *Art News* 23 (August 15, 1925): 4, lists § Charteris, *Sargent,* p. 295, listed as *Portrait of a Man Wearing Laurels* § "Rembrandt Caps Group," *Los Angeles Times,* December 2, 1928, pt. 3, p. 17, repro., as *The Victor* § Charles Merrill Mount, *John Singer Sargent* (1955; reprint, New York: Kraus, 1969), p. 337, listed as no. 8019, *Study of a Man Wearing Laurels,* dated 1880 § New York, Coe Kerr Gallery, *John Sargent: His Own Work,* exh. cat., 1980 (copublished with Wittenborn, New York), unpaginated, cites in list of works in American public collections.

serving the strokes of the brightest flesh tints for the nose and chin. Sargent's strokes are swift and sure, without concern for minute details or surface finishing. The shadowy light, reminiscent of Spanish painting, not only

Sargent, *Mme François Buloz (Christine Blaze).*

Mme François Buloz (Christine Blaze), 1879

Oil on canvas
21⁹/₁₆ x 18³/₈ in (54.7 x 46.6 cm)
Inscribed, signed, and dated lower left: à mon amie M'Buloz / John S. Sargent / Ronjoux. 1879
Gift of Mr. and Mrs. Harry F. Sinclair and Mary D. Keeler Bequest
M.71.70

Sargent began to receive commissions as a result of the success of his portrait of Carolus-Duran presented at the Paris Salon of 1879. The first of the Paris elite to patronize him was the playwright Edouard Pailleron. So pleased was Pailleron with his portrait that he asked Sargent to paint his wife at the country estate of Mme Pailleron's father, Edmund Buloz, editor of the influential *La Revue des deux mondes.* In August 1879 Sargent spent six enjoyable weeks at Ronjoux, the Buloz summer home in Savoy, in southeastern France. Before leaving, he painted a portrait of his hostess, Mme Buloz, as a gift for her. Mme Buloz (née Christine Blaze de Bury) later professed to her sister that she did not care for the portrait, "I do not find it flattering enough; it is as I will look in ten years time if God allows me to live that long!"

Despite Mme Buloz's objections, the portrait Sargent created clearly demonstrates his ability to capture a sitter's character. He presented Mme Buloz, an elderly woman, in a direct, frontal pose. As she quietly looks out at the viewer, her forthright but gentle gaze suggests a perceptive personality. Sargent's brushwork is spontaneous; with a deft hand and few strokes he sensitively modeled her expressive face. In such portrait sketches Sargent often conveyed

greater vitality and freshness than in his more finished, commissioned works. Although Mme Buloz wears black and emerges from a shadowy interior, the portrait is rich, demonstrating that at this early stage Sargent was already a master of the restricted palette that his teacher had extolled.

PROVENANCE
Mme Buloz, Ronjoux, France § Mme Henri Bourget-Pailleron (by descent), Paris, c. early 1960s § With Hirschl & Adler Galleries, New York, c. 1965 § With Meredith Long & Co., Houston, Tex., to 1971.

EXHIBITION
Paris, Centre Culturel Americain, *John S. Sargent, 1856–1925,* 1963, no. 4.

LITERATURE
Marie-Louise Pailleron, *Le Paradis perdu: Souvenirs d'enfance* (Paris: N.p., 1947), p. 159, quotes Mme

Buloz's opinion § Charles Merrill Mount, *John Singer Sargent* (1955; reprint, New York: Kraus, 1969), p. 336, listed as no. 797, pl. 2, facing p. 67 § Boston, Museum of Fine Arts, *Sargent's Boston,* exh. cat., 1956, p. 86, text by David McKibbin, listed § Charles M. Mount, "New Discoveries Illumine Sargent's Paris Career," *Art Quarterly* 20 (Autumn 1957): 310 § Richard Ormond, *John Singer Sargent: Paintings, Drawings, Watercolors* (New York: Harper and Row, 1970), pp. 19, 21, quotes Mme Buloz § Joseph T. Butler, "The American Way with Art," *Connoisseur* 176 (March 1971): 207, repro., 209 § Advertisement, *Antiques* 99 (April 1971): repro., 460 § Advertisement, *Connoisseur* 176 (April 1971): repro., 18 of advertising section § Ruth Davidson, "Museum Accessions," *Antiques* 101 (May 1972): 814, repro. § "Recent Acquisitions, Fall 1969–Spring 1973," *LACMA Bulletin* 19, no. 2 (1973): fig. 17 § "Permanent Collection," *LACMA Report 1969–1973* (as *LACMA Bulletin* 20, no. 1 [1974]), p. 19, repro., p. 18 § Olson, *Sargent: His Portrait,* p. 77.

Portrait of Mrs. Edward L. Davis and Her Son, Livingston Davis, 1890

(*Mother and Child; Portrait; Portrait Group*)
Oil on canvas
86⅛ x 48¼ in (218.3 x 122.6 cm)
Signed lower right: John S. Sargent
Frances and Armand Hammer Purchase Fund
M.69.18
Color plate, page 49

In December 1889 Sargent returned to the United States, and, owing to his international fame, he was immediately deluged with requests for portraits by the best of New York and Boston society.

Sargent spent the month of June 1890 in Worcester, Massachusetts, fulfilling a commission he had received several months earlier to paint the portrait of Mrs. Edward Livingston Davis. Maria Robbins Davis (1843–1916) came from a distinguished Boston family and, at the time of Sargent's portrait, was one of Worcester's most prominent women and the wife of a former mayor. The painting of Mrs. Davis with her son Livingston (1882–1932) was the most commanding and important of the portraits Sargent created in Worcester.

Sargent used the Davises' stable for his studio because of its size and perhaps its empty black interior. In the portrait he avoided any allusions to the location and instead focused on the figures themselves, allowing their character and relationship to dominate. Sargent produced a complex psychological grouping in which the mother is contrasted with her child. Standing —in the tradition of the formal, full-length portrait—Mrs. Davis projects her upper-class breeding by her erect posture and frontal pose, yet she is also shown as a spirited woman and a mother of great warmth. While she and her son do not look at each other, they interact, albeit in a polite manner, through the tender grasp of hands and physical proximity. The boy shyly leans toward his mother, and she responds by sheltering him with her left arm. In this and other family portraits Sargent masterfully avoided any sentimentality while sympathetically conveying his subjects' personalities.

Sargent combined a dark palette with strong lighting, so that the overall effect is bright. Following the example of Carolus-Duran on close attention to values and the example of Spanish art, Sargent limited his palette largely to black and white while creating a colorful effect: there are subtle shifts from the cool blue-black of Mrs. Davis's dress to the warmer brown-black of the background, and touches of light blues in the shadows of the boy's sailor suit. *Mrs. Davis and Her Son Livingston* shows off Sargent's vigorous, fluid brushwork, most notably in the ruffles, fichu, and embroidery of Mrs. Davis's dress and the shadows of Livingston's suit. Sargent combined his handling with an assured manipulation of dramatic lighting to firmly model the figures. He created a psychologically penetrating portrait as well as a technical tour-de-force.

Sargent's emulation of Spanish baroque painting is echoed in the faintly Spanish features of the portrait's original frame, designed by architect Stanford White.

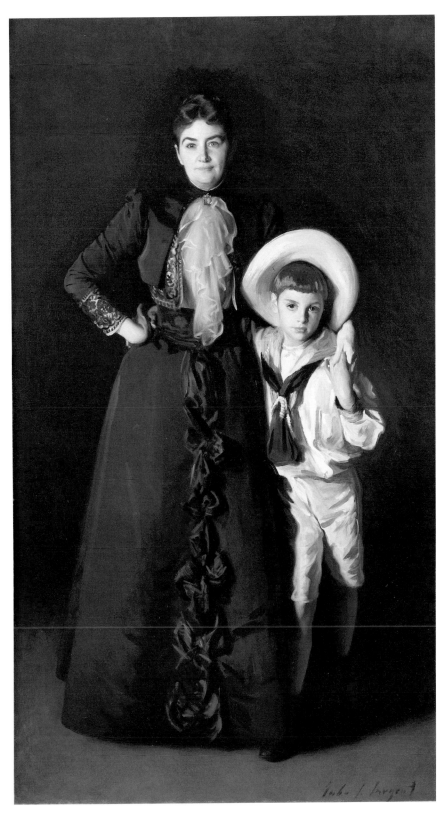

Sargent, *Portrait of Mrs. Edward L. Davis and Her Son, Livingston Davis.*

PROVENANCE
Mr. and Mrs. Edward Livingston Davis, Worcester, Mass., 1890–1916 § Mrs. A. Winsor Weld (by descent), Boston, 1918 § Mr. and Mrs. Livingston Davis (by descent), Boston, 1919–32 § Mrs. Livingston Davis (by descent), 1932–1969 (sale, Parke-Bernet Galleries, New York, *Eighteenth- to Twentieth-Century American Paintings,* 1969, no. 74) § With Schweitzer Gallery, New York, 1969 § With James Graham & Sons, New York, 1969.

ON DEPOSIT
Museum of Fine Arts, Boston, 1891; summers 1913, 1916, 1918–22, 1924, 1928–30 § Brooklyn Museum, 1969.

EXHIBITIONS
New York, National Academy of Design, *Autumn Exhibition,* 1890, no. 252 § Worcester, Mass., Public Library, organized by Worcester Art Society, *Loan Collection of Portraits,* 1891, no. 119 § Philadelphia, Pennsylvania Academy of the Fine Arts, *Sixty-first Annual Exhibition,* 1891–92, no. 257, as *Portrait Group* § Chicago, *World's Columbian Exposition: Official Catalogue, Fine Arts,* 1893, no. 875 of United States Section (no. 809 of revised catalogue), as *Mother and Child* § Boston, Copley Hall, *Loan Collection of Portraits of Women,* 1895, no. 257 § Worcester Art Museum, *The First Exhibition of the Worcester Art Museum with the Cooperation of the Worcester Art Society,* 1898, no. 76 of oil paintings, as *Portrait* § Boston, Copley Hall, *Paintings and Sketches by John Singer Sargent, R.A.,* 1899, no. 5 § Worcester Art Museum, *Twelfth Annual Exhibition of Oil Paintings,* 1909, no. 17, as *Portrait* § New York, Grand Central Art Galleries, *Retrospective Exhibition of Important Works of John Singer Sargent,* 1924, no. 20, repro., p. 45 § Boston, Museum of Fine Arts, *Memorial Exhibition of the Works of the Late John Singer Sargent,* 1925, no. 53 of paintings, incorrectly dated 1891 § New York, Metropolitan Museum of Art, *Memorial Exhibition of the Work of John Singer Sargent,* 1926, no. 26 of oils, repro., p. 40, incorrectly dated 1891 § Boston, Museum of Fine Arts, *Sargent's Boston,* 1956, no. 20, pp. 43, 91, text by David McKibbin, listed, fig. 23, p. 41 § Memphis, Brooks Memorial Art Gallery, *The Armand Hammer Collection,* 1969, no. 57, unpaginated, with provenance, exhibitions, literature, repro. § Washington, D.C., Smithsonian Institution, Museum of Natural History, and San Francisco, California Palace of the Legion of Honor, *The Armand Hammer Collection,* 1970–71, no. 63, unpaginated, with provenance, exhibitions, literature, repro. § LACMA and others, *The Armand Hammer Collection,* 1972–73, no. 54, unpaginated, entry by Larry Curry, repro. § Caracas, Venezuela, Museo de Bellas Artes, and Lima, Peru, Museo de Arte Italiano, *La Collecìòn de Armand Hammer,* 1975, no. 52 § LACMA 1975, no. 124, pp. 222–23, entry by Donelson Hoopes and Nancy D. W. Moure, repro., p. 128 § Tokyo, Japan, Ikebukuro-Seibu Museum, and others, *The Armand Hammer Collection,* 1975–76, no. 52 § Nashville, Tennessee Fine Arts Center at Cheekwood, *The Armand Hammer Collection: Special Selections,* 1976, no. 52, unpaginated, with provenance, exhibitions, literature, repro. § Mexico City, Palacio de Bellas Artes, and others, *La Collecìòn de Armand Hammer,* 1977, no. 52 § Oslo, Norway, National Gallery of Norway, and Stockholm, Sweden, Nationalmuseum, *The Armand Hammer Collection,* 1978–79, no. 57 § Houston, Museum of Fine Arts, *The Armand Hammer Collection: Four Centuries of Masterpieces,* 1979–80, no. 60 § LACMA, *Selections from the Armand Hammer Collection,* 1980, no. 58, repro., unpaginated § Washington, D.C., Corcoran Gallery of Art, and others, *The Armand Hammer Collection: Five Cen-*

turies of Masterpieces, 1980–81, no. 58, repro., unpaginated § LACMA 1981–82, no. 53, p. 71, essay by Michael Quick, p. 172, entry by Michael Quick, repro., p. 174 § Huntington, W. Va., Huntington Galleries, *The Armand Hammer Collection: Five Centuries of Masterpieces,* 1982, no. 58, p. 156, entry by Larry Curry, with provenance, exhibitions, literature, repro., p. 157 § Washington, D.C., National Gallery of Art, *American Paintings from the Armand Hammer Collection: An Inaugural Celebration,* 1985, entries not numbered, unpaginated § Whitney Museum of American Art, *Sargent,* entries not numbered, p. 159, essay by Gary A. Reynolds discusses in context of late portraiture, fig. 97, p. 147.

LITERATURE

"A Distinguished Artist: Mr. John S. Sargent at the Worcester Club," *Worcester Evening Gazette,* June 4, 1890, p. 4 § "Personal," *Worcester Daily Spy,* June 5, 1890, p. 8 § *Worcester Daily Spy,* June 21, 1890, p. 8 § Philadelphia, Pennsylvania Academy of the Fine Arts, Archives, newspaper clipping, Charles Henry Hart, "The Pennsylvania Academy Exhibition," *Independent,* February 26, 1891 § "A Fine Collection," *Worcester Evening Gazette,* March 30, 1891, p. 4 § "The Loan Exhibition," *Worcester Daily Spy,* April 1, 1891, p. 1, exhibited to much praise § *Worcester Daily Spy,* April 27, 1891, p. 8, Sargent wanted to exhibit portrait in London § "The National Academy of Design," *Art Amateur* 24 (January 1893): 93 § William A. Coffin, "The Columbian Exposition.—II. The Fine Arts: The United States Section," *Nation* 57 (August 10, 1893): 97 § "American Painting. IV—Whistler, Dannat, Sargent," *Art Amateur* 29 (November 1893): 134 § Leila Mechlin, "A Museum with a Fortune," *Art and Progress* 1 (November 1909): 17, repro., 2 § Nathaniel Pousette-Dart, comp., *John Singer Sargent,* Distinguished American Artists Series (New York: Stokes, 1924), p. VIII, essay by Lee Woodward Zeigler § New York, Grand Central Art Galleries, *Exhibition of Paintings and Sculpture: Yearbook* (1924): repro., unpaginated § Ralph Flint, "Sargent as a Modern Master in His Retrospective Show," *Christian Science Monitor,* March 3, 1924, p. 11 § Leila Mechlin, "The Sargent Exhibition: Grand Central Art Galleries, New York," *American Magazine of Art* 15 (April 1924): 177, "a charming composition, exquisitely rendered," repro., 184 § Rose V. S. Berry, "John Singer Sargent: Some of His American Work," *Art and Archaeology* 18 (September 1924): 101, 103, repro., 100 § Downes, *Sargent: Life and Work,* pp. 33, 157–58, repro., facing p. 128 § J. B. Manson, "Notes on the Works of J. S. Sargent," *Studio* 90 (August 1925): 81, repro. § Charteris, *Sargent* pp. 109–10, 137, 263, reprints letter from the artist to Marianna Van Rensselaer, December 15, [no year], thanking her for her praise of the painting, listed in catalogue of Sargent's oil paintings, with exhibitions § *Index 20th Cent. Artists* 2 (February 1935): 76; reprint, p. 342 § Charles Merrill Mount, *John Singer Sargent* (1955; reprint, New York: Kraus, 1969), pp. 153, 341, listed as no. 9024 § "Permanent Collections," *LACMA Report 1968–1969* (as *LACMA Bulletin* 19, no. 1 [1969]), p. 17–18, repro., 18 § *LACMA Members' Calendar* (September 1969): unpaginated, repros., cover, frontispiece § Richard Ormond, *John Singer Sargent: Paintings, Drawings, Watercolors* (New York: Harper and Row, 1970), pp. 43, 246, pl. 61, p. 162 § LACMA 1977, p. 142–43, repro., p. 143 § New York, Coe Kerr Gallery, *John Singer Sargent: His Own Work,* exh. cat., 1980 (copublished with Wittenborn, New York), unpaginated, cites in checklist of works in American public collections § *LACMA Members' Calendar* 19 (November 1981): repro., cover § "Gallery Scene," *Connoisseur* 208 (December 1981): repro., 242 § *LACMA Members' Calendar* 20 (November 1982): unpaginated, repro. § Susan E. Strickler, "John Singer Sargent and Worcester," *Worcester [Mass.] Art Museum Journal* 6 (1982–83): 19, 22, 26, 28, 35, 38, fig. 1, 18 § William Wilson, *The Los Angeles Times Book of California Museums* (New York: Abrams, 1984), p. 150, fig. 129 § Trevor J. Fairbrother, *John Singer Sargent and America* (New York: Garland, 1986), pp. 166–68, 203, pl. 43, p. 416 § *The Armand Hammer Collection* (Los Angeles: Armand Hammer Foundation, rev. ed., 1985), no. 100, p. 175, 244–5, entry by Ilene Susan Fort, with provenance, exhibitions, literature, repro., p. 174 § Fort 1986, p. 425 § LACMA 1988, p. 20, repro., p. 21.

William Keith

Born November 21, 1838,
Old Meldrum, Scotland
To United States 1850
Died April 13, 1911,
Berkeley, California

William Keith was the giant of California landscape painters during the late nineteenth century, attaining national recognition at a time when few West Coast artists were widely known. At the age of twelve he emigrated to New York with his widowed mother. Six years later he was apprenticed to a wood engraver. While working as an engraver for the publishing firm of Harper Brothers, he was sent on assignment to San Francisco in 1858 or 1859. Determined to reside in California, he returned West within the year.

He worked as an engraver until his wife encouraged him to paint. His first paintings were watercolors, and in the late 1860s he turned to oils, prompted by a commission to depict sites along the Northwest Coast route of the Oregon Navigation and Railroad Company. In 1868 he visited Yosemite for the first time. In 1870 he spent about six months in Düsseldorf, where he studied with Albert Flamm (1823–1906).

Keith developed an intimate knowledge of the Sierras through visits he made with his close friend, the naturalist John Muir. He sketched far afield, hiking through Utah in the company of the photographer Carleton Watkins (1829–1916) in 1873–74 and visit-

ing the California missions in 1882 and Alaska in 1886. In late 1882 Keith left for Europe, residing in Munich for three years but traveling throughout the Continent.

Keith's art falls into two distinct phases. From 1865 to 1882 he depicted California scenery in realistic, panoramic views. After 1882 most of his paintings were less grandiose and more in the Barbizon tradition—intimate and softly shadowed glades that convey a poetic mood rather than being described in detail. Several factors caused this change in style: the emotional upheaval caused by the death of his wife; his new friendship with the Reverend Joseph Worcester, head of the Swedenborgian Church in San Francisco; and his study in Munich.

His late, poetic landscapes were compared with the art of GEORGE INNESS (who was a follower of Swedenborg) and J. M. W. Turner (1775–1851). When Inness visited California in 1891 he worked in Keith's studio and accompanied him on sketching trips. During the San Francisco earthquake of 1906 two thousand of Keith's paintings were destroyed.

BIBLIOGRAPHY
Emily P. B. Hay, *William Keith as Prophet Painter* (1916; reprint, San Francisco: Kenneth Starosciak Bookseller, 1981) § "William Keith," *California Art Research Project* 2 (December 1936): 1–66, with lists of works, exhibitions, and collections, bibliography § Eugen Neuhaus, *William Keith: The Man and the Artist* (Berkeley: University of California Press, 1938) § Fidelis Cornelius, *Keith: Old Master of California* (New York: Putnam's, 1942), supplemental volume (Fresno: Academy Library Guild, 1956) § Alfred C. Harrison, Jr., *William Keith: The Saint Mary's College Collection,* ed. Ann Harlow (Moraga, Calif.: Hearst Art Gallery, Saint Mary's College, 1988), collection catalogue, with provenances, lists of exhibitions, literature references, published in conjunction with an exhibition held at Hearst Art Gallery, Saint Mary's College, Moraga, Calif., 1988.

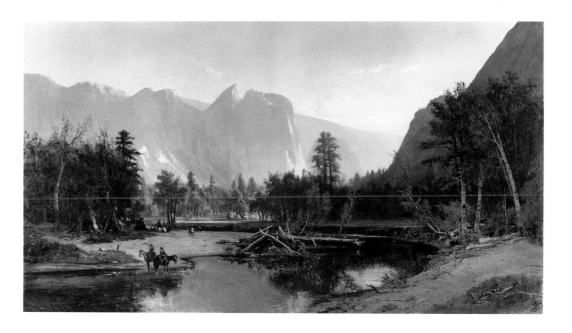

Keith, *Yosemite Valley,* 1875.

Yosemite Valley, 1875
Oil on canvas
40⁵/₁₆ x 72½ in (102.9 x 184.2 cm)
Signed and dated lower left: Wm. Keith / 75
A. T. Jergins Bequest
M.71.115
Color plate, page 43

In the autumn of 1872 Keith made the acquaintance of John Muir when he explored the hills beyond Yosemite with the naturalist. *Yosemite Valley* was a product of a later trip in 1875. A dramatic, composed image, it was painted in the artist's studio specifically as an exhibition piece. It portrays a commanding view of Cathedral Rocks, which are in the valley along a bend in the Merced River. Nothing obstructs the panoramic view. A bit of the river bank is included as a repoussoir to lead the viewer into the scene. The towering trees are arranged on the sides to permit an open vista of the cliffs. The addition of the riders, while suggesting a narrative, was also essential to the composition. Even the pile of dead tree trunks in the

center of the painting was arranged so that the large logs would link the two sides of the painting.

Keith created many such epic paintings during the period between his two European trips, and many of these were criticized as too artificial. Although the general appearance of this version might give the impression of a standard picturesque composition, Keith avoided the tight, linear painting style associated with the Düsseldorf school. He also escaped the pervasive grays of such German landscapes by infusing the background of *Yosemite Valley* with an array of soft, opalescent hues.

PROVENANCE
Andrew Turnbull Jergins II, San Antonio, to 1971 § Estate of Andrew Turnbull Jergins II.

EXHIBITION
LACMA, *Western Scene,* 1975, no. 21.

LITERATURE
"Recent Acquisitions, Fall 1969–Spring 1973," *LACMA Bulletin* 19, no. 2 (1973): p. 43, fig. 22 § "Permanent Collection," *LACMA Report 1969–1973* (as *LACMA Bulletin* 20, no. 1 [1974]), p. 19 § Gerald F. Brommer, *Landscapes* (Worcester: Davis, 1977), repro., p. 20 § LACMA, American Art department files, Barbara Beroza to Ilene Susan Fort, February 10, 1986, identifies the site.

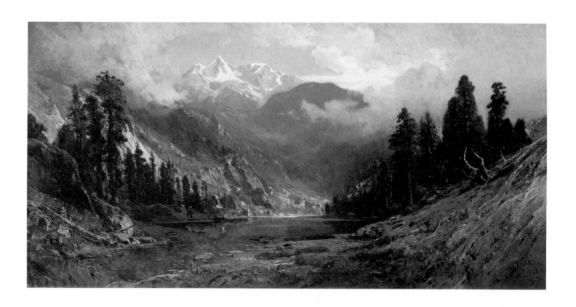

Keith, *California Pines.*

California Pines, 1878
(Landscape)
Oil on canvas
36³/₁₆ x 72³/₈ in (91.8 x 183.8 cm)
Signed and dated lower right: W. Keith. / 78. / S.F.
Gift of Museum Patrons Association and Mira Hershey Memorial Collection
29.19

In his search for the grand and scenic, Keith ventured throughout northern California and beyond. Consequently his repertoire of epic imagery was not limited to the stark, perpendicular, granite walls of Yosemite but also included alpine views such as *California Pines.* The painting is believed to be a view of east central California showing the upper reaches of the Kern River, which flows south from Mount Whitney towards Bakersfield in land that is now part of Sequoia National Park and the Dome Land wilderness. Alpine paintings by artists trained in Düsseldorf served as models for Keith's panoramic images with snow-capped mountains towering majestically in the background.

He presented the California view in a traditional composition with the trees and sloping hills as repoussoir elements and a meandering river leading into the scene. His manner of presenting the hills is reminiscent of the treatment of the Rockies in the work of ALBERT BIERSTADT.

While in the possession of the Vose Galleries, this landscape was shown throughout the country and eventually at the Biltmore Salon in Los Angeles, where it was purchased in 1929 for the museum. The painting was the first major acquisition funded by the museum's patron association.

PROVENANCE
The artist § With George Ainslie Galleries, New York, to 1916 § With Vose Galleries, Boston, 1916–29.

ON DEPOSIT
N. M. Vose, San Francisco, 1925 § George Gage Gallery, Minneapolis, 1927 § Wetzel Galleries, Tulsa, c. 1927–28 § Biltmore Salon, Los Angeles, 1928–29.

EXHIBITIONS
Probably San Francisco, Mechanics' Institute, *Report of the Fourteenth Industrial Exhibition,* 1879, entries not numbered, as *Landscape* § Columbus (Ohio) Gallery of Fine Arts, *Paintings by Old and Modern Masters,* 1924, no. 24 § Oberlin (Ohio) Art Association, Allen Memorial Art Museum, *Exhibition of Paintings by American and European Artists,* 1924, no. 18 § Dayton Art Institute, [exhibition title unknown], 1926, no cat. traced § San Francisco, California Palace of the Legion of Honor, *Catalogue of the First Exhibition of Selected Paintings by American Artists,* 1926–27, no. 107 § Pomona, Calif., Los Angeles County Fair, *National Exhibition of Sculpture and California Paintings,* 1941, no. 26 § Santa Barbara (Calif.) Museum of Art, *California Pictorial, 1800–1900,* 1962, pt. 2, no. 9 § LACMA and others, *The American West: Painters from Catlin to Russell,* 1972 (copublished by Viking Press, New York), no. 93, p. 28, essay by Larry Curry, pl. 101, p. 151 § New York, Whitney Museum of American Art, *The American Frontier: Images and Myths,* 1973, no. 39, p. 12, essay by Patricia Hills, fig. 50, p. 52 § Spokane, International Exposition on the Environment, *Our Land, Our Sky, Our Water,* 1974, no. 83.

LITERATURE
Boston, Vose Galleries, Archives, unidentified newspaper clipping, "Keith Canvas Purchased," May 10, 1929 (copy in LACMA, American Art department files), identifies the locale § "The Calendar: Art," *California Arts and Architecture* 36 (August 1929): 59 § Cornelius, *Keith,* 1: 81, 552 § LACMA, American Art department files, Robert C. Vose, Jr., to Ilene Susan Fort, May 23, 1986, and June 27, 1987, give exhibition history and provenance of the painting based on gallery's files.

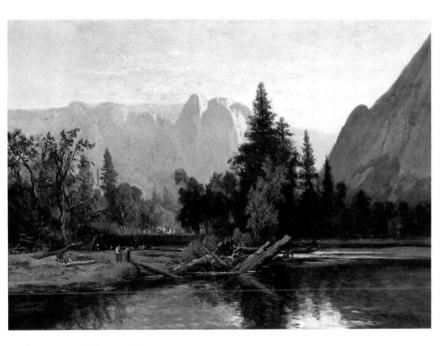

Keith, *Yosemite Valley,* c. 1880.

Yosemite Valley, c. 1880
Oil on canvas
24¹/₁₆ x 34 in (61.1 x 86.5 cm)
Signed lower right: W. Keith.
Canvas stamp verso, now relined: MORRIS / AND / KENNEDY'S / DEPOT OF ART / 19 & 21 Post St. / SAN FRANCISCO
Gift of Mrs. James D. Macneil
M.81.159

Keith realized that in a single visit an artist could not discover all the subtleties of Yosemite, and he made repeated excursions to the valley. This landscape closely resembles his larger *Yosemite Valley* dated 1875 (LACMA; q.v.) and may have been inspired by Keith's first visit to the area. It was painted later, however, since the canvas was stamped with the name of Morris and Kennedy's Depot of Art, a San Francisco art supplier and dealer first listed in city directories in 1880. Keith probably painted this landscape during that year, before he went to Munich. Why he painted this smaller version, so similar in view and composition, is not known. The later landscape has a fresher, less-composed quality, with a large pine obstructing the dramatic profile of the cliff and the entire image closer to the viewer, suggesting that it might be a preparatory study. However, the approximate date of the work based on the canvas stamp precludes the possibility that it was a study specifically for the museum's *Yosemite Valley* of 1875.

Keith's account of his trip to Yosemite in 1875 was published in *The Overland Monthly* and clearly indicates that he had already begun to discover the many nuances of this part of the country. He wrote about the region in painterly terms, dwelling primarily on aspects of color and atmosphere. His account could easily serve as a description of this painting:

> The cliffs are neither red nor yellow, but an indescribable shifting gray, changing and shifting even as you look. The . . . burnished light of evening, can not be gotten by a lucky hit. . . . In fact, the chief characteristics of this region are its rocks, bareness, the round and burnished domes, and dwarf twoleafed pines. . . . All this landscape is clear gray shadow which does not give one the feeling of shadow, and only the tops of the peaks are in the warm-colored sunlight.
> . . . Pines—green and purplish brown . . .
> ("An Artist's Trip in the Sierras,"
> *The Overland Monthly* 15 [August 1875]:
> pp. 198–200).

As is the case with the artist's 1875 *Yosemite Valley*, this painting reveals none of the tight brushwork associated with the Düsseldorf school. Keith varied the painting surface with thick passages in the sky and soft brushwork to describe the trees on the right. The water shimmers, appearing almost opalescent with short horizontal strokes of gray, mauve, white, dark purple, green, and brown.

PROVENANCE
Mr. and Mrs. James D. Macneil, Pasadena, Calif., to 1979 § Mrs. James D. Macneil (by descent), to 1981.

ON DEPOSIT
LACMA, 1979–81.

LITERATURE
LACMA, American Art department files, Barbara Beroza to Ilene Susan Fort, February 10, 1986, identifies the site.

William M. Chase

Born November 1, 1849, Williamsburg, Indiana
Died October 25, 1916, New York, New York

William Merritt Chase was the foremost portraitist and among the most popular artists and teachers of his day in New York. In 1861 his family moved to Indianapolis, where he received technical training from a local artist, Barton S. Hays (1826–1914). After briefly serving in the navy in 1867, he returned to Indianapolis. By 1868, when he left for New York, he was already considered an accomplished still-life painter. In New York he studied drawing at the National Academy of Design. In 1871 he moved to Saint Louis, where he continued to support himself as a still-life painter.

Commissions from a group of patrons in Saint Louis enabled him to enroll in 1872 in the Royal Academy of the Fine Arts in Munich. After studying with Alexander von Wagner (1838–1919), Chase was chosen in 1874 to study with the academy's most distinguished professor, Karl von Piloty (1826–1886), under whom he developed a forcefully realistic style based upon the baroque masters. At the same time he was intimately associated with his progressive German classmates and the leaders of the large colony of American students, with whom he painted in a more expressive, sketchy style. After visiting Venice, Chase returned to New York in 1878 to accept a teaching position at the Art Students League.

In New York he maintained an elaborate studio, quickly becoming one of the most successful and conspicuous figures among the younger artists. He was elected a member of the Society of American Artists in 1878, and he served as its president in 1880 and then again for ten years beginning in 1885. He was a founding member of the Society of Painters in Pastel in 1883. In 1887 Chase was elected an associate member of the National Academy of Design and in 1890 an academician. In 1905 he was elected a member of the independent exhibiting group, Ten American Painters.

During the 1880s and after 1903 he traveled to Europe almost every year, keeping in close touch with new stylistic currents. A fashionable portraitist, he was also successful as a landscape and genre painter and later as a still-life painter. Chase was active as a teacher, especially at the Art Students League and the Pennsylvania Academy of the Fine Arts in Philadelphia and at his Chase School in New York and his Shinnecock Summer School of Art near Southampton, Long Island, where he taught plein air painting. Intermittently for ten years, beginning in 1903, he taught summer classes at various places in Europe and once in Carmel, California.

BIBLIOGRAPHY
Katharine Metcalf Roof, *The Life and Art of William Merritt Chase* (1917; reprint, New York: Hacker, 1975), with introduction by Alice Gerson Chase, list of paintings by location § Indianapolis, John Herron Art Museum, *Chase Centennial Exhibition*, exh. cat., 1949, with text by Wilbur D. Peat, catalogue of known works § Abraham David Milgrome, "The Art of William Merritt Chase," Ph.D. diss., University of Pittsburgh, 1969, with Chase lectures, student reminiscences, catalogue of works, chronology, bibliography § Santa Barbara, University of California, Art Gallery, and others, *William Merritt Chase*, exh. cat., 1964, with text by Ala Story § Ronald G. Pisano, *A Leading Spirit in American Art: William Merritt Chase, 1849–1916*, (Seattle: Henry Art Gallery, University of Washington, 1983), with chronology and bibliography, published in conjunction with an exhibition held at the Henry Art Gallery, University of Washington, Seattle, and Metropolitan Museum of Art, New York, 1983–84.

Chase, *Pablo de Sarasate: Portrait of a Violinist.*

Pablo de Sarasate: Portrait of a Violinist, c. 1875

(*A Violinist; Pablo Sarasate; Portrait of an Artist*)
Oil on canvas
22½ x 18¹³/₁₆ in (57.1 x 47.8 cm)
Signed lower left: Chase.
Mary D. Keeler Bequest
40.12.9

Although the form of the signature is like that used by William Chase after about 1885, several stylistic features point to a date late in Chase's Munich period (1872–78), especially the broadly brushed colored background, the working of the hair into an unruly mass extended beyond reasonable limits, and the overly strong, flat lighting with white high-lights—characteristics of Chase's Munich style, which he abandoned soon after his return to New York in 1878.

By leaving parts of the composition in a con-spicuously unfinished state, Chase and his American and German associates in Munich drew attention to the forceful realism in the finished portions of the face, and to the fact that the rendering was achieved in just one sitting rather than as a result of two or more

sessions. For instance, in subsequent revisions the artist also would have worked in the back-ground light and shadow over the extended portion of the hair, bringing the entire painting to a state of uniform finish. The clarity of vision and economy of means that produced such realistic definition and strong character-ization bear witness to the technical brilliance achieved by Chase at the Munich Academy.

In 1928 the subject was identified as a violin-ist and in 1937 as the celebrated virtuoso and composer Pablo de Sarasate (1844–1904), who toured widely during the 1870s. Chase's sub-ject seems older than thirty-one, Sarasate's age in 1875, although the portrait bears a general resemblance to other images of the violinist. In 1875 Sarasate would not have worn the lapel rosette of the Legion of Honor, which may have been added at a later date.

The canvas may have been stored rolled up, causing a multitude of fine, horizontal cracks to appear. Chase later may have painted over the background, hair, and costume in a uniform dark tone and again signed the painting. This is the way the portrait must have appeared when Chase exhibited it early in this century. It was necessary to remove this overpainting during conservation by the museum's staff.

PROVENANCE
The artist § Mrs. William M. Chase (by descent), 1916 § With Newhouse Galleries, Saint Louis, 1927 § Mary D. Keeler, Los Angeles, by 1928 to 1938 § Estate of Mary D. Keeler, 1938–40.

EXHIBITIONS
Philadelphia, McClees Gallery, *Exhibition of Paint-ings: The Works of Mr. William M. Chase*, 1905, no. 33 § Probably New York, Society of American Artists, *Twenty-eighth Annual Exhibition*, 1906, no. 376, as *Portrait of an Artist* § Buffalo, Albright Art Gallery, and others, *A Collection of Paintings by William M. Chase, N.A.*, 1909, no. 30 § New York, National Arts Club, *William M. Chase Retrospective*, 1910, no. 102 § San Francisco, *Panama-Pacific International Exposition, Department of Fine Arts, Offi-cial Catalogue (Illustrated)*, 1915, no. 3743, as *Portrait of an Artist* § New York, American Academy of Arts and Letters, *Exhibition of the Works of William Mer-ritt Chase*, 1928, no. 23, with note that it was painted in Munich in 1875, as *A Violinist* § New York, Newhouse Galleries, *Paintings by William Merritt Chase*, 1933, no. 12 § Los Angeles Art Association, *Loan Exhibition of International Art*, 1937, no. 208, as *Pablo Sarasate* § John Herron Art Museum, *Chase*, no. 28, unpaginated, with date of c. 1890, listed in checklist of known male portraits as *Pablo de Sara-sate: Portrait of a Violinist* with inscribed date 1909 and in checklist of male figure studies as *Violinist*, repro. § Sacramento, E. B. Crocker Art Gallery, and others, *Munich and American Realism in the 19th Century*, 1978, exhibited but not listed.

LITERATURE
James W. Pattison, "William Merritt Chase, N.A.,"

House Beautiful 25 (February 1909): repro., 51, as *Portrait of an Artist* § "Four Notable Exhibitions," *Academy Notes* (Buffalo Fine Arts Academy) 4 (February 1909): 146, described as being "reminiscent of Mr. Chase's student days in Munich" § Katharine M. Roof, "William Merritt Chase: An American Master," *Craftsman* 18 (April 1910): 33, states it was done at a single sitting early in Chase's career, repro., 42, as *Portrait of an Artist* § Saint Louis, Newhouse Galleries, *Paintings by William Merritt Chase,* 1927, pl. 41, unpaginated, as *Portrait of a Violinist* § Edwina Spencer, "Around the Gal-leries," *Creative Art* 12 (April 1933): 319 § "Chase Exhibition Opens April 26th," *Art News* 26 (April 21, 1928): 7 § "Exhibitions in New York," *Art News* 26 (May 5, 1928): 11 § "William Merritt Chase: Newhouse Galleries," *Art News* 31 (March 11, 1933): 5, repro., 4, as *Pablo Sarasate* § *Index 20th Cent. Artists* 2 (November 1934): 26; reprint, p. 279; listed, as *Portrait of an Artist, Portrait of a Violinist,* and *Pablo Sarasate* § Milgrome, "Chase," p. 196, listed as no. 97 of male portraits, as *Pablo de Sarasate: Portrait of a Violinist,* dated 1909; p. 200, listed as no. 60 of male figure studies, as *Violinist.*

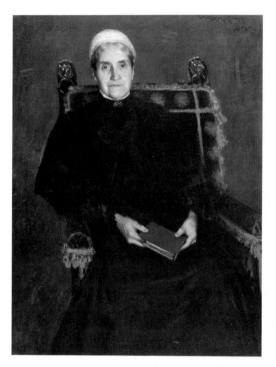

Chase, *Portrait of Mrs. George B. Ely (Caroline Boies Ely).*

Portrait of Mrs. George B. Ely (Caroline Boies Ely), 1895

(*Catherine Boies Ely*)
Oil on canvas
48¹/₁₆ x 36¹/₄ in (122.0 x 92.1 cm)
Signed and dated upper right: Wm M. Chase. / 1895
Miss Elizabeth L. Ely Bequest
42.7

Caroline Boies Ely (1825 or 1826–1904) was the daughter of Justus Boies of Northampton, Massachusetts. During her youth she met many prominent figures and wrote reminiscences of Rufus Choate and Daniel Webster. In 1848 she married George Byron Ely (1826–1886) and in 1851 they moved to Hanesville, Wisconsin, where he established a law practice and was later elected district attorney. In 1861, as captain, he raised a company that formed part of the Iron Brigade; he left the army with the brevet rank of lieutenant colonel. Appointed paymaster during the Civil War by President Abraham Lincoln, he and his family moved to Washington, D.C., where Mrs. Ely is known to have visited the wounded in the hospitals. At the outbreak of the Spanish-American War Mrs. Ely wrote an article protesting it, recalling the horrors of war she had known. Her son, Arthur H. Ely, was an attorney, and her three daughters, including Elizabeth L. Ely, who bequeathed the portrait to the museum, founded the distinguished Misses Ely's School, last located in Greenwich, Connecticut (LACMA, American Art department files, Mr. William F. McChesney to LACMA, August 18, 1973).

The frontal, seated pose, originally reserved for royalty, is one Chase frequently used, especially for women. The chair is probably one of the several armchairs of seventeenth-century Spanish design to be found in his elaborately furnished studio. The choice of a high-necked, black dress and a white head-covering enhances the sense of a period portrait.

PROVENANCE
Elizabeth L. Ely, to 1942.

EXHIBITIONS
New York, National Academy of Design, *Loan Exhibition of Portraits for the Benefit of the Ortheopaedic Hospital,* 1898–99, no. 62 § LACMHSA, *One Hundred Treasures,* 1946, no cat. § Los Angeles, Barnsdall Park, Municipal Art Gallery, *The American Scene,* 1956, no cat. traced.

LITERATURE
"American Studio Talk," *International Studio* 1, supp. (September 1898): x, ". . . on the chin and around the mouth there is evidence of the artist's having struggled to get the expression he desired" § Ernest Knaufft, "The Portrait Exhibition," *Art Interchange* 42 (February 1899): 28 § "Recent Acquisitions," *Los Angeles County Museum Quarterly* 2 (September 1942): 22 § John Herron Art Museum, *Chase,* unpaginated, listed in checklist of known female portraits, as *Catherine Boies Ely* § Milgrome, "Chase," p. 204, listed as no. 80 of female portraits, as *Catherine Boies Ely.*

Just Onions, 1912
(*Onions; Still Life*)
Oil on wood panel
21 x 25¹¹/₁₆ in (53.3 x 65.2 cm)
Signed lower left: WM M Chase.
Mary D. Keeler Bequest
40.12.8

According to art historian Katharine Roof, *Just Onions* was painted in Bruges, Belgium, in the summer of 1912, while Chase was conducting one of his annual summer art classes. For her, its richness of color and textures and

Chase, *Just Onions.*

the distinction of handling place it among the best still-life painting of the old masters.

PROVENANCE
The artist § Mrs. William M. Chase (by descent), 1916–still in 1923 § With Newhouse Galleries, Saint Louis and New York § Mary D. Keeler, Los Angeles, by 1928 to 1938 § Estate of Mary D. Keeler, 1938–40.

EXHIBITIONS
New York, Montross Gallery, "Ten American Painters Exhibition," 1913, no. 4 § San Francisco, *Panama-Pacific International Exposition, Department of Fine Arts, Official Catalogue (Illustrated)*, 1915, no. 3739 § Memphis, Brooks Memorial Art Gallery, *Paintings by Wm. M. Chase*, 1919, no. 115 § Buffalo, Albright Art Gallery, *An Exhibition of Important Works by a Number of America's Leading Painters*, 1920, no. 14 § Pittsburgh, Carnegie Institute, and others, *Exhibition of Paintings by William M. Chase (1849–1916,)*, 1922–23, no. 6 § Buffalo, Albright Art Gallery, *An Exhibition of Paintings by the Late William M. Chase*, 1923, no. 6 § New York, American Academy of Arts and Letters, *Exhibition of the Works of William Merritt Chase*, 1928, no. 34, repro., p. 19, as *Onions*, also known as *Just Onions* § Los Angeles Art Association, *Loan Exhibition of International Art*, 1937, no. 210, as *Onions* § Pomona, Calif., Los Angeles County Fair Association, *Painting in the USA, 1721–1953*, 1953, no. 20, repro., p. 27, as *Still Life.*

LITERATURE
Roof, *Chase*, p. 239 § "Paintings by the Late William M. Chase," *Academy Notes* (Buffalo Fine Arts Academy) 18 (January–June 1923): 4, repro. § Saint Louis, Newhouse Galleries, *Paintings by William Merritt Chase*, 1927, unpaginated, pl. 39, as *Onions* § Emily G. Hutchings, "Paintings by William Merritt Chase: A Review," *Art News* 25 (April 9, 1927): 8, as *Onions* § "Chase Exhibition Opens April 26th," *Art News* 26 (April 21, 1928): 7, as *Onions* § "Exhibitions in New York," *Art News* 26 (May 5, 1928): 11, as *Onions* § *Index 20th Cent. Artists* 2 (November 1934): 25–26; reprint, pp. 278–79; listed, as *Just Onions* and *Onions* § John Herron Art Museum, *Chase*, unpaginated, listed in checklist of known still lifes, as *Just Onions* and *Onions* § Milgrome, "Chase," p. 225, listed as no. 41 of still lifes, as *Just Onions*; p. 226, listed as no. 50 of still lifes, as *Onions.*

Winslow Homer

Born February 24, 1836,
Boston, Massachusetts
Died September 29, 1910,
Prout's Neck, Maine

One of the greatest of American artists, Winslow Homer was outstanding as both a figure and landscape painter and as a watercolorist. He was a descendant of generations of New Englanders. He apprenticed in Bufford's Lithography Shop in Boston and after 1859 worked as an illustrator for *Harper's Weekly* in New York. The strength of his illustrations, especially his Civil War subjects, first established his reputation. He was elected an associate of the National Academy of Design in 1864 at the age of twenty-eight and an academician the following year. After the Civil War he concentrated on oil painting. In 1866–67 he lived in Paris. He took up watercolor painting in 1873 and became an undisputed master of the medium.

In 1881 Homer abandoned his familiar subject matter of children and country scenes and moved to the fishing village of Cullercoats in England, where he began to paint the heroic life of the fisherfolk in their battle with the sea. He continued this subject matter after his return to the United States in late 1882 and his permanent move to isolated

Prout's Neck, Maine. He traveled to the Adirondacks and the Bahamas for recreation and subjects. During the 1890s his chief subject was the powerful sea itself. After late 1905 illness prevented Homer from painting, but near the end of his life he regained his strength and inspiration and painted important works.

BIBLIOGRAPHY
William Howe Downes, *The Life and Works of Winslow Homer* (Boston: Houghton Mifflin, 1911), with lists of paintings exhibited in group and solo exhibitions and in collection of Thomas B. Clarke, bibliography § Lloyd Goodrich, *Winslow Homer* (New York: Macmillan for Whitney Museum of American Art, 1944), with "Recollections of an Intimate Friendship," by John W. Beatty, bibliography, chronology § Albert Ten Eyck Gardner, *Winslow Homer—American Artist: His World and Work* (New York: Potter, 1961), with bibliography, chronology, list of collections § Philip C. Beam, *Winslow Homer at Prout's Neck* (Boston: Little, Brown, 1966), with bibliography § Melinda Dempster Davis, *Winslow Homer: An Annotated Bibliography of Periodical Literature* (Metuchen, N.J.: Scarecrow Press, 1975), with documentation to 1973, list of reproductions of works.

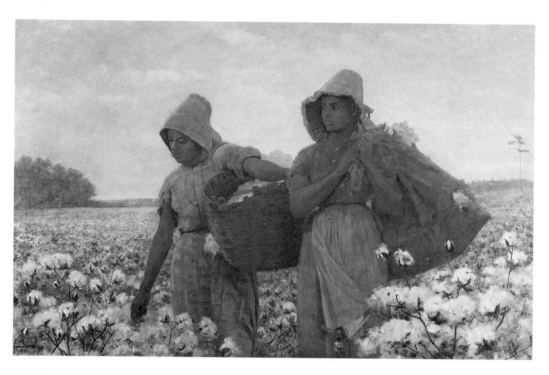

Homer, *The Cotton Pickers.*

The Cotton Pickers, 1876
(*The Cotton Pickers, North Carolina*)
Oil on canvas
24 x 38⅛ in (61 x 97.1 cm)
Signed and dated twice, lower left: WINSLOW
HOMER N.A. / 1876 [in black, over]
HOMER 1876 [in red]
Acquisition made possible through museum trustees
Robert O. Anderson, R. Stanton Avery, B. Gerald
Cantor, Edward W. Carter, Justin Dart, Charles E.
Ducommun, Mrs. F. Daniel Frost, Julian Ganz, Jr.,
Dr. Armand Hammer, Harry Lenart, Dr. Franklin D.
Murphy, Mrs. Joan Palevsky, Richard Sherwood,
Maynard J. Toll, and Hal B. Wallis
M.77.68
Color plate, page 44

Apparently during the period 1874–76 Homer returned for visits to Petersburg, Virginia, where, as a correspondent illustrator, he had spent time during the final siege of the Civil War. He made studies for and may have painted there a series of watercolors and paintings of the life of rural blacks. Critics hailed him as the first artist to have seen the possibilities of this untapped source of subject matter. In a historical perspective one can see how exceptional these paintings are for their realism and sensitive treatment of their subjects in contrast to the caricatured portrayals Homer had joined others in painting during and after the Civil War period.

The Cotton Pickers is quite simply the artist's most monumental painting of the figure; that it should also be of black subjects is remarkable. In painting rural workers in such heroic terms, Homer was no doubt drawing upon a tradition well developed in various European countries by 1876, perhaps best known today in the work of Jean-François Millet (1814–1875) and Jules Breton (1827–1906). Like them, Homer painted his rural workers as graceful majestic figures, but he chose as his subject unmistakably American materials. Homer brought the same respect and sympathy the French artists had for their nation's peasants to bear on his representations of American blacks. Presented from a low vantage point, these powerful figures fill the

canvas and dominate the composition. They are also portrayed as individuals, the figure on the right, gazing into the distance, a particularly poignant image of inner life and of aspiration. *The Cotton Pickers* was the climax of Homer's early figural style, and one of his most profoundly original works.

PROVENANCE
The artist, 1876–77 § Private collection, England, 1877–1911 § Dr. Charles B. Guinn, Carthage, Mo., 1911–44 § With Wildenstein & Co., New York, 1944–47 § James Cox Bandy II, New York, c. 1947–71 § Mrs. James Cox Bandy II (by descent), New Jersey, 1971–77.

ON DEPOSIT
Museum of Fine Arts, Boston, 1977.

EXHIBITIONS
New York, Century Club, March 10, 1877, no. 4 § London, Royal Academy of Arts, *Annual Exhibition*, 1878, no. 60, as *Cotton Pickers—North Carolina* § Chicago, Young's Art Galleries, *Paintings by Eminent American Old Masters and by Some of the Prominent Living American Artists*, [1916], no. 16, p. 28, repro., p. 29 § New York, Whitney Museum of American Art, *Winslow Homer Centenary Exhibition*, 1936–37, no. 13 § New York, Whitney Museum of American Art, *Oils and Watercolors by Winslow Homer*, 1944, entries not numbered § New York, Wildenstein & Co., *A Loan Exhibition of Winslow Homer*, 1947, no. 19, repro., p. 33 § LACMHSA, *Winslow Homer, Eastman Johnson*, 1949, no. 5, unpaginated, with list of exhibitions and references § Washington, D.C., Corcoran Gallery of Art, *American Processional*, 1950, published by the National Capital Sesquicentennial Commission, no. 279, repro., p. 208 § Washington, D.C., National Gallery of Art, and others, *Winslow Homer: A Retrospective Exhibition*, 1958–59, no. 34, repro., p. 45 § New Haven, Conn., Yale University Art Gallery, *American Art from Alumni Collections*, 1968, no. 106, repro., unpaginated § Boston, Museum of Fine Arts, and others, *A New World: Masterpieces of American Painting, 1760–1910*, 1983–84, no. 62, p. 107, essay by Theodore E. Stebbins, Jr., pp. 273–74, entry by John Caldwell and Carol Troyen, repros., pp. 123, 273.

LITERATURE
Francis Hopkinson Smith, *American Illustrators* (New York: Scribner's, 1892), part 4, pp. 49–50, gives circumstances of sale and description § Leila Mechlin, "Winslow Homer," *International Studio* 34 (June 1908): CXXVI § Downes, *Homer*, p. 89 § "A Fine Winslow Homer," *American Art News* 15 (December 9, 1916): repro., 1, as *The Cotton Pickers, North Carolina* § Theodore Bolton, "The Art of Winslow Homer: An Estimate in 1932," *Fine Arts* (New York) 18 (February 1932): 53, listed in cat. of oil paintings § *Index 20th Cent. Artists* 1 (November 1933): 8; reprint, p. 31; listed § Goodrich, *Homer*, p. 59 § Margaret Breuning, "Greatness of Homer Seen

Anew at Whitney," *Art Digest* 19 (October 15, 1944): 8 § "Winslow Homer: His Famous Pictures Assembled in a Notable Show," *Pictures on Exhibit* 9 (March 1947): 4, repro., 5 § Lloyd Goodrich, *Winslow Homer* (New York: Braziller, 1959), p. 29, pl. 34, p. 56 § Gardner, *Homer*, repro., p. 75 § Jean Gould, *Winslow Homer: A Portrait* (New York: Dodd, Mead, 1962), pp. 156, 158, repro., p. 159 § Brunswick, Maine, Bowdoin College Museum of Art, *The Portrayal of the Negro in American Painting*, exh. cat., 1964, unpaginated, essay by Sidney Kaplan § Sidney Kaplan, "The Negro in the Art of Homer and Eakins," *Massachusetts Review* (Winter 1966): 112 § New York, Whitney Museum of American Art, and others, *Winslow Homer*, exh. cat., 1973, p. 32, text by Lloyd Goodrich § Davis, *Homer Bibliography*, pp. 18, 69, as *Cotton Pickers* and *Cotton Pickers, North Carolina* § "New Acquisition," *LACMA Members' Calendar* 15 (November 1977): unpaginated, repros., detail as cover, frontispiece § LACMA 1977, pp. 138–39, repro., p. 138 § "American Art Department," *LACMA Report 1975–1977* (1978), p. 12, repros., detail as cover, frontispiece § Michael Quick, "Homer in Virginia," *LACMA Bulletin* 24 (1978): 60–81, repro., p. 60 § "Winslow Homer Masterpiece," *Antique Collector* 49 (February 1978): 41, repro. § "Art Across America," *Apollo* 107 (March 1978): repro., p. 223 § "La Chronique des arts: principales acquistions des musées en 1977," *Gazette des Beaux-Arts*, 6th ser., 91 (March 1978): fig. 242, supp. 54 § "Museum Accessions," *Antiques* 114 (August 1978): 250, repro. § Christopher Wood, "The Royal Academy of 1878," *Nineteenth Century* 4 (Autumn 1978): 62, fig. 11 § Gordon Hendricks, *The Life and Work of Winslow Homer* (New York: Harry N. Abrams, 1979), pp. 104, 129, 278, listed in checklist of works as no. CL-8, fig. 164, p. 107 § Mary Ann Calo, "Winslow Homer's Visits to Virginia during Reconstruction," *American Art Journal* 12 (Winter 1980): 10, 19, 25, fig. 19, 21 § William Wilson, *The Los Angeles Times Book of California Museums* (New York: Harry N. Abrams, 1984), p. 150, pl. 132, p. 152 § Reinhard Schultz, "Art and Labor in the United States," in Philip S. Foner and Reinhard Schultz, *The Other America: Art and the Labour Movement in the United States* (London: Journeyman Press, 1985), p. 15, notes the avoidance of depicting the plight of farm laborers, repro., p. 65 § Fort 1986, pp. 421, 424 § LACMA 1988, p. 17, repro. § Fine Arts Museums of San Francisco and others, *Winslow Homer: Paintings of the Civil War*, exh. cat., 1988 (copublished with Bedford Arts, San Francisco), p. 38, essay by Marc Simpson § Houston, Menil Collection, and others, *Winslow Homer's Images of Blacks: The Civil War and Reconstruction*, exh. cat., 1988 (copublished with University of Texas Press, Austin), p. 9, introduction by Richard J. Powell, pp. 95–97, essay by Peter H. Wood and Karen C. C. Dalton analyzes painting in terms of social criticism and labor relations in the South, suggest that the optimism for the future conveyed by the two women is dampened by the realities of violence and hardships of Reconstruction, fig. 51, p. 97.

Moonlight on the Water, early 1890s;
restretched in new format c. 1906
(*Marine Study; Moonlight; Watching the Rapids*)
Oil on canvas
15¹¹/₁₆ x 31⁷/₁₆ in (39.9 x 79.8 cm)
Inscription in another hand on verso: Painted by /
Winslow Homer 1906 / C. S. Homer / Executor
Inscription in another hand on stretcher bar:
Moonlight on Water Painted by Winslow Homer /
about 1906 / C. S. Homer
Paul Rodman Mabury Collection
39.12.10

their positions are reversed). It can also be
related to the painting *Moonlight, Wood Island
Light,* 1894 (Metropolitan Museum of Art,
New York), because of the exceptionally bold
technique of both paintings. According to the
art historian William Downes, that picture
was painted in 1894 during an impulsive four
or five hours' work one night, entirely by
moonlight, a seemingly impossible illumination
for judging colors. Because of its exceptionally
free technique, the museum's painting is dif-

Homer, *Moonlight on the Water.*

While living in Cullercoats in 1881–82, Homer
reinterpreted the popular image of women anx-
iously searching the stormy North Sea for their
loved ones. Quite unlike those heroic figures
are the diminutive silhouettes in the museum's
painting, who very well may represent the
summer visitors from the nearby hotels whom
Homer and his family are known to have joined
on at least one occasion as they watched the
moonlit sea on the rocks near Homer's home
and studio at Prout's Neck, Maine. On that
occasion, the artist left the group, completing
on the porch of his studio the charcoal drawing
that formed the basis of his painting *A Summer
Night,* 1890 (Musée du Louvre, Paris), in
which the figure at left in the museum's paint-
ing seems to appear. Like the watercolor *A
Moonlit Sea,* 1890 (Wadsworth Atheneum,
Hartford), the museum's painting may be a
study for *A Summer Night;* or it may be an
independent work of years earlier, related
to the watercolor, *Northeaster,* dated 1883
(Brooklyn Museum), a daylight scene in which
two women in tam-o'-shanter and round bon-
net watch the sea from the rocks (although

ficult to date on the basis of style. The con-
nection with the works of 1890 seems most
persuasive. For Homer, the moonlit sea was
a recurring romantic theme in which the
otherwise threatening sea seems tamed and
charmed. The violence of the sea in *Moonlight
on the Water* is somewhat unusual within
this group.

On the back of the painting the artist's
brother Charles, his executor, indicated the
date 1906, a period when Homer was known
to have begun no new pictures, only repainting
old ones. While there is no evidence of repaint-
ing on the picture's present surface, it may have
been at this time that Homer restretched the
painting, greatly changing its proportions by
folding portions of the painting back around
the stretcher at the top and sides to give it its
present, unusually elongated shape. In adopting
this format, Homer may have meant to accen-
tuate the characteristics of the painting that
relate to the Japanese prints he admired—the
theme of the great wave, diagonal composi-
tional elements, silhouetted figures, and strong
surface design.

PROVENANCE

The artist § Estate of the artist § With M. Knoedler & Co., New York, 1917 § Dr. George Woodward, to 1918 § With O'Brien Art Galleries, Chicago, 1918–21 § With John Levy, New York, 1921–23 § Paul Rodman Mabury, Los Angeles, 1923–39.

EXHIBITIONS

Los Angeles Art Association, *Loan Exhibition of International Art*, 1937, no. 203, as *Moonlight* § LACMHSA, *Temporary Installation and Catalogue of the Paul Rodman Mabury Collection*, 1939, no. 11, as *Marine Study* § Long Beach (Calif.) Museum of Art, *Old and Modern Masters from California Museums*, 1952, no cat. traced § New York, Metropolitan Museum of Art, and Boston, Museum of Fine Arts, *Winslow Homer: A Retrospective Exhibition*, 1959, no. 77 in New York and no. 71 in Boston, dated 1906 § Santa Barbara (Calif.) Museum of Art, and San Francisco, California Palace of the Legion of Honor, *Painters by the Sea*, 1961, no cat. traced § Spokane, International Exposition on the Environment, *Our Land, Our Sky, Our Water*, 1974, no. 5.

LITERATURE

Archiv. Am. Art, Macbeth Gallery Papers, Macbeth Gallery to Paul Rodman Mabury, September 25, 1937 (microfilm roll 2608, fr. 532); Mabury to Robert W. Macbeth, October 8, 1937 (ibid., frs. 529–30); Macbeth Gallery to Mabury, October 14, 1937 (ibid., fr. 528); discuss dealer John Levy's account of circumstances of painting's creation § LACMHSA, *The Paul Rodman Mabury Collection of Paintings*, c. 1940, p. 26, as *Watching the Rapids* § LACMA, Registrar's files, Lloyd Goodrich to Donelson Hoopes, February 23, 1973, with annotated worksheet, gives early provenance, describes, disputes date of 1906 and suggests that painting was probably a sketch for *A Summer Night* and therefore c. 1890, mentions as being painting 4769 in Knoedler "List of Winslow Homer Oils" § Gordon Hendricks, *The Life and Work of Winslow Homer* (New York: Harry N. Abrams, 1979), p. 278, listed in checklist of works as no. CL-9, repro.

Ross Turner

Born June 29, 1847,
Westport, New York
Died February 12, 1915,
Nassau, Bahamas

Ross Sterling Turner was a painter, watercolorist, and illustrator active in the Boston area known for his landscapes and floral subjects. As a youth he moved with his family to Williamsport, Pennsylvania, and in 1862 to Alexandria, Virginia. In 1875 he worked as a draftsman for the Patent Office in Washington, D.C., before leaving in 1876 to study in Europe, first briefly in Paris and then in Munich. He apparently did not enroll in the Royal Academy of the Fine Arts but instead sought informal instruction from the more experienced American students there, particularly J. Frank Currier (1843–1909). Loosely associated with the "Duveneck boys" after about 1879, Turner painted in Venice and Florence, and he also worked in Rome. In 1882 he settled in Boston, exhibiting more watercolors than oil paintings. He was closely associated with CHILDE HASSAM, becoming known for his impressionist watercolor paintings of gardens. He married in 1885 and moved to Salem, Massachusetts, but maintained a Boston studio until 1903. He had a summer house and studio in Wilton, New Hampshire. He was active as an instructor in the Boston area, teaching privately, at Grundmann Studios, at the Massachusetts Institute of Technology, and after 1909 at the Massachusetts Normal Art School. Turner wrote on watercolor technique and other art subjects. In 1899 he exhibited watercolors of Mexican scenes painted during a trip in 1898. He frequently traveled to the Caribbean and elsewhere in search of motifs.

BIBLIOGRAPHY

Boston Public Library, Art Division, artist's file, clippings § Frank T. Robinson, *Living New England Artists* (1888; reprint, New York: Garland, 1977), p. 173–78 § S. C. de Soissons, *Boston Artists: A Parisian Critic's Notes* (Boston: N.p., 1894), pp. 90–93 § Arthur Chamberlain, "Boston Artists: Walter Gilman Page—Ross Turner," *Art Interchange* 44 (December 1900): 134–36 § Boston, Museum of Fine Arts, *The Bostonians: Painters of an Elegant Age, 1870–1930*, exh. cat., 1986, p. 228, biographical note by Erica E. Hirshler.

Hollyhocks, 1876

Oil on canvas
31¼ x 16¹/₁₆ in (794 x 41.1 cm)
Signed and dated lower left: Ross Turner / Munchen 1876
Gift of Warren J. Adelson and LaTrelle B. Adelson
M.81.250

Few paintings from Turner's Munich period are known. Turner's mentor in Europe, Currier, was the most active still-life painter among the Americans in Munich and may have inspired Turner to attempt to work in that genre. Turner sent two still-life paintings from Munich to the Society of American Artists' annual in 1880. Of those known today, closest to the museum's paintings is *Still Life with Swords*, 1880 (with Child's Gallery, Boston), which bears the inscription "Munich 80." Although more finished, it shares the warm

Turner, *Hollyhocks.*

background and extremely oblong format of *Hollyhocks* and its concentration of incident at one end of the painting.

In an article on composition in 1896 (*The Art Interchange* 36 [February 1896]: 34) Turner praised oriental art, and Japanese motifs had appeared in his work by the mid-1880s. Although a consciousness of Japanese design is not generally associated with Munich in the 1870s, *Hollyhocks'* narrow, vertical format and flat, decorative arrangement of leaves and flowers against a lighter, somewhat golden background suggest that Turner was already aware of Japanese art and decorative concerns. The unfinish of the roughed-in lower half of the canvas also anticipates the tendency to simplification and reduction, which is seen—and was commented upon—in Turner's later still-life compositions. However, decorative, vertical still-life paintings with light backgrounds by the Austrian artist Hans Makart (1840–1884) are known. One of the outstanding students of the Munich academy in the 1860s, Makart continued to exert a strong influence on decorative painting in Munich even after his removal to Vienna.

PROVENANCE
With Coe Kerr Gallery, New York, to 1981.

EXHIBITION
Probably New York, Society of American Artists, *Third Exhibition,* 1880, no. 8 or 14.

Ernest Narjot

Born December 25, 1826,
near Saint-Malo, France
To United States 1849
Died August 24, 1898,
San Francisco, California

Ernest-Etienne Narjot de Franceville was one of San Francisco's foremost artists during the 1870s and 1880s. The son of painter Philippe Pierre Narjot de Franceville, Ernest Narjot studied art in Paris before joining the Gold Rush to California in 1849, sailing around Cape Horn to San Francisco. He both painted and prospected and in 1852 joined a mining expedition to Sonora, Mexico, where he settled and married a member of the Santos Ortiz family in 1860. In 1865 he returned with his wife to San Francisco, where he devoted himself to painting, achieving success with his portraits, landscape and genre paintings, and decorations for churches and public buildings. He was a member of the San Francisco Art Association and the Bohemian Club and was a frequent contributor to the annual Industrial Exhibitions of the Mechanics Institute, often winning cash awards. While working on frescoes in the tomb of Leland Stanford (destroyed 1906), paint dropped in one eye, resulting in partial blindness. The accident greatly depressed him, and although he continued to paint he created no significant work thereafter. In his later years he suffered from paralysis and delusions of grandeur. Unfortunately many of his paintings were destroyed in the fire that followed the San Francisco earthquake of 1906.

BIBLIOGRAPHY
Sacramento, Calif., California State Library, California Section, artist's file § Albert Dressler, *California's Pioneer Artist, Ernest Narjot* (San Francisco, 1936), with introduction by Louise Narjot Howard § Ellen Schwarz, *Nineteenth-Century San Francisco Art Exhibition Catalogues: A Descriptive Checklist and Index* (Davis: University of California, 1981), p. 104 § Edan Milton Hughes, *Artists in California, 1786–1940* (San Francisco: Hughes, 1986), pp. 327–28, with bibliography.

Narjot, *Portrait of a Girl with Dog.*

Although Narjot is best known for his scenes of the Gold Rush and life in early California, he was also active as a portraitist, and several portraits of children in outdoor settings are known. The subject of this painting remains unidentified. Her dark hair and pierced ears suggest that the child was probably Hispanic, and her informal dress suggests this is a family portrait rather than a commissioned work. Her age and the painting's date preclude her being one of the artist's own daughters, however. Narjot often included a dog in his portraits of children.

PROVENANCE
Mr. and Mrs. Willard William Erbeck, Sr., San Fernando, Calif., to 1954.

LITERATURE
LACMA, American Art department files, memo from Edward Maeder to Ilene Susan Fort, July 8, 1985, suggests that based on her attire the sitter is either Italian or Hispanic.

Portrait of a Girl with Dog, 1879
Oil on canvas mounted on board
34¹⁵/₁₆ x 39¹³/₁₆ in (88.8 x 101.1 cm)
Signed and dated lower right: E NARJOT / 1879
Gift of Mr. and Mrs. Willard William Erbeck, Sr.
54.35

Mary Cassatt

Born May 22, 1844,
Allegheny City, Pennsylvania
Died June 14, 1926,
Mesnil-Théribus, France

Mary Stevenson Cassatt holds a unique place in the history of American art. The only American to participate in the famed impressionist exhibitions, she achieved a reputation equal to those of her French counterparts.

Born near Pittsburgh, Cassatt received her early training at the Pennsylvania Academy of the Fine Arts in Philadelphia. In 1866 she briefly studied in the atelier of Charles Chaplin (1825–1891) and two years later exhibited for the first time at the Paris Salon. After extensive travel and study in Italy, Spain, Belgium, and the Netherlands, she settled permanently in France. Upon the invitation of Edgar Degas (1834–1917), who became her close friend and mentor, she showed in the *Fourth Impressionist Exhibition* of 1879 as well as those of the next three years and that of 1886. She also exhibited, usually more conservative paintings, in the United States, and she painted her only mural for the World's Columbian Exposition held in Chicago in 1893.

Typical of the impressionists was her use of a light palette and vigorous brushwork and interest in Japanese art and modern themes. While best known for her mother and child images, she also depicted various aspects of upper-middle-class life, such as scenes of the boudoir and theater. The figure, usually female, always dominates her images.

Cassatt became one of the outstanding printmakers of the period. She was also instrumental in encouraging American collectors, such as Louisine Havemeyer, to acquire paintings by the French impressionists at a time when few Europeans were interested in their art.

BIBLIOGRAPHY
Achille Segard, *Mary Cassatt: Un peintre des enfants et des mères* (Paris: Librairie Paul Ollendorff, 1913), with lists of exhibitions and collections, bibliography § Adelyn Dohme Breeskin, *Mary Cassatt: A Catalogue of the*

Graphic Work (1948; 2d rev. ed., Washington, D.C.: Smithsonian Institution Press, 1981) § Adelyn Dohme Breeskin, *Mary Cassatt: A Catalogue Raisonné of the Oils, Pastels, Watercolors, and Drawings* (Washington, D.C.: Smithsonian Institution Press, 1970), with bibliography, indexes of owners and sitters § Griselda Pollock, *Mary Cassatt* (New York: Harper and Row, 1980), with chronology § Nancy Mowll Mathews, ed., *Cassatt and Her Circle: Selected Letters* (New York: Abbeville, 1984), with chronology, genealogy, bibliography.

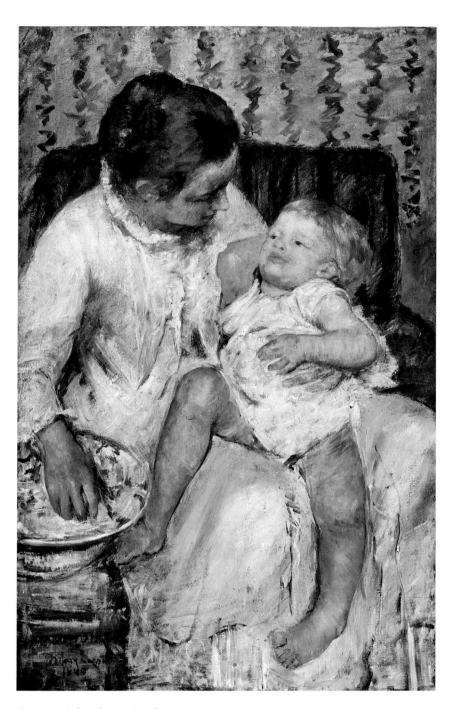

Cassatt, *Mother about to Wash Her Sleepy Child.*

Mother about to Wash Her Sleepy Child, 1880

(*Baby's Toilet; The Bath*)
Oil on canvas
39⁷/₁₆ x 25⁷/₈ in (100.3 x 65.8 cm)
Signed and dated lower left: Mary Cassatt / 1880
Mrs. Fred Hathaway Bixby Bequest
M.62.8.14
Color plate, page 46

This painting is considered among Cassatt's earliest, if not her first, treatment of her popular mother and child image. According to Achille Segard, the painting was exhibited during April 1880 in the *Fifth Impressionist Exhibition*. Although none of Cassatt's contributions is enumerated in the catalogue, she is known to have shown eight paintings. If *Mother about to Wash Her Sleepy Child* was included, then the customary explanation of Cassatt's use of this theme, i.e., that she began painting the subject after spending much time with her nieces and nephews during her brother Alexander's visit to France in the summer of 1880, is incorrect. Whatever her initial motivation, Cassatt would devote nearly one-third of her artistic production to such themes, as did many artists of the period.

Mother about to Wash Her Sleepy Child is an example of Cassatt's work as an impressionist, shortly before her mature, more solid style began to emerge. In the 1870s, no doubt inspired by Degas and other French impressionists, Cassatt began depicting intimate domestic scenes, often of figures in interiors. In this painting a woman tenderly washes her child. The image is cropped on both sides—a favorite device of Degas, who borrowed it from contemporary photographs and Japanese prints —and the entire scene is slightly tilted up and compressed into the narrow foreground. The stripes of the chair's upholstery and the wallpaper intensify this verticality. While the Japanese qualities of Cassatt's art are usually considered in terms of her later paintings and prints, she actually assimilated the oriental aesthetic quite early. Already apparent in *Mother about to Wash Her Sleepy Child* are the use of an intimate subject and a skillfully balanced surface design incorporating areas of patterning, both encouraged by the example of Japanese prints.

Historians have often commented on the pose of the child, especially the position of his legs, finding sources in Madonna and Child images by Parmigianino (1503–1540) and Antonio Correggio (1494–1534). Although Cassatt knew of Italian religious painting and late nineteenth-century artists tended to dress biblical persons in contemporary attire, such historical sources are not necessary to explain the pose. Such awkward naturalism is quite typical of works by her mentor, Degas, and

demonstrates how Cassatt utilized every aspect of the scene to convey the modernity, the untraditional representation, of the image. The overall surface is quite sketchy, as Cassatt vigorously brushed out contour lines with thick pigment to convey a sense of the momentary. Nevertheless, the form is not lost, as demonstrated by the mother's superbly delineated right hand.

In the 1870s, influenced by the impressionists, Cassatt began to lighten and brighten her palette. In her work she reflects the impressionist fascination with the color white. Although the palette used here is lighter than that of her previous paintings, it still exhibits an intense hue, as Cassatt explored the reflection of the blue and green of the setting and the flesh tones on the white attire of the figures and the interaction of all the colors. The delicate tints and brushwork are combined to create a shimmering surface.

The painting was bought by Mr. and Mrs. Alfred Atmore Pope, Americans whom Cassatt met in Naugatuck, Connecticut, in 1898–99 during her first trip home since the Franco-Prussian War. Pope had amassed a fortune in the steel industry, and by the time of his introduction to Cassatt had already begun to collect impressionist paintings, which now constitute the collection of the Hill-Stead Museum, Farmington, Connecticut. The Popes' daughter, Theodate, became Cassatt's most intimate young friend.

Cassatt, *Enfant Entendu,* n.d., see Related Work.

RELATED WORK
Enfant Entendu, n.d., pastel on paper, 24¼ x 18¼ in (61.6 x 46.4 cm). Antoinette and Isaac Arnold, Jr., Houston, Tex.

PROVENANCE
The artist, 1880–c. 1898/1900 § Mr. and Mrs. Alfred Atmore Pope, Cleveland, and Farmington, Conn., by 1900 § Mrs. John W. Riddle (Theodate Pope Riddle; by descent), Farmington, Conn., by 1923 to 1945(?) § With M. Knoedler & Co., New York, by 1945 to 1946 § Mrs. Fred Hathaway Bixby, Long Beach, Calif., 1946–62.

ON DEPOSIT
Wadsworth Atheneum, Hartford, Conn., 1927–37, as *The Bath* § Minneapolis Institute of Arts, 1945–46, as *The Bath.*

EXHIBITIONS
Possibly Paris, 10 rue des Pyramides, *5e Exposition de Peinture [Impressionist],* 1880, not listed in catalogue but in exhibition according to Segard (see Literature) § New York, Durand-Ruel, *Mary Cassatt,* 1895, no. 9 § Boston, Saint Botolph Club, *Paintings by Mary Cassatt,* 1909, no. 20 § Long Beach (Calif.) Municipal Art Center, [exhibition title unknown], 1953, no cat. traced, as *Mother and Child* § Balboa, Calif., Fine Arts Patrons of Newport Harbor, Pavilion Gallery, and LACMA, *Sterling Holloway's "Especially for Children,"* 1965–66, no. 4, as *The Bath* § Omaha, Joslyn Art Museum, *Mary Cassatt among the Impressionists,* 1969, no. 3, repro., p. 54, as *The Bath* § Washington, D.C., National Gallery of Art, *Mary Cassatt, 1844–1926,* 1970, no. 21, p. 23, repro., p. 58 § Houston, Tex., Meredith Long & Co., *Americans at Home and Abroad, 1870–1920,* 1971, no. 2, repros., pp. 8, 17 § Newport Beach, Calif., Newport Harbor Art Museum, and Santa Barbara (Calif.) Museum of Art, *Mary Cassatt, 1844–1926,* 1973–74, no. 5, unpaginated, introduction by Betty Turnbull, repro. § LACMA and University of California at Riverside Gallery, *The Impressionists and the Salon, 1874–1886,* 1974, no. 11, unpaginated, repro., as *The Bath* § LACMA and others, *Women Artists: 1550–1950,* 1976–77, no. 89, pp. 239, 351, with entry, list of exhibitions, literature by Nancy Mowll, repro., p. 238 § Ann Arbor, University of Michigan, Museum of Art, *The Crisis of Impressionism, 1878–1882,* 1979–80, no. 12, p. 84, with entry by Jacquelynn Baas Slee, repro., p. 85 § Moscow, State Tretyakov Museum, and others, organized by Smithsonian Institution Traveling Exhibition Service, *New Horizons: American Painting, 1840–1910,* 1987–88, no. 21, p. 60, repro., p. 61.

LITERATURE
Segard, *Cassatt,* p. 203, mentions it was in the fifth impressionist exhibition, repro., overleaf p. 12 § Edith Valerio, *Mary Cassatt* (Paris: Crès, 1930), pp. 6–7 § *Index 20th Cent. Artists* 2 (October 1934): 5; reprint, p. 251; listed, as *Baby's Toilet* § "La Chronique des arts," *Gazette des Beaux-Arts,* 6th ser., 61 (February 1963): supp. 43, repro. § LACMA, *Art Calendar* 8 (Fall 1964): 1, repro., cover, as *The Bath* § Breeskin, *Cassatt: Catalogue . . . of Oils,* p. 60, listed in cat. raisonné as no. 90, with provenance, lists of exhibitions and reproductions, repro. § E. John Bullard, *Mary Cassatt: Oils and Pastels* (New York: Watson-Guptill in association with National Gallery of Art, Washington, D.C., 1972), pp. 15, 36, pl. 8, p. 37 § John Wilmerding, ed., *The Genius of American Painting* (New York: Morrow, 1973), p. 172, repro. § E. John Bullard, "An American in Paris: Mary Cassatt," *American Artist* 37 (March 1973): 75, repro., 45 § Henry J. Seldis, "Mary Cassatt . . . The Rebel Retrieved at Newport Beach," *American Art Review* 1 (March/April 1974): repro., 62 § Gerald F. Brommer, *Movement and Rhythm* (Worcester, Mass.: Davis, 1975), repro., p. 66 § LACMA 1977, pp. 140–41, repro., p. 140 § Jay Roudebush, *Mary Cassatt* (New York: Crown, [c. 1979]), p. 38, repro., p. 20 § Pollock, *Cassatt,* pp. 13–15, 67, pl. 12, p. 44 § Nancy Mowll Mathews, "Mary Cassatt and the 'Modern Madonna' of the Nineteenth Century," Ph.D. diss., New York University, 1980, p. 68, fig. 35, p. 279 § Frank Getlein, *Mary Cassatt: Paintings and Prints* (New York: Abbeville, 1980), p. 36, repro., p. 37 § Mathews, *Cassatt and Her Circle,* p. 275, fig. 39, p. 276 § William H. Gerdts, *American Impressionism* (New York: Abbeville, 1984), pp. 39, 310, fig. 27, p. 42 § Stewart Buettner, "Images of Modern Motherhood in the Art of Morisot, Cassatt, Modersohn-Becker, Kollwitz," *Woman's Art Journal* 7 (Fall 1986–Winter 1987): 16, fig. 4, 18 § Nancy Mowll Mathews, *Mary Cassatt,* Library of American Art (New York: Harry N. Abrams, in association with National Museum of American Art, Smithsonian Institution, 1987), p. 60, fig. 47, p. 55 § LACMA 1988, p. 18, repro.

Sanford R. Gifford

Born July 10, 1823,
Greenfield, New York
Died August 29, 1880,
New York, New York

Sanford Robinson Gifford was a leading figure among the second generation of the Hudson River school. The year of his birth his family moved to Hudson, on the east bank of the Hudson River opposite the Catskill Mountains, where his father, owner of a successful iron foundry, raised his children in comfortable surroundings. Gifford attended Brown University in Providence, Rhode Island, from 1842 to 1844 but in 1845 went to New York to study drawing with John Rubens Smith (1775–1849). In 1846 he decided to dedicate himself to landscape painting, and he advanced rapidly in this specialty. His paintings were exhibited the following year at both the American Art-Union and the National Academy of Design, the latter of which elected him an associate member in 1850 and an academician in 1854. In 1857 he made his first trip to Europe, remaining two years. He served in the Union Army during the Civil War. In 1868 he made a shorter visit to Europe and the Near East. In 1870 he visited Colorado and Wyoming and in 1874 the West Coast. Throughout his career Gifford continued to paint both American and European scenes, based upon the sketches he had made while traveling. He was secretly married in 1877. In the early summer of 1880 his health began to fail, and he died of malarial fever.

BIBLIOGRAPHY
Archiv. Am. Art, Sanford R. Gifford Papers § New York, Century Association, *Gifford Memorial Meeting of The Century*, 1880, with addresses by John F. Weir, Worthington Whittredge, and Jervis McEntee § New York, Metropolitan Museum of Art, *A Memorial Catalogue of the Paintings of Sanford Robinson Gifford, N.A.*, 1881, with essay by John F. Weir, chronological list of known works § Austin, University of Texas, University Art Museum, and others, *Sanford Robinson Gifford, 1823–1880*, exh. cat., 1970–71, with introduction by Nicolai Cikovsky, Jr. § Ila Weiss, *Poetic Landscape: The Art and Experience of Sanford R. Gifford*, American Arts series (Newark: University of Delaware Press, 1988), with bibliography, appendixes of proportions and dimensions of canvases, annotated "List of Some of My Pictures" by the artist, 1874, updated 1880.

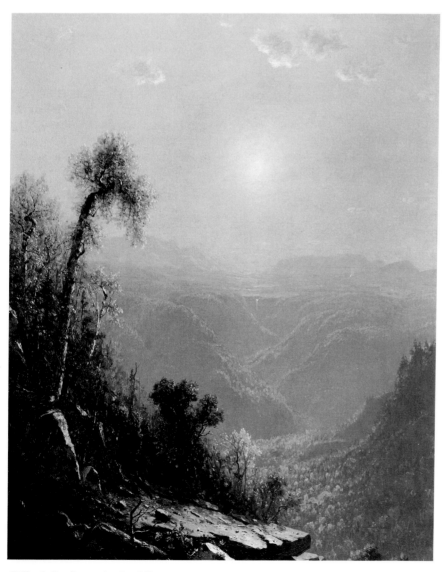

Gifford, *October in the Catskills.*

October in the Catskills, 1880
(*Autumn in the Adirondacks*)
Oil on canvas
36⁵/₁₆ x 29³/₁₆ in (92.2 x 74.2 cm)
Inscribed and dated on original wooden backing, now conserved: October in the Catskills / By S R Gifford 1880
Gift of Mr. and Mrs. J. Douglas Pardee, Mr. and Mrs. John McGreevey, and Mr. and Mrs. Charles C. Shoemaker
M.77.141
Color plate, page 47

In his address given at the memorial for Sanford Gifford, WORTHINGTON WHITTREDGE said that no autumn came that Gifford did not visit his mother in the town of Hudson and the nearby Catskills. He loved the mountains and painted them more than any other subject. The motif of this painting is the Kaaterskill, or Kauterskill, Clove, a scenic gorge of the small Kaaterskill Creek that extends about five miles between Haines Falls village and Palenville. It was a theme for numerous Hudson River school artists, and Gifford sketched there as early as 1845 and exhibited a painting of the clove. From this direct study, possibly together with others, he completed both the well-known *Kauterskill Clove,* 1862 (Metropolitan Museum of Art, New York), and the museum's painting *October in the Catskills,* eighteen years later. The artist was known for repeating favorite subjects with slight refinements. The true subject of the painting is the lighted atmosphere that fills a great natural bowl, as in some of his

other paintings. "With Mr. Gifford, landscape-painting is air-painting," wrote George Sheldon in 1879 (*American Painters* [New York: D. Appleton], p. 17). By sacrificing distant detail to the palpable, shimmering atmosphere, as in the museum's painting, Gifford achieved a poetic interpretation of impressions that the motif and nature in general had made on him. In this spirit he freely arranged and modified elements in his finished paintings, which were studio creations.

A comparison with the Metropolitan Museum's *Kauterskill Clove* (see illustration) shows how Gifford marshaled his materials in *October in the Catskills* for an entirely different effect and feeling. The vantage point is higher, eliminating the view of the lake but increasing awareness of the plain and mountains stretching into the distance. The artist has also moved the trees and rocks on the left from the near foreground to the immediate foreground. The combined effect of these changes is to sub-stitute, for the gentle progression into the distance in the Metropolitan Museum's paint-ing, a dramatic leap from a bulky, immediate foreground almost directly into the unin-habited far distance. This was a device often used by ALBERT BIERSTADT to enhance an impression of overwhelming distance. Also different is the quality of light in the two paintings. *Kauterskill Clove* is bathed in a deli-cate combination of yellows and blues, whereas the light in *October in the Catskills* is described by much hotter yellows and reds, emanating from a visible sun that seems to ignite the fore-ground foliage. Gifford has rearranged the ridges of the clove in a more regular arrange-ment that seems to center upon the sun. The sun is a potent force in the painting, appearing to dissolve the distant mountains into some-thing like the vortices that swirl within the landscapes of J. M. W. Turner (1775–1851). The distance is defined entirely in terms of the action of the sun, reflecting in the waterfall and tiny distant houses. The overall impression is that of a powerful force in a vast primeval wilderness.

A very similar painting of the same subject, dimensions, and date, but with the foreground rocks and trees reversed on the right side of the canvas, has recently appeared on the art market in New York (see illustration). It cannot be determined whether the provenance and early citations in the 1881 *Memorial Catalogue* refer to the museum's painting or this other one.

Gifford, *Kauterskill Clove,* 1862, oil on canvas, 48 x 39⅞ in (121.9 x 101.3 cm). Metropolitan Museum of Art, bequest of Maria DeWitt Jesup, 1914.

Gifford, *October in the Catskills,* 1880, see Related Works.

RELATED WORKS
Kauterskill Clove, in the Catskills, 1880, oil on canvas, 13⁵/₁₆ x 10¾ in (33.8 x 27.3 cm). Art Institute of Chicago § *October in the Catskills,* 1880, oil on canvas, 37¼ x 29¾ in (94.6 x 75.6 cm). James Maroney, New York.

PROVENANCE
Nelson Hollister, Hartford, Conn., 1881–97 (?) § With Kennedy Galleries, New York, as of 1963–64 § With Terry De Lapp Gallery, Los Angeles, 1964 § Steve Martin, Beverly Hills, Calif., as of 1964 § With Terry De Lapp Gallery, Los Angeles, to 1977.

EXHIBITIONS
Los Angeles, Terry De Lapp Gallery, *A Selection of Nineteenth-Century American Paintings,* 1964, entries not numbered, repro., cover, as *Autumn in the Adirondacks* § New York, Coe Kerr Gallery, *American Luminism,* 1978, no. 24, repro., unpaginated § Washington, D.C., National Gallery of Art, *American Light: The Luminist Movement, 1850–1875,* 1980, entries not numbered, p. 36, essay by Lisa F. Andrus describes composition as conventional for Gifford, p. 185, essay by David C. Huntington notes the painting superficially resembles Church's *Andes of Ecuador,* 1855 (Reynolda House, Museum of American Art, Winston-Salem, N.C.; repro., p. 153), pl. 4, p. 14.

LITERATURE
Possibly Metropolitan Museum, *Memorial Catalogue,* listed as no. 719, p. 45 § Ila Weiss, *Sanford Robinson Gifford* (New York: Garland Press, 1977), pp. XXVI–XXVII, discusses in terms of it being a transcription of *Sunset in the Adirondacks,* 1865 (private collection) § "New Acquisition: American Landscape," *LACMA Members' Calendar* 16 (May 1978): repro., unpaginated § LACMA, American Art depart-ment files, Ila Weiss to Nancy Dustin Wall Moure, October 25, 1978, discusses painting in context of other Adirondack and Catskill scenes and conjec-tures about circumstances of its commission § "American Art," *LACMA Report 1977–1979* (1980), p. 13 § Natalie Spassky and others, *American Paint-ings in the Metropolitan Museum of Art: Volume 2, A Catalogue of Works by Artists Born between 1816 and 1845,* ed. Kathleen Luhrs (New York and Princeton, N.J.: Metropolitan Museum of Art in association with Princeton University Press, 1985) p. 172, entry by Natalie Spassky discusses in relation to 1862 ver-sions § New York, Alexander Gallery, *The Hudson River School: Congenial Observations,* exh. cat., 1987, unpaginated, entry by Eva Peltz compares with other 1880 version and states that this other version, which is signed and dated, is no. 719 of *Memorial Catalogue* § Weiss, *Poetic Landscape,* pp. 157, 320–21, discusses in context of different variants of the Kauterskill Clove theme, p. 330, listed in Gifford's list of paintings, repro., p. 321.

George Inness

Born May 1, 1825, near
Newburgh, New York
Died August 3, 1894,
Bridge-of-Allan, Scotland

At the time of his death and well into this century, George Inness was considered to have been the greatest American landscape painter. The artist grew up in Newark, New Jersey, and New York City. Except for brief instruction from John Jesse Barker (1815–1860) and Regis François Gignoux (1816–1882), he was self taught. By 1844 Inness was exhibiting regularly at the National Academy of Design and in the following years made regular sales to the American Art-Union. He was elected an associate of the National Academy of Design in 1853. In 1851–52 he visited Italy and in 1853 France. During the early 1860s he lived in Medfield, Massachusetts, then Eagleswood, New Jersey, before moving back to New York in 1867.

Inness was elected to full membership in the National Academy of Design in 1868. From 1870 to 1875 he was in Italy and then in France before returning to Medfield. In 1877 he was a founding member of the Society of American Artists. The following year he moved to Montclair, New Jersey, thenceforth his permanent home. He sometimes wintered in Virginia and Florida and summered on Nantucket, Massachusetts. In 1891 he visited California. In 1884 a retrospective exhibition of his works was held at the American Art Galleries in New York.

BIBLIOGRAPHY
Elliott Daingerfield, *George Inness: The Man and His Art* (New York: Privately printed, 1911) § George Inness, Jr., *Life, Art, and Letters of George Inness* (New York: Century, 1917) § LeRoy Ireland, comp., *The Works of George Inness: An Illustrated Catalogue Raisonné* (Austin: University of Texas Press in cooperation with University Art Museum of University of Texas, 1965), with foreword by Robert G. McIntyre, chronology, list of exhibitions, bibliography § Nicolai Cikovsky, Jr., *The Life and Work of George Inness* (New York: Garland, 1977), with bibliography § LACMA and others, *George Inness*, exh. cat., 1985, with essays by Nicolai Cikovsky, Jr., and Michael Quick, with reprint of George Inness, "A Painter on Painting," *Harper's New Monthly Magazine* (1878), bibliography.

Inness, *October.*

October, 1882 or 1886
(*Autumn Landscape; Landscape; Near My Studio, Milton; October Woodlands*)
Oil on panel
19¹⁵/₁₆ x 29⅞ in (50.7 x 75.9 cm)
Signed and dated lower left: G Inness 1886
Paul Rodman Mabury Collection
39.12.12
Color plate, page 48

Inness apparently cared very little about the titles of his paintings. It is possible that many were titled by the executors of his estate and organizers of his memorial exhibition and that some of his works were even signed and dated after his death. During the early twentieth century dealers often gave to his paintings what they felt were more poetic titles.

When listed in the catalogue of the executor's sale, this painting was entitled *Near My Studio, Milton* and dated 1882. Its similarity in technique and motif to paintings of 1882, such as *June* (Brooklyn Museum), does seem greater than its resemblance to most paintings of 1886.

The painting's most striking feature, its firm structure of horizontal and vertical elements and their careful balance, might on the one hand seem to favor the later dating, since this principle of synthetic composition is strongest in the works of the artist's final ten years. On the other hand, this concept first seems to emerge as a governing principle in his paintings of 1882.

The painting's very deliberate structure was advanced for 1882 and even 1886 and may be considered among the earliest works organized according to such a conspicuously geometrical scheme. It is cut into equal quadrants by the horizon halfway up the picture surface and the central vertical line of the gap in the trees and its corresponding reflection halfway across the surface. The trees are arranged at measured intervals to add a rhythm to this balance. It is noteworthy, however, that Inness shortened the tall tree on the right, perhaps to avoid the monotony of too close a symmetry.

PROVENANCE
The artist, to 1894 § Estate of the artist, 1895 (sale, Fifth Avenue Art Gallery, New York, 1895, no. 230, as *Near My Studio, Milton,* dated 1882) § W. A. White, Boston, from 1895 § Alfred T. White (by descent), Brooklyn, to 1920 § Mrs. Adrian Van Sinderen (by descent), Brooklyn, 1920–21, as *October* § With Macbeth Gallery, New York, 1921 § Paul Rodman Mabury, Los Angeles, 1921–39, as *Autumn Landscape.*

EXHIBITIONS
New York, Fine Arts Building, *Inness Memorial Exhibition,* 1894, no. 71, as *Near My Studio* § San Diego, Palace of Fine Arts, *California Pacific International Exposition, Official Art Exhibition, Illustrated Catalogue,* 1936, no. 305, as *Landscape,* repro., p. 50 § Los Angeles Art Association, *Loan Exhibition of International Art,* 1937, no. 197, as *October Woodlands* § LACMHSA, *Temporary Installation and Catalogue of the Paul Rodman Mabury Collection,* 1939, no. 13, as *Autumn Landscape* § Pomona, Calif., Los Angeles County Fair Association, *Painting in the U.S.A., 1721–1953,* 1953, no. 72, repro., p. 24, as *Autumn Landscape* § Los Angeles, Barnsdall Park, Municipal Art Gallery, *The American Scene,* 1956, no cat. traced § Los Angeles, Barnsdall Park, Municipal Art Gallery, *Old Favorites Revisited,* 1959,

no. 26, repro., unpaginated, as *Autumn Landscape* § Austin, University of Texas, University Art Museum, *The Paintings of George Inness, 1844–94,* 1965–66, no. 105, p. 35, entry by Leroy Ireland § Oakland Museum and Santa Barbara (Calif.) Museum of Art, *George Inness Landscapes: His Signature Years, 1884–1894,* 1978–79, entries not numbered, p. 56, gives provenance, repro., p. 37 § LACMA and others, *Inness,* 1985–86, no. 46, pp. 35–36, essay by Michael Quick discusses painting as one of the clearest examples of Inness's "synthetic style," p. 168, entry by Cikovsky, repro., p. 169.

LITERATURE
Fifty Paintings by George Inness, with introduction by Elliott Daingerfield (New York: Privately printed, 1913), pl. 16, p. 49 § Archiv. Am. Art, Macbeth Gallery Papers, "Paintings Sold," card file, lists as *October* from Adrian Van Sinderen, sold to Mabury (microfilm roll 2823, fr. 1222); Macbeth Gallery-Paul Rodman Mabury correspondence, September 19–27, 1921 (roll N Mc 60B, frs. 30–43), concerning purchase of painting that Henry Miller of Macbeth Gallery considers an "extremely important Inness," for twelve thousand dollars; gallery to Mabury, September 30, 1921 (ibid., frs. 37–38), gives provenance and alternate title *Near My Studio, Milton,* states that collector/dealer Thomas B. Clarke thought it "one of the really great Innesses"; gallery to Mabury, October 4, 1921 (ibid., frs. 40–42); Mabury to Miller, October 20, 1921 (ibid., frs. 48–49), explains his disappointment with the intensity of the painting's color; Mabury to Macbeth Gallery, October 21, 1921 (ibid., fr. 45), prefers Inness's later, synthetic period; telegram, Miller to Mabury, January 16, 1922 (roll 2608, fr. 510), asks whether Mabury will sell Inness; Mabury to Miller, January 17, 1922 (ibid., fr. 511), Mabury will keep Inness for present; Mabury to Miller, January 17, 1922 (ibid., fr. 513–14), grown to appreciate the painting's color and tone, especially the soft, golden light; Mabury to Miller, June 3, 1922 (ibid., fr. 524), local people admiring painting, refers to it as a "big" picture in its scope and effects § *Index 20th Cent. Artists* 4 (December 1936): 362; reprint, p. 659; listed § LACMHSA, *The Paul Rodman Mabury Collection of Paintings* (c. 1940), p. 21, with provenance, repro., facing p. 21 § Higgins 1963, p. 127, no. 12 in checklist of Paul Rodman Mabury collection § Ireland, *Inness,* p. 249, listed in cat. raisonné as no. 1011, as *Near My Studio, Milton,* dated 1882, p. 306, listed in cat. raisonné as no. 1228, as *October,* dated 1886, both entries with provenance, exhibitions, bibliography, repro., p. 307 § Nicolai Cikovsky, Jr., *George Inness* (New York: Praeger, 1971), no. 73, repro., p. 125 § Alfred Werner, *Inness Landscapes* (New York: Watson-Guptill, 1973), p. 72, pl. 26, p. 73 § LACMA 1977, pp. 141–42, repro., p. 141.

Emil Carlsen

Born October 19, 1853,
Copenhagen, Denmark
To United States 1872
Died January 2, 1932,
New York, New York

At the turn of the century Soren Emil Carlsen was considered among the country's fore-most still-life painters. After studying architecture in Denmark, Carlsen emigrated to the United States in 1872, settling in Chicago, where he began to paint and to teach at the Art Institute. In 1875 he returned to Europe to study painting in Paris. For most of the next decade he lived in New York, supporting himself with teaching and other work as he gradually attained a reputation as a still-life painter. From 1884 to 1886 he worked in Paris, commissioned by an art dealer to paint still-life canvases. During this period he became known for his floral still lifes, especially of yellow roses. He lived in San Francisco from 1887 to 1891 and for two years was director of the School of Design of the San Francisco Art Association. He then moved permanently to New York, teaching at both the National Academy of Design and Pennsylvania Academy of the Fine Arts, Philadelphia. He married in 1896; his son Dines (1901–1966) was also an artist. His greatest success came shortly before the turn of the century and during the first two decades of this century, when he achieved fame for both his still lifes and his landscapes. His mature still lifes included both Chardinesque subjects and arrangements of oriental porcelains.

BIBLIOGRAPHY
California Art Research 4 (January 1937): 27–63, with lists of representative works, collections, and prizes, bibliography § Tyler (Tex.) Museum of Art, *Emil Carlsen,* exh. cat., 1973, with introduction by Meredith Long § San Francisco, Wortsman Rowe Galleries, and others, *The Art of Emil Carlsen, 1853–1932,* exh. cat., 1975, with reprints of early (1902–21) essays by Duncan Phillips, Eliot Clark, Arthur Edwin Bye, and others, lists of public collections and awards § New York, Hammer Galleries, *The Art of Emil Carlsen,* exh. cat., 1977, with essay by Dorothy Tananbaum, list of public collections § Jeffrey Stewart, "Soren Emil Carlsen," in *Plein Air Painters of California: The North,* ed. Ruth Lilly Westphal (Irvine, Calif.: Westphal Publishing, 1986): 52–57, with lists of studio locations, organizations, awards, and public collections.

Carlsen, *Still Life: Brass Bowl, Ducks, Bottles.*

Still Life: Brass Bowl, Ducks, Bottles, 1883
(*Still Life with Ducks*)
Oil on canvas
37¹¹/₁₆ x 50¹/₁₆ in (95.7 x 127.1 cm)
Signed and dated lower left: Emil. Carlsen
Gift of Jo Ann and Julian Ganz, Jr.
M.76.67.1

In 1883 Carlsen exhibited for the first time at the Pennsylvania Academy of the Fine Arts. At this point he was still a rising young artist,

but definitely a successful one. Although it is a still life of game, which were common among Carlsen's mature work, the museum's picture was painted before the artist developed his characteristic style during the coming half-decade. The painting's strong contrasts, rich chiaroscuro, and bold brushwork mark it as an early work, unlike the softly atmospheric, smoothly painted still-life canvases of his mature style. Nevertheless, it is a masterful painting, executed with economy and finesse. In its strongly asymmetrical arrangement and clear sense of pictorial geometry it reveals the essential qualities of Carlsen's approach to still life.

PROVENANCE
(Sale, Sotheby-Parke-Bernet, New York, *American Paintings, Drawings, Sculpture,* March 1967, no. 66, repro., p. 29) § Joseph D. Schwerin, New York and Newport, R.I., 1967–75 § Jo Ann and Julian Ganz, Jr., Los Angeles, 1975–76.

ON DEPOSIT
Yale University Art Gallery, New Haven, Conn., 1974.

EXHIBITION
New York, Coe Kerr Gallery, Inc., *150 Years of American Still Life Painting,* 1970, no. 40, repro., p. 27.

LITERATURE
William H. Gerdts and Russell Burke, *American Still-Life Painting* (New York: Praeger, 1971), p. 204, fig. 14-9, as *Still Life with Ducks,* p. 203 § "American Art Department," *LACMA Report 1975–1977* (1978), p. 12, repro., p. 13.

George Fuller

Born January 17, 1822,
Deerfield, Massachusetts
Died March 21, 1884,
Brookline, Massachusetts

George Fuller was one of the most important late nineteenth-century poetic painters. He began his career as an itinerant portrait painter in upstate New York in the early 1840s, first assisting his half-brother Augustus Fuller (1812–1873). For several months in 1842 he studied drawing in Albany, New York, with Henry Kirke Brown (1814–1886). Then he settled in Boston, where he joined the Boston Artists' Association to improve his draftsmanship and studied the art of GILBERT STUART and Washington Allston (1779–1834). Intending to continue his training while improving his portrait business, at the end of 1847 Fuller moved to New York, where he enrolled at the National Academy of Design and became immersed in the social circle of landscape painters and Pre-Raphaelites, including John Durand, William Stillman (1828–1901), and SANFORD R. GIFFORD. Three painting trips to the South, beginning in 1849 and continuing in the late 1850s, prompted his interest in depicting the life of the southern black.

With the death of his father in 1859 Fuller was forced to renounce his career to manage the family farm. Before returning to Deerfield, he made his only trip to Europe, visiting galleries in England and on the Continent, where he admired Venetian painting as well as the art of Edouard Frère (1819–1886), Jean-François Millet (1814–1875), and Jean-Baptiste-Camille Corot (1796–1875). Although he exhibited infrequently during the next fifteen years, he continued to paint during his leisure time. Financial problems with the farm prompted him to exhibit his paintings in 1876 at the Doll and Richards gallery in Boston. His paintings of fanciful female figures, blacks, and rustic genre scenes revealed a looser, more atmospheric style as well as liberal use of glazing and varnishing. This exhibition marked his full-time return to art and the beginning of a notable career as the farmer who painted in an advanced, yet spiritual style. He began to exhibit regularly in Boston and New York, and by 1880 the Society of American Artists accorded him the honor of being unanimously elected to full membership (he had been an associate member of the National Academy since 1857).

His themes have affinities with French Barbizon painting, but his sensibility was heralded by critics as representative of New England sentiment. They called him the Hawthorne of art.

BIBLIOGRAPHY

Deerfield, Mass., Memorial Libraries, Fuller-Higginson Papers (on microfilm, Archiv. Am. Art) § *George Fuller: His Life and Works* (Boston: Houghton, Mifflin, 1886), with introduction by Josiah B. Millet, essays by William D. Howells, Frank D. Millet, William J. Stillman, and others, list of all of Fuller's paintings § William I. Homer and David M. Robb, Jr., "Paintings by George Fuller in American Museums and Public Collections," *Art Quarterly* 24 (Autumn 1961): 286–94, checklist of known paintings § Sarah Burns, "A Study of the Life and Poetic Vision of George Fuller (1822–1884)," *American Art Journal* 13 (Autumn 1981): 11–37 § Sarah Burns, "George Fuller: The Hawthorne of Our Art," *Winterthur Portfolio* 18 (Summer–Autumn 1983): 123–45.

Girl with Turkeys, c. 1883–84
(Girl Driving Turkeys; Girl and Turkeys;
The Turkey Girl)
Oil on canvas
30 1/16 x 50 1/16 in (76.4 x 127.1 cm)
Signed lower left: G. Fuller
Inscribed on right stretcher bar: Copyrighted in
1884. by estate of G. Fuller. Boston.
Label on back of painting: A. A. WALKER & CO., /
IMPORTING / ARTISTS' COLORMEN, / 594 Washington Street, / BOSTON
Gift of William T. Cresmer
56.2

Rustic farm life not only furnished financial support for Fuller during the 1860s but also served as the main inspiration for his late landscapes. Even more than Millet and the other Barbizon painters he admired, Fuller viewed farm life in idyllic terms. His pastorals often consist of a small figure standing to the extreme side of a broad, open field. *Girl with Turkeys* is similar to *Turkey Pasture in Kentucky*, 1878 (Chrysler Museum, Norfolk, Va.) in which a single female stands to the left in the foreground near the flock of turkeys she is tending. During the last several years of his life Fuller created a number of such farm scenes, which reveal his rural New England heritage. As with all his pastorals, the activity depicted is of minor importance, for the open field with its light and air provide the vehicle for the artist to express the harmony of an idyllic rustic life.

Fuller painted the entire scene in his typical earthy, but nuanced palette of muted brown, beige, ocher, and khaki green. His handling of the paint was equally suggestive; the strokes, often applied one layer over another, and the scribbled effect of his brush handle drawn over the wet paint in the foliage suggest the activity of the trees, but the rest of the scene is enveloped in a delicate haze as the soft strokes of the atmosphere blur all outlines. Like other

Fuller, *Girl with Turkeys.*

advanced artists of the period, Fuller was as much interested in paint manipulation as in representation.

Contemporary critics recognized Fuller's poetic nature and his place in American culture. When this painting was exhibited at Doll and Richards an unidentified reviewer astutely noted:

> It is with the work of Fuller as it is with the work of Ralph Waldo Emerson. It matters little what one reads of Emerson . . . its influence is an indefinite exhilaration—or, rather, inspiration; the definite things he says are secondary in their value. So it is with Fuller. His pictures are impossible as nature but beyond value as dignifying and ennobling impulses. In the present instance the vague, phantasmal girl and her wandering turkeys, the shadowy hut close under the thick deep forest, the hazy shapes of trees . . . and the dull yellow sky, while none of them could be considered possible in the smallest degree, are yet details of a whole which is singularly impressive.

In the Fuller memorial volume *Girl with Turkeys* was dated to the artist's last year. The painting has a label from A. A. Walker of 594 Washington Street, who was a colorman located at such an address in Boston from 1877 to 1880. When it was sold at auction less than thirty years after its creation, the painting received a record price for a Fuller painting and the second highest price ever brought by a contemporary American picture at auction.

PROVENANCE

Estate of the artist, 1884 § Mr. Jewett, Brookline, Mass., by 1886 § With Williams and Everett, Boston § With William Macbeth, New York, to 1904 § Dr. Alexander C. Humphreys, New York, 1904–17 (sale, American Art Association, New York, *Illustrated Catalogue of the Very Notable Collection of American Paintings Formed by Dr. Alexander C. Humphreys,* 1917, no. 159, as *Girl and Turkeys*) § With Vose Galleries, Boston, 1917 § Worcester (Mass.) Art Museum, 1917–24 § With John Levy Galleries, New York, 1924, as *Girl Driving Turkeys* § Ralph Cudney, Chicago, by 1929, as *Girl Driving Turkeys* § With Vose Galleries, Boston, by 1939 § William T. Cresmer, Chicago, to 1956, as *Girl Driving Turkeys.*

EXHIBITIONS

Boston, Doll and Richards, [American paintings exhibition], c. 1883, no cat. traced § New York, The Engineers Club, [exhibition title unknown], c. 1904–11 § Boston, R. C. and N. M. Vose, *Exhibition of Paintings by George Fuller, A.N.A.,* 1917, no. 2, repro., unpaginated, as *Girl Driving Turkeys* § New York, Metropolitan Museum of Art, *Centennial Exhibition of the Works of George Fuller,* 1923, no. 33, pl. 33, p. 43, as *Girl with Turkeys,* dated 1884 § Pittsburgh, Carnegie Institute, *A Century of American Landscape Painting, 1800–1900,* 1939, no. 2 § Boston, Vose Galleries, *Inness and the Hudson River School,* 1944, no. 82, as *Girl Driving Turkeys.*

LITERATURE

Deerfield, Mass., Memorial Libraries, Fuller-Higginson Papers, unidentified newspaper clipping, "Art Notes," c. 1883 (Archiv. Am. Art, microfilm

roll 610, fr. 1493), reviews exhibition at Doll and Richards § *Fuller: His Life and Works,* p. 93, listed under 1884, as *Girl with Turkeys,* with owner § *American Art Annual* 14 (1917): 358, repro., facing 335, as *Girl and Turkeys* § "Humphreys Picture Sale (Second Session)," *American Art News* 15 (February 17, 1917): 7, as *Girl and Turkeys* § "Museum Gets the Fuller," *American Art News* 15 (February 24, 1917): 1, repro., as *Girl Driving Turkeys* § *American Magazine of Art* 8 (April 1917): 230, repro. § "Exhibitions Now On: Boston," *American Art News* 15 (April 21, 1917): 6, as *Girl Driving Turkeys* § James Britton, "George Fullers at Vose's," *American Art News* 15 (May 21, 1917): 4, as *Girl Driving Turkeys* § E. I. S., "Girl Driving Turkeys," *Bulletin of the Worcester Art Museum* 8 (October 1917): 53, 56, repro., 55 § "Purchases in 1916–1917," Worcester Art Museum, *Annual Report* 21 (1917): 16, lists as no. 13, as *Girl Driving Turkeys* § G. Frank Muller, "Paintings as an Investment," *Arts and Decoration* 9 (May 1918): 22, repro., 23, as *Girl with the Turkeys* § *Arts and Decoration* 11 (June 1919): repro., 56, as *Girl Driving Turkeys* § Worcester Art Museum, *Catalogue of Paintings and Drawings* (1922), p. 177,

lists, as *Girl Driving Turkeys* § William Howe Downes, "George Fuller's Pictures," *International Studio* 75 (July 1922): 271, repro., as *Girl Driving Turkeys* § Royal Cortissoz, *American Artists* (New York: Scribner's, 1923), p. 64 § "Fuller Centennial: An Attractive Show," *Art News* 21 (April 14, 1923): 5, as *Girl with Turkeys* § "Bostonians Admire New Vose Galleries," *Art News* 22 (May 31, 1924): 3, as *Girl Driving Turkeys* § Rilla Evelyn Jackman, *American Arts* (Chicago: Rand, McNally, 1928), pl. XXVII, between pp. 88 and 89, as *Girl Driving Turkeys* § "Chicago," *Art News* 27 (August 17, 1929): 24, as *The Turkey Girl* § Donald Jenks, comp. and ed., *Paintings on Parade* (Boston: Hale, Cushman, & Flint, 1939), p. 250, repro., as *Girl Driving Turkeys* § Homer and Robb, "Paintings by George Fuller," p. 290, lists, as *Girl with Turkeys* § Sarah Lea Burns, "The Poetic Mode in American Painting: George Fuller and Thomas Dewing," Ph.D. diss., University of Illinois at Urbana-Champaign, 1979, pp. 110, 119–20, 122, 128, fig. 11, p. 385, as *Girl Driving Turkeys* § LACMA, American Art department files, Carol Walker Aten to Ilene Susan Fort, April 28, 1986, gives early provenance.

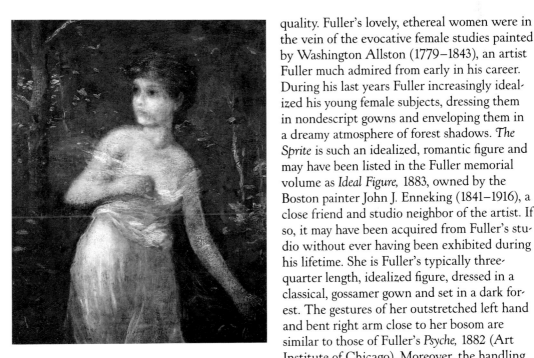

Fuller, *The Sprite.*

The Sprite, c. late 1870s–1884

(*Ideal Figure*)
Oil on canvas
20³/₁₆ x 16¹/₈ in (51.2 x 41.0 cm)
Signed lower right: G Fuller
Mary D. Keeler Bequest
40.12.21

Many of Fuller's paintings of the late 1870s and 1880s were of single female figures, quite romantic in mood, their solitary state and delicate beauty suggesting an other-worldly

quality. Fuller's lovely, ethereal women were in the vein of the evocative female studies painted by Washington Allston (1779–1843), an artist Fuller much admired from early in his career. During his last years Fuller increasingly idealized his young female subjects, dressing them in nondescript gowns and enveloping them in a dreamy atmosphere of forest shadows. *The Sprite* is such an idealized, romantic figure and may have been listed in the Fuller memorial volume as *Ideal Figure,* 1883, owned by the Boston painter John J. Enneking (1841–1916), a close friend and studio neighbor of the artist. If so, it may have been acquired from Fuller's studio without ever having been exhibited during his lifetime. She is Fuller's typically three-quarter length, idealized figure, dressed in a classical, gossamer gown and set in a dark forest. The gestures of her outstretched left hand and bent right arm close to her bosom are similar to those of Fuller's *Psyche,* 1882 (Art Institute of Chicago). Moreover, the handling of the paint is quite characteristic of Fuller's late manner; not only was the paint applied in thick and thin transparent layers with lights over darks, but in several areas, most noticeably her left arm, the artist used the handle of his brush to score patterns in the thick, wet paint. From a distance this scratched surface appears insubstantial and thereby harmonizes with the veiled and suggestive quality of the scene. The mellow, glowing, dark brown hues and richly textured paint surface suggest an affinity with the art of Adolphe-Joseph-

Thomas Monticelli (1824–1886), a contemporary French artist whose work Fuller may have known.

The titles of Fuller's paintings of single figures usually refer to literary characters, such as *Nydia*, 1883 (Metropolitan Museum of Art, New York), from Bulwer-Lytton's novel *The Last Days of Pompeii* (1834), and *Psyche*, from Hawthorne. Fuller usually titled his paintings after they were completed, and the literary ones probably were chosen because they corresponded to the spirit of the paintings. It is not known whether *The Sprite* is the original title of this painting. The idea of a sprite, that is, a disembodied spirit or elflike person, is in harmony with this figure, and is just how nineteenth-century critics often identified Fuller's figures, seeing them as mysterious, even dreamlike phantoms.

PROVENANCE
Possibly John J. Enneking, Boston, as of 1886 § John F. Braun, Philadelphia, as of 1919 § With Dalzell Hatfield Galleries, Los Angeles § Mr. and Mrs. Fred E. Keeler, Los Angeles, as of 1937 § Mrs. Fred E. (Mary D.) Keeler (by descent), Los Angeles, to 1940.

EXHIBITION
Los Angeles Art Association, *Loan Exhibition of International Art*, 1937, no. 192, repro., p. 34.

LITERATURE
Possibly *Fuller: His Life and Works*, p. 93, listed under 1883, as *Ideal Figure*, owned by J. J. Enneking § Homer and Robb, "Paintings by George Fuller," p. 290, fig. 7, p. 292 § Sarah Lea Burns, "The Poetic Mode in American Painting: George Fuller and Thomas Dewing," Ph.D. diss., University of Illinois at Urbana-Champaign, 1979, pp. 122, 124–25, dated c. 1881–84 § LACMA, American Art department files, Sarah Burns to Ilene Susan Fort, May 8, 1985, suggests that painting might have been the one owned by Enneking and states the paint handling, with Fuller's use of the brush handle to make squiggles in the paint, is characteristic of his late style.

Ralph Albert Blakelock

Born October 15, 1847,
New York, New York
Died August 19, 1919, near
Elizabethtown, New Jersey

Ralph Albert Blakelock's visionary landscapes are among the most powerful painted by an American artist. Blakelock began to paint at an early age. In September 1864 he entered what is now the City College of New York, which he left in February 1866 without being graduated. He first exhibited at the National Academy of Design in the fall of 1867 and continued to do so for the next six years; after 1879 he exhibited intermittently at both the National Academy of Design and Society of American Artists. In 1869 he made an extended trip to the West, crossing the Rockies and traveling along the California coast and perhaps into Mexico. He returned to New York in 1871.

Blakelock received only very unsympathetic criticism until about 1890 and had great difficulty selling his paintings except for sacrifice prices. In 1891 he had his first mental breakdown, and although he recovered, he became increasingly eccentric and was hospitalized in 1899, on the day his youngest child was born. In 1901 he was moved to the State Hospital for the Insane in Middletown, New York, where he remained until 1916. He stopped painting and then painted much less during his confinement, but by 1902 he was able to resume work on a smaller scale and in a different style.

It is cruelly ironic that just when Blakelock lost contact with events, no longer painted, and could not contribute to the support of his destitute family, his work began to be appreciated. In 1900 one of his landscapes won an honorable mention at the Exposition Universelle in Paris; in the same year his first solo exhibition was held in New York. His prices began to rise, benefiting collectors and speculators but not the Blakelock family, who continued to suffer in acute financial distress. By 1903 his paintings were being forged, as they continued to be in ever greater numbers during the years to come. In 1913 Blakelock was belatedly elected an associate of the National Academy of Design and in 1916 an academician. Blakelock's mind cleared to the point that he could be released from the mental hospital in 1916, but he returned to a private sanitorium in 1918.

BIBLIOGRAPHY
Elliott Daingerfield, *Ralph Albert Blakelock* (New York: Privately printed, 1914) § *Index 20th Cent. Artists* 4 (December 1936): 367–68; 4 (January 1937): 369–73; reprint, 663–69 § New York, Whitney Museum of American Art, *Ralph Albert Blakelock: Centenary Exhibition*, exh. cat., 1947, with text by Lloyd Goodrich § Santa Barbara, University of California, Art Galleries, and others, *The Enigma of Ralph A. Blakelock, 1847–1919*, exh. cat., 1969, with essays by Phyllis Stuurman and David Gebhard, bibliography, list of works in public collections § Lincoln, University of Nebraska, Sheldon Memorial Art Gallery, and Trenton, New Jersey State Museum, *Ralph Albert Blakelock, 1847–1919*, exh. cat., 1975, with text by Norman A. Geske.

Blakelock, *Landscape with Trees.*

Landscape with Trees, c. 1883–98
Oil on wood panel
17¹⁵/₁₆ x 23¹³/₁₆ in (45.6 x 60.5 cm)
Gift of Will Richeson, Jr.
M.75.107.4

Since Blakelock rarely dated any of his mature

works, it is impossible to precisely date his paintings. *Landscape with Trees* can, at least, be dated to the period of about 1883 to 1898, a time when the artist was working in his best-known style, employing silhouettes and lacy foliage effects. Particularly visible in the sky is the deliberately textured heavy paint surface that Blakelock liked to paint on with his generally thin paint and glazes. The compositional grouping of trees around a central vista is a familiar one in his work. The landscape is peppered with flickering highlights, as the light from the overcast sky seems to partially dissolve the foliage's tracery. The mood is that of an airless stillness and solitude, a visionary landscape of the spirit rather than of a particular place and time. More than many, which have greatly darkened over time, this evocative painting reveals Blakelock's sensitivity to delicate color, which is employed with an almost musical sense of abstract design.

PROVENANCE
With Terry De Lapp Gallery, Los Angeles § Will Richeson, Jr., San Marino, Calif., to 1975.

LITERATURE
LACMA, Registrar's files, memo from Nancy Moure to Kenneth Donahue, December 22, 1975, states that Norman Geske verified authenticity in a telephone call.

Albert Pinkham Ryder

Born March 19, 1847, New Bedford, Massachusetts
Died March 18, 1917, Elmhurst (now New York City), New York

Albert Pinkham Ryder was once considered to be among the greatest of American artists. He was a descendant of an old Cape Cod family. He developed eye trouble at an early age, and he did not continue his education beyond grammar school. Ryder began painting by himself before moving with his family to New York at some time after 1868 but before 1871. After initially being rejected, he enrolled in 1871 in the National Academy of Design, where he attended antique and life classes. He exhibited at the National Academy of Design in the spring of 1873 but only intermittently after that. He was featured in a group exhibition with John La Farge and pupils of William M. Hunt shown in the galleries of Cottier and Company about 1875. He exhibited mainly with the progressive Society of American Artists, of which he was a founding member. Ryder made brief visits to London in 1877, 1887, and 1896 and a longer trip with Daniel Cottier (1839–1891) and the sculptor Olin L. Warner (1844–1896) to England, France, Spain, Morocco, Italy, Switzerland, and Holland in 1882. It is hard to tell how greatly he was affected by his European experiences. He is known to have admired the work of Jean-Baptiste-Camille Corot (1796–1875), Adolphe-Joseph-Thomas Monticelli (1824–1886), and Matthijs Maris (1839–1917).

About 1880 Ryder moved to the Benedick Building on Washington Square in New York, where he lived for about the next fifteen years and befriended other artists who had studios there. Around this time his subject matter changed from primarily landscapes to literary, biblical, and operatic themes as well as the highly imaginative nocturnes for which he became best known. The increasingly eccentric and reclusive artist moved in the mid-1890s to rooms at 308 West Fifteenth Street. His creative abilities appear to have declined considerably after 1900, when he seems to have lost inspiration to begin new work. During the early twentieth century his paintings gained wide acceptance among

collectors and progressive artists, such as MARSDEN HARTLEY, and forgers. Ten of his paintings were included in the Armory Show of 1913. In 1915 he was hospitalized, and then lived with friends in Elmhurst, Long Island, where he died in 1917.

BIBLIOGRAPHY
Frederic Fairchild Sherman, *Albert Pinkham Ryder* (New York: Privately printed, 1920), with catalogue of paintings, bibliography, lists of paintings exhibited at the National Academy of Design, the Society of American Artists annuals, and the 1918 Metropolitan Museum of Art's memorial exhibition § Frederic Newlin Price, *Ryder: A Study of Appreciation* (New York: Rudge, 1932), with catalogue of paintings § Elizabeth Johns, "Ryder: Some Thoughts on His Subject Matter," *Arts* 54 (November 1979): 164–71 § Elizabeth Broun, *Albert Pinkham Ryder* (Washington, D.C.: Smithsonian Institution Press for the National Museum of American Art, 1989), with entries by Eleanor L. Jones and others, reprints of poems by the artist, list of works exhibited 1879–1917, bibliography, catalogue of exhibition at the National Museum of American Art, Smithsonian Institution, Washington, D.C., and Brooklyn Museum, 1990–91 § William Innes Homer and Lloyd Goodrich, *Albert Pinkham Ryder: Painter of Dreams* (New York: Harry N. Abrams, 1989), with note on technique by Sheldon Keck, reprints of writings by the artist, chronological list of paintings, chronology, bibliography.

Ryder, *The River.*

The River, c. 1884–94
(*Landscape*)
Oil on canvas
18½ x 22⁷⁄₁₆ in (47 x 56.9 cm)
Paul Rodman Mabury Collection
39.12.21

Ryder's work is among the most powerfully visionary and formally expressive that our country has produced. So strong are his small paintings that Ryder's life-work of only about 160 paintings has been sufficient to generate a posthumous reputation amounting at times to adulation.

Although firmly based in naturalism, Ryder's style involved the extreme simplification of elements and their arrangement in terms of an overall rhythmic force and harmony. Like others of his pure landscapes, *The River* is closer to naturalism than to the dramatic designs characteristic of Ryder's literary subjects and nocturnal marines. The scale of the indistinct figures in the left foreground and near the center of the right edge of the painting suggests that they are staffage rather than specific literary characters. As a delicately colored daytime scene rather than his characteristically more emotional nocturnal or crepuscular views,

The River also partakes more of the quality of a straightforward landscape, albeit with the visionary feeling that informs all of the artist's works.

Ryder never dated his paintings, and the unequal deterioration of different works adds to the difficulty of establishing dates. Ryder's friend, the artist Charles Melville Dewey (1849–1937), suggested that *The River* could be dated between 1884 and 1894. He also indicated that the painting stood on an easel at Ryder's bedside during his last illness. Because Ryder is known to have reworked his paintings again and again, it is difficult to determine how much of the final design dates from the period specified by Dewey. As is characteristic of Ryder's work, scientific examination of *The River* reveals a substantially different earlier design. Infrared photography, which can show changes just below the surface layer, reveals changes near the center of the right-hand edge of the painting: there is a second ghostly figure, and the distinctly rounded, archlike shape of the dark area behind the figures suggests that it is the entrance to a cave or building (see illustration). These two figures probably represent an earlier placement of the two figures in the left foreground rather than additional figures relating to them in a narrative sense.

The fact that the painting came into the possession of Ryder's executor, Charles Melville Dewey, raises the question of whether *The River* may have been completed by Dewey, who had restored certain deteriorated paintings with Ryder's approval and presumably with his advice. Perhaps he was the one who filled and inpainted the large cracks, work that appears to have been done before the painting was acquired by Paul Rodman Mabury in 1920. It was Lloyd Goodrich's opinion that Dewey did not repaint the picture; he wrote to the museum in 1962, "I hasten to add that your painting seems to me entirely characteristic of Ryder in style and technique, and that it shows no evidence of having been tampered with."

Ryder, *The River*, detail of infrared photograph.

PROVENANCE
The artist, to 1917 § Charles Melville Dewey, New York, 1917 § With Carson Pirie Scott & Co., Chicago, as of 1920 § Paul Rodman Mabury, Los Angeles, 1920–39.

EXHIBITIONS
San Diego, Palace of Fine Arts, *California Pacific International Exhibition, Official Art Exhibition, Illustrated Catalogue,* 1936, no. 325, as *Landscape* § Los Angeles Art Association, *Loan Exhibition of International Art,* 1937, no. 211 § Los Angeles Museum, *Temporary Installation and Catalogue of the Paul Rodman Mabury Collection,* 1939, no. 22 § Los Angeles, Barnsdall Park, Municipal Art Gallery, *The American Scene,* 1956, no cat. traced § San Francisco, California Palace of the Legion of Honor, *The Color of Mood: American Tonalism, 1880–1910,* 1972, no. 37 § Spokane, International Exposition on the Environment, *Our Land, Our Sky, Our Water,* 1974, no. 123.

LITERATURE
LACMA, Registrar's files, Charles Melville Dewey note, June 15, 1[9]19, dates painting between 1884 and 1894 and states that it stood on Ryder's easel during his final illness and that he owned it after Ryder's death; Carson Pirie Scott & Co. sales receipt to Mabury, July 29, 1920, sold for seventy-seven hundred dollars; Lloyd Goodrich to Henry Hopkins, June 1, 1962, discusses painting and its condition and gives his opinion that it is autograph (quotes letter from Mabury to Goodrich, May 26, 1938, discussing acquisition of painting) § LACMHSA, *The Paul Rodman Mabury Collection of Paintings,* (c. 1940), p. 24 § New York, Whitney Museum of American Art, Albert Pinkham Ryder Papers, Lloyd Goodrich, "Ryder, *The River* Worksheet," documents provenance, accepts the painting as being by Ryder, compares it with *The Forest of Arden,* 1888–1908? (Metropolitan Museum of Art, New York), and describes condition as of 1962 § Higgins 1963, p. 128, no. 21 in checklist of Paul Rodman Mabury collection.

J. Alden Weir

Born August 30, 1852, West Point, New York
Died December 8, 1919, New York, New York

Julian Alden Weir achieved prominence as an American impressionist painter, watercolorist, pastelist, and etcher. He grew up at West Point, where his father supervised his early artistic training. He studied from 1870 to 1872 in the antique and life classes of the National Academy of Design in New York, and from 1873 to 1877 he pursued his studies in Europe, principally in the studio of Jean-Léon Gérôme (1824–1904) at the Ecole des Beaux-Arts, Paris. In October 1877 he returned to New York, although he frequently visited Europe in later years. In 1877 Weir was elected to the Society of American Artists and Tile Club, and he was active in several other artist's groups. He was elected president of the Society of American Artists in 1882 and president of the National Academy of Design in 1915. Beginning in 1878 he taught at the Cooper Union and later for twenty years at the Art Students League.

Weir established himself as a painter of figure and still-life compositions, and later of impressionist landscapes, and won numerous honors during his career. After 1887 he was also active as a printmaker. He married in 1883, and his family divided their time between New York and a farm in Branchville, Connecticut.

BIBLIOGRAPHY
Private collections and Provo, Utah, Brigham Young University, Harold B. Lee Library, Weir Family Papers § J. B. Millet, ed., *Julian Alden Weir: An Appreciation of His Life and Works*, Phillips Publication no. 1 (1921; reprint, New York: Dutton, 1922), with "List of Paintings" by Dorothy Weir and essays by Duncan Phillips, Emil Carlsen, Royal Cortissoz, and others § Agnes Zimmerman, "An Essay towards a Catalogue Raisonné of the Etchings, Dry-points, and Lithographs of Julian Alden Weir," *Metropolitan Museum of Art Papers* 1, pt. 2 (1923): 1–50 § Dorothy Weir Young, *The Life and Letters of J. Alden Weir*, ed. and with introduction by Lawrence W. Chisholm (New Haven, Conn.: Yale University Press, 1960), with notes on dating of works § Doreen Bolger Burke, *J. Alden Weir: An American Impressionist* (Newark: University of Delaware Press, 1983), with bibliography, chronology, checklist of exhibition held at the Metropolitan Museum of Art, New York, and others, 1983–84.

Weir, *Portrait of Robert Walter Weir.*

Weir, *Portrait of Mrs. Robert Walter Weir.*

Portrait of Robert Walter Weir, c. 1885
Oil on canvas
23⅞ x 19¹⁵/₁₆ in (60.8 x 50.6 cm)
Gift of M. R. Schweitzer
M.72.104.1

Portrait of Mrs. Robert Walter Weir,
c. 1885
Oil on canvas
23⅞ x 19¹⁵/₁₆ in (60.8 x 50.6 cm)
Gift of M. R. Schweitzer
M.72.104.2

ROBERT W. WEIR, the father of the artist and also of the painter JOHN FERGUSON WEIR, was born in New York, New York, in 1803. He studied for three years in Florence and Rome, returning to New York in 1827. He was elected a member of the National Academy of Design two years later. He was instructor in drawing at the United States Military Academy from 1834 to 1876 and is best known for his paintings of historical subjects, such as *Embarkation of the Pilgrims,* 1837–43 (Capitol Rotunda, Washington, D.C.). He died in New York in 1889.

Robert W. Weir was J. Alden Weir's first teacher and continued to give his son advice and encouragement later in life. The son

retained a deep admiration for his father and freely acknowledged his debt to him. Among the first paintings he undertook after his return from study in Paris were a portrait of his father, exhibited in 1878 at the National Academy of Design, and a study for the portrait, exhibited at the Society of American Artists. When J. Alden Weir painted his self-portrait for the National Academy of Design in 1886, he acknowledged his debt to his father by including the finished portrait of 1878 in the background. (He also executed a watercolor study, c. 1878 [private collection], possibly in preparation for this important early portrait.)

The museum's portrait of Robert Weir is quite unlike the portrait of 1878 and was painted about seven years later. The earlier work's dramatic pose and conventional studio lighting from the side and above have been replaced by a direct gaze and frontal illumination. The lack of depth, flat lighting, and discrete brushstrokes in this portrait of his father and the accompanying one of Mrs. Weir may reflect the artist's interest during these years in the work of Edouard Manet (1832–1883). At the same time the example of the old masters is strong in all his early work.

Daughter of an Episcopal priest, Susan Martha Bayard was born in 1817. She taught school before joining the household of

Robert W. Weir in 1845 to help raise his nine children after the death of his first wife. On July 15, 1846, they were married, and she bore him seven more children. Most of the sons followed military careers, but John Ferguson Weir, a child of the first marriage, and J. Alden Weir, her youngest son, became artists. Mrs. Weir died in 1900.

PROVENANCE
The artist § Estate of Mrs. Thomas Sturgis (Helen Weir; by descent), to 1968 (sale, 1968) § M. R. Schweitzer, New York, 1968–72.

EXHIBITIONS
Roslyn, N.Y., Nassau County Museum of Fine Art,

William Cullen Bryant, The Weirs, and American Impressionism, 1983, *Portrait of Robert Walter Weir,* no. 31, p. 16, essay by Holly Joan Pinto, fig. 31, p. 47 § LACMA, *J. Alden Weir: An American Impressionist,* 1984, *Portrait of Robert Walter Weir,* exhibited but not listed in checklist in Burke, *Weir.*

LITERATURE
Collection Weir Family, J. Alden Weir Papers, ms. (1920s–40s), Dorothy Weir Young, "Records of the Paintings of J. Alden Weir," 2: 104 § Advertisement, *College Art Journal* 28 (Spring 1969): repros., 242 § Burke, *Weir,* p. 102, *Portrait of Mrs. Robert Walter Weir,* discusses resemblance to Rembrandt's *Portrait of an Eighty-three-Year-Old Woman,* 1634 (National Gallery, London), fig. 3.18.

Albert Jenks

Born May 26, 1830, Jordan, New York
Died July 22, 1901, Los Angeles, California

Albert Jenks was the most successful portrait painter in Los Angeles during the decade-and-a-half before the turn of the century. Raised in Illinois, he briefly studied medicine. Jenks successfully ran a general store and later operated a bank in Aurora, Illinois, from 1855 to 1861. During the Civil War he organized a company of soldiers, and his valiant conduct in the war earned him the commission of lieutenant colonel. He is reputed to have painted a portrait of Abraham Lincoln as early as 1860 and may have turned to painting when his bank failed. He is first listed in the city directory of Aurora as a portrait painter in 1868, but he soon moved to Chicago and later practiced his trade in Detroit. In 1875 he moved permanently to the West Coast, stopping in Denver but eventually settling in San Francisco, where he painted the state's politicians and leading professionals, such as Charles Crocker, Albert Gallatin, George Hearst, and six former governors of California.

In late 1885 or 1886 Jenks moved to Los Angeles, no doubt to take advantage of the area's prosperity due to a real estate boom. He was immediately besieged by commissions, and during the first year-and-a-half in the city was reputed to have executed 210 portraits, at an average price of one hundred fifty dollars. Exhaustion forced him to retire, but after a four-year rest he returned to painting. Among the more prominent people he painted were General H. G. Otis, owner of the *Los Angeles Times,* and General W. T. Sheridan. He was praised for his vigorous likenesses and delicate color and tones. Jenks is reputed to have been somewhat eccentric and a poor businessman, having at one time lost all his finances in mining and oil speculation.

BIBLIOGRAPHY
"Portrait Painting," *Los Angeles Tribune,* December 24, 1886, p. 5 § J. M. Guinn, *Historical and Biographical Record of Los Angeles and Vicinity* (Chicago: Chapman, 1901), pp. 800–1 § Henry Winfred Splitter, "Art in Los Angeles before 1900," *Historical Society of Southern California Quarterly* 41 (June 1959): 125, 132–33 § Moure with Smith 1975, p. 129, with bibliography.

Portrait of Colonel Guilford Wiley Wells, c. 1886
Oil on canvas
55¹⁵/₁₆ x 38⅛ in (142.1 x 97.0 cm)
Gift of Mrs. Bradner W. Lee
28.18.1
(not reproduced)

Portrait of Mrs. Guilford Wiley Wells, c. 1886
Oil on canvas
55⅞ x 37¹³/₁₆ in (141.9 x 96.0 cm)
Gift of Mrs. Bradner W. Lee
28.18.2

Guilford Wiley Wells, soldier, lawyer, and diplomat, was born at Conesus Center, New York, on February 14, 1840. During the Civil War he fought gallantly under General Sheridan, rising to the rank of brevet lieutenant-colonel. After being graduated from Columbian College in Washington, D.C., in 1869, he practiced law in Mississippi. Appointed district attorney for Mississippi by President Grant, Wells was the first to successfully prosecute the Ku Klux Klan. He served in the U.S. House of Representatives in the late 1870s. Recognizing his skills, President Rutherford B. Hayes appointed Wells in 1877 to the position of consul-general

Jenks, *Portrait of Mrs. Guilford
Wiley Wells.*

was this commission, or their shared Civil War experience, that inspired Wells to order portraits of his first wife and himself from Jenks. Both paintings are three-quarter length and large in scale. Wells, wearing a dark blue business suit, sits confidently in a red velvet upholstered armchair, his left arm propped up by a book. This book, along with others that lie open on the nearby table and in the bookcases on the wall behind him, refer to Wells's learned profession. Wells appears exactly as he did in photographs of the period. Given the intensely realistic facial expression and a certain stiffness of pose, Jenks may have relied heavily on a photograph when painting the portrait. The painting is not reproduced here because of its poor condition.

Mrs. Wells, born Katy C. Fox, married Guilford Wells in Avoca, New York, her birthplace, on December 22, 1864. She bore him one child, a son, who died at an early age.

Katy Wells is elegantly dressed in the height of mid-1880s fashion, befitting her social position. She wears a white satin gown trimmed in Battenberg lace and holds a carved wooden fan in her left hand. Her frizzed hair is braided in a chignon. A bouquet of pale roses lies on the edge of the nearby table. An ornamental screen decorates the background. At the time of its execution the portrait was praised for its fine drawing and delicate color effects.

PROVENANCE
Mr. and Mrs. Guilford Wiley Wells, c. 1886 § Mrs. Bradner W. Lee (by descent), Los Angeles, to 1928.

LITERATURE
"Portrait Painting," *Los Angeles Tribune*, mentions *Mrs. Guilford Wiley Wells* as still in Jenks's studio.

to Shanghai, but he remained less than a year. On his way home from China, he and Mrs. Wells visited Los Angeles and, delighted with the climate, resolved to settle there. In 1879 they returned and Wells set up a law office with Judge Brunson. Until an illness forced his retirement, he was an active attorney, involved in many notable cases, including several murder trials, which gained him national recognition.

In 1886 Jenks painted two prominent judges —one was Wells's former partner, Brunson— for the Los Angeles County Bar. Perhaps it

Walter Gilman Page

Born October 13, 1862,
Boston, Massachusetts
Died March 24, 1934,
Nantucket, Massachusetts

Walter Gilman Page was an academically trained figure painter in the late-nineteenth-century mold who worked in New England. After studying with Otto Grundmann (1844–1890) at the Boston Museum School in the early 1880s, Page attended the Académie Julian in Paris under the supervision of Gustave Boulanger (1824–1888) and Jules Lefebvre (1836–1911). He exhibited at the Paris Salon from 1887 through 1889 and then after returning to Massachusetts showed primarily in the Boston area.

Due to his training he focused on figure painting and portraiture, occasionally creating still-lifes. He painted many portraits of notable New Englanders, including Governor Erastus Fairbanks of Vermont, 1900 (State House, Montpelier, Vermont). He was greatly interested in American history, creating paintings and writing on the subject. He is best remembered for his active participation in organizations such as the Boston School Board, 1894–97; the Art Commission of the Commonwealth of Massachusetts, on which he served as secretary, commissioner, and chairman over the period 1910 to 1930; and the Boston Commission on Historic Sites. He wrote *Interior Decoration of School Houses* (1896) as well as articles on art and history.

BIBLIOGRAPHY
Boston Public Library, artist's file § "The Observer," *Art Interchange* 42 (March 1899): 59 § S. C. de Soissons, *Boston Artists: A Parisian Critic's Notes* (Boston: Schoenhof, 1894), pp. 38–39 § Arthur Cham-

berlain, "Boston Artists: Walter Gilman Page, Ross Turner," *Art Interchange* 44 (December 1900): 134–35 § *Who Was Who in America* (1968), s.v. "Page, Walter Gilman."

Page, *The Grandmother.*

The Grandmother, 1889

(*The Convalescent; Eve of Life*)
Oil on canvas
36³/₈ x 28⁷/₈ in (92.4 x 73.3 cm)
Signed and dated lower left: WALTER GILMAN PAGE / PARIS·1889
Gift of Mrs. Barney Kully
M.77.57

A powerful image of an old peasant woman resigned to her approaching death, this painting may be Page's masterpiece. The stark chiaroscuro and almost monochromatic palette of deathly blacks, browns, and grays convey the woman's condition. Her drawn and wrinkled face is propped up against a large pillow, which forms a halo around her face. With her hands tightly folded, she turns toward the right where a small glass of violets, symbols of death, rests on a bare wood table. In this vividly realist work Page displays a thorough knowledge of the human figure, based no doubt on his academic training.

This painting may have been exhibited in the Paris Salon of 1889 as *La Grand-mère.* A critic in the *American Register* noted Page's strongly drawn and expressive figure. Another critic may have been considering Page's painting when he deplored the large number of "funer[e]al, dolorious, or elegiac subjects" in the exhibition (Theodore Child, "The Paris Salon of 1889," *Art Amateur* 21 [June 1889]: 7).

George W. Lininger, who owned the painting in the early years of this century, had a large collection of old-master and nineteenth-century European and, to a far lesser extent, American paintings, sculptures, and objets d'art. He opened a gallery for his collection in Omaha in 1888 and permitted the public to visit twice weekly.

PROVENANCE
The artist § George W. Lininger, Omaha, by 1906 to 1907, as *The Convalescent* § Mrs. George W. Lininger (by descent), Omaha, 1907–27 § Mrs. George Joslyn, Omaha, probably 1927–30 § Barney Kully, Omaha and Los Angeles, 1930 § Mrs. Barney Kully (by descent), Los Angeles, to 1977, as *Eve of Life.*

EXHIBITION
Probably Paris, Société des artistes français, *Salon,* 1889, no. 2046.

LITERATURE
Probably "The Salon of 1889. III," *American Register* 22 (June 8, 1889): 6 § Chamberlain, "Boston Artists," p. 134, refers to the portrait of an old woman shown in 1889 Salon § *Catalog of the Lininger Art Gallery* (Omaha: N.p., 1909), no. 257, as *The Convalescent* § LACMA, Mrs. Barney Kully to Mary-Alice Cline, telephone conversation, October 4, 1984, explained how Mr. Kully obtained painting; American Art department files, Mrs. Kenneth A. Anderson to Mary-Alice Cline, October 29, 1984, and March 1, 1985, identify *The Convalescent* and *Eve of Life* as the same painting § M. Therese Southgate, "Editorial," *JAMA (Journal of the American Medical Association)* 260 (August 12, 1988): 744, discusses in context of late-nineteenth-century images of death and sickness, repro., cover, as *Eve of Life.*

J. J. Shannon

Born February 3, 1862,
Auburn, New York
Died March 6, 1923,
London, England

Sir James Jebusa Shannon was a noted expatriate portrait painter active in England during the last decades of the nineteenth century and the early decades of this one. When he was eight, his family moved to Saint Catharines, Ontario, Canada, where he received his initial art instruction under a little-known painter, William E. Wright (active c. 1864–1882). Shannon left for London in 1878 to study at the National Art Training School in South Kensington. There he came to the attention of the noted French-trained English artist Edward Poynter (1836–1919), who was his teacher. Shannon quickly established a reputation as a portrait painter with his early contributions to exhibitions at the Grosvenor Gallery. As one of the first generation of British-trained artists working in an advanced French style, he also frequently exhibited at other progressive establishments such as the New Gallery and the Grafton Gallery. Along with Henry Herbert La Thangue (1859–1929) and Stanhope Forbes (1857–1947) Shannon helped found the New English Art Club in 1886. In 1896 the Fine Arts Society in London accorded him his first solo exhibition. Shannon was elected to the Royal Society of British Artists in 1888 and to the Royal Academy in 1897; he achieved full membership in the latter in 1909. He was president of the Society of British Portrait Painters from 1910 to 1923. A year before his death he was knighted.

From the beginning of his career Shannon received commissions from the British aristocracy and the newly rich middle class. Although he lived in London, he made trips back to his native country to carry out commissions in New York, Boston, and elsewhere. He was primarily identified with portraiture in the Aesthetic manner that came into fashion in the late nineteenth century, encouraged by the example of James McNeill Whistler (1834–1903). In constant demand, Shannon was second only to JOHN S. SARGENT in popularity with the English. Many of his portraits were given fanciful or poetic titles, for example, *Magnolia,* 1899 (Metropolitan Museum of Art, New York), and Shannon also became known for his purely imaginative figurative works.

BIBLIOGRAPHY

James Creelman, "An American Painter of the English Court—J. J. Shannon," *Munsey's Magazine* 14 (November 1895): 129–37 § Christian Brinton, *Modern Artists* (New York: Baker & Taylor, 1908), pp. 229–42, a synthesis of two articles previously published in *Harper's Monthly Magazine* and *Munsey's Magazine* § Kitty Shannon, *For My Children* (London: Hutchinson, 1933) § Dayton Art Institute and others, *American Expatriate Painters of the Late Nineteenth Century,* exh. cat., 1976, text by Michael Quick, pp. 38, 132–34, 157, with bibliography § Barbara Dayer Gallati, "James Jebusa Shannon," *Antiques* 134 (November 1988): 1132–41.

Portrait of Cecilia Tower, 1889

Oil on canvas
71⅞ x 53¹/₁₆ in (182.6 x 134.9 cm)
Signed upper left: J·J·SHANNON
Dated upper right: 1889
Gift of Mr. and Mrs. Jacob M. Kaplan
M.87.142

Portrait of Cecilia Tower was one of Shannon's early mature works, painted and exhibited the year immediately following his first major critical success. He became best known for his portraits of women, and the museum's painting is characteristic of the type of decorative figure painting that brought him fame. Cecilia Tower is presented in neutral surroundings, allowing her dignified attitude, handsome attire, and the large size of the canvas to convey her social importance.

Following Whistler in viewing a portrait first as a work of art and typical of progressive artists allied with the Aesthetic movement, Shannon held that portraiture was more than merely reproducing a physical likeness of the sitter. In his portraits of women the refined beauty of all the formal elements—color, line, and composition—suggest elegance and wealth. Cecilia Tower wears a fashionable silk evening gown and a boa. The painting is an orchestration of gray tints. Shannon preferred a palette of softly modulated tones, and the lavenders and pearl grays of this canvas, along with pinks, were among his favorite hues. Delicacy of color contributes to the elegance of his portraits. Whistler's example inspired a host of later artists to employ soft, tonally limited palettes and place their sitters in spare environments and shallow spaces. Another characteristic of Aesthetic movement portraits found in *Cecilia Tower* is that of showing the sitter full-length and in life-size.

The sitter was a member of the Tower family, landed gentry from Weald Hall in Essex. Cecilia Tower may have been Mrs. Christopher Tower. A portrait by Shannon of a child, Hugh Christopher Tower (unlocated), the son of Christopher Tower, was exhibited in the winter 1890–91 exhibition at the London Institute

Shannon, *Portrait of Cecilia Tower.*

of Painters in Oil-Colours only a few years after *Portrait of Cecilia Tower* was shown in London. According to the art historian Barbara Dayer Gallati Shannon was often commissioned to paint different members of the same family.

PROVENANCE
(Sale, England, c. 1982) § With John C. Burrows, London, 1982 § Mr. and Mrs. Jacob M. Kaplan, New York, 1982–87.

ON DEPOSIT
LACMA, 1982–87.

EXHIBITIONS
London, Grosvenor Gallery, *Summer Exhibition,* 1889, no. 81 § Munich, Koniglischer Glaspalast, *Münchener Jahresausstellung,* 1891, no. 3220.

LITERATURE
"The Grosvenor Gallery," *Illustrated London News,* May 11, 1889, p. 598 § "The Grosvenor Gallery II," *Saturday Review* 67 (May 18, 1889): 603–4, reviews favorably in comparison with the portraits of Frank Holl § LACMA, American Art department files, Barbara Dayer Gallati to Ilene Susan Fort, July 27, 1988, discusses reception of portrait in the context of Shannon's first major critical success and suggests family association with Hugh Christopher Tower.

Louis M. Eilshemius

Born February 4, 1864,
Laurel Hill Manor,
near Newark, New Jersey
Died December 29, 1941,
New York, New York

Louis Michel Eilshemius is known for his bizarre scenes of nudes frolicking through land-scapes. Despite his reputation as a romantic primitive, his training and early years reflect a conservative art background.

The son of a socially prominent and wealthy family, he attended school abroad and received his first drawing lessons in Dresden. In 1884 he enrolled at the Arts Students League in New York and also studied privately with the landscape painter Robert C. Minor (1840–1904). In late 1886 he enrolled at the Académie Julian in Paris. His land-scapes of the 1880s reveal the influence of the Barbizon school, especially the work of Jean-Baptiste-Camille Corot (1796–1875). Eilshemius also briefly experimented with impressionism in 1889.

Financially secure, he traveled extensively—to California in 1889 and during the winter of 1893–94, Europe and Algeria in 1892, the South Seas in 1901—and remained independent of artistic trends. By the late 1890s his painting began to diverge from academic art, and during the first decade of the next century his work became more eccentric and disturbing. From 1906 to 1909 he painted a large number of Samoan sub-jects. In 1910 he painted smaller works, eventually replacing canvas with less expensive material, such as the tops of cigar boxes. At this time his art changed radically as the

elements of fantasy increased with his abandonment of technical control. From 1913 to 1917 he produced his largest paintings, of nymphs and battle subjects. In 1921 he stopped painting. Throughout most of his life he divided his time between painting, writing, and composing, publishing in 1895 the first of several books of verse and fiction.

Eilshemius became especially favored by the avant-garde in 1917 when Marcel Duchamp (1887–1968) proclaimed Eilshemius's entry submitted to the first exhibition of the Society of Independent Artists as one of the most important paintings. In 1920 he was accorded his first solo exhibition, organized by the Société Anonyme. The year 1932 marked the critical reception of his art and, ironically, the beginning of the artist's physical and mental deterioration due to an automobile accident.

BIBLIOGRAPHY
Archiv. Am. Art, Louis M. Eilshemius Papers § William Schack, *And He Sat among the Ashes: A Biography of Louis M. Eilshemius* (New York: American Artists Group, 1939) § Paul Johnson Karlstrom, "Louis Michel Eilshemius, 1864–1941: A Monograph and Catalogue of the Paintings," 2 vols., Ph.D. diss., University of California, Los Angeles, 1973, with bibliography, catalogue oeuvre, lists of Eilshemius paintings in the collections of Roy R. Neuberger and Joseph H. Hirshhorn § Paul J. Karlstrom, *Louis Michel Eilshemius* (New York: Abrams, 1978), with chronology, bibliography § Washington, D.C., Smithsonian Institution, Hirshhorn Museum and Sculpture Garden, and others, *Louis M. Eilshemius: Selections from the Hirshhorn Museum and Sculpture Garden,* exh. cat., 1978, published by Smithsonian Institution Press, with text by Paul J. Karlstrom, chronology, list of exhibitions, bibliographies.

Eilshemius, *Stormy Landscape.*

Stormy Landscape, 1890
(Lady and Church; Landscape with Woman and Haystack)
Oil on canvas
20¼ x 30 in (51.4 x 76.2 cm)
Signed and dated lower right: Eilshemius. / 1890
Gift of Jo Ann and Julian Ganz, Jr.
M.76.67.2

Eilshemius's early paintings were almost all landscapes. These were unlike the personal style with which he later became identified but were typical of the period. As did many late nineteenth-century artists, Eilshemius fell under the influence of GEORGE INNESS and Jean-Baptiste-Camille Corot (1796–1875) and produced paintings that could be considered to be in the Barbizon manner. *Stormy Landscape* reflects Inness's concern for weather conditions, specifically his love for approaching storms, as well as his colorful, poetic palette.

Eilshemius painted the clouds in shades of pink, lavender, and gold to form a brilliant foil for the somber greens and blues of the foreground and distant trees. Eilshemius also constructed his composition as Inness so often did by composing it around an expansive, open field in a settled area of the countryside. While Eilshemius captured the dramatic poetry of Inness, he avoided the hazy atmosphere of Inness's late paintings.

Small figures in peasant dress often appear in paintings of the Barbizon school. Here the woman seems to be wearing simple rustic clothes and wood shoes. The relatively large scale of the figure is more in keeping with those in the paintings of Corot than of Inness, except in the latter's work of the mid-1880s. While the painting reads as a landscape rather than as a figure composition set outdoors, the figure is an essential element of the painting, forming a compositional counterpoint to the stream on the right and row of trees in the background. Moreover, the woman contributes to the unsettling mood by her disproportionate scale and mysterious activity.

PROVENANCE
With Valentine Dudensing Gallery, New York § Clifford Odets, Beverly Hills, Calif. § With Paul Kantor Gallery, Beverly Hills § Robert A.

Rowan, Pasadena, Calif., to 1970 (sale, Pasadena Art Alliance, 1970) § Jo Ann and Julian Ganz, Jr., Los Angeles, 1970–76.

EXHIBITIONS
New York, Bernard Danenberg Gallery, *The Romanticism of Eilshemius*, 1973, no. 8, pp. 7–8, essay by P. Karlstrom, repro., p. 8, as *Lady and Church* § Santa Barbara (Calif.) Museum of Art, *American Paintings, Watercolors, and Drawings from the Collection of Jo Ann and Julian Ganz, Jr.*, 1973, no. 27, repro., unpaginated, as *Stormy Landscape (Lady and Church)* § University of California, Los Angeles, Frederick S. Wight Gallery, *Louis M. Eilshemius*, 1979–80, entries not numbered.

LITERATURE
Karlstrom, "Eilshemius," 1: 74, 108, discusses as landscape with staffage and debt to Inness, fig. 19; 2: 16–17, listed in cat. oeuvre as no. 52, with provenance § Karlstrom, *Louis Michel Eilshemius*, pp. 43, 56, pl. 105, p. 133, as *Landscape with Woman and Haystack*.

Eilshemius, *Delaware Water Gap.*

Delaware Water Gap, 1909
Oil on wood panel
21⅝ x 27⁹/₁₆ in (54.9 x 70.0 cm)
Signed and dated lower left: Elshemus / '09
Gift of Mr. and Mrs. Malcolm Smith
50.29

The Delaware Water Gap has attracted artists since the early nineteenth century. The gap, recognized by the sloping v-shaped land formation where the Delaware River cuts through Mount Minsi and Mount Tammany, is located about three miles north of Portland, Pennsyl-

vania, and Columbia, New Jersey. The area is noted for its scenic landscape and rustic towns and was the subject for a number of Eilshemius's paintings. His early Delaware Water Gap paintings were pure landscapes (such as the painting of c. 1888 at the Metropolitan Museum of Art, New York). He then began to include the human figure, which would become the main subject of his paintings. Several paintings of the same size as the museum's from the period 1908–9 are listed in the files of Valentine Dudensing, Eilshemius's dealer. The museum's scene is of The Kittinny, one of the largest hotels of the area, located just south of the gap, and one of several notable hotels and buildings that Eilshemius painted.

In this canvas Eilshemius focused on the figures, placing them in the foreground on a porch, the architecture of which determined the structure of the scene. Moreover, the pole obstructs a clear view of the gap's characteristic slope, thereby minimizing its importance. Eilshemius painted many genre paintings, usually using the countryside as the locale to explore the popular late nineteenth-century theme of the leisure activities of people on vacation. Eilshemius spent his summers migrating from one rural hotel to another, painting the popular resort areas of the Poconos, Catskills, and places in Connecticut and New England. In such images he often portrayed the vacationers fishing, boating, or swimming. In this evening scene, the time indicated by the long shadows and cool sky, the people are amusing themselves playing cards outdoors.

Eilshemius presented the scene in large simple shapes, which would suggest a sketch if not

for the size of the canvas. The naïve depiction of the figures' anatomy is typical of his paintings of this period and indicates the early stage of his moving away from his academic training and toward a more child-like painting style. The variant spelling of his name in the signature is also characteristic of his paintings from 1888 to 1913.

PROVENANCE
Mr. and Mrs. Malcolm Smith, Los Angeles, to 1950.

LITERATURE
Karlstrom, "Eilshemius," 1: 144, 410, fig. 91; 2: 55, listed in cat. oeuvre as no. 265.

Frederick Melville DuMond

Born July 15, 1867,
Rochester, New York
Died May 25, 1927,
Monrovia, California

Frederick Melville DuMond was a little-known figure and landscape painter at the turn of the century. Sometimes confused with his more famous brother, Frank Vincent DuMond (1865–1951), Frederick DuMond studied architectural and machine drawing at the Mechanics Institute, Rochester, from 1885 to 1888 and worked as a surveyor. He later traveled to Paris, where he enrolled at the Académie Julian and may have also studied with Fernand Cormon (1854–1924). He spent two decades in France as an expatriate, exhibiting annually at the Paris Salon from 1889 to 1908, obtaining an honorable mention in 1893 for a scene from the life of Christopher Columbus and a third-class medal in 1899 for *The Theater of Nero* (both unlocated). His work produced during the 1890s was on historical and religious themes. Art historian Sadakichi Hartmann discussed his taste for brutal animal scenes and categorized him as the only American adherent of the *genre féroce,* comparing his scenes of animals battling, such as *To the Tigers* (location unknown), to the work of Evariste Luminais (1822–1896) and Cormon. In search of the exotic, DuMond visited India in 1900. By 1905 he had written *Mes Chasses en Afrique* and *Les Giraffers du Lac Rodolph.* In the early 1900s he exhibited portraits.

When he returned to the United States in 1909 he settled in the Southwest and began specializing in desert scenes. In 1908 he was commissioned by the Santa Fe Railroad to paint a landscape of the Grand Canyon. In 1913 he homesteaded in the Mojave Desert and also established a residence in Monrovia, California. During these years he occasionally taught and exhibited in Los Angeles. As a specialist in landscapes of the American desert, he became noted for his high-keyed hues.

BIBLIOGRAPHY
The Artists' Year Book, ed. A. N. Hosking (Chicago: Art League Publishing Association, 1905), pp. 55–56 § Sadakichi Hartmann, *A History of American Art* (rev. ed., 1901; reprint, New York, Tudor, 1934), pt. 2: 192–93 § Obituary, *Art News* 25 (June 4, 1927): 9 § Moure with Smith 1975, p. 74, biographical note inaccurately attributes some of his brother's activities to him, with bibliography.

Legend of the Desert, 1892
(*Death on the Desert*)
Oil on canvas
59⅜ x 113½ in (150.9 x 288.3 cm)
Signed and dated lower right: Fred-Melville-DuMond-Tipazah-'92
Gift of Joseph Szymanski in memory of Dr. Joseph McLain and Rodger Smoot
M.85.232

Legend of the Desert was a major early painting exhibited by DuMond at the Paris Salon. It is very representative of the subject matter and aesthetics popular in late-nineteenth-century European painting. From midcentury on, artists of all nationalities produced thousands of paintings of the Mideast to satisfy the public's curiosity about exotic lands, and many artists in search of brilliant sunlight actually traveled to North Africa.

DuMond emphasized the glaring desert light by surrounding the figures with large expanses of reflective ocher sand. Based on the biblical story of Hagar and Ishmael dying of thirst while lost in the desert (Genesis 21: 8–20), DuMond took artistic liberties with the representation of Ishmael, making him older than the baby of the biblical story. The subject demonstrates the close association between orientalist themes and religious painting, which experienced a revival in the 1880s.

While DuMond modeled the figures fully, he approached the total composition two-dimensionally, eliminating the horizon and any sense of distance, thereby flattening the image. He attenuated the figures' anatomy, in particular Ishmael's, by splaying his body out across the picture plane. The scene becomes a highly manipulated, two-dimensional design. Somewhat unusual was DuMond's mixing of sand

and pebbles into the paint surface along the lower foreground to heighten the feeling of gritty sand.

When DuMond signed the painting he added the place name Tipazah, probably referring to Teashur, a village in the Holy Land near Beersheba. According to the biblical account, Hagar and Ishmael wandered in the part of the desert known as the Wilderness of Beersheba. It seems quite extraordinary that DuMond, striving for authenticity, would paint such a huge canvas on site, rather than back in

EXHIBITIONS
Paris, Société des artistes français, *Salon,* 1892, no. 618 § Chicago, *World's Columbian Exposition: Official Catalogue, Fine Arts,* 1893, no. 374 of United States section, as *A Legend of the Desert.*

LITERATURE
Catalogue illustré de peinture et sculpture: Salon de 1892 (Paris: Ludovic Baschet, 1892), repro., p. 155 § Charles M. Kurtz, ed., *Official Illustrations from the Art Gallery of the World's Columbian Exposition* (Philadelphia: George Barrie, 1893), p. 361, repro., p. 98 § *The Jonathan* 10 (October 1940): 20, repro., as *Death*

DuMond, *Legend of the Desert.*

his studio. Perhaps the reference to Tipazah in the signature merely refers to the place where the artist first conceived of the painting.

PROVENANCE
The artist § Jonathan Club, Los Angeles, by 1914 to 1985.

on the Desert § E. J. Green, "'Death on the Desert,'" *The Jonathan* 17 (May 1947): 27, reprints earlier *Jonathan* article with additions, repro. § LACMA, American Art department files, Edward Rime to Sharon Kneedler, February 6, 1973, recounts Charles Haskell's story of the artist's initial idea for the painting.

Julius L. Stewart

Born September 6, 1855, Philadelphia, Pennsylvania
Died January 4, 1919, Paris, France

Son of the wealthy expatriate art collector William Stewart, Julius LeBlanc Stewart spent his entire career abroad, socializing and working among the American expatriate society and European high society. In 1873 he enrolled in the atelier of Jean-Léon Gérôme (1824–1904). He also studied with the popular Spanish artists Eduardo Zamaçois (1842–1871) and Raimundo de Madrazo (1841–1920). Following the practice of his teachers, Stewart devoted himself to figure painting. He began exhibiting at the Paris Salon in 1878 and the National Academy of Design in New York in 1883. His first mature paintings were of single figures, but he soon turned to more elaborate, multifigured, narrative scenes. His first major success, *Five O'clock Tea,* painted by 1883 (unlocated) and shown in the Paris Salon that year, and *The Hunt Ball,* 1885 (Essex Club, Newark), won critical acclaim and established his reputation as a delineator of the formal life of the upper class. In this genre he was also influenced by the work of his close friend, the artist Jean Béraud (1849–1936), but Stewart's images of the wealthy were considered to evince a greater realism and vivacity. He often included in his scenes portraits of his friends, such as James Gordon Bennett, publisher of the *New York Herald,* Sarah Bernhardt, and the Astors.

Stewart continued to paint society images and individual portraits but by the late 1890s also turned to other themes, including scenes of Venice; the nude, usually in the

open air; and religious subjects. His interest in the outdoors developed during time spent in the summer home of his friend Bennett in Bougival. Throughout the 1890s Stewart's international reputation grew as he exhibited in numerous international expositions, serving as the cochairman for the Americans in Paris for the 1894 Salon. By 1898, however, his career seemed to have been eclipsed, and he received little critical or public attention thereafter.

BIBLIOGRAPHY

Clarence Cook, *Art and Artists of Our Time* (New York: Selmar Hess, 1888), 3: 290–92 § Georges Bal, "Au Jour le jour dans les ateliers," *New York Herald* (Paris ed.), January 16, 1904, p. 5, reprinted as "M. Jules Stewart in His Studio," *New York Herald,* December 23, 1906 § Dayton Art Institute and others, *American Expatriate Painters of the Late Nineteenth Century,* exh. cat., 1976, text by Michael Quick, pp. 22, 135–36, 157, with bibliography § Sue Carson Joyner, "Julius L. Stewart: Life and Works," Master's thesis, Hunter College, City University of New York, 1982, with bibliography and list of exhibitions § D. Dodge Thompson, "Julius L. Stewart: A 'Parisian from Philadelphia,'" *Antiques* 130 (November 1986): 1046–58.

Stewart, *The Baptism.*

The Baptism, 1892

Oil on canvas
79¼ x 117¼ in (201.3 x 297.5 cm)
Signed and dated lower right: JL. Stewart / Paris / '92 (JL. monogram)
Inscribed verso: Sunday 11 AM / V [indecipherable]
Purchased with funds provided by Museum Acquisition Fund, Mr. and Mrs. William Preston Harrison Collection, Mr. and Mrs. J. Douglas Pardee, Jo Ann and Julian Ganz, Jr., Mr. and Mrs. Charles C. Shoemaker, Mr. and Mrs. William D. Witherspoon, Mr. and Mrs. Thomas H. Crawford, and other donors
80.2

Stewart's paintings of the elegant and fashionable world in which he lived were sometimes inspired by specific events and often included his friends. In *The Baptism* he depicted with a studied realism an elaborate interior and the costume of members of high society gathered to witness the baptism of one of their own. The realistic details suggest that the figures were portraits of specific persons. In Stewart's earlier painting *The Hunt Ball,* a key was provided to identify many of the figures. No key is known to exist for *The Baptism.* The painting has been traditionally considered to be of the Vanderbilts, but all attempts to substantiate this have proved fruitless. Although most of the male figures have distinctive physiognomies, Stewart's social world was so large—encompassing not only Americans but those of many nationalities—that identification is difficult. The art historian Sue Carson Joyner has suggested that the male standing on the far right is a self-portrait. Stewart usually idealized his female figures, giving them handsome, aristocratic profiles, so the similarities among female figures in his paintings can be misleading.

The painting was probably not a specific commission, for Stewart was too wealthy to need such work, nor would he have offered it for sale if it were. The painting probably records the baptism of a friend's child, indicated by the faint inscription of a day and time on the back of the painting, but was not intended

to record the event for the public. *The Baptism* was the culmination of Stewart's development of elaborate multifigured scenes; thereafter he limited his compositions to smaller groupings.

Although the identities of the people remain an enigma, the painting can be appreciated on its own terms. It is a tour de force of technical skill and a prime example of late nineteenth-century academic aesthetics. The persuasiveness of Stewart's depiction of natural light suggests the fascination with outdoor effects that were just emerging in his art. The picture met with great acclaim at an international exposition held in Berlin in 1895. The realistic illusion of the rich damask wall coverings, the silk, satin, and lace trim of the figures' attire, and the soft, delicately rendered skin of the women and children captivate viewers even today.

PROVENANCE
The artist § (Sale, Paris, *Biennale des Antiquaires au Grand Palais,* 1967 or 1968) § Private collection, France, 1967/68 § With Hirschl & Adler Galleries, New York, 1979–80.

EXHIBITIONS
Chicago, *World's Columbian Exposition: Official Catalogue, Fine Arts Department,* 1893, no. 936 of United States section, as *Baptism* § Antwerp, *Exposition universelle des Beaux-Arts, Catalogue général illustré,* 1894, no. 2349 § *Grosse Berliner Kunst Ausstellung, Katalog,* 1895 (5th ed.), no. 1672, pl. 17 § Paris, Société Nationale des Beaux-Arts, *Salon,* 1896, no. 1176 § Philadelphia, Pennsylvania Academy of the Fine Arts, *Sixty-sixth Annual,* 1896–97, no. 300 § Munich Königlische Glaspalaste, *Offizieller Katalog der VII Internationalen Kunstausstellung,* 1897 (2nd ed.), no. 1613e.

LITERATURE
Charles M. Kurtz, ed., *Official Illustrations from the Art Gallery of the World's Columbian Exposition* (Philadelphia: Barrie, 1893), p. 378, repro., p. 31 § William Walton, *Art and Architecture: World's Columbian Exposition* (Philadelphia: Barrie, 1893), 1: 22 § "Artists and Their Work," *Munsey's Magazine* 13 (June 1895): repro., 221, as *A Baptism* § Pennsylvania Academy of the Fine Arts, Archives, the artist to H. Morris, September 24, 1896, painting is to be exhibited in Munich if not sold in the academy's exhibition § Hilton Kramer, "The Inanity of the Academic," *New York Times,* July 27, 1980, pt. D., pp. 25, 26, discusses in context of the present-day revival of nineteenth-century academic art, repro., p. 25 § "New Acquisition: American Art," *LACMA Members' Calendar* 18 (August 1980): unpaginated, repro. § Rev. James B. Simpson, "A Stylish Sprinkling Sanctified as Art," *Anglican Digest* 23 (Eastertide 1981): 23, 26, discussed in terms of 1890s American Anglicanism, repro., 24–25 § "A Backward Look at the Baptism," *Anglican Digest* 23 (Michaelmas 1981): 17–19, discussed in terms of baptism at home and describes clerical dress, repros. of details, 18–19 § Joyner, "Julius L. Stewart," pp. 49–50, 52–54, 57, cites exhibition record and states that it met with great acclaim in an international exposition held in Berlin in 1895, fig. 22, p. 104 § Fort 1986, p. 424 § Thompson, "Julius Stewart," pl. 9, p. 1054 § Brussels, American Cultural Center, *The Forgotten Episode: Nineteenth-Century American Art in Belgian Collections,* exh. cat., 1987, p. 16, text by Jennifer A. Martin Bienenstock, fig. 4, p. 19 § Jennifer A. Martin Bienenstock, "From Yankee Ingenuity to Yankee Artistry: American Artists at the Antwerp World's Fair of 1894," *Museummagazine* (Koninklijk Museum voor Schone Kunsten Antwerpen) no. 7 (1987): 38, 42, discusses the painting in the contexts of Stewart's participation in the fair and of other American contributions, fig. 9, p. 46 § LACMA 1988, p. 19, repro.

Grace Hudson

Born February 21, 1865, Potter Valley, California
Died March 23, 1937, Ukiah, California

Grace Carpenter Hudson's fame rests on her accurate portraits of the Pomo people of Northern California. In her teens Hudson studied in San Francisco at the California School of Design with Oscar Kunath (died 1904) and Raymond D. Yelland (1848–1900). In 1889 she set up a studio back home in Ukiah and began giving art lessons. Although she remained in Northern California for most of her life, her work was widely known. In the 1890s she began to participate in national exhibitions and her illustrations began appearing in various periodicals, including *Cosmopolitan, Overland Monthly, Sunset,* and *Western Fields.*

In 1890 she married Dr. John W. Hudson and began painting the Pomo. Her husband shared her fascination with them and eventually abandoned his medical practice to assist his wife and pursue his own related interests, researching and writing on the ethnology of the Native Americans. Recording the vanishing Pomo culture became their shared life-long passion. Hudson expanded her subject matter on two occasions: in 1901 she spent nine months in Hawaii painting native children, and in 1904 the couple were commissioned by the Field Museum of Chicago to document the Pawnees of Oklahoma. She continued painting until 1935, not drastically changing her somewhat sweet, but realistic depiction of the Pomo.

BIBLIOGRAPHY

Ukiah, Calif., The Sun House and Grace Hudson Museum, Grace Hudson Papers § Ninetta Eames, "The California Indian on Canvas," *Frank Leslie's Popular Monthly* 43 (April 1897): 380–87 § San Francisco, California Historical Society, *Grace Carpenter Hudson (1865–1937),* exh. cat., 1962, with text by Joseph Armstrong Baird, Jr. § Searles R. Boynton, *The Painter Lady: Grace Carpenter Hudson* (Eureka, Ca.: Interface California Corp., 1978), with illustrated catalogue raisonné § Palm Springs (Calif.) Desert Museum and others, *The Pomo: Gifts and Visions—Paintings of Pomo Indians by Grace Carpenter Hudson,* exh. cat., 1984, with text by Katherine Plake Hough.

Hudson, *Powley: Young Man Hoeing Corn.*

Powley: Young Man Hoeing Corn, 1895
(*Indian Boy with Hoe*)
Oil on canvas
17³/₁₆ x 10³/₁₆ in (44.8 x 26.0 cm)
Signed lower right: G. Hudson
Signed and dated below first signature: G Hudson '95
Inscribed verso lower center: Grace Hudson / Ukiah / Cal / June '95
Numbered verso lower left: 43
Charles H. Quinn Bequest
75.4.8

In 1895 Hudson painted *Powley's Sweetheart* (unlocated). Supposedly enough viewers of the painting asked, "Who's Powley?" that in response Hudson painted this picture of Powley, a young Pomo Indian who worked for white settlers, helping them plant corn, hops, and other crops. Hudson carefully detailed Powley as he stood at rest in a field of corn. Despite her provincial training, Hudson was proficient at drafting and at her best excelled in the academic rendering of the figure, as in this painting. Powley, on the verge of manhood, is a chubby, handsome boy, his dark, smooth skin and eyes standing out before the soft yellow field of corn surrounding him. *Powley* satisfied the late nineteenth-century taste for a sentimental and saccharine portrayal of innocence, as did the paintings of street urchins by Hudson's urban counterpart, John G. Brown (1831–1913). Powley's life, however, did not fulfill this ideal. His success as a performer in a tourist attraction led him to abandon traditional ways, change his name to Jeff Dick, and neglect his wife and child. Eventually he became an alcoholic, killed a man, and died of syphilis (Ukiah, The Sun House and Grace Hudson Museum, Grace Hudson Papers, "The Rise and Fall of Powley," manuscript).

Hudson left a diary in which she listed her paintings chronologically and assigned them numbers. Entitled *Indian Boy with Hoe* when it was donated to the museum, the painting was later correctly identified by the number "43" written on its verso.

PROVENANCE
G. L. W. Branman, Boston § Charles H. Quinn, Los Angeles, to 1975.

EXHIBITION
LACMA, *Western Scene,* 1975, no. 19.

LITERATURE
Ukiah, The Sun House and Grace Hudson Museum, Grace Hudson Papers, Hudson Record Notebook, lists painting as number 43, with title *Powley: Young Man Hoeing Corn* and purchaser § Eames, "The California Indian," p. 383, considers the pair of paintings "charming" and notes their "exhibition at an art room in San Francisco," repro., p. 382 § LACMA, American Art department files, Searles R. Boynton-Mr. and Mrs. Roy Farrington Jones correspondence, November 1–5, 1975, discusses history of the painting § Boynton, *Hudson,* pp. 41–42, 158, listed in cat. raisonné as no. 3, discusses, fig. 43, p. 158.

Childe Hassam

Born October 17, 1859,
Dorchester (now Boston),
Massachusetts
Died August 27, 1935, East
Hampton, New York

Frederick Childe Hassam was one of America's earliest and most significant impressionists. During his long and productive career he produced a tremendous body of work in oil paintings, watercolors, pastels, etchings, drypoints, and lithographs. He painted predominantly landscapes and cityscapes, often depicting his beloved New England, although he also painted figurative scenes, particularly later in life.

Hassam's unusual family name is that of a very old New England family. He began his career as a book illustrator in Boston. After his first visit to Europe in 1883 he returned home to paint tonalist views of that city. In 1886 he moved to Paris, where he lived for three years. There he enrolled at the Académie Julian, studying with Jules Lefebvre (1836–1911), and continued to paint cityscapes, his palette becoming increasingly paler and his brushstroke more impressionistic in response to French styles. Returning to the United States, he settled in New York but continued to summer as before in Appledore, on the Isle of Shoals off the coast of Maine. In 1896 Hassam began working at Cos Cob, Connecticut, no doubt inspired to go there by his friendships with other American impressionists. During the same decade he became an active exhibitor in annuals throughout the country and participated in artists' organizations, becoming the first president of the American Water Color Society and a member of the Society of American Painters in Pastel and the Players Club. He spent 1896–98 traveling in Italy, Brittany, and England.

Upon his return home Hassam exhibited in the first exhibition of the secessionist group Ten American Painters, which he was instrumental in organizing. In 1900 he expanded his subject matter, depicting Manhattan views, New England churches, laborers at work, and nudes. He first visited Old Lyme, Connecticut, in 1903, and his continued presence there transformed the art colony from a Barbizon-dominated group to an impressionist one.

In 1904 and 1908 he visited the West Coast at the invitation of his patron, Colonel Charles Wood of Portland, and painted in eastern Oregon. In 1914 he worked in San Francisco and environs. In 1910 he began to visit eastern Long Island and in 1919 bought a summer home in East Hampton, which would serve as the locale of many of his paintings during his last fifteen years. In 1915 he began his printmaking career. Hassam bequeathed the works in his estate to the American Academy of Arts and Letters, of which he had been a member since 1920.

BIBLIOGRAPHY
New York, American Academy of Arts and Letters, Childe Hassam Papers (on microfilm, Archiv. Am. Art) § *Index 20th Cent. Artists* 3 (October 1935): 169–83; 3 (August–September 1936): 1; reprint, pp. 461–75, 477 § Adeline Adams, *Childe Hassam* (New York: American Academy of Arts and Letters, 1938), with lists of awards and collections § Donelson F. Hoopes, *Childe Hassam* (New York: Watson-Guptill, 1979), with chronology, bibliography § East Hampton, Guild Hall Museum, *Childe Hassam, 1859–1935,* exh. cat., 1981, with essays by Stuart P. Feld and Judith Wolfe, chronology by Kathleen M. Burnside.

The Spanish Stairs, Rome, 1897
(Evening, The Piazza of Spain, Rome;
The Spanish Stairs)
Oil on canvas
29⁵/₁₆ x 23³/₈ in (74.5 x 59.3 cm)
Signed and dated lower right: Childe Hassam 1897 / Rome
Inscribed verso upper center: CH [encircled] / 1897
William Randolph Hearst Collection
46.44
Color plate, page 51

The Spanish Stairs in Rome have been favored by tourists since they were constructed. The monumental double staircase with more than 130 steps was built in 1725 by the French on land owned by them. The stairs lead up a steep hill from a plaza to San Trinità dei Monti, which had been constructed earlier by Charles VIII of France. Such throngs of people immediately flocked to see the stairs that guards from the nearby Spanish embassy were sent to keep order. While the French protested the Spanish intrusion onto their land, the Roman authorities ruled that the stairs fell under the jurisdiction of the Spanish. The public then began referring to the staircase as the Spanish Stairs.

Hassam painted the stairs during his trip to Europe in 1896–98, when he spent the month of January 1897 in Rome. As so many Americans before him, Hassam became entranced by this scenic spot in the Holy City, and he is known to have painted it at least three times. A comparison of this version with the one in the Newark Museum, of the same size, reveals a change in the artist's perception of the subject: in the museum's version Hassam viewed the staircase as a tourist image, presenting an expansive view of the stairs and church above

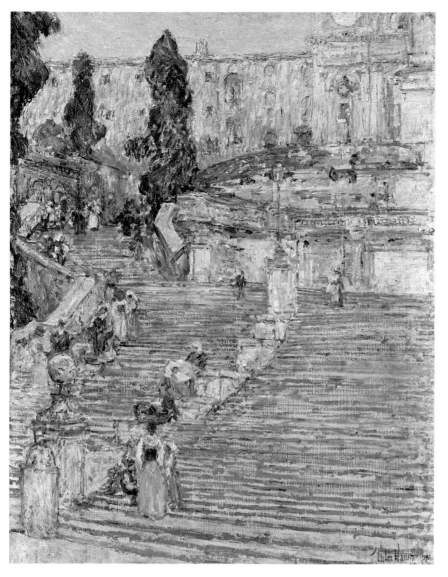

Hassam, *The Spanish Stairs, Rome.*

while in the Newark version he moved closer to the scene, thereby eliminating the church and the full sweep of the grand staircase.

In true impressionist fashion, Hassam may have used the motif of the Spanish Stairs to explore the effect of natural light during different times of the day. The Newark version has the brilliant color and intensity of a noonday sun, while the museum's painting has a more delicate, opalescent palette, suggesting the faint light at the onset of twilight. The hues subtly change from the warm orange of the light of the setting sun caught by the top of the church in the upper right corner of the painting to cooler tones of blue and lavender proceeding down the stairs. The indistinctness of the figures also suggests the crepuscular light of late afternoon. Hassam exhibited a painting titled *Le Soir Piazza de Spagna (Rome)* at the 1897 Salon of the Société National des Beaux-Arts, and the museum's version, which has on its verso part of a French label dating from the 1890s, may be this evening scene.

PROVENANCE
The artist, 1897–still in 1913 § With E. and A. Milch, Inc., New York, 1919 § With J. K. Newman, New York, to 1935 (sale, American Art Association, Anderson Galleries, Inc., New York, *Important Paintings . . . The Private Collection of J. K. Newman, New York,* 1935, no. 43, repro., p. 49, sold to W. H. Woods [pseud. of William Randolph Hearst]) § William Randolph Hearst, New York, 1935–46.

EXHIBITIONS
Probably Paris, Société Nationale des Beaux-Arts, *Salon,* 1897, no. 622, as *Le Soir Piazza de Spagna (Rome)* § Probably Art Institute of Chicago, *Tenth Annual Exhibition of Oil Paintings and Sculpture by American Artists,* 1897, no. 170 § Possibly New York, Durand-Ruel, *Ten American Painters: The First Exhibition,* 1898, no. 24, as *The Spanish Stairs* § Possibly Worcester, Mass., Public Library, organized by Worcester Art Society, *Catalogue of the First Exhibition of the Worcester Art Museum with the Cooperation of the Worcester Art Society,* 1898, no. 17 of oil paintings, as *The Spanish Stairs* § New York, Association of American Painters and Sculptors, Inc., Armory of the Sixty-ninth Regiment, *International Exhibition of Modern Art,* 1913, no. 72 § Possibly Buffalo, Albright Art Gallery, *Eighth Annual Exhibition of Selected Paintings by American Artists,* 1913, no. 51 § Possibly New York, Montross Gallery, *Exhibition of Pictures by Childe Hassam,* 1917, no. 3 § Art Institute of Chicago, *Half a Century of American Art,* 1939–40, no. 73, pp. 21–22, quotes Chicago newspaper reviews of the day, including *Times-Herald* of October 31, 1897, which refers to as "an alluring picture full of sunlight and pellucid color. It suggests Raffaelli in composition and handling" § Los Angeles, Cowie Galleries, *Two Hundred Years of American Painting,* 1961, no. 35 § Houston, Tex., Meredith Long & Co., *Americans at Home and Abroad, 1870–1920,* 1971, no. 16, p. 13, essay by Larry Curry, repro., p. 31.

LITERATURE
"New York Art Exhibitions and Gallery Notes," *Christian Science Monitor,* January 12, 1917, p. 8 § New-York Historical Society, Dewitt McClellan Lockman Papers, transcript of interview of the artist by Lockman, January 31, 1927, pp. 33–34, February 2, 1927, p. 25 (Archiv. Am. Art, microfilm roll 503, frs. 350–51, 383) § "Newman Paintings Bring $75,265 Total in Recent Dispersal," *Art News* 34 (December 14, 1935): 22 § Milton W. Brown, *The Story of the Armory Show* (New York: Joseph H. Hirshhorn Foundation, 1963), p. 249, lists § Utica, N.Y., Munson-Williams-Proctor Institute, and New York, Armory of the Sixty-ninth Regiment, *1913 Armory Show Fiftieth Anniversary Exhibition,* exh. cat., 1963, p. 191 § Hoopes, *Hassam,* p. 44, pl. 12, p. 45.

Strawberry Tea Set, 1912
Oil on canvas
36¹¹/₁₆ x 37¹⁵/₁₆ in (93.2 x 96.3 cm)
Signed and dated upper right: Childe Hassam / 1912
Inscribed on board covering canvas back upper
right: CH / 1912
Mr. and Mrs. William Preston Harrison Collection
29.18.13

Around 1910 Hassam began depicting single
female figures set in comfortable domestic inte-
riors. The critic Royal Cortissoz referred to
these paintings as the "window series," since
the figure either sits or stands in front of or
next to a window through which sunlight
streams into a room. Often the window pro-
vides an unobstructed view of the city, but
occasionally, as here, a drapery filters the light
or even obstructs the view. Usually little of
the room is shown, except for a highly polished
table, which reflects the sunlight, and upon
which is set a delicate vase of fresh flowers, a
tea set, platter of fruit, or an objet d'art. The
woman is never very active but instead is
engrossed in a book, thoughtful contemplation,
or quiet examination of an object. Often, as
in this painting and *Tanagra*, 1918 (National

Museum of American Art, Smithsonian
Institution, Washington, D.C.), the woman is
dressed in a loose fitting costume. *Tanagra* is
the window-series painting most closely related
to *Strawberry Tea Set*, sharing the similarity of
the woman's costume, the horizontal composi-
tion, and the woman's fascination with an
object that she holds in her hand. In these
paintings Hassam came close to the studio pro-
ductions of the Boston school painters and
their depictions of upper-class women living
comfortably in their elegant houses. Hassam
differed from them in his emphasis on mood,
which he conveyed through the figure's intro-
spective attitude and evocative lighting.

In his delineation of form Hassam was
more conservative in the window series than
in his flag paintings of the same period. This
is especially true of *Strawberry Tea Set*, where
the figure is slightly larger than in most of the
other window paintings. Hassam rendered her
as quite solid by modeling the form with heavy
brushstrokes and manipulating the filtered
light. Much less conservative was the palette,
as Hassam daringly carried out the composition
in a brilliant bluish green, ocher, an electric
purple for highlights, and a pure white.

PROVENANCE

The artist § With Milch Galleries, New York, 1920 § Mr. and Mrs. William Preston Harrison, Los Angeles, 1925–29.

EXHIBITIONS

New York, Montross Gallery, *Ten American Painters: Fifteenth Annual Exhibition,* 1912, no. 11 § City Art Museum of Saint Louis, *Seventh Annual Exhibition of Selected Paintings by American Artists,* 1912, no. 53 § Philadelphia, Pennsylvania Academy of the Fine Arts, *108th Annual Exhibition,* 1913, no. 453 § San Francisco, *Panama-Pacific International Exposition, Department of Fine Arts, Official Catalogue (Illustrated),* 1915, no. 3713 § Art Club of Philadelphia, [group exhibition, title unknown], 1919, no cat. traced § New York, Milch Galleries, *Exhibition of Works in the Various Mediums by Childe Hassam,* 1919, exhibited but not listed § Tucson, University of Arizona Museum of Art, and Santa Barbara (Calif.) Museum of Art, *Childe Hassam, 1859–1935,* 1972, no. 88, repro., p. 115.

LITERATURE

James B. Townsend, "PA. Academy Display (Second Notice)," *American Art News* 11 (February 15, 1913): 8, considers it one of best paintings in exhibition § Fullerton L. Waldo, "The Pennsylvania Academy Exhibition," *Arts and Decoration* 3 (April 1913): repro., 201 § E. C., "Studio-Talk," *International Studio* 49 (May 1913): 251, repro., 252 § Eugene Castello, "Philadelphia," *American Art News* 17 (April 19, 1919): 6, refers to painting as "stereotype" window image § "Childe Hassam's Work in Various Mediums: Art at Home and Abroad," *New York Times Magazine,* November 16, 1919, p. 12 § Advertisement, *Arts and Decoration* 12 (February 1920): repro., 279 § Nathaniel Pousette-Dart, comp., *Childe Hassam,* Distinguished American Artists series (New York: Stokes, 1922), repro., unpaginated § Advertisement, *American Magazine of Art* 14 (March 1923): repro., between pp. 112 and 114 § LACMA, Registrar's files, William Preston Harrison to Louise Upton, October 7, 1925, the painting is on its way to the museum from Hassam's studio § Rilla E. Jackman, *American Arts* (New York: Rand McNally, 1928), p. 170, mentioned § Advertisement, *Art News* 27 (February 23, 1929): repro., 16; 27 (June 1, 1929): repro., 14 § LACMNH, Archives, Museum Scrapbook, unidentified newspaper clipping, "Patron of Art Close with Taste," [1929–31], repro. § Harrison 1934, p. 31, repro., p. 14 § *Index 20th Cent. Artists,* p. 182; reprint, p. 474; listed § Higgins 1963, p. 60, no. 80 in checklist of Mr. and Mrs. William Preston Harrison collection.

Point Lobos, Carmel, 1914

(*Carmel Coast*)
Oil on canvas
28⁵/₁₆ x 36³/₁₆ in (72.0 x 92.0 cm)
Signed and dated lower left: Childe Hassam 19 [indecipherable]
Inscribed verso center: Point Lobo / CH [encircled] 1914
Mr. and Mrs. William Preston Harrison Collection 29.18.2
Color plate, page 56

California scenes by Hassam are not common; references suggest that there may not be more than a dozen. Hassam began traveling to the West Coast in the early years of this century, first to spend time with a patron in Oregon. Later he visited California several times. Hassam definitely visited the San Francisco area in 1914, to complete a lunette mural for the Panama-Pacific International Exposition of 1915. While in San Francisco he stayed at the Bohemian Club but made excursions to the favorite painting spots of local artists in the neighboring areas, among them Carmel.

Point Lobos, Carmel was the result of a sketching trip that Hassam took with the California landscape painter Francis J. McComas (1874–1938). McComas's second wife recounted to Kent Seavey the amusing story of how McComas became upset by Hassam when he insisted on turning his back upon a beautiful view of the coast to paint the scene from memory.

Hassam's painting method may account for the similarities between this Carmel view and his coastal scenes of Maine. Carmel was a favorite painting locale for artists, but Hassam may have found it especially attractive because it reminded him of his beloved Appledore in New England. Northern California shares with Maine a rugged coastline, and Hassam seems to have approached both shores in similar terms. He focused on the weather-hewn boulders, constructing them with the same forceful, short, vertical and diagonal brushstrokes and rich, contrasting, dark and light hues that appear in his Maine paintings. Only the cypress, bent from the ceaseless pounding of the ocean winds, alludes to a western locale.

When a group of Hassam's California landscapes was exhibited in the winter of 1915–16, they were considered "striking" and generally praised for their "remarkable effects of filtered sunlight" (*American Art News* 14 [December 4, 1915]: 5). *Point Lobos, Carmel,* however, describes a brilliantly sunny day.

PROVENANCE

The artist, 1914–26 § Mr. and Mrs. William Preston Harrison, Los Angeles, 1926–29.

EXHIBITIONS

New York, Montross Gallery, *Childe Hassam,* 1915,

Hassam, *Point Lobos, Carmel.*

no. 2 of Calif. group § San Diego, Palace of Fine
Arts, *California Pacific International Exposition,
Official Art Exhibition,* 1936, no. 300 § Monterey
(Calif.) Peninsula Museum of Art, *Artists of the
Monterey Peninsula, 1875–1925,* 1981, no. 36, unpagi-
nated, visited and sketched Point Lobos in the
company of Francis McComas.

LITERATURE
G. Pène du Bois, "An Almost Complete Exhibition
of Childe Hassam," *Arts and Decoration* 6 (January
1916): repro., 137, as *Point Lobos* § LACMA, Regis-
trar's files, William Preston Harrison to Louise
Upton, May 16, 1926 § "Harrison Gallery of Amer-

ican Art Enriched," *California Graphic* 4 (November
13, 1926): repro., 7 § "Recent Acquisitions—Art
Department," *LA Museum Graphic* 1, no. 2 supp.
(November–December 1927): 231, listed as *Carmel
Coast* § Harrison 1934, p. 31, repro., p. 14 § *Index
20th Cent. Artists,* pp. 170, 181; reprint, pp. 462,
473; listed in repros. and colls., as *Carmel Coast* §
Higgins 1963, p. 60, no. 83 in checklist of Mr. and
Mrs. William Preston Harrison collection §
LACMA, Registrar's files, Kent L. Seavey to Nancy
Dustin Wall Moure, July 14, 1970, recounts story
of sketching trip and suggests LACMA painting is
a later studio production § Gerald F. Brommer,
Landscapes (Worcester: Davis, 1977), repro., p. 64.

Avenue of the Allies: Brazil, Belgium, 1918

(*Avenue of the Allies, Brazilian, Belgian; Avenue of
the Allies: Front of Saint Thomas; Flag Day; Flag Day,
Belgium and Brazil; Flags Flying During War Time*)
Oil on canvas
36⁵⁄₁₆ x 24⁵⁄₁₆ in (92.1 x 61.8 cm)
Signed and dated lower left: Childe Hassam
Oct 19th 1918
Inscribed verso upper left: CH [monogram] 1918
Mr. and Mrs. William Preston Harrison Collection
29.18.1

The Preparedness Parade down Fifth Avenue
in New York on May 13, 1916, demonstrated

America's readiness to fight in World War I
and kindled Hassam's patriotic fervor, prompt-
ing him to begin his famous series of flag
paintings. By the end of the war he would
create approximately thirty oil paintings of
New York bedecked with displays of banners
and flags as part of the home-front effort to
inspire patriotism and help raise funds for war
relief efforts. Fifth Avenue was often deco-
rated, and for the Fourth Liberty Loan Drive
in the autumn of 1918 it became known as the
Avenue of the Allies, each block from Twenty-
fourth to Fifty-eighth streets being devoted to
the flags of a particular Allied country.

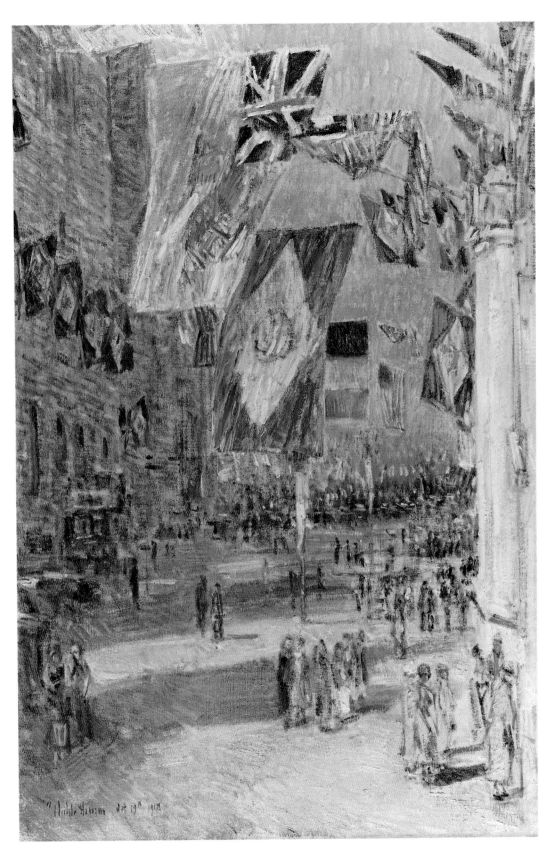

Hassam, *Avenue of the Allies: Brazil, Belgium.*

Hassam painted five pictures of Fifth Avenue during this celebration. In the museum's version the artist depicted the block between Fifty-fourth and Fifty-fifth streets, on which Brazil was represented. The flag of that country, a yellow diamond on a ground of bright green with a blue orb in the center, appears not only as the large flag waving in the center of the composition but also directly to the right and in a large grouping of flags to the left. The block south of Brazil was devoted to the British Empire and the one north to Belgium, so Hassam shows the New Zealand flag flying in the foreground and the flag of Belgium, a three-banded design with black on the top (Hassam always used dark blue), yellow in the center, and red on the bottom, flying behind the flag of Brazil. The flag of the United States also

appears several times, hanging from buildings and in the distance across the thoroughfare. The painting closest to this one is *Avenue of the Allies, Great Britain,* 1918 (Metropolitan Museum of Art, New York), in which Hassam depicted almost the same section of Fifth Avenue looking uptown but from the west side of the street rather than the east, so that the configuration of flags appears slightly different. The two versions share Hassam's use of architectural components—tall, sheetlike buildings—on both sides of the picture to frame the flag scene.

Street scenes were far from new in Hassam's oeuvre, for he had been fascinated with the hustle-and-bustle of the urban crowds since his early days in Boston. In the earlier images, however, figures usually assume a larger role. In the flag paintings it is the flags, not the figures, that are of primary importance. In the series Hassam experimented with the viewpoint, depicting the street from varying elevations—street level, slightly higher, above the flags, and even rooftop viewpoints. Hassam no doubt was inspired by the flag celebrations painted by Claude Monet (1840–1926) and other French impressionists, and his first flag paintings were watercolors done in Paris in 1889 during festivities for Bastille Day on July 14.

The flags increasingly became the main source of movement and decoration as the series progressed, as they not only became larger but also were more prominently placed. In the paintings from late 1918 such as this one Hassam viewed the flags from below to emphasize their size and positioned them in or near the center of the compositions against a pale sky to form a lively, two-dimensional pattern of colors and designs above the pedestrian-filled street. While the large flags strung across the street wave in the wind, a sense of air and movement is conveyed equally well through the pale palette and exceptionally sketchy, even unfinished surface.

The museum's painting was often exhibited during the years right after the war as part of Hassam's flag series. In 1919 an unsuccessful attempt was made by a committee of New Yorkers to purchase through popular subscription a group of the flag paintings as a permanent war memorial. The lithograph *Avenue of the Allies,* used as the frontispiece of A. E. Gallatin's *Art and the Great War* (1919), differs only slightly from the museum's painting in the details of a few of the foreground figures. William Preston Harrison's overwhelming enthusiasm for the art of Hassam, rather than his patriotism, may have been the crucial factor in his decision to purchase this painting.

Hassam, *Avenue of the Allies,* 1918, see Related Work.

RELATED WORK
Avenue of the Allies, 1918, lithograph, 5⅛ x 2⅜ in. (13.2 x 6.14 cm), inscribed "Oct 19th 1918 4 P.M.," frontispiece in Albert E. Gallatin, *Art and the Great War* (New York: Dutton, 1919). LACMA, gift of Mrs. Childe Hassam.

PROVENANCE
The artist, 1918–25 § Mr. and Mrs. William Preston Harrison, Los Angeles, 1925–29.

EXHIBITIONS
New York, Durand-Ruel, *Exhibition of a Series of Paintings of the Avenue of the Allies by Childe Hassam,* 1918, no. 5 § Pittsburgh, Carnegie Institute, Department of Fine Arts, *Childe Hassam: An Exhibition of Paintings, Flags of All Nations and Paintings of the Avenue of the Allies,* 1919, no. 18, as *Avenue of the Allies, Brazilian, Belgian* § New York, Milch Galleries, *Flag Pictures and Street Scenes by Childe Hassam,* 1919, no. 10 § New York, Church of the Ascension, Parish House, *Patriotic Street Scenes by Childe Hassam and Verdun Church Relics,* 1919, no. 10 § New York, College of the City of New York, [Hassam's flag pictures], 1919–20, no cat. traced § Washington, D.C., Corcoran Gallery of Art, *Exhibition of the Series of Flag Pictures by Childe Hassam,* 1922, probably no. 3, incorrectly identified as *Avenue of the Allies: Front of Saint Thomas* § Toledo Museum of Art and others, *Impressionism and Its Influence in American Art,* 1954, no. 18, as *Flag Day, Belgium and Brazil* § Laguna 1958, no. 53, as *Flag Day* § Eureka, Calif., and elsewhere, organized by California Arts Commission, *American Masters: Two Hundred Years of Painting in the United States,* 1966–67, no cat. traced § New York, Bernard Danenberg Galleries, *Childe Hassam: An Exhibition of His "Flag Series," Commemorating the Fiftieth Anniversary of Armistice Day,* 1968, no. 8, repro., unpaginated, as *Flag Day* § Tucson, University of Arizona Museum of Art, and Santa Barbara (Calif.) Museum of Art, *Childe Hassam, 1859–1935,* 1972, no. 109, repro., p. 40, as *Flag Day* § Grand Rapids Art Museum, *Themes in American Painting,* 1977, no. 84, p. 170, essay by J. Gray Sweeney, repro., p. 171, as *Flag Day* § Washington, D.C., National Gallery of Art, and others, *The Flag Paintings of Childe Hassam,* 1988–89 (related book by Ilene Susan Fort copublished by LACMA and Harry N. Abrams, New York, 1988), no. 24, pp. 20, 24–26, 78, 91, 94, 96, 103, 106, repro., p. 79.

LITERATURE
LACMA, Registrar's files, William Preston Harrison to Louise Upton, October 7, 1925, Hassam is shipping flag painting to the museum § Harrison 1934, p. 31, repro., p. 49, incorrectly lists 1926 as purchase date, as *Flag Day, Belgium, and Brazil,* incorrectly dated October 17, 1918 § *Index 20th Cent. Artists,* p. 170; reprint, p. 462; listed in colls., as *Flags Flying during Wartime* § Higgins 1963, p. 60, no. 82 in checklist of Mr. and Mrs. William Preston Harrison collection, as *Flag Day, Belgium and Brazil* § Richard J. Boyle, *American Impressionism* (Boston: New York Graphic Society, 1974), p. 157, repro., p. 131, as *Flag Day* § LACMA 1977, pp. 145–46, repro., p. 145, as *Flag Day* § LACMA 1988, p. 23, repro.

George Hitchcock

Born September 29, 1850,
Providence, Rhode Island
Died August 2, 1913, Marken,
the Netherlands

George Hitchcock was a leading expatriate painter around the turn of the century, the first such American to settle in Holland. He came late to art. After being graduated from Brown University in 1872 and Harvard Law School in 1874, Hitchcock practiced law for several years in Providence and New York. After determining to become an artist, he opened a studio in Chicago but soon realized he needed training. He went abroad, enrolling in Heatherley's School of Fine Art in London in 1879 but finding more satisfactory instruction in France at the Académie Julian in Paris, where he studied figure painting with Gustave Boulanger (1824–1888) and Jules Lefebvre (1836–1911), and in Germany at the Düsseldorf Academy. He spent several summers in The Hague studying with the Dutch marine painter and watercolor specialist Hendrik Mesdag (1831–1915). While traveling in Holland, he decided to set up a studio at Egmond. Although he wintered in France, he maintained a studio in Holland for the rest of his life.

In 1886 Hitchcock began exhibiting religious paintings. Following the example of such contemporaries as Fritz Von Uhde (1848–1911), he presented his religious themes in the guise of the contemporary Dutch peasant. Although he continued to focus on the Dutch peasant for the rest of his career, around the mid-1890s he ceased painting religious themes. Hitchcock developed an academic painting style, infusing it with such a strong sense of natural light that he became known as the "painter of sunlight." In his late paintings his representation of light in combination with vibrant hues and a flattening of the scene resulted in a more decorative quality. Although he had exhibited during the early 1880s in the United States at the New York Water Color Society and National Academy of Design, Hitchcock's reputation was not established until 1887, when his early peasant painting *La Culture des Tulips* was exhibited at the Paris Salon.

BIBLIOGRAPHY

Lionel G. Robinson, "Mr. George Hitchcock and American Art," *Art Journal* (London) 43 (October 1891): 289–95 § Arthur Fish, "George Hitchcock: Painter," *Magazine of Art* 21 (1898): 577–83 § Christian Brinton, "George Hitchcock: Painter of Sunlight," *International Studio* 26 (July 1905): i–vi § Dayton Art Institute and others, *American Expatriate Painter of the Late Nineteenth Century*, exh. cat., 1976, text by Michael Quick, pp. 32, 34, 106, 152, with bibliography § Annette Stott, "American Painters Who Worked in the Netherlands, 1880–1914," Ph.D. diss., Boston University, 1986, with bibliography.

Dutch Bride, c. 1898

(In Brabant; The Bride)
Oil on canvas
30⅛ x 24⅛ in (76.5 x 61.3 cm)
Signed lower right: G HITCHCOCK
Gift of Steve Martin
M.79.168

Hitchcock established his reputation during the 1890s with brilliantly colored paintings of peasants, such as *Dutch Bride*. He thought the country peasant in traditional costume was much more picturesque than the city dweller. He usually focused on one or two figures, often presenting them standing in a field of flowers and dressed in their Sunday best. The sun shines brightly in Hitchcock's images, clearly defining the solid figures in rich colors. In this painting his orchestration of a limited palette of yellow, green, purple, and white is masterly. The field of tulips is divided into two sections of yellow and a third of purple, the trees in the background form a brilliant green screen, and the woman, carrying rose-colored flowers, wears a white dress delicately colored with a floral pattern in green and lavender. Dutch women with their decorative headdresses particularly fascinated Hitchcock. Here the lovely young woman not only wears a beautiful muslin headdress with lace trim but also a thin gold band around her forehead and gold plaques at her temples, finery that Dutch women from certain locales added to their attire. Her elaborate headdress, bouquet, and shiny gold wedding band identify her as a bride.

Dutch Bride is typical of the single figure costume studies Hitchcock developed in the 1890s. In them he combined a strong sense of abstract design with his accurate observations. The figure was moved close to the picture plane and the background filled with fields of vividly colored flowers. Often, as in *Dutch Bride*, a dense row of trees or bushes limited the perspective, thereby adding to the feeling of flatness. The flowers as well as the Sunday-best costumes contribute to the rich sense of decorative patterns.

In 1898 Hitchcock contributed to the annual exhibition of the Carnegie Institute a full-length figure of a peasant bride, which, judging by the reproduction in the accompanying catalogue (see illustration), bears a strong resemblance to the museum's painting. No full-length depiction of a Dutch bride has been located. Passages of the background of the

Hitchcock, *Dutch Bride.*

Hitchcock, *Dutch Bride,* exhibited Pittsburgh, Carnegie Institute, Art Galleries, *The Third Annual Exhibition,* 1898–99 (illustration copied from exhibition catalogue, pl. 9).

museum's painting have been repainted; for example, minor changes were made in the shadows and details of the bride's dress and the field of yellow tulips was originally pink (as indicated by the edges of the canvas). These changes and the disappearance of the full-length version suggest that the museum's painting was originally the full-length work shown in Pittsburgh. The date of the alterations and the reason for them are not known; equally problematic is whether the repainting was done by the artist himself or by someone else, such as his wife, painter Cecile Jay.

When the painting was sold recently from the estate of the artist, its title was accidentally confused with that of *In Brabant,* by 1906 (private collection), another painting sold from the estate at the same time. Consequently, in the literature of the past fifteen years the painting has sometimes been inaccurately referred to as *In Brabant.*

PROVENANCE
The artist, to 1913 § Estate of the artist, 1913–74 (sale, Sotheby's Belgravia, London, *Victorian Paintings, Drawings, and Watercolours,* 1974, no. 166, repro., as *In Brabant*) § With R. Gordon Barton, The Sporting Gallery, Middleburg, Va., 1974–76 § Private collection, 1976–78 § With The Sporting Gallery, 1978 § With Marty Abram, Los Angeles, 1978 § Steve Martin, Beverly Hills, Calif., c. 1978–79 § With Terry De Lapp Gallery, Los Angeles, 1979.

EXHIBITIONS
Pittsburgh, Carnegie Institute, Art Galleries, *The Third Annual Exhibition,* 1898–99, no. 189, unpaginated, with the following lines of poetry, "In the Spring-time / The only pretty Ring-time," pl. 9, showing the canvas before it was cut down § Paris, Société des Artistes français, *Salon,* 1899, no. 990 § Dayton Art Institute and others, *American Expatriate Painters,* 1976–77, no. 22, p. 106, text by Michael Quick, pl. 13, p. 61, as *In Brabant,* with date of c. 1895 § Montclair (N.J.) Art Museum and others, *Down Garden Paths: The Floral Environment in American Art,* 1983–84, entries not numbered, p. 100, text by William H. Gerdts, repros., p. 58, after p. 64, as *In Brabant,* dated 1895.

LITERATURE
Paul Desjardins, "Les Salons de 1899 (3e article)," *Gazette des Beaux Arts,* 3rd ser., 32 (July 1899): 40, considers in context of the artist's balancing figure and decor § Aileen Hammond, "George Hitchcock— Painter of Sunlight: The Re-discovered American Impressionist," *Spinning Wheel* 30 (October 1974): repro., 12, as *The Bride* § Advertisement, *American Art Review* 1 (November–December 1974): repro., 34, as *In Brabant* § "American Art," *LACMA Report 1979–1981* (1982), p. 20, repros., detail p. 16, in full p. 17, as *In Brabant* § Stott, "American Painters in Netherlands," pp. 146–47, discusses in terms of typical studies of single figures Hitchcock painted during third phase of the Egmond school, repro., IV-18, as *In Brabant* § Annette Stott, "Dutch Utopia: Paintings by Antimodern American Artists of the Nineteenth Century," *Smithsonian Studies in American Art* 3 (Spring 1989): 52–53, discusses the nature of the provincial native dress, repro., 52, as *In Brabant.*

Thomas Eakins

Born July 25, 1844,
Philadelphia, Pennsylvania
Died June 25, 1916,
Philadelphia, Pennsylvania

Thomas Cowperthwait Eakins long has been considered one of America's outstanding artists, the foremost realist of the nineteenth century. He was born in Philadelphia, his lifelong residence. After high school he entered the Pennsylvania Academy of the Fine Arts while also studying anatomy at Jefferson Medical College. In 1866 he went to Paris for three years, where he attended the Ecole des Beaux-Arts, and studied with the painters Jean-Léon Gérôme (1824–1904) and Léon Bonnat (1833–1922) and the sculptor A. A. Dumont (1801–1884). During the winter of 1869–70 he painted and studied old master canvases in Seville and Madrid.

Returning to Philadelphia, Eakins painted outdoor sporting scenes and the first of his ambitious portraits of professional men. For the country's centennial exposition he painted a powerful portrait of Dr. Samuel Gross, known as *The Gross Clinic,* 1875 (Medical College of Jefferson University, Philadelphia), which was removed from the art exhibition and transferred to the medical exhibit because its forceful realism was considered objectionable. After the mid-1880s portraiture was to occupy the artist's chief attentions, although he painted a series of sporting pictures near the end of the century.

He was influential as an instructor, at the Pennsylvania Academy of the Fine Arts from 1873 to 1886 and after that for six years at the Art Students League of Philadelphia. He married the artist Susan Macdowell in 1884. Eakins painted little after his health began to fail in 1910.

BIBLIOGRAPHY

Gerald M. Ackerman, "Thomas Eakins and His Parisian Masters: Gérôme and Bonnat," *Gazette des Beaux-Arts,* 6th ser., 73 (April 1969): 235–56 § Gordon Hendricks, *The Life and Work of Thomas Eakins* (New York: Grossman, 1974), with bibliography, illustrated checklist of works in public collections by location § "Thomas Eakins" issue, *Arts* 53 (May 1979): with essays by Lloyd Goodrich, Evan Turner, John Wilmerding and others, pp. 96–160 § Lloyd Goodrich, *Thomas Eakins,* Ailsa Mellon Bruce Studies in American Art, 2 vols. (Cambridge, Mass.: Harvard University Press for the National Gallery of Art, Washington, D.C., 1982), with chronology, bibliography § Elizabeth Johns, *Thomas Eakins: The Heroism of Modern Life* (Princeton, N.J.: Princeton University Press, 1983), with bibliography.

The Wrestlers, c. 1899
(*Study for "Wrestlers"; Wrestlers [Study]*)
Oil on canvas
16¹/₁₆ x 20¹/₁₆ in (40.8 x 50.9 cm)
Inscription in another hand, probably by
Mrs. Eakins, lower right: T. E.
Mr. and Mrs. William Preston Harrison Collection
48.32.1

In Paris Eakins had been thoroughly trained in the academic system of preparing extensive studies before beginning a major painting. He practiced this approach all his life and taught it to his pupils. Before undertaking his paintings of the boxers and other athletes that he painted at the end of the 1890s, Eakins spent hours watching the men, studying their movements in light of his knowledge of anatomy.

He posed two wrestlers in the Quaker City Athletic Club and in his studio, where in May 1899 several photographs were taken. The man on top is Joseph McCann, a wrestler and champion boxer. He is posed holding his opponent in a half nelson and crotch hold, potentially close to winning. Eakins copied the photograph of this pose almost directly onto a canvas, 1899 (Philadelphia Museum of Art), the purpose of which would have been to clarify the details of musculature that were unclear in the photograph. The next step in the preparatory process

was the museum's painting, which served as a compositional sketch. In it the artist worked out the placement of the figures in the composition of the finished painting, *The Wrestlers,* 1899 (Columbus [Ohio] Museum of Art; see illustration). Eakins made some slight changes in the positions of the wrestlers, especially in the right leg of the lower man and in the head and shoulders of the upper man. Eakins's main interest was in placing them in relation to the figures he was now introducing, the lower body of an observer or referee on the right and a man at a rowing machine in the upper left. The short white line at the referee's foot represents the rope that marked off the boundaries of the wrestling arena. (The men were nude in the photograph and initial figure study but wear trunks in the finished painting. The black area in the museum's sketch that looks as though it might represent trunks probably is only an indication of an area of shadow. Athletes in the period wore light-colored trunks that were cut very high over the hips.)

Achieving the proper balance within the composition was especially important to Eakins at this point in his career, because of his increased awareness of surface design and internal structure. Like most artists at the turn of the century Eakins introduced into his paintings devices that had the effect of compro-

mising the illusion of depth while creating a more even, overall, decorative pattern; in this example he did so by the placement of the rower in the extreme upper left corner and by cropping the standing man with the top edge of the painting, which pulls what is normally the part farthest away into the same plane as that of the foreground figures of the wrestlers.

Eakins gave the final painting to the National Academy of Design as a diploma painting, satisfying a condition of his election as member in 1902. It is now in the collection

![Eakins, The Wrestlers.]

Eakins, *The Wrestlers.*

of the Columbus Museum of Art. William Preston Harrison bought the museum's painting, upon the advice of CHILDE HASSAM, when it was exhibited in Los Angeles.

RELATED WORKS

Wrestlers in Eakins's Studio, 1899, platinum print, 3½ x 4¾ in (8.9 x 12.1 cm). Hirshhorn Museum and Sculpture Garden, Smithsonian Institution, Washington, D.C. § *Study for "The Wrestlers,"* 1899, oil on canvas, squared for transfer, 40 x 50 in (101.7 x 127 cm). Philadelphia Museum of Art § *The Wrestlers,* 1899, oil on canvas, 48⅜ x 60 in (123.8 x 152.4 cm). Columbus Museum of Art, Ohio, museum purchase, Derby Fund.

PROVENANCE

The artist, 1916 § Susan Macdowell Eakins (by descent), Philadelphia, 1916–27 § Mr. and Mrs. William Preston Harrison, Los Angeles, 1927.

EXHIBITIONS

New York, Metropolitan Museum of Art, *Loan Exhibition of the Works of Thomas Eakins,* 1917, no. 46, repro., unpaginated § Probably Philadelphia, Pennsylvania Academy of the Fine Arts, *Memorial Exhibition of the Works of the Late Thomas Eakins,*

Eakins, *The Wrestlers,* 1899, see Related Works.

1917–18, no. 11 § Portland (Ore.) Art Museum, [Eakins exhibition], 1927, no cat. traced § LAMHSA, *Thomas Eakins/Valere de Mari,* 1927, no. 10 § San Francisco, *Golden Gate International Exposition, Department of Fine Arts, Historical American Paintings, Official Catalog,* 1939, no. 8, unpaginated, incorrectly states "purchased . . . 1928" § Los Angeles, University of Southern California, Elizabeth Holmes Fisher Gallery of Fine Arts, *American Painting of the Eighteenth and Nineteenth Centuries* (series 1940–41, no. 1), 1940, no. 10 § Washington, D.C., National Gallery of Art, and others, *Thomas Eakins: A Retrospective Exhibition,* 1962, no. 70, repro., p. 103, as *Study for "Wrestlers."*

LITERATURE

Alan Burroughs, "Catalogue of Work by Thomas Eakins," *Arts* 5 (June 1924): 332, lists a *Wrestler* owned by Mrs. Eakins that might be the museum's version § Louise Upton, "Thomas Eakins Exhibition," *Museum Graphic* 1 (May–June 1927): 216, states that Hassam saw the exhibition and encouraged Harrison to buy the painting § LACMA, Registrar's files, William Preston Harrison to Louise Upton, June 2, 1927, buying painting through Clarence Cranmer, Mrs. Eakins's friend and agent; Harrison to William H. Bowen and William A. Bryan, July 16, 1927, offers to donate *The Wrestlers* to the museum § "Recent Acquisitions-Art Department," *LA Museum Graphic* 1 supp. (November–December 1927): 231, repro. § Lloyd Goodrich, *Thomas Eakins: His Life and Work* (New York: Whitney Museum of American Art, 1933), p. 189, listed in catalogue of works as no. 318, as *Wrestlers (Study)* § *Index 20th Cent. Artists* 1 (January 1934): 58; reprint, p. 81; listed § Harrison 1934, p. 28, repro., p. 27, incorrectly states it was purchased in 1928 § LACMA, Registrar's files, William Preston Harrison to Louise Upton, February 3, 1935, mentions Hassam helping him select the painting § Higgins 1963, p. 66, no. 219 in checklist of Mr. and Mrs. William Preston Harrison collection, incorrectly lists year of donation as 1948 § LACMA, *Illustrated Handbook of the Los Angeles County Museum of Art,* 1965, p. 98, repro., p. 99 § New York, Hirschl & Adler Galleries, *The American Scene,* exh. cat., 1969, p. 27, mentioned as the small sketch for the version of *The Wrestlers* formerly at the National Academy of Design and now at the Columbus Museum of Art § Hendricks, *Eakins,* pp. 240, 314, no. 1 in checklist of works § Washington, D.C., Smithsonian Institution, Hirshhorn Museum and Sculpture Garden, *The Thomas Eakins Collection of the Hirshhorn Museum and Sculpture Garden,* 1977, published by Smithsonian Institution Press, p. 165, text by Phyllis Rosenzweig states that photograph owned by Hirshhorn served as basis for the museum's painting § Philadelphia Museum of Art, *The Thomas Eakins Collection,* c. 1978, pp. 149–50, by Theodor Siegl, suggests that Philadelphia version came before LACMA study § Goodrich, *Eakins,* 1: 251 § *The American Collections, Columbus Museum of Art,* ed. Norma J. Roberts (Columbus and New York, Columbus Museum of Art in association with Harry N. Abrams, 1988), p. 42, by William Kloss, suggests that LACMA version was first painted study.

John Twachtman

**Born August 4, 1853,
Cincinnati, Ohio
Died August 8, 1902,
Gloucester, Massachusetts**

At the time of his death John Henry Twachtman was considered by the leading American impressionist artists to have been the country's greatest landscape painter. At the age of fourteen he got a job decorating window shades. He took evening classes in drawing at the Ohio Mechanics Institute in Cincinnati from 1868 to 1871, when he began his studies at McMicken School of Design in that city. He studied there in 1874 with Frank Duveneck (1848–1919), and when Duveneck returned to Munich in 1875, he took with him Twachtman, who enrolled in the Royal Academy of the Fine Arts, studying with Ludwig Löfftz (1845–1910) until 1877. He spent the winter of 1877–78 in Venice with Duveneck and WILLIAM M. CHASE.

In 1878 Twachtman briefly returned to Cincinnati, then worked in the New York area. He exhibited at the annual exhibition of the Society of American Artists in 1878 and was made a member the following year. During the winter of 1879–80 he taught drawing and painting in Cincinnati, and in the fall of 1880 he taught in Florence at Duveneck's school. The following spring he was in Venice with Duveneck, then returned to Cincinnati to marry Martha Scudder; their wedding trip took them to England, Holland, and Belgium as well as to Munich and Venice. In 1882 Twachtman returned to Cincinnati, where he painted in the suburb of Avondale. From 1883 to 1885 he studied life drawing in Paris at the Académie Julian with Gustave Boulanger (1824–1888) and Jules Lefebvre (1836–1911). He also painted landscapes in France and Holland in a new style.

During the late 1880s Twachtman achieved recognition exhibiting his pastels, watercolors, and etchings. In 1888 he won the Webb prize of the Society of American Artists. In 1889 he and his close associate J. ALDEN WEIR exhibited their work at the Fifth Avenue Art Galleries, New York. From 1888 to 1893 he executed illustrations for *Scribner's,* and he began teaching at the Art Students League in 1889, when he purchased a farm in Greenwich, Connecticut. During the following decade he worked in the style most associated with his name. Recognition that came to him included a solo show at Wunderlich Gallery in New York in 1891, a silver medal at the World's Columbian Exposition in Chicago in 1893, and the Temple Gold Medal of the Pennsylvania Academy of the Fine Arts the following year. In 1897 Twachtman was a founder of the Ten American Painters exhibiting group. After 1900 he spent his summers in the town of Gloucester, Massachusetts.

BIBLIOGRAPHY

Eliot Clark, *John Twachtman* (New York: Privately printed, 1924), with bibliography § Allen Tucker, *John H. Twachtman,* American Artists Series (New York, Whitney Museum of American Art, 1931), with biographical note by Edmund Archer, bibliography § *Index 20th Cent. Artists* 2 (March 1935): 87–91; 2 (September 1935): I; 3 (August–September 1936): II; reprint, pp. 353–57, 365, 366 § John Douglass Hale, *The Life and Creative Development of John H. Twachtman,* Ph.D. diss., Ohio State University, 1957, with chronology, bibliography, catalogue of works by media § New York, Ira Spanierman Gallery, *Twachtman in Gloucester: His Last Years, 1900–1902,* exh. cat., 1987, published by Universe Books, New York, with essays by John Douglass Hale, Richard J. Boyle, and William H. Gerdts, catalogue by Lisa N. Peters.

Harbor Scene, c. 1900

Oil on canvas
30¹/₁₆ x 30⅛ in (76.4 x 76.6 cm)
Given in memory of Eileen W. Foster by her husband and children
M.87.173

Throughout his career Twachtman was attracted to harbors and scenes of shipping, and he painted harbors in Venice; the New York area; Newport, Rhode Island; Bridgeport, Connecticut; and Gloucester, Massachusetts. It is on the basis of its style that this harbor view is identified as a scene in Gloucester, where, during the last three summers of his short life, Twachtman developed a distinctive, new manner. Gloucester was both a resort and an active fishing town. Twachtman had received one of his earliest, favorable critical notices for the freshness of the views he painted in 1879 of unpicturesque wharves and shipping in New York harbor. In Gloucester he painted the countryside, but also close-up scenes of the ordinary wharves and fishing fleet. In this painting he seems to have set up his easel on the roof of one of the low sheds along the wharves, with one of the larger buildings to his left and behind him. This viewpoint looks down upon the deck of a large ship. Judging from the forward position of the two masts that are visible, this may be a three-masted vessel, presumably one of the large Italian barks that brought salt for processing the fish in Gloucester. Much larger than the two-masted fishing schooners, the barks were higher in the water, their decks also higher than the level of the wharves built for the schooners.

Twachtman used a high vantage point in some of the other paintings he did in Gloucester, producing a similarly high horizon line, which, together with the tilted-up foreground and square format of the canvas, tends to deny the illusion of spacial recession. The surface grid, which is suggested by the way the parallel masts intersect the top edge of the painting and the horizon line parallel to it, also contributes to an awareness of the picture's surface and the denial of depth. Counteracting these formal features is another familiar in the Gloucester paintings, the powerful, thrusting diagonal into space, along the length of the bark. An increased consciousness of pictorial geometry, its clear expression, and its use for dramatic effect are characteristic of Twachtman's more explicit picture-making in his Gloucester paintings.

The design of *Harbor Scene,* painted on Twachtman's largest canvas size of the period, is so strong that it reads clearly and forcefully even though the painting remained unfinished. Stimulated by the momentary scene and interested in problems of pictorial design, he began numerous paintings in Gloucester that he did not carry to completion. One sees in these unfinished paintings, as well as in the finished ones, a vigor of paint handling not seen in Twachtman's work since his early period in Munich. His classic paintings of the previous decade employed underpainting to produce very delicate effects of limited color and value. The Gloucester pictures were painted directly, with the direction and texture of the paint clearly visible. The color is stronger, the contrasts greater, and the action of paint application is a matter of separate interest. The vigor and exceptional skill of Twachtman's brush command attention in *Harbor Scene.*

PROVENANCE
Twachtman family (by descent) to 1985 (sale, Sotheby's, New York, *Important American Paintings, Drawings, and Sculpture,* May 30, 1985, no. 165, repro.) § Mr. and Mrs. Richard W. Foster, Glendale and Santa Barbara, Calif., 1985–87.

Twachtman, *Harbor Scene.*

John W. Alexander

Born October 7, 1856, Allegheny City, Pennsylvania
Died May 31, 1915, New York, New York

John White Alexander was one of the country's foremost figure painters at the turn of the century. In 1875 he moved to New York to pursue a career in the commercial arts, and he became one of the most successful illustrators working for the publishing firm of Harper & Brothers. Although he continued to support himself as an illustrator during the 1880s, he was determined to become a painter and in 1877 went to Europe to further his studies. He briefly attended life drawing classes at the Royal Academy of the Fine Arts in Munich, where he became part of the circle around J. Frank Currier (1843–1909), with whom he spent the summers of 1878 and 1879 at Polling, Bavaria. In October 1879 Alexander went with Frank Duveneck (1848–1919) and the "Duveneck boys" to Florence for two years, summering in Venice, where he met James McNeill Whistler (1834–1903).

In 1881 Alexander returned to New York and soon established a reputation painting portraits of notable literary, political, and theatrical figures. In 1884 he made a brief visit to North Africa and studied the work of Diego Velázquez (1599–1660) in Madrid. Recuperating from a debilitating illness, he settled in Paris in 1890, residing there for more than a decade. Alexander participated in French art circles, becoming an intimate of the symbolist painters and writers, renewing his association with Whistler, and exhibiting at the avant-garde Salon of the Société Nationale des Beaux-Arts.

Influenced by French artists and Whistler, he abandoned his dark, heavy Munich style of the 1880s for a fin-de-siècle art nouveau and symbolist aesthetic. He immediately won honors for his evocative figure paintings of beautiful women and was even invited to join the radical secessionist groups in Munich, Vienna, and Brussels.

In 1905 Alexander received a commission to paint murals for the Library of Congress and ten years later undertook an extensive mural project, *Apotheosis of Pittsburgh,* for Carnegie Institute in Pittsburgh. His last years were spent in the United States, where he continued to be a popular figure painter and portraitist and was active in art circles, becoming president of the National Academy of Design in 1909. Alexander also painted landscape and still-life paintings, although less frequently.

BIBLIOGRAPHY
New York, American Academy of Arts and Letters, John W. Alexander Papers (on microfilm, Archiv. Am. Art) § Pittsburgh, Carnegie Institute, *Catalogue of Paintings, John White Alexander Memorial Exhibition,* exh. cat., 1916, with introduction by John W. Beatty, annotated "Record of Paintings by John White Alexander: Incomplete List," bibliography § "John W. Alexander Memorial Number," *American Magazine of Art* 7 (July 1916): 345–81 § Washington, D.C., Smithsonian Institution, National Collection of Fine Arts, *John White Alexander (1856–1915),* exh. cat., 1976, with text by Mary Anne Goley § New York, Graham Galleries, *John White Alexander, 1856–1915: Fin-de-Siècle American,* exh. cat., 1980, with text by Sandra Leff and Elizabeth Dailey Kvam, lists of collections, honors, and sitters.

Alexander, *Portrait of Mrs. John White Alexander.*

Portrait of Mrs. John White Alexander, 1902

(*Changeable Taffeta; On a Balcony; Portrait; Portrait of a Woman; Portrait of Mrs. Alexander; Portrait, on a Balcony; Portrait—Pink; Portrait with Hat; Portrait* [*Woman in Large Hat on Balcony*])
62¼ x 52⅛ in (158.2 x 132.4 cm)
Signed lower left: John W. Alexander.
Gift of Dr. and Mrs. Matthew S. Mickiewicz
M.81.182
Color plate, page 52

Elizabeth Alexander (1867–1947) was the daughter of James W. Alexander, who was introduced to John White Alexander by Joseph Harper because of the similarity of their names. Elizabeth and John were married in 1887, and the following year their only child, James, was born. Elizabeth was an educated, attractive woman who enjoyed the company of her husband's circle of painters and writers.

This portrait of her was painted in Alexander's New York studio late in 1902 and immediately included in his exhibition at Durand-Ruel's galleries held in late November. It was one of the favorites of the exhibition, commended for its subdued color, flowing line, and grace. The portrait demonstrates Alexander's mature style as it developed from his symbolist days in Paris. It is an evocative figure study in which mood and atmosphere take precedence over frank likeness. The portrait was painted in a palette of muted pinks and moss green—the artist's favorite colors—on a coarse, loosely woven, absorbent canvas to produce a soft, hazy effect. Alexander cast his

wife in a somewhat ambiguous, shadowy out-door setting with dramatic spotlighting on her face and right hand. The strong light shining from below, which first appeared in Alex-ander's early theatrical portraits of the 1880s, reappeared in his paintings of the late 1890s. Such lighting seems quite appropriate for a por-trait of Elizabeth Alexander, for she not only shared her husband's interest in the theater, she also collaborated closely with him on cos-tume and lighting designs and, after his death, made a distinguished career in the theatrical arts. The shadowy illumination heightens the quiet sense of mystery which pervades the best of Alexander's mature figure paintings.

Despite her quite independent nature—in the 1910s she became active in the women's suffrage movement—Mrs. Alexander was por-trayed by her husband as a fragile beauty. Her billowing gown forms a gentle flowing line, echoing the curves of her hat and the shadowy trees and clouds in the background. Alexander was deeply interested in late nineteenth-century theories regarding the psychology of line, and in the 1890s he began to compose paintings of elegant women in terms of sensuous, curving shapes. His fascination with emotive line caused Alexander to become increasingly bold, and by the early twentieth century he was creating paintings in which the figures and their dresses form daringly abstract composi-tions of exaggerated line and flat patterns.

Elizabeth Alexander often posed for her hus-band; between 1893 and 1902 he painted at least five portraits of her. This is one of the largest compositions identified as her portrait. Its size, as well as the full length of the figure and the presence of a balustrade—a traditional motif of eighteenth-century portraits set in gardens—places the painting within the grand-manner portrait tradition. When the painting was first publicly displayed, critics commented on its English landscape setting and Mrs. Alex-ander's old fashioned gown, noting that it recalled the work of Thomas Gainsborough (1727–1788).

After the artist's death the portrait was included in numerous memorial exhibitions, usually with the title *On a Balcony*. By 1939 when it was included in an exhibition at the Art Institute of Chicago, the painting had become confused with another full-length por-trait of Mrs. Alexander, one dated 1894 and sometimes referred to as *Changeable Taffeta* (estate of the artist as of 1985). Consequently much of the subsequent literature on Alex-ander has included a date much too early for this painting and also incorrect exhibition and literature documentation.

PROVENANCE
The artist § James W. Alexander II (by descent), Princeton, N.J., 1915 to as of 1944 § Irina A. Reed (by descent), New York, to 1980 § Dr. and Mrs. Matthew S. Mickiewicz, Rolling Hills, Calif., 1980–81.

RELATED WORK
Possibly sketch of a woman with hat before a bal-ustrade, pencil on paper, in sketchbook, New York, American Academy of Arts and Letters, John W. Alexander Papers (Archiv. of Am. Art microfilm roll 1729, fr. 635).

EXHIBITIONS
New York, Durand-Ruel, *Exhibition of Paintings by John W. Alexander*, 1902, no cat. traced § Phila-delphia, Pennsylvania Academy of the Fine Arts, *Seventy-Second Annual Exhibition*, 1903, no. 53, as *Portrait* § Boston, Saint Botolph Club, *Exhibition of Pictures by John W. Alexander*, 1903, no. 11, as *Por-trait with Hat* § Saint Louis, Universal Exposition, *Official Catalogue of Exhibitors, Department B, Art*, 1904, no. 15 of group 9 (U.S. oil paintings), as *Portrait of Mrs. Alexander*, awarded gold medal § Brooklyn, Pratt Institute, Art Gallery, *Twenty-six Oil Paintings by John W. Alexander*, 1905, no. 1, as *Portrait of Mrs. Alexander* § Pittsburgh, Carnegie Institute, *Tenth Annual Exhibition*, 1905–6, no. 3, as *Portrait* § Buffalo, Albright Art Gallery, *Catalogue of a Retro-spective Exhibition of Paintings by John W. Alexander*, 1909–10, no. 1, as *Portrait of Mrs. Alexander* § Probably Art Institute of Chicago, *Exhibition of Paintings by John W. Alexander*, 1913, no. 15, as *Por-trait of Mrs. Alexander* § New York, Arden Gallery, *Exhibition of Selected Works by the Late John W. Alexander*, 1915, no. 1, as *Portrait, on a Balcony* § Carnegie Institute, *Alexander Memorial Exhibition*, 1916–17, no. 19, p. 47, listed as one of the portraits painted between October 1902 and October 1903, repro., p. 33, as *Portrait of Mrs. John W. Alexander* § Detroit Museum of Art, *Catalogue of Memorial Exhibition of Paintings by the Late John White Alex-ander*, 1916, no. 14, unpaginated, as *On a Balcony*, repro., as *Portrait of Mrs. Alexander* § Cincinnati Museum, *Memorial Exhibition of Work by John White Alexander, 1856–1915*, 1917, no. 12, as *On a Balcony*, repro., unpaginated, as *Portrait of Mrs. John W. Alex-ander* § Milwaukee Art Institute, *John White Alexander Memorial Exhibition*, 1917, no. 45, as *On a Balcony* § Colorado Springs (Colo.) Art Society, *Special Illustrated Catalogue, Memorial Exhibition of Paintings by the Late John White Alexander*, 1917, no. 11, unpaginated, as *On a Balcony*, repro., as *Por-trait of Mrs. John W. Alexander* § Rochester, N.Y., Memorial Art Gallery, *Catalogue of the John White Alexander Memorial Exhibition*, 1917, no. 9, as *On a Balcony* § Providence, Rhode Island School of Design, *Memorial Exhibition Paintings by John White Alexander*, 1917, no. 9, as *On a Balcony* § Art Institute of Chicago, *Half a Century of American Art*, 1939–40, no. 6, as *Portrait—Pink*, with incorrect note that it was exhibited at the Institute in 1894 as *Portrait—Pink* § New York, M. Knoedler & Co., *A Loan Exhibition of American Portraits by American*

Painters, 1730–1944, 1944, no. 27, as *Mrs. John W. Alexander* § National Collection of Fine Arts, *Alexander,* 1976–77, no. 10, with date of c. 1896 § Graham Galleries, *Alexander: Fin-de-Siècle American,* no. 10, with date and documentation for *Changeable Taffeta* instead of for *Portrait of Mrs. John White Alexander* § LACMA 1981–82, no. 61, p. 186, repro., p. 187, incorrectly dated c. 1894.

LITERATURE
New York, American Academy of Arts and Letters, John W. Alexander Papers, "Incomplete List, Portraits Painted in Season Oct. 1902-to Oct. 1903" (Archiv. Am. Art microfilm roll 1729, fr. 291), listed as "E. A. A. full-length seated with hat"; undated handwritten note in tablet, p. 24 (ibid., fr. 331), states it was painted in New York and gives inaccurate date of 1903; "List of Pictures in Memorial Exhibit" (ibid., fr. 363), no. 7, as "On a Balcony (not for sale) stretcher 52" x 63" owner—Mr. James W. Alexander"; "List of Paintings . . . shipped to Corcoran Gallery by the Carnegie Institute, On April 8, 1916" (ibid., fr. 381), as *Portrait (Woman in Large Hat on Balcony);* newspaper clipping, "Portraits by John W. Alexander," *New York Herald,* November 25, 1902 (roll 1730, fr. 15), described in detail and ranked as one of the best portraits in the show; clipping, "A Group of Portraits by John W. Alexander at Durand-Ruel's Gallery—Notes," *Commercial Advertiser* (New York), November 25, 1902 (roll 1730, fr. 15), favorably describes; newspaper clipping, Henri Pène du Bois, "Alexander at Durand-Ruel's," *New York Journal,* November 28, 1902 (ibid., fr. 17); newspaper clipping, B. F., "Attractive Portraits," *New York Post,* November 28, 1902 (ibid., fr. 16); newspaper clipping, "Good Art of Alexander," *New York Press,* November 28, 1902 (ibid.); newspaper clipping, "Art," *Mail and Express* (New York), December 1, 1902 (ibid., fr. 17); newspaper clipping, *North American* (Philadelphia), January 18, 1903 (ibid., fr. 22); newspaper clipping, *Public Ledger* (Philadelphia), January 18, 1903 (ibid., fr. 23) § "The Pictures of John White Alexander," *Harper's Weekly* 46 (December 20, 1902): 1971, fig. 5 § "Notes," *Craftsman* 3 (January 1903): 257, considered best work of Durand-Ruel exhibition, calls dress "quaint" and painting "a beautifully decorative portrait" § "Brilliant Display of High-Class Art," *Philadelphia Inquirer,* January 18, 1903, pt. 1,

p. 2 § "Exhibition of the Pennsylvania Academy of Fine Arts," *Literary Digest* 26 (February 7, 1903): 186 § New York, American Academy of Arts and Letters, John W. Alexander Papers, newspaper clipping, *Sun* (New York), February 9, 1903 (Archiv. Am. Art microfilm roll 1730, fr. 23), notes unfavorably; clipping, Arthur Hoeber, "The Fine Arts: Mr. Alexander's Exhibition at the Saint Botolph Club," *Boston Transcript,* March 31, 1903 (roll 1730, fr. 28); unidentified newspaper clipping, "John W. Alexander: Exhibition of His Works in Boston," April 3, 1903 (ibid., fr. 25), devotes paragraph to *Portrait of Mrs. John White Alexander;* newspaper clipping, *Herald* (Louisville), November 20, 1904 (ibid., fr. 75), repro.; newspaper clipping, "Alexander's Work," *Herald* (Louisville), November 27, 1904 (ibid.); newspaper clipping, "Alexander Exhibition," *Citizen* (Brooklyn), April 9, 1905 (ibid., fr. 15); newspaper clipping, *New York World,* April 16, 1905 (ibid.); clipping, *Standard Union,* April 16, 1905 (ibid., fr. 16); newspaper clipping, "Portrait of Mrs. John W. Alexander by John W. Alexander," *Pittsburgh Index,* November 4, 1905 (ibid., fr. 134); newspaper clipping, *Pittsburgh Gazette,* November 5, 1905 (ibid.), with cartoon diagram § Harriet Monroe, "John W. Alexander: His Paintings," *House Beautiful* 15 (January 1904): 68, repro., 66, as *Portrait of a Woman* § Charles Caffin, "John W. Alexander," *World's Work* 9 (January 1905): 5694, describes as "discreet voluptuousness," repro., 5693 § Elbert F. Baldwin, "John W. Alexander, Painter," *Outlook* 95 (May 28, 1910): repro., 173 § William H. Downes, "The Late John W. Alexander: His Standing and His Work in Review," *Boston Evening Transcript,* June 5, 1914, pt. 3, p. 4, repro., as *A Portrait* § "Work of the Late John W. Alexander," *Sun* (New York), June 20, 1915, pt. 4, p.15, repro. § "John White Alexander Memorial Number," *American Magazine of Art* 7 (July 1916): repro., 356 § Samuel Isham, *The History of American Painting* (New York: Macmillan, 1927), repro., p. 510, as *A Portrait* § Malcolm Vaughan, "The Evolution of the American Face," *Art News* 43 (May 1–14, 1944): repro., 17 § Sarah B. Sherrill, "Current and Coming," *Antiques* 111 (June 1977): repro., 1104 § "Outstanding Exhibitions," *Apollo,* n.s. 105, no. 184 (June 1977): repro., 500 § "American Art," *LACMA Report 1981–83* (1984), p. 20 § "Reinstallation," *LACMA Members' Calendar* 21 (March 1983): repro., unpaginated § Fort 1986, p. 425, pl. XI, p. 423.

Gari Melchers

Born August 11, 1860,
Detroit, Michigan
Died November 30, 1932,
Falmouth, Virginia

Julius Garibaldi Melchers was a well-known expatriate genre and portrait painter at the turn of the century. The son of a Westphalian sculptor, Julius Theodore Melchers (1828–1908), Gari studied with his father before enrolling in 1877 at the Düsseldorf Royal Art Academy, where he studied with Karl von Gebhardt (1839–1925). Four years later he moved to Paris to study at the Académie Julian with Gustave Boulanger (1824–1888) and Jules Lefebvre (1836–1912). He exhibited for the first time at the Paris Salon in 1882 and then visited Italy. By late 1884 he had established a studio in the Dutch fishing village of Egmond-aan-Zee, on the North Sea. Despite frequent trips to other parts of Europe and to America, Melchers would consider Holland to be his home until 1909.

In 1888 a solo exhibition of his work was organized in Detroit, and he continued to participate at the Paris Salon and in international expositions, winning numerous awards including the Legion of Honor in 1895 and the Royal Prussian Order of the Red Eagle in

1907. He established his reputation with genre scenes of Dutch peasants, often presenting them in church interiors or in mother-and-child groupings recalling the Virgin. Responding to the work of the impressionists, Melchers developed a more decorative style, with a lighter palette and thicker surface. At the turn of the century he also produced religious paintings. Lesser known are his portraits; Melchers received commissions from a number of wealthy and notable patrons, including Theodore Roosevelt, 1908 (Freer Gallery of Art, Smithsonian Institution, Washington, D.C.). He also painted murals for the World's Columbian Exposition, *The Arts of Peace and War*, 1892–93 (Library, University of Michigan, Ann Arbor), and the Library of Congress, 1895. In 1909 Gari Melchers accepted an invitation from the grand duke of Saxe-Weimar to teach at the academy in Weimar, and he lived in Germany until the outbreak of World War I forced him to return to the United States. After briefly working in New York, he settled permanently at Belmont, an estate in Falmouth, Virginia. During these last years he continued to paint genre scenes and receive important commissions for portraits and murals. In 1921 he painted murals depicting the early history of Detroit for the city's public library and the following year received a similar commission for the Missouri State House. Belmont, his home, became a memorial to him in 1955, when the house and its collection were given to the state of Virginia.

BIBLIOGRAPHY
Falmouth, Va., Belmont, Gari Melchers Memorial Gallery, Gari Melchers Papers (on microfilm, Archiv. Am. Art) § Henriette Lewis-Hind, *Gari Melchers: Painter* (New York: Rudge, 1928) § Fredericksburg, Va., Mary Washington College, *Gari Melchers (1860– 1932): Selections from the Mary Washington College Collection*, exh. cat., 1973, with essays by Leslie L. Gross, Sylvia Payne, Patricia Marshall, and others, chronology, bibliography § Joseph G. Dreiss, *Gari Melchers: His Works in the Belmont Collection*, ed. Richard S. Reid (Charlottesville: University Press of Virginia, 1984), with introduction by William H. Gerdts, chronology, lists of exhibitions, portraits, and additional works in Belmont collection, bibliography § Annette Stott, "American Painters Who Worked in the Netherlands, 1880–1914," Ph.D. diss., Boston University, 1986, with bibliography.

Melchers, *Writing*.

Writing, c. 1905–9
Oil on canvas
32⁹/₁₆ x 31¹¹/₁₆ in (82.7 x 80.4 cm)
Signed lower center: Gari Melchers.
William Randolph Hearst Collection
46.4.6

After his marriage to Corinne Lawton Mackall in 1903, Gari Melchers began painting interior genre scenes, which may reflect his new-found domestic bliss and increased financial security. Unlike his earlier work, these scenes are filled with light and brilliant color and convey a certain bourgeois materialism. Their themes relate to the domestic interiors of Jan Vermeer (1632– 1675), an artist who inspired Europeans, such as the Nabis, and Americans, such as Frank Benson (1862–1951) and EDMUND TARBELL, to paint images of middle-class women; they also parallel the "window series" CHILDE HASSAM was creating at about the same time. Mrs. Gari Melchers usually served as her husband's model and often was shown occupied in some commonplace activity, frequently accompanied by a servant. In *Writing*, as in most of Melchers's genre paintings from 1905 to 1909, the scene is set in Schuylenburg, the former home of GEORGE HITCHCOCK near the Egmonds, in Holland.

Melchers's interiors are usually bathed in sunlight. In *Writing* the sheer curtains of the double windows act as a filter, diffusing the strong light. Melchers painted his interiors with a full brush and pure color, demonstrating his new alliance with impressionism. In *Writing* Melchers used a brilliant palette of warm reds, pinks, and oranges, with passages of complementary colors—the vibrant kelly green chair seat and pale blue curtains—used as accents intensifying the effect of the major colors. The same shade of green appears in other of his interiors of the period, most notably *The Green Lamp*, 1905–9 (private collection). *Writing* is quieter than many of Melchers's other interiors, without the floral wallpaper and lively patterned garments usually depicted.

PROVENANCE
The artist, as of 1916 § With Montross Gallery, New York, 1917 § Charles V. Wheeler, Washington, D.C., as of 1918 to 1935 (sale, American Art Association, Anderson Galleries, New York, *Valuable Paintings . . . Property of the Estate of the Late Emma Rockefeller McAlpin, the Private Collection of Charles V. Wheeler, Paintings Collected by the Late Governor Franklin Murphy*, 1935, no. 54, repro., p. 41, sold to W. H. Woods [pseud. of William Randolph Hearst]) § William Randolph Hearst, New York, 1935–46.

ON DEPOSIT
Los Angeles County Health Department, Inglewood Health District, 1952–72.

EXHIBITIONS
San Francisco, *Panama-Pacific International Exposition, Department of Fine Arts, Official Catalogue (Illustrated)*, 1915, no. 3686 § New Orleans, Isaac Delgado Museum of Art, *Exhibition of Paintings by Gari Melchers*, 1915–16, no. 7 § Savannah, Telfair Academy of Arts and Sciences, *A Collection of Paintings by Gari Melchers*, 1916, no. 8 § New York, Montross Gallery, *Exhibition of Pictures by Gari Melchers*, 1916, no cat. traced § Washington, D.C., Corcoran Gallery of Art, *Paintings by Gari Melchers*, 1918, no. 10 § Boston Art Club Galleries, Copley Society, *Loan Exhibition of Paintings by Gari Melchers*, 1919, no. 34 § Baltimore Museum of Art, *Paintings by Gari Melchers*, 1923, no. 23 § Washington, D.C., Corcoran Gallery of Art, *Memorial Exhibition of Paintings, Drawings, and Etchings by Gari Melchers*, 1933, no. 42 § Fresno (Calif.) Art Center, *Two Hundred Years of American Painting*, 1977, no. 30, repro., cover.

LITERATURE
"Gari Melchers Exhibits," *American Art News* 14 (March 11, 1916): 2, discusses as one of the picturesque interiors on view at the Montross Gallery § LACMA, American Art department files, Richard S. Reid to Ilene Susan Fort, June 17, 1985, identifies the setting and discusses dating and the model.

Henry O. Tanner

Born June 21, 1859,
Pittsburgh, Pennsylvania
Died May 25, 1937,
Paris, France

An American expatriate painter, Henry Ossawa Tanner was one of the most important black artists of the premodern period. The son of an African Methodist Episcopal bishop, he first studied art in Philadelphia at the Pennsylvania Academy of the Fine Arts with THOMAS EAKINS, 1880–82. During the 1880s he attempted to support himself as an illustrator, photographer, and art instructor, while exhibiting at the National Academy of Design and Pennsylvania Academy. His early paintings were genre scenes of blacks.

In 1891 Tanner went to Paris to study, enrolling at the Académie Julian and studying with Jean-Joseph-Benjamin Constant (1845–1902) and Jean-Paul Laurens (1838–1921). He began exhibiting at the Paris Salon in 1894 and by 1896 received his first recognition when Jean-Léon Gérôme (1824–1904) singled out *Daniel in the Lions' Den*, by 1896 (unlocated), for praise. The following year his *Raising of Lazarus*, 1897 (Musée d'Orsay, Paris), received a medal and was bought by the French government, assuring his success. Thereafter he specialized in religious paintings, New Testament subjects in particular. To assure the accuracy of his paintings he traveled to the Levant in 1897 to study the landscape, people, and customs of Palestine. He returned the following year to sketch around Jerusalem and the Dead Sea. A later trip to Morocco and Egypt resulted in his expanding his themes to include Moroccan city views.

Tanner felt that American racial prejudice interfered with his career and so settled permanently in France, only occasionally visiting his native country. He became a popular figure in the American expatriate community and an active member of French groups such as the Société Artistique de Picardie, of which he was president in 1913. Unlike most Americans, he remained abroad during the First World War, working with the Red Cross. Tanner was one of the last important American exponents of late nineteenth-century romanticism.

BIBLIOGRAPHY
Archiv. Am. Art, Henry Ossawa Tanner Papers § William S. Scarborough, "Henry Ossian [*sic*] Tanner," *Southern Workman* 31 (December 1902): 661–70 § H. O. Tanner, "The Story of an Artist's Life," *World's*

Work 18 (June 1909): 11661–66; (July 1909): 11769–75 § Marcia M. Mathews, *Henry Ossawa Tanner: American Artist,* Negro American Biographies and Autobiographies Series (Chicago: University of Chicago Press, 1969) § Washington, D.C., Smithsonian Institution, National Museum of American Art, and others, circulated by Smithsonian Institution Traveling Exhibition Service, *Sharing Traditions: Five Black Artists in Nineteenth-Century America,* exh. cat., 1985, published by Smithsonian Institution Press, text by Lynda Roscoe Hartigan, pp. 99–116.

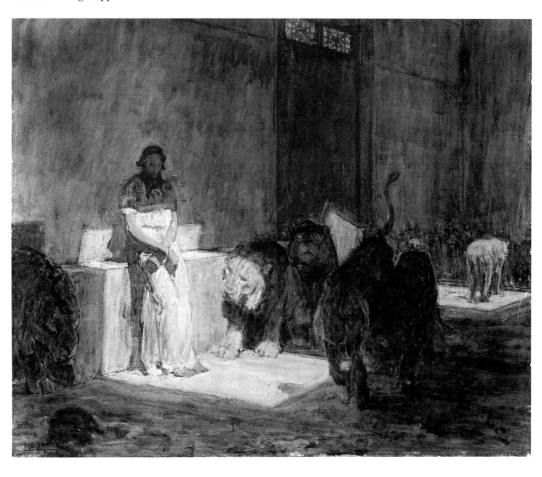

Tanner, *Daniel in the Lions' Den.*

Tanner, *Daniel in the Lions' Den,* by 1896, see Related Work (illustration copied from *Brush and Pencil* 6 [June 1900]: 98).

Daniel in the Lions' Den, c. 1907–18

Oil on paper mounted on canvas
41⅛ x 49⅞ in (104.5 x 126.8 cm)
Signed lower left: H. O. TANNER / PARIS
Mr. and Mrs. William Preston Harrison Collection
22.6.3
Color plate, page 53

Tanner first achieved recognition at the Paris Salon of 1896 with his painting *Daniel in the Lions' Den* (see illustration). Although the museum's painting of the same title has been often mistaken for the painting shown in the 1896 Salon, it is a similar, but later version. In both paintings Tanner delineated an Old Testament story set during the reign of King Darius in ancient Persia (Dan. 6:16–24). Tanner infused the drama of Daniel's unjust imprisonment with a quiet spirituality. The earlier canvas was Tanner's first major religious painting and indicated the direction that his art would take. The choice of a religious subject may have been inspired initially by his teacher Laurens, who was noted for dramatic biblical paintings. Tanner's depiction of a dark prison cell, dramatically lit by evening light streaming through a high window, may have also come from Laurens, whose *Le Grand Inquisiteur chez les rois catholiques,* 1886 (Philadelphia Museum of Art) —a painting also about an unjust imprisonment—is similar in composition and lighting. It is probably not coincidental that Tanner owned a reproduction of the Laurens painting and kept it throughout his career (it is among the Tanner Papers). The decision to select a narrative in which animals play a major role may have been determined by Tanner's previous success with animal paintings; he had sold *Lions at Home,* by 1885 (unlocated), when it was exhibited in 1885 at the National Academy of Design. When he decided to paint this subject he prepared himself by sketching the lions at the Jardins des Plants and by studying with the noted *animalier* Emmanuel Frémiet.

Tanner often painted variations on the same theme. The museum's version was probably executed in the years before the First World War, possibly as early as 1907. Tanner exhibited a painting entitled *Daniel in the Lions' Den* at the annual of the Pennsylvania Academy in 1896–97, at the 1901 Pan-American Exposition in Buffalo, the Louisiana Purchase Exposition of 1904 in Saint Louis, his 1908 show at the American Art Galleries in New

York, and the Anglo-American Exposition in London in 1914. It was probably the second version that was exhibited in the last two, however, none of the descriptions in the reviews of any of these exhibitions is specific enough for determining which version was shown. Although the museum's painting is on paper, it probably was not intended as a sketch but as an independent, second version. (In 1976 the canvas used to back the museum's painting was found to have on it an unfinished oil possibly illustrating a scene from the life of Job and able to be dated on stylistic grounds to the late 1890s or early years of the 1900s.)

The museum's painting is a recapitulation of the scene as Tanner depicted it in his 1896 Salon painting, but he changed the format and modified details. The earlier *Daniel in the Lions' Den* was a vertical painting in which half the composition was taken up by the shadowy, high-ceilinged structure above the head of Daniel. In the second version, Tanner eliminated the ceiling to focus more on the figure. Both paintings emphasized shadows, with a brilliant light illuminating the lower half of Daniel's figure, especially his bound hands. While the shape and size of the illuminated area were altered in the second version—to show more of the prisoner's figure—the change was not significant. The first version included an elaborate Assyrian frieze. Although such details were in keeping with the late nineteenth-century academic taste for archaeological accuracy and narration, they did not accord with Tanner's mature painting style.

During the first decade of this century Tanner developed a poetic style in which he used color and light to evoke the essence of a religious story. In the museum's painting Daniel appears calm, strengthened by his inner spiritual belief, and Tanner's use of a blue-green palette heightened this meditative mood. Experiments with pigments and glazing begun around 1907 enabled him to infuse his art with a soft, glowing light and shimmering color. While the overall color scheme of *Daniel in the Lions' Den* is tonal—typical of Tanner's mature canvases—the painting actually is much more varied in color than it initially appears, for the lions are sketched in brilliant shades of yellow, green, and lavender.

RELATED WORK
Daniel in the Lions' Den, exhibited Paris, Société des artistes français, *Salon,* 1896, oil on canvas, dimensions unknown. Unlocated (reproduced *Brush and Pencil* 6 [June 1900]: 98).

PROVENANCE
The artist, to 1918 § Mr. and Mrs. William Preston Harrison, Los Angeles, 1918–22.

EXHIBITIONS
Possibly Art Institute of Chicago, *Paintings and Sculpture by Six American Artists Residing in France,* 1908, no. 30 § Possibly Minneapolis Society of Fine Arts, *The Works of Six American Artists Residing in Paris,* 1908, no. 98 § Possibly New York, American Art Galleries, *Religious Paintings by the Distinguished American Artist Mr. Henry O. Tanner,* 1908, no. 8 § Possibly London, *Anglo-American Exposition,* 1914, no. 247 § LAMHSA, *Summer Exhibition of Paintings,* 1920, no. 51 § LAMHSA, *Summer Exhibition,* 1921, no. 57 § LAMHSA 1924, no. 37 § Atlanta, Spelman College, *Henry Ossawa Tanner Retrospective Exhibition,* 1969, no. 18, repro. § Washington, D.C., Smithsonian Institution, National Collection of Fine Arts, and others, organized by the Frederick Douglass Institute and the National Collection of Fine Arts, *The Art of Henry O. Tanner (1859–1937),* 1969–70, no. 61, with incorrect date of 1895–1921, repro., p. 41 § Los Angeles, Loyola University, *Loyola University's Black Culture Exhibit,* 1971, no cat. traced § Dominguez Hills, California State College, *Black Art from Suppression to Revolution,* 1972, entries not numbered, repro., back cover § Los Angeles, Martin Luther King, Jr., General Hospital, Opening Ceremonies, 1972, no cat. traced § Torrance, Calif., El Camino College, *Black Awareness Week,* 1972, no cat. § Berkeley, University of California, University Art Museum, and others, *The Hand and the Spirit: Religious Art in America, 1700–1900,* 1972–73, no. 108, p. 162, entry by Jane Dillenberger incorrectly states that the museum's painting is a third version § LACMA, *American Narrative Painting,* 1974, no. 85, p. 179, entry by Nancy Dustin Wall Moure, repro., p. 178 § LACMA and others, *Two Centuries of Black American Art,* 1976–77 (copublished with Alfred A. Knopf, New York), no. 57, p. 53, mentioned by David C. Driskell, pl. 57, p. 88 § Cedar Rapids (Iowa) Art Center, *Three Nineteenth-Century Afro-American Artists,* 1980, no. 11, unpaginated, with essay by Ellwood C. Parry III and note about version by Sherry Maurer.

LITERATURE
Possibly Royal Cortissoz, "Art Exhibitions: Paintings by Mr. H. O. Tanner and Portraits of Milton," *New-York Tribune,* December 19, 1908, p. 7, discusses theatricality of painting § Possibly "Exhibitions of the Month," *Independent* (New York) 65 (December 31, 1908): 1600, describes version shown in 1908 American Art Galleries exhibition § Archiv. Am. Art, Henry Ossawa Tanner Papers, photograph of the museum's painting (microfilm roll D307, fr. 2280), with inscription, "Daniel in the Lion's Den II"; Jessie Tanner, "Biographie H. O. Tanner II," n.d., manuscript (roll D306, fr. 1589), mentions 1920 Los Angeles exhibition and states "this picture must not be confused with one painted much earlier" § "Summer Exhibition," *LA Museum Art Dept. Bull.* 1 (July 1920): 27, repro., cover § Helen B. Wood, "Los Angeles," *American Art News* 18 (July 17, 1920): 7 § "Recent Donations to the Harrison Gallery," *LA Museum Art Dept. Bull.* 3 (April [sic] July 1922): 93 § Richard Walgrave, "Romance and the Background of Painting," *California Southland* 7 (November 1925): repro., 10 § Harrison 1934, p. 48, states painted in 1917, repro. § Higgins 1963, p. 57, no. 11 in checklist of Mr. and Mrs. William Preston Harrison collection § Mathews, *Tanner,* pp. 74–75, 179, incorrectly discusses it as if it were the 1896 Salon painting, repro., between pp. 46 and 47 § Elsa Honig Fine, *The Afro-American Artist: A Search for*

Identity (New York: Holt, Rinehart, & Winston, 1973), p. 71, repro. § Martha Hutson, "American Narrative Painting . . .," *American Art Review* 1 (November–December 1974): 98 § Leonard Simon, "The American Presence of the Black Artist," *American Art Review* 3 (November–December 1976): repro., 106 § LACMA 1977, pp. 144–45, repro.,

p. 145 § Samella Lewis, *Art: African American* (New York: Harcourt Brace Janovich, 1978), repro., p. 48 § National Museum of American Art, *Sharing Traditions*, p. 107, discusses as if third version, fig. 65 § Robin Landa, *Inspired by Faith* (Old Tappan, N.J.: Fleming H. Revell, 1988), p. 147, repro., p. 148.

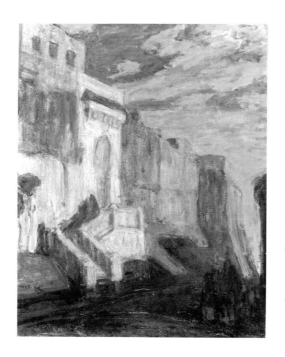

Tanner, *Moonlight: Walls of Tangiers.*

Moonlight: Walls of Tangiers, c. 1913–14
Oil on canvas
25⅞ x 21¼ in (65.7 x 54.1 cm)
Signed lower left: H. O. TANNER / Paris
Mr. and Mrs. William Preston Harrison Collection
48.32.46

Following his 1910 trip to Morocco, Tanner painted many scenes of Tangiers and exhibited them in Chicago at Thurber Art Galleries in 1911 and in New York at M. Knoedler & Co. in 1913. Although *Moonlight: Walls of Tangiers* has traditionally been dated 1914, based on William Preston Harrison's authority, the painting may have been executed earlier, for several of the works exhibited in 1913 have similar titles, in particular one painting entitled *Moonrise: Walls of Tangiers.* Although the North African locale provided the same exotic scenery incorporated in Tanner's religious images, the Moroccan scenes are not religious.

The elimination of a narrative may have assisted Tanner in his exploration of the formal aspects of painting, for it is just during these prewar years that his art underwent its last stylistic change. Tanner used his views of the streets, walls, and arcades of the city to explore the phenomena of color and light, not in an analytical manner as did the impressionists, but rather in harmony with both his own romanti-

cism and turn-of-the-century tonalist trends in Europe and the United States. The Moroccan paintings are all vague, shadowy scenes painted in one predominant hue with thick, scumbled passages over rich glazing on a white ground. The blue and green palette of *Moonlight: Walls of Tangiers* has shades of yellow, peach, and purple. Tanner had begun to experiment with pigments and glazes around 1907 and by World War I was almost exclusively using the complex technique of layered glazes. Perhaps it was his renewed acquaintance with the Orient that enabled Tanner to develop the more resonant and colorful painting style characteristic of his art from about 1910 until his death in 1937.

PROVENANCE
The artist, to 1914 § Mr. and Mrs. William Preston Harrison, Los Angeles, 1914–18.

EXHIBITIONS
Possibly Chicago, Thurber Art Galleries, *Exhibition of Paintings by Henry O. Tanner,* 1913, one of nos. 11–24 § Possibly New York, M. Knoedler & Co., *Catalogue of Recent Paintings by Henry O. Tanner,* 1913, one of nos. 1–10 § LAMHSA, *Summer Exhibition of Paintings by Contemporary American Artists Loaned by Mr. and Mrs. William Preston Harrison,* 1917, no. 47 § LAMHSA 1918, no. 23 § LAMHSA 1924, no. 36 § Washington, D.C., Smithsonian Institution, National Collection of Fine Arts, *The Art of Henry O. Tanner (1859– 1937),* 1969, no. 52 § La Jolla (Calif.) Museum of Art, *Dimensions of Black,* 1970, no. 182, repro., p. 70 § Los Angeles, Loyola University, *Loyola University's Black Culture Exhibit,* 1971, no cat. traced § Los Angeles, Martin Luther King, Jr., General Hospital, Opening Ceremonies, 1972, no cat. traced § Cedar Rapids (Iowa) Art Center, *Three Nineteenth-Century Afro-American Artists,* 1980, no. 22, repro., unpaginated.

LITERATURE
LACMA, Registrar's files, untitled annotated artists list, n.d., states that it was painted in 1904 § LAMHSA 1921, no. 23 § Archiv. Am. Art, Henry Ossawa Tanner Papers, Jessie Tanner, "Biographie H. O. Tanner II," n.d., manuscript (microfilm roll D306, fr. 1594), incorrectly states that Harrison donated painting to museum in 1925; photograph of painting with title (roll D307, fr. 2221) § Harrison 1934, p. 48, states painted in 1914 § Higgins 1963, p. 68, no. 252 in checklist of Mr. and Mrs. William Preston Harrison collection § Marcia M. Mathews, "Henry Ossawa Tanner: American Artist," *South Atlantic Quarterly* 65 (Autumn 1966): 468.

Arthur B. Davies

Born September 26, 1862,
Utica, New York
Died October 24, 1928,
Florence, Italy

Arthur Bowen Davies's art was an important link between nineteenth-century symbolist-romantic trends and early twentieth-century modernism. He received his first art instruction at an early age from Dwight Williams (1856–1932) and attended the school of the Art Institute of Chicago in the late 1870s and early 1880s. In 1886 he settled in New York, enrolled in the Art Students League, and began supporting himself as an illustrator for magazines such as *The Century*. In 1893 he exhibited for the first time at the National Academy of Design and with his first solo exhibition in 1896 began his long and fruitful association with the Macbeth Gallery. In the mid-1890s he traveled throughout Europe three times, studying ancient, old master, and contemporary art. His oil paintings of the 1890s are realistic scenes of figures in contemporary dress, usually women and children, presented in outdoor settings. His later paintings became more imaginative, reflecting the mingling of influences from such sources as ALBERT PINKHAM RYDER, Pierre-Cécile Puvis de Chavannes (1824–1898), Ferdinand Hodler (1853–1918), and Arnold Böcklin (1827–1901).

Around 1900 Davies began to focus on the nude as his art became infused with classicism and took on a poetic, even visionary quality, with themes suggesting mythological and literary allusions. Around this time he met ROBERT HENRI and through this association participated in the landmark exhibition of The Eight at the Macbeth Gallery in 1908. He continued to travel extensively in the United States and Europe. By 1905 his marriage to Dr. Virginia Merriweather Davies had disintegrated and he began living secretly with Edna Potter as Mr. and Mrs. David A. Owen. Potter was a dancer, and this association was crucial in furthering Davies's fascination with the motif of the figure in dancelike poses.

As principal organizer of the Armory Show Davies was instrumental in determining the exhibition's modernist orientation. The exhibition also briefly affected his art as he painted in a more modernist style from 1913 to about 1915, giving his nudes an overlay of colored planes inspired by cubism and synchromism. He returned to his more classical style in the late teens but began to experiment with different mediums, including sculpture, prints, and tapestry. In the 1920s during visits to Italy he worked more with watercolor, creating his most lyrical landscapes in soft colors.

During the last decade of his life he became an enthusiastic follower of the zoologist Gustav Eisen and his theory of inhalation, applying it to his depiction of the nude. Davies was the advisor of Lillie P. Bliss, helping her amass one of the foremost collections of modern art, which later became the core of the collection of the Museum of Modern Art in New York.

BIBLIOGRAPHY
Washington, D.C., Phillips Memorial Gallery, *Arthur B. Davies: Essays on the Man and His Art*, Phillips Publications no. 3 (Cambridge, Mass.: Riverside Press, 1924), with essays by Duncan Phillips, Dwight Williams, Royal Cortissoz, and others § *Index 20th Cent. Artists* 4 (February 1937): 385–400; reprint, pp. 679–94 § Brooks Wright, *The Artist and the Unicorn: The Lives of Arthur B. Davies (1862–1928)* (New City, New York: Historical Society of Rockland County, 1978), with bibliography § Joseph S. Czestochowski, *The Works of Arthur B. Davies* (Chicago: University of Chicago Press, 1979), with foreword by Mahonri Sharp Young, catalogue raisonné, bibliography § Boston, Institute of Contemporary Art, and others, *Dream Vision: The Work of Arthur B. Davies*, exh. cat., 1981, with essays by Stephen S. Prokopoff, Linda Wolpert, Garnett McCoy, and others.

Pastoral Dells and Peaks, c. 1908–11
(*Peaks and Pastoral Dells*)
Oil on canvas
18¼ x 30⁵⁄₁₆ in (46.2 x 76.9 cm)
Signed lower left: A. B. Davies
Dr. Dorothea Moore Bequest
43.15.1

In her list of her husband's paintings included in Royal Cortissoz's book *Arthur B. Davies* (1931), Dr. Virginia M. Davies assigned this painting to 1908. However, this list is not always accurate. Davies rarely dated his paintings himself and did not develop in a linear manner, so the dates of many of his works have never been clearly determined.

Pastoral Dells and Peaks relates to Davies's experience of the American West. In 1905 he traveled to Colorado, Nevada, Utah, and California and made several oil sketches of the dramatic, high-peaked mountains. After this trip West he abandoned the more domestic, arcadian landscapes of his earlier pastorals in favor of looming, powerful mountain ranges. It was Davies's memory of the Sierras and the soaring evergreens that inspired the back-

ground composition of *Pastoral Dells and Peaks,* although the artist simplified the setting, reducing its specificity.

Davies was acquainted with ancient art and mythology and had visited southern Italy and Greece in 1897, 1910, and 1911. He often depicted his figures as classically robed shepherds and herders. While this scene probably was not intended to illustrate a specific story, it recalls the myth of Io, a beautiful maiden who was turned into a heifer for being loved by Jupiter. Davies follows the tradition of Greek

Gallery of San Diego, Calif., *Memorial Exhibition of the Work of George Wesley Bellows, Various Examples by Arthur B. Davies,* 1926, no. 50 § Los Angeles, California Art Club Gallery, [exhibit of Arthur B. Davies paintings lent by Dr. Dorothea Moore], 1929, no cat. traced § Los Angeles, Cowie Galleries, *Two Hundred Years of American Painting,* 1961, no. 14 § Tucson (Ariz.) Art Center and others, *Arthur B. Davies: Paintings and Graphics,* 1967, no. 15 of paintings, unpaginated, essay by Sheldon Reich, repro. § New York, M. Knoedler & Co., *Arthur B. Davies: A Chronological Retrospective,* 1975, no. 14, repro., p. 20 § San Bernardino, California State College, Art

Davies, *Pastoral Dells and Peaks.*

vase painting by presenting the female figures in a paler color than the male figures. In 1908 the artist began to arrange his figures in dancers' poses in long, friezelike processions along a shallow foreground in what he referred to as "continuous compositions." *Pastoral Dells and Peaks* does not have as many figures, nor is it as stringently composed along a processional line as Davies's more mature paintings from about 1913. Consequently, it may be an early example of Davies's continuous composition, perhaps inspired by one of his trips to Greece. So *Pastoral Dells and Peaks* may date as early as 1908 but probably not later than 1911.

PROVENANCE
With Macbeth Galleries, New York, by 1914 § Dr. Dorothea Moore (Mrs. Ernest C. Moore), Los Angeles, 1914–43.

EXHIBITIONS
New York, Macbeth Gallery, *Exhibition of Paintings by Arthur B. Davies,* 1912, no. 18, as *Peaks and Pastoral Dells* § LAMHSA, *Summer Exhibition of Paintings,* 1918, no. 13 § LAMHSA, *Summer Exhibition,* 1921, no. 15 § LAMHSA, *Catalogue of a Loan Exhibition from Private Collections,* 1926, no. 28 § Fine Arts

Gallery, *Symbolism: Europe and America at the End of the Nineteenth Century,* 1980, no. 12, p. 14, entry by Vicki Younger, repro., p. 15 § Institute of Contemporary Art, *Davies: Dream Vision,* entries not numbered, repro., unpaginated.

LITERATURE
Archiv. Am. Art, Macbeth Gallery Papers, Artists' Credit Book, 1910–16, January 5, 1914, entry (not on microfilm), lists; statement from Macbeth Galleries to the artist, April 1, 1914 (microfilm roll NMc-37, fr. 1147), details sale of painting to Dr. Moore § Antony Anderson, "In the Realm of Art: The Loan Exhibition," *Los Angeles Times,* September 1, 1918, pt. 3, p. 5 § "Summer Exhibition," *LA Museum Art Dept. Bull.* 3 (October 1921): 67 § Louise Upton, "A Notable Loan Exhibition of Paintings," *LA Museum Graphic* 1 (November–December 1926): repro., 60 § "Exhibitions," *California Art Club Bulletin* 4 (January 1929): unpaginated, mentions loan exhibition § Royal Cortissoz, *Arthur B. Davies,* American Artists Series (New York: Whitney Museum of American Art, 1931), p. 30, listed in catalogue of known paintings compiled by Dr. Virginia M. Davies, as *Peaks and Pastoral Dells,* dated 1908 § *Index 20th Cent. Artists,* p. 397; reprint, p. 691; listed § Czestochowski, *Davies,* p. 37, listed in cat. raisonné as no. 2D4.

Davies, *Under the Bough.*

Under the Bough, by 1913
(Golden Bough; Underneath the Bough)
Oil on canvas mounted on panel
26³/₈ x 40¹/₁₆ in (66.9 x 101.8 cm)
Signed lower left: A. B. Davies·
Inscribed in another hand on bottom stretcher bar:
Golden Bough
Mr. and Mrs. William Preston Harrison Collection
71.2

The title *Golden Bough* is written in an uniden-
tified hand on the canvas stretcher of this
painting. Davies did exhibit a painting with
such a title in 1909, but no such work is listed
in Czestochowski's catalogue raisonné of
Davies's art. This particular canvas has been
exhibited under its present title since 1914. If it
was originally shown as *Golden Bough,* the rea-
son for Davies changing the title is not known.
The artist was familiar with Sir James Frazer's
The Golden Bough, and such an extensive study
on religion and mythology could easily have
initially inspired Davies. In fact, Davies named
his farm in upstate New York The Golden
Bough.

Under the Bough is an idyllic scene about
romance without any specific mythological
reference. A bird—symbol of sweetness—is
perched on the hand of the woman on the far
left. Her gesture is similar to that of the young
boy in Davies's *Earth's Secret as a Little Child,*
c. 1905 (private collection). The seated woman
raises a locket, which may signify memory,
and the cupid figure refers to love. Suggesting
beauty and youth, the lovely nude woman in
the foreground carries a basket of flowers. The
figures are set in a forest glade full of blossom-
ing plants. In several paintings from his mature

period, before his experiments with synchro-
mism, Davies placed a small group of figures
in such a tranquil forest setting near a lake.
In only a few instances did he detail the sur-
rounding shrubbery, using splotches of light-
colored leaves to highlight the dark scene. The
setting as well as the figures, which are garbed
in diaphanous gowns or are nude, hark back
to *Primavera* and the *Birth of Venus* by Sandro
Botticelli (1445–1510), an artist Davies greatly
admired. The inclusion of two medieval horse-
men on white chargers in the distant back-
ground are out of keeping with the classical
figures, but allude to Botticelli's time and to
the general themes of Botticelli's most famous
paintings: springtime and love.

Under the Bough has a compositional treat-
ment similar to that of *The Jewel-Bearing Tree of
Amity,* exhibited in 1913 (Munson-Williams-
Proctor Institute, Utica, N. Y.). Davies depicted
the figures in large scale, scattering them
throughout the landscape, so they are in dif-
ferent planes and do not communicate with
one another. The sense of isolation reinforces
the dreamlike mood of the scene. Indeed, the
cupid figure in the center seems to be walking
in a trance. In both paintings the figure in the
lower left foreground is cut off by the edge of
the picture.

PROVENANCE
The artist, to about 1924 § Hoyt L. Warner, Cleve-
land, by 1924 to 1929 § Stephen C. Clark, New
York, by 1931 § With Terry De Lapp Gallery, Los
Angeles, to 1971.

EXHIBITIONS
Possibly New York, Macbeth Gallery, *Exhibition
of Paintings by Arthur B. Davies,* 1909, no. 15, as

Golden Bough § Art Institute of Chicago, *Twenty-seventh Annual Exhibition of American Oil Paintings and Sculpture,* 1914, no. 83 § City Art Museum of Saint Louis, *Tenth Annual Exhibition of Selected Paintings by American Artists,* 1915, no. 43, repro., p. 24 § Buffalo, Albright Art Gallery, *Eleventh Annual Exhibition of Selected Paintings by American Artists,* 1917, no. 40, repro., p. 59 § New York, Macbeth Galleries, *Paintings by American Artists,* 1918, no cat. traced § Washington, D.C., Corcoran Gallery of Art, *Eighth Exhibition of Oil Paintings by Contemporary American Artists,* 1921–22, no. 59 § Buffalo, Albright Art Gallery, *Catalogue of a Collection of Paintings by Arthur B. Davies,* 1922–23, no. 2, as *Underneath the Bough.*

LITERATURE

Archiv. Am. Art, Frederic Newlin Price Papers, the artist to Price, undated letter (microfilm roll D-42, fr. 32), refers to *Under the Bough* netting twenty-five hundred dollars § *Art in California* (San Francisco:

Bernier, 1916), pl. 112 § "Summer Show at Macbeth's," *American Art News* 16 (July 13, 1918): 2 § Phillips Memorial Collection, *Davies: Essays,* repro. of detail, pls. unpaginated § Bryson Burroughs, "Arthur B. Davies," *Arts* 15 (February 1929): repro., 91 § Royal Cortissoz, *Arthur B. Davies,* American Artists Series (New York: Whitney Museum of American Art, 1931), p. 35, listed in catalogue of known paintings compiled by Dr. Virginia M. Davies § Frank Jewett Mather, Jr., *Estimates in Art,* ser. 2 (New York: Holt, 1931), repro., p. 317 overleaf § *Index 20th Cent. Artists,* p. 399; reprint, p. 693; listed § Ruth Davidson, "Museum Accessions," *Antiques* 101 (May 1972): 814, repro. § "Recent Acquisitions: Fall 1969–Spring 1973," *LACMA Bulletin* 19, no. 2 (1973): fig. 20, 42 § "Permanent Collection," *LACMA Report 1969–1973* (as *LACMA Bulletin* 20, no. 1 [1974]), p. 19, as *Underneath the Bough* § Czestochowski, *Davies,* p. 63, listed in cat. raisonné as no. 5G7, as *Underneath the Bough.*

Frederick Ballard Williams

Born October 21, 1871,
Brooklyn, New York
Died December 11, 1956,
Glen Ridge, New Jersey

During the early twentieth century Frederick Ballard Williams was a popular landscape painter in the late Barbizon style. He grew up in New Jersey and at an early age was sent to the New York School of Artists-Artisans, which was under the direction of John Ward Stimson (1850–1930). He also studied at night in New York at the Cooper Union and at the National Academy of Design with Charles Y. Turner (1850–1919). Williams visited England and France only briefly, on two occasions, but he traveled extensively throughout the United States in search of scenery. Nevertheless he mainly painted scenes of New England and the area around his home in New Jersey until taking an excursion in 1910 to the Grand Canyon as one of the guests of the Santa Fe Railroad—along with THOMAS MORAN and ELLIOTT DAINGERFIELD—which led him to expand his subject matter. In 1921 Williams spent the summer painting along the California coast, and his subsequent California landscapes were exhibited by his dealer, Macbeth Gallery in New York. In the second and third decade of this century he increasingly turned to more decorative forest scenes in which lovely young women frolic. In the late 1930s he returned to pure landscape painting, but as tastes changed his reputation declined.

Williams was a respected academic figure as a member of the National Academy of Design from 1907 and was a member of the Salmagundi Club, of which he served as president. He was a founder of the Montclair (N.J.) Art Museum and the American Artists Professional League. He also was instrumental in the crusade to have RALPH ALBERT BLAKELOCK, whose art inspired him greatly, made an academician of the National Academy of Design.

BIBLIOGRAPHY

Archiv. Am. Art, Macbeth Gallery Papers § New-York Historical Society, DeWitt McClellan Lockman Papers, interview of the artist (on microfilm, Archiv. Am. Art) § Leila Mechlin, "The Work of Frederick Ballard Williams," *International Studio* 152 (January 1911): LIII–LX § LACMA, American Art department files, transcript of slide lecture, Joan Hayes, "Frederick Ballard Williams, N.A., and His Contribution to the Art World" § Ulrich Thieme and Felix Becker, *Allgemeines Lexikon der bildenden Künstler von der Antike bis zur Gegenwart* (Leipzig: E.A. Seemann, 1947), s.v. "Williams, Frederick Ballard," with collections, bibliography.

The Trio, by 1909
(*Three Figures in a Glade*)
Oil on canvas mounted on wood panel
24 x 15¹⁵/₁₆ in (61.0 x 40.5 cm)
Signed lower left: Fredk Ballard Williams
Gift of Eloise Mabury Knapp
M.53.1.3

The Trio typifies Williams's romantic, arcadian figure paintings. Inspired by the *fêtes galantes* of Jean-Antoine Watteau (1684–1721), Williams dressed his female subjects in flowing gowns and elaborate coiffures of the rococo period and placed them in a forest setting pursuing some form of leisurely merriment. The activity

Williams, *The Trio.*

is always sweet and innocent. Here two lovely young maidens collect flowers as the third figure, in the back, plays her guitar and serenades them. Following the example of Adolphe Monticelli (1824–1886) and his highly impastoed surfaces, Williams applied his paint thickly, layering the glazes with scumbling so that the surface appears to be encrusted. He restricted the palette to the deep, sumptuous hues of the forest: oranges, ochers, greens, and browns.

The entire painting has an effervescence as light flickers over the jewellike surface. In paintings such as this Williams carried on the late nineteenth-century American romantic spirit of Blakelock and Daingerfield.

PROVENANCE
The artist § With Macbeth Galleries, New York, 1920 § Paul Rodman Mabury, Los Angeles, to 1939 § Carlotta Mabury (by descent), San Francisco and Los Angeles, 1939–51 § Estate of Carlotta Mabury, 1951–52 § Mrs. B. Knapp (Eloise Mabury Knapp; by descent), Brookline, Mass., 1952–53.

ON DEPOSIT
LACMHSA, 1951–52 § Los Angeles County Department of Charities, Bureau of Public Assistance, 1954–69.

EXHIBITIONS
New York, Macbeth Gallery, *Forty Selected Paintings by Living American Artists on Exhibition,* 1909, no. 39 § New York, Macbeth Gallery, *Paintings by Charles H. Davis, Paul Dougherty, Daniel Garber, William Sartain, F. Ballard Williams,* 1911, no. 27.

LITERATURE
Archiv. Am. Art, Macbeth Gallery Papers, Artists' Credit Book, 1910–16, July 12, 1911, entry (not on microfilm), listed as sold to W. G. Kirckhoff; Macbeth Gallery to the artist, March 29, 1920 (microfilm roll 2663, frs. 308–9), explains that the woman who bought the painting never paid for it, so the gallery was going to purchase it for $225; the artist to Robert Macbeth, March 30, 1920 (ibid., fr. 311), says that he had almost forgotten about the painting § Hayes, "Williams," p. 5, refers to as *Three Figures in a Glade.*

Edmund Tarbell

Born April 26, 1862,
West Groton, Massachusetts
Died August 1, 1938,
New Castle, New Hampshire

Edmund Charles Tarbell was a leading member of the Boston school and an influential art teacher. He was raised in South Boston. Showing an early interest in art, he attended evening drawing classes at the Massachusetts Normal School and in 1877 went to work for Forbes Lithographic Company. Three years later he entered the school of the Museum of Fine Arts, Boston, where he studied with Otto Grundmann (1844–1890) and Frederick Crowninshield (1845–1918). He and Frank Benson (1862–1951) went to Paris in 1883 to study at the Académie Julian with Gustave Boulanger (1824–1888) and Jules-Joseph Lefebvre (1836–1911). Tarbell also studied with the American expatriate William T. Dannat (1853–1929) and traveled in Europe before returning to Boston in 1886.

In 1888 Tarbell was elected to the Society of American Artists. He exercised a considerable influence on a generation of young Boston artists while teaching at the school of the Museum of Fine Arts from 1889 to 1913. Initially his influence was in terms of the impressionist style he employed during the early 1890s. In 1897 he helped found the progressive exhibiting group, Ten American Painters (usually referred to as "The Ten"). He was elected an associate of the National Academy of Design in 1904 and an academician in 1906. He moved to Washington, D.C., in 1917 to direct the Corcoran School of Art. In 1926 he returned to Boston and to his summer home in New Castle. He continued to paint until his death.

BIBLIOGRAPHY
Frederick W. Coburn, "Edmund Tarbell," *International Studio* 32 (September 1907): LXXV–LXXXVII § Charles H. Caffin, "The Art of Edmund C. Tarbell," *Harper's New Monthly Magazine* 117 (June 1908): 65–74 § John E. D. Trask, "About Tarbell," *American Magazine of Art* 9 (April 1918): 217–28 § Patricia Jobe Pierce, *Edmund C. Tarbell and the Boston School of Painting, 1889–1980*, ed. John Douglas Ingrahain (North Abington, Mass.: Pierce Galleries, 1980), with bibliography, catalogue raisonné, lists of awards, exhibitions, and students, has many errors § Boston, Museum of Fine Arts, and others, *The Bostonians: Painters of an Elegant Age, 1870–1930*, exh. cat., 1986, with essays by Theodore E. Stebbins, Jr., William Vance, and Trevor J. Fairbrother, biographical notes and bibliographies by Erica E. Hirshler, appendix listing instructors in the Museum School by Cynthia D. Fleming.

Tarbell, *Mrs. George Putnam and Her Daughters.*

Mrs. George Putnam and Her Daughters, c. 1910

(*The Christmas Snapshot*)
Oil on canvas
54¹/₁₆ x 60 in (137.3 x 152.4 cm)
Signed lower right: Tarbell
Gift of Jo Ann and Julian Ganz, Jr.
M.76.135

Tarbell was among the most prominent American portraitists of his day. The unfinished state of this canvas allows one to see the artist's skillful drawing with his brush and his use of color in the early stages of a design. The painting's friezelike arrangement of figures against the very firm architectural background fits into Tarbell's concern with surface design around the beginning of the century. The image of the seated woman approached by a girl recalls the familiar scenes of this kind on Attic stelae.

The artist's daughter, Mary Tarbell Schaffer, wrote to the M. R. Schweitzer Gallery of New York in 1966 that she recalled seeing this portrait in her father's studio at the Fenway Studios in Boston. She remembered that the painting remained unfinished because one of the children became ill, and when she recovered, her mother took them both to Europe for a year. When the Schweitzer Gallery sold this painting in 1967, it was stated that it was executed about 1910 and depicts the family of one George Putnam, an Episcopal bishop residing in Lenox, near Boston. Historical records mention neither a Putnam family living in Lenox nor a bishop named Putnam. The present rector of the Episcopal church in Lenox reports, however, that the Right Reverend Thomas F. Davies II, bishop of western Massachusetts from 1911 to 1919, lived in Lenox and married Anna F. Patten, the widow of William Patten. A portrait photograph that came along with the painting that apparently is of the lady and one girl in the painting is marked with the name of a photographer who was active in Portland, Oregon, in 1910.

Further confusion as to the identity of the sitters is added by the inscription on a supposedly related pastel that identifies the subjects as Mrs. Horatio Slater and her daughter. This pastel is quite different, however, from the oil of the Slaters (*Slater Family*, 1901 [private collection; sale, Christie's, New York, 1986, no. 195]), which includes four children, all of whom are posed frontally. Patricia Jobe Pierce speculates that the artist may have forgotten the family's name by the time he titled the pastel later in life. The authenticity of some purported Tarbell pastels of this type, which seem to be studies for elements of known compositions, has been questioned.

RELATED WORK
Portrait of Mrs. Horatio Slater and Her Daughter [incorrect identification], n.d., pastel on paper, 23½ x 18 in (59.7 x 45.7 cm). Collection Dr. and Mrs. S. Embury.

PROVENANCE
Private collection § New York, M. R. Schweitzer Gallery, New York, 1967, as *The Christmas Snapshot* § Jo Ann and Julian Ganz, Jr., Los Angeles, 1967–76.

EXHIBITIONS
New York, M. R. Schweitzer Gallery, *Americans: Home/Abroad*, 1966, no. 7, repro., unpaginated § LACMA, *Chosen Works of American Art, 1850–1924, from the Collection of Jo Ann and Julian Ganz, Jr.,* 1969, no. 17, unpaginated, text by Larry Curry,

pl. 17 § Santa Barbara (Calif.) Museum of Art, *American Paintings, Watercolors, and Drawings from the Collection of Jo Ann and Julian Ganz, Jr.,* 1973, no. 69, unpaginated, entry by Nancy Wall Moure, repro.

LITERATURE
LACMA, American Art department files, Mary

Tarbell Schaffer to M. R. Schweitzer Gallery, March 18, 1966 (photocopy), discusses circumstances of the painting; M. R. Schweitzer to Julian Ganz, Jr., November 13, 1967 (photocopy), identifies the sitters § "American Art Department," *LACMA Report 1975–1977* (1978), p. 12, repro., p. 13 § Pierce, *Tarbell,* p. 213, listed in cat. raisonné with exhibitions, provenance, and note about identification.

Elliott Daingerfield

Born March 26, 1859,
Harpers Ferry, Virginia
(now West Virginia)
Died October 22, 1932,
New York, New York

Elliott Daingerfield sought to evoke the spiritual qualities of all his subjects, whether landscapes or figures. He was raised in Fayetteville, North Carolina. In 1880 he went to New York, where he studied briefly with the painter Walter Satterlee (1844–1908) and at the Art Students League. In 1884 he opened his own studio in the same building in which GEORGE INNESS maintained a studio. The art and philosophy of Daingerfield was deeply affected by the work of Inness.

Daingerfield spent most of his career in New York, summering at his home in Blowing Rock, North Carolina. In the mid-1890s religious paintings replaced landscapes as his main interest. Official recognition was late in coming to Daingerfield; in 1902 he won the Clark Prize and was elected an associate member of the National Academy of Design, and he was elected academician in 1906. He traveled to Europe in 1897 and 1924; the Grand Canyon (a prominent theme in his art) in 1911, 1913, and 1915; and Carmel, California, in 1913. Because of poor health, he painted little after 1924. He published very sensitive interpretations of the art of George Inness, ALBERT PINKHAM RYDER, and RALPH ALBERT BLAKELOCK.

BIBLIOGRAPHY
Archiv. Am. Art, Macbeth Gallery Papers § Charles H. Wilson, "The Painting of Elliott Daingerfield," *Fine Arts Journal* 24 (May 1911): 308–12 § Elliott Daingerfield, "Retrospect and Impression," *International Studio* 61 (March 1917): III–VI § New York, Grand Central Art Galleries, *Memorial Exhibition of the Work of Elliott Daingerfield,* 1934 § Charlotte, N.C., Mint Museum of Art, and Raleigh, North Carolina Museum of Art, *Elliott Daingerfield: Retrospective Exhibition,* exh. cat., 1971, with text by Robert Hobbs, bibliography, chronology.

Daingerfield, *Temple Dancer.*

Temple Dancer, c. 1910–20
Oil on fiberboard
16 x 11¹⁵/₁₆ in (40.6 x 30.3 cm)
Signed lower right: Elliott Daingerfield
Mr. and Mrs. Allan C. Balch Collection
M.45.3.510

As in the artist's *The Moon Path,* 1910–15 (private collection), a ghostly nude figure dances on a pool of moonlit water. Like the nude figures that recline on the ledges in some of Daingerfield's Grand Canyon paintings, this dancer is symbolic, in this case of the quality and poetry of moonlight. An early champion of Ryder, Daingerfield was a symbolist painter who evoked concepts and feelings through his imaginary subjects. As Ryder and Blakelock tried to do, Daingerfield sought, in *The Temple Dancer,* to achieve richly colored, enamellike surfaces by the extensive use of glazes.

PROVENANCE
Mr. and Mrs. Allan C. Balch, Los Angeles, to 1943
§ Estate of Mr. and Mrs. Balch, 1943–45.

ON DEPOSIT
LACMHSA, 1940–45.

LITERATURE
Higgins 1963, p. 115, no. 44 in checklist of Balch collection § LACMA, American Art department files, Bruce W. Chambers to Ilene Susan Fort, February 3, 1986, relates painting to the artist's mystical Grand Canyon subjects.

John R. Grabach

Born March 2, 1880,
Newark, New Jersey
Died March 17, 1981,
Irvington, New Jersey

John R. Grabach determined to be an artist early on and took lessons from a local artist in New Jersey, Albert Dick, and joined the Newark Sketch Club before enrolling at the Art Students League in New York. Supporting himself as a machinist and then a designer of silverware, Grabach spent his free time painting. He began exhibiting publicly in 1913 at the National Academy of Design and in important annuals. In 1915 he returned from Massachusetts, where he had lived for three years, to settle permanently in New Jersey. In 1922 he and eleven other artists formed The Dialis for the purpose of exhibiting together.

Inspired by Ash Can school artists, Grabach became fascinated with the urban landscape. The decorative, dynamic character of his Wash Day series of the mid-1920s became the hallmark of his brand of urban realism. Toward the end of the decade his light-hearted treatment changed as he became more concerned with social conditions, and consequently during the Great Depression his urban images developed a stronger, satirical tone, and the figures were made larger and dominated the scene. At this time Grabach supported himself by working as a freelance illustrator and a teacher of life drawing at the Newark School of Fine and Industrial Art. Despite recognition and awards, Grabach began retreating from public attention and the mainstream art world. Thus he was all but forgotten, despite the fact that he continued to teach and paint, adopting in the 1940s a dark, Munich-inspired palette and brushwork.

BIBLIOGRAPHY
Henry Gasser, "The Career of John R. Grabach," *American Artist* 28 (March 1964): 38–43, 62–63 § Washington, D.C., Smithsonian Institution, National Collection of Fine Arts, *John R. Grabach: Seventy Years an Artist*, exh. cat., 1980, published by Smithsonian Institution Press, text by Virginia M. Mecklenburg, with chronology, list of exhibitions, bibliography § New York, Graham Galleries, *John R. Grabach, 1880–1981: Urban America between the Wars*, exh. cat., 1981, with introduction by Harry Rand.

Grabach, *Sunlit Houses.*

Sunlit Houses, c. 1912–15
Oil on canvas
27⅛ x 27⅛ in (68.8 x 68.8 cm)
Signed lower right: John R Grabach
Gift of Tommy and Gill LiPuma
M.85.230

In 1912 Grabach moved to Greenfield, Massachusetts, drawn there by the landscape of this section of the Connecticut River Valley. Until he moved back to New Jersey in 1915, he devoted much of his time to painting winter landscapes—possibly inspired by the snowy scenes of JOHN TWACHTMAN—that were well received at the National Academy of Design annuals. During the late nineteenth century artists had begun using such images as a means to explore the potential of the color white, but by Grabach's time such interest was more of a decorative nature. In true impressionist fashion Grabach found much color in the snowy image: a setting sun casts a golden orange on the rooftops, while cooler pastels of green and lavender describe the shadows. The impastoed brushwork is somewhat controlled in the delineation of the forms of the houses, but looser for the field of snow. The canvas is an exact square, a format popular with early twentieth-century impressionists and post-impressionists, as were a high viewpoint and

brushwork that served to emphasize the picture plane. The buildings and yards are read as flat shapes in a jigsaw-puzzle arrangement. As *Sunlit Houses* is a view of a town, it foreshadows Grabach's later urban images and probably was done just before he left Greenfield.

PROVENANCE
The artist, to 1981 § Estate of the artist § With Graham Galleries, New York, 1981 § Tommy and Gill LiPuma, Los Angeles, 1982–85.

EXHIBITIONS
Philadelphia, Pennsylvania Academy of the Fine Arts, *113th Annual Exhibition*, 1918, no. 249 § Rochester, N.Y., Memorial Art Gallery, *Paintings by Frederick J. Waugh, Harry Neyland, John R. Grabach, O. B. Judson, Harold C. Dunbar, Tod Lindenmuth*, 1918, no. 38 § Graham Galleries, *Grabach*, no. 6, pp. 6, 11–12, with list of exhibitions, repro., p. 14.

Grabach, *Pushcart Vendors.*

Pushcart Vendors, c. 1922
Oil on canvas
29 1/16 x 31 1/8 in (73.8 x 79.0 cm)
Signed lower right: John R Grabach
Gift of Tommy and Gill LiPuma
M.83.149

During World War I, when he worked as a mapmaker for the federal government, Grabach traveled to New York every day. He was so struck by the visual image of laundry dancing on clotheslines strung between the upper stories of tenement buildings and the activity of the inhabitants crowding the streets of the poor sections of the city that in the early 1920s he created a series devoted to the theme of wash day. *Pushcart Vendors* is one of the major paintings from the series. Grabach added to the view of clean white laundry fluttering in the wind an array of peddlers selling their wares from portable pushcarts. The locale was identified as New York when it was exhibited in 1924. Grabach was close friends with GEORGE LUKS and acquainted with the urban scenes of the Ash Can painters, and his paintings of lower-class New York neighborhoods were no doubt inspired by their example.

As did the Ash Can artists, Grabach created an image of lower-class city life without an element of dreariness, one characterized by constant activity and energy. A decade separates Grabach's street scenes from those of the original Ash Can painters, however. Grabach, reflecting his earlier impressionist and post-impressionist concerns, showed a greater interest in the decorative quality of images. Unlike GEORGE BELLOWS in his *Cliff Dwellers*, 1913 (LACMA; q.v.), Grabach viewed the city from above, from a distance that prevented the artist and now the viewer from becoming immersed in the activity below. This high vantage point also led the artist to flatten the view, to literally pile the alleyways and buildings one on top of another rather than depicting the scene in depth. The two-dimensionality of the scene was further enhanced by the canvas's high horizon line and almost square format. Grabach utilized formal devices that create the impression of liveliness, and he often incorporated diagonals into his compositions to intensify the sense of movement. In *Pushcart Vendors* the entire scene is set on an angle, with the wall that separates the buildings from the street functioning as the major diagonal. The wash on the clotheslines forms a counterpoint to the alley and buildings, thereby activating the densely packed scene. Grabach also used a greater variety of colors with less concern for pseudoscientific theory than did Bellows in *Cliff Dwellers*. Buildings are red, blue, white, and brown, the distant sky lavender, and a patch of grass sparkling green, and these colors flicker across the scene.

PROVENANCE
The artist, c. 1922–81 § Estate of the artist, 1981 § With Graham Galleries, New York, 1981–83 § Tommy and Gill LiPuma, Los Angeles, 1983.

EXHIBITIONS
New York, American Art Association, Salons of America, Inc., *Spring Salon*, 1923, no. 22 § Philadelphia, Pennsylvania Academy of the Fine Arts, *119th Annual Exhibition*, 1924, no. 162 § New

York, National Academy of Design, *One Hundredth Annual Exhibition,* 1925, no. 113 § Dayton Art Institute, *Exhibition of Paintings by Modern American Masters,* 1925, no. 7 § Newark, N.J., Cooperative Gallery, *John R. Grabach: Recent Paintings,* 1938, no. 10 § Graham Galleries, *Grabach,* no. 10, pp. 9, 12, with list of exhibitions, references, repro., cover.

LITERATURE
"A Characteristic Work by John R. Grabach," *Art News* 22 (February 23, 1924): repro., 4 § Private collection, John R. Grabach Papers, newspaper clipping, "Irvington Man Surprised at Taking Painting Prize at National Chicago Show," *Newark Evening News,* October 30, 1924, refers to *Pushcart Vendors* as a New York scene that had won favorable comment § "The One Hundredth Annual Brilliant in Color," *Art News* 23 (April 4, 1925): 2 § "Permanent Collection: American Art," *LACMA Members' Calendar* 22 (August 1984): unpaginated, repro. § "American Art," *LACMA Report 1983–1985* (1985), p. 16.

Philip L. Hale

Born May 21, 1865, Boston, Massachusetts
Died February 2, 1931, Dedham, Massachusetts

Philip Leslie Hale was a notable Boston painter, teacher, and writer. The son of the Reverend Edward Everett Hale, Philip studied art first at the Boston Museum School, 1883, and at the Art Students League in New York under J. ALDEN WEIR and Kenyon Cox (1856–1919) before moving to France. There he entered the Académie Julian, studying with Jules-Joseph Lefebvre (1836–1911) and Henri-Lucien Doucet (1856–1895), and in 1887 matriculated at the Ecole des Beaux-Arts. His early works were in the vein of José Ribera (1588–1652), and he made a sensation at the 1889 Salon des Champs de Mars with *The Ornithologist,* 1888 (private collection). About this time Hale fell under the spell of impressionism. During the early 1890s he traveled regularly between New England and France, summering in Giverny with his friend, the American painter Theodore Butler (1861–1936), who was Claude Monet's son-in-law. Hale created some of his most daringly impressionist paintings during the summer of 1890 in Matunuck, Rhode Island, when he posed models outdoors in diaphanous gowns. His study of blazing sunlight became almost an obsession, his landscapes with figures reflecting "the yellow fever" (the artist's own description). He dissolved form more than EDMUND TARBELL, Frank Benson (1862–1951), or others of the Boston school. In 1899 Durand-Ruel in New York held a solo exhibition of his paintings and pastels, works that the critics deemed extreme in color and dissolution of form. In 1901 he married the artist Lilian Wescott Hale (1881–1963). During the first years of this century his paintings became more academic as he tightened his drawing and modeling; he often depicted interior scenes.

Hale's reputation derives more from his long years as a teacher and writer. He taught anatomy and drawing of the antique at the Boston Museum School for almost forty years, beginning in 1893. He also held a summer school in Matunuck in 1898, gave instruction at the Pennsylvania Academy of the Fine Arts in Philadelphia, 1913–28, and lectured at various museums. His art writings appeared in a variety of journals, including the short-lived *Arcadia* (1892–93), and local newspapers, and he served as critic for the Boston *Herald* for many years. In 1913 he published his extensive study of the art of Jan Vermeer (1632–1675).

BIBLIOGRAPHY
Archiv. Am. Art, Philip L. Hale Papers § Northampton, Mass., Smith College, Sophia Smith Collection, Hale Family Papers § Frederick W. Coburn, "Philip L. Hale: Artist and Critic," *World Today* 14 (January 1908): 59–67 § Nancy Hale, *The Life in the Studio* (Boston: Little, Brown, 1969) § Boston, Vose Galleries, *Philip Leslie Hale A.N.A. (1865–1931),* exh. cat., 1988, with essay by Carol Lowrey, interview with Nancy Hale Bowers (1988), chronology, lists of awards, associations, collections, and exhibitions, bibliography.

A Family Affair, by 1913
(Grandmother's Birthday; Grandmother's Birthday Party)
Oil on canvas
30⅛ x 36¼ in (76.5 x 92.1 cm)
Signed lower left: COPYRIGHT BY
PHILIP L. HALE.
Gift of Mr. and Mrs. Hoyt S. Pardee
M.86.27

Hale, like the other academically trained Boston painters, was primarily a figure painter. His art of the early 1900s was less progressive than his paintings of the 1890s and reflects a lessening of interest in the effects of light and an increased emphasis on form, line, and modeling.

The art of Vermeer, rediscovered in the late nineteenth century, determined the course of

the Boston school in the first years of this century. Most Boston painters echoed Vermeer in their domestic scenes of genteel women. The year in which *A Family Affair* was first exhibited, Hale published a critical study on the artist. Following the manner of Vermeer, Hale placed his figures in an interior, emphasized the setting's geometric structure, and had daylight streaming in. Yet this scene of Hale's lacks the quiet intimacy for which Vermeer was admired. This is due to Hale's emphasis on the story, a young girl's visit to her grand-

Hale, *A Family Affair.*

mother. The figures are more actively posed, and the general mood of the scene more sentimental than in a painting by Vermeer. Thus, it is not surprising that when *A Family Affair* was exhibited in Boston, the *American Art News* did not compare the work with Vermeer's but rather emphasized the importance of the narrative element and aligned the painting to the work of Francis D. Millet (1846–1912) and Alfred Stevens (1823–1906).

Following his usual practice, Hale used friends and family for his models: Mrs. E. G. Wescott posed for the grandmother, Hale's wife was the maid, his daughter Nancy, age five, served as the young child, and model Rose Zeffler was the nurse.

PROVENANCE
The artist, as of 1926 § Franklin P. Folts, Boston, c. 1965–66 § With Vose Galleries, Boston, 1966–79, as *Grandmother's Birthday Party* § With DeVille Galleries, Los Angeles, 1979–82 § Mr. and Mrs. Sherwin Mitchell, Los Angeles, 1982–86 § With DeVille Galleries, Los Angeles, 1986.

ON DEPOSIT
First Vermont Bank, Boston, 1977 § Hotel Vendome, Boston, 1978.

EXHIBITIONS
Philadelphia, Pennsylvania Academy of the Fine Arts, *108th Annual Exhibition,* 1913, no. 3, repro., unpaginated § Buffalo, Albright Art Gallery, *Eighth Annual Exhibition of Selected Paintings by American Artists,* 1913, no. 44 § City Art Museum of Saint Louis, *Eighth Annual Exhibition of Selected Paintings by American Artists,* 1913, no. 40., repro., p. 36 § Art Institute of Chicago, *Twenty-sixth Annual Exhibition of American Oil Paintings and Sculpture,* 1913, no. 158 § Boston, Museum of Fine Arts, *Exhibition of Work by Instructors in the Museum School of Drawing and Painting,* 1914, no cat. traced § Cincinnati Art Museum, *Twenty-first Annual Exhibition of American Art,* 1914, no. 34, repro., unpaginated § San Francisco, *Panama-Pacific International Exposition, Department of Fine Arts, Official Catalogue,* 1915, no. 3775 § Boston, Museum of Fine Arts, *Guild of Boston Artists Exhibition,* 1916, no cat. traced § Detroit Museum of Art, *Second Annual Exhibition of Selected Paintings by American Artists,* 1916, no. 40 § Boston, Saint Botolph Club, *Exhibition of Paintings by Philip Leslie Hale,* 1921, no. 22 § Buffalo, Albright Art Gallery, *Eighteenth Annual Exhibition of Selected Paintings and Small Bronzes by American Artists,* 1924, no. 99, repro., p. 51 § Nashville and elsewhere, *Group Exhibition,* organized by American Federation of Arts, New York, 1925–26, no cat. traced § Boston, Vose Galleries, *Paintings and Drawings by Philip Leslie Hale, 1865–1931, from the Folts Collection,* 1966, no. 40, repro., unpaginated, as *Grandmother's Birthday.*

LITERATURE
"The Eighth Annual Exhibition of Selected Paintings by American Artists at the Albright Art Gallery," *Academy Notes* (Buffalo Fine Arts Academy) 8 (July 1913): 122, notes its sentiment § Archiv. Am. Art, Philip L. Hale Papers, "Chronological Catalogue of Exhibitions of His Paintings, n.d., typescript (microfilm roll D103, fr. 174), refers to John Nutting, "By Instructors at Art Museum," *Boston Daily Advertiser,* January 1914, praising the composition, handling, and subject § "Boston," *American Art News* 12 (January 24, 1914): 9, discusses narrative quality § W. H. D., "The Fine Arts," *Boston Evening Transcript,* February 12, 1921, pt. 3, p. 12, comments favorably on the painting as "a pleasant light comedy" § "Eighteenth Annual Exhibition of Selected Paintings and Small Bronzes by American Artists," *Academy Notes* (Buffalo Fine Arts Academy) 19 (August 1924): 51 § Archiv. Am. Art, Philip L. Hale Papers, "List of Pictures by Mr. Hale—Arranged Alphabetically," n.d., typescript, p. 41 (microfilm roll D103, fr. 589), lists painting with some exhibition information; "Chronological Catalogue of Exhibitions of His Paintings," n.d., typescript (ibid., frs. 170–241), includes complete exhibition listings, 1913–26 § New York, *Important American 19th and 20th Century Paintings, Drawings, and Sculpture,* Sotheby-Parke-Bernet, December 6, 1984, offered for sale, no. 65, as *Grandmother's Birthday,* repro., unpaginated, did not sell § Nancy Hale Bowers, telephone conversation with Lisa Murphy, February 24, 1987, identifies figures § LACMA, American Art department files, Nancy H. Bowers to Ilene Susan Fort, August 1, 1988.

Theodore C. Steele

Born December 11, 1847,
Owen County, Indiana
Died July 24, 1926, near
Bloomington, Indiana

A leading figure in Midwestern art, Theodore Clement Steele was the dean of Indiana artists at the turn of the century. His family moved in 1852 to Waveland, Indiana, where he grew up. Virtually self-taught, he was earning his living as a portrait painter by 1870. In 1873 Steele moved to Indianapolis. In 1880 patrons sponsored his studies at the Royal Academy of the Fine Arts in Munich, where he took a class in life drawing and studied painting with Ludwig von Löfftz (1845–1910), winning the academy's silver medal in 1884. He also studied landscape painting with the American expatriate J. Frank Currier (1843–1909). In 1885 Steele returned to Indianapolis, where he worked increasingly as a landscape painter. By 1893, at the time of the World's Columbian Exposition in Chicago, he had emerged as a practitioner of and spokesman for American impressionism, writing an article entitled "Impressionalism," which appeared in the avant-garde journal *Modern Art* (1 [Winter 1893]: unpaginated). In 1907 he built his House of the Singing Winds in Brown County, an area he discovered to be good for painting and which attracted a growing colony of Hoosier artists.

BIBLIOGRAPHY
Indianapolis, Collection of Theodore L. Steele, and Archiv. Am. Art, Theodore C. Steele Papers (partially on microfilm) § Mary Elizabeth Steele, "Impressions" (1893; reprinted in Indianapolis Museum of Art, *Realities and Impressions: Indiana Artists in Munich, 1880–1890,* exh. cat., 1985) § Mary Q. Burnet, "Indiana University and T. C. Steele," *American Magazine of Art* 15 (November 1924): 587–91 § Selma N. Steele, Theodore L. Steele, and Wilbur D. Peat, *The House of the Singing Winds: The Life and Work of T. C. Steele* (Indianapolis: Indiana Historical Society, 1966) § William H. Gerdts and Judith Vale Newton, *The Hoosier Group: Five American Painters* (Indianapolis: Eckert, 1985), with chronology.

Steele, *Sunlight, Late Summer.*

Sunlight, Late Summer, 1913
Oil on canvas
Signed and dated lower right: T C Steele / 1913
30 x 45 in (76.2 x 114.3 cm)
Gift of Mr. and Mrs. Robert B. Neubacher
M.82.93

This example of Steele's mature style is characteristic of his interest in expressing the simple beauty of the hills and fields of Indiana while applying impressionist techniques toward the development of a distinctly American school of art. Its free paint handling and informal composition contribute to the sense that it is a fresh transcription of nature. The site is reminiscent of the Salt Creek and nearby smaller Schooner Creek valleys that lie at the foot of the high, wooded crest where Steele's House of the Singing Winds was located.

PROVENANCE
The artist § Rembrandt (Brandt) T. Steele (by descent) Indianapolis, 1926 § Mr. and Mrs. Robert B. Neubacher (by descent), Pacific Palisades, Calif., by 1982.

EXHIBITION
Indianapolis, John Herron Art Institute, *Theodore Clement Steele, Memorial Exhibition,* 1926, no. 123, p. 29, described by George C. Calvert.

LITERATURE
LACMA, American Art department files, Theodore L. Steele to Ilene Susan Fort, November 15, 1986, suggests possible identification of site.

George Bellows

Born August 19, 1882,
Columbus, Ohio
Died January 8, 1925, New
York, New York

Although always a progressive artist, George Wesley Bellows enjoyed early success and has attained classic status for his vigorous paintings and lithographs of the America of his day. He was raised in Columbus, Ohio. He enrolled in Ohio State University and remained until the beginning of his senior year, when, in 1904, he enrolled in the New York School of Art. He studied there with ROBERT HENRI, with whom he became closely associated. Although he was not chosen to be a member of the independent exhibiting group The Eight, the vigorous execution and urban subject matter of Bellows's early work are closely related to the paintings of the members of that group associated with the Ash Can school. Bellows's work received early recognition, and he was elected the youngest associate member of the National Academy of Design in 1909. He continued to win prizes and to support the avant-garde. In 1913, the year he was elected an academician, he also exhibited in the Armory Show. He married in 1910. While maintaining a studio in New York, he often summered away from the city, in Maine, in Woodstock, New York, or elsewhere. He also had a distinguished career as a lithographer. Bellow's career was cut short by death following an appendectomy.

BIBLIOGRAPHY
Index 20th Cent. Artists 1 (March 1934): 81–94; 1 (September 1934): I; 2 (September 1935): III; 3 (August–September 1936): V; reprint, pp. 117–30, 133, 135, 137 § Charles H. Morgan, *George Bellows: Painter of America,* with introduction by Daniel C. Rich (New York: Reynal, 1965) § Lauris Mason, *The Lithographs of George Bellows: A Catalogue Raisonné,* (Millwood, N.Y.: KTO Press, 1977), assisted by Joan Ludman, with foreword by Charles H. Morgan, bibliography, list of works in museums, concordances § Washington, D.C., National Gallery of Art, *Bellows: The Boxing Pictures,* exh. cat., 1982, with essays by E. A. Carmean, Jr., John Wilmerding, Linda Ayres, and Deborah Chotner, catalogue by Ayres and Chotner, chronology by Trinkett Clark § Jane Myers and Linda Ayres, *George Bellows, the Artist and His Lithographs, 1916–1924* (Forth Worth, Tex.: Amon Carter Museum, 1988), with introduction by Jean Bellows Booth, additions to print catalogue raisonné, list of print exhibitions, bibliography, published in conjunction with an exhibition held at the Amon Carter Museum, Forth Worth, and others, 1988–90.

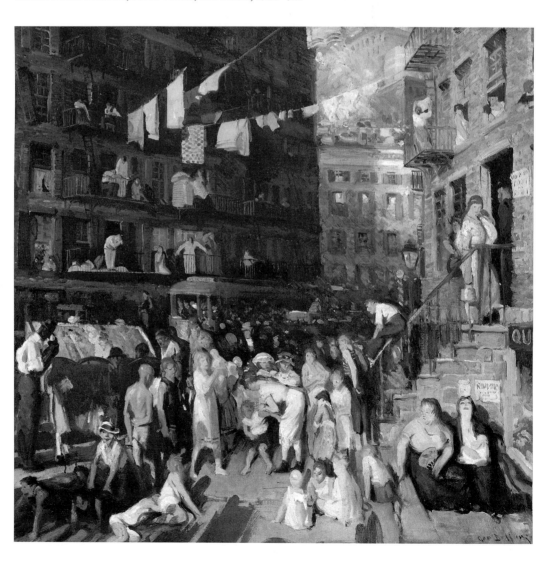

Bellows, *Cliff Dwellers.*

Cliff Dwellers, 1913

(*The Dwellers; An Eastside Street*)
Oil on canvas
40³/₁₆ x 42¹/₁₆ in (102.0 x 106.8 cm)
Signed lower right: Geo Bellows
Los Angeles County Fund
16.4
Color plate, page 54

Among the first paintings acquired by the County Museum, *Cliff Dwellers* is still its best known and most often reproduced American painting.

A large part of the work's attraction to students of American history has been the fact that it appears to stand out among Ash Can school paintings as a statement of strong social criticism. This interpretation has been derived not so much from the appearance of the canvas as from the fact that it is very similar to the drawing "*Why Don't They Go to the Country for a Vacation?*" 1913 (LACMA, see illustration), executed by Bellows for the socialist journal *The Masses* and published as the frontispiece of its issue of August 1913.

Almost all the Ash Can school artists who contributed to *The Masses* stopped short of creating outright political statements. For the most part, they simply considered themselves to be realist artists, producing vignettes of urban life that fit with the journal's alert, down-to-earth editorial tone. Their consciously artistic, realist drawings of indulgent social satire are distinctly different from the bald editorial cartooning that also appeared in *The Masses*. Their paintings were yet further removed from the editorial tone of the magazine. JOHN SLOAN, for instance, who occasionally contributed scathing editorial cartoons to *The Masses,* did not express any sense of social criticism in his paintings, which portray the energy and simple pleasures of the poor.

One cannot find in *Cliff Dwellers* any trace of a change in tone from Bellows's other urban scenes, whose subject and spirit center on the excitement and bustling activity of the city and the surging vitality of its lower classes. The spirit of the scene is established by the innocent joie de vivre of the brightly lighted foreground group of young women and children, especially the bawling, grinning, brawling boys so familiar in Bellows's works. Another prominent note is the mother ascending the stairs on the far right, so reminiscent of the hard-working homemakers of Daumier and Chardin. On the far left, the bright colors of a market cart attract the eye. Except for the large building in deep shadow, the effect is that of sunshine, with a stiff breeze lifting some of the laundry. The irregular angles of the streets and the streetcar's "Vesey Street" destination sign suggest that this is a location in the Lower East Side of Manhattan between the Bowery and

Catherine Slip below Chatam Square.

Bellows's record book indicates that the painting was completed in May 1913. He wrote the title originally as *The Cliff Dwellers* but then crossed out the definite article. As noted in his record book during April 1913, Bellows completed three drawings for *The Masses,* including the museum's drawing reproduced in the August 1913 issue. Its title was recorded as *Why don't they go to the Country for a Vacation?* but is also identified, in parentheses, as "(study for) *Cliff Dwellers*." The fact that the drawing reproduced in *The Masses* was completed at a time when Bellows very well may have been working on *Cliff Dwellers* raises the question of whether that drawing may originally have been made in preparation for the painting and then given a second life as a frontispiece in the magazine. On the other hand, the drawing is a transfer lithograph reworked with pen and ink, an uncharacteristic working method for Bellows, but one that he used for other *Masses* illustrations, which suggests that the drawing was done especially for the magazine.

The record book reveals that *Cliff Dwellers* was organized according to a disciplined color scheme, primarily based on the ideas of the color theorist and paint supplier Hardesty G. Maratta (1864–1924), which were of much interest to Bellows, Robert Henri, and others in the 1910s. The painting's palette is indicated as:
Three c[h]ords.
Orange—Red-purple—Green-blue.
Blue-purple—Green—Red-orange
Yellow-green—Red—Blue
[colors indicated by initials in original]
"Chords" were a concept of Maratta's, triads of usually complementary colors that were chosen, like notes of the musical scale, to establish a particular harmony and mood for a painting. These chords of colors appear to work in different sections of *Cliff Dwellers*. In the produce wagon the first chord of orange, red-purple, and green-blue can be found, and these colors recur throughout the lower section of the painting in the crowd. Even the notes of yellow and blue there probably were created by mixing a good deal of white with the orange and the blue-green of the chord. The blue-purple of the second chord can be said to dominate the shadowed building at the left, with its green shutters and red brick wall. The wall, however, has too much blue in it to be called a red-orange. The yellow-green of the third chord is prominent in the lighted building at the right, although its patches of red and blue both tend toward purple. The chords are similar enough to blend easily into a unified painting with areas of relative emphasis on one chord or another. Bellows's remarkable skill at mixing together different colors on the canvas, as he painted wet-into-wet, also enriched *Cliff Dwellers* with a multitude of intermediate hues

Bellows, *Drawing for "Cliff Dwellers,"* 1913, see Related Works.

Bellows, "*Why Don't They Go to the Country for a Vacation?*" 1913, LACMA, see Related Works.

that soften the discipline of what was to have been a limited palette while at the same time contributing to the quality of unity.

Along with Maratta's system of colors, Henri, Bellows, and other students of Henri's spent long hours studying and elaborating Maratta's approach to composition, which sought a similar harmony and balance, using a structure of simple geometrical forms. Bellows's fascination with geometrical compositions after about 1917 is well known, but technical aspects of *Cliff Dwellers* suggest that his efforts in that direction had begun by at least 1913. Bellows appears to have inserted at least ninety pins into the canvas at regular intervals, making horizontal, vertical, and diagonal rows. He apparently painted around them and then pulled them out while the paint was still soft, leaving very small craters, some of which he painted over. In a few areas, where the paint is thinner, portions of diagonal lines in red paint can be seen. These coincide with diagonal rows of pinholes and may have been used either at an earlier stage of the painting or to establish the rows. The intervals between the rows were established so that the pinholes form equilateral triangles, the key concept of the Maratta system. Some of these relate closely to elements of the composition. For instance, the figure of a woman with a fan in the lower right corner has a pinhole at the top of her head and at the point of each elbow. Other features, such as the strong edge of the silhouetted building to the right of center, are aligned with rows of pinholes. Of course, numerous geometrical forms can be constructed from a web of pinholes like this one. Further study of geometry in Bellows's earlier paintings will be necessary to establish which regular forms he used and how they contributed to his compositional objectives. Another question is posed by the numerous, apparently random pinholes in the museum's related drawing. Were they somehow used to transfer elements of the design, while aligning them with the structure of the painting?

The painting was well received, winning five hundred dollars and the third-prize medal in the annual exhibition of 1914 at the Carnegie Institute of Art, Pittsburgh. It toured the country and was shown in Los Angeles several times, in group and solo Bellows exhibitions, before its purchase by the museum on September 16, 1916. Although it was not included in the catalogue of the museum's exhibition of contemporary American paintings in the summer of 1916, the *American Art News* states that it was bought out of that exhibition.

RELATED WORKS
Why Don't They All Go to the Country for a Vacation? 1913, charcoal, black crayon, India ink with brush, and watercolor on paper, 21¹/₁₆ x 26¹⁵/₁₆ in (53.6 x 68.4 cm). Art Institute of Chicago § *Drawing for Cliff Dwellers,* 1913, transfer lithograph on paper, 19½ x 18 in. (49.5 x 45.7 cm). Private collection, New York § *"Why Don't They Go to the Country for a Vacation?"* 1913, transfer lithograph with pen and crayon alterations on paper, 25 x 22½ in (63.5 x 57.1 cm). LACMA, Los Angeles County Funds § *"Why don't they go to the Country for a Vacation?" The Masses* 4 (August 1913): frontispiece, p. 4.

PROVENANCE
The artist, 1913–16.

EXHIBITIONS
Boston, Saint Botolph Club, *Paintings by Five New York Painters,* 1913, no. 8 § New York, Montross Gallery, [group exhibition], no cat. traced § New York, Montross Gallery, *Paintings by George Bellows,* 1914, no. 3 § Pittsburgh, Carnegie Institute of Art, *Eighteenth Annual Exhibition,* 1914, no. 17, repro., unpaginated, awarded third-class prize § Toronto, *Canadian National Exhibition, Department of Fine Arts, Catalogue,* 1914, no. 199, repro., p. 42 § American Federation of Arts sponsored traveling exhibition, [Sixteen Oil Paintings], 1914 no cat. traced § LAMHSA, *Paintings by George Bellows, N. A.,* 1915, exhibited according to the museum's registrar's records, but not listed in catalogue § LAMHSA, *American and European Artists,* 1915, no. 8 § Cincinnati Museum, *Special Exhibition of Paintings by Mr. George Bellows,* 1915, no. 8 § New York, Holland House, Whitney-Richards Galleries, *Works of George Bellows,* 1915, no cat. traced § LAMHSA, *Summer Exhibition of Paintings,* 1916, not listed but exhibited according to *American Art News,* Oct. 21, 1916 (see Literature below) § Philadelphia, Pennsylvania Academy of the Fine Arts, *111th Annual Exhibition,* 1916, no. 195 § Poughkeepsie, N.Y., Vassar College, *Exhibition of Oil Paintings by George Bellows, N.A., and Clarence K. Chatterton,* 1916, no. 3 § City Art Museum of Saint Louis, *Eleventh Annual Exhibition of Selected Paintings by American Artists,* 1916, no. 9 § New York, Metropolitan Museum of Art, *Memorial Exhibition of the Work of George Bellows,* 1925, no. 18, repro., p. 54 § Fine Arts Gallery of San Diego, Calif., *Inaugural Exhibition,* 1926, no. 9 of American paintings § LAMHSA, *The George Wesley Bellows Memorial Exhibition,* 1926, no cat., exhibition was abbreviated version of Metropolitan Museum's 1925 *Memorial Exhibition,* painting listed as no. 4 in *A Loan Exhibition from Private Collections* § LAMHSA 1928, no. 3 § LAMHSA 1930, no. 35 § New York, Metropolitan Museum of Art, *Life in America: A Special Loan Exhibition of Paintings Held During the Period of the New York World's Fair,* 1939, no. 282, repro., p. 213 § New York, Whitney Museum of American Art, *This Is Our City,* 1941, no. 2, repro., unpaginated § Santa Barbara (Calif.) Museum of Art, *Painting Today and Yesterday in the United States,* 1941, no. 7 § London, Tate Gallery, *American Painting from the Eighteenth Century to the Present Day,* 1946, no. 14 § Pomona, Calif., Los Angeles County Fair, *Masters of Art from 1790 to 1950,* 1950, entries not numbered, repro., unpaginated § New York, Wildenstein Galleries, *Landmarks in American Art, 1670–1950,* 1953, no. 43, unpaginated § Los Angeles, Barnsdall Park,

Municipal Art Gallery, *The American Scene,* 1956, no cat. traced § Washington, D.C., National Gallery of Art, *George Bellows: A Retrospective Exhibition,* 1957, no. 24, repro., p. 56 § Columbus (Ohio) Gallery of Fine Arts, *Paintings by George Bellows,* 1957, no. 27 § New York, Gallery of Modern Art, *George Bellows: Paintings, Drawings, Lithographs,* 1966, no. 30, repro., p. 24 § New York, Jewish Museum, *The Lower East Side: Portal to American Life (1870–1924),* 1967, no. 3, p. 64, entry by Cynthia Jaffee § LACMA, *John Sloan and George Bellows,* 1968, no. 16 § Edinburgh, Royal Scottish Academy, and London, Hayward Gallery, organized by Arts Council of Great Britain and others, *The Modern Spirit: American Painting, 1908–1935,* 1977, no. 3, repro., p. 29 § Columbus Museum of Art, *George Wesley Bellows: Paintings, Drawings, and Prints,* 1979, no. 20, p. 9, essay by Budd H. Bishop, repro., p. 31.

LITERATURE

La Jolla, Calif., Jean Bellows Booth Collection, Bellows Record Book, bk. A, p. 157, with color notes and abbreviated exhibition list § "Art at Home and Abroad: The Younger Generation," *New York Times,* October 26, 1913, Magazine, p. 15 § Guy Pène du Bois, "Fifteen Young Americans at the Montross Gallery," *Arts and Decoration* 4 (December 1913): 71 § "George Bellows at Montross's," *American Art News* 12 (January 24, 1914): 3, 6, refers to as *An Eastside Street* § "Annual Carnegie Display," *American Art News* 12 (May 2, 1914): 2 § "Annual Exhibition Carnegie Institute," *Fine Arts Journal* 30 (June 1914): 291, repro., 292 § "Exhibitions at the Galleries: The Only Annual International Show in America," *Arts & Decoration* 4 (June 1914): 321 § W. H. de B. Nelson, "Pittsburgh International, 1914," *International Studio* 52 (June 1914): CX, repro. § "The Carnegie Institute's International Exhibition," *Art & Progress* 5 (July 1914): 326, "Whether it is a sermon or an achievement is hard to say—perhaps it is both," repro. § Charles L. Buchanan, "George Bellows: Painter of Democracy," *Arts & Decoration* 4 (August 1914): 371, repro., 373 § H. C. R., "The George Bellows Show," *American Art News* 14 (December 18, 1915): 3 § "Los Angeles (Cala.)," *American Art News* 15 (October 21, 1916): 2, mentions purchase of painting from LAMHSA summer 1916 exhibition § Frank Jewett Mather, Jr., "Some American Realists," *Arts & Decoration* 7 (November 1916): 15, repro., as *The Dwellers* § Evelyn Marie Stuart, "Contemporary American Art as an Investment," *Fine Arts Journal* 35 (April 1917): repro., 245 § LAMHSA 1921, no. 29 § Eugene Neuhaus, *The Appreciation of Art* (Boston: Ginn, 1924), repro., p. 74 § "George Bellows' Last Canvases," *For Art's Sake* (Los Angeles) 2 (March 1, 1925): 6 § "Bellows Memorial Exhibit at Museum," *Art News* 24 (October 17, 1925): 1 § Theodore Dreiser, "'The Cliff Dwellers': A Painting by George Bellows," *Vanity Fair* 25 (December 1925): 55, 118, comments on the painting's social perspective, repro., 55 § "Bellows Memorial Exhibit at Los Angeles Museum," *California Graphic* 3 (August 7, 1926): repro., 7 § Reginald Poland, "Woodstock Art in San Diego," *Art News* 26 (April 28, 1928): 1 § *Index 20th Cent. Artists,* p. 87; reprint, p. 123; listed § LACMA, Registrar's files, William Preston Harrison to Louise Upton, July 6, 1928–February 3,

1935, discuss means of acquiring painting for the Harrison Gallery § Emma S. Bellows, *Paintings of George Bellows* (New York: Knopf, 1929), pl. 39, unpaginated § Arthur Millier, "Museum's Own Collection of Paintings Now on View," *Los Angeles Times,* July 30, 1933, pt. 3, p. 5 § "Art Exhibitions Reviewed," *Los Angeles Times,* July 28, 1935, pt. 2, p. 7 § Eugene Neuhaus, *The World of Art* (1924; rev. ed., New York: Harcourt Brace, 1936), repro., p. 65 § Harry Salpeter, "George Bellows, Native," *Esquire* 5 (April 1936): 137 § Forbes Watson, "My Country 'tis of Thee," *Magazine of Art* 32 (June 1939): repro., 331 § "New York Scenes Depicted in Show at Whitney Museum," *New York Herald Tribune,* March 11, 1941, p. 23 § Henry McBride, "'This Is Our City,'" *Sun* (New York), March 15, 1941, p. 8, discusses in context of upper- and lower-class life § James W. Lane, "This Is Our City: New York by Its Painters," *Art News* 40 (April 1, 1941): 28 § Peyton Boswell, Jr., *George Bellows* (New York: Crown, 1942), p. 18, repro., p. 108 § LACMHSA, *Thirty-Five Paintings from the Collection of Los Angeles County Museum,* Picture Book no. 1, 1950, no. 32, repro., p. 40 § LACMHSA, *1952 Annual Exhibition, Artists of Los Angeles and Vicinity,* exh. cat., 1952, p. 9, essay by James B. Byrnes § Thomas Craven, ed., *A Treasury of Art Masterpieces* (New York: Simon & Schuster, 1952), repro., p. 231 § Alexander Eliot, *Three Hundred Years of American Painting* (New York: Time, 1957), p. 300 § Richard F. Brown, "The Art Division," *LA Museum Quarterly* 16 (Spring 1960): 17, repro., 16 § William Henry Pierson, Jr., and Martha Davidson, eds., *Arts of the United States: A Pictorial Survey* (Athens: University of Georgia Press, 1960), p. 331, repro. § LACMA, *Illustrated Handbook of the Los Angeles County Museum of Art,* 1965, p. 98, repro., p. 99 § Morgan, *Bellows,* repro., p. 333 § Donald Braider, *George Bellows and the Ashcan School of Painting* (Garden City, New York: Doubleday, 1971), pp. 88, 92–93, fig. 16, between pp. 58 and 59 § Vincent Price, *The Vincent Price Treasury of American Art* (Waukesha, Wis.: Country Beautiful Corp., 1972), p. 208, repro. § John Wilmerding, *The Genius of American Painting* (New York: Morrow, 1973), p. 211, repro., p. 212 § Mahonri Sharp Young, *The Paintings of George Bellows* (New York: Watson-Guptill, 1973), p. 82, repro., p. 83 § Marshall B. Davidson, *The American Heritage History of the Artists' America* (New York: American Heritage, 1973), repro., p. 272 § Gail Reed, "American City: Hot Afternoon," *Christian Science Monitor,* March 22, 1974, p. F7, repro. § Charlene Stant Engel, "George W. Bellows' Illustrations for the *Masses* and other Magazines and the Sources of His Lithographs of 1916–1917," Ph.D. diss., University of Wisconsin-Madison, 1976, p. 114 § LACMA 1977, p. 144, repro. § Joshua C. Taylor, *The Fine Arts in America* (Chicago: University of Chicago Press, 1979), repro., p. 182 § Milton W. Brown and others, *American Art: Painting, Sculpture, Architecture, Decorative Arts, Photography* (New York: Harry N. Abrams, 1979), pp. 356–57, pl. 51, p. 302 § Washington, D.C., Smithsonian Institution, National Collection of Fine Arts, *John R. Grabach: Seventy Years an Artist,* exh. cat., 1980, p. 15, text by Virginia M. Mecklenburg considers the parallels between *Cliff Dwellers* and Grabach's *East Side, New York* § Mahonri Sharp Young, "Old

Timers" in "American Realists of 1930's," *Apollo* 113 (March 1981): repro., 157 § New York, Graham Galleries, *John R. Grabach, 1880–1981: Urban America between the Wars,* exh. cat., 1981, p. 9, introduction by Harry Rand discusses Grabach's thematic

and compositional borrowings from *Cliff Dwellers* § William Wilson, *The Los Angeles Times Book of California Museums* (New York: Harry N. Abrams, 1984), fig. 130, p. 151 § Fort 1986, p. 420, fig. 3, p. 422 § LACMA 1988, p. 22, repro.

Bellows, *The Coming Storm.*

The Coming Storm, 1916
Oil on canvas
26¹/₁₆ x 32¹/₁₆ in (66.2 x 81.5 cm)
Signed lower left: Geo Bellows
Mr. and Mrs. William Preston Harrison Collection
18.1.1

In 1911 Bellows began to summer in Maine. During his visits there, until 1916, he moved increasingly away from the almost exclusively urban subject matter of his early career and turned toward landscape painting. *The Coming Storm* was painted during June 1916, when Bellows and his family were summering in remote Camden, Maine, with LEON KROLL. Early in their stay they were visited almost daily with storms, and Bellows's paintings from June and July are among his most dramatic in their contrast and energetic brushwork. By this time he was systematically using the Maratta palette, and *The Coming Storm* is fairly strong in color

despite its overcast tonality. In his record book the artist indicated the color scheme for his painting as follows:

Yellow-Green 13.9.5.3.1, Yellow 11-7, Green 11, Green-Blue 9.1, Blue-Purple 9
Orange-Yellow 1, Red-Purple 5, Red-Orange 5
[colors indicated by initials in original]

The numbers by each of the abbreviations of color names refer to the value of the hue that Bellows used. This system of assigning numbers to color values was established at a meeting in 1915 at which Bellows, Maratta, and others were present and which resulted in a chart of colors and values. It was one of several elaborations of the Maratta color system worked out in Henri's circle.

RELATED WORK
Seascape, lithograph crayon on paper, 5¹/₂ x 4 in (13.9 x 10.1 cm). Formerly Doris Harris Autographs, Los Angeles.

PROVENANCE
The artist, 1916 § Mr. and Mrs. William Preston Harrison, Los Angeles, 1916–18.

EXHIBITIONS
LAMHSA, *Summer Exhibition of Paintings by Contemporary American Artists Loaned By Mr. and Mrs. William Preston Harrison,* 1917, no. 1 § LAMHSA 1918, no. 1 § LAMHSA 1924, no. 15 § Los Angeles, University of Southern California, Elizabeth Holmes Fisher Gallery of Fine Arts, *American Painting of the Eighteenth and Nineteenth Centuries* (series 1940–41, no. 1), 1940, no. 2.

LITERATURE
La Jolla, Calif., Collection Jean Bellows Booth, Bellows Record Book, bk. B, p. 46, with color notes § "In the Realm of Art: The Harrison Collection," *Los Angeles Times,* August 26, 1917, pt. 3, p. 16 § Roland Johnstone, "A Notable Gift to Los Angeles," *Graphic* 52 (April 10, 1918): 12, notes its being purchased directly from the artist § LAMHSA 1921, no. 1 § "George Bellows' Last Canvases," *For Art's Sake* (Los Angeles) 2 (March 1, 1925): 6 § "Recent Accessions," *LA Museum Art Dept. Bull.* 6 (April 1925): 183 § "Harrison Gallery Great Gift to Los Angeles," *California Graphic* 3 (November 28, 1925): repro., 19 § "Bellows Memorial Exhibit at Los Angeles Museum," *California Graphic* 3 (August 7, 1926): repro., 7 § Harrison 1934, p. 20, repro., p. 21 § *Index 20th Cent. Artists,* p. 82; reprint, p. 118; listed in colls. § Higgins 1963, p. 56, no. 1 in checklist of Mr. and Mrs. William Preston Harrison collection.

Marsden Hartley

Born January 4, 1877,
Lewiston, Maine
Died September 2, 1943,
Ellsworth, Maine

Marsden Hartley (born Edmund Hartley) was among the most innovative of early American modernists. He led a peripatetic life during his adulthood, never remaining in one place for more than nine months. With this constant moving came changes in his art as he explored the gamut of European avant-garde styles and evolved a truly personal means of expression, yet his home state of Maine and nature in general played a crucial role in Hartley's art. In the late 1890s he took his first art lessons in Cleveland, Ohio, with local artists such as Cullen Yates (1866–1945) and at the Cleveland School of Art; he then moved to New York, attending the Chase School and later the National Academy of Design for four years. In 1909 his impressionist and neoimpressionist landscapes were shown at his first solo exhibition in New York at Alfred Stieglitz's gallery "291"; this initiated his long association as an intimate of the Stieglitz circle.

During four years spent in France and Germany before World War I Hartley immersed himself in European avant-garde circles and, fascinated with the ideas of the cubists and Wassily Kandinsky (1866–1944), began to create his own mystical abstractions. In Berlin during 1915 he painted symbolic abstractions inspired by the pageantry of military displays and by Native American art. He painted his most abstract, cubist works during 1916, when he spent the summer in Provincetown, Rhode Island, with CHARLES DEMUTH. He then returned to representational painting and from 1918 to 1919 fell under the spell of the desert and Native American imagery during visits to New Mexico. Despite a brief Cézannesque period in the late 1920s, Hartley grew increasingly expressionistic in his handling of paint while retaining his romantic view of nature. His dramatic landscapes and figurative compositions culminated in the paintings he created in Nova Scotia and Maine during the late 1930s and 1940s.

Hartley was also a prolific writer, the largest body of his published work appearing between 1917 and 1923. He wrote poems as early as 1902. Many of his writings remain unpublished and are in the collection of the Beinecke Library, Yale University. His essays appeared in *The Dial, Nation,* and other magazines, and some were published in *Adventures in the Arts* (1923). Two anthologies have recently been published, *On Art* (1982) and *The Collected Poems of Marsden Hartley, 1904–1943* (1987), both edited by Gail R. Scott.

BIBLIOGRAPHY
Paul Rosenfeld, *Port of New York* (1924; reprint, Urbana: University of Illinois Press, 1966), pp. 83–101 § "Marsden Hartley: Special Issue," *Arts Magazine* 54 (October 1979): 154–76, articles by Gail Levin, Gail R. Scott, Roxana Barry, and Vivian Endicott Barnett § New York, Whitney Museum of American Art, and others, *Marsden Hartley,* exh. cat., 1980 (copublished by New York University Press, New York), text by Barbara Haskell, chronology, list of exhibitions, bibliography of Hartley's published writings compiled by Peter Freeman § Halifax, Nova Scotia, Canada, Mount Saint Vincent University Art Gallery, and Toronto, Art Gallery of Ontario, *Marsden Hartley and Nova Scotia,* exh. cat., 1987, published by Press of Nova Scotia College of Art and Design, ed. Gerald Ferguson, with essays by Ronald Paulson and Gail R. Scott, reprints of Hartley's letters to Adelaide Kuntz, 1936 journal entries, essay "Cleophas and His Own" and related poems, with chronology, bibliography § Gail R. Scott, *Marsden Hartley* (New York: Abbeville Press, 1988), with chronology, lists of exhibitions and public collections, bibliography.

Abstraction: Blue, Yellow, and Green, c. 1913

(*Abstraction: Blue, Yellow; Abstraction in Red, Yellow, and Green*)
Oil on canvas
25³/₁₆ x 19¹/₈ in (64.0 x 48.6 cm)
Inscribed in another hand on left stretcher bar: Hartley Abstraction in Red Yellow and Green
Gift of Morton D. May
53.254

During his first trip abroad Hartley felt closest to the German avant-garde, who shared with him a concern for the spiritual. After having studied the newly published, illustrated almanac *Der Blaue Reiter* and Kandinsky's theoretical treatise *Über des Geistige in der Kunst,* 1912—both of which he recommended to Stieglitz—Hartley visited Kandinsky in January 1913. Contact with such a painter, as well as his recent reading of Henri Bergson and William James, made Hartley realize the value of abandoning the representation of objective reality in order to create a more abstract art. From May to November 1913 Hartley lived in Berlin, where he created several color abstractions that reveal the impact of Kandinsky more than any of his other works. *Abstraction: Blue, Yellow, and Green* no doubt dates from this first Berlin period.

In palette and handling Hartley's *Abstraction* is comparable with Kandinsky's paintings of

Hartley, *Abstraction: Blue, Yellow, and Green.*

of a landscape were abstracted into geometric and irregular shapes. Hartley's abstraction is closer to Kandinsky's early Improvisations of 1910 rather than those of 1913, which were more fluid and open: the peaked yellow trapezium in the center of Hartley's abstraction is analogous to the houses and mountains that Kandinsky presented as simplified, jagged, and towering forms. Hartley's painting conveys a greater sense of overlapping planes than those by Kandinsky do, and this may have been due to the former's recent exploration of cubism.

Kandinsky's abstractions often had religious or mystical significance. He believed that geometric shapes were abstract entities that had life in themselves and that color likewise conveyed inner meanings. The triangle was of primary importance for it was symbolic of the spiritual life. Hartley was equally fascinated with the idea of creating an art expressing the spiritual, but it is not known to what extent this small abstraction reflects such concerns. It may have only been an experiment with new formal concepts.

PROVENANCE
Possibly Alfred Stieglitz, New York § With An American Place, New York § Morton D. May, Saint Louis, to 1953.

EXHIBITIONS
San Francisco Museum of Art, *Art in the Twentieth Century, Commemorating the Tenth Anniversary of the Signing of the United Nations Charter,* 1955, entries not numbered § Claremont, Calif., Pomona College Galleries, *Stieglitz Circle,* 1958, no. 24, as *Abstraction: Blue, Yellow,* dated 1911 or 1916 § Louisville, Ky., J. B. Speed Art Museum, and others, organized by Museum of Modern Art, New York, *Stieglitz Circle,* 1961–63, catalogue only for last venue: Balboa, Calif., Fine Arts Patrons of Newport Beach, Pavillion Gallery, no. 15 § Fine Arts Gallery of San Diego, Calif., and others, *Color and Form, 1909–1914: The Origin and Evolution of Abstract Painting in Futurism, Orphism, Rayonnism, Synchromism, and the Blue Rider,* 1971–72, no. 24, dated 1916, repro., p. 58, printed upside down § New York, Whitney Museum of American Art, and others, *Synchromism and American Color Abstraction, 1910–1925,* 1978–79 (copublished with George Braziller, New York), entries not numbered, p. 43, text by Gail Levin, pl. 146, p. 115 § Düsseldorf, Städtische Kunsthalle, and others, *2 Jahrzehnte amerikanische Malerei, 1920–1940,* 1979, no. 23 § London, Tate Gallery, *Abstraction: Towards a New Art, Painting, 1910–20,* 1980, no. 434, pp. 114, essay by Gail Levin, repro., p. 118.

LITERATURE
"Recent Acquisitions: American Paintings," *LA Museum Art Div. Bull.* 6 (Summer 1954): repro., 28, printed upside down.

1909. Hartley used primary and secondary hues, with a great deal of black and some white brushed in to modulate the flat shapes. The juxtaposition of red, yellow, and green in the center with blue added above and below suggests that Hartley might have been following certain color theories, as did Kandinsky, although Hartley was never as obsessed with them. An alternate version of the title emphasizing the red rather than blue shapes is written on the stretcher in an unknown hand. Hartley closely followed Kandinsky in applying his paint in thick strokes to create a rough, painterly surface.

While Hartley's simplified shapes appear similar to those in Kandinsky's paintings of 1909, his overall image is more like those in somewhat later paintings by the Russian. Gail Levin has related *Abstraction* to Kandinsky's Improvisations, paintings in which components

Hartley, *Pink and White Flowers in a Vase.*

Pink and White Flowers in a Vase, c. 1929

Oil on canvas
13⅞ x 10¹¹/₁₆ in (35.2 x 27.2 cm)
Inscribed in another hand on top stretcher bar:
Hartley / 1929
Gift of Burt Kleiner
61.8.2

Hartley painted still lifes throughout his career. Beginning in 1916, during a stay in Province-town, he began to simplify his subjects, and in his still-life paintings done the following year in Bermuda, he often focused on a single vase of flowers arranged before a window, close to the picture plane and to the bottom of the picture. During this period he also painted individual floral arrangements set against an unmodulated black background, on glass, in the tradition of German folk art. In *Pink and White Flowers in a Vase* Hartley pared down the elements of the still life as he did in his glass paintings, omitting any references to a background or table. Unlike the glass pictures, this still life was vigorously painted with light and dark grays, perhaps to suggest atmosphere or shadows.

While such a heavily impastoed, creamy surface, bold use of black outline, and stark palette of gray, green, black, and white with only a touch of pink are seen in some of Hartley's paintings of the early 1920s, these characteristics became more typical of his work from the 1930s, beginning with his Dogtown paintings. A penciled inscription on the upper stretcher bar, written by an unknown hand, dates the painting to 1929.

PROVENANCE
Estate of the artist § With Paul Rosenberg and Company, New York, to 1959 § With Paul Kantor Gallery, Beverly Hills, Calif., 1959 § Burt Kleiner, Beverly Hills, to 1961.

EXHIBITION
La Jolla (Calif.) Museum of Art, *Marsden Hartley/John Marin*, 1966, no. 12.

The Lost Felice, c. 1939

Oil on canvas
40⅛ x 30³/₁₆ in (101.9 x 76.6 cm)
Inscribed verso across top: THE LOST / FELICE. / Marsden / Hartley / 1939–40.
Mr. and Mrs. William Preston Harrison Collection
63.5
Color plate, page 76

In September 1935 Hartley was in southern Nova Scotia seeking a less expensive locale than Gloucester, Massachusetts, in which to paint. There he met the Masons, a family of fishermen who lived on a rugged island off Blue Rocks. He became immediately attracted to the two Mason brothers, Alty and Donny, and arranged to live with the Masons during his trips north. For the first time since the death of his mother in 1885, Hartley felt he was part of a close-knit family. He became especially attached to Alty, admiring his youth, physical power, and beauty, and may have become his lover. Hartley's new-found happiness was shattered on September 19, 1936, when the two brothers and their cousin drowned at sea in a violent rainstorm.

From this experience arose a series of important figure paintings of great emotional intensity. From the beginning of his association with the Masons, Hartley conceived of the family's difficult, yet pious life as one touched by Christian martyrdom. Not surprisingly the tragedy experienced by the family inspired him to create symbolic paintings with Christian overtones. In *Fishermen's Last Supper*, 1938 (private collection), Hartley arranged the Mason family along a table in the manner of images of the Last Supper, indicating the sons who would die by placing a star over their heads, an allusion to the brothers Castor and Pollux in Greek myth, who are represented with such stars as a good omen for ships. Also symbolic is *The Lost Felice*, with its three figures—the two dead brothers and their sister in the center. While it would have been natural for Hartley to depict fishermen wearing rain slickers and holding fish, he infused the image with spiritual significance by painting halos over their heads. He

Hartley, *The Lost Felice.*

shades of blue-black and blood-red for the faces and hands of the men and fish in the bowl. Hartley drew the figures in a primitive manner, which conveys what he perceived as the raw vigor of the Mason family. For this reason Hartley referred to his figure paintings of the Mason family as archaic portraits. The stark, sonorous palette and rawness of the figure types underscore not only the ruggedness of the Nova Scotian fishermen's life but also the pain that Hartley and the Mason family suffered as a result of the brothers' deaths.

The title no doubt refers to this lost happiness. In his essay "Cleophas and His Own: A North Atlantic Tragedy," in which he recounted his friendship with the Mason family and the boating disaster, Hartley gave the name Marguerite Felice to the sister. The French name *Felice* derives from the Latin word for happiness, *felicita.* Although an article in *Life* magazine in 1950 reported that Hartley had said the central figure was the brothers' mother, the parallel between the painting's title and the name of the character in his essay confirms the identification of the woman in *The Lost Felice* as their sister. According to Hartley, Alice Mason was built like a man, extremely devoted to her family, and always involved in domestic chores to make their lives happier.

The painting was originally intended for a seaman's bethel in the far north that Hartley planned but never realized. The 1938 version of *Fishermen's Last Supper* was actually the cartoon for a proposed mural in the chapel. As Henry Hopkins has noted, *The Lost Felice* would have been a fitting altarpiece for that bethel.

RELATED WORK

Untitled (Two fishermen and woman), c. 1938–39, pen and black ink and pencil on beige paper, 10⅜ x 7⅞ in (26.4 x 20.0 cm). Treat Gallery, Bates College, Lewiston, Maine.

PROVENANCE

The artist § With Macbeth Gallery, New York, 1941–42 § Estate of the artist, 1943 § With Paul Rosenberg and Company, New York, 1942–46 § Mr. and Mrs. Walter Bareiss, Greenwich, Conn., 1946–c. 1960 § With Paul Kantor Gallery, Beverly Hills, Calif., to 1963.

EXHIBITIONS

New York, Hudson D. Walker Galleries, *Recent Paintings of Maine,* 1940, no. 3, unpaginated, notes it was painted for a "seamen's bethel in the far north," repro. § Cincinnati Modern Art Society, *Marsden Hartley, Stuart Davis,* 1941, entries not numbered, repro., p. 6 § New York, Museum of Modern Art, *Lyonel Feininger/Marsden Hartley,* 1944–45, entries not numbered, p. 86, reprints statements by the artist, repro., p. 54 § New York, Paul Rosenberg and Company, *Paintings by Marsden Hartley,* 1948, no. 7, dated 1940 § New York, guest house of Mrs. John D. Rockefeller III, organized by the Junior Council of

modified the traditional Man of Sorrows image to express the Mason family's personal tragedy. The sister, Alice Mason, replaces the figure of a suffering Christ, while the two dead brothers replace the usual supporting angels. In other paintings relating to the Mason family Hartley depicted the two brothers with square faces and bushy hair. In *The Lost Felice* the two men have lost their individuality, their faces are masklike, and they have become universal symbols of death. Their sister's face is etched with the pain of her double loss. The fish as symbols of the instrument of the brothers' death, the sea, as well as of Christ are crucial to the reading of the painting; in a related sketch of two fishermen and a woman, c. 1938–39 (Treat Gallery, Bates College, Lewiston, Maine), the fish are omitted.

The strict, hieratic representation of the three figures accords with medieval religious paintings but is also typical of Hartley's portraits during this period. Also characteristic of the artist in the 1930s is the dark palette, here limited mostly to colors associated with death:

Museum of Modern Art, New York, *Young Collectors*, 1955, no cat. traced § Paris, Musée national d'art moderne, *Cinquante ans d'art aux Etats-unis*, 1955, no. 15, pl. 18 § New York, guest house of Mrs. John D. Rockefeller III, organized by the Junior Council of Museum of Modern Art, New York, *Young Collectors*, 1958, no. cat. traced § New Haven, Conn., Yale University Art Gallery, *Paintings, Drawings, and Sculpture Collected by Yale Alumni: An Exhibition*, 1960, no. 134, repro., p. 127 § Louisville, Ky., J. B. Speed Art Museum, and others, organized by Museum of Modern Art, New York, *Stieglitz Circle*, 1961–63, catalogue only for last venue: Balboa, Calif., Fine Arts Patrons of Newport Beach, Pavillion Gallery, no. 56 § New York World's Fair, Better Living Center Gallery, organized by Skowhegan School of Painting and Sculpture, *Four Centuries of American Masterpieces*, 1964, no. 31, repro., unpaginated § San Francisco, M. H. De Young Memorial Museum, *Man: Glory, Jest, and Riddle—A Survey of the Human Form through the Ages*, 1964–65, no. 253, repro., unpaginated § La Jolla (Calif.) Museum of Art, *Marsden Hartley/John Marin*, 1966, no. 24, repro., unpaginated § Los Angeles, University of Southern California, University Galleries, and others, *Marsden Hartley, Painter/Poet, 1877–1943*, 1968–69, no. 36, repro., unpaginated § Omaha, Joslyn Art Museum, *The Thirties Decade: American Artists and Their European Contemporaries*, 1971, no. 83, repro., p. 42 § LACMA, *Two Decades of Art Museum Council Gifts*, 1972–73, entries not numbered § Indianapolis Museum of Art and others, *Perceptions of the Spirit in Twentieth-Century American Art*, 1977–78, no. 21, p. 18, essay by John Dillenberger, p. 66, entry by Jane Dillenberger § Gallery Stratford (Ont., Canada), *Coasts, the Sea, and Canadian Art*, 1978, no. 51, repro., unpaginated § Düsseldorf, Städtische Kunsthalle, and others, *2 Jahrzehnte amerikanische Malerei, 1920–1940*, 1979, no. 36, repro., p. 64 § Whitney Museum of American Art, *Hartley*, no. 86, p. 116, Haskell discusses in context of "archaic portraits" and stylistic affinity to work of Orozco, pl. 104, p. 179.

LITERATURE
"The 'New' Hartley Emerges from Down East," *Art Digest* 14 (March 15, 1940): 8, repro. § Duncan Phillips, "Marsden Hartley," *Magazine of Art* 37 (March 1944): repro., 82 § Robert M. Coates, "The Art Galleries: Two Pairs," *New Yorker* 20 (November 4, 1944): 51 § Howard Devree, "Expressionist Views," *New York Times*, October 24, 1948, pt. 10, p. 9 § Robert M. Coates, "The Art Galleries: Marsden Hartley's Maine," *New Yorker* 24 (October 30, 1948): 85 § Charles Z. Offin, "Gallery Previews in New York," *Pictures on Exhibit* 11 (November 1948): repro., 17 § "Reviews and Previews," *Art News* 47 (November 1948): 44 § "Marsden Hartley," *Life* 32 (June 16, 1952): repro., 89, caption quotes Hartley, "In the center sits their mother who sees only shadows of 'these two that yesterday were men' and hears only 'the moan of the wave'," and dates 1939 § Christopher E. Fremantle, "New York Commentary," *Studio* 149 (February 1955): 56, repro., 57 § B. H. Friedman, "The New Collector," *Art in America* 46 (Summer 1958): 13, repro., 16 § "Accessions of American and Canadian Museums," *Art Quarterly* 27 (1964): 111, lists, repro., 105 § "Curatorial Division," LACM, Department of History, Science, and Art, *Biennial Report 1961–63*, typed, p. 9 § Henry T. Hopkins, "Marsden Hartley's *The Lost Felice*," *LACMA Bulletin* 16, no. 3 (1964): 3–11, repros., cover, fig. 1, 5 § LACMA, *Illustrated Handbook of the Los Angeles County Museum of Art*, 1965, p. 83, repro., p. 100 § Henry J. Seldis, "West Coast Milestone," *Art in America* 53 (April 1965): repro., 105 § Editors of *Art in America*, comp., *The Artist in America* (New York: Norton, 1967), repro., p. 168 § Gail R. Scott, ed., *On Art by Marsden Hartley* (New York: Horizon Press, 1982), pl. 11, between pp. 96 and 97 § Mount Saint Vincent University Art Gallery, *Hartley and Nova Scotia*, p. 13, introduction by Ferguson, p. 65, essay by Scott relates imagery in "Cleophas" essay to painting, pl. 4, p. 54, repro., p. 154 § Scott, *Hartley*, fig. 90, p. 102 § Ilene Susan Fort, "Selected Masterpiece: Hartley's *Lost Felice*," *LACMA Members' Calendar* 27 (April 1989): 8, repro.

Morgan Russell

Born January 25, 1886, New York, New York
Died May 29, 1953, Broomall, Pennsylvania

Morgan Russell, along with STANTON MACDONALD-WRIGHT, created synchromism, the first abstract color theory developed by Americans. After studying architecture, Russell attended classes at the Art Students League taught by George Bridgman (1864–1943) and James Earle Fraser (1876–1953). He also studied with ROBERT HENRI. In 1906 Russell took his second trip to France, where he would live for long periods; through Gertrude, Leo, and Sarah Stein he met Pablo Picasso (1881–1973) and also Henri Matisse (1869–1954), with whom he studied briefly. In 1911 he met Macdonald-Wright, who was also studying in Paris. During the next two years they formulated the theory of synchromism based on their fascination with color theory, abstraction, and sculpture. Of the two artists Russell was the more daring, fully abandoning representation by 1913. In 1913 and 1914 the two Americans established an international reputation through their joint exhibitions in Munich, Paris, and New York. By 1916 Russell had tired of painting color synchromies. After briefly visiting New York to see his entries in the *Forum Exhibition of Modern American Painters* at the Anderson Galleries, he settled in southern France in 1917 and returned to representational art, painting landscapes, still lifes, and the figure.

During the 1920s Russell planned to construct a kinetic light machine, but the project was never realized; instead, in 1922 he again began painting synchromies in order to satisfy his fascination with color and light. His financial straits were relieved somewhat by occasional sales made for him by Macdonald-Wright in California. Russell spent almost a year in California in 1931–32, a busy time during which he exhibited in San Francisco and Los Angeles with Macdonald-Wright and taught and lectured at various schools. While living in Rome from 1932 to 1936 he painted religious subjects. In 1946 Russell returned permanently to the United States, settled in Pennsylvania, and converted to Roman Catholicism.

BIBLIOGRAPHY
Montclair (N.J.) Art Museum, Morgan Russell Papers § Janet Funston, "Morgan Russell and the Origins of Synchromism," Fine Arts Gallery of San Diego, *Annual Report 50* (1974/75): 8–13 § Gail Levin, "Morgan Russell: The Avant-garde Dilemma," in LACMA, *California: Five Footnotes to Modern Art History,* exh. cat., 1977, ed. Stephanie Barron, pp. 13–20, with chronology § New York, Whitney Museum of American Art, and others, *Synchromism and American Color Abstraction, 1910–1925,* exh. cat., 1978 (copublished with George Braziller, New York), text by Gail Levin, with reprints of synchromist catalogues, biographical notes, bibliography § New York, Washburn Gallery, *Morgan Russell,* exh. cat., 1978, with essay by Barbara Rose.

Russell, *Sketch for "Synchromie en bleu-violacé."*

Sketch for "Synchromie en bleu-violacé," c. 1913

(*Sketch for "Synchromy to Light"; Sketch for "To Light"*)
Oil and pencil on canvas board
13 1/16 x 9 7/16 in (33.1 x 24.0 cm)
Signed lower right: M. Russell
Numerous faded inscriptions on verso in ink, including: B Viol / B Viol // B. Green. / foreign note / considered / [illegible] / but best is a / symmetric [principles?] of interval // B. Viol / Orange / Modulation // Sketch for / Synchromy to light // The character of the / whole by its principle of / symmetrical intervalls / results in this "mode" / If small intervals [form?] [illegible] / jumps it is minor for instance
Gift of Mr. and Mrs. David E. Bright
59.63
Color plate, page 55

In the Paris showing of the synchromists at Galerie Bernheim-Jeune in 1913 Russell exhibited his first completely abstract synchromist paintings, this study and the much larger, final version, *Synchromie en bleu-violacé,* 1913 (Regis collection, Minneapolis). William Agee states that the study and the final version were both painted in the summer of 1913 between the synchromist exhibitions in Munich and Paris, although the germination of the painting actually began much earlier, as is documented in sketchbooks and oil sketches dating from 1912.

The composition moves around two curves—an arc in the upper right and counter-curve in the lower left—which Russell derived from the contrapposto pose of Michelangelo's *Dying Slave,* 1513–16 (Louvre, Paris). Russell applied his pigment in pie shapes similar to the wedges that Bridgman had taught him were the essential shapes of a moving body. In a small booklet that he wrote to explain the painting (see Related Works), Russell described the movement as a "development in depth."

A basic tenet of synchromism is that the sensation of form in space can be created through the use of color. Russell was familiar with the late nineteenth-century color theories of Michel-Eugène Chevreul and Ogden Rood and had studied with the Canadian artist and color theorist Percyval Tudor-Hart (1873–1954). He presented color according to their laws of color harmony and contrast. Choosing dark blue-violet as the dominant tone and orange-red as the "under dominant," he placed the blue in four points of support (center top, bottom, sides) and used this color to surround the central passage of yellow. Warm colors appear to advance, while cool colors recede; when complementaries—such as the yellow and blue-violet in the center—are placed side by side, the contrast is intensified. Numerous notes were hastily written on the back of the painting, and those that can be read reveal Russell's preoccupation with the placement of colors according to the principle of symmetry. He arranged the passages of color to suggest an orderly rhythm of movement in space.

Russell dedicated the large, final version to his patron Gertrude Vanderbilt Whitney and in a letter to her explained that it was a "synchromie to light," for in his effort "to organize a rhythmic ensemble with the simplest elements of light I could not help but have as a result an artistic synthese of the motion experienced by the first eye that opened on this world of varied color and light that we all are so familiar with." When the painting was first exhibited, the following passage from the book of Genesis was included in the catalogue:

> And God said "let there be light." And there was light. And God saw that it was good; and God divided the light from the darkness.

RELATED WORKS
Sketch, pencil on paper, May 1912 notebook, 5³/₄ x 3⁵/₈ in (14.6 x 9.2 cm); *Sketch*, pencil on paper, July 1912 notebook, 3¹/₂ x 5⁵/₈ in (8.9 x 14.3 cm); *Study*, 1913, oil on paper, 9³/₄ x 7 in (24.8 x 17.8 cm); *Study*, 1913, oil on paper, 3³/₄ in (9.5 cm) square. Morgan Russell Papers, Montclair (N.J.) Art Museum § *Harmonic Analysis of the Big Synchromie in Blue Violacé*, 1913, booklet with diagrams, watercolor, ink, and pencil on paper, 4¹⁵/₁₆ x 6¹/₈ in (12.5 x 15.6 cm). Collection Whitney family § *Synchromie en bleu-violacé*, 1913, oil on canvas, 124 x 90 in (315.0 x 228.6 cm). Regis collection, Minneapolis § *Synchromy in Deep Blue-Violet (Synchromy to Light)*, no. 2, 1913 or possibly later, oil on canvas mounted on board, 13 x 9⁵/₈ in (33.0 x 24.4 cm). Collection Mrs. Harry Lewis Winston, Birmingham, Mich. § *Synchromy*, c. 1913, ink on paper, 5⁷/₈ x 3³/₄ in (19.9 x 9.5 cm). Washburn Gallery, New York.

PROVENANCE
The artist § Estate of the artist § With Rose Fried Gallery, New York, to 1959 § Mr. and Mrs. David E. Bright, Los Angeles, 1959.

EXHIBITIONS
Paris, Bernheim-Jeune et Cie., *Les Synchromistes: Morgan Russell et Stanton Macdonald-Wright*, 1913, no. 14, repro., unpaginated § New York, Carroll Galleries, *Exhibition of Synchromist Paintings by Morgan Russell and S. Macdonald-Wright*, 1914, entries not numbered § New York, Rose Fried Gallery, *Three American Pioneers of Abstract Art: The Synchromists and Bruce*, 1950, entries not numbered, as *Sketch for "To Light"* § New York, M. Knoedler & Company, *Synchromism and Color Principles in American Painting, 1910–1930*, 1965, no. 43, p. 52, text by William Agee discusses dating and first exhibition § Oswego, N.Y., State University of New York College at Oswego, and others (organized by Museum of Modern Art, New York), *Synchromism and Color Principles in American Painting, 1910–1930*, 1967–68, no. 18 § Whitney Museum of American Art and others, *Synchromism*, 1978–79, entries not numbered, pp. 22–24, 28, Levin quotes October 20, 1925, letter from the artist to Macdonald-Wright and a passage from Genesis included in catalogue of final painting's first exhibition, pl. 9, p. 57 § London, Tate Gallery, *Abstraction: Towards a New Art, Painting, 1910–1920*, 1980, no. 412, p. 115, essay by Gail Levin, repro., p. 117 § Boston, Institute of Contemporary Art, and others, *Art and Dance*, 1982–83, entries not numbered, p. 30, essay by Marianne Martin discusses spiraling "S" motif in conjunction with dance of Isadora Duncan, repros., pp. 5, 31 § LACMA, *Contrasts: Selections from the Permanent Collection, Twentieth-Century Art*, 1985, no cat. § Fort Worth (Tex.) Art Museum, *Modern and Contemporary Masters: Selections from the Los Angeles County Museum of Art*, 1985–86, no cat.

LITERATURE
La Revue moderne (Paris) no. 22 (November 25, 1913): repro., 12 § Archiv. Am. Art, Rose Fried Gallery Papers, Nancy Dustin Wall Moure to Rose Fried Gallery, October 25, 1969 (microfilm roll 2206, fr. 494), annotations by Fried state that painting came directly from the family; photographs (ibid., frs. 553–54, 565–66), inscribed on back "early synchromy," dated 1916 § Barbara Evans-Decker, "Morgan Russell: A Re-Evaluation," Master's thesis, State University of New York at Binghamton, 1973, pp. 22, 139, lists as no. 38, with provenance, exhibitions, and literature, inaccurately states sketch first exhibited in Munich, pl. VI, p. 89 § Gail Levin, "Morgan Russell's Notebooks: An American Avant-garde in Paris," *Revue d'art canadienne/Canadian Art Review* 3, no. 2 (1976): 77, fig. 5 § Levin, "Russell," p. 14, discusses in context of final version and quotes letter from Russell to Gertrude Vanderbilt Whitney about aim of painting.

Russell, *Piscine*.

Piscine, 1933
Oil on canvas
36⅛ x 43¼ in (91.8 x 109.9 cm)
Signed lower left: Morgan Russell
Inscribed and dated verso center: BAIGNADE /
MEN·PISCINE·NO·1· / ·ROME· / ·1933·
Gift of Stanton Macdonald-Wright
55.88

Many of Russell's later canvases were of male nudes, and he considered these figure paintings to be his most significant work after the synchromies. Sometimes the nudes were depicted in a mythological guise but often they were bathers, as in *Piscine*. Russell was preoccupied with the heroic form of the human figure from his earliest days as an artist, when, inspired by Michelangelo, he sculpted a nude male; even the synchromies were based on the movement of the human form. In his late paintings Russell stressed the solidity of the nude's body as would a sculptor.

Piscine reveals the artist's fascination with the human physique. The lack of interaction between the figures would suggest that Russell explored different aspects of the body by painting one model in four different poses and from four different angles. Russell knew that a rich palette would distract from the figures, which he intended to be the primary expressive element, and consequently *Piscine* is limited to dull tones of gold and bluish purples. Color was always important to Russell, however, and in his late figure painting he based his palette on what he considered to be classic colors. As do the figures in his late religious paintings, the nudes in *Piscine* seem to float rather than to stand solidly at the edge of the pool.

Piscine was one of several paintings that the artist asked Frank L. Stevens to store for him. Unknown to Russell, Stevens buried the paintings. After Stevens's death the paintings were disinterred, and Macdonald-Wright obtained some of them, including *Piscine*.

PROVENANCE
The artist § On loan to Frank L. Stevens, Los Angeles § Stanton Macdonald-Wright, Los Angeles, by 1955.

EXHIBITION
LACMA, *California: Five Footnotes to Modern Art History*, 1977, no. 15, p. 11, foreword by Maurice Tuchman recounts story of painting's burial, repro., p. 30.

LITERATURE
Barbara Evans-Decker, "Morgan Russell: A Re-Evaluation," Master's thesis, State University of New York at Binghamton, 1973, pp. 61–62, 158, lists as no. 190, with provenance, pl. XXXIII, p. 115.

Frederick Carl Frieseke

Born April 7, 1874,
Owosso, Michigan
Died August 28, 1939, Le
Mesnil-sur-Blangy, France

Frederick Carl Frieseke was the most internationally acclaimed American impressionist during the first two decades of this century. Frieseke trained at the School of the Art Institute of Chicago, the Art Students League in New York, and in 1898 at the Académie Julian in Paris with Jean-Joseph-Benjamin Constant (1845–1902) and Jean-Paul Laurens (1838–1921). He is reputed to have also received instruction from James McNeill Whistler (1834–1903). Whistler may have influenced Frieseke's early figure paintings, which are somber tonal studies. Frieseke first visited Giverny in 1900 and summered there often after that. By 1904 his art had been transformed by impressionism as he became fascinated with light and air. Although he was a neighbor of Claude Monet (1840–1926) in Giverny, Frieseke focused on the figure, as did Pierre-Auguste Renoir (1841–1919), whom he most admired of all the impressionists. Frieseke set his models—almost always women or women and children—in flowering gardens, capturing the transitory nature of the sun filtering through the trees or flickering on various surfaces. Frieseke is best known for his images of the nude, painted with short, vigorous strokes and in brilliant, saturated hues

that are almost expressionist in quality. He also depicted the intimate domestic life of women in numerous boudoir images.

Frieseke began exhibiting internationally in 1901, was given a solo exhibition at the 1909 Venice Biennale, and had his first extensive showing in the United States at the Macbeth Gallery in New York in 1912. In 1920 he bought a summer house in Le Mesnil-sur-Blangy in Normandy, and around this time his style changed: his figures, always solidly rendered, became even more so as his fascination with decorative patterns diminished. Frieseke's palette also became more somber, and his brushstrokes softened as he enveloped his figures in a quiet atmosphere. Frieseke remained in France for his entire career, continuing to find his wife and daughter his favorite subjects to paint.

BIBLIOGRAPHY
Clara MacChesney, "Frederick Carl Frieseke: His Work and Suggestions for Painting from Nature," *Arts and Decoration* 3 (November 1912): 13–15 § *Index 20th Cent. Artists* 4 (March 1937): 401–8; reprint, pp. 695–702 § Allen S. Weller, "Frederick Carl Frieseke: The Opinions of an American Impressionist," *College Art Journal* 28 (Winter 1968): 160–65 § Savannah, Telfair Academy of Arts and Sciences, *Frederick Frieseke, 1874–1939*, exh. cat., 1974, with text by Moussa M. Domit, chronology § San Francisco, Maxwell Galleries, *A Retrospective Exhibition of the Work of F. C. Frieseke*, exh. cat., 1982, with preface by Nicholas Kilmer, introduction by Ben L. Summerford, excerpts from unpublished memoirs by Frances Frieseke and the artist, chronology.

Frieseke, *In the Boudoir.*

In the Boudoir, by 1914
(Boudoir)
Oil on canvas
35³/₁₆ x 46 in (89.3 x 116.9 cm)
Signed lower left: F. C. Frieseke
Mr. and Mrs. Allan C. Balch Collection
M.45.3.526

In the Boudoir is typical of the many informal interior scenes Frieseke painted throughout his career. Although he much preferred to paint outdoors, the American public of the 1910s more readily bought his boudoir scenes of women involved in their toilette or in some other feminine activity. The artist's wife, Sarah, better known as Sadie, usually posed as his model in their home. In this painting, as in many of Frieseke's interiors of the 1910s, the model lounges in a room decorated with elegant French rococo furniture and an oriental carpet. In contrast to the figure's restful pose, the scene is alive with decorative patterning. Frieseke's interior is similar to those by Edouard Vuillard (1868–1940). Both artists often presented their figures in corners of rooms, viewing them diagonally and from a slightly elevated viewpoint. The floor tilts up, flattening the space of the room and thereby emphasizing the painting as an arrangement of flat shapes and patterns. Frieseke differed from Vuillard in his tendency to present his models more intimately attired or involved in more personal activities. In *Torn Lingerie*, 1915 (Saint Louis Art Museum), the model reveals her lovely leg while mending her slip, and in *In the Boudoir* she abandons her sewing basket to stretch out comfortably on the settee, allowing her kimono to slip off and expose her shoulders and breast.

The palette of Frieseke's interiors from his middle period varies in brilliance, some being as intense as his sunlit garden views. *In the Boudoir* is, in fact, one of his more delicate interiors of the mid-1910s: soft pastel blues, lavenders, and yellows predominate, and a silvery white is pervasive. There exists a smaller, almost exact version of *In the Boudoir* painted in a stronger palette (see Related Work). Frieseke occasionally painted smaller versions of completed paintings he admired. It is not known if the smaller version of this composition is such a replica or a study for the larger painting.

When the painting was exhibited at the Anglo-American Exposition in London in 1914, it was praised for its subtlety and found more satisfactory than Frieseke's other exhibit, *The Garden Umbrella*, n.d. (Telfair Academy of Arts and Sciences, Savannah, Ga.).

According to a letter from the New York dealer Robert Macbeth to Frieseke, *In the Boudoir* was bought out of the 1915 Panama-Pacific International Exposition in San Francisco, where it won the grand prize. Mr. and Mrs. Balch, the collectors who donated the painting to the museum, began acquiring art in the mid-1910s and were known to purchase works from San Francisco dealers. Although it cannot be verified, it is quite plausible that the Balches may have bought *In the Boudoir* in 1915.

RELATED WORK
Mrs. Frederick Carl Frieseke (Sarah A. O'Bryan), c. 1903–4, oil on canvas, 26 x 32 in (66.0 x 81.3 cm). Jordan-Volpe Gallery, New York.

PROVENANCE
The artist, 1914–1915 § Mr. and Mrs. Allan C. Balch, Los Angeles, by 1937 to 1943 § Estate of Mr. and Mrs. Balch, 1943–45.

ON DEPOSIT
LACMHSA, 1940–45.

EXHIBITIONS
London, *Anglo-American Exposition,* 1914, no. 273, p. 26, with introduction by C. Lewis Hind, refers to its "sensitive" color § Paris, Société Nationale des Beaux-Arts, *Salon,* 1914, no. 448, repro., p. 101 § San Francisco, *Panama-Pacific International Exposition, Department of Fine Arts, Official Catalogue (Illustrated),* 1915, no. 4124, as *Boudoir,* awarded grand prize § Los Angeles Art Association, *Loan Exhibition of International Art,* 1937, no. 233 § Laguna 1958, no. 48 § Houston, Tex., Meredith Long and Co., *Americans at Home and Abroad, 1870–1920,* 1971, no. 11, repro., p. 26.

LITERATURE
A. R., "American Art at the Anglo-American Exposition," *Studio* 62 (September 1914): 298, considered more interesting than *The Garden Umbrella* § E. A. Taylor, "The Paintings of F. C. Frieseke," *Studio* 62 (September 1914): repro., 267 § Archiv. Am. Art, Macbeth Gallery Papers, Robert Macbeth to the artist, November 11, 1915 (microfilm roll NMc46, fr. 214), informs the artist that all his paintings exhibited in the Panama-Pacific Exposition except the nudes have sold § *Index 20th Cent. Artists* 4 (March 1937): 407; reprint, p. 701; listed § Higgins 1963, p. 115, no. 46 in checklist of Balch collection § LACMA, American Art department files, Nicholas Kilmer to Ilene Susan Fort, September 20, 1989, discusses details of artist's life and issues of the model in and dating of *In the Boudoir.*

Frieseke, *Youth.*

Youth, 1926
(*Portrait de garçon*)
Oil on canvas
50³/₁₆ x 60¹/₁₆ in (127.5 x 152.6 cm)
Signed and dated lower right: F. C. Frieseke 1926
Mr. and Mrs. William Preston Harrison Collection
27.7.5

This charming painting of a boy with his stuffed rabbit is a portrait of Preston Carter Harrison (born about 1921), son of Mr. and Mrs. William Preston Harrison. No doubt Preston Harrison chose Frieseke to paint the portrait on the advice of his artist-friends; indeed, Harrison records in a letter dated June 5, 1926, that Ernest Lawson (1873–1939) thought Frieseke the "greatest of all to paint youngsters." This sentiment was expressed to Harrison when the collector visited New York on his way to France. Frieseke painted the portrait a few weeks later at his summer home in Le-Mesnil-sur-Blangy. The Harrisons arrived there in late July, and by August 12 Harrison could write to Louise Upton at the museum that the portrait was completed.

Harrison was quite satisfied with the finished painting, considering it not only a typical Frieseke but a painting worthy of being in the museum. It combined the best of Frieseke's talents, being a figure painting to which natural light is essential. Young Carter sits politely on the edge of an elegant French chair, obviously posing for the artist and oblivious to the sunlight filtering into the room through the windows and door. The sun's intense rays contrast with the soft interior light. The pastel palette used to describe the scene is unlike that of most late works by Frieseke, which are delicate but usually darker. In fact, although Frieseke completed the painting, it appears

almost unfinished. Despite the delicate effect, the painting has a strong structure organized by the lines of the room and the placement of the furniture. The variety of decorative patterns within the composition do not confuse the legibility of the scene, and, in fact, the patterned objects—upholstered chair, oriental rug, and garden flowers in the distance—form a contrast with the figure of the quiet boy. Harrison entitled the painting *Youth* rather than identifying it as a portrait of his son to avoid the type of criticism that the portrait of Mrs. Harrison by ROBERT HENRI, 1925 (LACMA; q.v.), had received.

PROVENANCE
Mr. and Mrs. William Preston Harrison, Los Angeles, 1926–27.

EXHIBITION
Paris, Hôtel Jean Charpentier, *Exposition des Artistes Américaines de France,* 1926, no. 17, as *Portrait de garçon.*

LITERATURE
LACMA, Registrar's files, William Preston Harrison to Louise Upton, June 5, 1926, records Lawson's comment; July 26–August 12, 1926, discuss progress of painting; Upton to Harrison, September 4, 1926; Harrison to Upton, February 3, 1935, identifies the sitter and explains reason for title § Louise Upton, "Gift to the Harrison Gallery," *LA Museum Graphic* 1 (January–February 1927): 93 § "Recent Acquisitions: Art Department," *LA Museum Graphic* 1 supp. (November–December 1927): 231 § Harrison 1934, p. 29, repro., p. 30 § Higgins 1963, p. 59, no. 53 in checklist of Mr. and Mrs. William Preston Harrison collection.

Hanson Puthuff

Born August 21, 1875, Waverly, Missouri
Died May 12, 1972, Corona del Mar, California

Hanson Duvall Puthuff was an early member of what is now known as the eucalyptus school of California landscape painters. Raised in the Midwest and Colorado, he studied with Ida De Steiguer (active 1881–1907) at the Fine Arts Department of the University of Denver from 1890 to 1893 and at the Chicago Academy of Fine Arts. He began his professional career in Peoria, Illinois, painting murals in the city hall and local churches. For nine years he worked as a sign painter in Denver. In 1903 Puthuff settled in Los Angeles to work for the Wilshire Advertising Firm. Except for a year spent in Chicago in 1906, where he worked for the Sasmun Studio as a set painter along with Victor Higgins (1884–1949), Puthuff remained in California. Until 1926 he supported himself as a commercial artist, painting billboards, theatrical advertisements and backdrops, and museum dioramas. His major work at this time included commissions for the decorations of Homer Laughlin's new theater in Long Beach, c. 1915, the backdrops for the first habitat displays installed at the Los Angeles Museum of History, Science, and Art, 1924, backgrounds for model displays of the Sante Fe Railroad in various cities around the country, until the 1940s, and the panoramas for the Theodore Roosevelt Memorial in the American Museum of Natural History in New York, 1938.

Puthuff executed easel paintings throughout the time he worked as a commercial artist. Before he came to California his work largely consisted of figure paintings, but after his move to Los Angeles Puthuff became so enamored with the countryside that he became a landscape specialist. His late paintings were mostly of the La Crescenta area around his home, of the Sierras, and of Arizona. In 1904 he was given his first solo exhibition, and by 1914 the first of several solo museum exhibitions of his work was held at the Los Angeles Museum. He also exhibited throughout the country in national exhibitions. Puthuff was active in local art organizations, helping establish the Painter's Club, predecessor of the California Art Club, and, with his friend the critic Antony Anderson, the Art Students League of Los Angeles. He was also an active member of the Laguna Beach Art Association.

BIBLIOGRAPHY
George Wharton James, "Hanson Puthuff and His Work: A Study and an Appreciation," *Arroyo Craftsman* 1 (October 1909): 31–37 § Everett Carroll Maxwell, "Painters of the West—Hanson Puthuff," *Progressive Arizona* 11 (September 1931): 10–11 § Louise and Hanson Puthuff, *Hanson Duvall Puthuff: The Artist, the Man, 1875–1972* (Costa Mesa, Calif.: Privately printed, [c. 1974]), with autobiography, notes by Louise Puthuff, excerpts of reviews (1909–73), reprinted correspondence (1967–74), lists of organizations and awards § Moure with Smith 1975, pp. 202–3, with bibliography § Westphal 1982, pp. 84–89, with lists of awards and public collections, bibliography.

Puthuff, *Laguna Hills.*

Laguna Hills, by 1914
(*Summer Morning*)
Oil on canvas
24⅛ x 36³/₁₆ in (61.2 x 91.9 cm)
Signed lower left: H. Puthuff
Inscribed in another hand on top stretcher bar:
H. Puthuff - / Summer Morning
Gift of Mrs. William Matern
M.86.9

In 1910, after his marriage, Puthuff moved northeast of Los Angeles to Eagle Rock and then in 1926 moved to the nearby community of La Crescenta. Although he sometimes traveled as far afield as the Grand Canyon and Cuernavaca, Mexico, he preferred to paint the hills and mountains of Southern California. He began visiting the Laguna area in 1907.

In this early canvas Puthuff accurately caught the spirit of the gently rolling coastal mountains. After settling in California, Puthuff fell in love with the openness and freedom of such hills. The landscape is a classic example of the eucalyptus school, with its emphasis on the empty, sun-filled hills of Southern California. When this painting was exhibited at a group show during the early years of the new Los Angeles Museum, the *Los Angeles Times* critic Antony Anderson praised Puthuff for capturing "the lovely golden brown of Southern California's hills in summer." This palette of soft golds, ochers, and greens as well as the fluid brushwork are characteristic of the lyrical style for which Puthuff was known. The landscape may have been titled *Summer Morning* at some time.

PROVENANCE
Mr. and Mrs. William Matern, Santa Fe Springs, Calif., as of 1914 to 1986.

ON DEPOSIT
LAMHSA, LACMHSA, 1914–c. 1945 § Whittier College, Whittier, Calif., c. 1945–72 § LACMA, 1972–86.

EXHIBITIONS
LAMHSA, *Exhibition of Works by American and European Artists,* 1914, no. 35 § LAMHSA, *Summer Exhibition of Paintings,* 1918, no. 44 § LAMHSA, *Summer Exhibition of Paintings,* 1919, no. 32.

LITERATURE
LAMHSA, Gallery of Fine and Applied Arts, *Catalogue,* 1914, listed as no. 44 § Antony Anderson, "Summer Exhibition," *Los Angeles Times,* July 13, 1919, pt. 3, p. 2, "Perhaps you did not realize the lovely golden brown of Southern California's hills in summer until you saw Hanson Puthuff's *Laguna Hills,* in which the modeling is as notably good as the delicacy of the rendering of lights and shadows."

Guy Rose

Born March 3, 1867, San Gabriel, California
Died November 17, 1925, Pasadena, California

Among the most talented of the early painters of Los Angeles, Guy Rose was also the closest to the style of the French impressionists. After attending high school in Los Angeles, Rose spent several years in San Francisco. There he studied with EMIL CARLSEN at the San Francisco Art Association's School of Design, where he received several awards. In 1888 Rose went to Paris to study at the Académie Julian. During his three years in France he visited Giverny, home of Claude Monet. He returned to the United States in 1891, landing in New York, where he became a successful illustrator and exhibited his paintings with the Society of American Artists. In 1893 he went back to Paris for additional study, and he won an honorable mention in the Salon of the Société des Artistes Français in 1894. During a trip to Greece that summer he fell ill with lead poisoning caused by the white paint he used, so he was forbidden to paint for several years.

In 1895 Rose visited California for six months, then returned to New York, where he again worked as an illustrator, also teaching at Pratt Institute in Brooklyn and conducting sketching classes in the country during the summer. In 1899 he and his wife returned to Paris, where he continued to work as an illustrator. He took trips to Algeria and Italy and also visited California again. Rose moved to Giverny in 1904, to a house and garden near those of Claude Monet (1840–1926). When he began painting again, he developed

an impressionist style. He became close friends with American impressionists FREDERICK CARL FRIESEKE, Richard Miller (1875–1943), and Lawton Parker (1868–1954) and exhibited with them at the Madison Art Gallery in New York in 1910.

In 1912 Rose returned to the United States, exhibiting his paintings in New York at Macbeth Gallery and elsewhere. For two summers he painted and taught out-of-doors at Narragansett Pier, Rhode Island. In 1914 he returned to California to stay. He lived in Pasadena and was an instructor and later director of the Stickney Memorial School of Art there. He won a bronze medal at the Pan-American Exposition in Buffalo in 1901, and in 1915 he won a silver medal at the Panama-Pacific International Exposition in San Francisco and a gold medal the same year at the Panama-California International Exposition in San Diego. He won the William Preston Harrison Prize awarded by the California Art Club at the Los Angeles Museum in 1921 and served as a member of the museum's board of governors from 1915 to 1922. His painting was curtailed by a stroke he suffered in February 1921 and the resulting paralysis. The year following his death Stendahl Art Galleries in Los Angeles organized a memorial exhibition of his work.

BIBLIOGRAPHY
Archiv. Am. Art, Stendahl Art Galleries Papers § Los Angeles, Stendahl Art Galleries, *Guy Rose: A Biographical Sketch and Appreciation, Paintings of France and America,* exh. cat., 1922, with essays by Antony Anderson and Earl L. Stendahl § Rose V. S. Berry, "A Painter of California," *International Studio* 80 (January 1925): 332–37 § Los Angeles, Stendahl Art Galleries, *Catalogue of the Guy Rose Memorial,* exh. cat., 1926, with essays by Peyton Boswell and Antony Anderson, entries by Boswell § Ilene Susan Fort, "The Cosmopolitan Guy Rose," in Laguna Art Museum, Laguna Beach, Calif., and others, *California Light, 1900–1930,* exh. cat., forthcoming.

Rose, *In the High Canadian Rockies.*

In the High Canadian Rockies,
c. 1914–20
Oil on canvas
28¹/₁₆ x 29¼ in (71.2 x 74.2 cm)
Stamped verso center: guy rose / SALE / MAR 1926
STENDAHL GALLERIES / Ethel Rose
Signed verso center beneath stamp: Earl L. Stendahl
Inscribed verso upper left: In the High Canadian Rockies / 27³/₄ x 29¼ / GUY ROSE / SALE / MAR 1926 / Ethel Rose / STENDAHL GALLERIES / Earl L. Stendahl
Gift of Mr. and Mrs. Thomas H. Crawford, Jr.
M.69.23.2

It is not known in what year Rose traveled to the Canadian Rockies and painted this and several other views of them. Painted in the softly atmospheric manner of the artist's impressionist style, the bright snowy scene is rendered in tints of blue, pink, and ivory. Rather than majestic, the mountains are delicate and fanciful, a lyrical and poetical impression of the scene.

In the catalogue of the Rose memorial exhibition of 1926 the critic Peyton Boswell called the painting "one of the artist's master works, a poem of the peaks and clouds. As deep and rich of color as a piece of Limoges enamel, and with harmony as striking as it is entrancing. This magnificent picture is as good as anything Monet ever painted. A fine flower of Impressionism, it is yet typically American, in spirit as well as theme."

The landscape was bought shortly after the exhibition for two thousand dollars, one of the highest prices then obtained for a painting by Rose.

PROVENANCE
The artist § Estate of the artist, 1925–26 § With Stendahl Art Galleries, Los Angeles, 1926 § Mrs. John V. Vickers, Los Angeles, from 1926 § Mr. and Mrs. Thomas H. Crawford, Jr. (by descent), Los Angeles, to 1969.

EXHIBITION
Stendahl Art Galleries, *Rose Memorial,* no. 106, p. 16, description by Boswell, repro.

LITERATURE
Archiv. Am. Art, Stendahl Art Galleries Papers, Stendahl Galleries to Ethel Rose, April 30, 1926 (microfilm roll 2722, fr. 873), discusses sale; clipping, *Clubwoman* (South Pasadena) (May 1928) (ibid., fr. 1027): repro. § Peyton Boswell, "Guy Rose and His Poetic Landscapes," *Los Angeles Times,* February 21, 1926, pt. 3, p. 34, refers to it as a "masterpiece" of sublimity.

Rose, *Carmel Dunes.*

Carmel Dunes, c. 1918–20
(*Carmel Dunes—No. 1; Carmel Coast*)
Oil on canvas
24¹/₁₆ x 29¹/₁₆ in (61.2 x 73.8 cm)
Signed and dated lower left: Guy Rose / 11 [?]
Inscribed verso upper left: Carmel Dunes / $500 / Guy Rose
Gift of Mr. and Mrs. Reese H. Taylor
55.99
Color plate, page 63

Rose often painted California coastal views, many around Carmel, and depicted the variety of weather conditions of the region. *Carmel Dunes* conveys the solitude of empty sand dunes and the power of nature. The sky is filled with a brilliant, almost glaring light, and the colors highly saturated. Rose delineated the wiry shrubbery in the foreground with an impasto, but the view reads as a series of barely overlapping planes in a two-dimensional arrangement.

The painting entered the museum with the title of *Carmel Coast.*

PROVENANCE
Mr. and Mrs. Reese H. Taylor, San Marino, Calif., to 1955.

EXHIBITIONS
Stendahl Art Galleries, *Rose: Paintings of France and America,* no. 15, p. 21, description by Boswell, repro., as *Carmel Dunes—No. 1* § Claremont, Calif., Galleries of the Claremont Colleges, Montgomery Art Center, Pomona College Gallery, *Los Angeles Painters of the Nineteen-Twenties,* 1972, no. 40, as *Carmel*

Dunes § LACMA 1980, no. 9, p. 16, repro., p. 17 § Oakland Museum and others, *Impressionism: The California View, Paintings, 1890–1930*, 1981–82, entries not numbered, p. 13, essay by John Caldwell, repro., p. 63 § Laguna Art Museum, Laguna Beach, Calif., *Early Artists in Laguna: The Impressionists*, 1986, no. 68, repro., p. 17.

LITERATURE
Archiv. Am. Art, Stendahl Art Galleries Papers, unidentified clipping, Francis Betts, "Art" (microfilm roll 2722, fr. 1005a), repro., p. 48 § Maudette Ball, "Los Angeles and the Modern Era," *Artweek* 11 (November 8, 1980): 5, repro. § Westphal 1982, repro., p. 98.

Robert Henri

Born June 24, 1865,
Cincinnati, Ohio
Died July 12, 1929,
New York, New York

A highly successful portraitist and figure painter, Robert Henri was also extremely influential as a teacher and leader of progressive artists during the early years of this century. Robert Henri was born Robert Henry Cozad. Because his father feared reprisals after a shooting in self-defense, the family fled in 1882 to Denver, Colorado, and later Atlantic City, New Jersey, assuming various names. At the age of twenty Henri entered the Pennsylvania Academy of the Fine Arts in Philadelphia, where he studied with Thomas Anshutz (1851–1912). In 1888 he left with some friends from the academy to seek further training in Paris at the Académie Julian. In 1891 he returned to Philadelphia, studying again at the academy, this time with Robert Vonnoh (1858–1938).

Henri's long career as one of the country's most influential art teachers was begun there the following year. He emerged during this period as the leader of a group of young artists and spokesman for progressive approaches. With William Glackens (1870–1938) he left Philadelphia and went to Paris again in 1895. Two years later he returned to Philadelphia, held a successful solo exhibition, married, and left again for Paris in 1898 for another two years. In 1900 he settled in New York, his home for the rest of his life. Henri resumed teaching, joining the faculty of the New York School of Art in 1903, and turned his attention to portraiture. He met with considerable success, winning election to the Society of American Artists in 1903 and the National Academy of Design as an academician in 1906. Continuing to champion progressive art, in 1908 he helped organize the exhibiting group The Eight, which caused a sensation with its boldly painted, frank portrayals of life in New York. That same year he established his own school of art, which remained open for five years. His first wife died in 1905, and he remarried in 1908. He continued to live in New York but traveled extensively, especially during the summer, to Maine, Holland, Spain, Ireland, the Southwest, and other places.

In the autumn of 1914 Henri had a solo exhibition at the recently founded Los Angeles Museum. He taught almost every year through 1928 at the Art Students League, inspiring a generation of young painters. He taught them a solid technique but also the importance of expressing their individuality. His lectures were published posthumously as *The Art Spirit* (1939). He died in New York, where he was honored with a memorial exhibition at the Metropolitan Museum of Art.

BIBLIOGRAPHY
New York, Janet Le Clair Collection, Robert Henri Papers (portions on microfilm, Archiv. Am. Art) § E. Ralph Cheyney, "The Philosophy of a Portrait Painter: An Interview with Robert Henri," *Touchstone* 5 (June 1919): 212–19 § *Index 20th Cent. Artists* 2 (January 1935): 49–60; 2 (September 1935): i; 3 (August–September 1936): iii; reprint, pp. 311–22, 327, 329 § William Innes Homer, *Robert Henri and His Circle* (Ithaca, N.Y.: Cornell University Press, 1969), with the assistance of Violet Organ, with bibliography § Wilmington, Delaware Art Museum, and others, *Robert Henri, Painter*, exh. cat., 1984, with essay by Helen Farr Sloan, catalogue by Bennard B. Perlman, epilogue by Rowland Elzea, chronology, bibliography.

Edna, 1915

(*Edna Ramon; Portrait; A Portrait of Edna*)
Oil on canvas
32³/₁₆ x 26¹/₈ in (81.8 x 66.3 cm)
Signed lower center: Robert Henri
Dr. Dorothea Moore Bequest
43.15.14
Color plate, page 58

The subject is Edna Smith, a professional model who posed for other paintings, at least two of them nudes. Since they did not require him to capture the personality of the model as he did in his portraits, figure studies were for Henri an opportunity to explore formal issues that interested him, especially the Maratta system of color and the compositional ideas that

interested him and his circle. The color in this work is exceptionally vivid, the model's red hair and fair coloring set off by a complementary blue-green background. The brushwork is vigorous and joyous, clearly showing his dashing execution. Henri's already powerful technique had steadily increased in facility into the middle of the second decade of the century. In a painting such as this, where it is given completely free play, one can see what a dex-

Henri, *Edna*.

terous and masterly craftsman Henri had become. Henri taught his students to "work quickly. Don't stop for anything but the essential. . . . It's the spirit of the thing that counts" (Henri diary, August 25, 1926, entry).

Dr. Dorothea Moore, who donated *Edna* to the museum, was an early Los Angeles enthusiast of the painter. At one time she also owned Henri's *The Dancer Resting* (unlocated), which she lent to the museum for a 1921 exhibition.

PROVENANCE
With Macbeth Gallery, New York, 1924 § Dr. Dorothea Moore (Mrs. E. C. Moore), Los Angeles, 1924–43.

EXHIBITIONS
New York, National Association of Portrait Painters,

Fifth Annual Circuit Exhibition, 1915, no cat. traced § Washington, D.C., Smithsonian Institution, National Gallery of Art, *Twenty-seven Portraits,* 1915, no cat. traced § Ithaca, N.Y., Cornell University, Goldwin Smith Building, *Art Exhibition,* 1915, no cat. traced § Art Institute of Chicago and others, *Exhibition of Paintings by Robert Henri of New York,* 1915–16, no. varies at different venues § Los Angeles Modern Art Society, [first annual exhibition], 1916, no cat. traced § New York, M. Knoedler & Co., *Paintings by Robert Henri,* 1917, no. 14 § New York, Macbeth Gallery, [exhibition title unknown], 1917, no cat. traced § Lynchburg, Va., Randolph-Macon Woman's College, *Exhibition by Jules Guerin, Childe Hassam, Robert Henri, J. Alden Weir,* 1917, no. 16 § Chicago, Young Gallery, [exhibition title unknown], 1919, no cat. traced § New York, City Club, [group exhibition], 1921, no. cat. traced § Philadelphia, Pennsylvania Academy of the Fine Arts, *117th Annual Exhibition,* 1922, no. 245 § Buffalo, Albright Art Gallery, *Sixteenth Annual Exhibition of Selected Paintings by American Artists,* 1922, no. 54 § Art Association of Newport, R.I., *Eleventh Annual Exhibition of Pictures by American Painters,* 1922, no. 67 § Art Gallery of Toronto, *Exhibition of Paintings by Contemporary American Artists,* 1923, no. 34 § Buffalo, Albright Art Gallery, *Seventeenth Annual Exhibition of Selected Paintings and Small Bronzes by American Artists,* 1923, no. 85 § Rochester, N.Y., Memorial Art Gallery, *Summer Exhibition of Contemporary American Paintings and Small Bronzes,* 1923, no. 38 § Columbus, Ohio State Fair, 1923, no cat. traced § New York, Macbeth Gallery, *Paintings by Robert Henri N.A. and Grace Ravlin,* 1924, no. 4 § LAMHSA, *Portraits by Robert Henri,* 1925, exhibited but not listed § LAMHSA, A *Loan Exhibition from Private Collections,* 1926, no. 44 § Los Angeles, California Art Club Gallery, [paintings lent by Dr. Dorothea Moore], 1929, as *Portrait,* no cat. traced § Los Angeles, Barnsdall Park, Municipal Art Gallery, *The American Scene,* 1956, no cat. traced § Laguna 1958, no. 54.

LITERATURE
New York, Janet Le Clair Collection, Henri Record Book, lists painting as 1-234, with color description, sketch of painting, list of exhibitions, and sales information § "Exhibitions at the Art Institute," *Fine Arts Journal* 33 (October 1915): 436, as A *Portrait of Edna* § Frank Sottek, "Toledo," *American Art News* 14 (January 29, 1916): 5, as *Edna Ramon* § Antony Anderson, "Of Art and Artists," *Los Angeles Times,* December 3, 1916, pt. 3, p. 2, "Henri is 'modern' in his vivid and colorful portrait" § "Los Angeles (Cal.)," *American Art News* 15 (December 30, 1916): 5 § Guy Pène du Bois, "Notes of the Studios and Galleries," *Arts and Decoration* 7 (February 1917): repro., 214 § Willard Huntington Wright, "Modern Art: From Daumier to Marsden Hartley," *International Studio* 61 (March 1917): repro., xxxi § "Eight Artists at City Club," *American Art News* 20 (December 10, 1921): 7, comments on vividness of the figure's red hair against a green background § "Newport Art Association's Show," *American Art News* 20 (August 19, 1922): 1 § "Henri Exhibits Type Studies," *Art News* 22 (January 5, 1924): 3 § Helen Appleton Read, "Portraits by Robert Henri," *Brooklyn Daily Eagle,* January 13, 1924, pt. B, p. 2,

faults its "easy virtuosity" § Archiv. Am. Art, Macbeth Gallery Papers, Artists' Credit Book (not on microfilm), November 26, 1924, entry lists sale to Mrs. Moore for two thousand dollars § New York, Janet Le Clair Collection, Henri Diary, December 4, 1924, entry (Archiv. Am. Art microfilm roll 884, fr. 737), discusses Mrs. Moore's visit to the artist's stu-dio and the purchase § Elizabeth Bingham, "Los Angeles," *Art News* 23 (August 15, 1925): 11 § "Exhibitions," *California Art Club Bulletin* 4 (January 1929): unpaginated, lists a *Portrait* by Henri among paintings from Dr. Moore's collection on view § *Index 20th Cent. Artists,* p. 56; reprint, p. 318; listed.

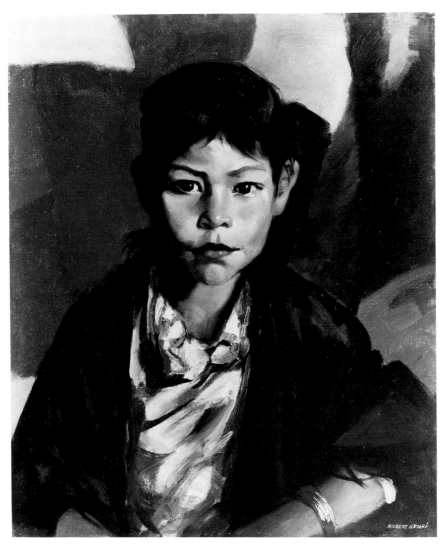

Henri, *Pepita.*

Pepita, 1917
(Pepette; Pepita of Santa Fe)
Oil on canvas
24⅛ x 19¹⁵/₁₆ in (61.2 x 50.7 cm)
Signed lower right: ROBERT HENRi
Inscribed verso across top: 47 / K / Robert Henri
Mr. and Mrs. William Preston Harrison Collection
20.3.2

The artist's record book indicates the title of this painting is *Pepita,* and it notes elsewhere that it was painted in Santa Fe.

While summering in La Jolla, California, in 1914, Henri planned the art exhibition at San Diego's Panama-California International Exposition (1915) and became close friends with Dr. Edgar L. Hewett, an ethnologist and director of the School of American Archaeol-ogy in Santa Fe, who was in charge of the ethnology and art exhibits. At Dr. Hewett's invitation Henri spent the summers of 1916, 1917, and 1922 in Santa Fe, where Hewett introduced him to the Native Americans and their cultures. Henri's ethnological interest in them fits into the larger pattern of his traveling in search of national or ethnic types, such as his Irish, Chinese, and black subjects. In his paintings of Native Americans he paid atten-tion to costumes and daily habits while attempting to convey the spirit of the people, which he saw as noble and mysterious. For this purpose he preferred to paint children rather than adults, saying in *The Art Spirit,* "I have never respected any man more than I have some children. In the faces of children I have seen a look of wisdom and of kindness expressed with such ease and such certainty that I knew it was the expression of a whole race" (p. 242). The word *Pepita* simply means "little girl"; Henri's record book indicates that the model's name was Juanita.

Several of Henri's paintings of Native Americans include geometric blankets as backgrounds, perhaps reflecting his growing consciousness of abstract art and surface struc-ture. *Pepita*'s multicolored background may refer to such textiles. Henri advised in *The Art Spirit:* "If there are objects in the background, they must not be painted because they are interesting in themselves. Their only right of existence is a complementary of harmonic ben-efits to the head of the figure" (p. 35).

William Preston Harrison bought *Pepita* upon the suggestion of GEORGE BELLOWS, an artist the collector much admired.

PROVENANCE
The artist § Mr. and Mrs. William Preston Harrison, Los Angeles, 1918–20.

EXHIBITIONS
LAMHSA 1924, no. 22 § Laguna 1958, no. 42, as *Pepita of Santa Fe* § Fort Worth, Tex., Amon Carter Museum of Western Art, and others, *Taos and Santa Fe: The Artist's Environment, 1882–1942,* 1963–64, published by University of New Mexico Press, Albuquerque, no. 51, repro., p. 40.

LITERATURE
New York, Janet Le Clair Collection, Henri Record

Book, lists painting as K-47, with color description, sketch of painting, sales information, and name of model § "Los Angeles, Cal.," *American Art News* 18 (February 14, 1920): 6, as *Pepita of Santa Fe* § "New Additions to the Harrison Collection," *LA Museum Art Dept. Bull.* 1 (April 1920): 19 § LAMHSA 1921, no. 11, as *Pepita of Santa Fe*, incorrectly dated 1918 § Nathaniel Pousette-Dart, comp., *Robert Henri* (New York: Stokes, 1922), unpaginated, as *Pepette* § Richard Walgrave, "Romance and the Background of Painting," *California Southland* 7 (November 1925): repro., 10, as *Pepita of Santa Fe* § Sonia Wolfson, "Art and Artists," *California Graphic* 3 (November 14, 1925): repro., 7, as *Pepita of Santa Fe* § Harrison 1934, p. 33, repro., as *Pepita of Santa Fe* § *Index 20th Cent. Artists,* pp. 50, III; reprint, pp. 312, 329; listed in colls. and repros., as *Pepita of Santa Fe* § Higgins 1963, p. 56, no. 7 in checklist of Mr. and Mrs. William Preston Harrison collection, as *Pepita of Santa Fe* § *The Vincent Price Treasury of American Art* (Waukesha, Wis.: Country Beautiful Corp., 1972), repro., p. 192, as *Pepita of Santa Fe.*

Henri, *Portrait of Mrs. William Preston Harrison.*

Portrait of Mrs. William Preston Harrison, 1925

Oil on canvas
52⅛ x 40 in (132.4 x 101.5 cm)
Signed lower left: Robert Henri
Inscribed verso upper left: 205 / M [encircled] / LOS ANGELES / CALIFORNIA / 1925
Inscribed verso upper center: Robert Henri / PORTRAIT OF / MRS. WILLIAM PRESTON HARRISON
Mr. and Mrs. William Preston Harrison Collection 25.6.7

Ada M. Sanberg (1885–1947) met William Preston Harrison in Chicago in 1910 and married him in 1915. Theirs was the story of a poor girl marrying a rich man, and possibly because of this circumstance the couple eventually moved to Los Angeles. They had one child, Carter Preston.

Henri was supposed to paint the portrait in the summer of 1924, at the same time that WAYMAN ADAMS was originally scheduled to paint Mr. Harrison's portrait, but Henri's trip to Los Angeles was delayed until February of the following year. The artist was never very anxious to accept portrait commissions and viewed them mainly as a source of income. Because Harrison had been a strong supporter of his art, he probably felt he could not refuse the commission. Henri's sentiment notwithstanding, the portrait is a good example of the artist's late style. Instead of the thick, robust paint surface of his earlier paintings, this portrait has a thinner and flatter appearance.

Henri's portrayal of Ada Harrison is somewhat conservative, probably due to her social prominence and to the fact that the work was intended to hang in the museum next to Adams's portrait of her husband. Mrs. Harrison was a large woman, and although Henri did not falsify this aspect of her appearance, he did give her an air of dignity. He minimized Mrs. Harrison's bulk somewhat by showing her in a black dress partially covered by a fur-trimmed, deep orange wrap. She holds a large, feathered fan. In his early paintings of dancers Henri often included such fans. The fan does not contradict the image of Mrs. Harrison's respectability but does add an important color note to this basically dark painting.

Harrison noted in 1935 that his wife had become the victim of endless criticism because of the portrait. He felt that much of it was due to other women's jealousy over its being in a public museum and regretted not having had the sitter's identity remain anonymous. Harrison was dismayed with this problem partly because he viewed the painting as a superb example of Henri's art rather than primarily as a portrait of his wife.

RELATED WORK
Study for Portrait of Mrs. William Preston Harrison, 1925, oil on canvas, 15 x 24 in (38.1 x 61.0 cm). Destroyed (listed in Henri record book as M-214).

PROVENANCE
Mr. and Mrs. William Preston Harrison, Los Angeles, 1925.

LITERATURE
New York, Janet Le Clair Collection, Henri Record Book, lists painting as M-205, with color description, sketch of painting, and commission information § "Recent Additions to the Harrison Gallery," *LA Museum Art Dept. Bull.* 5 (January 1924): 141, tells of Henri's future visit to Los Angeles for the commission § "Gifts to the Los Angeles Museum," *American Magazine of Art* 15 (May 1924): 263 § "Paintings Loaned by Mr. and Mrs. Preston Harrison," *LA Museum Art Dept. Bull.* 6 (October 1924): 163 § "More Harrison Art for Los Angeles," *Art News* 23 (January 3, 1925): 4 § Archiv. Am. Art, Macbeth Gallery Papers, William Preston Harrison to Mr. Macbeth, February 18, 1925 (microfilm roll N Mc 51, fr. 414); Harrison to Macbeth, February 27, 1925 (ibid., fr. 425); Harrison to Macbeth, March 25, 1925 (ibid., fr. 435), records progress of the portrait

and his satisfaction with the completed painting § *For Arts Sake* 2 (March 1, 1925): 7, mentions Henri's recent arrival in Los Angeles for Harrison commission § New York, Janet Le Clair Collection, Henri Diary, February 10–March 27, 1925, p. 57 (Archiv. Am. Art microfilm roll 886, fr. 761), discusses his reception in Los Angeles and the portrait § "Give Los Angeles Six More Pictures," *Art News* 23 (May 30, 1925): 1 § "Los Angeles," *Art News* 23 (May 30, 1925): 8, portrait to be placed on view in the Harrison Gallery in the autumn § *California Graphic* 2 (July 25, 1925): repro., 22 § "Harrison Gallery Great Gift to Los Angeles," *California Graphic* 3 (November 28, 1925): repro., 18 § *California Art Club Bulletin* 1 (December 1925): repro., unpaginated § "The Harrison Gallery," *LA Museum Art Dept. Bull.* 7 (January 1926): 203 § "The Harrison Collection of Paintings," *California Southland* 8 (February 1926): repro., 15 § LACMA, Registrar's files, Louise Upton to William Preston Harrison, June 6, 1931; Harrison to Upton, June 11, 1931; Harrison to Upton, February 3, 1935, discusses the public's and critics' reactions to the painting § Harrison 1934, p. 33, repro., p. 15 § *Index 20th Cent. Artists,* p. 50; reprint, p. 312; listed in colls. § Higgins 1963, p. 57, no. 21 in checklist of Mr. and Mrs. William Preston Harrison collection.

Hugh H. Breckenridge

Born October 6, 1870,
Leesburg, Virginia
Died November 4, 1937,
Philadelphia, Pennsylvania

Hugh Henry Breckenridge was long associated with Philadelphia as a modernist painter and teacher. From 1887 to 1892 he was a student at the Pennsylvania Academy of the Fine Arts, where he then taught for more than forty years. In 1892 he was awarded a scholarship enabling him to study in Paris at the Académie Julian with William Adolphe Bouguereau (1825–1905) and to travel through Europe, going with the Pennsylvania impressionist Walter E. Schofield (1869–1944). His subsequent landscapes, portraits, and figure paintings reveal the influence of impressionism and an overwhelming fascination with color. His first solo exhibition in 1904 included both paintings and pastels. Breckenridge also produced many commissioned portraits, which provided him with a source of income; these exhibit the dazzling brushwork typical of society portraiture of the period.

A second trip to Europe with Schofield in 1909 made Breckenridge aware of more avant-garde trends. During the 1910s he worked alternately in a vigorous neoimpressionist technique, which he referred to as "tapestry painting," and in a somewhat academic style enriched by an expressionist palette. These paintings gained for him national recognition as a foremost modernist whose art was easily accessible to the public. In 1922 Breckenridge began exhibiting abstract paintings, some of which recall the Improvisations of Wassily Kandinsky (1866–1944). These abstractions of irregularly shaped, colored planes most commonly suggest the nature or the velocity of modern life. Above all they demonstrate his fascination with the theoretical basis of color.

Breckenridge began teaching at the Pennsylvania Academy of the Fine Arts in 1894. During the summer of 1900 he and Thomas Anshutz (1851–1912) established the Darby School of Painting in Darby, Pennsylvania; Breckenridge later established his own school in East Gloucester, Massachusetts. In 1919 he became director of fine arts at the Maryland Institute in Baltimore. In his last years Breckenridge sometimes returned to impressionism, painting landscapes of Gloucester and still-life paintings.

BIBLIOGRAPHY
Dallas, Valley House Gallery, and Dallas, Dorothy Breckenridge Collection, Hugh H. Breckenridge Papers (on microfilm, Archiv. Am. Art) § Arthur Hoeber, "Hugh H. Breckenridge," *International Studio* 37 (March

1909): XXXIV–XXXVI § Dallas, Valley House Gallery, *The Paintings of Hugh H. Breckenridge (1870–1937)*, exh. cat., 1967, with essay by Margaret Vogel, chronology, lists of collections, awards, and exhibitions § Washington, D.C., Smithsonian Institution, National Collection of Fine Arts, and Philadelphia, Pennsylvania Academy of the Fine Arts, *Pennsylvania Academy Moderns, 1910–1940*, exh. cat., 1975, published by Smithsonian Institution Press, essays by Joshua C. Taylor and Richard J. Boyle, pp. 14–15 § Gerald L. Carr, "Hugh Henry Breckenridge: A Philadelphia Modernist," *American Art Review* 4 (May 1978): 92–99, 119–25.

Breckenridge, *The Altar Cloth.*

The Altar Cloth, 1916
Oil on canvas
Signed lower left: Hugh H. Breckenridge
50³/₁₆ x 46¹/₁₆ in (127.5 x 117.0 cm)
Mr. and Mrs. William Preston Harrison Collection
48.32.11
Color plate, page 59

In the 1910s Breckenridge painted and exhibited a large number of tabletop arrangements, usually including an assortment of fruit, vases, and pots. These still-life paintings became Breckenridge's primary means of experiment. He wrote that still life was "the purest art of painting" for "it has no story to tell, other than that of line, form and color" (Valley House Gallery, unpublished book, p. 64 [Archiv. Am. Art microfilm roll 2410, fr. 266]). *The Altar Cloth* is typical of such experiments and is also characteristic of Breckenridge's bolder style. Like many early American modernists, he was most influenced by Paul Cézanne (1839–1906) and Henri Matisse (1869–1954). He considered Cézanne to be the greatest artist of modern times, and the slightly tilted tabletop here recalls Cézanne's still lifes. The painting is indebted to Matisse's paintings

of his fauve period for its brilliant color. Breckenridge did not hesitate to employ richly saturated hues of rose, emerald green, lavender, and ultramarine, even utilizing equally expressive colors in the shadows. The tall white vase in the center is framed by a green jar on the right and a white bowl and bright green cloth on the left. In typical postimpressionist fashion, Breckenridge placed the complementary color of the rose drape next to the green objects. Breckenridge often borrowed from Matisse the device of placing a painting or patterned hanging, here an altar cloth, behind the objects on the table to compromise the illusion of space by emphasizing surface pattern.

During the 1910s Breckenridge often worked closely with Arthur B. Carles (1880–1952), and the two even used the same objects in their still-life compositions. Both artists shared pictorial concerns and a debt to the fauve palette of Matisse. When *The Altar Cloth* is compared with Carles's still-life paintings of this period an essential difference arises: no matter how bold Breckenridge is with his palette, he remains more conservative than Carles in his treatment of form. In *The Altar Cloth* Breckenridge did not completely relinquish traditional modeling and shading, while in his paintings Carles boldly flattened and simplified his objects. Breckenridge's modernism at this stage of his development was allied to his use of nonreferential, expressionist color. Indeed, years later Carles acknowledged Breckenridge as the one who taught him about color resonance. It was the color of GEORGE INNESS that first attracted Breckenridge to painting in the 1880s, and color was always to dominate in his more avant-garde works.

The museum's painting was frequently exhibited before William Preston Harrison saw it in Chicago and acquired it in 1923. While Harrison knew that artists with an impressionist slant, such as FREDERICK CARL FRIESEKE, disliked Breckenridge's modernism, Harrison believed that Breckenridge was a fine painter with "a style all his own."

PROVENANCE
The artist, 1916–23 § Mr. and Mrs. William Preston Harrison, Los Angeles, 1923–24.

EXHIBITIONS
Philadelphia, Pennsylvania Academy of the Fine Arts, *112th Annual Exhibition*, 1917, no. 324 § City

Art Museum of Saint Louis, *Twelfth Annual Exhibition of Paintings by American Artists*, 1917, no. 36 § New York, National Academy of Design, *Winter Exhibition*, 1917–18, no. 118 § Baltimore, Maryland Institute, [exhibition title unknown], 1919, no cat. traced § Kansas City, Mo., Fine Art Institute, [exhibition title unknown], 1920, no cat. traced § Philadelphia, Art Alliance, [exhibition title unknown], 1921, no cat. traced § Boston, Saint Botolph Club, *Exhibition of Paintings by Hugh Breckenridge*, 1921, no. 5 § Rochester, N.Y., Memorial Art Gallery, *Exhibition of Paintings Lent by Mrs. Coonley Ward and . . . Oils by Hugh Breckenridge and Victor Charreton*, 1921, no. 52 § Toledo Museum of Art, *Paintings by Hugh H. Breckenridge*, 1922, no. 112 § Kansas City, Mo., [exhibition location and title unknown], 1922, no cat. traced § Detroit, Mich., John Hanna Galleries, [Breckenridge exhibition], 1922–23, no cat. traced § Chicago, Carson Pirie Scott, [exhibition title unknown], 1923, no cat. traced § Syracuse (N.Y.) Museum of Fine Arts, *Exhibition of Paintings by Hugh H. Breckenridge and Abraham Molarsky*, 1923, no cat. traced § LAMHSA 1924, no. 2.

LITERATURE
Dallas, Valley House Gallery, artist's logbook, p. 41 (Archiv. Am. Art, microfilm roll 1779, fr. 313), provides date, lists exhibitions, refers to letter from William Preston Harrison to the artist dated November 27, 1923, in which Harrison agrees to purchase painting for $750 for the museum § "Paintings Loaned by Mr. and Mrs. Preston Harrison," *LA Museum Art Dept. Bull.* 6 (October 1924): 162 § "Mr. and Mrs. William Preston Harrison's Gift," *LA Museum Art Dept. Bull.* 6 (January 1925): 172 § "More Harrison Art for Los Angeles," *Art News* 23 (January 3, 1925): 4 § "*The Altar Cloth* by Hugh Breckenridge," *LA Museum Art Dept. Bull.* 7 (July 1926): 222, repro., cover § *California Graphic* 3 (August 7, 1926): repro., 7 § LACMA, Registrar's files, William Preston Harrison to Louise Upton, May 8, 1933, states his approbation of the artist's style § Harrison 1934, p. 21, inaccurately dates acquisition of painting to 1924, repro., p. 23 § *California Arts and Architecture* 57 (February 1940): repro., 14 § Higgins 1963, p. 66, no. 215 in checklist of Mr. and Mrs. William Preston Harrison collection.

Samuel Halpert

Born December 25, 1884,
Bialystok, Russia
To United States 1889
Died April 5, 1930,
Detroit, Michigan

Samuel Halpert was one of the first American artists to be exposed to European modernism and for a brief period was one of our more progressive painters. He studied in New York at the Educational Alliance and National Academy of Design from 1899 to 1902, continuing his training in 1902 at the Ecole des Beaux-Arts in Paris under Léon Bonnat (1833–1922). Within a year of his settling in France, where he lived for eight years, Halpert, along with his friend MAX WEBER, fell under the spell of successively more vanguard styles, from impressionism to fauvism and cubism. He fused modernist ideas onto a basically representational art rather than developing a revolutionary style. The work of Paul Cézanne (1839–1906) was very important to Halpert, whose landscapes and views of Paris and New York were often organized as studies of mass, space, and light. A more restrained version of Matisse's and Marquet's fauvism affected his palette.

Halpert returned to the United States in 1911, sharing a house with Man Ray (1890–1976) in New Jersey and becoming one of the few Americans to exhibit modernist paintings at the Armory Show. By 1919 his style had already lost much of its modernism, and during the succeeding decade it became increasingly academic. His interior and exterior views as well as his still-life paintings and figure studies continued a tendency toward simplified volume and structure despite their traditional style.

He found a receptive audience throughout his career, from his first solo exhibition at the progressive Daniel Gallery in 1914 to numerous exhibits at C. W. Kraushaar Galleries. In 1918 he married Edith Gregor, who through her Downtown Gallery in New York became one of the leading art dealers in American modernist art. Halpert was a member of the New Society of Artists and served as vice-president and director of the Society of Independent Artists, and during the last three years of his life he taught at the art school of the Society of Arts and Crafts in Detroit, Michigan.

BIBLIOGRAPHY
Archiv. Am. Art, Downtown Gallery Papers § Helen Comstock, "Samuel Halpert, Post-Impressionist," *International Studio* 75 (April 1922): 144–50 § Obituary, *Art News* 28 (April 12, 1930): 14 § New York, Bernard Black Gallery, *Samuel Halpert, 1884–1930: A Pioneer of Modern Art in America*, exh. cat., 1969, with chronology § Bernard Dorival, "L'Affaire Delaunay a l'Armory Show d'aprés des documents inèdits," *Bulletin de la Société de l'Histoire de l'Art Français* (1977): 323–32, with Halpert-Delaunay correspondence concerning modern art in New York, specifically the Armory Show.

Halpert, *Toledo Cathedral.*

Halpert, *Cathedral Interior,*
c. 1915, see Related Work.

Toledo Cathedral, 1916

(*Cathedral, Toledo; Cathedral at Toledo; Toledo Cathedral [Spain]*)
Oil on canvas
45 x 35⅛ in (114.4 x 89.3 cm)
Signed and dated lower left: S. Halpert 16
Mr. and Mrs. William Preston Harrison Collection
33.11.3

In the summer of 1916 Halpert returned to
New York after several months in Spain and
Portugal with Robert Delaunay (1885–1941)
and his wife Sonia Delaunay (1885–1979). This
view of the interior of the Toledo Cathedral
was no doubt painted during that trip. Halpert
had originally met Robert Delaunay years
before in Brittany, and they remained friends
even after Halpert's return to New York in
1911. Halpert acted as Delaunay's American
representative during the dispute over the
installation of Delaunay's *City of Paris,* 1910–12
(Musée national d'Art moderne, Centre
national d'Art et de Culture Georges Pom-
pidou, Paris) in the Armory Show.

Toledo Cathedral was no doubt inspired by
Robert Delaunay's series on Saint Severin
painted in 1909. Both artists shared a fascina-
tion with color and light and expressed this
interest through the motif of a church interior.
Halpert, however, did not become as abstract
in his work as did Delaunay, who manipulated
the architecture of the Saint Severin church so
that its structure became a series of prismat-
ically colored planes in flux. Instead, Halpert
used the solid Gothic architectural structure
as a frame contrasted to the light and color
filling the nave. The sunlight is softened as it
enters through the stained glass windows and
forms an almost tangible, hazy atmosphere in
the church. Color and light constitute the
subject of the painting, as the stained-glass
windows cause patterns of alternating colors—
violet, yellow, orange, red, and green—to
flicker across the surfaces of the stone columns
and floor.

The museum's painting is very similar to
another one of Toledo Cathedral (see illustra-
tion) done about the same time. The three-
story elevation with clerestory depicted in the
museum's version appears to be of the Gothic
cathedral's transept near the crossing, while
the other painting with its two-story elevation
is of the nave. Although there are more stained
glass windows in the cathedral's nave, both of
Halpert's interpretations are equally concerned
with light and color. The differences between
the two versions are subtle. In the museum's
painting Halpert positioned himself almost
directly in front of the wall of glass and stone
rather than on a slightly oblique angle as in the
other version. Consequently the piers and
arches appear less as a series of abstract, arcing
lines and more as clearly defined archways.
Both paintings have small figures, differing
only in number and placement.

According to photographs of the painting
published when it was first exhibited in the
autumn of 1916, the cathedral interior orig-
inally was shown with a plain stone floor.
Sometime thereafter, for reasons unknown,
Halpert changed the floor and some minor
architectural details, such as the balustrade
in the far-right triforium window.

William Preston Harrison had wanted to
purchase a major work by Halpert since 1916,
the year of this painting. He was not able to
obtain one until 1933, when he traded a dealer
paintings by WALTER UFER, Grace Ravlin
(born 1885), and WILLIAM WENDT for this
painting.

RELATED WORK
Cathedral Interior, c. 1915, oil on canvas, 45 x 34 in
(114.3 x 86.4 cm). Dr. and Mrs. Wesley Halpert,
New York.

PROVENANCE
The artist § Estate of the artist, 1930–33 § With C. W. Kraushaar Galleries, New York, 1933 § Mr. and Mrs. William Preston Harrison, Los Angeles, 1933.

EXHIBITIONS
New York, Daniel Gallery, [group exhibition], 1916, as *Cathedral, Toledo* § Possibly New York, Montross Gallery, *Contemporary Group Exhibition*, 1916, no. 16, as *Cathedral: Toledo* § Possibly New York, City Club, [group exhibition], 1917, as *Cathedral at Toledo*, no cat. traced § New York, C. W. Kraushaar Galleries, *Exhibition of Paintings by Samuel Halpert*, 1923, no. 4 § New York, C. W. Kraushaar Galleries, *Illustrated Catalogue of an Important Collection of Paintings . . . Marbles and Bronzes*, 1924, no. 21, repro. § New York, Society of Independent Artists, *Eleventh Annual Exhibition*, 1927, no. 373.

LITERATURE
Forbes Watson, "At the Art Galleries," *Evening Post* (New York), October 14, 1916, Magazine, pp. 2, 16, refers to the artist's new palette, repro. § New York, Metropolitan Museum of Art, Research Library, artist's file, newspaper clipping, *American* (New York), [October] 21, 1916 [clipping dated incorrectly], *Cathedral, Toledo* on view at Daniel Gallery, repro. § "At the New Daniel Galleries," *American Art News* 15 (October 21, 1916): 3 § "Exhibitions in the Galleries," *Arts and Decoration* 7 (November 1916): 35–36, repro., p. 36 § Willard Huntington Wright, "Modern Art: The New Spirit in America," *International Studio* 60 (December 1916): LXV, considers "little more than a school drawing in the early manner of Delaunay, with certain Puy-Manguin-Friesz-Vlaminck tendencies" § "Contemporary Group Exhibition," *American Art News* 15 (December 16, 1916): 3 § "'Moderns' at City Club," *American Art News* 17 (February 1, 1919): 2 § "Varied Schools at Kraushaar's," *Art News* 21 (December 9, 1922): 1 § "Halpert's Fine Show," *Art News* 21 (March 10, 1923): 2 § "A Group Show at Kraushaar's," *Art News* 22 (January 19, 1924): 10 § LACMA, Registrar's files, William Preston Harrison correspondence, October 15, 1933–January 2, 1937 § Harrison 1934, p. 31, repro., p. 30, as *Toldeo Cathedral (Spain)* § Higgins 1963, p. 62, no. 125 in checklist of Mr. and Mrs. William Preston Harrison collection, as *Toledo Cathedral, Spain* § Bernard Black Gallery, *Halpert*, unpaginated.

Leon Kroll

Born December 6, 1884, New York, New York
Died October 25, 1974, Gloucester, Massachusetts

Abraham Leon Kroll was best known during the decades between the wars for his figure paintings. Trained in New York at the Art Students League under JOHN TWACHTMAN and at National Academy of Design, he went to Paris to study for two years, beginning in 1908. He studied at the Académie Julian with Jean-Paul Laurens (1883–1921) but felt that he learned more at museums and galleries. On this and a subsequent trip to Europe in 1914 Kroll was drawn to the work of Paul Cézanne (1839–1906), Nicholas Poussin (1594–1665), and Piero della Francesca (c. 1420–1492), artists who would determine his classical interpretation of the human figure and the landscape.

Although his first paintings after his return to the United States were Ash Can school images of New York City's street life, by the end of the 1910s he was specializing in the figure. During the 1920s Kroll painted mainly women, often nude, presenting them in interiors that often have windows looking out to landscapes or placing them outdoors. He always depicted solid, fully modeled, large-scale figures. His landscapes, whether of Central Park, Maine, Woodstock, or other places, were highly reminiscent of the work of Cézanne. Kroll also produced some still-life paintings. His well-defined, classical figure types and pastoral settings accorded well with mural-painting aesthetics, and beginning in the 1930s he won several commissions, including panels for the United States Department of Justice Building in Washington, D.C., the Worcester (Mass.) War Memorial, and the Indiana State Capitol. During the first twenty of his mature years he supported himself by teaching at a variety of schools in New York and elsewhere.

BIBLIOGRAPHY
Archiv. Am. Art, Leon Kroll Papers (portions on microfilm) § *Index 20th Cent. Artists* 1 (January 1934): 59–64; 1 (September 1934): II; 2 (September 1935): IV; 3 (August–September 1936): VI; reprint, pp. 82–87, 89, 91, 93 § James W. Lane, "Leon Kroll," *Magazine of Art* 30 (April 1937): 219–23 § New York, Bernard Danenberg Galleries, *The Rediscovered Years: Leon Kroll*, exh. cat., 1970, with foreword by Bernard Danenberg, biographical note, lists of awards, collections, and affiliations, bibliography § Nancy Hale and Fredson Bowers, eds., *Leon Kroll: A Spoken Memoir* (Charlottesville: University Press of Virginia for the University of Virginia Art Museum, 1983), primarily an interview with quotations from the artist, with list of awards, bibliography by Willa Kay Lawall.

Broadway and Forty-Second Street, New York, 1916

Oil on canvas
40⁵/₁₆ x 34¼ in (102.4 x 87.2 cm)
Signed and dated lower right: Kroll 1916
Mr. and Mrs. William Preston Harrison Collection
18.1.4

When Kroll returned from Paris in 1914 he began painting images of New York City, depicting the life of its crowded streets, bridges, and waterfront. He continued to paint such images until about 1917. The scenes were very well received when exhibited throughout the country. Collector William Preston Harrison may have decided to buy one of Kroll's New York scenes after seeing several exhibited in annuals of the Art Institute of Chicago. Kroll painted at least four canvases of the Forty-second Street and Broadway area, three of them in 1916. While two include a bit of Bryant Park, in this version Kroll omitted the park and any glimpse of nature. He focused on the skyscrapers that were then drastically changing the skyline of New York. As in most of his urban scenes, Kroll captured the energy and congestion of the metropolis by depicting the streets crowded with trolleys and pedestrians.

New York was not a dark, dingy place to Kroll. This painting is in a high-keyed blue palette. Although not documented as being an enthusiastic disciple of Hardesty Maratta's color theory, as was his close friend GEORGE BELLOWS, Kroll may have been stimulated to use such an intense hue by the general interest in color then prevalent among artists. The cool hue suggests the cold of winter, and Kroll is known to have painted many Manhattan snow scenes. The artist would go to any extreme, painting outdoors or even hanging from windows, to capture a sense of the city. The intense palette was equaled by the bold brushwork that characterizes most of Kroll's New York paintings.

PROVENANCE
The artist, 1916 § Mr. and Mrs. William Preston Harrison, Los Angeles, 1916–18.

ON DEPOSIT
Los Angeles County Data Processing Department, 1970–73.

EXHIBITIONS
LAMHSA, *Summer Exhibition of Paintings by Contemporary American Artists Loaned by Mr. and Mrs. William Preston Harrison*, 1917, no. 33 § LAMHSA 1918, no. 14 § LAMHSA 1924, no. 25 § Laguna 1958, no. 40.

LITERATURE
"The Harrison Collection," *Los Angeles Times*, September 9, 1917, pt. 3, p. 15, describes painting as early evening § Roland Johnstone, "A Notable Gift to Los Angeles," *Graphic* (Los Angeles) 52 (April 10, 1918): 12, says that Harrison purchased the painting from the artist § LAMHSA 1921, no. 14 § LACMA, Registrar's files, William Preston Harrison to William A. Bryan, June 27, 1924, Harrison traveled to Woodstock to ask the artist's opinion of this painting, to which he replied that he felt well represented by it; Harrison to Louise Upton, August 7, 1938, Harrison is convinced that this example of Kroll's early career will always be esteemed § *Index 20th Cent. Artists*, p. 60; reprint, p. 83; listed in colls. § Harrison 1934, p. 35, purchased in 1916, repro. § Hale and Bowers, *Kroll*, pp. 109–10, no. 58, the artist refers to the painting's Cézannesque handling, pl. 58 § Higgins 1963, p. 56, no. 4 in checklist of Mr. and Mrs. William Preston Harrison collection.

Kroll, *Broadway and Forty-Second Street, New York.*

John Sloan

Born August 2, 1871,
Lock Haven, Pennsylvania
Died September 7, 1951,
Hanover, New Hampshire

John Sloan was the leader of the Ash Can school artists who painted scenes of everyday life in the city. At the age of five his family moved to Germantown, then a suburb of Philadelphia, and then to Philadelphia itself. In 1890 he attended evening classes in drawing at the Spring Garden Institute and established himself as a graphic artist and illustrator. Beginning in 1892 he studied for two years at the Pennsylvania Academy of the Fine Arts under Thomas Anshutz (1851–1912). His association with ROBERT HENRI also began at this time. He rapidly achieved success as a poster designer and illustrator for Philadelphia newspapers and books. Sloan exhibited his paintings for the first time in 1900. He made his permanent home in New York in 1904, and during the next decade painted the scenes of New York street life for which he is best known. In 1908 he exhibited at Macbeth Gallery as a member of the progressive group called The Eight. He had his first solo exhibition in 1916, and teaching replaced illustrating as his primary source of regular income. From 1914 to 1918 he summered in Gloucester, Massachusetts, and almost every year thereafter in Santa Fe, New Mexico. His first retrospective exhibition was held in 1938, at the Addison Gallery of American Art, Andover, Massachusetts.

Sloan had a long and notable career as a teacher, beginning in 1907 as an instructor at the Pittsburgh Art Students League. His most important tenure was at the Art Students League in New York, where he taught from 1916 to 1938. He also taught at the Maryland Institute in Baltimore during 1923, at Alexander Archipenko's L'Ecole d'Art in New York in 1932, and at George Luks's New York school from 1933 to 1935. In 1939 his ideas on teaching were published as *The Gist of Art*. Sloan was also active in artists' organizations: he was an original member of the Whitney Studio Club and was president of the Society of Independent Artists from 1918 until his death.

BIBLIOGRAPHY

Wilmington, Delaware Art Museum, John Sloan Archives § Lloyd Goodrich, *John Sloan* (New York: Macmillan for the Whitney Museum of American Art, 1952), with research by Rosalind Irvine, bibliography § Van Wyck Brooks, *John Sloan: A Painter's Life* (New York: Dutton, 1955) § *John Sloan's New York Scene: From the Diaries, Notes, and Correspondence, 1906–1913,* ed. Bruce St. John (New York: Harper & Row, 1965), with introduction and notes by Helen Farr Sloan, chronology § Washington, D.C., National Gallery of Art, and others, *John Sloan, 1871–1951,* exh. cat., 1971, with essays by David W. Scott and E. John Bullard, list of books illustrated by the artist, bibliography.

Town Steps, Gloucester, 1916
(*The Town Steps*)
Oil on canvas
32¹/₁₆ x 26¹/₈ in (81.5 x 66.3 cm)
Signed lower right: John Sloan
Inscribed on top stretcher bar: John Sloan N.Y.C. "The Town Steps"
Mr. and Mrs. William Preston Harrison Collection
27.7.1
Color plate, page 60

Sloan's decision to work in Gloucester, a popular spot among artists, arose from his desire for new and different material, and the paintings he executed there represent a departure from the subject matter and style of his earlier and better-known paintings in several respects. The impact of postimpressionist and School of Paris paintings exhibited in the Armory Show of 1913 challenged him to modify his approach to painting. Prior to this time he had waited to encounter an interesting subject and then painted it from memory in his studio; now he recognized the validity of landscapes and of more randomly chosen motifs, as well as the need to paint on a regular basis.

During his five summers in Gloucester Sloan painted approximately three hundred pictures, most of them done on his portable easel. These outdoor scenes were painted quickly and directly, with very few sketches. Seeing the limitations of his formerly low-key palette, Sloan now employed a much greater variety of color, using for each painting a different, set palette, limited according to the scheme of color advocated by the color theorist and paint supplier Hardesty Maratta. In *Town Steps* and other works Sloan also explored the theories of architectonic structure advocated by Maratta and others, developing a firm geometry and long diagonals, while also tilting up his backgrounds to better balance surface design with perspective recession. In this painting Sloan displays a new vigor of paint application and interest in painting textures, inspired by his having seen paintings by Vincent van Gogh (1853–1890).

According to Sloan the figures in *Town Steps* were anonymous pedestrians, typical citizens of Gloucester. As is characteristic of his paintings of the area, it is a landscape with figures rather than a genre subject, as were his New

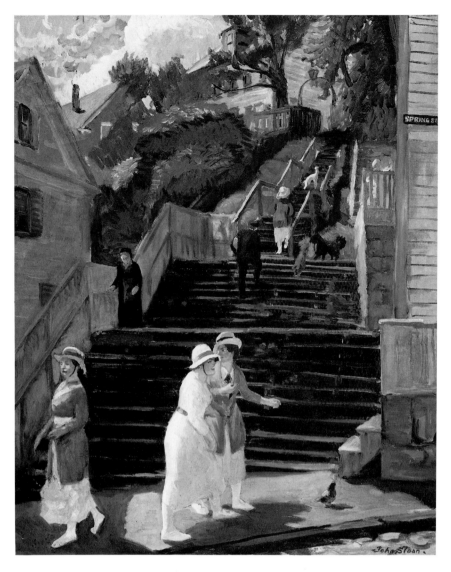

Sloan, *Town Steps, Gloucester*.

EXHIBITIONS

Washington, D.C., Corcoran Gallery of Art, *Sixth Biennial Exhibition of Oil Paintings by Contemporary Artists,* 1916–17, no. 135 § Philadelphia, Pennsylvania Academy of the Fine Arts, *112th Annual Exhibition,* 1917, no. 26, as *The Town Steps* § Detroit Museum of Art, *Third Annual Exhibition of Selected Paintings by American Artists,* 1917, no. 120 § Toledo Museum of Art, *Annual Summer Exhibition of Selected Paintings by American Artists,* 1917, no. 120 § New York, Society of Independent Artists, *Second Annual Exhibition,* 1918, no. 706, as *The Town Steps* § New York, Art Students League, 1920–21, no cat. traced § Los Angeles, University of Southern California, Elizabeth Holmes Fisher Gallery of Fine Arts, *American Painting of the Eighteenth and Nineteenth Centuries* (series 1940–41, no. 1), 1940, no. 30 § Laguna 1958, no. 36.

LITERATURE

"Exhibitions: Third Annual Exhibition of American Art," *Bulletin of the Detroit Museum of Art* 11 (April–May 1917): 78 § Sloan Archives, undated letter, Dolly Sloan to Marjorie Henri, mentions purchase of painting by William Preston Harrison § LACMA, Registrar's files, William Preston Harrison to Louise Upton, June 5, 1926, states that he closed a deal for George Luks's *Pedro,* early 1920s (LACMA; q.v.) and imagined he would for *Town Steps* (he almost purchased the latter in 1916 when he met the artist in Gloucester), describes the painting as colorful and "a fine thing"; Harrison to Upton, June 24, 1926, details the purchase of the painting from Kraushaar Galleries; [LAMHSA] to Harrison, September 4, 1926, painting has arrived in Los Angeles, "it is a stunning picture"; Harrison to Upton, November 11, 1934 § "Harrison Gallery of American Art Enriched," *California Graphic* 4 (November 13, 1926): repro., 7 § Louise Upton, "Gift to the Harrison Gallery," *LA Museum Graphic* 1 (January–February 1927): 95, repro., 94 § Harrison 1934, p. 47, repro., incorrectly states that the painting was purchased from the artist in 1925 § *Index 20th Cent. Artists* 1 (August 1934): 168, 173; reprint, pp. 231, 237; listed in colls. and repros. § John Sloan, *The Gist of Art* (New York: American Artists Group, 1939), p. 250, comments on the painting as quoted above, repro. § *California Arts and Architecture* 57 (February 1940): repro., 5 § Higgins 1963, p. 59, no. 71 in checklist of Mr. and Mrs. William Preston Harrison collection § LACMA, American Art department files, Rowland Elzea to Ilene Susan Fort, December 2, 1985, discusses Gloucester paintings and provides exhibition history for *Town Steps, Gloucester* § Rowland Elzea, *John Sloan's Oil Paintings: A Catalogue Raisonné* (forthcoming, University of Delaware Press, Wilmington), listed as no. 469.

York paintings. The original title, *The Town Steps,* is misleading because of the definite article. There were several sets of stairs between the streets of Gloucester, none singled out as "the" town steps.

Years later, after looking at a reproduction of the painting, Sloan commented, "Thoroughly satisfactory is my memory of this painting refreshed by the photograph. These wooden steps were a pedestrian thoroughfare connecting streets on two levels. The girls are healthy types of the native population. Rich in color and convincing in light. I'd like to see it again."

PROVENANCE

The artist § With C. W. Kraushaar Galleries, New York, 1926 § Mr. and Mrs. William Preston Harrison, Los Angeles, 1926–27.

William Wendt

Born February 20, 1865,
Bentzen, Prussia (now
Germany)
To United States 1880
Died December 29, 1946,
Laguna Beach, California

Known as "the dean of Western artists" and "painter laureate of California," William Wendt was widely considered to be the best landscape painter working in Los Angeles during the first quarter of the twentieth century. He immigrated to Chicago in 1880, and, except for attending evening classes at the School of the Art Institute of Chicago, he was self-taught. After winning the second Yerkes Prize of the Chicago Society of Artists exhibition at the Art Institute in 1893, he decided to begin his career as a professional artist. He soon achieved success as a landscape painter, winning a bronze medal at the Pan-American Exposition in Buffalo in 1901, a silver medal at the Universal Exposition in Saint Louis in 1904, and other awards. In 1894 Wendt began traveling to California for extended visits. He spent about a year painting in England, 1898–99, and made a second trip to England and the Continent in 1903. In 1906 he married the sculptor Julia Bracken (1871–1942) of Chicago and they settled permanently in Los Angeles. A joint exhibition of their work was held in Chicago at the Art Institute in 1909.

Wendt quickly assumed leadership among Southern California artists, helping in 1909 to organize the California Art Club and serving as its president from 1911 to 1917; he was appointed president emeritus in 1930. He was elected an associate member of the National Academy of Design in 1912. Wendt built a second studio in Laguna Beach in 1918 and moved there about 1923. He was given a solo exhibition at Stendahl Art Galleries, Los Angeles, in 1926, near the end of what was his most productive period. He made his last trip to Europe, primarily to Bavaria, in 1926. Stendahl Art Galleries and the Los Angeles Museum organized retrospective exhibitions of his work in 1938 and 1939 respectively. He painted little after the late thirties.

BIBLIOGRAPHY
Charles Francis Browne, "Some Recent Landscapes by William Wendt," *Brush and Pencil* 6 (September 1900): 257–63 § Mabel Urmy Seares, "William Wendt," *American Magazine of Art* 7 (April 1916): 232–35 § *William Wendt and His Work* (Los Angeles: Stendahl Art Galleries, 1926), with essays by Antony Anderson, Fred S. Hogue, Alma May Cook, and Arthur Millier, list of honors, published in conjunction with a solo exhibition at the Stendahl Art Galleries § Laguna Beach (Calif.) Museum of Art, *William Wendt, 1865–1946*, exh. cat., 1977, with text by Nancy Dustin Wall Moure § Long Beach, California State University, University Art Museum, *In Praise of Nature: The Landscapes of William Wendt*, exh. cat., 1989, eds. Constance W. Glenn and Sue Taylor-Winter, with introduction by Glenn, essays by Diane M. Roe, Lynn O' Brien, and Patricia Colby-Hanks, chronology by Colby-Hanks, bibliography.

Wendt, *The Mantle of Spring.*

The Mantle of Spring, 1917
(*Spring's Mantle*)
Oil on canvas
50 x 60¼ in (127.0 x 153.0 cm)
Signed and dated lower right: ·1917·WILLIAM WENDT·
Gift of Los Angeles District Federation of Women's Clubs
21.2

Wendt's earliest work appears to have been in the poetic tonalist style of the Chicago painters of the period that had evolved toward a form of impressionism, but throughout his career Wendt retained a sensitivity to the spiritual and poetic aspects of nature, as shown in his choice of motifs and titles.

He was particularly attracted to the appearance of the hills in springtime, when the seasonal rains bring a lush greenness to the grass and live oaks, as in this painting. Its unusually strong greens and deep shadows combine to make it one of Wendt's most lyrical and tender works, notwithstanding its large size and vigorous, choppy brushwork. The high horizon and even, overall pattern of light and shade

contribute to the decorative quality often found in Wendt's variety of impressionism.

The Mantle of Spring was an early acquisition of the museum, the first work of art given to any institution by the Los Angeles District Federation of Women's Clubs, who presented it in "grateful tribute to the Boys of America who gave their lives and the Mothers who gave their Sons in the World War." It was one example of the numerous cases nationwide of art patronage resulting from the First World War.

PROVENANCE
The artist, 1917–21.

ON DEPOSIT
Office of Judge James H. Pope, Hall of Justice, Los Angeles, 1942–45 § Whittier College, Whittier, Calif., 1945–75.

EXHIBITIONS
New York, National Academy of Design, *Ninety-Third Annual Exhibition,* 1918, no. 84 § City Art Museum of Saint Louis, *Thirteenth Annual Exhibition of Paintings by American Artists,* 1918, no. 72, as *Spring's Mantle* § LAMHSA, *Summer Exhibition,* 1921, no. 59 § LAMHSA 1928, no. 52 § LACMHSA, *William Wendt, A.N.A., Retrospective Exhibition,* 1939, no. 23 § Laguna Beach Museum of Art, *Wendt,* no. 31, repro., p. 18.

LITERATURE
"A War-Time Academy," *American Art News* 16 (March 23, 1918): 2 § LAMHSA, *Foreign Arts and Crafts Exhibit, under the Auspices of the Americanization Department of the Los Angeles District California Federation of Women's Clubs,* exh. cat., 1921, unpaginated, text by Alma May Cook, repro. § "Painting Presented to the Museum," *LA Museum Art Dept. Bull.* 2 (July 1921): 57–58, repro., 57 § Mildred McLouth, "William Wendt: An Appreciation," *LA Museum Graphic* 1 (November–December 1926): repro., 56 § *Wendt and His Work,* repro., p. 19 of illustrations, with descriptive caption § Arthur Millier, "Museum's Own Collection of Paintings Now on View," *Los Angeles Times,* July 30, 1933, pt. 3, p. 5 § John Allan [*sic*] Walker, "William Wendt Retrospective: Sunshine and the Brooding Melancholy of Nature," *American Art Review* 4 (January 1978): 54, 56, 104, compared with the "Ocean Park" series begun in 1967 by Richard Diebenkorn, repro., 104.

Wendt, *California Landscape.*

California Landscape, 1920
Oil on canvas
31⁵⁄₁₆ x 70³⁄₁₆ in (79.6 x 178.3 cm)
Signed and dated lower left: ·WILLIAM WENDT·1920·
Gift of James O. McReynolds, Robert Coulter McReynolds, and Mrs. Edwin L. Harbach in fond memory of their mother, Frances Coulter McReynolds, and their father, Dr. Robert Phillips McReynolds
53.13

According to James O. McReynolds, his parents, Dr. and Mrs. Robert Phillips McReynolds, commissioned this painting from Wendt. Its unusual proportions may indicate that it was intended for a specific location in the McReynoldses' house. The painting would have been very successful as a decorative design, the vigor of its brushwork enlivening the generally flat and rhythmic composition.

PROVENANCE
Dr. and Mrs. Robert Phillips McReynolds, 1920 § James O. and Robert Coulter McReynolds and Mrs. Edwin L. Harbach (by descent), Los Angeles, to 1953.

ON DEPOSIT
Los Angeles County Marriage License Bureau, 1954–72.

EXHIBITIONS
Pasadena (Calif.) Center, *California Design 1910,* 1974, entries not numbered § Laguna Beach Museum of Art, *Wendt,* no. 5.

LITERATURE
LACMA, Registrar's files, James O. McReynolds to Jean Delacour, June 2, 1953, states that the artist "undertook" the painting for his parents § "American Paintings," *LACMA Bulletin* 6 supp. (Summer 1954): repro., 13 § Nancy Dustin Wall Moure, "California Design 1910: Southern California Landscape Painting," *American Art Review* 1 (November–December 1974): 138.

Wendt, *Where Nature's God Hath Wrought.*

Where Nature's God Hath Wrought, 1925

(*What Nature's God Hath Wrought*)
Oil on canvas
50�5/16 x 60�1/16 in (127.8 x 152.6 cm)
Signed and dated lower right: ·WILLIAM WENDT·1925·
Mr. and Mrs. Allan C. Balch Collection
25.19.1
Color plate, page 67

This painting regularly has been referred to as Wendt's masterpiece since first being called that in the book published in conjunction with the Stendahl Art Galleries' 1926 exhibition of Wendt's work. In many respects it is entirely characteristic of Wendt's mature paintings: in its subject being the California foothills, its restrained palette, its noon light, its broad, long, regular brushstrokes, and its simplification of forms.

Wendt's approach to composition was to find a motif and let it dictate the structure of the composition. His paintings generally give the impression of an intimate encounter with a modest portion of a landscape and are not formally composed. *Where Nature's God Hath Wrought,* in contrast, is an extremely bold and powerful composition, at once dramatic and unified. Wendt always sought the spirit of the landscape and its deeper meaning; the title of this painting is his strongest statement of that philosophy. Many have remarked on the inspirational quality of the mountain's upward thrust. According to critic Arthur Millier, the view is of Morro Bay, north of San Luis Obispo in central California, where Wendt occasionally worked in the 1920s. As Millier noted, the bay's distinctive soaring hill formations afforded Wendt a "supreme opportunity to express his profound feeling for the structural balance."

The last digit of the date Wendt inscribed on the canvas is ambiguous. In recent literature the date given has been 1923, but exhibition and literature references suggest that the artist painted *Where Nature's God Hath Wrought* in 1925 or shortly before. The first record of the painting is its inclusion in the Los Angeles Museum's *First Pan-American Exhibition of Oil Paintings* of 1925–26. It is doubtful that Wendt would have contributed a painting several years old to such a significant exhibition. Furthermore, the fact that the canvas is unusually large for Wendt might be explained by its function as a major showpiece.

The painting shared, with the modernist *Parthenope* by JOHN CARROLL (LACMA; q.v.), the Balch Prize in the *Pan-American Exhibition,* achieving for the artist considerable local distinction. It was the one exception to the awards jury's preference for progressive styles. This may be explained, in part, by a deference to Wendt's preeminence among Los Angeles artists. At the same time, however, the painting's breadth and simplified, somewhat geometric forms would have appealed to the taste of the jurors.

PROVENANCE
The artist, 1925.

ON DEPOSIT
Whittier College, Whittier, Calif., 1945–72.

EXHIBITIONS
LAMHSA, *First Pan-American Exhibition of Oil Paintings,* 1925–26, no. 52, repro., unpaginated, awarded Balch Prize § San Francisco, California Palace of the Legion of Honor, *First Exhibition of Selected Paintings by American Artists,* 1926–27, no. 217, repro., unpaginated § LAMHSA 1928, no. 51 § San Francisco, *Golden Gate International*

Exposition, Department of Fine Arts, Division of Contemporary Painting and Sculpture, Official Catalogue: Contemporary Art, 1939, no. 401 § Pomona, Calif., Los Angeles County Fair Association, National Exhibition of Sculpture and California Paintings, 1941, no. 54 of noncompetitive works § Claremont, Calif., Pomona College, Montgomery Art Center, Los Angeles Painters of the Nineteen-Twenties, 1972, no. 48, dated 1923 § Oakland Museum, California Landscape, 1975, no cat. § Laguna Beach Museum of Art, Wendt, no. 72, p. 27, repro., p. 33, dated 1923 § LACMA 1980, no. 11, pp. 18–19, repros., cover, p. 18, dated 1923 § Newport Beach, Calif., Newport Harbor Art Museum, and Santa Barbara (Calif.) Museum of Art, California: The State of Landscape, 1872–1981, 1981, no. 23, p. 14, mentioned in essay by Betty Turnbull, repro., p. 32, dated 1923.

LITERATURE
Sonia Wolfson, "Pan-American Exhibition," California Graphic 3 (November 28, 1925): repro., 13 § LACMNH, Archives, Museum Scrapbook, undated clipping, Los Angeles Evening Express, Alma May Cook, "Both Artists and Laymen Find Appeal in Landscape Interpretation," "unlike Carroll's Parthenope, the painting appeals to both the educated and the layman"; unidentified clipping, Caroline Walker, "Awards Give Museum New Art Works" § "Record Crowds View Pan-American Art Exhibit," Los Angeles Times, December 1, 1925, pt. 2, repro., p. 12 § "Wendt and Carroll Win Chief Awards," Art News 24 (December 5, 1925): 1, five-thousand-dollar Balch award shared between the artist and John Carroll § Sonia Wolfson, "Art and Artists," California Graphic 3 (December 12, 1925): 6, repro., 7 § Antony Anderson, "Of Art and Artists: More Hours with the Pan-American," Los Angeles Times, December 13, 1925, pt. 3, p. 39, mentioned as winning Balch purchase prize, considered among the finest of the artist's landscapes, repro. § M. Urmy Seares, "The All-American Art Show in Los Angeles," California Southland 8 (January 1926): 10, repro., 9 § "Awards for Pan-American Exhibition," LA Museum Art Dept. Bull. 7 (January 1926): 205, "this landscape is one of his finest canvases, painted with dignified taste, reserved skill and a strong feel-

ing for construction that is characteristic of Mr. Wendt's work," repro., 207 § Antony Anderson, "Of Art and Artists: Our Own Painters at Pan-American," Los Angeles Times, January 3, 1926, pt. 3, p. 26 § California Art Club Bulletin 1 (January–February 1926): repro., cover § Mary M. Buff, "The Pan-American Exhibition," American Magazine of Art 17 (February 1926): repro., 73 § Roberta Balfour Thudichum, "The Significance of the Pan-American Exhibition," Western Arts 1 (February 1926): 30, listed under award winners § Wendt and His Work, unpaginated text section, listed under "Honors," repro. of photograph of the artist "working on his masterpiece," p. 15 of illustrations, repro. of painting, p. 21 of illustrations § Arthur Millier, "Of Art and Artists," Los Angeles Times, April 25, 1926, pt. 3, p. 30, identifies the site § Mildred McLouth, "William Wendt: An Appreciation," LA Museum Graphic 1 (November 1926): repro., cover § American Art Annual 23 (1926): repro., facing 65 § Arthur Millier, "Museum's Own Collection of Paintings Now on View," Los Angeles Times, July 30, 1933, pt. 3, p. 5 § "Best Southern California Art Selected for Showing at San Francisco Fair," Los Angeles Evening Herald and Express, December 17, 1938, pt. A, p. 16, repro., as What Nature's God Hath Wrought § Higgins 1963, p. 105, dated 1923 § John Alan Walker, "William Wendt, 1865–1946," Southwest Art 4 (June 1974): repro., 45 § Gerald F. Brommer, Landscapes (Worcester, Mass.: Davis, 1977), repro., p. 24, dated 1923 § John Allan [sic] Walker, "William Wendt Retrospective: Sunshine and the Brooding Melancholy of Nature," American Art Review 4 (January 1978): 56, 102, repro., p. 57, dated 1923 § "Painting and Sculpture in Los Angeles, 1900–1945," LACMA Members' Calendar 18 (September 1980): unpaginated, repro., cover, dated 1923 § Maudette Ball, "Los Angeles and the Modern Era," Artweek 11 (November 8, 1980): 5, "Wendt's painting, which captures the low, scrub-covered California hills against a rough outcropping of rock, is installed as a signature for the exhibition" § Who's Who in the California Art Club, Inc., Roster and By-Laws (Los Angeles: California Art Club, 1984), p. 6, repro., p. 7, dated 1923 § Fort 1986, p. 425, fig. 5, p. 424.

Stanton Macdonald-Wright

Born July 8, 1890,
Charlottesville, Virginia
Died August 22, 1973,
Los Angeles, California

Cofounder of synchromism and one of the most influential artists in Southern California, Stanton Macdonald-Wright was raised in Santa Monica and studied art as a teenager with Joseph Greenbaum (1864–1940) and at the Art Students League of Los Angeles with Warren T. Hedges (1883–1910). In 1907 he went to Paris, where he enrolled at the Sorbonne, Académie Colarossi, Ecole des Beaux-Arts, and Académie Julian. He exhibited publicly for the first time in 1910 at the Salon d'Automne. In 1911 he attended classes conducted by Ernest Percyval Tudor-Hart (1873–1954) in which he learned much about color theory and met MORGAN RUSSELL. Together they formulated the theory of synchromism, asserting that color was an abstract medium capable of conveying light, space, and form. The two first exhibited together as synchromists in June 1913 at the Neue Kunstsalon in Munich and again a few months later in Paris at the Bernheim-Jeune gallery; they showed the following year in New York at Carroll Galleries. Macdonald-Wright exhibited in the landmark Forum Exhibition of Modern American Painters of 1916 and was given a solo exhibition by Alfred Stieglitz (1864–1946) at his "291" gallery in

March 1917. From 1916 to 1919 Macdonald-Wright worked in New York, painting synchromies that were based on human figures, still-life paintings, and landscapes.

Macdonald-Wright returned to Southern California in 1919 and maintained a residence in the Los Angeles area for the rest of his life, becoming the area's dean of modernist art and, along with LORSER FEITELSON (after his arrival in 1927), influencing the next generation. He directed the Art Students League of Los Angeles for most of the twenties, beginning in 1922. During that decade he experimented with color film, an extension of his interest in colored light. He continued to paint figures and landscapes but in a less cubist, fragmented manner. During the depression Macdonald-Wright served as director of the Southern California Federal Art Project. He received mural commissions, the most extensive for the Santa Monica Public Library (National Museum of American Art, Smithsonian Institution, Washington, D.C.); he also invented "petrachrome," a modification of terrazzo for permanent murals.

In his search for a new means of artistic freedom he became increasingly fascinated with the Orient, visiting Japan in 1937 and later, in 1952–53, dividing his time between Kyoto and Santa Monica. Zen philosophy and oriental art offered him the means to create a more transcendent vision. By the 1930s Macdonald-Wright's subjects were often oriental sages and Buddhist myths and legends. He taught oriental philosophy and art history at the University of California, Los Angeles, for a decade beginning in 1942. His paintings of the mid-1940s are basically synthetic-cubist compositions; he returned briefly to synchromism in the 1950s. After suffering a severe heart attack he devoted his time to writing on art and poetry. In 1965–66 he illustrated haiku poems with wood-block prints.

BIBLIOGRAPHY
Willard Huntington Wright, "Synchromism," in *Modern Painting: Its Tendency and Meaning* (New York: Dodd, Mead, 1915), pp. 277–304 § Washington, D.C., Smithsonian Institution, National Collection of Fine Arts, *The Art of Stanton Macdonald-Wright,* exh. cat., 1967, published by Smithsonian Institution Press, with introduction by David W. Scott, excerpts and treatise on color by the artist, bibliography § Los Angeles, University of California, Art Galleries, *Stanton Macdonald-Wright: A Retrospective Exhibition, 1911–1970,* exh. cat., 1970, with interview with the artist by Frederick Wight § *American Art Review* 1 (January–February 1974): 48–68, issue devoted to the artist, with essays by David W. Scott and Henry Clausen and interview with the artist by John Alan Walker § New York, Whitney Museum of American Art, and others, *Synchromism and American Color Abstraction, 1910–1925,* exh. cat., 1978 (copublished with George Braziller, New York), by Gail Levin, with reprints of synchromist catalogues, biographical notes, bibliography.

Synchromy in Purple, c. 1917
(*Synchromy in Purple and Green*)
Oil on canvas
36 x 28¹/₁₆ in (91.5 x 71.2 cm)
Inscribed and signed verso across top, now relined:
"America" / Synchromy in Purple / S. Macdonald Wright / California
Los Angeles County Fund
60.51
Color plate, page 61

Macdonald-Wright created relatively few completely nonobjective synchromies, fearing that such work could deteriorate into "aimless 'free' decoration" ("The Artist Speaks: Stanton Macdonald-Wright," *Art in America* 55 [May 1967]: 73). He preferred instead to base his color abstractions on the figure. He and Morgan Russell both greatly admired the muscular figures of Michelangelo (1475–1564) and used his powerful human forms in their paintings. *Synchromy in Purple* is one of many paintings in which the artist based the composition on a heroic figure. In *Synchromy in Blue,* 1916 (Weyhe Gallery, New York, as of 1978), the figure is presented in almost the same seated pose, its large, muscular body nearly bursting beyond the edges of the canvas.

Synchromy in Purple is typical of the color abstractions Macdonald-Wright painted around 1916 and 1917. The artist purged his palette of blended tertiary colors, relying largely on the primary and secondary hues of the color spectrum—in this case using reds, blues, purples, and yellows—and often presenting them as complementary color chords. While Russell's palette had been limited to these colors as early as 1913, Macdonald-Wright did not adopt such prismatic hues until later. Unlike Russell, Macdonald-Wright employed white extensively, thereby creating paintings with a softer, more crystalline luminosity. Moreover, he did not present the colors as fractured colored planes; here he sketched in the basic contours and even some of the details of the face with arcing blue lines and applied the brilliant hues in long strokes. The white and color passages function together to suggest

Macdonald-Wright, *Synchromy in Purple.*

chromies such as this example appear less avant-garde. Macdonald-Wright's paintings would always retain a certain luminous delicacy, and these qualities accorded well with his later fascination with oriental philosophy and art.

PROVENANCE
Stanley Barbee, Beverly Hills, Calif. § With Paul Kantor, Los Angeles § With Rose Fried Gallery, New York, as of 1955 § With Esther-Robles, Los Angeles, to 1960.

EXHIBITIONS
New York, Rose Fried Gallery, *Stanton Macdonald Wright,* 1955, no. 3, dated 1918 § Fort Worth, Tex., Amon Carter Museum of Western Art, and others, *The Artist's Environment: The West Coast,* 1962–63, no. 24, repro., p. 71 § Albuquerque, University of New Mexico Art Museum, and San Antonio, Marion Koogler McNay Art Institute, *Cubism: Its Impact in the USA, 1910–1930,* 1967, no. 36, repro., p. 38 § LACMA and New York, Metropolitan Museum of Art, *The Cubist Epoch,* 1970 (copublished with Phaidon, New York), no. 200, repro., p. 179 § University of California, Los Angeles, Art Galleries, *Macdonald-Wright,* no. 9, repro., unpaginated § San Jose (Calif.) Museum of Art, *American Series,* VII: *America between the Wars,* 1976, no cat. traced § Whitney Museum of American Art and others, *Synchromism,* 1978–79, entries not numbered, pl. 112, p. 106 § LACMA, *Contrasts: Selections from the Permanent Collection, Twentieth Century,* 1985, no cat.

LITERATURE
LACMA, *Illustrated Handbook of the Los Angeles County Museum of Art,* 1965, p. 101, repro. § Joseph E. Young, "Los Angeles," *Art International* 15 (May 20, 1971): 77, repro., 91 § John Alan Walker, "Interview: Stanton MacDonald-Wright," *American Art Review* 1 (January–February 1974): repro., 60 § Moure with Smith 1975, repro., p. 306 § LACMA 1980, p. 33, discussed as *Synchromy in Purple and Green,* not exhibited § Fort 1986, p. 425.

light and dark and consequently a modeled human body. Despite Macdonald-Wright's intentions, the color becomes almost a decorative overlay, and consequently the later syn-

Preston Dickinson

Born September 9, 1889, New York, New York
Died November 30, 1930, Irun, Spain

Preston Dickinson was a modernist and is most often identified with precisionist images of New York. His subject matter and style, however, were much more eclectic and varied. From 1906 to 1910 he studied at the Art Students League under WILLIAM M. CHASE and others, deriving from Chase a dark, impressionist style. An extended period of study in Paris from 1910 or early 1911 to 1914 exposed him to cubism, fauvism, and non-Western art, especially Japanese prints.

Upon his return to New York Dickinson's modernist paintings attracted the attention of the progressive dealer Charles Daniel. Fascinated by New York's skyscrapers and bridges, in particular the Harlem Bridge, Dickinson began in the late 1910s to paint urban scenes. At first he used a flat, somewhat decorative planar style, which was transformed into his mature precisionist style during the next decade. In 1918 he expanded his imagery to include industrial forms such as factories and grain elevators. He also often drew and painted still-life compositions. Although he participated in exhibitions of the more avant-garde artists, Dickinson was a loner. He traveled extensively and while in Spain with fellow artist Oronzo Gasparo (born 1903) died suddenly of pneumonia.

BIBLIOGRAPHY
Index 20th Cent. Artists 3 (January 1936): 217–18; 3 (August–September 1936): 1; reprint, pp. 510–11, 525 § *Dictionary of American Biography,* s.v. "Dickinson, Preston," with bibliography § Lincoln, University of Nebraska, Sheldon Memorial Art Gallery, and others, *Preston Dickinson, 1889–1930,* exh. cat., 1979–80, text by Ruth Cloudman, bibliography § Richard Lee Rubenfeld, "Preston Dickinson: An American Modernist, with a Catalogue of Selected Works," Ph.D. diss., Ohio State University, 1985, with bibliography, list of exhibitions.

Dickinson, *Maine Landscape.*

Maine Landscape, c. 1917–21

Oil on canvas
20 1/16 x 24 3/8 in (51.0 x 61.9 cm)
Signed lower right: Preston Dickinson
Mr. and Mrs. William Preston Harrison Collection
35.18.3

Although best known for his urban images, Dickinson did paint landscapes, and in the late 1910s he began a series of watercolors and drawings of houses and mountains that was inspired by paintings of Mont Sainte-Victoire by Paul Cézanne (1839–1906). In these paintings Dickinson presented the buildings and terrain as a series of angular planes compressed in space. *Maine Landscape* is not as cubist as his other landscapes. The artist seems to have reveled in the circular movement of the tree form. His vigorous handling of the tree is carried through the entire painting, with thick strokes applied in an almost explosive manner. While perhaps revealing the early influence of Chase, the brushwork and vibrant, nonrepresenta-

tional color are indebted to fauvism. Indeed, these Cézannesque landscapes are the most expressive Dickinson ever painted.

Dickinson rarely titled or dated his paintings, and the titles and dates that were established by his dealers Charles Daniel and Edith Halpert have been questioned by the art historians Ruth Cloudman and Richard Rubenfeld. *Maine Landscape* entered the museum's collection in 1935 with a "circa 1929" dating but later was given a date of about 1927. Rubenfeld dates Dickinson's Cézannnesque landscapes as early as 1916 and Cloudman slightly later, 1919, both suggesting that his less radically modernist works were painted shortly after his first stay in Paris. While Dickinson is known to have visited Maine for a month in 1926, he traveled extensively and may have been in the area earlier. Moreover, the identification of the locale as Maine may not be accurate, since many of the paintings were given titles by dealers. Stylistically similar landscapes were purchased by Ferdinand Howald in October 1917 and January 1921, so *Maine Landscape* probably dates from the period 1917–21.

PROVENANCE
B. D. Saklatwsalla § (Sale, S. G. Rains Galleries, New York, 1934) § With C. W. Kraushaar Art Galleries, New York, 1934 § Mr. and Mrs. William Preston Harrison, Los Angeles, 1934–35.

EXHIBITIONS
Laguna 1958, no. 56 § Albuquerque, University of New Mexico Art Museum, and others, *Cubism: Its Impact in the USA, 1910–1930,* 1967, no. 25.

LITERATURE
LACMA, Registrar's files, William Preston Harrison to Louise Upton, July 6, 1934–January 2, 1937, discusses how he acquired the painting at auction through Kraushaar Galleries' assistance § *Index 20th Cent. Artists,* 217; reprint, p. 510; listed in colls. incorrectly as *Marine Landscape* § Higgins 1963, p. 63, no. 141 in checklist of Mr. and Mrs. William Preston Harrison collection, incorrectly as *Marine Landscape* § Rubenfeld, "Dickinson," pp. 361–62, lists as no. 36, considers similar to *The Hill* (National Museum of American Art) and dates c. 1918–19., fig. 37, p. 214.

George Luks

Born August 13, 1866,
Williamsport, Pennsylvania
Died October 29, 1933,
New York, New York

George Benjamin Luks was one of the original Ash Can school painters whose scenes of lower-class city life upset conservative taste for propriety and genteel subject matter. Not many details of his life are known. He was quite a storyteller, and most of what is known about him derives from the myth that he cultivated about his own personality. He supposedly was boisterous, a hard drinker, and a braggart.

Luks studied at the Pennsylvania Academy of the Fine Arts in Philadelphia for only one month in 1884, but five years later he went abroad to study in Düsseldorf and Munich and to visit museums in Paris and London. He associated with the small group of artists who congregated around ROBERT HENRI in Philadelphia during the early 1890s and consequently became indoctrinated with Henri's attitudes toward subject matter and technique.

Luks began his career as a newspaper illustrator, first working for the Philadelphia *Press,* then covering the Spanish-American War in Cuba for the *Evening Bulletin.* He later made illustrations for the New York *World* and *Journal.* At the *Journal* he drew the weekly comic page known as "The Yellow Kid." When his paintings began to sell he stopped working for newspapers. He moved to New York sometime during the late 1890s. In 1908 he participated in the landmark exhibition of The Eight at Macbeth Gallery that established the validity of the themes painted by the Henri circle.

Luks was known for his gutsy images of street life, in particular his figure paintings of beggars, urchins, and other colorful personalities, all painted in a dark palette and with energetically brushed, impastoed surfaces. He also painted landscapes and numerous portraits on commission—among his most famous is *Otis Skinner as Colonel Bridau,* 1919 (Phillips Collection, Washington, D.C.)—and he submitted drawings to the socialist weekly *The Masses.* In 1925 Luks spent two months in Williamsport, in the coal-mining region of Pennsylvania, drawing and painting coal miners. He taught at the Art Students League in New York from 1920 to 1924 and later organized his own school.

BIBLIOGRAPHY
Elisabeth Luther Cary, *George Luks,* American Artists Series (New York: Whitney Museum of American Art, 1931), with biographical note, bibliography § Newark (N.J.) Museum, *Catalogue of an Exhibition of the Work of George Benjamin Luks,* exh. cat., 1933, with biography § *Index 20th Cent. Artists* 1 (April 1934): 97–104; 1 (September 1934): I; 2 (September 1935): III; 3 (August–September 1936): V; reprint, pp. 139–46, 155, 157, 159 § Utica, N.Y., Munson-Williams-Proctor Institute, *George Luks, 1866–1933,* exh. cat., 1973, with essays by Ira Glackens and Joseph S. Trovato § Wilkes-Barre, Pa., Wilkes College, Sordoni Art Gallery, and others, *George Luks: An American Artist,* exh. cat., 1987, with essays by Stanley L. Cuba, Nina Kasanof, and Judith O'Toole.

Czechoslovakian Army Entering Vladivostok, Siberia, in 1918, 1918
(*Czecho-slovak Soldiers in Snow*)
Oil on canvas
36½ x 53⅜ in (92.6 x 135.5 cm)
Signed and dated lower right: George Luks / 1918
Inscribed, painted over, lower left:
CZECHO-SLOVAK ARMY / ENTERING
VLADIVOSTOK-SIBERIA / PERSONAL DESCRIPTION
BY LIEUTENANT DANIELOVSKY
Mr. and Mrs. William Preston Harrison Collection
25.6.1
Color plate, page 62

Artists actively participated in the numerous efforts to raise money for the Allied cause during World War I. As part of the Fourth Liberty Loan Drive, New York's Fifth Avenue was transformed into an art gallery during October 1918. Paintings devoted to the different Allied nations were displayed in shop windows. During this period Luks was inspired to paint a series of war-related compositions.

The Czechoslovakian march through Siberia and the Czechoslovakian drive for independence during the war were causes célèbres that were repeatedly headlined in the newspapers. During the war Czech troops joined the Russians to fight on the side of the Allies. With the withdrawal of Russia from fighting after the signing of the Treaty of Brest-Litowsk in 1918, the Czechs were forced to leave Russia. They marched through Siberia and despite many impediments caused by poor weather and adverse political conditions reached Vladivostok in May 1918. There they boarded ships to journey to France, where they were to join other Allied forces. Luks depicted these soldiers arriving in Vladivostok.

Luks no doubt became involved in the Czech cause through his friendship with the sculptor Gutzon Borglum (1871–1941), who had became closely involved in the Czech cause and even permitted his home in Stamford, Connecticut, to be used as a military base for the training of American-born Czech volunteers. Luks visited Borglum during this time and once joined him

in painting posters to raise funds for the camp. Although Luks did not see the Czech army advancing in Siberia, he may have observed new soldiers practicing marching and attacking. He depicted the camp in Connecticut at least once, in *Czechoslovakians in American Camp Celebrating Their Recognition as a Country*, 1918 (unlocated; exhibited Allied War Salon, American Art Association Galleries, New York, 1918). Such an experience enabled Luks to become familiar with the Czech uniforms as depicted in *Czech-slovak Chieftain*,

erty Loan Drive. It certainly was finished by the time of the Allied War Salon in December.

In his usual bold brushwork Luks depicted the long column of Czech soldiers marching behind their leader on a cold winter day. The scene is simple, reduced to a central horizontal band of figures on a slight diagonal, with the background consisting of a few buildings. The composition of the scene relates to Luks's other war paintings of marching figures, *The Blue Devils on Fifth Avenue*, 1917 (Phillips Collection, Washington, D.C.), and *The Bersaglieri*,

Luks, *Czechoslovakian Army Entering Vladivostok, Siberia, in 1918*.

1919 (Newark [N.J.] Museum), and also the new country's flag. Although the red-and-white striped flag Luks delineated in the museum's painting is not the design eventually selected for the national flag, it is the one depicted by Henry Rittenberg (1879–1969) in his painting of the Czech army that was carried down Fifth Avenue during the celebrations in October 1918.

This is the only major war scene Luks painted that he could not have witnessed first-hand. He based his painting on a photograph and description of the actual event told to him by a Lieutenant Frank Danielovsky. Danielovsky was one of the select dignitaries asked to participate in the Czechoslovak Day celebrations along Fifth Avenue on October 3, 1918. Luks inscribed in the lower-left corner of the painting that Danielovsky was his source, but at some unknown time the inscription was painted over. Although Luks could have painted *Czechoslovakian Army Entering Vladivostok, Siberia, in 1918* as early as May, he may have painted it as late as October, after the Czech Day celebrations of the Fourth Lib-

1918 (National Gallery of Art, Washington, D.C.). The overall impression is less agitated, however, due to the larger and broader areas of color. The palette is intense, with a cool, white, snowy foreground against a brilliant blue sky and touches of flaming oranges in the flag and distant buildings.

RELATED WORK
Study for painting, 1918, on paper, 32 x 66 in (81.3 x 167.6 cm). New York art market, 1950s.

PROVENANCE
With C. W. Kraushaar Galleries, New York § Mrs. D. C. Phillips, Washington, D.C., 1918–24 § With C. W. Kraushaar Galleries, New York, 1924 § Mr. and Mrs. William Preston Harrison, Los Angeles, 1924–25.

EXHIBITIONS
Possibly New York, C. W. Kraushaar Galleries, [exhibition title unknown], 1918, no cat. traced § New York, Galleries of the American Art Association, *Allied War Salon*, 1918, no. 225 § Washington, D.C., Corcoran Gallery of Art, *Exhibition of Selected Paintings from the Collections of Mrs. D. C. Phillips and Mr. Duncan Phillips of Washington*, 1920, no. 3, as

Czecho-slovak Soldiers in Snow § Newark Museum, *Luks,* no. 38, p. 23, mentions it was painted from a description by Lieutenant Danielovsky § Munson-Williams-Proctor Institute, *Luks,* no. 48, repro., p. 37.

LITERATURE
"What Local Artists Are Doing," *New York Herald,* October 6, 1918, pt. 3, p. 6, refers to a Czecho-Slovak painting in Kraushaar Galleries and notes that Luks was now assisting Gutzon Borglum in his war efforts in Connecticut § *American Art News* 17 (November 23, 1918): repro., 1 § "Current Notes," *Art World and Arts and Decoration* 10 (December 1918): repro., 97 § A. E. Gallatin, "The Allied War Salon," *American Magazine of Art* 10 (February 1919): repro., 114 § Leila Mechlin, "Notes of Art and Artists," *Sunday Star* (Washington, D.C.), March 7, 1920, pt. 2, p. 11, considers it impressive but less brilliant than Luks's *The Blue Devils on Fifth Avenue* § Catherine Beach Ely, *The Modern Tendency in American Painting* (New York: Sherman, 1925), p. 91 § "A Luks for Los Angeles Museum,"

Art News 23 (May 9, 1925): 3 § "Give Los Angeles Six More Pictures," *Art News* 23 (May 30, 1925): 1 § *Art News* 24 (January 23, 1926): repro., 11 § "The Harrison Collection of Paintings," *California Southland* 8 (February 1926): repro., 15 § Louise Upton, "Gift to the Harrison Gallery," *LA Museum Graphic* (January–February 1927): 93 § LACMA, Registrar's files, William Preston Harrison to Louise Upton, June 11, 1934, notes Mr. Kraushaar called the painting "a sort of Tour de Force—a masterpiece perhaps" § *Index 20th Cent. Artists,* pp. 98, 101; reprint, pp. 140, 143; listed in colls. and repros. § Harrison 1934, p. 39, purchased 1924, repro. § Higgins 1963, p. 57, no. 22 in checklist of Mr. and Mrs. William Preston Harrison collection § LACMA 1977, p. 146, repro. § LACMA, American Art department files, Martha Carey to Ilene Susan Fort, May 29, 1985, clarifies the early ownership of the painting § Sordoni Art Gallery, and others, *Luks,* 1987–88, p. 37, Cuba discusses in context of Luks' association with Gutzon Borglum and the Czech cause.

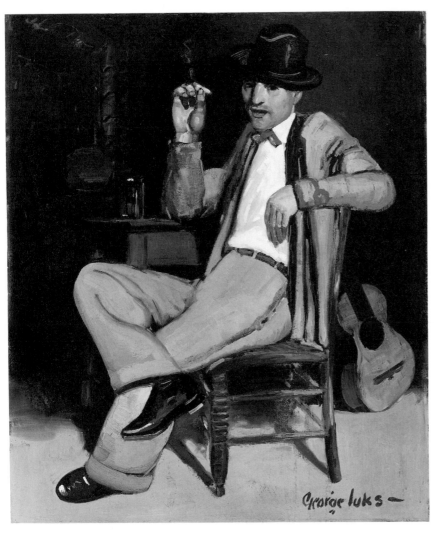

Luks, *Pedro.*

Pedro, early 1920s
Oil on canvas
52⅜ x 44⅜ in (133.0 x 112.9 cm)
Signed lower right: George luks-
Mr. and Mrs. William Preston Harrison Collection
27.7.11

The collector William Preston Harrison purchased *Pedro* directly from Luks after examining all the works in his studio. He was delighted with the acquisition, considering it a prime museum piece and definitely portraying a modern character. Harrison even preferred it to the artist's *The Polish Dancer,* c. 1927 (Pennsylvania Academy of the Fine Arts, Philadelphia), which had been exhibited at the Los Angeles Museum's Pan-American exhibition in 1925–26 and which Harrison thought to be one of the greatest works in the show. His purchase of the painting out of the artist's studio may explain why the painting was not mentioned in any of the early literature on Luks.

Luks painted the café scene in a somber palette of metallic blue, gray, dark brown, and black. It is enriched by a bravura surface, the paint being laid on so thickly and with such flat, broad strokes that the artist probably built it up with a palette knife. The brushwork is almost coarse in appearance, a treatment complementary to the low-life character that Luks portrayed. As Harrison so perceptively noted, the painting is a "character study" of "a queer looking type of chap with guitar alongside."

PROVENANCE
The artist, to 1926 § Mr. and Mrs. William Preston Harrison, Los Angeles, 1926–27.

EXHIBITIONS
Honolulu Academy of Arts, *American Paintings,* 1932, no. 33 § Newark Museum, *Luks,* 1933–34, no. 53 § Laguna 1958, no. 45.

LITERATURE
LACMA, Registrar's files, William Preston Harrison to Louise Upton, June 5 [?], 1926, discusses

subject; Harrison to William A. Bryan, October 9, 1926 § Louise Upton, "Gift to the Harrison Gallery," *LA Museum Graphic* 1 (January–February 1927): 93, repro. § Sonia Wolfson, "Art and Artists," *California Graphic* 4 (January 8, 1927): repro., 6 § Harrison 1934, p. 39, incorrectly lists date of purchase as 1925, repro., cover, dated c. 1922 § *Index 20th Cent. Artists*, pp. 98, 103; reprint, pp. 140, 145; listed in colls. and repros. § *California Arts and Architecture* 57 (February 1940): repro., 14 § Higgins 1963, p. 59, no. 59 in checklist of Mr. and Mrs. William Preston Harrison collection.

Armin Hansen

Born October 23, 1886,
San Francisco, California
Died April 23, 1957,
Monterey, California

Armin Carl Hansen was among the foremost Northern Californian artists in the early twentieth century and was heralded as "the Winslow Homer of the West Coast." He was most often identified with powerful seascapes and genre scenes of fisherfolk. Inspired by the example of his father, the frontier painter H. W. Hansen (1854–1924), Armin Hansen began studying art in 1903 at the Mark Hopkins Institute of Art with Arthur Mathews (1860–1945), but the San Francisco earthquake of 1906 cut short his studies there. He continued his studies abroad with Carlos Grethe (1864–1913) at the Royal Academy in Stuttgart. Hansen maintained a studio at Nieuwpoort, a rustic art colony near Oostende, on the coast of Belgium, where he painted the life of fishermen. While working on a trawler in the North Sea, he became well versed in the sea's moods. In 1910 he created his first works in etching, a medium in which he excelled.

Despite the recognition he received while exhibiting abroad—where he won a prize for his painting *Low Tide* (unlocated) at the 1910 Exposition Universelle et Internationale de Bruxelles—Hansen returned to the United States in 1912 and began teaching at the University of California, Berkeley. Within a year he had settled permanently in Monterey, where he painted his best-known, dramatic canvases of the coast. During the 1910s and 1920s he directed the summer landscape classes of the Monterey branch of the California School of Art and formed the Carmel Art Association. He exhibited extensively throughout the country, receiving many honors, and was accorded several solo exhibitions, among them one at the Helgesen Gallery in San Francisco in 1913 and several at the Milch Galleries, New York, during the 1920s. In 1925 he was elected to the National Academy of Design. As a result of a visit to Taos, New Mexico, in 1930, he briefly turned away from his marine paintings to depict the desert and people of the Southwest.

BIBLIOGRAPHY
Harry Noyes Pratt, "Three California Painters," *American Magazine of Art* 16 (April 1925): 198–201 § *California Art Research* 9 (1937): 105–33, with lists of works, collections, exhibitions, and awards, bibliography § "Dean of Western Painters," *Western Woman* 7 (1944): 3–4 § San Francisco, Maxwell Galleries, Ltd., *Armin Carl Hansen*, exh. cat., 1982 § Raymond R. White, *The Graphic Art of Armin C. Hansen* (Los Angeles: Hennessy & Ingalls, 1986), with catalogue of prints.

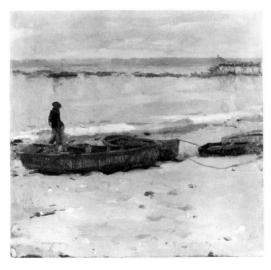

Hansen, *Boy with a Cod.*

Boy with a Cod, by 1919
(*Boy with Cod*)
Oil on canvas
30³/₁₆ x 32¼ in (76.7 x 81.9 cm)
Signed lower left: ARMIN HANSEN
Los Angeles County Fund
19.6
Color plate, page 64

Despite the title, *Boy with a Cod* is not one of Hansen's typical genre scenes of fishermen in which large figures dominated. The boy is small in scale and the cod not easily discernible. The painting is a seascape in which the figure of a boy merely serves to direct the viewer's gaze beyond the boats into the wide expanse of ocean and sky. Hansen was best known for his dramatic, stormy marines, but, as *Boy with a Cod* demonstrates, he was equally skilled in capturing the more delicate and

serene aspects of nature. The soft, grayish tones of blue and green are characteristic of the palette he established early on, and such color symphonies enabled the artist to capture the atmospheric conditions and mood of the coast on a cold afternoon. His practice of posing the figure in the open air no doubt encouraged the direct, fresh brushwork.

PROVENANCE
The artist, to 1919.

ON DEPOSIT
Whittier College, Whittier, Calif., 1945–72.

EXHIBITIONS
LAMHSA, *Exhibition of Paintings by a Group of Artists of San Francisco and Vicinity*, 1919, no. 10 § Brooklyn Museum, *Ninety-fifth Annual Exhibition of the National Academy of Design*, 1920, no. 268, awarded first Julius Hallgarten Prize § LAMHSA, *Summer Exhibition of Paintings*, 1920, no. 18 § LAMHSA, *Summer Exhibition*, 1921, no. 29, as *Boy with Cod* § LAMHSA, *Summer Exhibition*, 1922, no. 12, as *Boy with God* [*sic*] § LAMHSA, *Exhibition of Paintings from the Museum's Permanent Collection*, 1923, no. 7 § Laguna 1979, entries not numbered, repro., p. 91 § San Diego (Calif.) Museum of Art, *The Golden Land*, 1986–87, entries not numbered.

LITERATURE
Antony Anderson, "Of Art and Artists: The Northern Painters," *Los Angeles Times*, November 16, 1919, pt. 3, p. 2, describes as "a delicate play of grays and blues in a suave technique" § "Boy with a Cod," *LA Museum Art Dept. Bull.* 1 (January 1920): 14, repro. § "Los Angeles (CAL.)," *American Art News* 18 (January 3, 1920): 3 § "The National Academy Prizes," *American Art News* 18 (April 3, 1920): 1 § "Spring Academy in Brooklyn," *American Art News* 18 (April 10, 1920): 2 § "Summer Exhibition," *LA Museum Art Dept. Bull.* 1 (July 1920): 27 § *Paintings from the Permanent Collection* (Los Angeles: LAMHSA, 1928), no. 23 § *California Art Research*, p. 126 § Maxwell Galleries, *Hansen*, unpaginated.

Louis Ritman

Born January 6, 1889,
Kamenets-Podolski, Russia
To United States 1903/4
Died November 25, 1963,
Winona, Minnesota

A notable second-generation impressionist, Louis Ritman was best known for his informal scenes of women in gardens and interiors. Ritman began his career in Chicago, working as a sign painter while studying with Wellington J. Reynolds (b. 1869) at the Chicago Academy of Fine Arts. In 1907 he entered the School of the Art Institute of Chicago, studying with John H. Vanderpoel (1857–1911), and exhibited for the first time. He also studied with WILLIAM M. CHASE at the Pennsylvania Academy of the Fine Arts in Philadelphia before leaving for France in 1909. Although he attended the Ecole des Beaux-Arts, the painting excursions he made to the area around Giverny had a greater impact on his art. Having adopted impressionism by 1911, the following year Ritman rented a house in Giverny near the home of Claude Monet (1840–1926). He remained in France for most of World War I, returning in 1915 only for his solo exhibition at the Art Institute of Chicago. During his years in France Ritman continued to exhibit regularly in the United States and was accorded many solo exhibitions, including several at the Art Institute (1915, 1920, 1923) and throughout the Midwest and in New York at Macbeth Gallery (1919, 1925) and the Milch Galleries (1924, 1929). In 1930 Ritman returned permanently to Chicago and became professor of painting at the School of the Art Institute. He occasionally visited France. From 1951 to 1963 he summered in southeast Michigan, where he devoted himself to landscape painting.

BIBLIOGRAPHY
C. H. Waterman, "Louis Ritman," *International Studio* 67 (April 1919): LXII–LXIV § Chicago, Signature Galleries, *The Paintings of Louis Ritman (1889–1963)*, exh. cat., 1975, with essay by Richard H. Love, chronology, lists of awards and museum collections § Nicole de Fleur, *Ritman* (Random Lake, Wis.: Privately printed, n.d.).

Mademoiselle Gaby, by 1919
(*Gaby*)
Oil on canvas
45¼ x 57⅝ in (114.9 x 146.4 cm)
Signed lower right: L. RITMAN
Gift of Maurice Ritman and Mrs. Louis Ritman
M.81.161

Ritman shared with other American impressionists who worked at Giverny a fondness for intimate boudoir and parlor scenes. Such images were used by FREDERICK CARL

FRIESEKE and Ritman for the exploration of formal concerns, such as the action of sunlight in an interior. In *Mademoiselle Gaby* the young woman is at rest, holding a bunch of flowers that she has just picked. The woman's static pose, like that of an odalisque, is countered by the movement of the decorative patterns of her dress and the curtains and by the flickering of the broken, impressionist brushwork. In the early 1920s Ritman's palette deepened, as is evidenced by the warm red and blue of this

under the title *Gaby* at Macbeth Gallery in 1919 and during the next few years at the Paris Salon (1920), the Art Institute of Chicago (1920), and the Milch Galleries (1924).

painting. At the same time his compositions became simpler.

Early on during his residence at Giverny Ritman persuaded a young model now known only by her first name, Gabriel, to live with him. She served as the figure for many of his paintings and can even be seen wearing the same broad-brimmed hat that is in the museum's painting in *At the Table* (unlocated, illustrated *International Studio* 67 [April 1919]: LXII). Because Gaby was painted so often and Ritman created at least one other very similar interior scene, the exhibition records of *Mademoiselle Gaby* are difficult to verify. This painting may have been exhibited

Leopold Seyffert

Born January 6, 1887,
California, Missouri
Died June 13, 1956, Bound
Brook, New Jersey

Leopold Gould Seyffert was a popular portrait painter active in Philadelphia and New York from the late 1910s through the 1920s. He grew up in Colorado and was formally trained from 1906 to 1913 at the Pennsylvania Academy of the Fine Arts in Philadelphia, where he studied with Thomas Anshutz (1851–1912), Cecilia Beaux (1863–1942), HUGH H. BRECKENRIDGE, and WILLIAM M. CHASE. These instructors determined Seyffert's specializing in figure painting and his vigorous handling and rich palette. Chase also was influential in assisting the artist in obtaining his first portrait commissions.

Seyffert visited Europe in 1910 and again in 1912, staying the second time in Vollendam, Holland, and painting Dutch peasants. In the summer of 1914 he studied briefly with the Spanish artist Ignacio Zuloaga (1870–1945). On his return to Philadelphia he became involved in avant-garde art and music circles, forming a close friendship with Arthur B. Carles (1882–1952) and the conductor Leopold Stokowski. In the late 1910s he painted nude figures but in the next decade turned almost exclusively to portraiture, attracting commissions from such major figures in business and politics as Henry Clay Frick, Samuel Gompers, and Andrew Mellon. He was also noted for his charcoal portraits. Sponsored by the Grace Shipping Lines, Seyffert visited Guatemala in 1934, painting peasant subjects for canvases destined to decorate the company's ships. He taught at the School of Design for Women (now Moore College of Art) in Philadelphia and then at the School of the Art Institute of Chicago. Seyffert exhibited extensively throughout the country and received many awards. He was elected a full academician of the National Academy of Design in 1925.

BIBLIOGRAPHY
J. Frederick Lowes, "Leopold Seyffert," *All-Arts Magazine* 2 (March 1926): 7–15, 61, with lists of awards and portraits § George William Eggers, "Leopold Seyffert and His Place in American Portraiture," *American Magazine of Art* 20 (February 1929): 64–73 § New York, Berry-Hill Galleries, *Leopold Seyffert (1887–1956): Retrospective Exhibition,* exh. cat., 1985, with foreword by Gary A. Reynolds, essay and catalogue by Bruce W. Chambers, chronology, bibliography.

Nude with Chinese Background, 1919
(Nude [Oriental Background]; Nude with Oriental
Background; Reclining Figure; Silver Screen)
Oil on canvas
54½ x 60¼ in (138.5 x 153.1 cm)
Signed and dated lower left: Leopold Seyffert—
191[9]
Mr. and Mrs. William Preston Harrison Collection
23.6.3

From 1916 to 1922 Seyffert produced a number
of major canvases devoted to the nude, and
these were so well received when they were

Seyffert, *Nude with Chinese
Background.*

exhibited throughout the country that they
were usually immediately acquired for major
museums. The most modernist works Seyffert
was ever to produce, these canvases were no
doubt influenced by the nude studies painted
by his friend Arthur B. Carles. Both men used
the same model, beautiful red-haired Grace
Vernon, better known as "Bobby," who would
later become Seyffert's second wife. In several
paintings Seyffert placed Bobby in highly deco-
rative interiors with an ornate oriental screen,
panel, or drape as a backdrop. Her body was
treated as a single form and her extremities
generalized or attenuated. In *The Lacquer
Screen,* 1918 (Pennsylvania Academy of the
Fine Arts, Philadelphia), the curves of the
nude echo the calligraphic lines in the Chinese
coromandel screen behind her, but in *Nude*

with Chinese Background the figure is more
abstracted, her linear body contrasting with
the curving lines depicting the lohans (en-
lightened disciples of the Buddha) on the
background panel. By stylizing the figure and
using a creamy ivory, Seyffert accentuated the
woman's sensuous flesh. She appears almost
luminous, the shadows on her skin colored by
softer tints of the deep burgundy and green in
the drapery and the earth-colored panel that
surround her.

The painting was altered by the artist after
it was first exhibited. When shown at the
Pennsylvania Academy annual in 1919, it was
entitled *Silver Screen,* after the burnished silver
screen behind the figure. Seyffert decided to
repaint the background in about 1920,
incorporating a much more elaborate panel,
somewhat like the one in *The Lacquer Screen.*
He painted the background in large, sweeping
strokes, and the lohans seem to take on a life of
their own. William Preston Harrison, who
bought the painting from the artist, had seen
the work in both its original and altered states.

PROVENANCE
The artist, 1919–23 § Mr. and Mrs. William
Preston Harrison, Los Angeles, 1923.

EXHIBITIONS
Philadelphia, Pennsylvania Academy of the Fine
Arts, *114th Annual Exhibition,* 1919, no. 175, as *Silver
Screen* § Pittsburgh, Carnegie Institute, *Nineteenth
Annual International Exhibition of Paintings,* 1920,
no. 303, as *The Silver Screen* § Probably City Art
Museum of Saint Louis and others, *Paintings and
Drawings by Leopold Seyffert,* 1922, no. 1, as *Reclining
Figure* § LAMHSA 1924, no. 34, as *Nude (Oriental
Background)* § LACMHSA, *Review of the Mr.
and Mrs. William Preston Harrison Collection,* 1956,
no cat.

LITERATURE
"Pa. Academy Display," *American Art News* 17
(February 15, 1919): 2, refers to *Silver Screen* as a
"typical" Seyffert and describes the painting before
it was repainted § LACMA, Registrar's files,
William Preston Harrison to Louise Upton, April 5,
1923; Harrison to William A. Bryan, May 24, 1923,
describes recently acquired painting; Harrison to
Bryan, June 26, 1923, mentions that the painting was
on tour for the last six months; Harrison to Miss
Newton, June 28, 1923, discusses exhibitions,
literature references, the artist's repainting of back-
ground; Harrison to Bryan, November 21–December
3, 1923, discusses donation; Harrison to Bryan, June
27, 1924, says the artist is the most talked of man in
New York, the painting could not be bought for five
thousand dollars § "Mr. and Mrs. Harrison's Gift,"
LA Museum Art Dept. Bull. 5 (October 1923): 130,
repro., cover, as *Nude (with Oriental Background)* §
"Gives Los Angeles American Pictures," *Art News*

22 (November 3, 1923): 4, Harrison plans to donate painting § "Recent Additions to the Harrison Gallery," *LA Museum Art Dept. Bull.* 5 (January 1924): 140 § "Paintings Changed in Harrison Gallery," *For Arts Sake* 1 (January 1, 1924): 2 § Elizabeth Bingham, "Los Angeles," *Art News* 22 (January 12, 1924): 10 § "Gifts to the Los Angeles Museum," *American Magazine of Art* 15 (May 1924): 263, discusses change of background § Harrison 1934, p. 46, as *Nude with Oriental Background,* quotes unlocated letter from the artist of November 13, 1923, in which he explains dating, title, and repainting, repro. § "Harrison Gallery Great Gift to Los Angeles," *California Graphic* 3 (November 28, 1925): repro., 18 § Jules Langsner, "Moderns Newly Seen," *Art News* 55 (May 1956): 15 § Higgins 1963, p. 57, no. 14 in checklist of Mr. and Mrs. William Preston Harrison collection.

Hernando G. Villa

Born October 1, 1881, Los Angeles, California
Died May 7, 1952, Los Angeles, California

Hernando Gonzallo Villa was among the artists active in Los Angeles in the early part of this century and one of the few of Mexican descent. His father, Esiquia, was an artist, who with Hernando's mother had come from Baja California in 1846. In 1905 Villa graduated from the first local art academy, Los Angeles School of Art and Design, where he studied with its founder, Louise Elizabeth Garden MacLeod (1857–1944). After visiting England and Germany, in 1906 he began his career as a commercial artist and a forty-year association with the Sante Fe Railroad. He also worked for the Southern Pacific Railroad and illustrated West Coast magazines, such as *Town Talk,* but he was perhaps best known for the image of *The Chief,* which became the emblem for the Santa Fe Railroad. Villa also painted murals, and his decorations for the Panama-Pacific International Exposition of 1915 in San Francisco won him a gold medal. He specialized in paintings depicting early Californian, Native American, and Southwestern themes. He exhibited extensively in Los Angeles and in the mid-1930s showed easel paintings at the Academy of Western Painters.

BIBLIOGRAPHY
Los Angeles, Sotheby-Parke-Bernet, *American Indian Art and a Collection of Western Paintings by Hernando Villa,* auction cat., 1972 § Los Angeles, Sotheby-Parke-Bernet, *Important Nineteenth- and Early Twentieth-Century American Paintings . . . A Collection of Paintings by Hernando Villa,* auction cat., 1973 § Moure with Smith 1975, p. 258, with bibliography § Peggy and Harold Samuels, *The Illustrated Biographical Encyclopedia of Artists of the American West* (Garden City, N.Y.: Doubleday, 1976), p. 501 § Edan Milton Hughes, *Artists in California, 1786–1940* (San Francisco: Hughes Publishing, 1986), p. 478, with bibliography.

Villa, *Mission Ruins.*

Mission Ruins, 1920
Oil on board
11 x 14 in (27.9 x 35.6 cm)
Signed lower right: H.G. VILLA / Oct 18 / 20
Gift in memory of Dr. Carl S. Dentzel
M.80.193.2

Villa often painted the missions of Southern California and was so well acquainted with their architecture that he served as a consultant during the restoration of the Santa Barbara mission. The ruins in this painting are probably those of San Juan Capistrano, for other paintings of that mission inscribed with dates place Villa there in October 1920. Founded in 1776 by Father Junipero Serra, the San Juan Capistrano mission was one of twenty-one built by the Spaniards. After suffering extensive damage in an earthquake in December 1812, the church was used only as a warehouse, and many of the structure's stones and tiles taken for use elsewhere. The arches and wall fragment Villa delineated may have been from the mission's patio corridor.

PROVENANCE
The artist § Carl S. Dentzel, Los Angeles § Elisabeth Waldo-Dentzel (by descent), Northridge, Calif., 1960s–1980.

LITERATURE
LACMA, American Art department files, Elisabeth Waldo-Dentzel to Ilene Susan Fort, October 15, 1986, describes husband's collection of works by Villa.

Granville Redmond

Born March 9, 1871,
Philadelphia, Pennsylvania
Died May 24, 1935,
Los Angeles, California

Granville Redmond was one of the best and most prominent landscape painters of Los Angeles during the first decade of the century. Born Grenville Richard Seymour Redmond, the artist was four years old when his family moved to San José, California. They later moved to Los Angeles. Having been left completely deaf by scarlet fever, Redmond lived at the California School for the Deaf (then called the Institution of the Deaf, the Dumb, and the Blind) in Berkeley, where he received training in drawing and sculpture. After his graduation in 1890 he next attended the California School of Design in San Francisco, studying with Arthur Mathews (1860–1945) and Amédée Joullin (1862–1917) and receiving recognition for his good work. With funds lent by his former school's board of directors, in 1893 he was sent to Paris, where he studied with Benjamin Constant (1845–1902) and Jean-Paul Laurens (1838–1921) at the Académie Julian. He exhibited a winter landscape in the Paris Salon of 1895.

Leaving Paris in 1898, Redmond settled in Los Angeles. He changed his first name to Granville and married in 1899. He painted views of the Los Angeles area until 1908, when he moved to Northern California. In contrast to his absence from exhibitions in later life, during this period he sent works to exhibitions in Philadelphia, Saint Louis, and Seattle. He settled in Parkfield in Monterey County in early 1908, but moved to Menlo Park, California, in 1910, and that year exhibited in San Francisco and Los Angeles. He had solo exhibitions at commercial galleries and in 1914 at the Los Angeles Museum.

In 1917 Redmond returned to Los Angeles and worked as a pantomimist; he was befriended by Charlie Chaplin, who gave him roles in several of his movies, including *City Lights* (1931). Redmond also had a feature role in Raymond Griffith's mystery, *You'd Be Surprised* (1926). Chaplin also gave the artist the use of a studio on his movie lot to paint in, where Redmond worked until shortly before his death in 1935.

BIBLIOGRAPHY
Everett C. Maxwell, "Art and Drama Department," *West Coast Magazine* 13 (December 1912): 347–50 § Arthur Millier, "Our Artists in Person," *Los Angeles Times,* March 22, 1931, pt. 3, p. 28 § Nancy Dustin Wall Moure, "Five Los Angeles Artists in the Collections of the Los Angeles County Museum of Art," *Southern California Quarterly* 57 (Spring 1975): 27–51 § Mildred Albronda, "Granville Redmond: California Landscape Painter," *Art and Antiques* 5 (November–December 1982): 46–53 § Oakland Museum and others, *Granville Redmond,* exh. cat., 1988, with text by Harvey Jones and Mary Jean Haley, chronology by Mildred Albronda, bibliography.

Redmond, *Landscape.*

Landscape, c. 1920
Oil on canvas
30⅜ x 40½ in (76.7 x 102.3 cm)
Stamped verso upper right: G. G. Redmond / 1871 1935
Gift of Edith H. Redmond in memory of Jean Redmond
M.83.9

Granville Redmond came to prominence as a landscape painter at a time when ideal, tonal landscapes were painted by a substantial percentage of artists both in Southern California and internationally. Foggy, nocturnal, and twilight scenes in which subdued light suppressed details, flattened space, and reduced the range of color to a dominant tonality were characteristic of his early work in Los Angeles. Although many of his paintings are undated, it seems that Redmond continued the tonal style throughout much of his career alongside the

brightly colored impressionist scenes that he began to paint about 1912 and for which he is known today. In an interview in 1931 Redmond complained that he preferred to paint pictures of solitude and silence but could only sell poppy fields (in Millier, "Our Artists in Person"). The distinctness of the brushstrokes, uniform in length and direction, creating a tapestrylike quality similar to that in the museum's *California Poppy Field*, c. 1926, suggests that *Landscape* was painted later in

Redmond's career, after the formation of his mature style. It is among the largest and most developed of his later tonal landscapes.

PROVENANCE
The artist § Jean Redmond (by descent) § Edith H. Redmond (Mrs. Jean Redmond, by descent), La Crescenta, Calif., 1983.

EXHIBITION
Oakland Museum, and others, *Redmond*, 1988–89, no. 63, repro., p. XVII.

Redmond, *California Poppy Field.*

California Poppy Field, c. 1926

Oil on canvas
40¼ x 60¼ in (102.3 x 153.1 cm)
Signed lower right: Granville Redmond
Inscribed verso upper right: G. G. Redmond / 1871
1935
Gift of Raymond Griffith
40.7
Color plate, page 68

Soon after developing his more brightly colored impressionist style during the early 1910s, Redmond became identified with his paintings of poppy fields, meeting a steady demand with not a few potboilers. It is easy to imagine why this subject should have become so popular, since the dry, nearly colorless native Southern California landscape offers nothing to compare with the broad expanses of poppies, lupine, and other wildflowers that transform the landscape with their brief springtime blossoming during several weeks in February and March. The carpet of bright flowers is seen against the more

delicate colors of the brush and foliage that have been freshened by the winter rains. Like many others of his mature works, the museum's exceptionally large and impressive example was painted on an especially rough fabric that adds to the strong sense of overall texture. Redmond's brushstrokes, distinct, short dashes of color strongly suggesting intervening atmosphere, contribute to this sense of texture. Except for accents, such as the blooms in this painting, Redmond's palette is usually deeper than that of many of the American impressionists. Its ownership by Raymond Griffith suggests a date for the museum's painting of around the time of his association with the artist in 1926.

PROVENANCE
Raymond Griffith, Beverly Hills, Calif., to 1940.

ON DEPOSIT
Los Angeles County Health Department, 1941 § Sanitation Office, Old Hall of Records, Los Angeles, 1969 (or earlier) to 1971.

EXHIBITIONS
Pasadena (Calif.) Center, *California Design 1910,* 1974, entries not numbered § LACMA 1980, no. 3, p. 11, repro., p. 10, dated c. 1910 § Montclair (N.J.) Art Museum and others, *Down Garden Paths: The Floral Environment in American Art,* 1983–84, entries not numbered, repros., p. 95, facing p. 112 § Oakland Museum and others, *Redmond,* 1988–89 no. 36, repro., p. 84.

LITERATURE
Nancy Dustin Wall Moure, "California Design 1910: Southern California Landscape Painting," *American Art Review* 1 (November–December 1974): repro., 141 § Moure, "Five Los Angeles Artists," repro., 43 § Moure with Smith 1975, repro., p. 300 § LACMA, American Art department files, Mildred Albronda to Michael Quick, May 1, 1987, discusses dating and possible commission.

Guy Pène du Bois

Born January 4, 1884, Brooklyn, New York
Died July 18, 1958, Boston, Massachusetts

Guy Pène du Bois holds a distinctive place in the history of twentieth-century American art for he was as famous for his art criticism as for his painting. He enrolled in the Chase School in New York in 1899, and when ROBERT HENRI took over in 1902, du Bois came under his spell. In 1905 he accompanied his father, Henri Pène du Bois, a noted critic and writer, to Paris, where he studied at the Académie Colarossi and with Theodore Steinlen (1859–1923). After the death of his father in 1906 du Bois returned to the United States. Following his father's example, he turned to journalism, first as a reporter on the *New York American.* By 1909 he had become their full-time art critic. Until well into the 1920s financial demands necessitated that his writing take priority over his painting. He spent a year on the *New York Tribune* as Royal Cortissoz's assistant. Du Bois also edited the magazine *Arts and Decoration* (1913–16, 1917–21) and wrote for the *New York Post.* During the 1920s he was a frequent contributor to *The Arts* and in 1932 to the short-lived *Arts Weekly.* He also participated in the planning of the Armory Show and was a member of the Society of Independent Artists and of the Whitney Studio Club, where he had his first solo exhibition in 1918. He taught occasionally, opening his own school in 1932, teaching at the Art Students League in 1935, and in 1938 at a summer art school in Amagansett, New York.

Beginning in 1924 du Bois devoted himself exclusively to painting. He and his family moved to France, where they lived for almost six years, residing in the countryside near Paris. This move marked the beginning of his mature period and the painting of his best-known works. During his entire painting career du Bois focused on contemporary city life. Bringing a somewhat cynical attitude to his depiction of the upper class, du Bois developed a sleek figurative style to reflect his view of an over-indulgent society. He thus developed a personal brand of realism that was an outcome of Henri's teachings but infused with urbanity and sophistication derived from his French heritage and experiences abroad.

BIBLIOGRAPHY
New York, Collections of Willa Kim, Yvonne McKenney, and William Pène du Bois, Guy Pène du Bois Papers (on microfilm, Archiv. Am. Art) § *Index 20th Cent. Artists* 2 (November 1934): 28–32; 2 (September 1935): II; 3 (August–September 1936): V; reprint, pp. 281–85, 287, 289 § Guy Pène du Bois, *Artists Say the Silliest Things* (New York, American Artists Group, 1940) § John Baker, "Guy Pène du Bois on Realism," *Archiv. Am. Art Journal* 17, no. 2 (1977): 2–13, with unedited draft of the artist's manuscript "Realism" § Washington, D.C., Corcoran Gallery of Art, and others, *Guy Pène du Bois: Artist about Town,* exh. cat., 1980, with text by Betsy Fahlman, chronology, bibliography.

An American Oriental, 1921

(*New York Oriental*)
Oil on canvas
20 1/16 x 25 1/8 in (50.8 x 63.9 cm)
Signed and dated lower left: Guy Pène du Bois 21
Mr. and Mrs. William Preston Harrison Collection
39.9.7

An American Oriental dates from the first years of du Bois's mature period and consequently is not completely characteristic of his later work. It was originally exhibited as *New York Oriental,* the term *Oriental* referring to a dark, exotic woman. The woman in this painting is not one of the fashionably dressed ladies du Bois usually depicted in his typical mature paintings but is a common, urban gypsy. In contrast to the two flappers depicted in *Shops,* 1922 (LACMA; q.v.), who also stand before a black, wrought-iron fence on a city street, this Oriental brazenly confronts the viewer with her direct gaze and open, frontal pose.

Du Bois was a master of modern design. He conceived the Oriental as dark, shadowy, and fully modeled in contrast to the flat, brilliant orange brick wall she stands before and the gleaming white steps nearby. The scene is a slightly asymmetrical arrangement of three simplified areas of color held together by the iron

fence. The woman's head is slightly cropped by the top of the canvas. In the late nineteenth century this compositional device became synonymous with contemporaneity; it does not, however, appear in du Bois's other paintings. The brick wall and adjoining door are painted in the highly saturated hues that became the hallmark of his paintings from the 1920s.

University, Laband Art Gallery, *The Spirit of the City: American Urban Paintings, Prints, and Drawings, 1900–52,* 1986, entries not numbered.

LITERATURE
New York, Willa Kim Collection, Guy Pène du Bois Papers, Diary, May 23, 1921, entry (Archiv. Am. Art microfilm roll 2008, fr. 113), mentions finishing in Connecticut the painting of a "Jewess" that he had

Du Bois, *An American Oriental.*

PROVENANCE
With C. W. Kraushaar Art Galleries, New York, to 1931 § Mr. and Mrs. William Preston Harrison, Los Angeles, 1931–33.

EXHIBITIONS
New York, New Society of Artists, *Third Annual Exhibition,* 1921, no. 15, as *New York Oriental* § Philadelphia, Pennsylvania Academy of the Fine Arts, *119th Annual Exhibition,* 1924, no. 21, as *New York Oriental* § Los Angeles, Loyola Marymount

begun in New York that winter § LACMA, Registrar's files, William Preston Harrison to Louise Upton, November 9, 1931, refers to the "peculiar composition" § "Harrison Gifts," *Art Digest* 8 (March 1, 1934): 8 § *Index 20th Cent. Artists,* p. 28; reprint, p. 281; listed in colls., as *New York Oriental* § Harrison 1934, p. 26, incorrectly dates purchase to 1933, repro., p. 27 § Higgins 1963, p. 65, no. 194 in checklist of Mr. and Mrs. William Preston Harrison collection § Ruth Weisberg, "The City Revisited," *Artweek* 17 (March 22, 1986): 1.

Shops, by 1922
Oil on panel
25¹/₁₆ x 20¹/₁₆ in (63.6 x 50.9 cm)
Inscribed across shop fronts: GUY PENE DU BOIS
PAINTER FLOY PEN[E]
Los Angeles County Fund
25.7.3

Shops demonstrates that du Bois had fully developed his mature style and imagery by 1922. Two of his typical, fashionably attired women stop before a store so that one of them can adjust her stockings. Such a private act performed in a public place demonstrates the importance of appearances to flappers and the superficiality of their chic life-style. Du Bois's women always appear doll-like with the same mannered physical features—sleek, curvaceous outlines, rounded faces, and exceptionally tiny feet. Such stylization precludes any sense of individuality. Above the awning across the top of the picture du Bois printed his name and that of his wife, Floy (Florence Sherman Duncan). Besides being a clever signature, the inscription may indicate that du Bois's wife served as his model.

Shops won the Third Museum Prize when it was shown at the *First Pan-American Exhibition of Oil Paintings* at the Los Angeles Museum. One critic considered the painting very French in its light, gay spirit. Its rich colors and brilliant sunlight surely contributed to this impression. *Shops* was one of several paintings from the *Pan-American Exhibition* to be paro-

Du Bois, *Shops.*

Du Bois, verso of *Shops*.

died at the annual fakir celebration of the California Art Club, with Luvena Vysekal (d. 1954), artist and wife of EDOUARD VYSEKAL, depicting *GUY PENNY DE PEEP* as a striped awning above two pairs of legs.

On the back of the panel is an incomplete painting of a woman (see illustration).

PROVENANCE
The artist, to 1925.

EXHIBITIONS
New York, C. W. Kraushaar Art Galleries, *Paintings by Guy Pène du Bois*, 1922, no. 2, repro., cover § Pittsburgh, Carnegie Institute, *Twenty-second Annual International Exhibition of Paintings*, 1923, no. 34 § LAMHSA, *First Pan-American Exhibition of Oil Paintings*, 1925–26, no. 13, awarded Third Museum Prize of five hundred dollars § Fine Arts Society of San Diego, *Selected American Paintings*, 1927, no. 14 § LAMHSA 1928, no. 20 § LAMHSA 1930, no. 38.

LITERATURE
"The Social Satires of du Bois," *American Art News* 20 (April 8, 1922): 1 § LACMNH, Archives, Museum Scrapbook, unidentified clipping, Mary Marsh, "Art," characterizes as "very French in spirit" § "Wendt and Carroll Win Chief Awards," *Art News* 24 (December 5, 1925): 1 § Sonia Wolfson, "Art and Artists," *California Graphic* 3 (December 12, 1925): 6 § Antony Anderson, "Of Art and Artists: More Hours with the Pan-American," *Los Angeles Times*, December 13, 1925, pt. 3, p. 39 § "Awards for Pan-American Exhibition," *LA Museum Art Dept. Bull.* 7 (January 1926): 205 § Roberta Balfour Thudichum, "The Significance of the Pan-American Exhibition," *Western Arts* 1 (February 1926): 30, listed § *Index 20th Cent. Artists*, pp. 28, 32; reprint, pp. 281, 285; listed in colls. and repros. § du Bois, *Artists Say the Silliest Things*, repro., p. 275 § Corcoran Gallery, *du Bois*, p. 50 § Betsy L. Fahlman, "Guy Pene du Bois: Painter, Critic, Teacher," Ph.D. diss., University of Delaware, 1981, p. 122.

Jan Matulka

Born November 7, 1890, Vlachovo Brezi, Bohemia (now Czechoslovakia)
To United States 1907
Died June 25, 1972, New York, New York

Jan Matulka was active in the New York avant-garde during the decades between the world wars. His greatest impact was as one of the few modernist teachers in New York during the late 1920s and early 1930s. Matulka studied art in Prague for two years before his family immigrated to New York in 1907. In 1908 he began studying at the National Academy of Design, where he won the Joseph Pulitzer Prize, which enabled him to travel during 1917 and 1919 through Florida, Mexico, the Southwest, and Canada. Around 1916, as a result of his friendship with James Daugherty (1887–1974) and Jan Van Everen (1875–1947), he began to explore less-conservative ideas, and by 1920 he exhibited abstract works at the Société Anonyme's gallery in New York and in its landmark *International Exhibition of Modern Art* held at the Brooklyn Museum of Art in 1926. From 1920 to 1925 he made several extended trips to Europe, spending most of his time working in Paris and summering in Czechoslovakia. He became deeply involved in the artistic and intellectual life of Paris and Prague and exhibited with other European modernists in both cities. In New York Matulka participated in many group exhibitions, often at the Whitney Studio Club, and began his first sustained commercial affiliation with his 1927 exhibition at the Frank K. M. Rehn Galleries in New York. He became an active printmaker at this time. After 1925 his increased political consciousness was reflected in numerous illustrations contributed to the communist publication *New Masses* and his serving as artistic advisor to the Marxist Czech-American *Dělnik Kalendar* (Worker's Almanac). From 1929 to 1932 Matulka was an instructor at the Art Students League. With his extensive knowledge of advanced art trends of Western and Eastern Europe, he was one of the few teachers in New York who could encourage his students—among then Burgoyne Diller (1906–1965), Irene Rice Pereira (1907–1971), and David Smith (1906–1965)—to adopt modernism. During the Great Depression Matulka worked on various New Deal projects and was one of the few abstractionists to design murals, one of which was placed in the Williamsburg Federal Housing Project in Brooklyn.

Matulka's first modernist works were landscapes and still lifes influenced by the early work of Pablo Picasso (1881–1973), but by the 1920s he fell under the spell of the purists, such as Fernand Léger (1881–1955), and produced his most abstract still lifes and cityscapes. His later still-life compositions were similar to the work of Stuart Davis, while his landscapes reflected the influence of both Paul Cézanne (1839–1906) and the expressionists. By the mid-1940s Matulka was no longer considered an important figure in the art world. His work thereafter decreased in quality.

BIBLIOGRAPHY
Archiv. Am. Art, Jan Matulka Papers § Newark, Delaware Art Museum, *Avant-garde Painting and Sculpture in America, 1910–25,* exh. cat., 1975, p. 98, "Jan Matulka," by Gilbert T. Vincent, with bibliography § Washington, D.C., Smithsonian Institution, National Collection of Fine Arts, and others, *Jan Matulka, 1890– 1972,* exh. cat., 1980, published by Smithsonian Institution Press, with essays by Patterson Sims, Merry A. Foresta, and Dorothy Dehner, chronology, checklist of known prints by Janet A. Flint, lists of exhibitions, works in public collections, bibliography.

Matulka, *Autumn Landscape.*

Autumn Landscape, c. 1921–26
(*Landscape*)
Oil on canvas
28¹⁵/₁₆ x 34 in (73.5 x 86.4 cm)
Signed lower left: Matulka
Inscribed and dated upper stretcher bar: J. Matulka / Landscape 1926
Gift of Carl Hamilton
M.82.39

Matulka painted landscapes throughout his career; he interpreted them in a modernist idiom less radical than that of his still-life compositions. In 1921 he began summering regularly in Czechoslovakia and while there began his "Village" scenes. Although *Autumn Landscape* has an inscription on the stretcher dating it to 1926, the painting's style is more like that of his landscapes of 1921–23. The cubic structure of the houses suggests the influence of Cézanne and Picasso. The rich palette and exuberant brushwork reveal the impact of more contemporary art. Matulka may have known of the art of Franz Marc (1880–1916),

yet it is more likely that landscapes such as *Autumn Landscape* were informed by the post-World War I School of Paris, in particular, artists such as Roger de la Fresnaye (1885–1925) who were active in Paris when Matulka lived in that city. The brilliant hues—clear yellows, oranges, and russets, and bold blues and greens—are more allied with the second-generation cubists than with Picasso himself. Critics commented on the vibrance of Matulka's palette when this painting was exhibited in his first solo exhibition. Also seen in this and other landscapes shown in that 1927 exhibit is Matulka's overwhelming love of movement: not only did he often use the motif of a sweeping road to lead the viewer into his scenes, he also enlivened his surfaces with patches of flickering color that almost contradict the solidity of the forms.

Although the brilliant autumnal colors might suggest a New England locale, an area in which Matulka is known to have summered during the mid-1920s, the site may have been in France or Czechoslovakia. A partially erased inscription on the frame indicates Provence as the locale. For Matulka landscapes were personal reminiscences of places he knew intimately.

PROVENANCE
Carl Hamilton, Hollywood, as of 1930 to 1982.

ON DEPOSIT
LAMHSA, LACMHSA, and LACMA, 1930–82, as *Landscape.*

EXHIBITION
New York, Frank K. M. Rehn Galleries, [Jan Matulka and Hayley Lever exhibition], 1927, no cat. traced.

LITERATURE
Archiv. Am. Art, Jan Matulka Papers, unidentified newspaper clipping (microfilm roll D-251, fr. 260), review of 1927 Rehn Galleries exhibition, concentrates primarily on this landscape, praising its rich color and contrasts, repro. § "Jan Matulka, Hayley Lever, Rehn Galleries," *Art News* 25 (April 16, 1927): 9, refers to "screeching yellows" § Lloyd Goodrich, "Exhibitions in New York," *Arts* 11 (May 1927): repro., 268.

John E. Costigan

Born February 29, 1888,
Providence, Rhode Island
Died August 5, 1972,
Nyack, New York

John Edward Costigan gained prominence as the "American Millet" for his pastoral images. In 1903 he moved to New York, where he was hired by the H. C. Miner Lithographing Company. Costigan was to remain with the company for twenty-eight years, supporting his family and his own painting activities by his designs of theatrical posters. His art training was brief, consisting of a short stay at the Art Students League in 1906 and attendance at the unsupervised life classes at the Kit-Kat Club. He exhibited publicly for the first time in 1915 and became a frequent exhibitor at all the major annuals throughout the country, winning many awards during the 1920s, the high point of his career. In 1924 he was elected an associate member of the National Academy of Design and in 1928 was accorded full membership. His first solo exhibition in 1924 at the Frank K. M. Rehn Galleries in New York received favorable critical reviews. Having lost his job during the depression, he joined the Public Works of Art Project. In 1945 he returned to commercial art, illustrating McCall's *Bluebook* magazine for five years.

In 1919 Costigan married and moved to a farm in Orangeburg, New York, a rural community in Rockland County near New York City. His farm, livestock, and family would serve as his constant subjects for the rest of his life. The nature of his pastoral images changed only slightly over the years. In the 1920s he often painted scenes of his family enjoying nature in a forested area. In the 1930s Costigan presented his family in more open views, often actively working the land. The etchings and lithographs produced during the 1930s were allied with the then-popular school of social realism. Costigan also became known for his prints and watercolors.

BIBLIOGRAPHY
Ralph Flint, "Costigan, American Pastoralist," *International Studio* 80 (March 1925): 426–32 § Ivan Narodny, "John E. Costigan," in *American Artists,* Essay Index Reprint Series (1930; reprint, Freeport, N.Y.: Books for Libraries Press, 1969), pp. 13–22 § Ernest W. Watson, "John Costigan: The Millet of American Painting," *American Artist* 13 (October 1949): 27–29, 64 § Oshkosh, Wis., Paine Art Center and Arboretum, and others, circulated by Smithsonian Institution Traveling Exhibition Service, *John E. Costigan: A Retrospective Exhibition,* 1968, with essay by Richard N. Gregg, chronology, lists of awards and public collections.

Costigan, *Landscape with Figures.*

Landscape with Figures, 1923
(*Early Spring*)
Oil on canvas
Signed lower right: J E. COSTIGAN
45³/₁₆ x 50³/₁₆ in (114.7 x 127.4 cm)
Mr. and Mrs. William Preston Harrison Collection
25.6.5

During the early 1920s Costigan's characteristic themes and painting style emerged. In his most important canvases of this decade, such as *Landscape with Figures,* he depicted a peasant mother with a child and goats or other farm animals walking through a forest glade. Costigan used his wife, Ida Blessin (b. 1894), an accomplished sculptress, and their five children as models. Despite financial problems, which must have made life on the farm difficult, Costigan idealized rural life, conveying in his pictures a quiet, pastoral peacefulness. Removed from nearby New York City, Orangeburg became Costigan's Barbizon.

Despite the calm, soothing quality of his subjects, Costigan's paintings of the 1920s were alive with energy, created by his almost inces-

sant movement of pigment and flickering color. *Landscape with Figures* is a superb example of Costigan's work with its heavily encrusted surfaces, at times almost one-eighth inch thick. With a palette knife and the fullest of brushes he created impastoed passages that appear to be woven skeins of dripped pigment. His palette is equally charged: flecks of brilliant white, red, orange, magenta, yellow, green, dark blue, and brown emerge from a generally pale blue tonality. While the overall palette of *Landscape with Figures* is slightly sweeter than usual for this period, his paintings of the 1920s always glow with a variety of intense, warm hues. Costigan's treatment is a late and extreme manifestation of American impressionism, characterized not only by a decorative quality but by a vigor of paint and light.

This flickering of light and paint suggests an atmosphere alive with the movement and spirit of nature. The source for this transcendental mood—as well as a decorative quality—may have been one of Costigan's favorite paintings, *The Hermit*, 1908, by JOHN S. SARGENT, which Costigan often studied at the Metropolitan Museum of Art in New York. Both artists presented a landscape in which rich foliage and sunlight animate the scene and make it difficult to distinguish the figures from their setting. The figures literally as well as metaphorically become one with nature.

PROVENANCE
The artist, 1923–25 § Mr. and Mrs. William Preston Harrison, Los Angeles, 1925.

EXHIBITIONS
Possibly Art Institute of Chicago, *Thirty-sixth Annual Exhibition of American Paintings and Sculpture,* 1923, no. 51 § New York, National Academy of Design, *One Hundredth Annual Exhibition,* 1925, no. 333, awarded Saltus Medal for Merit § Laguna 1958, no. 46 § Los Angeles Municipal Art Department, *Artmobile for L.A. Elementary Schools,* 1968–70, no cat. traced.

LITERATURE
Flint, "Costigan," repro., p. 430, as *Early Spring* § Helen Comstock, "The One Hundredth Annual Brilliant in Color," *Art News* 23 (April 4, 1925): 1 § "Give Los Angeles Six More Pictures," *Art News* 23 (May 30, 1925): 1 § Harrison 1934, p. 23, dates to 1923, repro., p. 24 § Higgins 1963, p. 57, no. 19 in checklist of Mr. and Mrs. William Preston Harrison collection § LACMA, *George Inness,* exh. cat., 1985, p. 64, essay by Michael Quick, fig. 50, p. 66.

Eugene Savage

Born March 29, 1883, Covington, Indiana
Died October 19, 1978, Waterbury, Connecticut

Eugene Francis Savage was a late proponent of allegorical academic figure painting who continued this tradition in mural painting well into the middle of the twentieth century. He began his art education in 1899 by attending evening classes at the Corcoran School of Art in Washington, D.C. He also studied at the School of the Art Institute of Chicago, where he won the Prix de Rome competition. He resided at the American Academy in Rome from 1912 to 1915, and his experiences there determined the course of his art. Not only did he become a practitioner of academic painting, drawing heavily on allegorical subject matter and classical elements, he also became a proponent of the need for collaboration among the arts, a belief that led to his working as a muralist.

Savage is reported to have been in Munich for several months in 1913, studying art with Wilhelm Menzler (born 1846) and color theory with Hermann Groeber (1865–1935). He may have been exposed to Jugendstil and expressionist art at that time. In New York during the 1920s he gained a reputation as the most successful painter trained at the American Academy of Rome when he exhibited a series of easel paintings of idyllic subjects at the Architectural League. Savage also painted in the Florida Everglades and Hawaii. His first major mural commission was for the Elks National Memorial rotunda in Chicago, a large cycle completed in the late 1920s (watercolor studies for it are in the museum's collection; q.v.). Among the many mural commissions he received were ones for the Yale University Library, 1932–33, the Communication Building at the 1939 New York World's Fair, 1937–38, and the New York State Court of Appeals in Albany, 1958–59. Late in life he designed several mosaic murals. Savage taught at Yale University for more than twenty-five years, beginning in 1923. In 1933 he was appointed by President Hoover to the National Commission of Fine Arts, on which he served during the Roosevelt administration as well.

BIBLIOGRAPHY
Waterbury, Conn., Mattatuck Museum, artist's file § F. Newlin Price, "An Apostle of Unity," *International Studio* 79 (April 1924): 2–8 § Grand Lodge of the Benevolent and Protective Order of Elks of the United States, *The Elks National Memorial* (1931; reprint, Chicago: Elks National Memorial and Publication Commis-

sion, 1974) § *Index 20th Cent. Artists* 2 (April 1935): 109–11; 2 (September 1935): III; 3 (August–September 1936): IX; reprint, pp. 380–82, 386, 392 § Jean C. Sapin, "Eugene Francis Savage: American Muralist," Master's thesis, California State University, Northridge, 1979, with bibliography, list of known works.

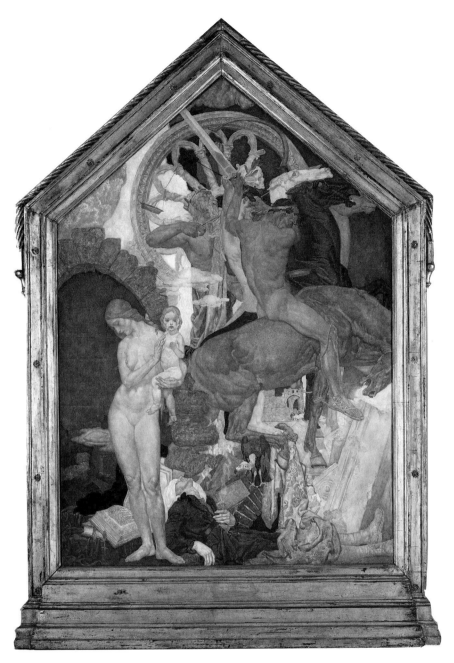

Savage, *Recessional.*

Recessional, 1923
Oil on canvas attached to panel
67½ x 47½ in (171.5 x 120.7 cm), peaked top
Signed and dated lower right: EVGENE / FRANCIS
SAVAGE / XXIII
Inscribed verso on panel upper left: RECESSIONAL
Gift of Los Angeles Art Association
M.78.85

Recessional was Savage's most critically acclaimed easel painting from the 1920s. He painted two almost identical versions, both dated 1923. He exhibited these canvases simultaneously throughout the country at annual art exhibitions from 1923 to 1925. The other version (Mattatuck Museum, Waterbury,

Connecticut) was awarded prizes when it was exhibited at the National Academy of Design in New York and the Art Institute of Chicago, while the museum's painting was awarded the John Schaffer Prize at the *First Pan-American Exhibition of Oil Paintings* at the museum in 1925–26.

Although the smaller of the two, the museum's painting is probably not a study in view of its large scale and complete finish. It may have been the first version, since in it basic changes to the composition are discernible: areas of a more opaque overpainting cover alterations, most notably a change in direction of the scales. The Italianate architectural frame is original and typical of Savage's presentation of his early easel paintings as early Renaissance altarpieces. The frame and painting technique reflect Savage's attempt to echo the early Renaissance masters he had studied in Italy.

Desiring his painting to appear as an old master fresco, Savage prepared the canvas surface with a thick layer of gesso, roughened the overall surface, and then sculpted many of the details before beginning to paint. The oil paint was applied in thin, transparent layers, which were wiped and set with a fixative, further creating the illusion of a frescoed surface.

Although the size and format suggest that Savage intended the painting to resemble an altarpiece, the subject is a modern allegory inspired by World War I. The artist employed the religious imagery of the Four Horsemen of the Apocalypse as the central motif to symbolize the war's destruction. A bulletin that was issued at the time the Los Angeles Art Association purchased the painting provides a detailed analysis of the imagery: the Four Horsemen trampling the world into ruins signify not only the tragedy of war in general but the recurring cycle of war, conquest, plague, and death. The older figure of the crowned archer is Greed, who releases his shaft of envy and hate toward the far horizon, while War, bearing a sword, is joined by Pestilence with his scales and Death with his scythe. A wounded man in uniform lies dying in the foreground. Remnants of the civilization that was destroyed by the war are scattered throughout. The large rose window of a cathedral forms a center backdrop and refers to the church, the support of humanity through the ages. For Savage the church imagery refers to the literary source of the painting's theme and title: Rudyard Kipling's famous poem "Recessional" (1897). Kipling believed that throughout the course of history God alone was immutable.

On the left, sheltered by a stone arch, an idealized female nude symbolizing Bereavement and Truth holds an infant who symbolizes the hope of Regeneration. At her feet are scattered a number of books, the largest of which is a Bible open to the Beatitudes.

The two versions of *Recessional* differ only in minor details: in the museum's version the infant has hair falling over her left eye (perhaps symbolically obstructing her view of the future), fewer books are piled up in the lower left, and the stonework of the wall in the background is different.

The painting was acquired through public subscription; over two hundred subscribers, including socially prominent figures and artists organizations, contributed through the Los Angles Art Association. Among them were the critic Arthur Millier and painters Carl Oscar Borg, Paul Sample, and HANSON PUTHUFF. Such diverse support reveals both Savage's stature during the thirties and the continued appetite for war memorials following the first World War.

RELATED WORKS
Recessional, 1923, oil on canvas, 105 x 72 in (266.7 x 182.9 cm). Mattatuck Museum, Waterbury, Conn. § Preparatory drawing, n.d., unlocated (reproduced *Scribner's Magazine* 75 [February 1924]: 234).

PROVENANCE
The artist, to 1935 § Los Angeles Art Association, 1935–78, purchased by subscription.

ON DEPOSIT
LACM and LACMA, 1961–78.

EXHIBITIONS
Washington, D.C., Corcoran Gallery of Art, *Ninth Exhibition of Contemporary American Oil Paintings,* 1923–24, no. 6 § Philadelphia, Pennsylvania Academy of the Fine Arts, *119th Annual Exhibition,* 1924,

no. 253 § Pittsburgh, Carnegie Institute, *Twenty-third Annual International Exhibition of Paintings,* 1924, no. 31 § City Art Museum of Saint Louis, *Nineteenth Annual Exhibition of Paintings by American Artists,* 1924, no. 84, repro., p. 37 § Indianapolis, John Herron Art Institute, *Eugene Francis Savage,* 1925, no. 2 § LAMHSA, *First Pan-American Exhibition of Oil Paintings,* 1925–26, no. 42, awarded John Schaffer Prize § Venice, XVII *Esposizione biennale internazionale d'arte,* 1930, no. 73.

LITERATURE
Mattatuck Museum, artist's file, "Artist's Statement," n.d., discusses theme; unidentified clipping, "*Recessional,* from the Painting by Eugene Savage," January 1, 1933, calls it "a first composition for the larger picture," repro. § "John's 'Mme. Suggia' Wins First Award," *Art News* 22 (May 3, 1924): 6 § LACMNH, Archives, Museum Scrapbook, unidentified clipping, Mary Marsh, "Art," in review of *Pan-American Exhibition* the painting is praised for its composition and careful detail; Museum Scrapbook, unidentified clipping, Caroline Walker, "Beauty Shown in Art for L.A. Exhibition," reviews *Pan-American Exhibition,* discusses painting at length; Museum Scrapbook, undated clipping, Vennerstrom Cannon, "The Pan-American Exhibition of L.A.," *La Jolla* [Calif.] *Journal* § Sonia Wolfson, "Pan-American Exhibition," *California Graphic* 3 (November 28, 1925): repro., 14 § "*Recessional* by Eugene F. Savage, N.A.," *Los Angeles Art* [Association] *Bulletin* 3 (1935): 1–4, discusses the artist and the iconography, with donor list and cover reproduction of the version in the collection of the Mattatuck Museum § Sapin, *Savage,* pp. 33–34, 38, 46, 49–50, 141, discusses frame, medium, palette, and iconography, lists selected exhibitions, pl. 7, facing p. 88.

NOTE
In all exhibition notices and literature, no mention is made of which version of Recessional *is considered. In some instances, such as the 1935 Los Angeles* [Association] *Art Bulletin article, the version reproduced is not the version discussed. Identification has been based on illustrations, archival material, and labels affixed to the back of the museum's version.*

Andrew Dasburg

Born May 4, 1887,
Paris, France
To United States 1892
Died August 13, 1979,
Taos, New Mexico

Andrew Michael Dasburg was an early American modernist long associated with New Mexico. He studied in New York at the Art Students League with Kenyon Cox (1856–1919), Frank V. DuMond (1865–1951), and Birge Harrison (1854–1929). While in Paris from 1909 to 1910 he met Gertrude and Leo Stein, Henri Matisse (1869–1954), and Pablo Picasso (1881–1973) and was introduced to the work of Paul Cézanne (1839–1906). Upon his return to the United States he became a prominent member of the modernist Rock City group of the Woodstock art colony.

Dasburg participated in the Armory Show in 1913. As the result of his friendships with MORGAN RUSSELL and Konrad Cramer (1888–1965) and his exposure to avant-garde ideas about abstraction and color, he created his first abstract paintings in 1913. He showed these in 1913 and 1915 at the progressive exhibits at the MacDowell Club and in the important *Forum Exhibition of Modern American Painters* in 1916. Dasburg's flirtation with pure abstraction was short lived, and by 1916 he had returned to more recognizable imagery. He remained, however, an important modernist, with his love of Cézanne and cubism determining the course of his art for the remainder of his life.

During the early teens Dasburg became an intimate of Mabel Dodge Luhan's circle and at her invitation first visited Taos in the winter of 1918. From 1920 until the early 1930s, when he moved permanently to the Southwest, Dasburg spent every winter in New Mexico and the remainder of the year in Woodstock or New York City. Until his art began to receive official recognition Dasburg supported himself by selling Indian and Spanish artifacts and occasionally teaching. In 1937 he was stricken with Addison's disease and stopped working until 1943, when he began to make works on paper. During the mid-1970s, in association with Tamarind Institute, he produced a series of lithographs.

BIBLIOGRAPHY
Archiv. Am. Art, Andrew Dasburg Papers § *Index 20th Cent. Artists* 3 (May 1936): 289–90; 3 (August–September 1936): II; reprint, pp. 587–88, 596 § Van Deren Coke, *Andrew Dasburg* (Albuquerque: University of New Mexico Press, 1979), with chronology, lists of paintings and drawings in public collections § Clinton Adams, "The Prints of Andrew Dasburg: A Complete Catalogue," *Tamarind Papers* 4 (Winter 1980–81): 18–25 § Sheldon Reich, *Andrew Dasburg: His Life and Art* (Lewisburg, Pennsylvania, and London: Bucknell University Press and Associated University Presses, 1989), with chronology, bibliography.

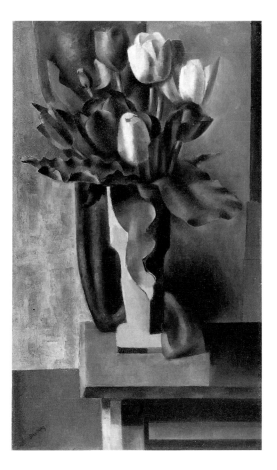

Dasburg, *Tulips*.

Tulips, c. 1923–24
Oil on canvas
30¹/₁₆ x 18³/₁₆ in (76.5 x 46.2 cm)
Signed lower left: Dasburg
Los Angeles County Fund
25.7.2
Color plate, page 65

Still-life paintings were important to Dasburg from the time he copied a Cézanne painting of apples owned by Leo Stein in Paris. During the 1920s he painted quite a few floral and fruit still lifes, using them as a vehicle for his analytical explorations of formal elements. As did Cézanne, he usually set his still-life objects before a plain background on a simple, wood table that appears tilted. The upward movement of the tulip's shape fascinated him, and he depicted the flower in a number of paintings. *Tulips* is one of the sparest and most vertical of Dasburg's still lifes, and its verticality may have been determined by the flower, which Dasburg placed almost in the center of the composition. The curved petals and the curves and ripples of the leaves establish a sense of movement and form both the dominant horizontal and vertical elements of the composition.

Since its showing in the *First Pan-American Exhibition of Oil Paintings* in the winter of 1925–26 the painting has been given a date of 1923. In an inventory compiled years later, Dasburg, somewhat hesitantly, dated it 1924. Either date could be correct, since Dasburg demonstrated his strongest interest in cubism at this time. He even published an article on cubism (*Arts* 4 [November 1923]: 278–84). *Tulips* is a classic example of Dasburg's interpretation of the aesthetic, for he defined cubism as "a kind of architectonic paraphrase of a motif." In his geometric shapes, flattening of objects and space, and jigsaw puzzle composition, Dasburg clearly acknowledged his debt to synthetic cubism.

Dasburg did not wholly adopt that aesthetic. He always retained more of the three-dimensional form than did the French—here in the softly modeled flowers. Moreover, he rejected the flatness, airlessness, and high-keyed palette of synthetic cubism. In *Tulips* Dasburg limited the intensity of the hues (muted purple, pink, orange, green, and gray) while giving them a rich subtlety by the use of passages of translucent paint. By applying the pigment in short, square strokes he increased the liveliness of the surface, so instead of being static, this highly geometric painting seems to shimmer and pulsate with life.

PROVENANCE
The artist, c. 1923–25.

EXHIBITIONS
Possibly New York, Whitney Studio Club, *An Exhibition of Paintings by Andrew Dasburg and Katherine Schmidt*, 1925, no. 1 § LAMHSA, *First Pan-American Exhibition of Oil Paintings*, 1925–26, no. 131, awarded Second Museum Prize of one thousand dollars § Fine Arts Gallery of San Diego (Calif.), *Paintings by the Woodstock Group of Artists*, 1928, no cat. traced § LAMHSA 1928, no. 17 § LAMHSA 1930, no. 37 § San Diego (Calif.), Palace of Fine Arts, *California Pacific International Exposition, Official Art Exhibition, Illustrated Catalogue*, 1936, no. 289 § Pomona, Calif., Los Angeles County Fair Association, *Painting in the U.S.A., 1721–1953*, 1953, no. 32, repro., p. 32 § Dallas Museum of Fine Arts, *Andrew Dasburg*, 1957, entries not numbered, unpaginated, cited in list of collections, repro. § American Federation of Arts (New York) sponsored traveling exhibition, *Andrew Dasburg*, 1959–61, no. 2, repro., unpaginated § Albuquerque, University of New Mexico Art Museum, *Andrew Dasburg: A Retrospective Exhibition*, 1979, exhibited but not listed.

LITERATURE
"Record Crowds View Pan-American Art Exhibit," *Los Angeles Times*, December 1, 1925, pt. 2, p. 12, repro. § "Wendt and Carroll Win Chief Awards," *Art News* 24 (December 5, 1925): 1 § Sonia Wolfson, "Art and Artists," *California Graphic* 3 (December 12, 1925): 6 § Antony Anderson, "Of Art and Artists: More Hours with the Pan-American," *Los Angeles Times*, December 13, 1925, pt. 3, p. 39 § "Awards for Pan-American Exhibition," *LA Museum Art Dept. Bull.* 7 (January 1926): 205 § Roberta Balfour Thudichum, "The Significance of the Pan-American Exhibition," *Western Arts* 1 (February 1926): 30, listed under award winners § Reginald Poland, "Woodstock Art in San Diego," *Art News* 27 (April 28, 1928): 2 § Arthur Millier, "Museum's Own Collection of Paintings Now on View," *Los Angeles Times*, July 30, 1933, pt. 3, p. 5 § *Index 20th Cent. Artists* 3 (May 1936): 289; reprint, p. 587, listed § Martha Chandler Cheney, *Modern Art in America* (New York: McGraw-Hill, 1939), pl. 4, facing p. 34 § Archiv. Am. Art, Andrew Dasburg Papers, "Oil Paintings by Andrew Dasburg: List Dictated by Dasburg . . . December 21, 1947" (microfilm roll 2053, fr. 58), no. 8 of paintings, with annotation "painted 1924 (?)" § LACMA, Registrar's files, Charlotte Trego to Nancy Dustin Wall Moure, May 23, 1975, discusses Dasburg's recollection of the painting § Coke, *Dasburg*, pp. 71, 73–75, 137, fig. 36, p. 72, incorrectly dated 1926.

Orrin A. White

Born December 5, 1883,
Hanover, Illinois
Died April 28, 1969,
Pasadena, California

Orrin Augustine White was a prolific landscape painter in Southern California, where his scenes appealed to the popular taste for impressionism. He was graduated from the University of Notre Dame, Notre Dame, Indiana, in 1902 and taught science and drawing at Columbia University (now the University of Portland) in Portland, Oregon, from 1902 to 1904. He studied textile design at the Philadelphia School of Applied Arts and was a textile designer for several years. He came to Los Angeles in 1912, painting landscapes in his spare time while working for an interior decorating firm. Two of his landscape paintings were accepted for the Panama-Pacific International Exposition in San Francisco in 1915, and the same year White won silver and bronze medals at the Panama-California International Exposition in San Diego. He exhibited with the California Art Club beginning in 1917 and during World War I served briefly as second lieutenant in the Fortieth Engineers Camouflage Division. After the war White devoted himself solely to landscape painting, building a studio in Pasadena and frequently traveling in California and Mexico in search of scenery to paint. He studied with GEORGE K. BRANDRIFF in Laguna Beach, California, and exhibited there with the local art association in the 1920s. The Battey Gallery in Pasadena gave White his first solo exhibition, but it was not until 1940 the Los Angeles Art Museum organized a solo exhibition of his work.

BIBLIOGRAPHY
LACMHSA, *Orrin A. White*, 1940, with lists of awards and public collections § Nancy Dustin Wall Moure and Phyllis Moure, *Artists' Clubs and Exhibitions in Los Angeles before 1930*, Publications in Southern California Art, no. 2 (Los Angeles: Privately printed, 1975), unpaginated, s.v. "Orrin A. White" § Moure with Smith 1975, pp. 273–74, with bibliography.

Spectacular Baja California, after 1923
Oil on canvas
25¹/₁₆ x 30¹/₁₆ in (63.6 x 76.4 cm)
Signed lower left: Orrin A. White
Gift of Dr. and Mrs. W. Watte Weeks
M.82.168.3

White's studio in Pasadena was near that of artists Elmer Wachtel (1864–1929) and Marion Wachtel (1876–1954), and his broadly brushed decorative landscape style is related to the work of these and other traditional South-

ern California artists in the 1920s. He painted in Mexico with Alson Clark (1876–1949) in the summer of 1923 and was among the first North American artists to appreciate the pictorial potential of that country, which he continued to paint for most of his career.

PROVENANCE
Dr. and Mrs. W. Watte Weeks, Woodland Hills, Calif., to 1982.

ON DEPOSIT
Los Angeles County Administrative Office, 1986–87.

White, *Spectacular Baja California.*

Bernard Karfiol

Born May 6, 1886, near Budapest, Hungary, to American parents
Died August 16, 1952, Irvington-on-Hudson, New York

Raised in Brooklyn, Bernard Karfiol was a precocious student, attending Pratt Institute and the National Academy of Design before the age of fifteen. In 1902 he spent a year studying in Paris with Jean-Paul Laurens (1883–1921) at the Académie Julian and in 1904 participated in the Salon d'Automne. He then traveled throughout Europe and England. In Paris he associated with Gertrude and Leo Stein and through his studio partner, SAMUEL HALPERT, met Henri Rousseau (1844–1910).

Back in the United States, Karfiol struggled to support himself by teaching until dealer/collector Hamilton Easter Field saw his work in the Armory Show in 1913. Field purchased his paintings and organized Karfiol's first large showing in 1917. In 1914 Karfiol began to summer at Ogunquit, Maine, at the invitation of Field. The New England landscape and coast were to appear in many of his figure studies and landscapes. Karfiol is best known, however, for his figure paintings of children and his nudes.

Karfiol exhibited widely, and during the 1920s three solo exhibitions of his work were organized at the progressive Brummer Gallery in New York; thereafter he was represented by Edith Gregor Halpert's Downtown Gallery. His travels to Cuba, Jamaica, and Mexico in the 1930s provided him with new subject matter. During the mid-1930s he attempted unsuccessfully to paint larger, more complex figure compositions.

BIBLIOGRAPHY
Private collection, Bernard Karfiol Papers (on microfilm, Archiv. Am. Art) § Jean Paul Slusser, *Bernard Karfiol,* American Artists Series (New York: Whitney Museum of American Art, 1931), with biographical note, bibliography § *Index 20th Cent. Artists* 1 (March 1934): 94–96; 1 (September 1934): II; 2 (September 1935): IV; 3 (August–September 1936): VI; reprint, pp. 130–32, 134, 136, 138 § Harry Salpeter, "Pure Painter: Bernard Karfiol," *Esquire* 7 (March 1937): 76–77, 137 § *Bernard Karfiol* (New York: American Artists Group, 1945), with essay by the artist, list of awards and museums, bibliography.

Seated Figure, by 1924
Oil on canvas
48⅛ x 33¹⁵/₁₆ in (122.2 x 86.2 cm)
Signed lower left: B. Karfiol
Gift of Cora Eshman
38.9.1

In the 1920s Karfiol's art became more classical as he focused on standing nudes, odalisques, and females dressed in loose gowns of indefinite period. Along with his classicism went a modernist interest in color and form, which was inspired in part by Paul Cézanne (1839–1906) and Pablo Picasso (1881–1973). The woman in *Seated Figure* is fully modeled, as would be expected of an academically trained artist such as Karfiol, but her body has been simplified into solid geometric forms. She is placed in the center of the composition, sitting on a stool. The stool is actually too small and low to enable the woman, who is quite massive, to sit comfortably. She appears to be comfortable, however, because her pose gives the form of a pyramid, producing an effect of stability. She appears almost stonelike due to the monochromatic beige and white palette. Only by subtly varying the tones of pink, yellow, and brown for the flesh did Karfiol suggest that the figure was alive.

When *Seated Figure* was exhibited in 1925–26 at the *First Pan-American Exhibition of Oil Paintings* in Los Angeles, where it was awarded an honorable mention, it hung next to *Parthenope* by JOHN CARROLL (LACMA; q.v).

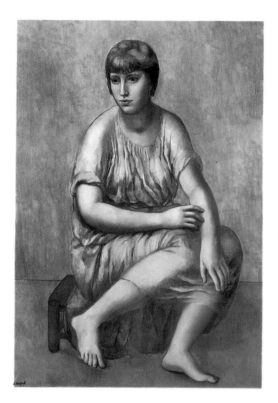

Karfiol, *Seated Figure.*

EXHIBITIONS
New York, Brummer Gallery, *Paintings and Drawings by Bernard Karfiol,* 1924–25, no. 6 § LAMHSA, *First Pan-American Exhibition of Oil Paintings,* 1925–26, no. 139, awarded honorable mention § LAMHSA 1928, no. 26 § LAMHSA 1930, no. 39 § Los Angeles, City Hall, Municipal Art Department, [exhibition title unknown], 1951, no cat. traced § Art Center in La Jolla, Calif., *Twentieth Anniversary Loan Exhibition: American Paintings from Pacific Coast Museums,* 1961, no. 13.

LITERATURE
Private collection, Bernard Karfiol Papers, newspaper clipping, "Karfiol's Rank Among the Poets," *The Sun* (New York), January 3, 1925 (Archiv. Am. Art microfilm roll NKA-1, fr. 11), considers it excellent but that brushwork and drawing could be improved; newspaper clipping, "Bernard Karfiol," *New York Post,* January 3, 1925 (ibid.), calls it one of best in Brummer Gallery exhibition, describes the subtlety of tone and color as "amazing"; unidentified newspaper clipping (ibid., fr. 12), repro. § LACMNH, Archives, Museum Scrapbook, unidentified clipping, Carolyn Pearson, "Pan-American Exhibition of Paintings Acclaimed," comments on the subtleties of tones, repro. § Antony Anderson, "Of Art and Artists: More Hours with the Pan-American," *Los Angeles Times,* December 13, 1925, pt. 3, p. 39, mentions Hellenic sense of beauty, repro. § "Awards for Pan American Exhibition," *LA Museum Art Dept. Bull.* 7 (January 1926): 205–6 § "Los Angeles," *Art News* 24 (January 9, 1926): 11 § Roberta Balfour Thudichum, "The Significance of the Pan-American Exhibition," *Western Arts* 1 (February 1926): 30, listed as award winner § Arthur Millier, "Museum's Own Collection of Paintings Now on View," *Los Angeles Times,* July 30, 1933, pt. 3, p. 5 § *Index 20th Cent. Artists,* pp. 92, 94; reprint, pp. 130, 132; listed in colls. and repros. § "Art Exhibitions Reviewed," *Los Angeles Times,* July 28, 1935, pt. 2, p. 7, repro. § "Gift to the Museum," *LA Museum Bulletin* 2 (October–December 1938): unpaginated, repro., cover.

The two paintings reflect the interest in classicism prevalent during the decade among artists who wished to synthesize figure painting and modernist abstract concerns. Karfiol's manipulation of the formal elements of his painting appears less extreme than does Carroll's. The art critic Antony Anderson noted that *Seated Figure* followed "the Hellenic ideal in pose, arrangement of drapery, and in feeling."

PROVENANCE
The artist, to 1926 § Cora Eshman, Los Angeles, 1926–38.

ON DEPOSIT
LAMHSA and LACMHSA, 1926–38.

Wayman Adams

Born September 23, 1883, Muncie, Indiana
Died April 7, 1959, Austin, Texas

Wayman Adams was a notable portraitist in the years between the two world wars. In 1904 he began four years of study with William Forsyth (1854–1935) at the John Herron Art Institute in Indianapolis, and he later studied with WILLIAM M. CHASE in Italy and ROBERT HENRI in Spain. Adams's reputation was established in Indianapolis, where his first major exhibition was held in 1911. He remained active in the Midwest until the early 1930s, although beginning in 1919 he made his home in New York City, maintaining a studio in the Sherwood Building there. He exhibited extensively throughout the country.

Adopting the painterly techniques of his teachers, Adams developed a vigorous, yet conservative style that satisfied his upper-class clientele. Among the many writers, financiers, and politicians he painted were Hamlin Garland, Robert Underwood Johnson, Booth Tarkington, and three presidents, including Herbert Hoover. He was also highly respected by his peers and painted numerous portraits of such fellow artists as JOSEPH PENNELL, Jerome Myers (1867–1940), and Irving Wiles (1861–1948). Although considered primarily a painter of men, Adams produced many portraits of women and children He also executed figural subjects based upon his travels. Late in life he organized a summer art school at his farm in Elizabeth, New York. His last years were spent in Texas.

BIBLIOGRAPHY

Helen Comstock, "Portraits of Wayman Adams," *International Studio* 77 (May 1923): 86–91 § New-York Historical Society, DeWitt McClellan Lockman Papers, "Interview with Wayman Adams," 1926 (on micro-film, Archiv. Am. Art) § Rose Henderson, "Wayman Adams: Portrait Painter," *American Magazine of Art* 21 (November 1930): 640–48 § Rose Henderson, "Wayman Adams: American Portrait Painter," *London Studio* 8 (September 1934): 145–48 § Indianapolis, John Herron Art Museum, *Wayman Adams, N.A.: Memorial Exhibition of Paintings*, exh. cat., 1959, with essay by Wilbur D. Peat.

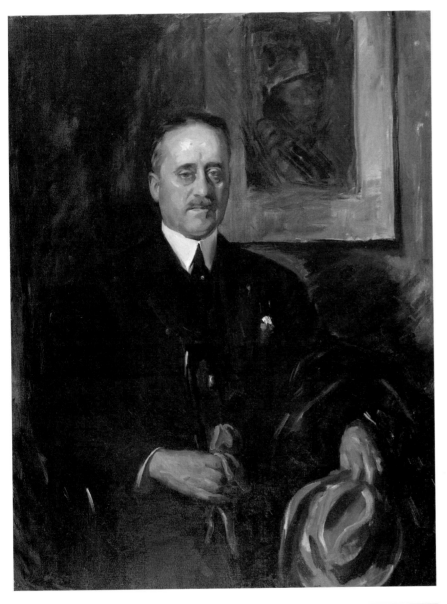

Adams, *Portrait of William Preston Harrison*.

Portrait of William Preston Harrison, 1924

Oil on canvas
52¹/₁₆ x 40¹/₁₆ in (132.2 x 101.8 cm)
Signed and dated upper left: Wayman Adams 1924
Mr. and Mrs. William Preston Harrison Collection
25.6.2

William Preston Harrison (1869–1940) was the pioneer collector of American art in Los Angeles, and his collection, given to the Los Angeles Museum during the 1920s and 1930s, formed the basis of its early holdings. He was also an important collector of French art.

Son of Carter H. Harrison, five-time mayor of Chicago, and brother of Carter Harrison,

also a Chicago mayor, Preston Harrison came to Los Angeles in 1918 after having been involved in the family's real estate ventures and serving as editor and publisher of the *Chicago Times*. He settled in Los Angeles with his wife, Ada Sanberg Harrison (see entry under ROBERT HENRI), and although he lived on the West Coast until his death, he maintained close ties with the Midwest. As did his brother in Chicago, Preston Harrison became involved in local cultural affairs: he served on the board of governors of the Los Angeles Museum (at the time of his death he was vice-president of the board) and was active in the Los Angeles Art Association and the Friends of Art of the Huntington Library.

From its inception this portrait was intended for presentation to the museum, and it hung in the Harrison Room along with other paintings donated by the Harrisons. The portrait was painted in New York in June 1924. Typical of Adams's painting method, it was completed in one day. Adams delineated the figure with long, sure strokes and the background with equally broad brushwork. Such rapid execution is characteristic of a student of Chase and Henri, and Henri may have suggested to Harrison that Adams be the one to paint his portrait.

Adams portrayed Harrison with dignity, befitting his station. Harrison's importance as a major patron of the arts is alluded to by the inclusion of a portrait of a crowned figure hanging on the wall behind him. Harrison wears a dark blue business suit and in his hands are a pair of gloves, a cane, and a hat. Every aspect of the painting evokes respectability and decorum. Adams was a master of facial characterization, and he presented Harrison as a generous, elderly man.

Although admired by artists, the portrait received some criticism locally. The attacks by Los Angeles society were probably due mostly to jealousy over the portrait's installation in a public museum, but even Harrison thought that the painting might be called "Old Grouch."

PROVENANCE
Mr. and Mrs. William Preston Harrison, Los Angeles, 1924–25.

EXHIBITION
LAMHSA 1924, no. 1.

LITERATURE

"Recent Additions to the Harrison Gallery," *LA Museum Art Dept. Bull.* 5 (January 1924): 141, Adams to paint the portrait in the coming summer § "Gifts to the Los Angeles Museum," *American Magazine of Art* 15 (May 1924): 263, portrait to be painted during the upcoming summer § LACMA, Registrar's files, William Preston Harrison to Dr. Bryan, June 4, 1924 (transcription, original unlocated), "After dinner the whole bunch went over to Mr. Wayman Adams Studio to see my portrait. Ben Foster, Henry B. Snell, Gardner Symons, Massie Rhind the sculptor and several others criticized it—all speaking highly of it both as a work of art as well as a likeness. Gardner Symons in fact was with me in the Studio all the time Adams was working" § *For Art's Sake* 2 (September 1, 1924): unpaginated, refers to upcoming exhibit of the portrait § "Paintings Loaned by Mr. and Mrs. Preston Harrison," *LA Museum Art Dept. Bull.* 6 (October 1924): 162 § Sam W. Small, Jr., "Personalities and Comment," *California Graphic* 2 (November 15, 1924): repro., 3 § "More Harrison Art for Los Angeles," *Art News* 23 (January 3, 1925): 4 § "Harrison Gallery Great Gift to Los Angeles," *California Graphic* 3 (November 28, 1925): repro., 18 § *California Art Club Bulletin* 1 (December 1925): repro., unpaginated § "The Harrison Gallery," *LA Museum Art Dept. Bull.* 7 (January 1926): 203 § "The Harrison Collection of Paintings," *California Southland* 8 (February 1926): 15, Harrison recounts how the portrait was painted in one day § "Art and Artists," *California Graphic* 4 (November 13, 1926): repro., 6 § Harrison 1934, p. 19, "The painting was done at one sitting 9 A.M. to 5 P.M. Intended for Museum representation and not just a portrait commission," repro., p. 16 § LACMA, Registrar's files, William Preston Harrison to Louise Upton, February 3, 1935, discusses problem of public knowing the identity of the sitter § "He Wants His Gifts Revalued in 1956," *Art Digest* 9 (August 1935): repro., 2 § Richard F. Brown, "The Art Division," *LA Museum Quarterly* 16 (Spring 1960): repro., 17 § Higgins 1963, p. 57, no. 16 in checklist of Mr. and Mrs. William Preston Harrison collection § LACMA, *American Pastels and Watercolors*, exh. cat., 1969, repro. of detail, unpaginated.

Hilaire Hiler

Born July 16, 1898, Saint Paul, Minnesota
Died January 19, 1966, Paris, France

Despite his cosmopolitan life and numerous writings on art, Hilaire Hiler's paintings are not well known to the American public. This is due partly to his long residence abroad and his activities in other fields, including aesthetics, costume history, and psychoanalysis. His paintings evolved from a primitive manner to complete nonobjectivity.

After withdrawing from the University of Pennsylvania's Wharton School of Finance, Hilaire Hiler (born Hiler Harzberg) studied briefly at the Pennsylvania Academy of the Fine Arts and then went to Paris around 1919 or 1920. There he became an intimate of the Montparnasse circle of artists and literati, numbering among his friends Ezra Pound, Ernest Hemingway, Marcel Duchamp (1881–1968), Man Ray (1890–1976), and Henry Miller. Hiler remained in France for fifteen years, supporting himself at times as a jazz musician. During this time he also painted murals for several nightclubs. He had his first solo exhibition in Paris in 1923 and in New York in 1925. During the late 1920s he began creating cubist-influenced urban views.

In 1934 Hiler returned to the United States, working in San Francisco and then Los Angeles and briefly in the 1940s in Santa Fe; he commissioned Rudolf Schindler to design his Los Angeles studio. His return also marked a switch to American themes, as he created oils, watercolors, rug designs, and lithographs based on the symbols and abstract designs of Native American decorative arts, the Native American way of life, and the landscape they inhabited. From 1936 to 1939 Hiler worked as a mural painter and served as a supervisor on the Works Progress Administration/Federal Art Project in San Francisco, designing entire rooms for the Aquatic Building. These murals offered Hiler the opportunity to express his fascination with color on a large scale. He then became obsessed by color and theories relating color to psychology. He studied psychology with Otto Rank in Paris and briefly maintained a psychotherapeutic practice in Los Angeles in 1946 after obtaining a Ph.D. degree at Golden State University.

Starting in the 1930s he wrote numerous books and articles on color; his earliest writings, such as *Notes on the Technique of Painting* (1932) and *Color Harmony and Pigments* (1940), were primarily technical manuals. In Los Angeles he lectured on color theory and founded Fremont College, which specialized in teaching color and design theories. More importantly he formulated a concept of "structuralism" that would dominate his art for the rest of his life. In his 1945 manifesto *Why Abstract?* he explained how in this completely nonrepresentational art he was able to present structure, order, and color in terms of the harmonious relation of a geometric progression.

In 1942 Hiler's first solo exhibition in many years was held at Frank Perls Gallery in Hollywood; the catalogue essay was written by William Saroyan. Hiler's continued fascination with dynamics, composition, and color was demonstrated in what he called his psychromatic paintings exhibited in New York and on the West Coast that year.

BIBLIOGRAPHY
Archiv. Am. Art, Hilaire Hiler Papers § Waldemar George (pseud.), *Hilaire Hiler et la vision panoramique* (Paris: Editions des Quatre Chemins, [1933]) § Henry Miller, "Hiler and His Murals," in *The Air-Conditioned Nightmare* (New York: New Directions, 1945), pp. 278–82 § Waldemar George (pseud.), *Hilaire Hiler and Structuralism: New Conception of Form-Color,* English ed. (New York: Wittenborn, 1958), with essays by the artist and Vincent Schmidt, biographical note, bibliography, lists of exhibitions, collections, and murals § Albuquerque, University of New Mexico, Art Museum, *Hilaire Hiler, 1898–1966,* exh. cat., 1976, with text by Michael Regan and Nicolai Cikovsky, Jr., bibliography.

Hiler, *Barber Shop.*

primitive style is quite apparent in the multiple perspectives, awkward anatomy, lack of modeling, and exaggerated facial expressions. The last named accentuate the humor of the scene as Hiler subtly mocks convention. Critics compared Hiler's delicate sense of irony with that of Pieter Breughel (1525–1569), but his early scenes were also reminiscent of the great French primitive, Henri Rousseau (1844–1910), whose paintings Hiler was surely introduced to by the Parisian avant-garde.

The interior is compressed so that the major compositional lines of the scene are the horizontals and verticals of the mirror, countertop, posters, and wall decorations. Hiler used a similar handling of figures lined up in a narrow space in his *Restaurant dans la rue Torte,* 1930 (unlocated). Indeed, this emphasis on geometric, man-made objects reflects the artist's underlying formalism, an aspect of his art that would become more apparent with his paintings of the late 1920s.

Barber Shop, 1924
Oil on canvas
23 9/16 x 35 15/16 in (59.8 x 91.3 cm)
Signed and dated lower right: PARIS / HILER / 1924
Gift of Harvey Leepa
51.31.1

During his first years in Paris Hiler painted charmingly naïve vignettes of Parisian city life: the streets, theater, and cafés. He supported himself by playing piano and managing the Jockey Club and so became immersed in the artistic and literary life of the Left Bank. *Barber Shop* differs from many of his early paintings in being an interior scene that does not relate specifically to the artist's avant-garde life-style. Moreover, the figures are larger than those in earlier paintings by Hiler. His early

PROVENANCE
Harvey Leepa, Santa Barbara, Calif., to 1951.

ON DEPOSIT
Los Angeles County Board of Supervisors, 1973–80.

EXHIBITIONS
Paris, Bernheim-Jeune, *Hiler: Peintures et dessins,* 1925, no. 9, repro., unpaginated § New York, New Gallery, *Hiler: Paintings and Drawings,* 1926, no. 9 § London, Dover Gallery, *Pictures and Drawings by Hiler,* 1926, no. 9.

LITERATURE
Desmond Fenell, "Hilaire Hiler's Exhibition in Dublin," *Art International* 7 (January 25, 1963): 71–72.

Factories at Lyon, 1930
Oil on canvas
21 1/4 x 28 13/16 in (54.0 x 73.1 cm)
Signed and dated lower right: OCT. 1930 / HILER .
CAGNES
Gift of Dr. Phillip Rothman and Edward Rothman
47.21.1

Around 1928 Hiler began to omit the figures from his urban views and focus on the city's buildings as cubic forms and geometric planes. Eventually, as in *Factories at Lyon,* he also combined flatly painted surfaces with highly impastoed, striated areas. The textured areas often took on a life of their own, divorced

Hiler, *Factories at Lyon.*

paintings demonstrate a concept invented by him, which Ezra Pound dubbed "neonaturism." As the artist explained in his book *Why Abstract?*, neonaturism was his attempt to combine design with representation, something which he thought was essential. Hiler felt that for a painting to be successful it had to demonstrate the "physiological appeal satisfying to man's geometrical instinct through the use of strictly mathematical composition" ("Hiler's Neo-Naturism in Philadelphia Show," *Art Digest* 8 [November 1, 1933]: 14).

The painting is inscribed with the name Cagnes, which may refer to the coastal town near Nice on the French Riviera where Hiler lived occasionally during the early 1930s, although the scene has none of the spirit of the resort town. Rather, by his emphasis on geometric, industrial imagery and use of a dark, dingy palette of brown, gray, and black, Hiler captured the spirit of Lyon, which in 1930 was one of the largest cities in France and a major chemical and engineering center.

from the overall scene, thereby destroying an already limited sense of painted reality. When Hiler included an occasional figure, he often presented it as a silhouette, as he did here, thereby enhancing the mysterious mood of the scene. Formally, the emphasis on textures relates to synthetic cubism while the flat, planar emphasis of the painting bears a resemblance to some of the precisionist images painted in New York in the 1920s. Not surprisingly, Hiler was a close friend of the artist Niles Spencer (1893–1952). They met in New York around 1917, and when both lived in Paris during the early 1920s they spent many hours discussing artistic issues of subject matter and geometry. However, Hiler's own abstracted

PROVENANCE
Edward Rothman and Phillip Rothman, Los Angeles, to 1947.

ON DEPOSIT
Los Angeles County Superior Court, 1959–75.

EXHIBITION
San Francisco, City of Paris Galleries, *Exhibition of Modern Art by Hilaire Hiler,* 1938, no. 2, incorrectly dated 1928.

LITERATURE
George, *Hiler et la vision panoramique,* repro., unpaginated.

John Carroll

Born August 14, 1892,
Kansas City, Kansas
Died November 7, 1959,
Albany, New York

Most often associated with Woodstock, New York, and Detroit, John Carroll is best known for his paintings of mysterious, sad-eyed women. He grew up in San Francisco, where he attended the Mark Hopkins Art Academy from 1902 to 1906; he studied at the University of California, Berkeley, in the early 1910s. He also studied briefly with Frank Duveneck (1848–1919) in Cincinnati before serving in the navy during World War I. After the war he lived in New York City and beginning about 1920 also in Woodstock, where he associated with both modernist and Ash Can school artists. Although he produced some portraits, during this period he devoted himself to painting landscapes and figure studies, incorporating the modernist ideas of Paul Cézanne (1839–1906), GEORGE BELLOWS, and ANDREW DASBURG. During the 1920s Carroll became known as one of the most promising modernist artists, and solo exhibitions of his work were held at the Daniel and the Rehn galleries.

Carroll traveled to Europe in 1924 and again in 1927, the second time as a Guggenheim Fellow. He taught at the Art Students League in New York in the late 1920s, and in 1930 he was appointed head of the art department of the Arts and Crafts Society in Detroit. He taught there for more than a decade, during which time he painted frescoes for the Detroit Institute of Arts. His easel paintings underwent a transformation and lost their modernity as he became obsessed with images of mysterious, wide-eyed, sad females. During the early 1940s Carroll briefly abandoned art to settle in East Chatham, New

York, to raise cattle for the war effort. Within a short time, however, he returned to painting and teaching, resuming his position in New York at the Art Students League in 1944 and opening his own school in 1951. His late art exemplified a new style, more opaque and vigorous than his earlier, softly romantic paintings.

BIBLIOGRAPHY
Archiv. Am. Art, John Carroll Papers § Augusta Owen Patterson, "The Art Creed of John Carroll," *International Studio* 83 (February 1926): 75–79 § Harry Salpeter, "John Carroll: Non-Conformist," *Esquire* 10 (August 1938): 65–67, 157–59 § Ernest W. Watson, "John Carroll: Interview," *American Artist* 15 (January 1951): 28–34 § Obituary, *New York Times,* November 8, 1959, p. 88.

Carroll, *Lady in Blue.*

Lady in Blue, c. 1924
(*Girl in Blue; A Lady; A Study in Blue*)
Oil on canvas
50½ x 40½ in (128.3 x 103.0 cm)
Signed lower left: John Carroll
Mr. and Mrs. William Preston Harrison Collection
34.12.2

It is said that it was George Bellows who first suggested to William Preston Harrison that Carroll should be represented in his collection and ROBERT HENRI who actually urged the commission that resulted in the painting *Lady in Blue.* This seems plausible since Carroll knew both artists from Woodstock. In fact, Bellows was Carroll's neighbor. The residence of the Ash Can artists prompted Woodstock modernists to become more concerned with realism.

Encouraged by Andrew Dasburg, Carroll had experimented with abstraction, creating cubist still-life paintings similar to the arrangement of tulips and sheet music that he incorporated into the composition of *Lady in Blue.* Carroll's treatment of the figure as a series of cylinders no doubt was also influenced by the work of Cézanne and of Fernand Léger (1881–1955) and the other French purists. The compression of space into a series of overlapping planes and an emphasis on curving lines describing the figure, chair, and flowers reflect Carroll's fascination with abstract line, an interest that critics sometimes thought too decorative. Color is limited to a cool palette of tin blue for the dress and gray for the background.

The painting's archaic quality is in keeping with the strong interest of some modernists in American folk art during the late 1910s and early 1920s. The figure's stiff, primitive character may also have been due the fact that it was based on an old photograph, which may also explain the painting's monochromatic palette. *Lady in Blue* is a portrait of William Preston Harrison's mother, Sophonisba Grayson Preston (c. 1834–1876), who was descended from the Puritans. Harrison suggested that the painting be titled *Lady in Blue* to avoid any criticism that might arise if a portrait of one of his relatives were installed in the museum. Regardless of the identity of the figure, the painting is of a type with the other images of single figures painted by Carroll in the 1920s.

PROVENANCE
Mr. and Mrs. William Preston Harrison, Los Angeles, 1924–34.

EXHIBITIONS
Stockton, Calif., Pioneer Museum and Haggin Art Galleries, *Modes and Moods in Painting,* [1955], no. 5, as *Girl in Blue* § Laguna 1958, no. 47.

LITERATURE
LACMA, Registrar's files, William Preston Har-

rison to Louise Upton, October 7, 1925, suggests title, *A Study in Blue*; Harrison to Upton, November 11, 1934, "So far as I can see our John Carroll is by long odds his masterpiece to date. I admit I was troubled at first. I was afraid he was trying a stunt. Now I see he succeeded no matter what his original motive. I have forgotten completely that it is supposed to be my mother—a shock at first I confess—now just a fine painting"; Harrison to Upton, February 3, 1935; Harrison to William A. Bryan, October

8, 1935 § Elizabeth Bingham, "Los Angeles," *Art News* 24 (October 10, 1925): 10, as *A Lady* § "Harrison Gallery Great Gift to Los Angeles," *California Graphic* 3 (November 28, 1925): repro., 19, as *Study in Blue* § "Awards for Pan-American Exhibition," *LA Museum Art Dept. Bull.* 7 (January 1926): 205, repro., cover § Patterson, "Art Creed of Carroll," p. 78 § Harrison 1934, p. 22, repro., overleaf p. 1 § Higgins 1963, p. 62, no. 131 in checklist of Mr. and Mrs. William Preston Harrison collection.

Carroll, *Parthenope*.

Parthenope, by 1925
(*Three Graces*)
Oil on canvas
40⁵/₁₆ x 60³/₈ in (102.5 x 153.3 cm)
Signed lower right: John Carroll
Mr. and Mrs. Allan C. Balch Collection
25.19.2
Color plate, page 66

Throughout his career Carroll was fondest of painting the female figure, especially the nude. *Parthenope* served as a vehicle for the artist's exploration of progressive ideas. Indeed, it was the painting's modern character that attracted attention when it was exhibited at the Los Angeles Museum in the *First Pan-American Exhibition of Oil Paintings* in 1925–26. At that time controversy arose over whether the coveted Balch prize should be given to a conservative or a modern painting. The result was a compromise, with the award being shared between *Where Nature's God Hath Wrought*, 1925 (LACMA; q.v.), by WILLIAM WENDT and *Parthenope*. Consequently Car-

roll's painting received much attention from the press. Most critics appreciated his harmonious color and fluid line. Antony Anderson of the *Los Angeles Times* wrote, "never was rhythm of line and form more alluringly rendered," and Vennerstrom Cannon of the *La Jolla Journal* thought it remarkable and worth the excursion to Los Angeles. Others could not comprehend Carroll's modernism, one critic referring to his "haulking maidens" set against "sausage-like hills." It was even parodied in comic versions created for the annual fakir celebration of the California Art Club. E. Roscoe Shrader referred to his version—which also appeared as a cartoon in a local newspaper—as *Bare 'n' Soapy*, portraying the maidens as women taking a shower and attaching an actual shower nozzle and soap dish to the canvas.

Parthenope exemplifies certain aesthetic and pseudoscientific ideas held by progressive artists during the period. Carroll's tendency to simplify his figures into solid geometric shapes recalls similar neoclassical figures painted in

306

the 1920s by the purists and Pablo Picasso (1881–1973). Since Carroll usually focused on a single figure, he may have felt the need for a theoretical basis for the design of this, his most complex figure composition. To assure a well-proportioned and harmonious arrangement, Carroll constructed the composition on the design principles of the "whirling square rectangle" as propounded by Jay Hambidge (1867–1924) and his disciple George Bellows. The arrangement of figures across the foreground plane and the placement of their arms and heads—especially those of the woman at center with tilted head and shoulders—accords precisely with Hambidge's theory, in particular his emphasis on diagonals to create controlled, rhythmic movement (see illustration). The arcing lines of the softly rolling, distant mountains repeat the curves and rhythms of the figures' anatomy and drapery. Such a treatment of the landscape, although idealized, is similar to that in Bellows's Woodstock landscape with figures, *Picnic*, 1924 (Peabody Institute of the City of Baltimore), which also was based on Hambidge's theory of dynamic symmetry.

Diagram showing "whirling square rectangle" that forms the basis of the composition (diagram by Ilene Susan Fort).

Hambidge's concept was founded on principles expounded by the ancient Greeks, and this classical origin may have encouraged Carroll's use of a classical motif. There are several legends about Parthenope, in one of which she is a siren who, with her sisters, threw herself into the sea, which many have been Carroll's inspiration. Such an allusion to antiquity and the idealized presentation were not typical of Carroll's art.

Antony Anderson referred to the painting's "synchronism [*sic*] of color," and its rainbow effect suggests that Carroll may have applied to *Parthenope* some of the pseudoscientific color theories then popular. The drape of each of the three foreground figures is painted a single intense hue—red, blue, or green—and these colors as well as the yellow in the middle distance constitute the painting's palette. Carroll merely added white to create pastel tints for the background and skin. Even the short, striated brushwork in the background suggests that he sought to present his colors as if seen through a prism.

PROVENANCE
The artist, to 1925.

ON DEPOSIT
Los Angeles County Health Department, Inglewood Health District, 1952–74.

EXHIBITIONS
LAMHSA, *First Pan-American Exhibition of Oil Paintings*, 1925–26, no. 129, repro., awarded Balch Prize § Fine Arts Society of San Diego (Calif.), *Selected American Paintings*, 1927, no. 5 § LAMHSA 1928, no. 13 § LAMHSA 1930, no. 36 § LACMHSA, organized by American Federation of Arts, New York, *Exhibition of Contemporary Eastern American Paintings and Lithographs*, 1938–39, no cat. traced § Compton (Calif.) Chamber of Commerce, Allied Arts Committee, [exhibition title unknown], 1947, no cat. traced.

LITERATURE
LACMNH, Archives, Museum Scrapbook, unidentified clipping, Caroline Walker, "Beauty Shown in Art for Los Angeles Exhibition," considers the color and line striking, if unusual; unidentified clipping, Columbine [pseud.], "Short Flights," critic does not understand modernist aspects of painting; undated newspaper clipping, Vennerstrom Cannon, "The Pan-American Exhibition of Los Angeles," *La Jolla* [*Calif.*] *Journal*, considers it "remarkable"; unidentified clipping, Caroline Walker, "Awards Give Museum New Art Works," describes and identifies the artist § Sonia Wolfson, "Pan-American Exhibition," *California Graphic* 3 (November 28, 1925): repro., 15 § "Record Crowds View Pan-American Art Exhibit," *Los Angeles Times*, December 1, 1925, pt. 2, p. 12, repro. § "Wendt and Carroll Win Chief Awards," *Art News* 24 (December 5, 1925): 1, five-thousand-dollar Balch Prize shared between William Wendt and John Carroll § Sonia Wolfson, "Art and Artists," *California Graphic* 3 (December 12, 1925): 6, repro., 7 § Antony Anderson, "Of Art and Artists: More Hours with the Pan-American," *Los Angeles Times*, December 13, 1925, pt. 3, p. 39, praises its beauty, repro. § Antony Anderson, "Of Art and Artists: The Pan-American Without Prejudice," *Los Angeles Times*, December 20, 1925, pt. 3, p. 44, discusses in terms of attitudes towards modern art § Myra Paule, "Art Exhibition Disappointing," *Los Angeles Times*, December 27, 1925, pt. 2, p. 3, describes and compares painting with Greek statuary § "Awards for Pan-American Exhibition," *LA Museum Art Dept. Bull.* 7 (January 1926): 205, comments on strong classical tendency, Balch Prize divided between Carroll and Wendt, repro., 204 § M. Urmy Seares, "The All-American Art Show in Los Angeles," *California Southland* 8 (January 1926): 10, lists award § Patterson, "Art Creed of Carroll," pp. 77–79, repro., p. 79 § Roberta Balfour Thudichum, "The Significance of the Pan-American Exhibition," *Western Arts* 1 (February 1926): 30, listed under awards § Sonia Wolfson, "Castor Oil for Bacchus," *California Art Club Bulletin* 5 (September 1930): 4 § "Pot and Kettle," *Art Digest* 4 (September 1930): 15, reprint of S. Wolfson's "Castor Oil for Bacchus" § Arthur Millier, "Museum's Own Collection of Paintings Now on View," *Los Angeles Times*, July 30, 1933, pt. 2, p. 5, discusses painting at length, including Carroll's use of distortion to create linear rhythm § Arthur Millier, "Eastern Painting in Good Museum Show," *Los Angeles Times*, December 25, 1938, pt. 3, p. 7, as *Three Graces*, describes as "flamboyant" work from his "unregenerate youth."

John C. Johansen

Born November 25, 1876,
Copenhagen, Denmark
To United States 1877
Died May 23, 1964, New
Canaan, Connecticut

John Christen Johansen was considered one of the leading portraitists of his day, receiving numerous important commissions and many honors. He grew up in Chicago, and from 1891 to 1897 he attended the School of the Art Institute of Chicago, studying with, among others, Frank Duveneck (1848–1919). He then went to Paris, where he attended the Académie Julian and briefly the class of James McNeill Whistler (1834–1903). Returning to Chicago in 1901, he taught at the Art Institute until 1906, when he went to Venice for two years. In 1908 he opened his studio in New York, where he worked for the rest of his career, also maintaining a summer studio in Stockbridge, Massachusetts, after 1917. He painted landscapes, interiors, and figure paintings, but achieved his greatest success with his portraits. He was married to the artist Myrtle Jean MacLane (1878–1964), who was as well known for her portraits of women and children as he was for his portraits of men.

BIBLIOGRAPHY
"Studio Talk," *International Studio* 26 (September 1905): 264–66 § Arthur Hoeber, "John C. Johansen: A Painter of the Figure, Landscape, and of Architecture," *International Studio* 42 (November 1910): III–X § Rilla Evelyn Jackman, *American Arts* (Chicago: Rand McNally, [c. 1928]), pp. 246–47 § *National Cyclopedia of American Biography,* s.v. "Johansen, John," with lists of collections and honors.

Johansen, *Portrait of Paul Rodman Mabury, Esquire.*

Portrait of Paul Rodman Mabury, Esquire, 1925
Oil on canvas
47³/₁₆ x 34³/₁₆ in (119.9 x 86.9 cm)
Signed and dated lower right: J.C. JOHANSEN. 1925.
Paul Rodman Mabury Collection
39.12.14

Paul Rodman Mabury was born in San Jose, California, on December 17, 1869. He lived in California his entire life but did not make his residence in Los Angeles until about 1906. His father, who had helped establish the Security Pacific Bank of California, left him a considerable fortune, which he managed during his lifetime. He was himself a banker and president of H. & J. Mabury Company, a dried-fruit concern.

Mabury was an anonymous contributor to several art organizations. He had long been an art lover and collector, and during the last twenty-five years of his life he assembled a collection of old masters and American art that was one of the finest in the city and of the greatest importance to the museum, which received it upon his death on January 10, 1939.

William Preston Harrison wrote of him in the foreword to the catalogue of Mabury's collection: "He had given his life, and his untiring efforts in that phase of culture he so loved— the collecting of rare art treasures. Art and great art alone, was the essence of his existence and he never varied an inch nor changed a moment from that goal, in order that someday the masses might share in that which had always been his own great source of pleasure and enrichment."

The portrait's breadth, simplicity, and strength are characteristic of Johansen's mature style.

PROVENANCE
Paul Rodman Mabury, Los Angeles, 1925–39.

EXHIBITION
LACMHSA, *Temporary Installation of the Paul Rodman Mabury Collection,* 1939, no. 15.

LITERATURE
LACMHSA, *The Paul Rodman Mabury Collection of Paintings,* c. 1940, p. 27, repro., frontispiece § "Mabury's Gift," *Art Digest* 14 (August 1, 1940): 10 § Richard F. Brown, "The Art Division," *LA Museum Quarterly* 16 (Spring 1960): repro., 15, incorrectly dated 1926 § Higgins 1963, p. 128, no. 14 in checklist of Paul Rodman Mabury collection.

Kenneth Hayes Miller

Born March 11, 1876,
Oneida, New York
Died January 1, 1952,
New York, New York

Kenneth Hayes Miller is best known as a teacher and founder of what became known as the Fourteenth Street school. While paintings of middle-class female shoppers from his mature period are his best known, he had a long, distinctly different early phase.

Miller was born in the utopian community of Oneida and studied art in the 1890s at the New York School of Art with WILLIAM M. CHASE and later at the Art Students League with several prominent, traditional, mural painters, such as Kenyon Cox (1856–1919) and H. Siddons Mowbray (1858–1928). Works from his first sustained period of painting are mostly of nude figures set in idealized, romantic landscapes. These poetic, somewhat symbolic paintings, similar to the art of his contemporaries ARTHUR B. DAVIES and Bryson Burroughs (1869–1934), were largely inspired by ALBERT PINKHAM RYDER, an artist Miller admired and befriended.

After World War I Miller turned to realism. Like the Ash Can school painters, he became a delineator of the ordinary pedestrian, but unlike them was fascinated with the human figure as a vehicle for plastic interpretation. His painting style became less atmospheric as he brightened his palette and delineated objects more clearly. His depictions of robust female shoppers in groups, pairs, or alone established his reputation in the 1920s and 1930s. He also continued to paint the female nude but placed the figure in interior settings and rendered it as a more sensuous and real body than he had in his earlier idealized works. Throughout his career Miller was also interested in etching and sometimes repeated his painted images in prints.

After a trip to Europe in 1900 Miller began a long teaching career, first at the Chase School of Art, and when that dissolved, in 1911 he began his more than forty-year association with the Art Students League. His numerous students there included Isabel Bishop (1902–1988), Yasuo Kuniyoshi (1893–1953), and REGINALD MARSH. In his teaching Miller stressed the importance of learning from the art of the past, in particular that of the Renaissance. He was also instrumental in reviving old-master techniques such as casein and tempera painting.

BIBLIOGRAPHY
Oneida, N.Y., Mrs. Louise Miller Smith Collection, Kenneth Hayes Miller Papers (on microfilm, Archiv. Am. Art) § Alan Burroughs, *Kenneth Hayes Miller,* American Artists Series (New York: Whitney Museum of American Art, [c. 1931]), with biographical note, bibliography § *Index 20th Cent. Artists* 3 (December 1935): 197–200; 3 (August–September 1936) III; reprint, pp. 488–91, 494 § Harry Salpeter, "Kenneth Hayes Miller: Intellectual," *Esquire* 8 (October 1937): 88–89, 197–98, 200, 203 § Lincoln Rothschild, *To Keep Art Alive: The Effort of Kenneth Hayes Miller, American Painter (1876–1952)* (Philadelphia: Art Alliance Press, 1974), with catalogue of paintings, bibliography.

Woman in Sculpture Hall, 1925
(*Girl in Sculpture Gallery; In a Sculptor's Gallery; Woman in a Sculpture Gallery; Woman in a Statue Hall*)
Oil on canvas
41¼ x 36¼ in (104.7 x 92.1 cm)
Signed and dated on base of capital: Hayes Miller.'25
Mr. and Mrs. William Preston Harrison Collection
27.7.13

Although Miller usually depicted his women in shops, he occasionally presented them in other public places, such as an art museum. He sometimes would take his students to the Metropolitan Museum of Art on a Saturday morning to examine works of art firsthand. This painting depicts such an excursion, for the model was one of Miller's students, Dorothea Schwarcz Greenbaum (b. 1893), who would later become a sculptor. As she recalled, "Although we would pay homage to Titian and Rubens, most of our time was spent in the gloomy basement, studying the casts of Greek sculpture. He knew every fold in the draperies of the figures from the Parthenon and could draw them from memory. I do not know why he was a painter and not a sculptor—all his teaching led in that direction." Miller filled a large part of the scene with a huge Corinthian capital that vies in importance with the figure. Other classical objects are partially visible, and the model rests her arm on the edge of a Roman sarcophagus. The setting of this painting may be the then newly opened Cloisters of the museum, but Miller did not render the ancient objects literally enough for them to be identified definitely as works in the Metropolitan Museum's collection.

Woman in Sculpture Hall summarizes Miller's mature art for it demonstrates two of his obsessions: modern woman and antique sculpture. Greenbaum is presented as a typical Miller woman, somewhat chubby, with a round face, large eyes, and full lips, wearing the usual "shopper" attire—a fashionable overcoat, beaded necklace, and cloche—with handbag at her side. The museum setting may have been chosen as a vehicle for Miller to express more openly his respect for classical art. Once Miller adopted the shopper image, he rarely referred to antique motifs, even in his nudes. Instead, he conceived his women as sculpture, painting them fully modeled and like stone works of art. The artist described this painting's masses as "falling in two columns." Miller also seems to have purposely limited his palette to dull beiges and oranges, alluding to the color of stone. With such a color scheme he was able to present his two interests in a single, unified image.

PROVENANCE
The artist, 1925–26 § Mr. and Mrs. William Preston Harrison, Los Angeles, 1926–27.

EXHIBITIONS
San Diego (Calif.), Palace of Fine Arts, *California Pacific International Exposition, Official Art Exhibition, Illustrated Catalogue,* 1936, no. 318 § New York, National Academy of Design, sponsored by the Art Students League, *A Memorial Exhibition, Kenneth Hayes Miller,* 1953, no. 31 § Los Angeles, Loyola Marymount University, Laband Art Gallery, *The Spirit of the City: American Urban Paintings, Prints, and Drawings, 1900–1952,* 1986, entries not numbered, repro., p. 47, as *Girl in Sculpture Gallery.*

Miller, *Woman in Sculpture Hall.*

LITERATURE

Oneida, Mrs. Louise Miller Smith Collection, Kenneth Hayes Miller Papers, the artist to Helen Miller (his wife), July 30, 1925, and August 27, 1926 (Archiv. Am. Art, microfilm roll N583, frs. 454 and 464), discuss how the design of *Woman in Statue Hall* has three masses instead of his usual two and purchase by Harrison § LACMA, Registrar's files, William Preston Harrison to Louise Upton, August 12, 1926, selected *Woman in Statue Hall* for purchase; assistant curator, LAMHSA, to Mrs. Fred H. Bixby, April 21, 1928 § Louise Upton, "Gift to the Harrison Gallery," *LA Museum Graphic* 1 (January–February 1927): 94, repro., 95 § Sonia Wolfson, "Art and Artists," *California Graphic* 4 (January 8, 1927): repro., 6 § "Art," *Saturday Night* 7 (April 16, 1927): repro., 7 § "The Art of Kenneth Hayes Miller," *Studio* 106 (July 1933): 42, lists, as *Woman in a Sculpture Gallery* § Harrison 1934, p. 41, repro., p. 42 § *Index of 20th Cent. Artists*, pp. 197, 200; reprint, pp. 488, 491; listed under colls. and repros., as *In a Sculptor's Gallery* § LACMA, Registrar's files, copy of Harrison to Reginald Poland, February 29, 1940 § Higgins 1963, p. 59, no. 61 in checklist of Mr. and Mrs. William Preston Harrison collection, as *Girl in Sculpture Gallery* § LACMA, Registrar's files, Louise Miller Smith to Nancy Wall, April 13, 1970, discusses Harrison's fondness for the painting § Rothschild, *To Keep Art Alive*, p. 62, discusses Miller's teaching practices and quotes Greenbaum's reminiscences, fig. 44, as *Girl in Sculpture Gallery* § LACMA, American Art department files, Joan R. Mertens to Ilene Susan Fort, September 23, 1985, discusses identification of ancient objects and suggests the Cloisters as possible setting § *Artweek* 17 (March 22, 1986): repro., cover.

Walter Ufer

Born July 22, 1876,
Louisville, Kentucky
Died August 2, 1936,
Santa Fe, New Mexico

Walter Ufer was a leading figure among the colony of artists who painted Native American and other Western subjects in Taos, New Mexico, during the 1910s, 1920s, and 1930s. He worked for lithographic firms in Louisville and, after 1893, in Hamburg and Dresden, Germany. After studying at the Royal Academy of the Fine Arts in Dresden, he returned in 1898 to Louisville, where he worked for a newspaper for two years. He next worked as a graphic artist while attending the J. Francis Smith School in Chicago and later teaching there. In 1911 he traveled in Europe and North Africa and then studied with Walter Thor (1870–1929) at the Royal Academy of the Fine Arts in Munich until 1913. Returning to the United States, Ufer first settled in Chicago, where he came to the attention of Mayor Carter Harrison. Harrison subsidized a trip, Ufer's first, to the American Southwest in 1914. Fascinated with the brilliant sunlight, Ufer became a plein-air painter and settled in Taos, New Mexico, but for several years he made annual trips to Chicago and New York. By 1920 he had achieved recognition and success with his bright, sunlit scenes of the life of Native Americans; he was one of the first to present them in a more honest, less idealized depiction.

Among other honors, Ufer was the first Taos artist to be awarded a prize at the Carnegie International; he was awarded the Temple Gold Medal of the Pennsylvania Academy of the Fine Arts in 1923. Ufer was elected an associate member of the National Academy of Design in 1920 and an academician in 1926. A solo exhibition of his work was held at the Corcoran Gallery of Art, Washington, D.C., in 1922.

BIBLIOGRAPHY

Denver, Rosenstock Arts, Walter Ufer Papers § "The Santa Fe-Taos Art Colony: Walter Ufer," *El Palacio* 3 (August 1916): 74–81 § Rose V. S. Berry, "Walter Ufer in a One-Man Show," *American Magazine of Art* 13 (December 1922): 507–14 § Stephen L. Good, "Walter Ufer: Munich to Taos, 1913–1918," in Laura M. Bickerstaff, *Pioneer Artists of Taos* (1955; rev. ed., Denver: Old West, 1983), pp. 113–73 § Washington, D.C., Smithsonian Institution, National Museum of American Art, and others, *Art in New Mexico, 1900–1945: Paths to Taos and Santa Fe*, exh. cat., 1986, published by Abbeville Press, New York, with essays by Charles C. Eldredge, William H. Truettner, and Julie Schimmel, biography by Sharyn R. Udall and Andrew Connors, bibliography.

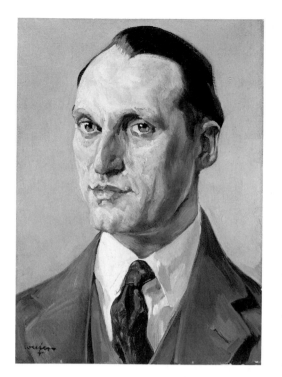

Portrait of Samuel Lustgarten,
c. 1925–27
Oil on canvas
16⅛ x 12¼ in (41.0 x 31.1 cm)
Signed lower left: WUfers
Gift of Alfred Lustgarten
M.83.173

Ufer's training in Munich had prepared him
to work as a portraitist, which he did briefly in
Chicago before settling in Taos. His late self-
portraits are virtually the only examples of his
skill at portraiture that are known today.

This painting was commissioned by Samuel
Lustgarten (1888–1971), according to his son
Alfred Lustgarten. A Chicago businessman
and avid art collector, Samuel Lustgarten
owned many of Ufer's Taos scenes. The artist
was a frequent visitor to the Lustgarten fam-
ily's home in Chicago and often dined with the
family (Alfred Lustgarten, telephone conversa-
tion with Ilene Susan Fort, July 31, 1986).

PROVENANCE
Samuel Lustgarten, Chicago § Mr. and Mrs. Alfred
Lustgarten (by descent), Los Angeles, to 1983.

Ufer, *Portrait of Samuel
Lustgarten.*

Ben Berlin

Born November 16, 1887,
Washington, D.C.
Died October 16, 1939,
Los Angeles, California

Little is known of this early Los Angeles modernist, although during the 1920s and 1930s
Benjamin F. Berlin was considered by his peers to be among the most talented of local
abstract artists. He may have attended college before studying illustration in Los Angeles,
first at the Cannon Art School from 1911 to 1912 and for about six months at a school
run by John H. Rich (1876–1954) and William V. Cahill (died 1924). He was one of
several artists who maintained studios at the Lyceum Theater Building. He may also have
worked for the motion-picture industry.

Although Berlin began his career as a portraitist and continued to paint representa-
tional works into the 1920s, he participated in the first modernist show in Los Angeles
held in 1923 at the MacDowell Women's Club and was a member of the governing com-
mittee that organized the Group of Independent Artists. He had one of the largest bodies
of work in the 1923 exhibition, nineteen pieces, including *Owngz* (unlocated), an arrange-
ment of semitransparent, geometrical, overlapping shapes. He continued to exhibit cubist-
inspired paintings during the mid-1920s and perhaps as late as the early 1930s. He
frequented Margery Winter's salon, where he associated with art historian and critic
Sadakichi Hartmann and EJNAR HANSEN.

Around 1930 Berlin painted watercolors of the Grand Canyon, possibly for the tourist
trade. He also participated in the Works Progress Administration Federal Art Project,
producing easel paintings in the studio of Area Director LORSER FEITELSON, who be-
came his close friend. During the mid-1930s his art became more surreal, perhaps under
Feitelson's influence.

BIBLIOGRAPHY
"Ben Berlin Paints Fourth Dimension, Says Occultist, after Viewing Exhibit," *For Art's Sake* 1 (January 15,
1924): 3 § Los Angeles Art Association, artist's file, newspaper clipping, "'Psycho-Imagistic' Artist Enters
Row," *Los Angeles Examiner,* November 1, 1926 [?] § Ted LeBerthon, "Night and Day," *News* (Los Angeles),
June 27, 1940, p. 32 § Archiv. Am. Art, Oral History Project, "Interview with Nick Brigante," by Betty
Hoag, May 25, 1964, transcription, pp. 7–10, includes discussion of Berlin § Moure with Smith 1975, p. 16,
with bibliography.

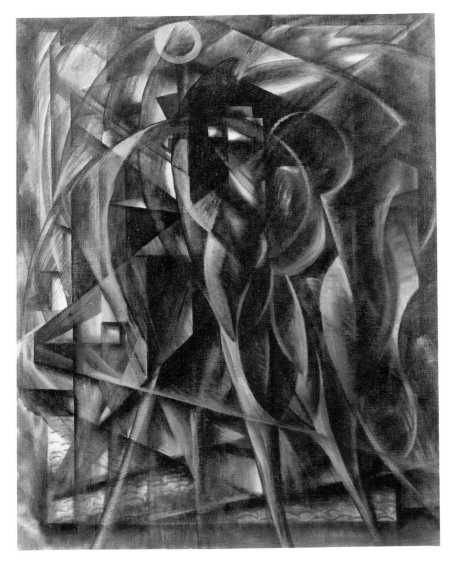

Berlin, *Figures*.

Figures, c. mid- to late 1920s
Oil on canvas
32¼ x 27⅜ in (82.0 x 69.6 cm)
Gift of Mr. and Mrs. David Sokol
61.59.1

Berlin's turn to modernism was supposedly initiated by his reading of Jerome Eddy's notable book *Cubists and Post-Impressionism* (1914), and his earliest abstractions are indebted to cubism. Although Berlin probably never visited France, by the 1920s cubism was well known in Los Angeles and he would have been aware of it.

In this painting the figures are fused with the surrounding environment in a configuration of overlapping and intersecting faceted planes and ray lines, standard cubist devices. During the 1920s, when this canvas may have been painted, STANTON MACDONALD-WRIGHT was the dominant force in Los Angeles's modernist circles. His art, although exhibiting more arabesque lines, may have influenced Berlin's treatment of the figure, especially in his use of delicate, translucent planes. The cubist art of Lorser Feitelson, who became a major progressive force in Los Angeles after his move to the West Coast in 1927, also may have served as a model for Berlin.

A painting that may have directly inspired *Figures* is *Nude Descending a Staircase (No. 2),* 1912 (Philadelphia Museum of Art), by Marcel Duchamp (1887–1968). Duchamp's often reproduced painting was a notorious modernist work, and it is likely that Berlin became acquainted with it through the collector Walter Arensberg, who had settled in Hollywood in the 1920s and always opened his home to artists. Arensberg did not acquire the painting until 1930, but before that time he proudly displayed a color reproduction of it. As in Duchamp's painting, Berlin's cubist analysis of movement results in an allover composition of intersecting planes and diagonal lines colored in a somber dominant hue. The dark lines are in blue with brighter, warm colors brushed in to create a translucent effect. *Figures* may have been one of the paintings, as was *Rhythmic Forms* (unlocated), in Berlin's 1924 exhibition at the Potboiler, for in an article commenting on the show, Berlin was praised for being one of the first to attempt the depiction of the fourth dimension.

PROVENANCE
Mr. and Mrs. David Sokol, Malibu, Calif., to 1961.

LITERATURE
Moure with Smith 1975, repro., p. 304.

Robert Brackman

Born September 25, 1898,
Odessa, Russia
To United States 1910
Died July 16, 1980, Noank,
Connecticut

In his day Robert Brackman was among the country's most prominent portraitists, and he received numerous awards for his figure paintings and still lifes. He studied at the Francisco Ferrer School in New York with ROBERT HENRI and GEORGE BELLOWS and then at the school of the National Academy of Design with LEON KROLL and Ivan Olinsky (1878–1962) from 1919 to 1922. He traveled to England with his friend ROBERT PHILIPP. Brackman exhibited widely in annuals, and his first solo exhibition was held at the Milch Gallery in New York in 1925. He was elected an associate of the National Academy of Design in 1932 and a member in 1940. He devoted considerable time to teaching, at the Art Students League from 1934, as well as at other schools, including the Madison Art School in Connecticut, which he opened in 1957. After 1926 he summered in Noank,

Connecticut, and in 1938 moved there permanently, giving up his New York studio. He was a member of virtually every artists' group devoted to conservative art.

BIBLIOGRAPHY
Archiv. Am. Art, Robert Brackman Papers § Malcolm Vaughan, "Robert Brackman," *Creative Art* 12 (April 1933): 276–83 § Kenneth Bates, *Brackman: His Art and Teaching* (Noank, Conn.: Noank Publishing Studio, 1950), with lists of collections, portraits, and prizes, bibliography § Joseph De Bona, "Robert Brackman: Rebel with a Brush," *American Artist* 25 (December 1961): 32–39, 80–81 § Norfolk (Va.) Museum of Arts and Sciences, *Paintings by Robert Brackman: A Retrospective Exhibition,* exh. cat., 1965, with foreword by Henry B. Caldwell.

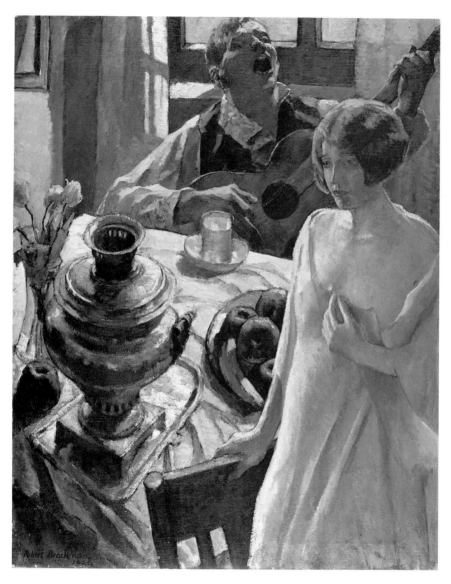

Brackman, *A Song.*

A Song, by 1926
(*The Song*)
Oil on canvas
56 x 45⅞ in (142.2 x 116.5 cm)
Signed and dated lower left: Robert Brackman / 192[6?]
Inscribed verso upper right: A SONG– / ROBERT BRACKMAN / 1926
Gift of Irving Mills
M.80.142.1

Although Brackman later became the bête noir of the modernists, he apparently had trouble placing his works in national exhibitions during the early 1920s: "The academicians found me too modern and the moderns, too academic," he recalled in an interview in 1961. Indeed, the modernist elements found in *A Song* continued to influence his art even after his study of the Renaissance masters had led him toward a very deliberate classicism. As a young man he had admired the styles of Pierre-Auguste Renoir (1841–1919), Claude Monet (1840–1926), Paul Cézanne (1839–1906), and other French painters. His overriding interest in the effects of light and color—which was derived from the impressionists and proved to be the foundation of his technique as a painter—can be readily detected in *A Song.* From the works of Cézanne, whom he acknowledged as the source for his lifelong enthusiasm for still life, Brackman derived the use of rich color for modeling, faceted forms, tilted tabletops, and a balance of two-dimensional and three-dimensional elements. With its strong color, disorienting perspective, and boisterous energy, *A Song* reflects these influences more directly than his better known, more classical works.

The singer's shirt and the samovar may refer to the artist's Russian origins, but because of the singer's expression and the angle of his face it is difficult to determine whether the painting was intended as a self-portrait. The combination of a seminude figure with a still life in a studio setting was to become a familiar Brackman theme. *A Song* was one of numerous paintings by Brackman owned by the music publisher Irving Mills, an early patron.

The inscriptions on the canvas and its verso may be by different hands. The last digit in the date on the front is ambiguous, suggesting 3, 5, or 6. A review of Brackman's 1926 exhibition at Babcock Galleries in New York definitely identifies this painting as *The Song.* Given the prominence of the samovar, however, it is possible that the painting may have been exhibited the year before as *The Samovar* in his one-man show at the Milch Galleries.

PROVENANCE
The artist § Irving Mills, Beverly Hills, Calif., to 1980.

EXHIBITION
New York, Babcock Galleries, *Paintings by Robert Brackman*, 1926, no cat. traced, as *The Song*.

LITERATURE
"New York Exhibitions: Robert Brackman," *Art News* 24 (April 10, 1926): 7 § *LACMA Members' Calendar* 19 (September 1981): repro., unpaginated § *LACMA Members' Calendar* 23 (September 1985): repro., unpaginated.

Lorser Feitelson

Born February 11, 1898,
Savannah, Georgia
Died May 24, 1978, Los
Angeles, California

Lorser Feitelson was the dean of Southern California modernism for half a century, the best-known proponent of surrealism on the West Coast, and one of the West's earliest hard-edge painters. He devoted his entire career to developing a classical-abstract art, which he perceived as the most satisfying means of fusing the spirit of the Renaissance and modern art.

As a teenager in New York Feitelson was exposed to old master and modernist European and American painting simultaneously. He saw the Armory Show, read avant-garde art journals and Jerome Eddy's *Cubists and Post-Impressionists* (1914), and by the age of eighteen had his own studio. In 1919 he visited Paris for the first time, and in the early 1920s he traveled to Italy. Influenced by Paul Cézanne (1839–1906), cubism, futurism, Henri Matisse (1869–1954), and André Derain (1880–1954), Feitelson experimented with kineticism and compositional structure. During the early 1920s he began to develop a neoclassical art, at first utilizing mythological and peasant themes.

After achieving success in New York, where he exhibited at the progressive Daniel Gallery, Feitelson settled in Los Angeles in 1927. He was immediately given solo exhibitions in Los Angeles and San Francisco. During the 1930s he opened the first gallery of contemporary art in Los Angeles, served as the supervisor of the murals, paintings, and sculpture section of the Southern California Works Progress Administration/Federal Art Project, and taught at a number of schools. In 1934 he and his wife, artist Helen Lundeberg (born 1908), developed an aesthetic that they called Subjective Classicism and which the critics dubbed postsurrealism. Responding to the Second World War, Feitelson began painting Magical Forms, a series of nonrepresentational images, in the hope that the forms would reflect a new world. In the 1950s his continued fascination with the purity of form and line led to his creating geometric, abstract, hard-edge paintings, and by 1959 Feitelson banded with three other West Coast hard-edge artists—Karl Benjamin (born 1925), Frederick Hammersley (born 1919), and John McLaughlin (1898–1976)—as Abstract Classicists to exhibit their geometric, abstract paintings. Through the 1960s and 1970s Feitelson continued to develop his hard-edge paintings with a growing sensuousness of line and color.

BIBLIOGRAPHY
Archiv. Am. Art, Lorser Feitelson Papers and Helen Lundeberg Papers § Jules Langsner, "Permanence and Change in the Art of Lorser Feitelson," *Art International* 7 (September 25, 1963): 73–76 § Diane Degasis Moran, "The Painting of Lorser Feitelson," Ph.D. diss., University of Virginia, 1979, with bibliography § San Francisco Museum of Modern Art and Los Angeles, University of California, Frederick S. Wight Art Gallery, *Lorser Feitelson and Helen Lundeberg: A Retrospective Exhibition*, 1980, with text by Diane Degasis Moran, bibliography, list of exhibitions § Diane Degasis Moran, *Feitelson: Three Analytical Essays* (Los Angeles: Lorser Feitelson and Helen Lundeberg Feitelson Arts Foundation, 1981).

Two Peasant Children, 1927
(*Peasant Children; The Peasant Children*)
Oil on canvas
36 x 36 in (91.4 x 91.4 cm)
Signed lower left: FEITELSON
Gift of Mrs. W. H. Russell
33.13.1

While in Europe in 1923 Feitelson spent some time on the island of Corsica sketching Italian peasants. He admired the Corsicans, finding them endowed with simplicity and dignity and leading lives of great tranquility despite their poverty. The peacefulness of the island contrasted with the chaotic and tense atmosphere

of postwar Europe, which prompted in Feitelson the realization that pastoral subject matter could reflect the eternal spirit of classicism. Consequently, from 1925 through the first years of the next decade, Feitelson created a series about peasants in which the themes of youth, old age, and the continuity of life predominate. Often an older woman dressed in traditional costume—a modest frock, apron, and kerchief—is presented with her offspring.

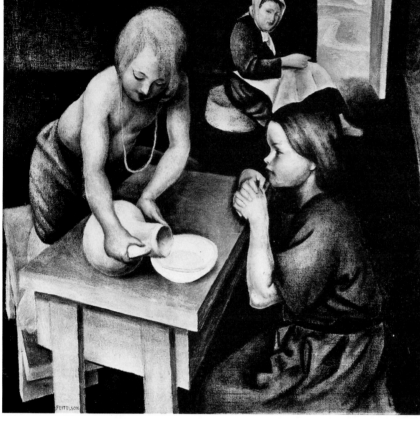

Feitelson, *Two Peasant Children.*

 In *Two Peasant Children* an older woman is placed in the back while children fill the foreground. The children are at a small table that sits close to the picture plane, and their size and placement in relation to the old woman suggest both the passage of time into the present and the passage of life from youth to old age.

 When Feitelson exhibited his peasant paintings in an exhibition at the Los Angeles Museum in autumn 1929, a critic acutely observed that such subject matter was merely an excuse for the artist to create elaborate figure paintings in which he could apply his analytical study of the compositions of the late Renaissance (LACMNH, Archives, Museum Scrapbook, unidentified clipping, September 8, 1929). Feitelson's neoclassicism was indeed based upon his deep understanding of Italian Renaissance art. His spare, solid figure types reveal his awareness of such early Renaissance masters as Masaccio (1401–1428), while compositions such as that of *Two Peasant Children* demonstrate the more convoluted spatial organization of mannerist painting. Feitelson's interest in a unified palette was manifested in the peasant paintings' rich earth colors and deep, mellow tones.

PROVENANCE
With Ilsley Galleries, Los Angeles, 1932 § Mrs. William H. Russell, Los Angeles, 1932–33.

ON DEPOSIT
Los Angeles County Juvenile Court, 1970–78.

EXHIBITIONS
San Francisco, California Palace of the Legion of Honor, [Lorser Feitelson and Nathalie Newking exhibition], 1928, no cat. traced § LAMHSA, *The Tenth Annual Exhibition of Painters and Sculptors,* 1929, no. 29, as *Peasant Children* § Fine Arts Gallery of San Diego (Calif.), *The Fourth Annual Exhibition of Southern California Art,* 1929, no. 26, as *Peasant Children,* awarded Leisser-Farnham Memorial Prize § Brooklyn Museum, *A Group Exhibition of Paintings and Drawings by American and Foreign Artists,* 1930, no. 118 § San Francisco, California Palace of the Legion of Honor, *Fifty-third Annual Exhibition of the San Francisco Art Association,* 1931, no. 155 § Los Angeles, Ilsley Galleries, *Olympiad Exhibit: Great Eastern and Western Art,* 1932, no cat. traced § Los Angeles, University of Southern California, Elizabeth Holmes Fisher Gallery, *Some Contemporaneous California Painters* (series 1939–40, no. 3), 1940, no. 11 § Los Angeles, Bullock's, *Fashion Color of Modern Masters,* 1954, no cat. traced § Claremont, Calif., Pomona College, Montgomery Art Center, *Los Angeles Painters of the Nineteen-Twenties,* 1972, no. 23, repro., unpaginated.

LITERATURE
Jehanne Biétry Salinger, "In San Francisco Galleries," *Argus* 3 (September 1928): repro., 9 § "Prize Awards in San Diego Show," *Art News* 27 (August 17, 1929): 5 § "Brooklyn Museum Shows Neo-Classic Art," *Art Digest* 4 (August 1930): repro., 13 § "Two Paintings Bought for Museum," *Los Angeles Times,* August 14, 1932, pt. 3, p. 18, repro. § Milton Merlin, "Ars California," *Touring Topics* (July 1933): 32, repro. § Arthur Millier, "Museum's Own Collection of Paintings Now on View," *Los Angeles Times,* July 30, 1933, pt. 3, p. 5 § Arthur Millier, "Local Artists' Fiesta Proves Elusive Affair," *Los Angeles Times,* August 7, 1933, pt. 3, p. 16, neoclassic painting bought out of Ilsley Galleries Olympic exhibition § Arthur Millier, "New Developments in Southern California Painting," *American Magazine of Art* 27 (May 1934): repro., 247, as *The Peasant Children* § Arthur Millier, "Lorser Feitelson," *California Arts and Architecture* 57 (May 1940): repro., 8 § Moran, "Painting of Feitelson," p. 279 § LACMA 1980, p. 48.

Maternity, 1931–32

Oil on canvas
50 x 60 in (127.0 x 152.0 cm)
Signed lower left: FEITELSON
Gift of Charles McCutcheon
33.14

Maternity was Feitelson's last peasant paint-
ing and served as a link between his classical
paintings of the 1920s and works based on his
postsurreal concepts of the mid-1930s.

Landscape became a major component in
Feitelson's art for the first time in this canvas.
The craggy mountains of Corsica are the basis
of the setting. The deep chasm in the center
forms a physical and psychological barrier
between the two figure groupings, the young
people on the left and the elderly on the right.
The two strongly vertical elements of the com-
position are unified by what Feitelson termed
"the dynamics of directional suggestion," that
is, by the figures' gazing across the chasm at
one another and thereby uniting the two sides
by the directions of their gazes. According to
the art historian Diane Moran, this was a
major discovery for Feitelson and marked a
turning point in his development of a classical
art structured by subjective means. This new
compositional device was so important to him
that when he first exhibited *Maternity* in San
Francisco in 1932—in his most important

exhibition to date—and then at the Los
Angeles Museum the next year, a diagram of
his analysis of the composition's directional
rhythms (see illustration) was hung next to the
painting.

While *Maternity* was in the Los Angeles
Museum's *Fourteenth Annual Exhibition of
Painters and Sculptors* in 1933, it was singled out
in a dispute over modernism. A conservative
group of protesting artists headed by Karl Yens
(1868–1945) referred to it as a conglomeration
of mere daubings and criticized its incorrect
perspective. In defense of his art Feitelson
offered to debate publicly in support of the
modernist cause, stating in an article for the
Los Angeles Times that he strove for a neoclassic
painting that would be a "deathless art,
achieved in a new manner . . . but worthy to
live as long as art shall live."

RELATED WORK
Analytical drawing of *Maternity,* by 1932, ink and
pencil on paper, 7⅛ x 8¼ in (18.1 x 21.0 cm). Helen
Lundeberg, Los Angeles.

PROVENANCE
Charles McCutcheon, Los Angeles, 1933.

EXHIBITIONS
San Francisco, California Palace of the Legion of
Honor, *Feitelson and Newking,* 1932, no cat. traced,
dated 1931–32 § LACMHSA, *The Fourteenth*

Feitelson, Analytical drawing of
Maternity, by 1932, see Related
Work.

Feitelson, *Maternity.*

Annual Exhibition of Painters and Sculptors, 1933, no. 13 § San Francisco Museum and Wight Art Gallery, *Feitelson and Lundeberg*, no. 17, p. 12., repro.

LITERATURE
San Francisco, California Palace of the Legion of Honor, Registrar's files, n.d., typed explanation of the artist's theoretical aims in *Maternity* § "Art War Breaks Out," *Los Angeles Times*, May 26, 1933, pt. 2, p. 18 § Marian Rhea, "Paintings of Controversy: 'Freight Yard Art' Rapped in Museum Row," *Los Angles Evening Herald and Express*, May 26, 1933, p. 3, considered unsound modernist painting by Karl Yens, repro. § LACMNH, Archives, Museum Scrapbook, unidentified newspaper clipping, "Artist Offers to Debate in Art Row," quotes the artist's aims for neoclassic painting § Herman Reuter, "Works Seen at L.A. Museum Termed Nightmarish Phantasmagoria," *Hollywood Citizen-News,* August 3, 1935, p. 6, considers one of the better modernist paintings on view § "Our Artists in Person: Lorser Feitelson," *Los Angeles Times,* February 16, 1936, pt. 3, p. 9 § Moran, "Painting of Feitelson," pp. 81–82, 279, fig. 45, p. 317, repro. of related diagram, p. 392 § LACMA 1980, p. 64 § Diane Moran, "Post-Surrealism: The Art of Lorser Feitelson and Helen Lundeberg," *Arts Magazine* 57 (December 1982): 124, fig. 1.

Edouard Vysekal

Born March 17, 1890, Kutná Hora, Czechoslovakia
To United States 1907
Died December 2, 1939, Los Angeles, California

Edouard Antonin Vysekal was one of the early modernists active in Southern California. Born into a family of artists, he was introduced to art at an early age, attending the Industrial and Art Polytechnic School, Prague. After immigrating to the United States at age seventeen, he sought instruction first at the Art Institute of Saint Paul and then the School of the Art Institute of Chicago, where he studied with J. H. Vanderpoel (1857–1911) and Harry M. Walcott (1870–1944). He taught at the Art Institute from 1912 to 1914, when he moved to California, his wife, Luvena Buchanan Vysekal (d. 1954), having received a mural commission for the Hotel Barbara Worth in El Centro, California.

The Vysekals settled permanently in Southern California and immediately became active in the local art life, both exhibiting in 1919 with the modernist group the California Progressive Painters and later with the Group of Eight. Vysekal's work won acclaim from both conservative and avant-garde critics because he demonstrated in his figure and still-life paintings the ability to retain a command of draftsmanship like the old masters' while exploring the potential of abstract color and form. Vysekal exhibited regularly in the annual exhibitions of the California Art Club, the Los Angeles Museum, and the California Watercolor Society. He inspired many Southern California painters through his teaching, first at the Art Students League of Los Angeles and at the Otis Art Institute, where he taught life drawing and landscape painting from 1922 till his death.

BIBLIOGRAPHY
Luvena Buchanan, "Edouard A. Vysekal, Painter," *Czechoslovak Review* 8 (June 1924): 157–59 § Sonia Wolfson, "Two Ironic Romanticists," *Argus* 4 (October 1928): 3, 14 § Arthur Millier, "Our Artists in Person, no. 3: The Vysekals," *Los Angeles Times,* July 20, 1930, pt. 3, p. 12 § LACMHSA, *Edouard Vysekal Memorial Exhibition,* exh. cat., 1940, with preface by Arthur Millier § Moure with Smith 1975, pp. 260–61, with bibliography.

The Herwigs, 1928
Oil on canvas
54³/₈ x 39¹/₄ in (138.2 x 99.6 cm)
Signed lower right: VYSEKAL
Gift of Mr. and Mrs. Louis Saran Strauss
46.42
Color plate, page 69

In the catalogue for the Vysekal memorial exhibition held at the Los Angeles Museum in 1940, Arthur Millier declared *The Herwigs* to be "a landmark in the figure painting" of Southern California. During his lifetime Vysekal became best known for multifigured compositions evidencing his early academic training. He had an excellent command of anatomy and depicted his characters brimming with life, their physiques healthy and robust. In *The Herwigs* he moved further from his training. Although Vysekal depicted fellow artist William K. Von Herwig (b. 1901) and his family, the figures were only a means to exercise his interest in color abstraction. This becomes more apparent when the unusual presentation of the figures is considered: the mother sits inside on a window seat playing with the child while the father looks on from outside, his hands pressed against the window. The figures form a contemporary Holy Family: the placement of the father outside the house accords with the not uncommon practice of depicting Saint Joseph slightly apart from the Virgin and Child. The family is encircled by the Hollywood Hills, which the artist has transformed into a bright background of color and light. The child's gesture of stretching upward leads the viewer's eye toward the prismatic glass wind chime, which recalls the

coloristic and formal experiments of modernist artists.

As early as 1916 Vysekal became fascinated by the abstract quality of color, and by 1921 this was reflected in the titles of many of his now lost paintings, such as *Mlle R.: Arrangement in Green; Brickyard: Violet Major;* and *Arrangement: Scale of Orange.* Color theories were popular among artists during the early twentieth century, and Vysekal may have been first introduced to them at the presentation of the Armory Show in Chicago. The art and teaching of STANTON MACDONALD-WRIGHT in Los Angeles during the 1920s no doubt encouraged Vysekal to apply color theory to his solidly rendered figure studies. In a warm palette of oranges and yellows Vysekal constructed the figures of the Herwigs with

flickering planes of light and dark. While he did not completely relinquish modeling of the figure, he was more daring in his treatment of the background, abstracting the landscape into arcing color bands. Moreover, the use of a screen between the figures enabled him to play with the refraction of color and light. The brilliant light almost dissolves the forms while creating a halo effect. Arthur Millier described the glowing color as "spiritualizing" the painting's conception.

PROVENANCE
The artist, 1928–39 § Luvena Vysekal (by descent), Los Angeles, 1939 § Mr. and Mrs. Louis Saran Strauss, Van Nuys, Calif., 1946.

ON DEPOSIT
LAMHSA, LACMHSA, 1930–46 § Los Angeles County Health Department, 1951–73.

EXHIBITIONS
LAMHSA, organized by California Art Club, *Eighteenth* [actually Nineteenth] *Annual Exhibition,* 1928, no. 58 § Oakland Art Gallery and Art League, *Annual Exhibition,* 1929, no. 84 § LAMHSA, *Boris Deutsch, E. Roscoe Shrader, Edouard A. Vysekal, Luvena Buchanan Vysekal,* 1929, no. 21 § Fine Arts Gallery of San Diego (Calif.), *Fourth Annual Exhibition of Southern California Art,* 1929, no. 95, awarded special prize § Pasadena Art Institute, *Third Annual Exhibition of California Artists,* 1930, no cat. traced § LACMHSA, *Artists of Southern California,* 1930–31, no. 22 § LACMHSA, *Vysekal Memorial Exhibition,* no. 17, unpaginated, preface by Arthur Millier § Los Angeles, Foundation of Western Art, *Only Yesterday: Southern California Art in Retrospect, 1940–1896,* 1942, no. 28 § Claremont, Calif., Pomona College, Montgomery Gallery, *Los Angeles Painters of the Nineteen-Twenties,* 1972, no. 46 § Laguna 1979, entries not numbered, pl. 189.

LITERATURE
Wolfson, "Ironic Romanticists," p. 3, mentioned as the artist's latest painting § Arthur Millier, "Throngs See Art Exhibit," *Los Angeles Times,* November 18, 1928, pt. 3, pp. 13, 18, describes and states painting attracted large crowds, repro., p. 18 § Florence Wieben Lehre, "Oakland May Abolish Juries," *Argus* 5 (April 1929): 7, exhibited at the 1929 Oakland annual, "the most striking work in the show . . . a complete departure from Vysekal's former methods" § "Southern Californians at the Oakland Annual," *California Art Club Bulletin* 4 (May 1929): unpaginated § "Prize Awards in San Diego Show," *Art News* 27 (August 17, 1929): 5, awarded prize of fifty dollars § Arthur Millier, "Jewish Genius at Museum," *Los Angeles Times,* September 22, 1929, pt. 3, p. 16, praises use of brilliant color to set forth rhythmically composed forms § "Recent Gifts," *LA Museum Art Div. Bull.* 1 (Spring 1947): 27–28 § Moure with Smith 1975, repro., p. 306.

Vysekal, *The Herwigs.*

Alfred Maurer

Born April 21, 1868,
New York, New York
Died August 4, 1932,
New York, New York

Alfred Henry Maurer was one of this country's early modernists, the first American to adopt fauvism. During his lifetime his art was largely overshadowed by the reputation of his father, the noted illustrator Louis Maurer (1832–1932). At first Alfred's work was allied with traditional academic painting; he studied in New York at the National Academy of Design in 1884 and in Paris at the Académie Julian in 1897. Except for a brief visit home in 1901 he remained in Paris until the beginning of World War I. He received critical praise for figurative scenes in the turn-of-the-century manner of James McNeill Whistler (1834–1903) and WILLIAM M. CHASE that emphasized a decorative, tonalist quality.

Maurer became involved with vanguard art through Leo and Gertrude Stein, and by 1905 he began to abandon his dark, conservative style for the brilliantly colored, expressionist art of the fauves. He was one of the first Americans to study with Henri Matisse (1869–1954). In 1909 Alfred Stieglitz began showing Maurer's paintings in New York at his gallery "291."

After he returned to New York in 1914, Maurer continued to paint fauvist landscapes while experimenting with other abstract styles, especially cubism, encouraged by his new friendships with MARSDEN HARTLEY and Arthur Dove (1880–1946). During the last years of 1920s he created a group of forcefully painted, synthetic-cubist tabletop still lifes. The most significant paintings of the last decade of his life were heads of women presented alone or in pairs.

Except for Stieglitz's early attention Maurer's modernist art was ignored until 1924, when Weyhe Gallery in New York held the first of numerous exhibitions devoted to his work. These shows brought his art to the critics' attention. It came too late, however: in 1932, after a long illness, Maurer committed suicide only days after his father's death.

BIBLIOGRAPHY
Archiv. Am. Art, Elizabeth McCausland Papers and Bertha Schaefer Gallery Papers § Christian Brinton, "Maurer and Expressionism," *International Studio* 49 (March 1913): VIII–IX § Elizabeth McCausland, *A. H. Maurer* (New York: A. A. Wyn for the Walker Art Center, Minneapolis, 1951) with chronology, bibliography, note on Maurer's painting technique § Washington, D.C., Smithsonian Institution, National Collection of Fine Arts, *Alfred H. Maurer, 1868–1932*, exh. cat., 1973, published by Smithsonian Institution Press, with text by Sheldon Reich, chronology, lists of exhibitions and awards, bibliography § Nick Madorno, "The Early Career of Alfred Maurer: Paintings of Popular Entertainment," *American Art Journal* 15 (Winter 1983): 4–34.

Maurer, *Head.*

Head, c. 1928
Tempera with oil glazes on board
21¹³/₁₆ x 18³/₁₆ in (55.5 x 46.2 cm)
Bertha Schaefer Bequest
75.5

Maurer first exhibited his heads of women in 1921 and continued to paint them for the rest of his life. Most are undated and have been grouped together on the basis of similarity of style and facial expression. Sometime between 1926 and 1928 Maurer developed a more abstract vocabulary as he simplified and distorted the facial features in a manner reminiscent of African masks and the early cubist works of Pablo Picasso (1881–1973).

The faces and necks of the late heads are elongated, the mouths tiny, the eyes exceptionally large. As Elizabeth McCausland wrote, "The eyes of Alfred Maurer's women

never close. Wide open windows in the pale, rosy stucco of their physiognomies, these eyes successfully draw one's attention . . . from the disturbing sensitiveness of the unreal proportions and the fine essential line. Terrible is the dead straightness of their stare" (McCausland, *Maurer,* p. 206). The heads became increasingly somber and introspective, and their sad eyes took on an obsessive intensity, which many historians have related to Maurer's own increasingly distraught psyche. This painting probably dates from about 1928 or shortly before, for around 1928 Maurer increased the distortion to the point of disintegrating natural shapes.

Head is largely gray in color, the background painted thinly with broad strokes and the figure described with somewhat thicker brushwork. Much of the picture has been overpainted, probably the work of the artist rather than of a restorer. Maurer often reworked his paintings and was very experimental in the materials he used; the ground of *Head,* for example, is a white dental plaster. As a result, the pigment surfaces of many of his paintings made after 1914 have suffered from flaking, as has this example.

PROVENANCE
Probably with Hudson Walker, New York § With Bertha Schaefer Gallery, New York, to 1971 § Estate of Bertha Schaefer, 1971–75.

Boza Hessova

Born Kralove, Czechoslovakia
To United States 1913

Very little is known about Boža Hessová. She studied with Rudolph Vacha (1860–1939) and Alois Kalvoda (b. 1875) at the art academy in Prague. After living in Paris for some time, she immigrated to the United States in 1913. Working in Chicago, she painted murals in churches and was also employed by the department stores Marshall Field and Ingstrup-Buhrke, Inc. She painted portraits and landscapes after moving to Los Angeles in 1928. In the early 1930s she briefly used the name Beatrice Hess.

BIBLIOGRAPHY
Moure with Smith 1975, pp. 115–16, with bibliography.

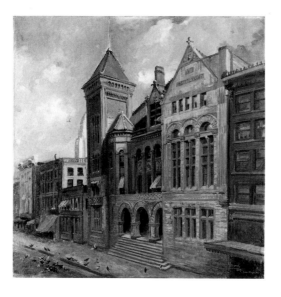

Hessova, *Old City Hall of Los Angeles.*

Old City Hall of Los Angeles, 1929
Oil on canvas
28³/₁₆ x 28³/₁₆ in (71.6 x 71.6 cm)
Signed and dated lower right: Boža Hessová / 1929.
Loos [*sic*] Angeles.
Los Angeles County Fund
36.23.1

Soon after her arrival in Los Angeles in late 1928 Hessova began this view of the old City Hall, just before it was demolished early in 1929. The Richardsonian Romanesque structure was erected in 1888 at Broadway Street between Second and Third streets in what was originally the civic center of the city. With the completion of the new City Hall in 1927, the structure was considered obsolete and in an inappropriate location and was torn down.

PROVENANCE
The artist, 1929–36.

ON DEPOSIT
Los Angeles County Health Department, Glendale, 1941–52 § Los Angeles County Board of Supervisors, 1952–75 § Los Angeles mayor's residence, since 1977.

EXHIBITION
LAMHSA, *The Tenth Annual Exhibition of Painters and Sculptors,* 1929, exhibited but not listed.

LITERATURE
Arthur Millier, "Old City Hall Inspires Artist, Demolished Building Now on Canvas," *Los Angeles Times,* March 10, 1929, pt. 3, p. 11, repro.

John Cotton

Born October 29, 1868,
Toronto, Ontario, Canada
To United States by early
1900s
Died November 23 or 24,
1931, Toronto, Ontario,
Canada

John Wesley Cotton was active as a painter and etcher in the Los Angeles area during the 1920s. He studied and worked in several countries, training under Eli Marsden Wilson (b. 1877) in London and at the School of the Art Institute of Chicago. Although the dates of his study at the Art Institute are not known, beginning in 1905 Cotton exhibited at the museum for a decade, and he had a studio in Chicago in 1909. He worked in England, Belgium, and possibly France in 1911 and in Toronto from 1912 to 1917. He took up residence in southern California in 1918, and although he became associated with the Glendale area just outside of Los Angeles, he was known to travel afield for inspiration, visiting the coastal area of Laguna as well as the High Sierras in northern California. Cotton was actively involved in local art organizations both as an exhibitor and organizer, and he was elected president of the Glendale Art Association in 1928. A frequent participant in exhibitions held at the Los Angeles Museum, Cotton was given a one-man exhibition of his watercolors by the museum in 1923. He left southern California in 1930 to visit France again and then returned to the city of his birth, where he died the following year.

BIBLIOGRAPHY
Obituary, *Los Angeles Times*, November 28, 1931, pt. 2, p. 6; November 29, 1931, pt. 3, p. 18 § Obituary, *Art Digest* 6 (December 15, 1931): 8 § Moure with Smith 1975, p. 55, with bibliography.

Cotton, *Landscape*.

Landscape, c. 1920s
Oil on canvas
30⅛ x 40 in (76.4 x 101.6 cm)
Signed lower left: JOHN COTTON
Gift of John Cotton
M.86.26

During the decade Cotton spent in the Los Angeles area he adopted the *plein-air* approach to landscape painting that was so popular among local artists. *Landscape* is a typical example: the tall, thin, eucalyptus trees frame hilly, broadly rolling terrain, and a shadowy foreground serves as a contrast to the brilliant sunlit mountains. The palette consists of soft yellow-ochers, harmonious sunny greens, and cool lavenders.

PROVENANCE
The artist, to 1931 § Estate of the artist, 1931–86.

ON DEPOSIT
LAMHSA, LACMHSA, LACM, LACMA, 1930–1986.

Eugene Speicher

Born April 5, 1883, Buffalo,
New York
Died May 11, 1962,
Woodstock, New York

Eugene Edward Speicher was one of the foremost figure painters in America during the 1920s and 1930s. After studying at the Art Students League in Buffalo he moved to New York and in 1907 entered the Art Students League, where he studied with WILLIAM M. CHASE and Frank V. DuMond (1865–1951). As a result of his friendship with GEORGE BELLOWS, Speicher also studied with ROBERT HENRI in 1908. Speicher first achieved recognition in the 1910s as a portrait painter, but after a period in Europe devoted to studying the postimpressionists and old masters, he turned to studio pictures, usually representing women seated in comfortable interior settings. In the 1920s he won critical praise for figure paintings such as *The Young Hunter*, 1921 (Pittsburgh Athletic Association), and *Katherine Cornell as Candida*, 1926 (Albright-Knox Art Gallery, Buffalo). His figure paintings reveal a modernist sensitivity to form and abstraction combined with an

old master draftsmanship, an understated, but rich palette, and soft brushwork, the last inspired by Pierre-Auguste Renoir (1841–1919). He also created paintings and drawings of the female nude.

In 1907 Speicher helped found the art colony in Woodstock, New York. He spent his summers there, painting landscapes and floral still lifes, while in the winter he worked on figure paintings in his New York studio. He was elected an associate of the National Academy of Design in 1912 and an academician in 1925; he became director of the American Academy of Arts and Letters in 1945.

BIBLIOGRAPHY
New York, American Academy of Arts and Letters, Eugene Speicher Papers (on microfilm, Archiv. Am. Art) § Virgil Barker, "Eugene Speicher: Painter and Artist," *Arts* 6 (December 1924): 314–28 § *Index 20th Cent. Artists* 1 (December 1933): 37–42; 1 (September 1934): I; 2 (September 1935): IV; 3 (August–September 1936): VI; reprint, pp. 44–49, 65, 68, 70 § Harry Salpeter, "Big American: Speicher," *Esquire* 6 (December 1936): 72–73, 195–96, 198, 201–2 § Buffalo, Albright Art Gallery, *Eugene Speicher: A Retrospective Exhibition of Oils and Drawings, 1908–1949,* exh. cat., 1950, with essay by Charles E. Burchfield, chronology, list of exhibitions, bibliography, and list of collections compiled by Beatrice Howe.

Speicher, *Landscape.*

Landscape, c. 1920s
Oil on canvas
24³⁄₈ x 30¹⁄₈ in (61.5 x 76.5 cm)
Signed lower right: Eugene Speicher
Gift of T. Dwight Partridge
M.77.39

Although not known for them, Speicher seems to have painted landscapes throughout his career, exhibiting them with his figure paintings. After the late 1930s he increasingly concentrated on the landscape. His landscapes are more modernist than his figure paintings and reveal the impact of Paul Cézanne (1839–1906). No doubt because of his affiliation with the Woodstock colony, most are of sites in upstate New York. *Landscape* was painted at Rondout Basin, near Kingston, New York, a small town along the Hudson River north of New York City.

This painting probably dates from the 1920s, perhaps the later part of the decade, as indicated by the similarity of its brushwork to that in dated landscapes from that period or later. A dating to the 1920s would coincide with the period when George Bellows, a close friend of Speicher's, was working at Woodstock, which also may explain the vigor of the brushwork. The warehouse and ramshackle buildings are presented as simplified geometric forms built up with short, heavy, staccato brushstrokes of opaque paint. While the overall palette is somber to convey the drabness of the town's riverfront, it is enlivened with passages of warm rose and orange hues. Speicher retained some of Henri's and Bellows's rich color sense in his use of lavender, pink, and blue in the cloudy, gray sky.

PROVENANCE
T. Dwight Partridge, Pasadena, Calif., by 1930 to 1977.

ON DEPOSIT
LAMHSA, LACMHSA, and LACMA, 1930–77.

LITERATURE
Albright Art Gallery, *Speicher,* p. 25, lists § LACMA, American Art department files, Sam Klein to Ilene Susan Fort, August 4, 1986, identifies site of work.

Red Moore: The Blacksmith, c. 1933–34
(*Red Moore*)
Oil on canvas attached to wood board
64⅛ x 52⅛ in (162.9 x 132.4 cm)
Signed lower right: Eugene Speicher
Gift of Sidney and Diana Avery
M.84.197

In 1933 Speicher met Vincent Moore, a farmer from Glenford, New York, a village three miles from Woodstock. Speicher first saw Moore, who was nicknamed "Red" because of his red hair and formidable moustache, swinging a hammer in his blacksmith shop and was so struck by his exceptional physical presence that he persuaded Moore to pose for him. Eventually Moore became one of Speicher's favorite models, sitting for him every year for five years, but only in the autumn after the farming and hunting seasons. What resulted was a series of drawings and paintings in which the artist was able to convey the strength and ruggedness of this modern version of Longfellow's "Village Blacksmith," as one critic referred to him.

Speicher usually depicted the brawny Moore wearing work clothes—a rough shirt, pants, and heavy shoes—characteristic of the rural American laborer. (Speicher thought of him as an independent son of the soil.) He placed Moore in interior settings natural for him, often with different implements indicative of his manly activities: an anvil and wheel for this blacksmith scene, a gun for the painting of Moore as a hunter, and a table laden with food for the image of Moore as a farmer. A restrained palette was typical of Speicher, and

Speicher, *Red Moore: The Blacksmith.*

324

here the choice of browns was exceptionally well suited for underscoring the rugged, masculine quality of the image. Further conveying Moore's physical power is his assertive gesture of crossing his muscular arms over his broad chest.

The painting was exhibited in several major American cities during the mid-1930s, winning awards that confirmed Speicher's being one of the most important figure painters of the day. Although his approach to the figure was conservative, Speicher's handling was that of a modernist, for he built form with a soft, but square, planar and economical brushstroke. The artist was commended for this "direct painting" in a review of the Whitney Biennial.

Speicher painted another version of Moore as a blacksmith (see Related Works). His reason for creating this other version is not known nor is the chronology. The two blacksmith paintings were the only images of Moore that Speicher made as full-length figures, and they are among the most monumental of his images. Speicher's romantic conception of such rural American figures seems to be midway between the classicism of academic painting and American regionalism.

RELATED WORKS

Red Moore: The Blacksmith, n.d., oil on canvas, approx. 64⅛ x 52⅛ in. (162.9 x 132.4 cm). Mr. and Mrs. Robert E. Currie, Newport Beach, Calif. § *Head of Red Moore,* 1933, oil on canvas, 21½ x 17¾ in (54.6 x 45.1 cm). Albright-Knox Art Gallery, Buffalo § *Red Moore,* 1934, charcoal on paper, 17¹⁵⁄₁₆ x 12⁵⁄₁₆ in (45.7 x 31.3 cm). Addison Gallery of American Art, Phillips Academy, Andover, Mass.

PROVENANCE

The artist, as of 1958 § With Joan Michelman, New York, 1984 § Sidney and Diana Avery, Los Angeles, 1984.

EXHIBITIONS

New York, Whitney Museum of American Art, *Second Biennial Exhibition, of Contemporary American Painting,* 1934–35, no. 77, repro., p. 13, as *"Red" Moore* § Washington, D.C., Corcoran Gallery of Art, *Fourteenth Biennial Exhibition of Contemporary American Oil Paintings,* 1935, no. 170, repro., p. 22, as *Red Moore,* awarded William A. Clark First Prize of two thousand dollars and Corcoran Gold Medal § Art Institute of Chicago, *Forty-sixth Annual Exhibition of American Paintings and Sculpture,* 1935, no. 198, repro., as *Red Moore* § Montclair (N.J.) Art Museum, *Twenty-five Years of American Art,* 1938, no. 48 § Pittsburgh, Carnegie Institute, *A Survey of American Painting,* 1940, no. 260, pl. 94 § Washington, D.C., Corcoran Gallery of Art, and Toledo Museum of Art, *Twenty-fifth Biennial Exhibition of Contemporary American Oil Paintings,* 1957, no. 14 of historical section § Seattle, Charles and Emma Frye Art Museum, and others, circulated by American Federation of Arts, *Fifty Years at the Corcoran,* 1957–58, no. 13, no cat. traced.

LITERATURE

Archiv. Am. Art, Philip Evergood Papers, newspaper clipping, Henry McBride, "Biennial at Whitney Museum," *Sun* (New York), December 1, 1934 (microfilm roll 429, fr. 1044), "studioesque, but solidly made and typical" § *Art Digest* 9 (December 1, 1934): repro., cover § New York, Whitney Museum of American Art Papers, Scrapbook, unidentified newspaper clipping, Margaret Breuning, "Second Biennial Exhibit of American Paintings on View at Whitney Museum," December 1, 1934 (Archiv. Am. Art microfilm roll no. N595, fr. 373), considered one of the outstanding figure paintings in exhibit and "the best" painting by Speicher: "the felicity of the arrangement, the beauty and suavity of the brushwork, the surety of touch in definition of form and the subtlety of the color pattern, all enhance the vitality of the presentment," repro.; newspaper clipping, "Exemplifying Permanent Values in American Painting," *Brooklyn Daily Eagle,* December 2, 1934 (ibid., fr. 376), discusses at length and ranks as Speicher's finest achievement in the genre, repro. § Archiv. Am. Art, James Britton Papers, Diary, December 2, 1934, entry (not on microfilm), refers to reproduction of painting in Royal Cortissoz's column of the *New York Herald Tribune* and considers it well worked out despite "posed" character § Edward Alden Jewell, "In the Realm of Art: The Whitney's Second Biennial," *New York Times,* December 2, 1934, pt. 10, p. 9, "if inclined to be academic, is expertly painted and ambitious" § New York, Whitney Museum of American Art Papers, Scrapbook, newspaper clipping, *Press* (Pittsburgh), December 9, 1934, repro.; magazine clipping, Lewis Mumford, "The Art Galleries," *New Yorker* 10 (December 15, 1934) (Archiv. Am. Art microfilm roll no. N595, fr. 378), critic dislikes the most of exhibition, questions its modernity § Horace Gregory, "Some American Paintings," *New Republic* 81 (January 23, 1935): 304, an example of "direct painting" § "Maturity of American Art Is Discerned at the Corcoran Biennial," *Art Digest* 9 (April 1, 1935): 1, repro. § "Corcoran Gallery of Art, Washington," *Studio* 109 (June 1935): 348, repro., 349 § Peyton Boswell, "American Art as It Is Today," *Studio* 113 (January 1937): repro., 15 § W. S. Hall, *Eyes on America: The United States as Seen by Her Artists* (New York: Studio, 1939), p. 129, repro. § Samuel N. Manierre, "Eugene Speicher," *Studio* 127 (June 1944): 163, repro. § New York, Metropolitan Museum of Art, Library, artist's file, newspaper clipping, "'Red Moore' Is Art Feature at Exhibit," *Post* (Saugerties, N.Y.), August 11, 1944 § International Association of Plastic Arts, New York, Fourth Congress, *Profile: Art and Artists in the U.S.A.* (New York: U.S. Committee of the International Association of Plastic Arts, 1963), repro., p. 67 § "American Art," *LACMA Report 1983–1985* (1985), p. 16, repro., p. 18.

Florine Stettheimer

Born August 29, 1871,
Rochester, New York
Died May 11, 1944,
New York, New York

Identified as both a primitive and a modernist, Florine Stettheimer created a personal art that reflected her eccentric, bohemian life. She was one of three daughters of a wealthy, immigrant German-Jewish banker. During the 1890s Florine studied at the Art Students League with J. Carroll Beckwith (1852–1917) and Kenyon Cox (1856–1919). She and her mother traveled extensively on the Continent and during the first decade of this century spent long periods in Berlin, Munich, and Stuttgart, where she encountered symbolist painting. The family settled in the United States just before the outbreak of World War I. Her sister Ettie became a novelist, and her sister Carrie devoted her life to creating a magnificent doll house.

Upon moving to New York, Florine immersed herself in art circles and with her mother and sisters held a salon that attracted the most gifted of the avant-garde. Among the salon visitors who became their friends were Marcel Duchamp (1887–1968), GASTON LACHAISE, WILLIAM ZORACH, and Carl Van Vechten. Florine lived with her sisters until the death of her mother in 1935 and then established her own studio apartment, decorating it in a somewhat eccentric, rococo style, which paralleled her exceedingly feminine paintings. She painted portraits of her family and close friends, which were sometimes satiric, and floral still lifes presented in a seemingly naïve style with bright colors and arcane symbols. From 1929 until her death in 1944 she worked on an ambitious series on American urban life, the narrative scenes and complex symbolism of which reveal her to have been much more socially aware than she is usually credited to have been. She designed the sets and costumes for a 1934 production of *Four Saints in Three Acts,* a play by Gertrude Stein with a score by Virgil Thomson.

Stettheimer's first exhibition was held at M. Knoedler & Co. in New York in 1916, and thereafter she participated at the annuals of the Society of Independent Artists until 1926. Her poems were published posthumously as *Crystal Flowers* (1949).

BIBLIOGRAPHY
New Haven, Conn., Yale University, Beinecke Rare Book and Manuscript Library, Florine Stettheimer Papers § New York, Museum of Modern Art, *Florine Stettheimer,* exh. cat., 1946, by Henry McBride, with bibliography § Parker Tyler, *Florine Stettheimer: A Life in Art* (New York: Farrar, Straus, 1963) § Boston, Institute of Contemporary Art, and others, *Florine Stettheimer: Still Lifes, Portraits, and Pageants, 1910 to 1942,* exh. cat., 1980, with essay by Elisabeth Sussman, chronology by Robert McDaniel, catalogue and bibliography by Lamia Doumato § Linda Nochlin, "Florine Stettheimer: Rococo Subversive," *Art in America* 68 (September 1980): 64–83.

Stettheimer, *Zinnias.*

Zinnias, c. 1920s?
Oil on canvas
32⁵⁄₁₆ x 48¼ in (82.1 x 122.5 cm)
Ettie Stettheimer Estate
60.31

Stettheimer painted flowers throughout her life, incorporating them into her figurative compositions or using them as the focal point of her still-life paintings.

Zinnias exhibits all the typical elements of a mature Stettheimer still life. A bouquet of flowers is placed beneath a festoon on a table in the center of the composition. In the 1920s Stettheimer became fascinated with the design theories of Adolfo Best-Maugard (1891–1964), whose principles of composition were based on simplicity and conventionalized, childlike images. Stettheimer's repeated use of a frontal

view of a vase of flowers and drapery swag may have been related to Best-Maugard's emphasis on such motifs.

Stettheimer painted the vase, background, and festoon in white with tints of pink and gray underpaint. White was her color, for she not only used it extensively in her painting as a color and to key up her palette, she also surrounded herself with white, often wearing a fringed white dress and decorating her studio in white lace and fringed drapery. The garland draped above the vase in the museum's paint-ing alludes to her canopied bed. The vase of flowers appears to exist in a sheltered, private niche, safe from the outside world, just as Stettheimer lived in an exclusive, refined world that she created. Even the thickly impastoed surface, characteristic of Stettheimer's mature art, suggests the pure sensuosity of her maid-enly, but artistically rich, life.

PROVENANCE
The artist, to 1944 § Ettie Stettheimer (by descent), New York, 1944–55 § Estate of Ettie Stettheimer, 1955–60.

Boris Deutsch

Born June 4, 1892, Krasnogorka, Russian Turkistan
To United States 1916
Died January 16, 1978, Los Angeles, California

Boris Deutsch was a modernist figurative painter important in Southern California dur-ing the 1930s and 1940s. Before immigrating from Russia, he studied briefly in Riga at the art academy and with a commercial artist, and in 1912 he attended the Kunstgewer-bemuseum, Berlin. After coming to the United States he spent three years in Seattle before settling in Los Angeles. He began exhibiting in 1922 and was one of the four organizers of the Group of Independent Artists exhibition in 1923 at the MacDowell Women's Club in Los Angeles, the West Coast equivalent of the Armory Show. Deutsch was given his first solo exhibition in 1926 by the Los Angeles Museum and thereafter had numerous exhibitions in other cities, including a solo exhibition in New York in 1933. At times he supported himself by working as a commercial artist and set designer for motion pictures. He received numerous mural commissions sponsored by the New Deal projects, winning in 1941 the large competition to decorate the Terminal Annex Post Office in Los Angeles.

In Russia Deutsch had studied for the rabbinate, and his Jewish heritage furnished him with subject matter and endowed his art with an emotional intensity. His first major series, on contemporary Jewish life, revealed a brooding, contemplative aspect and re-flected his Talmudic studies. In the 1930s he began painting portraits of his wife, explor-ing the emotional power of form and color. In 1946 he won the third annual Pepsi-Cola Art Competition with his *What Atomic War Will Do to You*, 1946 (unlocated). Late in life he turned to printmaking and experimented with monotypes.

BIBLIOGRAPHY
Archiv. Am. Art, Boris Deutsch Papers (not on microfilm) § Arthur Millier, "Our Artists in Person, no. 1: Boris Deutsch," *Los Angeles Times,* June 29, 1930, pt. 3, p. 18 § Ralph Flint, "Boris Deutsch," *Creative Art* 8 (June 1931): 430–32 § LACMA, Research Library, artist's file, "Data on Boris Deutsch," flyer issued by Pepsi-Cola, 1946 § Laguna 1979, p. 68.

Riva, 1930
(*Girl with Fruit*)
Oil on canvas
37^{15}/$_{16}$ x 30 in (96.4 x 76.2 cm)
Signed upper right: Boris Deutsch
Inscribed verso, possibly in a different hand: Boris Deutsch 1944
Boris Deutsch Bequest
M.81.102

Deutsch is best known for his paintings of his wife, Riva (Rebecca Segal), whom he had mar-ried in 1924. Over the course of several decades he portrayed her in numerous paintings, usu-ally as a thoughtful, attractive young woman with dark hair and large eyes. In these some-what idealized portraits she became for him a timeless motif. *Riva* exemplifies Deutsch's mod-ernist painting style. With soft, blunted strokes

the figure is presented in terms of light and dark planes, the facial features delicately described with lines. The subdued palette of dark blue for the dress and blues and whites for the background, typical of the artist's early work, harmonizes with the reflective nature of the portrait.

PROVENANCE
The artist, 1930–78 § Estate of the artist, 1978–81.

EXHIBITIONS
Oakland Art Gallery, *Annual Exhibition of Works by Western Artists,* 1932, either no. 32, as *Riva,* or no. 35, as *Girl with Fruit* § LACMHSA, *Paintings by Boris Deutsch,* 1932 (cat. published as *LA Museum Art News* [May 1932]), no. 31, unpaginated, as *Girl with Fruit* § Oakland Art Gallery, *Annual Exhibition of Oil Paintings,* 1940, no. 32, awarded first prize § Los Angeles, Biltmore Art Galleries, *Boris Deutsch: Exhibition of Oils,* 1945, no. 1, repro., unpaginated, as *Girl with Fruit* § Art Institute of Chicago, *Fifty-sixth Annual American Exhibition of Paintings,* 1945–46, no. 39, as *Girl with Fruit* § San Francisco, California Palace of the Legion of Honor, *First Spring Annual Exhibition,* 1946, entries not numbered, as *Girl with Fruit* § Ontario, Calif., Chaffey College, Chaffey Community College Art Association, *Sixth Invitational Purchase Prize Art Exhibit,* 1946, no. 7, as *Girl with Fruit* § LACMA 1980, no. 37, p. 34, erroneously dated 1944 based on inscription on canvas back, repro., p. 35.

LITERATURE
Archiv. Am. Art, Boris Deutsch Papers, "Paintings by Boris Deutsch," photograph no. 5; "List of Paintings," June 29, 1960, p. 1, no. 11, listed as "*Riva—(Girl with Fruit)* 30 x 38 oil on c[anvas]. 1930" § "Deutsch Wins Oakland 'First,'" *Art Digest* 14 (May 1, 1940): 10 § J. O'C. Jr., "Given Anonymously," *Carnegie Magazine* 19 (February 1946): 236.

Deutsch, *Riva.*

Thomas Hart Benton

Born April 15, 1889, Neosho, Missouri
Died January 19, 1975, Kansas City, Missouri

Thomas Hart Benton has been considered among the most popular American artists of the twentieth century, renowned for his regionalist aesthetic and many mural projects. He was also an important teacher, influencing an entire generation of artists.

Born into a family of famous politicians, Benton grew up in Washington, D.C., where he first studied art at the School of the Corcoran Gallery of Art. After working as a cartoonist for the Joplin, Missouri, newspaper *The American* in 1906, he studied briefly at the School of the Art Institute of Chicago. From 1908 to 1911 he lived in Paris, attending traditional art academies and studying and painting in an impressionist style under the supervision of John Thompson (1882–1945). Benton's association with STANTON MACDONALD-WRIGHT in Paris, however, determined his modernist leanings of the next decade.

In New York he became an active member of the avant-garde, exhibiting color abstractions at the *Forum Exhibition of Modern American Painters* in 1916 and at the progressive Daniel Gallery in 1917 and 1924. Service in the U. S. Navy from 1918 to 1919 interrupted his career; he resumed it with a new interest in socially relevant art. As a result, his style changed and he was drawn to a new format, large-scale murals. In the mid-1920s he traveled throughout America, attempting to express in his art the regional diversity of the country.

His first mural project, which he worked on from 1916 to 1926, was entitled *The American Historical Epic* (Nelson-Atkins Museum of Art, Kansas City, Mo.). In the early 1930s

he created his two most famous mural cycles, *America Today,* 1930–31, for the New School for Social Research (now located in the Equitable Center, New York), and *The Arts of Life in America,* 1932, for the Whitney Museum of American Art (now in the New Britain Museum of American Art, New Britain, Connecticut).

From 1926 until 1935, when he left New York, Benton taught at the Art Students League. His move to the Midwest in 1935 was prompted by an invitation to teach at the Kansas City Art Institute and a commission to paint a mural for the Missouri State Capital. Among his later mural commissions were those for Lincoln University, Jefferson City, Missouri, 1954; the Power Authority of the State of New York, Massena, 1961; and the Harry S. Truman Library, Independence, Missouri, 1962.

BIBLIOGRAPHY
Thomas Hart Benton, *An Artist in America* (1937; 4th rev. ed., Columbia: University of Missouri Press, 1983), with afterword by Matthew Baigell § Thomas Hart Benton, *An American in Art* (Lawrence: University Press of Kansas, 1969) § Mary Scholz Guedon, *Regionalist Art—Thomas Hart Benton, John Steuart Curry, and Grant Wood: A Guide to the Literature* (Metuchen, N.J.: Scarecrow Press, 1982), an extensive, annotated bibliography § Karal Ann Marling, *Tom Benton and His Drawings: A Biographical Essay and a Collection of His Sketches, Studies, and Mural Cartoons* (Columbia: University of Missouri Press, 1985) § Henry Adams, *Thomas Hart Benton: An American Original* (New York: Alfred A. Knopf, 1989), with bibliographical notes, published in conjunction with the exhibition at the Nelson-Atkins Museum of Art, Kansas City, Mo., and others.

Benton, *Burlesque.*

Burlesque, c. 1930

(*Burlesque Theater*)
Tempera with oil glazes on canvas mounted on pressboard
18³/₁₆ x 25¹/₈ in (46.2 x 63.8 cm)
Signed lower left: TBenton (TB in monogram)
Gift of Mr. and Mrs. Ira Gershwin
M.80.104

Burlesque is related in theme and composition to Benton's New School for Social Research mural project *America Today* of 1930–31 and may have served as a study for it. The theatrical scene expresses the artist's new interest in contemporary urban life, first demonstrated in *Bootleggers,* 1927 (Reynolda House, Museum of American Art, Winston-Salem, North Carolina) and expanded in *America Today.* Benton

was fond of depicting burlesque dancers and strippers and wrote nostalgically of a Fourteenth Street theater where the strippers "used to make the old boys drool at the mouth and keep their hands in their pockets" (*An Artist in America,* p. 269).

The burlesque dancer—with her vigorously thrusting elbow, head, and buttocks—is similar in gesture to the cavorting performer in the upper-right corner of the City Activities panel in the *America Today* mural. In the finished mural Benton omitted the audience since all the mural images are only fragmentary scenes, one overlapping another, arranged to convey the hustle and bustle of twentieth-century American life. While Benton presented a more complete view of a theater in *Burlesque,* the easel painting shares with the mural panels a similar compositional approach: the theater interior is arranged in segmented groupings, the stage, orchestra, balcony, and boxes conceived as irregular shapes that fit together. Moreover, the large, arcing forms of the stage and balcony in the museum's painting echo the decorative molding that divides various scenes in the mural.

RELATED WORKS
Burlesque, n.d., egg tempera on board, 9¹/₂ x 12¹/₂ in (24.1 x 31.7 cm). Edward Suckle, Los Angeles § "City Activities with Subway" panel of the mural *America Today,* 1930–31, distemper and egg tempera on gessoed linen with oil glaze, 92 x 134¹/₂ in (233.7 x 341.6 cm). Equitable Life Assurance Society of the U.S., New York.

PROVENANCE
Crosby Gaige, New York, to 1932 § George Gershwin, 1932 § Mr. and Mrs. Ira Gershwin (by descent), Beverly Hills, Calif., 1952–80, as *Burlesque Theater.*

EXHIBITIONS
Arts Club of Chicago, *Exhibition of the George Gershwin Collection of Modern Paintings*, 1933, no. 1 § New York, Museum of Modern Art, *Summer Collection: The Museum Collection and a Private* *Collection on Loan*, 1936, no cat. § Los Angeles, Municipal Art Department, City Hall, *The Collection of Mr. and Mrs. Ira Gershwin*, 1952, no cat. traced.

Benton, *The Kentuckian*.

The Kentuckian, 1954
Oil on canvas
76⅛ x 60⁶/₁₆ in. (193.4 x 153.4 cm)
Signed and dated lower left: Benton '54
Signed and dated lower right: Benton '54
Gift of Burt Lancaster
M.77.115

In 1953 the motion-picture company Norma Productions hired Benton to execute a painting to be used for publicity purposes for the movie *The Kentuckian*, starring Burt Lancaster. Lancaster and Harold Hecht, producers of the motion picture, admired Benton's art, and it was upon their initiative that Benton received the commission. Except for its showing at the movie's premiere in Washington, D.C., the canvas was never exhibited until its donation to the museum. It was, however, reproduced on labels for bottles of Beam's Choice whiskey.

As early as the 1910s Benton had painted portraits and historical pieces for the budding

motion-picture industry, which was then based in Fort Lee, New Jersey. In 1937 Benton was sent by *Life* magazine to paint *Hollywood*, 1937 (Nelson-Atkins Museum of Art, Kansas City, Mo.), perhaps his best-known work related to the industry. He visited the movie capital many times over the next decades and was often commissioned by the studios to create works used as advertisements, such as lithographs for *The Grapes of Wrath* and a painting for *The Long Voyage Home.* In 1946 he came to Hollywood to work with Walt Disney.

To capture the essence of *The Kentuckian,* Benton read the script and in the autumn of 1953 spent several days on location in Rockport, Indiana, watching the filming. The movie features a backwoodsman and his son who confront civilization in the form of a frontier village. Benton chose to epitomize the movie's theme with the image of the backwoodsman, Big Eli Wakesfield, played by Burt Lancaster, and his son Little Eli, played by Donald MacDonald, just before they see the town for the first time.

The American West and the progress of civilization were of special interest to Benton, who had portrayed these themes in his early murals. In this painting the Kentuckian becomes the archetypal frontiersman leading his family to the golden land in the West. The Kentuckian heads toward the unseen village, located somewhere ahead in a sunny valley. He strides forward, high on a hill against a cloud-filled sky. This baroque compositional device, echoed by the diagonal positions of the boy and the dog, emphasizes the Kentuckian's dynamic vitality. Although the painting's large size may have been determined by the commission, the heroic presentation was surely Benton's idea, for many of his late easel paintings are more tightly focused around a single large figure than were his early mural scenes. Also typical of Benton's later paintings is his portrayal of the forms in strong colors with crisp outlines and an undulating plasticity.

Benton's methodical working procedure was always laborious, and for *The Kentuckian* he created numerous drawings, including a cubist, diagrammatic study (see illustration); preparatory oils; and a clay model of the boy's figure. The full-length composition was painted in Benton's Kansas City studio.

Benton, *The Kentuckian, Cubist Study,* 1954, see Related Works.

RELATED WORKS
Head of Burt Lancaster, 1953, oil on canvas, 19 x 19½ in (48.3 x 49.5 cm). Burt Lancaster, Los Angeles § *Head of Donald MacDonald,* 1953, pencil on paper, 17¾ x 12¾ in (45.1 x 32.4 cm). Mrs. Donald MacDonald, Beverly Hills, Calif. § *Head of Donald MacDonald,* 1953, tempera on paper, 21 x 17¼ in (53.3 x 43.8 cm). Mrs. Donald MacDonald, Beverly Hills § *The Kentuckian, Cubist Study,* 1954, ink and pencil on paper, 10⅞ x 8⅜ in (26.3 x 21.3 cm). Lyman Field and United Missouri Bank of Kansas City, N.A., cotrustees of Thomas Hart and Rita P. Benton Testamentary Trusts, Kansas City, Missouri § *The Kentuckian, Study,* 1954, pencil on paper, 16½ x 12¾ in (41.3 x 32.3 cm). Lyman Field and United Missouri Bank of Kansas City, N.A., cotrustees of Thomas Hart and Rita P. Benton Testamentary Trusts, Kansas City, Missouri § *The Kentuckian, Study of Boy,* 1954, pencil on paper, 11⅝ x 16½ in (29.5 x 41.9 cm). Lyman Field and United Missouri Bank of Kansas City, N.A., cotrustees of Thomas Hart and Rita P. Benton Testamentary Trusts, Kansas City, Missouri § *The Kentuckian, Study of Boy,* 1954, ink and pencil on paper, 16½ x 13¾ in (41.3 x 33.9 cm). Lyman Field and United Missouri Bank of Kansas City, N.A., cotrustees of Thomas Hart and Rita P. Benton Testamentary Trusts, Kansas City, Missouri § *The Kentuckian, Study of Dog,* 1954, pencil on paper, 16½ x 13¾ in (41.3 x 33.9 cm). Lyman Field and United Missouri Bank of Kansas City, N.A., cotrustees of Thomas Hart and Rita P. Benton Testamentary Trusts, Kansas City, Missouri.

PROVENANCE
Burt Lancaster, Los Angeles, 1954–77.

ON DEPOSIT
Reynolda House, Museum of American Art, Winston-Salem, N.C., 1985–86.

EXHIBITION
Palm Springs (Calif.) Desert Museum, *The West as Art: Changing Perceptions of Western Art in California Collections,* exh. cat. for *Western American Art in California Collections,* 1982, no. 6, pl. 98, p. 148.

LITERATURE
"New Acquisition: American Painting," *LACMA Members' Calendar* 16 (February 1978): unpaginated, repro. § "Reynolds to Star in Romance," *Los Angeles Herald Examiner,* February 11, 1978, pt. B, p. 9 § LACMA, American Art department files, miscellaneous newspaper clippings, February–March 1978 § "American Art," *LACMA Report 1977–1979* (1980), p. 13 § Hilton Kramer, "Critics's Notebook: Los Angeles Putting Focus on Modern Art," *New York Times,* July 25, 1980, pt. C, p. 20, repro. § Benjamin H. D. Buchloh, "Allegorical Procedures: Appropriation and Montage in Contemporary Art," *Artforum* 21 (September 1982): 51, repro., 49 § Marling, *Benton,* pp. 35–36, with reproductions of preparatory drawings § Fort 1986, p. 425, fig. 6.

George K. Brandriff

Born February 13, 1890,
Millville, New Jersey
Died August 14, 1936,
Laguna Beach, California

During his brief professional career George Kennedy Brandriff painted a wide range of Southern California motifs, expressing a distinctive point of view. Brandriff grew up in the East and came to California in 1913. He received a degree in dentistry from the University of Southern California and in 1916 began his practice in Hemet, California. While there he painted with and received some instruction from local artists such as Anna Hills (1882–1930) and Carl Oscar Borg (1879–1947). He eventually moved to Los Angeles and in 1928 devoted himself exclusively to painting. During 1929–30 he traveled and studied in Europe.

In addition to still lifes, Brandriff painted coastal, mountain, and desert landscapes but seldom were they conventional views. During the late 1920s and early 1930s frequent solo exhibitions of his work were held in Los Angeles at the Biltmore Salon and the Kanst Galleries. Brandriff was also commissioned to paint murals for local high schools. He was elected president of the Laguna Beach Art Association in 1934.

BIBLIOGRAPHY
Arthur Millier, "Our Artists in Person, no. 26: George K. Brandriff," *Los Angeles Times*, April 19, 1931, pt. 3, pp. 10, 26 § Los Angeles, Cowie Galleries, *George K. Brandriff*, exh. cat., 1958 § Moure with Smith 1975, pp. 26–27, with bibliography § Westphal 1982, pp. 128–33, with lists of associations, awards, and collections § Laguna Beach, Calif., Laguna Art Museum, *Early Artists in Laguna Beach: The Impressionists*, exh. cat., 1986, essays by Janet Blake Dominick, pp. 24, 76, 91, with biographical note and bibliography.

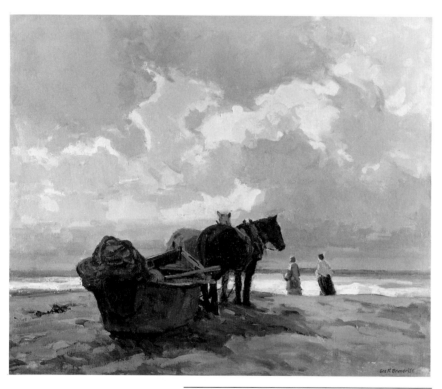

Brandriff, *All Weather Friends.*

All Weather Friends, by 1931
Oil on canvas
25¼ x 30⅜ in (64.2 x 77.1 cm)
Signed lower right: Geo. K. Brandriff
Gift of Charles Haskell
31.20

Although the scene looks European and may have been chosen because of the artist's experiences in Europe and knowledge of European paintings, *All Weather Friends* represents Newport Beach, California. Fishermen of the area rose before dawn to row their dories miles out to sea to haul in the fish caught in the nets they had set the day before. After returning to the beach around noon, they and their wives cleaned the fish and sold them to the public from their boats. This took place on the north side of the pier and was known as the dorymen's fish market. Horses were used to pull the boats to and from the water and also to pull nets in to the beach when the fish were running near the shore. Here Rex and Molly, two horses well known in the area, are pulling a dory with its net toward the surf to be launched.

All Weather Friends was one of seven scenes of the dorymen's fish market that Brandriff included in his exhibition at the Biltmore Salon in the spring of 1931. His choice of this unusual subject is characteristic of the freshness of vision found in all his art.

The painting is one of several that were donated to the museum around the same time with the objective of forming a representative collection of Southern California artists.

PROVENANCE
With Biltmore Salon, Los Angeles, 1931 § Charles Haskell, Los Angeles, 1931.

ON DEPOSIT
Whittier (Calif.) College, 1945–68.

EXHIBITIONS
Los Angeles, Biltmore Salon, *Recent Paintings by George K. Brandriff*, 1931, no cat. traced § Laguna 1979, entries not numbered, repro., p. 35 § Laguna Art Museum, *Early Artists in Laguna: The Impressionists*, entries not numbered, no. 8, repro., p. 17.

LITERATURE
George Douglas, "Haskell Buys Oil Painting," *Los Angeles Examiner*, June 22, 1931, pt. 2, p. 3, repro. § "Three Recent Gifts to the Museum," *Los Angeles Times*, June 28, 1931, pt. 3, p. 21, repro. § "Museum Accessions," *American Magazine of Art* 23 (November 1931): 412, repro. § "Charles L. Haskell Gives Painting as Nucleus for California Art Collection," *LA Museum Art News* [7] (December 1931): unpaginated, repro. § LACMA, American Art department files, Frances C. Brooks to Nancy Dustin Wall Moure, February 16, 1977, identifies and explains the subject § LACMA 1980, p. 16 § Westphal 1982, repro., p. 131.

Henry Lee McFee

Born April 14, 1886,
Saint Louis, Missouri
Died March 19, 1953,
Pasadena, California

Henry Lee McFee was an early modernist active in Woodstock, New York, and New York City who later introduced his avant-garde approach to a generation of Southern California artists. After studying art in Saint Louis and at the Stevenson Art School in Pittsburgh, he moved to Woodstock in 1908 to study landscape painting with Birge Harrison (1854–1929). In 1909 he began working independently, and through ANDREW DASBURG, who remained a lifelong friend, he was introduced to European modernism. McFee studied the work of Georges Braque (1882–1963), Pablo Picasso (1881–1973), and Pierre-Auguste Renoir (1894–1974) as well as Italian Renaissance painters and the art theories of Clive Bell, Roger Fry, and Willard Huntington Wright. The work of Paul Cézanne (1839–1906), however, was the most significant influence on McFee's development.

McFee was one of the leading members of the Woodstock colony's modernist Rock City Group (which also included Dasburg, Konrad Cramer [1888–1963], and EUGENE SPEICHER). Although he first exhibited at the MacDowell Club in New York in 1912, it was not until 1916, when he participated in the landmark *Forum Exhibition of Modern American Painters,* that he showed more progressive cubist still lifes. Throughout his career still lifes predominated in his work, yet he never stopped painting landscapes. His landscapes of the 1920s are reminiscent of Picasso's spare, geometric landscapes of 1907. Although he never abandoned his concern for plastic expression and the organization of color, in the mid-1920s McFee began to paint more traditionally with glazing techniques inspired by both old and modern masters. In the mid-1930s he produced a notable group of figure paintings of blacks.

Frank K. M. Rehn Galleries in New York held a series of solo exhibitions of McFee's art beginning in 1927. Even so, in 1937 financial demands forced him to begin teaching full time, for which he moved first to San Antonio, Texas, and Savannah, Georgia, and then in 1940 settled in Los Angeles. That year he was awarded a Guggenheim Fellowship. McFee became known as one of the important painters and foremost teachers in Southern California, inspiring an entire generation with his instruction in figure and still-life painting, first at Chouinard School of Art in Los Angeles and from 1943 at Scripps College in Claremont.

BIBLIOGRAPHY
Henry Lee McFee, "My Painting and Its Development," *Creative Art* 4 (March 1929): XXVII–XXXII § Virgil Barker, *Henry Lee McFee,* American Artists Series (New York: Whitney Museum of American Art, 1931), with biographical note, bibliography § Warren Wheelock, "Henry Lee McFee: Comments on the Man and His Painting," *Art Instruction* 2 (November 1938): 4–9 § Arthur Millier and Henry Lee McFee, *Henry Lee McFee* (Claremont, Calif.: Fine Arts Foundation of Scripps College, 1950), with biographical note, list of awards, bibliography § John Baker, *Henry Lee McFee and Formalist Realism in American Still Life, 1923–1936,* A Center Gallery Publication (Lewisburg, Pa., and London: Bucknell University Press and Associated University Presses, 1987), with bibliography, published in conjunction with an exhibition at the National Museum of American Art, Smithsonian Institution, Washington, D.C., and others, 1986–87.

Still Life with Carafe, by 1931
(*Still Life; Still Life: Cut-Glass Bottle; Still Life with Decanter*)
Oil on canvas
32¼ x 30³/₁₆ in (82.0 x 76.7 cm)
Signed lower right: McFee
Gift of Mr. and Mrs. David N. Allison in memory of Mr. and Mrs. David C. Allison
M.84.196
Color plate, page 71

McFee's tabletop still lifes remained consistent throughout his career. They always contain the same basic components: a wood table that is tilted toward the viewer, and often draped with some fabric, with an array of objects atop it. An assortment of fruit, arranged around and on plates or in other containers, was usually placed near a potted plant or vase of flowers, as in *Still Life with Carafe.* After the 1910s McFee's still lifes often featured a glass object, no doubt because the reflective and transparent qualities of the glass enabled him to explore his modernist fascination with forms and planes. The faceted, cut-glass decanter in the museum's painting seems to have been especially appealing to the artist, for he used it in several other still lifes of the 1930s. The arrangement in the museum's painting is slightly more elaborate than in most of his other compositions, since, following an old still-life tradition, McFee presented both whole and cut fruit. He also included in the background of this painting a second table with books placed on it.

Although McFee's still-life compositions of his mature years appear more traditional than his early abstractions, they continue to dem-

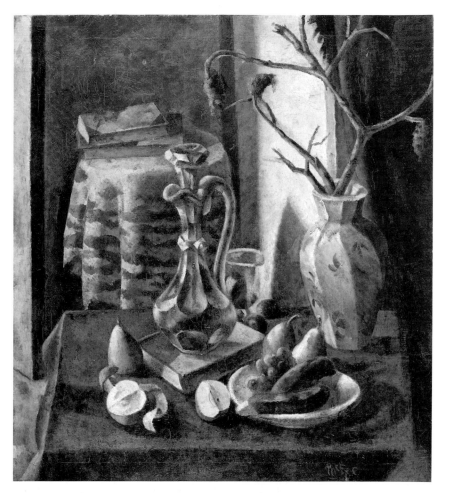

McFee, *Still Life with Carafe.*

cately brushed pigments that give a soft, almost shimmering quality to his surfaces. The objects appear both solid and delicate. In *Still Life with Carafe* the overall gray tonality is infused with a wealth of other colors—deep green, alizarin, warm brown, and orange—that are repeated throughout. The overall appearance of a McFee painting is one of great sensuality.

PROVENANCE
The artist § Mr. and Mrs. David C. Allison, Los Angeles, as of 1950 § Mr. and Mrs. David N. Allison (by descent), Los Angeles, to 1984.

EXHIBITIONS
Probably Philadelphia, Pennsylvania Academy of the Fine Arts, *126th Annual Exhibition,* 1931, no. 37, as *Still Life* § Art Institute of Chicago, *Forty-fourth Annual Exhibition of American Paintings and Sculpture,* 1931, no. 126, as *Still Life: Cut-Glass Bottle,* repro., unpaginated § Probably New York, Frank K. M. Rehn Galleries, *Paintings and Drawings by Henry Lee McFee,* 1933, no. 13 § San Francisco Museum of Art and others, *American Paintings from the Rehn and Kraushaar Galleries,* 1939, no. 11, no cat. traced § Claremont, Calif., Scripps College, Lang Art Gallery, circulated by American Federation of Arts, *Henry Lee McFee Retrospective,* 1950, no cat. § Washington, D.C., Smithsonian Institution, National Museum of American Art, *Henry Lee McFee,* 1986, entries not numbered.

LITERATURE
Barker, *McFee,* repro., no. 24, as *Still Life with Decanter,* dated 1930 § Millier and McFee, *McFee,* repro., unpaginated, as *Still Life with Decanter* § John I. H. Baur, *Revolution and Tradition in Modern American Art* (Cambridge, Mass.: Harvard University Press, 1951), fig. 129, between pp. 100 and 101, as *Still Life with Decanter,* dated 1930 § "American Art," *LACMA Report 1983–1985* (1985), p. 16 § Baker, *McFee and Formalist Realism,* pp. 87–88, fig. 103, dated 1930.

onstrate the artist's fundamental loyalty to Cézanne. In the use of a simple table, the type of still-life arrangement, and an emphasis on cubic form, McFee followed Cézanne's example, but he gave a greater sense of depth to the overall scene. His mature still lifes also reveal his personal exploration of painting techniques. As did Dasburg, McFee presented his objects not in flat, opaque planes but in layers of deli-

Sleeping Black Girl, c. 1933–34
(*Black Girl Sleeping*)
Oil on canvas
40¼ x 30¼ in (102.2 x 76.8 cm)
Signed lower right: McFee
Signed verso upper left: Mc Fee-
Gift of Stanley Barbee
54.94

Beginning in the late 1920s and continuing for some eight or ten years, McFee wintered at Bellevue, a former plantation in Bedford County, Virginia, where he devoted much of his energy to painting black farm workers. McFee found them to be much more interesting than professional models, and he empathized with them. As he explained, "I

think I came closer to painting something of their life and my life with understanding" (quoted in Ernest W. Watson, "Still Life Paintings by Henry Lee McFee," *American Artist* 12 [February 1948]: 20). A maid at the plantation named Gertrude posed for *Sleeping Black Girl.* In it McFee succeeded in conveying the young woman's total exhaustion through her posture. He carefully drew, corrected, and changed the figure before he began to paint "to make clear the stress and sag of the figure." McFee's mellow palette, which gives a deep resonance to the painting, further underscores the mood of quiet sympathy. The girl's tawny skin and the white drape determined the palette, with the greenish black wallpaper, gray head scarf, and white chair repeating the color tones.

Typical of McFee's painting technique is the delicate layering of the paint in thin, transparent layers to model the forms. Despite the solid rendering, McFee has perceived the figure and chair as large geometric shapes, and consequently the painting is at once academic and modern.

Critic Arthur Millier dated the painting to 1930, which is probably too early. It was first exhibited in late 1934. As it was not shown with other pictures of similar subjects in McFee's January 1933 exhibition at Frank K. M. Rehn Galleries in New York, it was probably painted during the following winter of 1933–34. The images of blacks exhibited in 1933 were praised for their "grave dignity and unity of effect" (*Sun* [New York], January 7, 1933, p. 10), and *Sleeping Black Girl* has these qualities.

McFee considered it to be his best, if not most important, work, and was bewildered by his inability to sell it. Millier seems to have agreed with the artist, for he ranked *Sleeping Black Girl* the greatest American painting created in the 1930s.

PROVENANCE
The artist § With Frank K. M. Rehn Galleries,

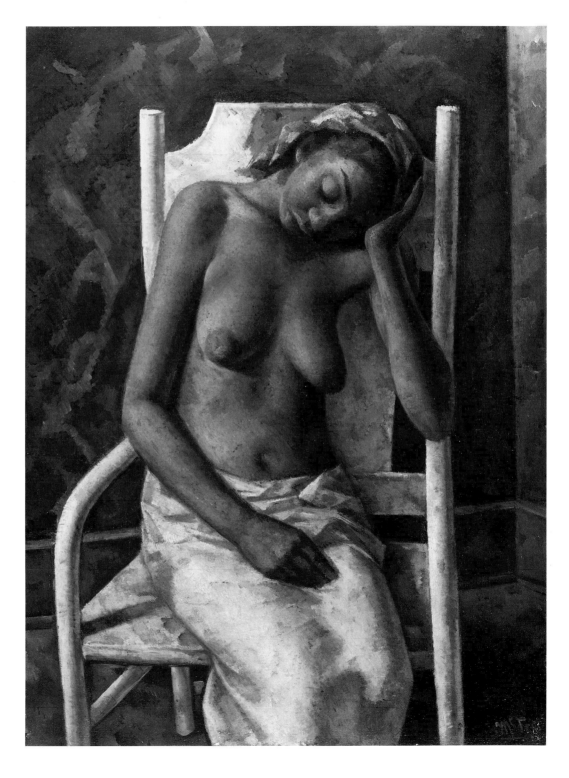

McFee, *Sleeping Black Girl.*

New York, 1934–38 or later § Stanley Barbee, Beverly Hills, Calif., probably 1940 to 1954.

EXHIBITIONS

Pittsburgh, Carnegie Institute, *The 1934 International Exhibition of Paintings*, 1934, no. 22, pl. 51, as *Black Girl Sleeping* § Philadelphia, Pennsylvania Academy of the Fine Arts, *132nd Annual Exhibition*, 1937, no. 1, awarded Temple gold medal for best picture § Washington, D.C., Corcoran Gallery of Art, *Fifteenth Biennial Exhibition of Contemporary American Oil Paintings*, 1937, no. 180 § Worcester (Mass.) Art Museum, *Third Biennial Exhibition, American Painting of Today*, 1938, no. 74 § London, Wildenstein & Co., *Contemporary American Paintings*, 1938, no. 31 § Montclair (N.J.) Art Museum, *Twenty-five Years of American Art*, 1938, no. 39, as *Black Girl Sleeping* § New York World's Fair, organized by National Art Society, *American Art Today*, 1939, no. 369, repro., p. 117 § West Hollywood, Calif., William Haines Galleries, *Famous American Paintings*, 1940, no. 44, no cat. traced § Claremont, Calif., Scripps College, Lang Art Gallery, circulated by American Federation of Arts, *Henry Lee McFee Retrospective*, 1950, no cat. § Los Angeles, Orbach's, Inc., [exhibition title unknown], 1956, no cat. traced § Los Angeles County Art Institute, *Masterpieces*, 1957–58, no cat. traced § Art Center in La Jolla, Calif., *Twentieth Anniversary Loan Exhibition: American Paintings from Pacific Coast Museums*, 1961, no. 14, repro., unpaginated, dated 1936.

LITERATURE

Ruth Pickering, "Paintings for Sale," *Arts and Decoration* 42 (December 1934): 28, repro., 32 § "Pennsylvania's Annual Emphasizes Sound Technique, Craftsmanship," *Art Digest* 11 (February 1, 1937): 5, repro. § "Native Artists in New England," *Art News* 36 (January 29, 1938): 11 § Wheelock, "McFee," 7, quotes the artist and discusses his use of formal devices to describe sleep and exhaustion, repro., as *Black Girl Sleeping* § Edward Alden Jewell, *Have We an American Art?* (New York: Longmans, Green & Co., 1939), pp. 66, 218, quotes from various reviews of Wildenstein exhibition, including T. W. Earp, *Daily Telegraph and Morning Post* (London), 1938 § Holger Cahill, "Modern American Art at the New York World's Fair," *International Studio* 117 (June 1939): repro., 239, as *Black Girl Sleeping* § Achiv. Am. Art, Andrew Dasburg Papers, the artist to Dasburg, March 18, 1940 (microfilm roll 2047, fr. 700), "*Black Girl Sleeping* has been everywhere and is probably my best picture—but I still own it—Why—?"; the artist to Dasburg, December 30, 1940 (ibid., fr. 811), "I have placed three of my most important canvases— . . . *Sleeping Black Girl*" § "Millier's Nomination," *Art Digest* 15 (October 15, 1940): 21, calls it the greatest American painting executed between 1930 and 1940 § "Arts Foundation Introduces Henry L. McFee," *Scripture* (Scripps College) 14 (September 16, 1943): repro., 1 § Millier and McFee, *McFee*, repro., unpaginated, as *Black Girl Sleeping*, dated 1930 § Arthur Millier, "McFee Exhibit Shows Greatness of Artist," *Los Angeles Times*, April 23, 1950, pt. 4, p. 1 § Arthur Millier, "Los Angeles Event," *Art Digest* 25 (May 1, 1950): 27 § Arthur Millier, "McFee's *Sleeping Black Girl* Highlights County Art Additions," *Los Angeles Times*, January 16, 1955, pt. 4, p. 7 § Richard F. Brown, "Recent Gifts of Paintings," *LA Museum Art Div. Bull.* 7 (Spring 1955): 12–14, compares it with *Seated Nude*, by Emil Kosa, c. 1941–47 (LACMA; q.v.), fig. 9, 12 § Arthur Millier, "Final Art Column, New Vantage Point," *Los Angeles Evening and Sunday Herald Examiner*, October 19, 1969, pt. E, p. 8, repro. § LACMA 1980, p. 68, compares it with Kosa's *Seated Nude* § Robert Perine, *Chouinard: An Art Vision Betrayed, the Story of the Chouinard Art Institute, 1921–1972* (Encinitas, Calif., Artra Publishing, 1985), repro., p. 91 § LACMA, American Art department files, John Baker to Ilene Susan Fort, March 19, 1986, identifies sitter § Baker, *McFee and Formalist Realism*, pp. 91, 93, 123, 134, fig. 114, p. 93, dated between 1930 and 1934.

Reginald Marsh

Born March 14, 1898, Paris, France, to American parents
Died July 3, 1954, Dorset, Vermont

Reginald Marsh's reputation is based on his spirited vision of the life of the working class in New York. Born in France to American parents, both of whom were artists, he was brought to the United States at the age of two. He graduated in 1920 from Yale University, where he had begun his study of art. He started his career by working as an illustrator for various newspapers and magazines, including the *New York Daily News*, 1922–25, and *The New Yorker*, 1925–31. During the 1920s he also designed sets for the theater. He continued to study sporadically, at the Art Students League with George Bridgman (1864–1943), GEORGE LUKS, and KENNETH HAYES MILLER, and later by copying old-master paintings during several trips abroad. Marsh became associated with the Whitney Studio Club, where he was given his first solo exhibition in 1924.

The late 1920s marked the beginning of Marsh's mature period, for which he is best known. His most famous paintings of burlesque halls, the Bowery, the Fourteenth Street area, and Coney Island date from the 1930s or early 1940s. During this period he also began working in new mediums, including egg tempera, etching, and lithography. In 1934 he studied anatomy, and his book *Anatomy for Artists* (1945) revealed not only his great knowledge of the subject but also the important role Renaissance art played in his painting. During the Great Depression he received two major mural commissions—painting

frescoes for the Post Office Building in Washington, D.C., and the United States Customs House in New York. Always fascinated by technical aspects of painting, in 1939 he temporarily abandoned the egg tempera medium and the following year began studying the emulsion technique developed by Jacques Maroger. During the 1940s he worked extensively in watercolor and ink. Marsh was a popular instructor at the Art Students League in New York, where he taught from 1935 until his death in 1954, and at the Moore Institute of Art, Science, and Industry in Philadelphia, where he lectured for five years beginning in 1949.

BIBLIOGRAPHY
Archiv. Am. Art, Reginald Marsh Papers (portions on microfilm) § New York, Whitney Museum of American Art, and others, *Reginald Marsh*, exh. cat., 1955, with text by Lloyd Goodrich, extensive bibliography compiled by Rosalind Irvine § Norman Sasowsky, *Reginald Marsh: Etchings, Engravings, Lithographs* (New York: Praeger, 1956), with preface by A. Hyatt Mayor, introduction by Isabel Bishop § Lloyd Goodrich, *Reginald Marsh* (New York: Harry N. Abrams, 1972), with bibliography § Marilyn Cohen, *Reginald Marsh's New York: Paintings, Drawings, Prints, and Photographs* (New York: Whitney Museum of American Art in association with Dover Publications, 1983), with bibliography, checklist of exhibition held at Whitney Museum of American Art at Philip Morris and others.

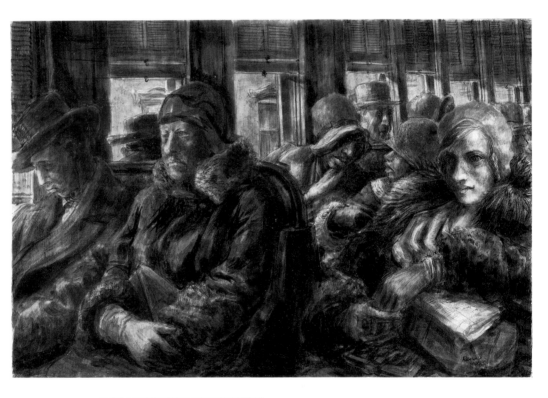

Marsh, *Third Avenue El.*

Third Avenue El, 1931
(*Second Avenue El* [incorrect])
Egg tempera, watercolor, and ink on paper backed by canvas and Masonite
24 x 36⅛ in (61.0 x 91.6 cm)
Signed lower right: REGINALD / MARSH
Inscribed on top stretcher bar: 4/26/36 [or 30]
Inscribed on right stretcher bar: MARSH 3rd ave El
Inscribed in two different hands on left stretcher bar: R. Marsh The second ave El.
Gift of American Art Council, Mr. and Mrs. Alan D. Levy, Mr. and Mrs. Willard G. Clark, Mr. and Mrs. Will Richeson, Jr., Mr. and Mrs. William D. Witherspoon, and Mr. and Mrs. J. Douglas Pardee
M.82.146
Color plate, page 72

Fascinated by the activity of city life, Marsh set much of his work in buses, subways, trains, and stations. *Third Avenue El* illustrates the crowded conditions of the New York elevated trains but does not give a sense of the extreme congestion often experienced by the daily passenger. This is somewhat surprising since Marsh delighted in the hustle and bustle of urban crowds, but his depictions of buses and trains lack the raucous quality of his other New York images. They are quieter and more serious. By focusing on a few figures and presenting them as physically and psychologically separated—as in *Second Avenue El*, 1929 (formerly Frank K. M. Rehn Galleries, New York), and *Why Not Use the "L"?* 1930 (Whitney Museum of American Art, New York)—he demonstrated how those who live

in a large, crowded city could feel alone. Although the passengers in *Third Avenue El* sit close together, they remain isolated from each other.

The obvious source of Marsh's painting is *Third Class Carriage,* c. 1860–70 (Metropolitan Museum of Art, New York), by Honoré Daumier (1808–1879), a work that he could have known through any one of several painted and lithographed versions or through reproductions, which were numerous. Marsh not only borrowed the composition of this well-known image, he shared the French master's appreciation of the dignity and worth of working-class people. Each passenger is a large, statuesque figure with a monumental presence. Marsh painted *Third Avenue El* in his characteristic, thin tempera wash, drawing in many details, such as the facial features and fur collars and cuffs. Deep colors, transparent washes, opaque passages, and drawing describe the solid forms.

Based on various inscriptions in more than one hand on the stretcher, the museum's painting has been dated to both 1930 and 1931 and at times referred to as *Second Avenue El.* According to the artist's own detailed records in his notebook however, this painting was created during January 1931 and titled *Third Avenue El.*

A number of drawings and an etching are related to the painting. Drawing was essential to Marsh's art, and he felt that the print medium aided the development of his painting. The related print (see illustration) was probably created after the painting. Art historian Norman Sasowsky dates the etching to 1930, but according to records the artist kept of the states of his etchings, he first executed states of the print sometime between January and March 1931.

Marsh made a major change in the print, substituting a black man for the white woman in the center foreground. Marsh had included blacks in the painted scene, as two female figures in the near background. Perhaps by giving a black a more prominent position in the print, the most important position in fact, Marsh felt he was updating Daumier's image. It is not clear when in the evolution of the related images Marsh changed the figure from a woman to a man. The female figure in the painting has a masculine appearance despite her fox-trimmed coat and handbag. Such ambiguity of gender is present in a number of related drawings. Marsh carried a sketch pad wherever he went, and in several drawings there are jottings of figure groupings and scenes similar to the painting *Third Avenue El.* Despite the sketchy nature of the drawings, in one in sketchbook 130 (Archiv. Am. Art, Reginald Marsh Papers, microfilm roll NRM8, fr. 583) Marsh so reworked the head of the center figure that its sex cannot be conclusively determined.

Marsh, *Third Avenue El,* 1930 [1931], see Related Works.

RELATED WORKS

Third Avenue El, 1930 [actually 1931], etching on paper, 6 x 8⅞ in (15.2 x 22.9 cm). Print Collection, Miriam and Ira D. Wallach Division of Art, Prints, and Photographs, New York Public Library, Astor, Lenox, and Tilden Foundations § Preparatory drawings of figures, sketchbooks 63, 109, 130. Archiv. Am. Art, Reginald Marsh Papers.

PROVENANCE

The artist § Estate of the artist, 1954 to at least 1955 § With Frank K. M. Rehn Galleries, New York, as of 1955 § Frank and Flora Winston, Birmingham, Mich. § With ACA American Heritage Gallery, New York, c. 1965 § Seymour Wadler, New York, c. 1965 § With Erma Rudin, New York § With Rowe Company Fine Arts, Chicago, to 1982.

EXHIBITIONS

Frank K. M. Rehn Galleries, [Reginald Marsh exhibition], 1931, no. 15, dated 1930 § Pittsfield, Mass., Berkshire Museum, *Works by Reginald Marsh,* 1944, no. 14 § New York, Whitney Museum of American Art, *Marsh's New York,* 1955–56, no. 4 § New York, Bernard Danenberg Galleries, *Reginald Marsh,* 1971, no. 1 § Los Angeles, Loyola Marymount University, Laband Art Gallery, *The Spirit of the City: American Urban Paintings, Prints, and Drawings, 1900–1952,* 1986, entries not numbered.

LITERATURE

Archiv. Am. Art, Reginald Marsh Papers, Notebook 7, unpaginated (roll 2234, fr. 312), lists 1931 Rehn Galleries exhibition; Notebook 10, p. 78 (ibid., fr. 459), includes sketch, dates January 1931, and gives detailed technical description of medium; "Inventory of R. Marsh Estate," 1954, typed, p. 8 (roll 2233, fr. 161), notes painting has April 26, 1930, date on stretcher; Norman Sasowsky, "Catalog of Reginald Marsh's Paintings," December 1955, typed list, 3: no. 31-11, lists owners, medium, conservation, dated 1931 § E. M. Benson, "The American Scene," *American Magazine of Art* 27 (February 1934): repro., 63, as *Second Avenue El* § Harry Salpeter, "The Roar of the City," *Esquire* 3 (June 1935): 128, identifies as *Second Avenue El* and compares with Daumier § Goodrich, *Marsh,* repro., p. 49 § Archiv. Am. Art, Frank K. M. Rehn Galleries Papers, "Records," letter by unknown person to Jerry Bywaters, October 24, 1955, recommends that the Dallas Museum of Fine Arts buy painting § "Recent Acquisitions: American Painting," *LACMA Members' Calendar* 21 (January 1983): unpaginated, repro. § "American Art," *LACMA Report 1981–1983* (1984), p. 20, discussed briefly, repro., p. 23 § "Permanent Collection, American Art," *LACMA Members' Calendar* 22 (August 1984): unpaginated § Fort 1986, p. 425, fig. 4, p. 422 § Ilene Susan Fort, "Selected Masterpieces: *Third Avenue El,*" *LACMA Members' Calendar* 24/25 (December 1986–January 1987): unpaginated, repro. § Marilyn Ann Cohen, "Reginald Marsh: An Interpretation of His Art," Ph.D. diss., New York University, 1987, p. 38, fig. 43, p. 311.

Millard Sheets

Born June 24, 1907,
Pomona, California
Died March 31, 1989,
Gualala, California

Recognized as a major figure for more than five decades, Millard Owen Sheets was perhaps the best-known traditional Southern California artist of his generation. He was equally accomplished in oils, watercolors, prints, murals, and mosaics. He also was a greatly admired art instructor, teaching at Chouinard School of Art, Los Angeles, from 1929 to 1935 and associated with Scripps College, Claremont, for more than 20 years beginning in 1932, first as a professor and then as director of the art school; he also was director of Los Angeles County Art Institute (Otis Art Institute) from 1953 to 1959. From 1965 to 1975 he held painting classes in Greece, Mexico, and other exotic lands.

As a teenager Sheets received criticism from Clarence Hinkle (1880–1960) in Laguna, California, then studied with F. Tolles Chamberlin (1873–1961) at Chouinard. Immediately following his graduation from Chouinard in 1929, Sheets toured Europe and then returned to the United States to teach and participate in national exhibitions. During the 1930s Sheets assisted STANTON MACDONALD-WRIGHT and Dalzell Hatfield in managing the Works Progress Administration/Federal Art Project of Southern California, and for twenty-five years he administered the annual Fine Arts Exhibition at the Los Angeles County Fair in Pomona.

In 1929 Sheets had his first solo exhibition in Los Angeles at Newhouse Galleries and in 1934 his first exhibition in New York at Milch Galleries. He was praised for his watercolors, which were compared with those of WINSLOW HOMER. Sheets's early mature paintings of the 1930s were scenes of Los Angeles and of the farms, ranches, and beaches of Southern California. The last named were tinged with a romanticism that later found expression in exotic subject matter. Throughout his career Sheets traveled to all parts of the world. During World War II he served as an artist-correspondent in India and in the early 1960s acted as an art representative for the United States State Department abroad.

Beginning in 1929 the artist's sense of decorative design manifested itself most clearly in his murals. In 1953 he established a production studio, Millard Sheets Designs, Inc., to fabricate his designs for painted and mosaic murals and stained-glass windows. His success as a muralist resulted in his resigning from the Los Angeles County Art Institute. He designed murals for buildings throughout the United States; in California he is perhaps best known for his mosaic murals that embellish the facades of Home Savings and Loan Association buildings.

BIBLIOGRAPHY
Arthur Millier, Hartley B. Alexander, and Merle Armitage, *Millard Sheets* (Los Angeles: Dalzell Hatfield, 1935), with lists of murals, works in collections, and exhibitions § Moure with Smith 1975, p. 228, with bibliography § University of California, Los Angeles, Oral History Program, interview with the artist by George M. Goodwin, November 17, 1976–February 9, 1977 § Laguna Beach (Calif.) Museum of Art and others, *Millard Sheets: Six Decades of Painting,* exh. cat, 1983, with essays by Susan C. Larsen and Janice Lovoos, chronology, lists of exhibitions and collections, selected bibliography § Janice Lovoos and Edmund F. Penney, *Millard Sheets: One-Man Renaissance* (Flagstaff, Ariz.: Northland Press, [c. 1984]), foreword by Richard Armour, with chronology, lists of murals, exhibitions, and honors.

Angel's Flight, 1931

Oil on canvas
50⁷/₁₆ x 40⁵/₈ in (128.1 x 102.6 cm)
Signed and dated lower left: MILLARD SHEETS 1931
Gift of Mrs. L. M. Maitland
32.17
Color plate, page 73

At the beginning of his career, early in the 1930s, Sheets created several urban views of Los Angeles like *Angel's Flight* and *Tenement Flats,* 1928 (National Museum of American Art, Smithsonian Institution, Washington, D.C.). While Sheets may have been encouraged to create such cityscapes by his early teacher, Theodore Modra (1873–1930), a disciple of ROBERT HENRI, he was probably inspired just as much by the American Scene painting popu-

lar during the Great Depression. In *Tenement Flats* and *Spring Street, Los Angeles,* 1930 (estate of the artist) Sheets presented the traditional view of city structures from ground level, possibly prompted by the example of the well-known *Cliff Dwellers* by GEORGE BELLOWS, 1913 (LACMA; q.v.), which had been on view in the Los Angeles Museum since 1916. As noted by contemporary critics, however, Sheets proved more inventive with *Angel's Flight:* he viewed a poor section of Los Angeles from high on a hill. This unusual vantage point must have seemed logical though, given the unusually steep terrain of the area depicted, which is now known as Bunker Hill. A friend of Sheets's who also painted the Los Angeles scene, Paul Sample (born 1896), was fascinated with unusual viewpoints.

The title of the painting, *Angel's Flight* (with the variants *Angels Flight* and *Angels' Flight*), refers to the now dismantled electric cable railway that was built in 1901 to carry pedestrians on Third Street up the steep hill from Hill Street to Olive, on the top of Bunker Hill. The funicular was built south of a road tunnel. At the same time a pedestrian stairway of 123 steps and ten ramps was constructed on the north side to give those who could not afford the railway free access to the top of Bunker Hill. On the crest of the hill a tall observation

Sheets, *Angel's Flight.*

tower, known as Angel's View, was constructed. The young women in the painting—the model for both of whom was the artist's wife, Mary—may be standing on either the observation tower or a railway platform on the hilltop. Sheets omitted the famous cable railway and chose to view the scene looking north toward the stairway. He did not depict the stairs as straight, as they actually were, but showed them as meandering up the hill,

thereby exaggerating the sense of height. Each of the buildings has a slightly different perspective vanishing point. Furthermore, the two women placed in the foreground shadow serve as repoussoir elements, introducing the viewer to the scene below, and as a contrast to the brilliantly sunlit hill below, which further exaggerates the perspective. The prominence of the figures in the foreground and the effect of the unusual viewpoint are quite baroque, a quality seen in the paintings of THOMAS HART BENTON and other regionalist artists.

Sheets's palette is bright and varied, with the apartment buildings and boarding houses painted in vivid orange, red, yellow, and green. The color, combined with the perspective and contrasting light and dark areas, gives the painting a distinctively dynamic quality. Despite its social-realist subject, *Angel's Flight* was a precursor to Sheets's brighter, more decorative postwar compositions.

Sheets painted *Angel's Flight* expressly for the 1931 *Carnegie International Exhibition* in Pittsburgh, the first major international show in which he was invited to participate. In 1932 the painting won a prize for the "most representative work" at the annual exhibition held at the Los Angeles Museum and was subsequently purchased for the museum. *Angel's Flight* is generally considered to be Sheets's masterpiece.

PROVENANCE
The artist, 1931–32 § Mrs. Leslie M. Maitland, Los Angeles, 1932.

ON DEPOSIT
Los Angeles County Superior Court, 1968.

EXHIBITIONS
Pittsburgh, Carnegie Institute, *Thirtieth Annual International Exhibition of Paintings,* 1931, no. 50 § Philadelphia, Pennsylvania Academy of the Fine Arts, *127th Annual Exhibition,* 1932, no. 7 § LAMHSA, *Thirteenth Annual Painting and Sculpture Exhibition,* 1932 (cat. published as *LA Museum Art News* no. 13 [April 1932]), no. 86, repro., cover, awarded 1932 painting prize for most representative work § Art Institute of Chicago, *Forty-fifth Annual Exhibition of American Paintings and Sculpture,* 1932–33, no. 179 § LAMHSA, *Sixteenth Annual Exhibition of Painters and Sculptors,* 1935, no. 97 of paintings § Los Angeles, University of Southern California, Elizabeth Holmes Fisher Gallery, *Some Contemporaneous Southern Californian Painters* (series 1939–40, no. 3), 1940, no. 31 § Pasadena (Calif.) Art Institute, *Millard Sheets in Retrospect, 1929 to 1950,* 1950, no. 58, repro., unpaginated § Duluth, University of Minnesota, Tweed Gallery, *Millard Sheets,* 1952, no. 5 § Pomona, Calif., Mount San Antonio College, *Millard Sheets Retrospective,* 1955, no cat. traced § Laguna Beach (Calif.) Art Gallery, *Millard Sheets Retrospective Exhibition,* 1962, no cat. traced § Los Angeles, Westside Jewish Community Center, *Landmarks,* 1969, no cat. traced § Clare-

mont, Calif., Pomona College, Montgomery Art Center, *Los Angeles Painters of the Nineteen-Twenties,* 1972, no. 43, repro., unpaginated § Claremont, Calif., Scripps College, Lang Art Gallery, *Millard Sheets,* 1976, no. 4, repro., p. 6 § San Francisco Museum of Modern Art, *Painting and Sculpture in California: The Modern Era,* 1976, no. 61, repro., p. 103 § LACMA 1980, no. 18, p. 57, repro., p. 56 § Laguna Beach Museum of Art and others, *Sheets,* 1983–84, no. 15, p. 12, essay by Susan C. Larsen describes as a poetically rendered regionalist painting, repro., p. 28.

LITERATURE

Edward Alden Jewell, "American Art Climbs the Bright Hill of Renaissance," *New York Times,* October 25, 1931, pt. 8, p. 12, repro. § *Los Angeles Times,* November 1, 1931, Rotogravure, p. 5, repro. § *California Artist* (Chouinard School of Art) (January 1932): repro., 1 § Edward Alden Jewell, "The Pennsylvania Academy Show," *American Magazine of Art* 24 (March 1932): 198, described as a canvas of originality and genuineness § Alma May Cook, "Modernism in Fine Art Exhibit," *Los Angeles Evening Herald and Express,* April 16, 1932, pt. B, p. 5 § Alma May Cook, "Art Exhibit Shows Life," *Los Angeles Evening Herald and Express,* April 23, 1932, pt. B, p. 5, praises and discusses winning of award § Arthur Millier, "Local Scene Fit Subject for Artists," *Los Angeles Times,* April 24, 1932, pt. 3, p. 13 § "Prize-Winning Painting Presented to Museum," *Los Angeles Times,* April 28, 1932, pt. 2, p. 7, explains why Mrs. Maitland donated the painting to the museum § Alma May Cook, "Great Record Made by Millard Sheets, *Los Angeles Evening Herald and Express,* April 30, 1932, pt. B, p. 5 § "Art Calendar," *California Arts and Architecture* 41 (May 1932): repro., 6 § "Prizes Awarded to Club Members," *California Art Club Bulletin* 7 (May 1932): unpaginated § "Barse Miller's Prize-Winning Picture Is Removed from Show," *Art Digest* 6 (May 1, 1932): 9 § "Famed Work of Art Wins Home Here," *Los Angeles Examiner,* May 3, 1932, pt. 2, p. 1, repro. § "The Local Scene Emerges in Los Angeles," *Art Digest* 6 (May 15, 1932): 5, the painting, according to Arthur Millier, "definitely establishes the 'local

scene' trend among the younger Los Angeles artists," repro., cover § "Items of Interest," *California Art Club Bulletin* 7 (June 1932): unpaginated § "Los Angeles," *American Magazine of Art* 24 (July 1932): 57, repro., 58 § A. M. [Arthur Millier?], "The Art of Millard Sheets," *Christian Science Monitor,* October 1, 1932, p. 8 § LACMA, Registrar's files, William Preston Harrison to Louise Upton, October 27, 1932, referring to the Art Institute of Chicago annual, states "Millard Sheets's *Angels' Flight* is hung in an important spot—stands up well, too" § Arthur Millier, "Museum's Own Collection of Paintings Now on View," *Los Angeles Times,* July 30, 1933, pt. 3, p. 5 § Millier, Alexander, and Armitage, *Millard Sheets,* pl. 4, unpaginated § "Art Exhibitions Reviewed, *Los Angeles Times,* July 28, 1935, pt. 2, p. 7 § Martha Chandler Cheney, *Modern Art in America* (New York: Whittlesey House, 1939), p. 142, "he shows girls who have escaped to the roof of a tall building," pl. 64, between pp. 106 and 107 § Los Angeles, Dalzell Hatfield Galleries, *Millard Sheets: Tenth Anniversary Exhibition,* exh. cat., 1939, repro., unpaginated § Arthur Millier, "The Art Thrill of the Week," *Los Angeles Times,* April 7, 1940, pt. 3, p. 8, describes as one of the local landmarks on view § Arthur Millier, "The Pacific Coast: Artists Are Stimulated by Its Diverse Climates," *Art Digest* 26 (November 1, 1951): repro., 30 § Kenneth Ross, "Eloquent Dean of California Watercolorists," *Los Angeles Times,* April 11, 1976, Calendar, p. 82, repro. § *LACMA Members' Calendar* 18 (September 1980): repro., unpaginated § Maudette Ball, "Los Angeles and the Modern Era," *Artweek* 11 (November 8, 1980): repro., p. 5 § "Reinstallation: American Painting and Sculpture," *LACMA Members' Calendar* 19 (September 1981): unpaginated § Lovoos & Penney, *Sheets,* pp. 32, 35, states it shows a daring, vertiginous perspective and a subject matter that is rare for the artist, repro., p. 34 § "Permanent Collection: American Art," *LACMA Members' Calendar* 22 (August 1984): unpaginated, repro. § Fort 1986, p. 425 § Michael Quick, "Selected Masterpiece: *Angel's Flight,*" *LACMA Members' Calendar* 26/27 (December 1988–January 1989): 10–11, repro., 11 § Janet Dominick, conversation with Ilene Susan Fort, April 1, 1990, identifies the model.

Ivan Albright

Born February 20, 1897, North Harvey, Illinois
Died November 18, 1983, Woodstock, Vermont

Ivan Le Lorraine Albright's forcefully realistic figure paintings made him one of the most celebrated artists in Chicago during the second half of his life. He grew up in an area that is now part of Chicago. In 1910 his family moved to Hubbard Woods, Illinois. He studied drawing with his father, the artist Adam Emory Albright (1862–1957), and attended Northwestern University in Evanston, Illinois, and the University of Illinois at Urbana, where he studied architecture. While serving in the army, 1918–19, he drew medical illustrations, becoming chief draftsman with the American Expeditionary Force Medical Corps in 1919. He worked in an architectural office and did illustrations, some of them medical, before deciding in 1919 that he wanted to become a painter.

Albright studied at the School of the Art Institute of Chicago from 1920 to 1923 and then briefly attended the Pennsylvania Academy of the Fine Arts in Philadelphia and the National Academy of Design in New York. From 1927 to 1947 he maintained a studio at Warrenville, Illinois, and later moved to Chicago. During the late 1920s and 1930s he developed his distinctive style in which the textures of his distorted and dimpled surfaces

are developed with seemingly obsessive detail; this technique makes the flesh of the figures seem to be diseased and decomposing. From November 1943 to September 1944 he was in Hollywood, painting the canvas *The Picture of Dorian Gray* (Art Institute of Chicago) for the film of the same name. Honors came to him in the 1940s.

BIBLIOGRAPHY
Marilyn Robb, "Ivan Le Lorraine Albright Paints a Picture," *Art News* 49 (June–August 1950): 44–47 § Katharine Kuh, *The Artist's Voice: Talks with Seventeen Artists* (New York: Harper & Row, 1962), pp. 23–37, with chronology § Art Institute of Chicago and New York, Whitney Museum of American Art, *Ivan Albright: A Retrospective Exhibition*, exh. cat., 1964, with essays by Frederick A. Sweet, Jean Dubuffet, and Ivan Albright, chronology § Peter Pollack, "The Lithographs of Ivan Albright," *American Art Journal* 8 (May 1976): 99–104 § Michael Croydon, *Ivan Albright* (New York: Abbeville, 1978), with bibliography, chronology.

Albright, *Self-Portrait.*

Self-Portrait, 1933
Oil on canvas
Signed and inscribed in pencil lower right: To my pal, dear Hazel. / Ivan Le Lorraine Albright
15³/₁₆ x 11¹/₁₆ in (38.5 x 28.1 cm)
Gift of Mr. and Mrs. Berny Schulman in memory of Mr. Reuben L. Freeman
M.81.124

Over the course of his career Albright painted numerous self-portraits, most notably a powerful series executed shortly before his death in 1983. He described his probing, realist style in

metaphysical terms, and his self-portraits are among the most searching and penitential produced by an American artist.

The present work is unfinished, and, because of its modest format, apparently a study. *Self-Portrait* thus lacks the minute finish for which Albright is best known, but instead reveals much of his working method and approach to form. Comparing it with the frontal likenesses of his self-portraits of 1934 and 1935, one can see a similar use of highlighting to define complex, corrugated planes, a comparable use of exaggerated color, and a common linear movement through the likeness. This painting, however, reveals more frankly the expressionist nature of Albright's style.

The inscription refers to Hazel Buntman, first wife of Leo Buntman, a dealer and friend of Albright's, who helped organize the first Grant Park Exhibition for local artists in Chicago.

PROVENANCE
Mrs. Leo Buntman (Hazel), Chicago, 1933 § Mr. and Mrs. Berny Schulman, Glencoe, Ill., c. 1935–81.

EXHIBITION
Art Institute of Chicago and Whitney Museum of American Art, *Albright,* 1964–65, no. 20, repro., p. 35.

LITERATURE
Margarita Walker Dulac, "Ivan Albright: Mystic-Realist," *American Artist* 30 (January 1966): repro., 32 § Croydon, *Albright,* p. 97, pl. 48, p. 143 § LACMA, American Art department files, Michael Croydon to Ilene Susan Fort, January 2, 1986, explains inscription.

Conrad Buff

Born January 15, 1886,
Speicher, Switzerland
To United States 1905
Died March 11, 1975,
Laguna Hills, California

From 1900 to 1903 Conrad Buff (the second of that name) studied lace design at the School of Arts and Crafts in Saint Gallen, Switzerland, and in 1900 briefly attended a private art school in Munich. In 1905 he came to the United States, working his way west from Wisconsin. In 1907 he settled in Los Angeles, supporting himself as a house painter and decorator until about 1918, painting when he could.

Buff participated in exhibitions at the Los Angeles Museum beginning in 1920, and was given solo exhibitions there in 1921 and 1940. Solo exhibitions of his work were held

in Los Angeles at the Ilsley Galleries in 1933 and the Stendahl Art Galleries in 1934. He won the painting prize from the California State Fair in 1924, the Mrs. Henry E. Huntington Prize from the Los Angeles Museum in 1925, and the Fine Arts Society First Prize from the Fine Arts Gallery, San Diego, in 1926.

In 1922 he married Mary Marsh. Together they illustrated children's books, the first published in 1937, and traveled to Europe, the Southwest, Central America, and the Orient to gather material. During the late 1920s and early 1930s Buff was also active as a muralist. He created three murals under the auspices of the New Deal projects in 1934 and 1940. During and after the depression he devoted himself increasingly to lithography and book illustrations, and it was his graphic work that earned for him a national reputation.

BIBLIOGRAPHY
Archiv. Am. Art, Stendahl Art Galleries Papers § Arthur Millier, "Our Artists in Person, no. 7: Conrad Buff," *Los Angeles Times,* August 10, 1930, pt. 3, pp. 20, 22 § University of California, Los Angeles, Oral History Program, "Conrad Buff: Artist," interview by Elizabeth I. Dixon, 1964, with list of books by Conrad Buff and Mary Buff § Moure with Smith 1975, pp. 32–33, with bibliography § Los Angeles, Security Pacific National Bank, Gallery at the Plaza, *Conrad Buff II: Western Landscapes, 1920–1975,* exh. cat., 1983, with essay by Tressa R. Miller and lists of public collections, murals, major exhibitions, and awards.

Buff, *Westward.*

Westward, c. 1933–34
(Hurricane Pass on the Covered Wagon Trail in Southern Utah; Westward Ho!)
Oil on canvas
Signed lower left: C BUFF
36 x 48⁵/₁₆ in (91.5 x 122.7 cm)
Los Angeles County Fund
37.23
Color plate, page 74

In April 1879 an exploration party of Mormons left the Cedar City-Fillmore area of Utah to scout out southeastern Utah before a group went to colonize the area. The larger party crossed Hole-in-the-Rock on their way to Bluff, where they eventually settled. Their passage was fraught with difficulties, not the least of which was the lowering of their wagons down the east slope of Hole-in-the-Rock, a process depicted in *Westward.*

Buff had first become interested in the history of the Mormons in the late 1920s when he was asked to decorate the Church of Jesus Christ of Latter Day Saints in Los Angeles.

There he painted a series of lunettes depicting the original group of pioneering Mormons who moved West in 1847. For this and other commissions for smaller Mormon churches that he later received, Buff explored Nevada and Utah, travels which increased his admiration for members of the church.

The subject of *Westward* fascinated Buff and he made several versions of it in oil as well as a lithograph. A photograph of *Westward I* in the transcript of the Buff interview in the Oral History Program, University of California, Los Angeles, and given the date 1933 is of a version similar to the museum's painting in overall conception, but it differs in details of the rock formation and the wagon train and in the placement of the signature. The next year he completed a large oil on canvas mural, *Westward II* (Santa Monica [Calif.] High School), for the Public Works of Art Project. In it the details of geography differ somewhat from those in the museum's painting and Buff added in the foreground a cliff on which a pioneer mother and two children perch precariously. In 1934, the same year he painted the mural *Westward II*, he included in his solo exhibition at the Stendahl Art Galleries a painting titled *Hurricane Pass on the Covered Wagon Trail in Southern Utah*. Judging by its reproduction in the *Los Angeles Times* (July 22, 1934, pt. 2, p. 8) this appears to have been almost identical to the version now owned by the museum. Pentimenti in the museum's painting indicate that the placement of the small figures in the foreground was changed slightly. This suggests that the museum's version, which is undated, may have been first exhibited in 1934 as *Hurricane Pass* . . . and then changed slightly and given a new title. If so, the reason for the artist's alterations are not known.

Buff's typical subject was the Western mountain landscape, its dramatic forms rendered as bold, clear shapes with an almost architectural quality. Its historical subject and rustic figures (one posed for by the artist's son) give *Westward* a more regionalist flavor. The genre element as well as the baroque viewpoint were typical of murals created in the 1930s.

Westward displays the technique of the artist's earlier paintings: a thin underpainting of various colors applied in large areas of light and shade, each color enlivened by a series of short lines of a different and sometimes complementary color. The cliffs are maroon, orange, lavender, and beige; the distant hills are pastel blue, lavender, ocher, and green. The technique, which the artist described as "pointillist," may recall Italian divisionist painting, which he might have known from his youth in Switzerland and southern Germany. Buff maintained this mature style until he gradually broadened it in later life.

Although Buff was invited to exhibit paintings in his pointillist style with the city's modernists in the early 1920s, *Westward* won the first prize in the "conservative class" at the museum's *Eighteenth Annual Exhibition: Painting and Sculpture,* from which it was purchased. The Los Angeles art world had changed, but Buff had an individual style independent of the art movements around him.

RELATED WORKS
Westward I, 1933, oil (?), dimensions unknown. Unlocated (illustrated in "Conrad Buff: Artist," Oral History Program, UCLA, following p. 52) § *Westward* [II], 1934, oil on canvas, approx. 120 x 156 in (304.8 x 383.2 cm). Santa Monica (Calif.) High School § *American Pioneers,* c. 1935, lithograph, 9½ x 12½ in (24.1 x 31.8 cm). LACMA.

PROVENANCE
The artist, to 1937.

ON DEPOSIT
Los Angeles County Board of Supervisors, 1952–73.

EXHIBITIONS
Los Angeles, Stendahl Art Galleries, [Conrad Buff exhibition], 1934, no cat. traced, as *Hurricane Pass on the Covered Wagon Trail in Southern Utah* § LACMHSA, *Eighteenth Annual Exhibition: Painting and Sculpture,* 1937, no. 14, awarded prize in conservative category § Fine Arts Gallery of San Diego (Calif.), *Eleventh Annual Exhibition of Southern California Art,* 1939, no. 11 § Compton, Calif., Chamber of Commerce, Allied Arts Committee, [exhibition title unknown], 1947, no cat. traced § Fine Arts Gallery of San Diego, *Exhibition of Historic Art: California Centennial Celebration,* 1950, entries not numbered, as *Westward Ho!* § Laguna 1979, entries not numbered, repro., p. 45.

LITERATURE
Fred Hogue, "Canvases of Conrad Buff Recall Work of Primitives," *Los Angeles Times,* July 22, 1934, pt. 2, p. 8, repro., as *Hurricane Pass on the Covered Wagon Trail in Southern Utah* § "Museum Painting, Sculpture Winners Told," *Hollywood Citizen News,* April 9, 1937, p. 13, won five-hundred dollar purchase prize award, repro. § O. Uzzell, "Painters, Sculptors Exhibit at Museum," *Los Angeles Times,* April 18, 1937, pt. 3, p. 9, repro. § Alma May Cook, "Buff Painting Tops L.A. Exhibit," *Los Angeles Evening Herald and Express,* April 24, 1937, pt. B, p. 1, repro. § "Los Angeles Awards Prizes in Triplicate," *Art Digest* 11 (May 1, 1937): 12 § *LA Museum Bulletin* 1 (July–September 1937): repro., unpaginated § UCLA, Oral History Program, "Conrad Buff: Artist," pp. x, 324, refers to painting (dated 1933) winning purchase prize in 1937, repro., following p. 52 § Moure with Smith 1975, repro., p. 294 § LACMA, Registrar's files, Conrad Buff III to Nancy Dustin Wall Moure, January 27, 1977, discusses paint handling and subject matter, notes he posed for figure of young boy; Arley G. Curtz to Nancy Moore, March 4, 1977, identifies site and activity.

Ejnar Hansen

Born January 9, 1884,
Copenhagen, Denmark
To United States 1914
Died September 26, 1965,
Pasadena, California

Ejnar Hansen was a notable figure painter in Southern California during the years between the wars. He began his career in Copenhagen, where he studied at the Royal Academy of Fine Arts while supporting himself as a painting contractor. This double career in the commercial and fine arts continued until the 1940s. In Denmark he was a member of the secessionist group *De Tretten* (The Thirteen), which advocated modernist art. After immigrating to the United States in 1914, he settled in the Midwest, exhibiting and winning awards for his portraits at the annual exhibitions of the Art Institute of Chicago. In 1925 he moved to California and the following year settled in Pasadena. In the late 1930s he began supporting himself by teaching, first at Chouinard Art Institute, Los Angeles, then at Pomona College, Claremont, and John Muir College, Los Angeles. He was also active in the California Water Color Society, serving as its vice-president and president in the late 1930s. He received numerous commissions.

Hansen's art was generally somber, moody, and tending toward the melancholy, which aligns him with Scandinavian artists such as Edvard Munch (1863–1944). Although Hansen's figure paintings were the most sought after, he also produced still lifes and landscapes. All of his California-period paintings reveal Hansen as a modernist in his manipulation of form, space, and composition, and the figure paintings also demonstrate his mastery of characterization.

BIBLIOGRAPHY
Santa Barbara, Calif., Jorgen Hansen Collection, Ejnar Hansen Papers § Arthur Millier, "Ejnar Hansen Interviewed," *American Artist* 14 (October 1950): 28–33, 62 § Pasadena (Calif.) Art Museum, *Ejnar Hansen: Fifty Years of His Art,* exh. cat., 1956, with introduction by Frode N. Dann, chronology, lists of awards, exhibitions, and collections, bibliography § Moure with Smith 1975, p. 109, with bibliography § Santa Barbara, James M. Hansen, *Ejnar Hansen, 1884–1965: Retrospective Exhibition,* exh. cat., 1984, with introduction by James M. Hansen, lists of awards and exhibitions.

Hansen, *Portrait of Sadakichi Hartmann.*

Portrait of Sadakichi Hartmann, by 1934
(Seated Figure)
Oil on canvas
51⅛ x 41⅛ in (129.9 x 104.5 cm)
Signed lower left: EH (monogram); [to the left of initials, a patch with a printed "6" is visible]
Signed and dated verso upper right: EH (monogram) / Ejnar Hansen / 1934 [1934 with lines through it as if crossed out]
Purchased with funds provided by Mrs. Spencer Tracy and family, Marian and John Bowater, and Eileen and Dick Foster
M.82.1

Carl Sadakichi Hartmann (1867–1944) was one of the most astute art historians and critics of the early twentieth century, best remembered for his *History of American Art* (1901) and perceptive reviews and essays on photography published in *Camera Work.* Always ahead of his times, he edited and published two of the earliest avant-garde magazines in America, wrote reviews for newspapers (often using the pseudonym Sidney Allen), and was instrumental in bringing the symbolist movement to the attention of people in the United States.

An eccentric character, Hartmann was involved in such unusual ventures as the production of the first perfume concert in New York in 1902. He spent his most creative years in New York but due to asthma moved to California in the early 1920s. His health continued to deteriorate, worsened by the effects of alcohol. He became involved in the Hollywood circle of actors around John Barrymore and

more importantly in the group of artists cen-
tered around the home of Margery Winter.
Among the artists he met there was Ejnar
Hansen, with whom he formed a long and
close friendship.

Hartmann thoroughly enjoyed posing for
artists and during his life was painted and
photographed by numerous American and
foreign artists. Hansen drew, painted, and
sculpted Hartmann many times. This painting
is probably his best-known portrait of Hart-
mann. Hansen was exceptionally perceptive
in conveying old age, and in all of his portraits
of Hartmann the artist did not balk at making
an honest portrayal. Hansen clearly depicted
how greatly ill health and dissipation had aged
Hartmann. Yet Hansen was also very sympa-
thetic to the man whom many in Los Angeles
considered a mere caricature of what he had
been. Hansen continued to convey Hartmann's
intelligence, even entitling one of his portraits
The Old Philosopher, 1940 (estate of the artist as
of 1965). In the museum's portrait Hartmann
thoughtfully sits next to a table full of books,
as if he has paused to contemplate what he has
just read. With his hand to his head, Hartmann
appears in the traditional pose of the thinker.
The soft light filtering through the interior and
the delicate browns, grays, and oranges create a
protective, mellow atmosphere around the
tired Hartmann.

This portrait won the Foundation of West-
ern Art's first prize for the best painting of
1934. Generally considered to be one of Han-
sen's masterpieces, it demonstrates his
conservative interpretation of Cézannesque
form, composition, and brushwork.

PROVENANCE
The artist, to 1965 § Jorgen Hansen (by descent),
Santa Barbara, Calif., 1965–82.

EXHIBITIONS
Los Angeles, Ilsley Galleries, *Oil Paintings by Ejnar
Hansen,* 1934, no. 3 § Los Angeles Foundation of
Western Art, *Contemporary Painters of California,*
1934, no cat. traced, awarded medal for best portrait
painting § LACMHSA, *Sixteenth Annual Exhibi-
tion of Painters and Sculptors,* 1935, no. 41, as *Seated
Figure,* awarded honorable mention § Pasadena
(Calif.) Society of Artists, Grace Nicholson Gal-
leries, *Twelfth Annual Exhibition,* 1936, no cat.

traced, awarded honorable mention § New York,
American Fine Arts Society Galleries (sponsored by
the Municipal Art Committee), *Second National
Exhibition of American Art,* 1937, no. 97, as *Tadakichi*
[sic] *Hartmann* § Los Angeles, University of South-
ern California, Elizabeth Holmes Fisher Gallery,
Some Contemporaneous Southern Californian Painters
(series 1939–40, no. 3), 1940, no. 12 § Probably
LACMHSA, *Ejnar Hansen,* 1941, no. 2, as *Sadakichi* §
Probably Pasadena (Calif.) Art Institute, [exhibition
title unknown], 1945, no cat. traced § Art Institute
of Chicago, *Fifty-sixth Annual American Exhibition of
Paintings,* 1945–46, no. 63 § Los Angeles, Barnsdall
Park, Municipal Art Gallery, *The American Scene,*
1956, no cat. traced § Riverside, University of Cal-
ifornia, University Library, *The Life and Times of
Sadakichi Hartmann, 1867–1944,* 1970, no. 81, repro.,
p. 43, dated 1932 § LACMA 1980, no. 21, p. 66,
repro., p. 67 § Washington, D.C., Federal Reserve
Board, *Aspects of California Modernism, 1920–1950,*
1986, no. 19, with essay by Diane De A. Moran, p. 3.

LITERATURE
Arthur Millier, "Ejnar Hansen's Art Praised," *Los
Angeles Times,* April 29, 1934, pt. 2, p. 8, "a work that
should go to an important museum," repro. § "A
Master Portrayal of Sadakichi Hartman [sic]," *Art
Digest* 8 (May 15, 1934): 7, repro. § "Wins Portrait
Prize," *Los Angeles Herald and Express,* August 15,
1934, pt. B., p. 1, repro. § "Serious Portraiture," *Cal-
ifornia Art News,* August 27, 1934, repro., p. 6 §
Alma May Cook, "Martin's Painting Is Awarded
$500 at Show," *Los Angeles Evening Herald and
Express,* April 25, 1935, pt. A, p. 16, repro., as *Seated
Figure* § "Our Artists in Person: Ejnar Hansen,"
Los Angeles Times, December 15, 1935, pt. 3, p. 8 §
"Injar [sic] Hansen comes to Chouinard," *Chouinard
Art Institute Catalog* (1936–37), p. 5, portrait of
Hartmann in recent Ilsley Galleries exhibition,
repro. § Arthur Millier, "The Art Thrill of the
Week," *Los Angeles Times,* April 7, 1940, pt. 3, p. 8
§ Herman Reuter, "Varied New Art Exhibits Dis-
cussed by Reviewer," *Citizen-News* (Hollywood),
May 3, 1941, p. 6, Hartmann portrait "destined to
become a classic" § "The Power of Hansen," *Art
Digest* 15 (May 15, 1941): 20, quotes Herman Reuter,
Citizen-News (Hollywood): "the large *Sadakichi
Hartmann* is destined to become a classic" § Santa
Barbara, Jorgen Hansen Collection, Ejnar Hansen
Papers, "1945 Record of Ejnar Hansen's Works and
Awards" lists "large painting 'Sadakichi'" on exhibit
in Pasadena § "Californiens Store Danske Maler,"
Aarchuus Stiftstidende, February 6, 1949, repro.,
unpaginated § Millier, "Hansen Interviewed," p. 30,
repro., p. 31 § James Hansen, pp. 3, 21, *Hansen,*
discusses history of exhibitions and awards.

Paul Cadmus

Born December 17, 1904,
New York, New York
Lives in Weston, Connecticut

The controversial social satires of Paul Cadmus gained wide visibility during the 1930s. More recently his superb academic drawings have garnered wide acclaim. The son of two artists, Cadmus entered the National Academy of Design in 1919. During the 1920s he studied at the Art Students League while supporting himself with illustrations published in the *New York Herald-Tribune* and used in commercial advertisements. In 1931 he left the United States with his close friend Jared French (born 1905) for a two-year stay in Europe, spending most of his time painting in a fishing village in Majorca. In December 1933 he returned to New York and immediately became involved with the Public Works of Art Project, painting *The Fleet's In!*, 1934 (Naval Historical Center, Washington, D.C.). This scene of rowdy sailors cavorting with women made Cadmus a celebrity overnight.

Despite the controversies his work provoked, he won commissions from the Treasury Department Relief Art Project and from *Life* magazine. In 1940 Jared French introduced him to tempera painting, and the following year Cadmus commenced a series of Fire Island beach scenes related to photographs taken by French and his wife. During the 1940s Cadmus created a series of highly erotic, obsessive panels, *The Seven Deadly Sins.* Afterwards, influenced by the writings of E. M. Forster, he turned to more self-reflective, lyrical expressions. While through the 1950s he continued to make meticulously rendered, symbolic paintings, in 1965 he turned more to drawing, creating sensitive, academic renderings of the nude. In the 1970s he moved to Connecticut.

BIBLIOGRAPHY
New York, Midtown Galleries, *Paul Cadmus,* exh. cat., 1937, with statement by the artist § Harry Salpeter, "Paul Cadmus: *Enfant Terrible,*" *Esquire* 8 (July 1937): 105–7, 112 § Una E. Johnson with Jo Miller, *Paul Cadmus: Prints and Drawings, 1922–1967,* American Graphic Artists of the Twentieth Century, Monograph no. 6 (Brooklyn: Brooklyn Museum, 1968), with chronology, lists of awards and collections, bibliography § Oxford, Ohio, Miami University Art Museum, and others, *Paul Cadmus: Yesterday and Today,* exh. cat., 1981, with text by Philip Eliasoph, chronology § Lincoln Kirstein, *Paul Cadmus* (New York: Imago Imprint, 1984), with catalogue raisonné of paintings, lists of public collections, exhibitions, and awards, bibliography.

Cadmus, *Coney Island.*

Coney Island, 1934

Oil on canvas
32⁷/₁₆ x 36⁵/₁₆ in (82.4 x 92.2 cm)
Signed lower left: paul cadmus
Gift of Peter Paanakker
59.72

Coney Island was the first painting Cadmus made after he ceased working for the federally sponsored Public Works of Art Project. It is typical of his paintings of the period in both theme and form.

Cadmus viewed the prosaic activity of bathing on a beach in devastatingly satirical terms. Poking fun at the bathers' carefree pleasures, Cadmus accumulated an odd assortment of bulging, burnt bodies. The bathers are oblivious to their ridiculous appearance and uncouth behavior. Swarming the beach, their bodies are strangely intertwined, their faces smiling inanely. Everything is exaggerated, the color verging on the garish to intensify their grossness.

In the 1930s Cadmus used oil paint almost as if it were a graphic medium, consequently *Coney Island* looks more like a tinted drawing than a painting. His small, exacting brushstrokes impart a flickering quality to the surface, which intensifies the impression that the figures are in constant motion.

Cadmus actually began to sketch the scene on Martha's Vineyard, before he visited Coney Island. He was attracted to the Brooklyn beach because it offered him the opportunity to delineate the human figure with as little clothing as possible. Moreover, he considered the beach scene to be a classical subject. His treatment, however, is rather baroque. As was his friend REGINALD MARSH, Cadmus was attracted to the elaborate compositions of old master paintings. *Coney Island,* with its seminude figures arranged in complex groupings, their bodies twisted and in constant motion, was for Cadmus the twentieth-century version of a baroque allegorical composition.

Cadmus claimed that his intent was not to be sensational, but when the painting was exhibited in the Whitney Museum of American Art's second biennial, it suffered the same hostile reception as did his earlier *The Fleet's In!* The Coney Island Showmen's League, a local trade group, denounced the painting as offensive and inaccurate and threatened a libel suit if the painting was not removed from the exhibition. According to the artist's incomplete records, it seems that the painting was rejected from several annual exhibitions to which it was submitted soon after it was shown at the Whitney biennial, probably because of the controversy it stirred.

In 1935 Cadmus produced an etching from a photograph of the painting in the hope that it would reach a larger public. In the etching the image is reversed but otherwise differs only in a few minor details.

RELATED WORKS
Coney Island, by 1934, drawing. Unlocated § *Coney Island,* 1935, etching, 9¼ x 10¼ in (23.5 x 26.7 cm). LACMA.

PROVENANCE
The artist, 1934–37 § With Midtown Galleries, New York, 1937 § J. R. Stark, Cincinnati, Ohio, 1937–c. 1949 § With Midtown Galleries, New York, c. 1949–59 § Peter A. Paanakker, Los Angeles, 1959.

EXHIBITIONS
New York, Whitney Museum of American Art, *Second Biennial Exhibition of Contemporary American Painting,* 1934–35, no. 97 § New York, Hearns Department Store, Gallery, *The New York Scene,* 1935, no. 35, no cat. traced § Brooklyn Museum, *Humor in Art,* 1935, no. 9 § New York, Midtown Galleries, *Paul Cadmus,* 1937, no. 10 § Cincinnati Art Museum, *Forty-fifth Annual Exhibition of American Art,* 1938, no. 19 § Baltimore Museum of Art, *Paintings and Prints by Paul Cadmus,* 1942, no cat. traced § Des Moines Art Center, *Nineteenth and Twentieth Century European and American Art,* 1948, no. 15 § Museum of the City of New York, *Coney Island: Playground of the World,* 1954, no cat. traced § New York, Whitney Museum of American Art, and Berkeley, University of California, University Art Museum, *Human Concern/Personal Torment: The Grotesque in American Art,* 1969–70, no. 23, repro., unpaginated § Coral Gables, Fla., Metropolitan Museum and Art Center, *American Magic Realists,* 1977, entries not numbered, repro., cover § Miami University Art Museum and others, *Cadmus,* 1981–82, no. 10, p. 22, essay by Eliasoph comments on satiric quality, repro., p. 45, incorrectly dated 1935.

LITERATURE
Archiv. Am. Art, Whitney Museum of American Art Papers, Scrapbook, newspaper clipping, "Artists Depict American Scene with Bitterness," *World Telegram* (New York), November 27, 1934 (microfilm roll no. N595, fr. 371), the "message seems to be it [Coney Island] is an awful place"; newspaper clipping, Royal Cortissoz, "The Whitney Biennial and Other Episodes," *New York Herald-Tribune,* December 2, 1934 (ibid, fr. 375), characterizes painting as "somewhat lurid"; newspaper clipping, "Is This Coney Island?—An Artist's Impression," *Press* (Middletown, Conn.), December 3, 1934 (ibid., fr. 376), repro.; newspaper clipping, "Is This Coney Island?—An Artist's Impression," *Nassau Review* (Freeport, N.Y.), December 4, 1934 (ibid.), repro. § "Cadmus Canvas 'Insults' Coney," *New York Daily Mirror,* December 1, 1934, p. 9 § Archiv. Am. Art, Whitney Museum of American Art Papers, artist's file, C. Adolph Glassgold to Paul Cadmus, December 5, 1934 (roll N650, fr. 381), tells of *American Weekly* reporter Charles Robbins, who wrote earlier article with interview on *The Fleet's In!,* wanting to do a sensational story on paintings in the Whitney Biennial, and asks Cadmus if he wants to give Robbins a photograph of *Coney Island* for reproduction,

also refers to December 1, 1934, article on *Coney Island* in the *Mirror;* Cadmus to Glassgold, December 7, 1934 (ibid., fr. 379–80), prefers not to give *Coney Island* photo to *American Weekly,* saying, "I have had enough publicity of a sensational character to last me quite a while. Publicity of such a nature may give the false impression that my aim is to be sensational. If my aim were such, I would gladly accept the proffered notoriety. As it is not, I will refuse" § "New Notes," *Brooklyn Museum Quarterly* 23 (April 1936): repro., 81 § Henry McBride, "Attractions in the Galleries," *Sun* (New York), March 27, 1937, p. 38 § "Paul Cadmus of Navy Fame Has His First Art Show," *Life* 2 (March 29, 1937): repro., 45 § "Cadmus: Satirist of Modern 'Civilization,'" *Art Digest* 11 (April 1, 1937): 17, "full of ludicrous and somewhat cruel characterizations" § Martha Davidson, "New Exhibitions of the Week," *Art News* 35 (April 3, 1937): 17 § Lewis Mumford, "The Art Galleries," *New Yorker* 13 (April 10, 1937): 51 § Salpeter, "Cadmus: *Enfant Terrible,*" p. 112, repro., 107 § "Speaking of Pictures," *Life* 3 (July 1937): fig. 16, 9 § Peyton Boswell, Jr., *Modern American Painting* (New York: Dodd, Mead, 1939), pp. 80, 133, repro., p. 111 § "Sweet Briar Acquires Vital Cadmus Canvas," *Art Digest* 14 (December 1, 1939): 16 § "Baltimore Examines Paul Cadmus, Satirist," *Art Digest* 16 (September 1, 1942): 7 § LACMA, Registrar's files, the artist to Nancy Dustin Wall Moure, August 20, 1970, discusses sale of painting and related print § Diane Casella Hines, "The Figure Drawings of Paul Cadmus," *American Artist* 36 (November 1972): 31 § "New Acquisition: American Art," *LACMA Members' Calendar* 18 (October 1980): unpaginated, repro. § Elizabeth N. Armstrong, "American Scene as Satire: The Art of Paul Cadmus in the 1930s," *Arts* 56 (March 1982): 123, 125 § Kirstein, *Cadmus,* pp. 27, 29, 133, listed in cat. raisonné, repro., p. 28, incorrectly dated 1935 § LACMA, American Art department files, the artist to Ilene Susan Fort, April 6, 1985, confirms 1934 dating and discusses exhibition history and related works § Fort 1986, p. 425 § LACMA 1988, p. 24, repro.

Max Weber

Born April 18, 1881,
Bialystok, Russia
To United States 1891
Died October 4, 1961,
Great Neck, New York

Max Weber was among the leading first-generation American modernists, exploring abstraction in painting, sculpture, and poetry. After studying with the innovative teacher Arthur Wesley Dow (1857–1922) at Pratt Institute in Brooklyn, Weber taught art for five years in Virginia and Minnesota. In 1905 he went to Paris and studied in several traditional academies, but his real education in France came with his introduction to the avant-garde. He became a devoted disciple of Paul Cézanne (1839–1906), met Guillaume Apollinaire, Robert Delaunay (1885–1941), Pablo Picasso (1881–1973), and Leo and Gertrude Stein and became close friends with Henri Rousseau (1844–1910), later organizing the first exhibition of Rousseau's work in the United States. Weber was instrumental in organizing an art class under Henri Matisse (1869–1954). He also was one of the first Americans to realize the importance of primitive art and study the ethnographic collections housed in Paris museums.

Returning to New York in 1909, Weber became a core member of the group of American modernists who exhibited in Alfred Stieglitz's gallery "291," having his first solo exhibition there in 1911. In 1910 he published an essay on the fourth dimension, and he was one of the few Americans to be concerned with such advanced ideas at this time. He also created some of the earliest abstract sculptures made by an American. Before World War I Weber exhibited his exceptionally progressive paintings of landscapes, nudes, and still lifes, which reflected the forceful brushwork and brilliant color of Matisse. Possibly because of the hostile critical reception his paintings received, Weber turned to religion for solace and in the late 1910s incorporated in his repertoire figures of Talmudists, rabbis, and the Hassidim, and these recur in his art throughout his career despite stylistic changes.

In 1930 critical attention was redirected to his art when the Museum of Modern Art, New York, accorded him a retrospective exhibition. By the late 1930s, he had developed his final style. In his paintings of religious figures and nudes a thin, exuberant brushstroke and wiry, calligraphic line dominated, and in the 1940s the brilliant fauvist palette of his early years reappeared.

Among his numerous writings are *Cubist Poems* (1914), *Essays on Art* (1916), and *Primitives* (1926).

BIBLIOGRAPHY
Private collection, and New York, Columbia University, Special Collections, Max Weber Papers (those in private collection on microfilm, Archiv. Am. Art) § Holger Cahill, *Max Weber* (New York: Downtown Gallery, 1930) § Alfred Werner, *Max Weber* (New York: Harry N. Abrams, 1975), with chronology, bibliography § New York, Jewish Museum, and others, *Max Weber: American Modern,* exh. cat., 1982, with text by Percy North, chronology, list of exhibitions, bibliography.

Still Life with Two Tables, c. 1934
Oil on canvas
28¼ x 36⅜ in (71.8 x 92.5 cm)
Signed lower right: MAX WEBER
Inscribed verso, lower left: I am happy to know that
/ this painting will dwell in / the home of my new
friends / Mr. and Mrs. William Goetz / Max Weber
/ New York / Sept. 26, 1947
Gift of Mr. and Mrs. William Goetz
M.62.48

Weber, *Still Life with Two Tables.*

Weber painted still lifes throughout his career.
In *Essays on Art* he expressed his reverence for
the simple objects of a still life: "We speak
about things, but we seldom hear things speak
to us. Things, objects, mutely cry to us: 'Touch
us, taste us, feel us, see us, understand us, make
us more than we are through your association,
through your tactile and spiritual intimacy'"
(p. 31). His still-life paintings of the 1920s and
1930s reflect Weber's move away from abstrac-
tion toward a more naturalistic art. While
Weber was often more adventuresome in his
figure paintings, in his still lifes he remained
conservative for a longer period of time. Well
into the 1930s his still lifes reflected the influ-
ence of Cézanne.

Almost all of Weber's still lifes are tabletop
arrangements. *Still Life with Two Tables* is
among the most complex, including two tables
laden with many objects. Following Cézanne,
Weber tilted the tables up and arranged the
fruit in and around dishes and drapery in a
seemingly haphazard arrangement. The appar-
ent casualness of the scene belies the carefully
constructed composition. Weber subtly bal-
anced the smaller table on a slightly oblique

angle behind the larger one. Details are also
orchestrated for total harmony: the crumpled
white drapery on the right of the large table is
balanced by the exposed wood of the table on
the left, just as the large, circular orange vase
echoes the shape of the light blue plate with
bread.

In *Still Life with Two Tables* forms are con-
structed with contrasting shades of color,
heavy black outlines, and built-up paint. Al-
though Weber presents commonplace objects,
he creates a sensuous beauty out of the rich-
ness of his pigments, boldly stroked on the
canvas, and the delicacy of his palette. While
Weber was heavily indebted to Cézanne in the
compositions of his still lifes, he differed from
the French master in his use of color. In his
still lifes of the 1930s Weber turned more to
a grayed palette, which he referred to as
"mellow," to achieve a greater range of delicate
tones. He felt that with this coloring he could
achieve more control and serenity. Paintings
such as *Still Life with Two Tables,* with its cool
blues, grays, and browns, became studies of
hushed silence, reflecting the artist's controlled
interior world.

PROVENANCE
The artist, as of 1940 § With Paul Rosenberg &
Co., New York, as of 1945 to 1947 § Mr. and Mrs.
William Goetz, Los Angeles, 1947–62.

EXHIBITIONS
Pittsburgh, Carnegie Institute, *International Exhibi-
tion of Paintings,* 1934, no. 3 § Richmond, Virginia
Museum of Fine Arts, *First Biennial Exhibition of
Contemporary American Paintings,* 1938, no. 175,
repro., unpaginated § Art Institute of Chicago,
*Forty-Ninth Annual Exhibition of American Paintings
and Sculpture,* 1938, no. 233 § Art Institute of Chi-
cago, *Half a Century of American Art,* 1939–40,
no. 171, incorrectly dated 1937 § New York, Paul
Rosenberg & Co., *Exhibition of Still-Life Paintings,*
1945, no. 14, incorrectly dated 1940 § New York,
Whitney Museum of American Art, and others,
Max Weber: Retrospective Exhibition, 1949, no. 41,
dated c. 1934, repro., p. 29 § San Jose (Calif.)
Museum of Art, *American Series,* VII: *America
between the Wars,* 1976, no cat. traced § Jewish
Museum, *Weber,* no. 67.

LITERATURE
"Inauguration of the Virginia Biennial," *Art News* 36
(March 19, 1938): 17, recommended for purchase by
jury, repro. § Winthrop Sargeant, "Max Weber,"
Life 19 (August 20, 1945): repro., 86, dated to 1930 §
Private collection, Max Weber Papers, newspaper
clipping, "Still-Life Paintings Mark New Rosenberg
Showing," *World-Telegram* (New York), October 6,
1945 (Archiv. Am. Art microfilm roll NY 59-6, fr.
608), emphasizes Cézanne influence, repro., incor-
rectly dated 1940 § Manny Farber, "Weber
Answers Questions," *Art News* 48 (March 1949):
repro., 24 § Werner, *Weber,* pl. 102, p. 141 §
"Permanent Collection: American Art," *LACMA
Members' Calendar* 22 (August 1984): unpaginated.

Robert Philipp

Born February 2, 1895,
New York, New York
Died November 22, 1981,
New York, New York

During the years between the wars Robert Philipp was considered a prominent, conservative figure painter. In the 1910s he studied for six years at the Art Students League in New York with George Bridgman (1864–1943) and Frank V. DuMond (1865–1951) and at the National Academy of Design for another four years. After a brief career as a comedy singer during the early 1920s, Philipp returned to art. Although he had exhibited at the National Academy of Design since 1919, he did not begin receiving awards until the 1930s. His series of café scenes and nudes, which were compared with those of Pierre-Auguste Renoir (1841–1919) and Edgar Degas (1834–1917), brought him numerous awards. He also received a number of portrait commissions and in 1940 went to Hollywood as one of nine notable artists commissioned to paint works related to John Ford's production of *The Long Voyage Home.* Beginning in 1939, he taught at the Art Students League in New York for over fifteen years. He was also a founding member of the American Artists Group and a participant in Portraits, Inc.

BIBLIOGRAPHY
Archiv. Am. Art, Robert Philipp Papers § Harry Salpeter, "Robert Philip [*sic*]: Collector's Artist," *Esquire* 11 (January 1939): 59–61, 149 § "Art: Philipp, Noted for Nudes, Painter Goes to Hollywood to Portray Stars," *Life* 8 (April 8, 1940): 62–65 § "The Drawings of Robert Philipp," *American Artist* 8 (November 1944): 8–13, repro., cover § "Robert Philip [*sic*]: 2+4+4 = Ten Years of Drawing," *Art Students League News* 6 (April 1953): 5–6.

Philipp, *In a Pensive Mood.*

In a Pensive Mood, by 1935
(*Girl in Pensive Mood; In Pensive Mood*)
Oil on canvas
34³/₁₆ x 40¹/₈ in (87.0 x 101.9 cm)
Signed lower right: Philipp
Inscribed verso: Young Girl in Pensive Mood
Gift of Terry De Lapp in memory of Yrma Marcus
M.81.197

In a Pensive Mood is typical of Philipp's figure studies in theme and composition. Often he portrayed a thoughtful, attractive young woman seated at a table on which is arranged a still-life composition. During the 1930s he was much influenced by impressionism and

postimpressionism. The compressed sense of space and the placement of the figure off to the side, balanced by the bouquet of chrysanthemums and daisies, is reminiscent of the art of Degas, while Philipp's slightly textured, soft surface has been compared with that of Renoir. Placing the table on a diagonal was one of Philipp's favorite compositional devices.

This painting was singled out as one of the best in Philipp's second solo exhibition at the Grand Central Galleries in New York in 1935. His handling of color and glowing, sensuous flesh tones were highly praised. Philipp was elected an associate of the National Academy of Design as a result of his showing *In a Pensive Mood* at its 1935 annual.

PROVENANCE
Mrs. George F. Tyler, Philadelphia (?), 1935–as of 1938 § With Terry De Lapp, Los Angeles, to 1981.

EXHIBITIONS
New York, Grand Central Galleries, *Philipp*, 1935, no. 15, as *In Pensive Mood* § New York, National Academy of Design, *110th Annual Exhibition*, 1935, no. 194, as *In Pensive Mood* § Art Institute of Chicago, *Forty-sixth Annual Exhibition of American Paintings and Sculpture*, 1935, no. 161, repro., unpaginated § Venice, XXI *Esposizione biennale internazionale d'Arte, Catalogo*, 1938, no. 38 of United States exhibits.

LITERATURE
Margaret Breuning, "Robert Phillipp [*sic*] at Grand Central Galleries," *New York Post*, January 12, 1935, p. 26, repro. § Archiv. Am. Art, Robert Philipp Papers, newspaper clipping, Royal Cortissoz, "High Tide Again in the Art Galleries," *New York Herald Tribune*, January 13, 1935, (microfilm roll no. D295, fr. 1210), "singularly moving in [his] delicate manner of painting," repro. § *Art News* 33 (May 18, 1935): repro., 12, as *Girl in Pensive Mood* § James O'Donnell Bennett, "Five Thousand a Day Join

Fiery Dispute over Art Show," *Chicago Tribune,* November 3, 1935, pt. 1, p. 18, singled out of Art Institute of Chicago annual and commended for color and tranquil atmosphere, repro. § "Robert Philipp," *Art Students League News* 6 (April 1953): 5.

Joseph di Sigall

Born Poland
Immigration date unknown
Death date unknown

Very little is known about Joseph di Sigall. Born in Poland, he lived in South America before moving to Los Angeles in the 1920s. He was trained as a physician, and he worked as a portrait painter in California.

BIBLIOGRAPHY
Edan Milton Hughes, *Artists in California: 1786–1940* (San Francisco: Hughes Publishing, 1986), p. 426.

Sigall, *The Wanderer.*

The Wanderer, 1935
Oil on board
46½ x 30⅜ in (118.2 x 77.1 cm)
Signed and dated upper right: Sigall / 1935
Gift of Mr. Perry Steiner
M.87.40

This painting came to the museum with no title but has been called *The Wanderer* because of its subject matter. The image of the Wandering Jew in art dates back several centuries and took on many levels of meaning, often referring to a person on the fringes of or outside of society. Sigall, who may have been Jewish, might have intended this elderly man to allude to his own emigrations. However, the wanderer was quite an appropriate subject during the Great Depression, during which thousands of people were displaced, some of them forced to live as hobos. In this painting Sigall has presented in quite sympathetic terms an old man who stops to rest and contemplate his situation. A tear stands on his eyelid. Although the background does not seem to be the depiction of a specific locale, the remnants of the front page of a *Los Angeles Times* in the immediate foreground place the wanderer in the Southern California area.

The picture's somewhat piecemeal nature gives it a rather naïve quality, but Sigall's meticulously detailed rendering and application of paint in a tempera technique suggest that he was trained in traditional old master methods. Such realistic depiction accords with the revival of Renaissance art that was occurring in American painting at the time. Whether Sigall encountered such art through studies in Europe, South America, or the United States is not known.

PROVENANCE
Duncan McMartin, Beverly Hills, Calif., to 1947 § Mr. and Mrs. Perry Steiner, Beverly Hills, 1947–87.

Louis Bouché

Born March 18, 1896,
New York, New York
Died August 7, 1969,
Pittsfield, Massachusetts

The son of a French interior decorator, Louis George Bouché came naturally to art. As a young man he trained in Paris with Bernard Naudin (1876–1946) and at the Académie Colarossi and La Grande Chaumière. With the outbreak of World War I he and his mother returned to New York, where he studied for a year at the Art Students League. After serving in the navy, he became involved in modernist circles, sharing a studio with Alexander Brook (1898–1980) and obtaining Charles Daniels as his dealer. In 1915 Bouché began exhibiting at the Whitney Club and two years later showed at the first Salon of Independent Artists. His early cubist-inspired still lifes and interiors with figures are identified with his "Nottingham Lace Period," so named because of his propensity for

including cheap lace curtains in most scenes. This attempt at glorifying bad taste and the seamier side of life was done almost tongue-in-cheek and revealed Bouché's humorous, dadaesque view of the world around him. Bouché drastically changed his styles throughout his career, but he never lost his wit.

After visiting Europe in 1921, he returned to New York, where he became director of the Belmaison Gallery of Decorative Arts in Wanamaker's department store. While there he organized displays of both decorative art and contemporary French and American painting. About 1926 he gave up this position to begin working almost exclusively as a painter of murals in historical styles decorating private residences. He continued to paint murals throughout the 1930s, working at Radio City Music Hall and for the Pennsylvania Railroad Company, and he received two major commissions to decorate federal buildings in Washington, D.C. In 1936, with Allen Saalberg (born 1899) and Everett Henry (1893–1961) he formed a company to paint mural decorations.

In 1932 Bouché received a Guggenheim Fellowship, which enabled him to resume easel painting. He briefly came under the influence of Pablo Picasso (1881–1973) and Giorgio de Chirico (1888–1978). By the middle of the decade he had settled into his mature style, a realism in which scenes of everyday life are often painted from an unusual perspective and always with an appreciation of the paint medium. He taught at the Art Students League in New York, was a visiting professor in Cincinnati, Ohio, and Des Moines, Iowa, and in 1951 established his own art school with JOHN CARROLL in Chatham, New York. In 1953 he joined with REGINALD MARSH, Isabel Bishop (1902–1988), and other artists who wished to promote more "human" qualities in art rather than the then prevailing abstract expressionism in publishing several issues of *Reality*.

BIBLIOGRAPHY
Archiv. Am. Art, Louis Bouché Papers (portions on microfilm) § *Index 20th Cent. Artists* 3 (May 1936): 287–88; 3 (August–September 1936): I–II; reprint, pp. 585–86, 595–96 § Harry Salpeter, "Louis Bouché: Boulevardier of Art," *Esquire* 8 (November 1937): 70–71, 247–49 § "Louis Bouché," *Life* 11 (August 18, 1941): 48–50 § New York, Kraushaar Galleries, *Louis Bouché (1896–1969)*, exh. cat., 1989, with essay by Jane Bouché Strong, biographical note, lists of exhibitions and collections.

The Mural Assistant, 1937

(*Rest Period; Mural Assistant*)
Oil on canvas
40 1/16 x 27 1/16 in (101.8 x 68.8 cm)
Signed and dated right center: LOUIS BOUCHÉ / 1937
Gift of Mr. and Mrs. Billy Wilder
56.24

Bouché, Mural, 1937, oil on canvas, 140 x 286 in (355.6 x 492.8 cm). Formerly Auditorium, Department of Interior, Washington, D.C., now on deposit at National Museum of American Art, Smithsonian Institution, Washington, D.C.

In 1937 Bouché won the Treasury Section competition to paint a mural on the rear wall of the auditorium of the Department of the Interior Building in Washington, D.C. This commission was one of the most sought-after awards of the New Deal projects and was covered extensively by the press. Bouché created a three-part mural of the landscape of the Far West (see illustration). The figure in *The Mural Assistant* sits in front of the incomplete Interior Building mural. The figure's placement is somewhat ambiguous since the mural does not at first appear to be a painting. Although there are photographs in the Bouché papers of the artist sitting on a ladder in front of his mural, just as in the painting, the figure in *The Mural Assistant* is not the artist.

According to Bouché's daughter, she was supposed to pose for this painting but became dizzy and was replaced by her uncle, Milton Wright. Published accounts give a different version of the circumstances, however: Bouché, who was always ready to see the humor in ordinary scenes, thought his small brother-in-law seemed ludicrous sitting atop the ladder and so decided to paint him. Wright is situated before the center of the landscape where several deer are sketched in. The figures of the Native American and White Man overlooking the land in the extreme left of the mural are not included. Nor had Bouché yet drawn in the medallions with the symbols of the Department of the Interior in the border along the bottom of the mural. Its incomplete state gave Bouché the opportunity to paint the landscape background of the easel painting in broad, full strokes. One can see in their application the artist's love of the sensuous qualities of the medium, which brought life to Bouché's seemingly drab genre scenes. This is especially true in paintings such as *The Mural Assistant*, which has a palette limited primarily to quiet grays, beiges, and ochers.

Bouché, *The Mural Assistant.*

PROVENANCE
The artist, 1937–39 § With C. W. Kraushaar Art Galleries, New York, 1939 § Mrs. H. H. Warner, 1939 § With Frank Perls Gallery, Los Angeles § Mr. and Mrs. Billy Wilder, Los Angeles to 1956.

EXHIBITIONS
New York, C. W. Kraushaar Art Galleries, *Exhibition of Paintings by Louis Bouché*, 1938, no. 16, as *Mural Assistant* § San Francisco, *Golden Gate International Exposition, Department of Fine Arts, Contemporary Art, Official Catalogue*, 1939, no. 40, repro., p. 33 § Los Angeles, Ohrbach's Inc., [exhibition title unknown], 1956, no cat. traced § Art Center in La Jolla, Calif., *Twentieth Anniversary Loan Exhibition: American Paintings from Pacific Coast Museums*, 1961, no. 12, unpaginated § New York, Kraushaar Galleries, *Louis Bouché: A Memorial Exhibition*, 1970, no. 9 § Allentown (Pa.) Art Museum, *The Artist's Studio in American Painting, 1830–1980*, 1983–84, no. 32, repro., unpaginated.

LITERATURE
Emily Genauer, "Over-Abundance of Art Shows Is Problem for Critic," *New York World-Telegram*, April 9, 1938, p. 13, repro., as *Rest Period* § "Bouché's Incidents," *Art Digest* 12 (April 15, 1938): repro., 21, as *Mural Assistant* § Howard Devree, "Four Solos," *Magazine of Art* 31 (May 1938): 309, repro., 296 § Peyton Boswell, Jr., *Modern American Painting* (New York: Dodd, Mead, 1939), pp. 128, 205, repro., p. 181, as *Mural Assistant* § "Art: Director Treks Thirty Thousand Miles to Get Best U.S. Art for Golden Gate Fair," *Life* 6 (February 13, 1939): repro., 38 § Alexander Eliot, *Three Hundred Years of American Painting* (New York: Time, 1957), p. 210, discusses story behind the painting, repro., p. 209 § Archiv. Am. Art, interview with the artist by John Morse, August 7, 1959, transcript, pp. 6–7, the artist mentions sale of the painting § Mrs. Harold Strong (Jane Bouché Strong), telephone conversation with Ilene Susan Fort, June 19, 1985, discussed circumstances of choice of model.

Ben Messick

Born January 9, 1901,
Strafford, Missouri
Died December 31, 1981,
Apple Valley, California

Benjamin Newton Messick began his art career in Los Angeles after serving in the armed forces during World War I. He studied at Chouinard Art Institute with F. Tolles Chamberlin (1873–1961) from 1925 to 1932. Thereafter he supported himself as a designer for department stores, a mural painter for the Works Progress Administration and Treasury Section, and during the early 1940s as a sketch artist for the motion-picture industry, first at Disney Studios and then for Metro-Goldwyn-Mayer. Throughout his career Messick also supported himself by teaching, as an instructor of life drawing at Chouinard, 1943–51, and of drawing and painting at the San Diego School of Arts and Crafts in La Jolla and at the Los Angeles Athletic Club. In the 1950s he established with his wife, artist Velma Hay (born 1912), a teaching studio in Long Beach. In 1956 he was elected a fellow of the Royal Society of Art in England.

Messick became known nationally for his circus images, particularly his painting of Emmett Kelly, the noted Ringling Brothers' clown. Messick viewed the circus as a pleasurable escape from reality.

He was one of the few regionalists working in Los Angeles to infuse his art with social commentary. His early wartime experiences formed in him a compassion for his fellow

man, especially the unfortunate. His favorite subjects included bums, preachers, prostitutes, and performers, which were portrayed with sympathy and gentle humor. The art critic Alfred Frankenstein referred to Messick as a "modern Daumier."

BIBLIOGRAPHY
Archiv. Am. Art, Ben Messick Papers § Archiv. Am. Art, interview with the artist by Betty Hoag, 1965 § Janice Penney, "Ben Messick: An Artist Who Is in Love with Everybody," *American Artist* 14 (November 1950): 49–51, 69–70 § Moure with Smith 1975, p. 167, with bibliography § Janice Lovoos, "Ben Messick (1901–1981): A Regionalist Artist Rediscovered," *Antiques & Fine Art* 5 (March–April 1988): 55–60.

Messick, *Main Street Cafe Society.*

Messick, *Main Street Cafe Society,*
n.d., see Related Work.

Main Street Cafe Society, by 1938
Oil on canvas
30⅛ x 24³/₁₆ in (76.5 x 61.5 cm)
Signed lower right: Ben Messick
Inscribed verso across top: Main Street Cafe
Society / #5
Gift of Velma Hay-Messick
M.81.196

This is an early painting, probably of the late 1930s, which was exhibited in Messick's first solo exhibition. It demonstrates his social-realist tendencies in its depiction of ordinary people engaged in everyday activities of a life that is far from luxurious but is still respect-able. A man shares a newspaper with a faceless woman while an elderly gentleman hungrily slurps his soup in a sparsely furnished restaurant.

Main Street Cafe Society is painted in a palette of earth tones. Color was essential to Messick for conveying the mood of his scenes, and he usually selected a restricted color scheme for each painting. While the browns and beiges of this painting bespeak a poor and spare life, the overall pink cast of the palette suggests a positive, almost rosy attitude toward it. Messick also believed a good composition should move rhythmically, and in *Main Street Cafe Society* the viewer proceeds through the scene by means of fluid lines and alternating areas of light and dark. Messick was a master draftsman, and it is not surprising that his linear, expressive painting style was often compared with Thomas Hart Benton's fluid, linear style. Messick heard Benton lecture at the California Arts Club when he visited Los Angeles in 1937.

Messick usually produced a number of preliminary sketches for each work. A lithograph that differs in some details may have been based either on the museum's painting or on a study for it (see illustration). Messick usually worked from such sketches rather than painting from a model.

RELATED WORK
Main Street Cafe Society, n.d., lithograph on paper, 17³/₈ x 13³/₈ in (44.1 x 34.0 cm). LACMA, gift of Velma Hay-Messick.

PROVENANCE
The artist, c. 1938–81.

EXHIBITIONS
Los Angeles, Stendahl Art Galleries, *Ben Messick: Exhibition of Recent Paintings and Drawings,* 1938, no. 1 § Los Angeles, Chouinard Art Institute, *Ben Messick: Exhibition of Organic Art Forms,* 1941, no. 5 of oil paintings § Long Beach, Calif., Jergins Arcade, [Messick exhibition], 1946, no cat. traced § San Francisco, M. H. de Young Memorial Museum, *Exhibition of Paintings by Ben Messick,* 1947, no. 5 § La Jolla, Calif., San Diego School of Arts and Crafts, *Ben Messick: An Exhibition of Paintings,* 1948, no. 2, repro., cover § Sacramento, Calif., E. B. Crocker Art Gallery, *An Exhibition of the Work of Ben Messick,* 1950, no. 10 § Springfield, Illinois State Museum, and others, *Paintings by Ben Messick,* 1951–52, exhibited but not listed.

LITERATURE
Alma May Cook, "Definite Division in California Art Shown by Exhibit," *Los Angeles Evening Herald and Express,* September 24, 1938, pt. B, p. 7, in review of Stendahl Art Galleries show is considered a "good-natured satire without being sarcastic" § Archiv. Am. Art, Ben Messick Papers, Scrapbook, unidentified newspaper clipping, "Ben Messick Paintings at Art Center Friday" (microfilm roll no. 1, fr. 32); unidentified newspaper clipping, "Mes- sick Has One-Man Show in Arcade" (ibid., fr. 73), includes photo of Messick surrounded by exhibited works, including *Main Street Cafe Society* § Arthur Millier, "Messick's Friendly Eye Looks at Local Scene," *Los Angeles Times,* September 25, 1938, pt. 3, p. 7, considers it "tops for pictorial clarity" § "News and Comment on Art: M. H. De Young Memorial Museum," *Architect and Engineer* 168 (February 1947): 9.

Paul Lauritz

Born April 18, 1889,
Larvik, Norway
To United States 1912
Died October 31, 1976,
Glendale, California

Paul Lauritz was a noted Southern California painter of the desert. Born in the pictur- esque resort town of Larvik, Norway, which was often visited by artists, he received his first instruction in art at an early age from such visiting artists and studied at the Larvik art school for three years. He may have had some contact with the noted landscape painter Fritz Thaulow (1847–1906) and the figure painter Christian Krogh (1852–1925). At age sixteen Lauritz immigrated to eastern Canada, where he worked in the quarries. He went west and first in Vancouver, British Columbia, and then in Portland, Oregon, did some commercial art work and began to paint. Attracted to Alaska by the gold rush of 1915, he painted there and met Sidney Lawrence (1865–1940). In late 1919 Lauritz set- tled in Los Angeles, taking up painting as his sole occupation. He quickly established himself as a landscape painter, winning numerous prizes through the years, and became active in various art associations, particularly the California Art Club and Los Angeles Municipal Art Commission. Lauritz taught privately and at Chouinard Art Institute in 1928 and Otis Art Institute (Los Angeles County Art Institute). He traveled throughout the Southwest in search of motifs and in 1925 returned to Norway for a visit. In the early 1930s he developed his own brand of paints, selling them under the name of *Perma.* His art changed little after this time. Lauritz actively continued exhibiting through the 1950s, winning awards in group shows in California and other parts of the West. In 1957 he visited Norway as well as France and England.

BIBLIOGRAPHY
Arthur Millier, "Our Artists in Person, no. 30: Paul Lauritz," *Los Angeles Times,* July 5, 1931, pt. 3, pp. 12, 15 § Ed Ainsworth, "Paul Lauritz: The Man Who Paints the Desert's Spirit," *Palm Springs (Calif.) Villager* (May 1957) § *Paul Lauritz* (N.p., n.d.), with remarks by Herman Reuter, Alma May Cook, M. J. Karpf, and Ed Ainsworth, reprints Alma May Cook article from *Los Angeles Evening Herald and Express,* September 1957, with lists of awards (to 1960) and collections § Moure with Smith 1975, pp. 146–47, with bibliography § Westphal 1982, pp. 74–77, with list of awards and public collections.

Lauritz, *Desert Landscape (Mojave Desert).*

Desert Landscape (Mojave Desert), 1930s?
Oil on canvas
40¹/₁₆ x 46 in (101.7 x 116.8 cm)
Signed lower left: PAUL LAURITZ
Inscribed on stretcher bar lower center: Mojave Desert
Gift of Mr. and Mrs. William A. Mallet
M.85.231.1

Lauritz painted a wide variety of landscape themes, including dramatic Alaskan snow scenes and coastal views but received the most acclaim for his paintings of the desert. He made

his first trip to the desert in 1920 and often camped near Palm Springs and the Salton Sea. In his characteristic desert paintings Lauritz sought to capture the effect of bright light. These fairly tonal paintings convey a certain stillness and peace. In *Desert Landscape* he contrasts the quiet of the desert with the drama of a mountain storm. As do all his paintings, *Desert Landscape* displays the simple and broad technique Lauritz achieved using exceptionally large brushes.

This painting and a canvas of identical size depicting the Pico House, n.d. (LACMNH), hung for years in the Mayflower Hotel in downtown Los Angeles. The hotel, which opened in 1927, was designed by Charles Whittlesey in the rococo Spanish Colonial revival style popular in the 1920s.

PROVENANCE
Mayflower Hotel, Los Angeles § Mr. William A. Mallett, Studio City, Calif., to 1985.

Gladys Nelson Smith

Born August 15, 1890,
near Chelsea, Kansas
Died September 15, 1980,
Washington, D.C.

Gladys Nelson Smith was an active figure painter and landscapist in Washington, D.C., from 1925 to 1941. She was graduated from the University of Kansas, where she trained as an art teacher with William V. Cahill (d. 1924) and other artists known for their impressionist landscape paintings. She enrolled for a short time at the Art Students League in New York in 1918 but returned with her husband to Kansas the following year. In 1923 they moved to Chicago, where she attended the School of the Art Institute of Chicago in 1924 and studied with LEOPOLD SEYFFERT and Karl Albert Buehr (1866–1952). She was successful in selling her paintings in both Kansas and Chicago and in 1921 began a more than twenty-year association with the What-Not Shop, an art gallery in Topeka, Kansas.

Early in 1924 the Smiths moved to Washington, D.C. Gladys studied portraiture for several years at the Corcoran School of Art. Among her teachers there were EDMUND TARBELL, Richard Meryman (1882–1963), and Samuel Burtis Baker (1882–1967). In December 1930 Smith brought her studies to a close with a trip to Europe to visit museums and galleries. In 1932 she joined the Society of Washington Artists and thereafter became active in several other local groups, among them the Art League of Washington, the Arts Club, and Twenty Women Painters.

The decade of the 1930s was Smith's most productive and successful period. She received numerous portrait commissions and became well known for her images of children. She also painted still lifes, city genre scenes, and landscapes. The last led the Smiths to purchase a farm in Frederick County, Maryland, and five years later they moved to Chevy Chase. Although she continued to paint until the 1970s, the artist's removal from Washington as well as the increasing popularity of the modernist Washington color school resulted in her feeling isolated, and she consequently withdrew from professional circles.

BIBLIOGRAPHY
Silver Spring, Md., Josephine Nelson Collection, European travel diary of Gladys Nelson Smith § Washington, D.C., Corcoran Gallery of Art, *Gladys Nelson Smith*, exh. cat., 1984, with essays by Linda Crocker Simmons and Josephine Nelson, chronology, list of exhibitions.

The Tippler, late 1930s–early 1940s
Oil on canvas
30¼ x 34¼ in (76.5 x 87.0 cm)
Signed lower right: Gladys Nelson Smith
Gift of Josephine Nelson
M.87.67

In *The Tippler* Smith combined the types of painting with which she was most identified—figure, landscape, and even still life—to create a pleasant genre scene of a working-class man enjoying a drink. During the late 1930s the artist painted several images of elderly people, endowing each figure with a sense of dignity

Smith, *The Tippler.*

and strength. Both *The Tippler* and *Time Out,* of about the same date (private collection), are half-length figures of robust workmen.

While always retaining an impressionist concern for color, Smith painted her mature figure paintings in a darker and richer palette. The silvery gray and purply browns of *The Tippler* and *Time Out* enhance the evocation of age and manual labor. Equally rich was Smith's bravura handling: she built up the form of the man with long, strong strokes of a full brush in the tradition of earlier artists such as WILLIAM M. CHASE and her teacher Tarbell. The unfinished state of the wintry landscape hanging on the back wall to the left further demonstrates the vigor of her handling.

PROVENANCE
The artist, to 1980 § Josephine Nelson (by descent), Silver Spring, Md., 1980–87.

EXHIBITIONS
Washington, D.C., Veerhoff Galleries, *Thirty-four Paintings by Gladys Nelson Smith,* 1979, no cat. § Corcoran Gallery of Art, *Gladys Nelson Smith,* 1984–85, no. 41, repros., pp. 6, 45.

Bendor Mark

Born June 5, 1912,
New York, New York
Lives in La Jolla, California

Trained as a figure painter, Bendor Mark has devoted most of his art to political statements. Born Bernard Marcus and raised in Brooklyn, he studied art with William Brantley Van Ingen (b. 1858) at the Cooper Union in the late 1920s. During the early 1930s he supported himself as a textile designer. He became an activist, joining the Artists Union formed in 1934 to strengthen the artist's position as a worker, and participated in the Federal Art Project. Mark's work reflected political issues and became associated with the social realists' in criticizing national ills and international problems. In 1937 he painted a series condemning the exploitation of mine workers and exhibited one of the scenes at the 1939 New York World's Fair. Around 1939 he began to propose mural projects heavily influenced ideologically and stylistically by the Mexican muralists; none of these, however, was ever realized. It was about this time that he assumed the name Bendor Mark to distinguish his politically inspired work from his early art. He became active in Queens, teaching adult art classes and supporting the Flushing Art Center. During World War II he prepared classified drawings for army contractors and when the fighting ended continued to work as a graphic artist. From 1945 until his move to Southern California in 1948 he worked in the printing industry. In 1949 he resumed painting, and his art thereafter was as politically oriented as before. After moving to California he resided first in Los Angeles but eventually settled in La Jolla. Around 1955 his work began to be rejected from exhibitions, and he consequently withdrew from the public eye. Thereafter his political paintings became increasingly satirical.

BIBLIOGRAPHY
Archiv. Am. Art, Bendor Mark Papers (not on microfilm) § *Who's Who in American Art,* 1947, 1953, 1972, 1984, s.v. "Mark, Bendor."

Execution, 1940
Oil on canvas
20⅛ x 24³/₁₆ in (51.1 x 61.4 cm)
Signed lower right: Bendor Mark
Signed and dated verso across top: Bendor Mark / 40
Given anonymously
M.80.194.1

Mark created several paintings expressing his horror and anger over the atrocities inflicted by the Japanese on the Chinese when they invaded the mainland in 1937. The artist read newspaper accounts of the war, and *Execution* may have been directly inspired by newspaper photographs or motion-picture newsreels. *Bound Man,* 1939 (National Museum of Ameri-

Mark, *Execution.*

murder by his forceful brushstrokes, inspired by the surfaces and thick muscular style of Mexican muralists such as David Alfaro Siqueiros (1896–1974). In *Execution* the entire image points to the unseen murderer. What appears to be several bodies is actually only one man, who, in the agony of excruciating pain and death, gyrates from side to side until he collapses to the ground. The man's constricted, bound body has been compressed into the shape of a sack. Human life had become worthless; as if to suggest that the victim has lost his humanity, Mark portrayed him faceless, devoid of any individuality. Such treatment also suggests that Mark intended this image to have universal application, a pictorial condemnation of all inhuman barbarism.

PROVENANCE
The artist, 1940–80.

LITERATURE
Archiv. Am. Art, Bendor Mark Papers, typescript by the artist, n.d., discusses painting § LACMA, Twentieth Century Art department files, the artist to Maurice Tuchman, November 21, 1980, the painting was produced at "what may be considered the end of his early period" and he considers it to be an example of social realism § LACMA, American Art department files, the artist to Ilene Susan Fort, December 23, 1985, explains meaning of painting.

can Art, Smithsonian Institution, Washington, D.C.), and *Execution* are concerned with the brutal killing of defenseless victims and reveal Mark's spiritual debt to Francisco Goya (1746–1828). Mark conveyed the brutality of

Fletcher Martin

Born April 29, 1904,
Palisade, Colorado
Died May 30, 1979,
Guanajuato, Mexico

Fletcher Martin's evocative and powerful painting of contemporary life during the 1930s and 1940s later gave way to more abstract and decorative works. He was the son of a newspaper editor. In 1910 he moved with his family to Idaho and during World War I spent time in Washington State. He worked at a range of jobs before a tour of duty in the navy from 1922 to 1926. Beginning in 1927 he worked for a printer in Los Angeles, also teaching himself what he could about art through associations with artists, including David Alfaro Siqueiros (1896–1974). In 1931 he began painting in oil, and the following year he assisted Siqueiros with a mural for the estate of movie director Dudley Murphy. Martin was active in the Los Angeles chapter of the socially concerned American Artists Congress, serving as president in 1939. In 1932 Martin had his first solo exhibition of prints at the Dalzell Hatfield Galleries in Los Angeles; he spent that summer in Woodstock, New York, and New York City, meeting many artists. He attracted attention in solo and group painting exhibitions in Southern California, having his first museum exhibition at the San Diego Fine Arts Gallery in 1934 and one the following year at the Los Angeles Museum. From 1936 to 1945 he executed mural commissions for the Works Progress Administration and the Treasury Section. In 1938 he began his teaching career. That year *Trouble in Frisco* became the first of Martin's paintings to be purchased by a museum (Museum of Modern Art, New York), and in 1940 he had his first exhibition in New York, at the Midtown Gallery. The same year he succeeded Grant Wood (1892–1942) as artist-in-residence at the State University of Iowa, Iowa City, and in 1941 succeeded THOMAS HART BENTON as head of the Department of Painting at Kansas City Art Institute, where he remained until 1943. In 1942 he was one of eighteen artists represented in the Museum of Modern Art's landmark exhibition *Americans 1942: Eighteen Artists from Nine States.* After wide-ranging service as a war correspondent, he settled in New York City in 1945 and then in Woodstock, although he traveled widely as a teacher and illustrator.

BIBLIOGRAPHY
Peyton Boswell, Jr., "Fletcher Martin: Painter of Memories," *Parnassus* 12 (October 1940): 6–13 § New York, Museum of Modern Art, *Americans 1942: Eighteen Artists from Nine States,* exh. cat., 1942, ed. Dorothy Miller, pp. 97–98, statement by the artist, biographical note § Barbara Ebersole, *Fletcher Martin,* with foreword by William Saroyan (Gainesville: University of Florida Press, 1954) § Binghamton, N.Y., Roberson Center for the Arts and Sciences, *Fletcher Martin: A Thirty-Year Retrospective,* exh. cat., 1968, with essays by Keith Martin, Peter Pollack, and the artist, chronology § H. Lester Cooke, Jr., *Fletcher Martin* (New York: Harry N. Abrams, 1977), with chronology, bibliography.

Martin, *Air Raid.*

Air Raid, 1940
Oil on canvas
26¹/₁₆ x 34¹/₁₆ in (66.2 x 86.4 cm)
Signed and dated lower right: fletcher martin / 1940
Gift of Southern California artists in memory of
Antony Anderson
40.9

The international conflicts of the era were reflected in some of the paintings produced in Los Angeles around 1940. Pablo Picasso's *Guernica,* 1936 (The Prado, Madrid), was exhibited briefly in Los Angeles during 1939, when Hans Burkhardt (born 1904) was at work on a painting protesting the events of the Spanish Civil War. Martin later reacted strongly to his experiences in the Second World War and won acclaim for his powerful illustrations. Nevertheless, *Air Raid* need not be seen as referring to a specific battle or campaign of the 1930s. Since so many of his paintings of that decade present images of violent movement or struggle, *Air Raid* should be considered an expression of the artist's broader outlook, tinged by an awareness of the global situation. As a "painter of memory," Martin would have had many experiences in the navy and as a boxer that would have evoked feelings

of fright and unseen menace such as expressed in *Air Raid.*

Although he was identified with regionalist or American-scene painters, Martin differs from most regionalists in the degree to which he selected and presented his figures from everyday life so that they became emblematic of basic situations and emotions. *Air Raid* and Martin's *The Fugitive,* 1930s (formerly Midtown Galleries, New York), call to mind *Flight and Pursuit,* 1872 (Museum of Fine Arts, Boston), by William Rimmer (1816–1879) in the way that each presents symbolically a state of mind or feeling of anxiety, although the expressionist distortions of Martin's paintings are unlike the academic precision of Rimmer's. The common subject matter of Martin's paintings also differs from the exotic setting of Rimmer's but it is not sufficient to make Martin's a realistic style. Although his subjects are derived from his experiences, Martin abstracted from them a broader significance, describing them in an ideal rather than specific manner. In some cases figures are developed to represent a social type, in others to represent an emotional state. *Exit in Color,* 1939 (Abbott Laboratories Art Collection, Chicago), and *Home from the Sea,* 1939 (University of Iowa Museum of Art, Iowa City), like *Air Raid,* rely on soft forms, empty space, and the impact of strong contrasts and vigorous diagonals to generate a feeling of dreamlike symbolism akin to magic realism.

Air Raid was donated to the museum by sixty Southern California artists in memory of Antony Anderson (1863–1939). Trained as an artist in New York and Chicago, Anderson moved in 1903 to Los Angeles, where he turned to writing. He edited a quarterly review published by the Stendahl Art Galleries and wrote several monographs on Southern California artists that remain important sources on them. He was best known as the art critic for the *Los Angeles Times,* a position he held for over twenty years, ending in 1926. In 1938 a group of local artists donated works of theirs for a sale to raise money for Anderson, who was then ailing. After his death they decided to purchase for the museum a work by one of their number as a tribute to him.

PROVENANCE
With Midtown Galleries, New York, 1940.

ON DEPOSIT
Los Angeles County Superior Court, 1959–75.

EXHIBITIONS
New York, Midtown Galleries, *Fletcher Martin: Exhibition of Paintings*, 1940, no. 14 § San Francisco, California Palace of the Legion of Honor, *Exhibition of Oils, Watercolors, and Drawings by Fletcher Martin*, 1944, cat. published as *Bulletin of the California Palace of the Legion of Honor* 2 (August 1944), pp. 35–37.

LITERATURE
"Former Art Critic of 'Times,' Honored with Martin Painting," *Los Angeles Times*, September 15, 1940, pt. 2, p. 2, relates story of purchase, repro. § Ted Cook, "Fletcher Martin," *California Arts and Architecture* 57 (September 1940): repro., 17 § "Sixty Artists Honor Critic—And Sensibly!" *Art Digest* 15 (October 15, 1940): 7, repro. § "Recent Acquisitions, Art Division," *LA Museum Quarterly* 1 (January 1941): 24, lists § Arthur Millier, "Selection of Art Gifts Being Shown at Museum," *Los Angeles Times*, June 7, 1942, pt. 3, p. 5 § Helen Foss, "Monograph on Fletcher Martin," Master's thesis, State University of Iowa, 1943, pl. 27, p. 79 § Cooke, *Martin*, p. 26, pl. 35, p. 65.

Emil Kosa, Jr.

Born November 28, 1903,
Paris, France
To United States 1907
Died November 4, 1968,
Los Angeles, California

A notable Southern California landscape painter, Emil Jean Kosa, Jr., was also one of the region's most respected watercolorists, achieving national prominence in the 1940s. As a youth he went to Czechoslovakia, his father's homeland, to study in Prague at the Academy of Fine Arts and Karlova University; he was graduated from the latter in 1921. He then settled in Los Angeles, where he studied at the Clay School of Art (later known as the California Art Institute) in 1922 and began a career as an easel painter and muralist. He returned briefly to Europe in 1927 to study at the Ecole des Beaux-Arts in Paris with Pierre Laurens (1875–1932). In 1928 he returned permanently to Los Angeles. First he supported himself working for decorators, and then in 1933 he began a thirty-five year association with Twentieth Century Fox as a set painter and special-effects artist, winning an Oscar in 1964 for his work in *Cleopatra*.

Kosa's first solo exhibition was organized in 1939 at the Oakland Museum, and in 1940 he showed at the Macbeth Gallery in New York; throughout his life he would be accorded many solo exhibitions. In 1945 he was elected president of the California Water Color Society and in 1948 director of Southern California Artists Equity. Unlike most Southern California artists he taught only infrequently, for a year after World War II at Chouinard Art Institute and in 1962 at the Laguna Art School. He was one of the few California artists to become a member of the National Academy of Design.

Kosa was known primarily for his panoramic landscapes, although he also painted portraits and figure paintings of nudes, clowns, and dancers. By the late 1930s he had developed a bold watercolor style that helped bring California art to national prominence. His watercolors were noted for their strong brushwork and clear light, and his oils were admired for their golden tonalities. In 1943 the critic Arthur Millier praised Kosa for bringing a new power to California landscape painting. In 1957 he first exhibited his abstract paintings, which were inspired by an interest in astronomy.

BIBLIOGRAPHY
Arthur Millier, "Kosa Sings California," *Los Angeles Times*, February 7, 1943, pt. 3, p. 5 § Emil Kosa, "Sketching on the California Coast," *American Artist* 14 (March 1950): 39–43 § Moure 1975, pp. 17–18, 52–53, with bibliography § Moure with Smith 1975, pp. 141–42, with bibliography § Gordon T. McClelland and Jay T. Last, *The California Style: California Watercolor Artists, 1925–1955* (Beverly Hills, Calif.: Hillcrest Press, 1985), pp. 100–1.

Seated Nude, c. 1941–47
Oil on canvas
40⅛ x 30⅛ in (101.9 x 76.5 cm)
Signed lower right: E Kosa Jr (E backwards)
Gift of Merle Oberon
M.54.41.4

Although known primarily as a landscape painter, Kosa was also interested in the human figure. When in the early 1940s his wife became ill and he stayed home to nurse her, he turned to studio subjects such as the nude. By the 1940s the battle over the morality of the nude in art had been won in Los Angeles as visiting artists from the East who came to teach in Southern California, such as HENRY LEE MCFEE and Alexander Brook (1898–1980), exhibited their nudes.

Kosa painted nudes in a more academic manner than he did landscapes. *Seated Nude* is painted fairly thinly, the figure tightly drawn and fully modeled in delicate transitional shades from light to dark. Kosa presented the partially clothed woman in a traditional manner, with a lavender-tinted fabric draping her thighs and curtains framing her as she sits on a

green upholstered stool, with only the handbag on the floor dating the image to the 1940s. The woman's midriff and legs are delicately highlighted, her head and shoulders cast in shadow, and her gaze is directed away from the viewer. In the winter of 1941 Kosa exhibited a variation of this painting, *A Study* (unlocated, reproduced in *Art Digest* 16 [March 1, 1942]: 12), in which the model is seen more from the side, with her head completely in shadow. In the museum's painting Kosa glorified the woman by carefully painting her soft, pearly skin. He rendered the background objects with an equal sensitivity to texture. *Seated Nude* is somewhat startling in its frank sensuality. *Seated Nude* and *A Study* number among Kosa's few paintings of the nude; his other renderings seem to have been only partial figures.

PROVENANCE
With Cowie Galleries, Los Angeles, to 1947 §
Merle Oberon, Beverly Hills, Calif., 1947–54.

ON DEPOSIT
Merle Oberon, Beverly Hills, 1955–70.

LITERATURE
Richard F. Brown, "Recent Gifts of Paintings," *LA Museum Art Div. Bull.* 7 (Spring 1955): 13–14, compares with Henry McFee's *Sleeping Black Girl,* c. 1933–34 (LACMA; q.v.), "[Kosa's *Seated Nude*] relies more upon fluent and confident drawing. His composition is freer, looser, and less intellectual, but nonetheless perfectly suited to enhance the human warmth of his approach to the subject. . . . Each of these pictures is one of the top masterpieces of its respective author," fig. 10, 13 § LACMA 1980, p. 68, compares with McFee's *Sleeping Black Girl* and discusses subject matter, fig. 39.

Kosa, *Seated Nude.*

Frank C. Kirk

Born May 11, 1889,
Zhitomir, Russia
To United States 1910
Died October 30, 1963,
New York, New York

Frank Cohen Kirk was a representational artist active during the period between the two world wars. After his exile from Russia in 1906 because of his political activities, Kirk wandered through Europe for four years. From 1910 to 1929 he lived in Philadelphia, where he participated in the Graphic Sketch Club and attended the Industrial Arts School and the Pennsylvania Academy of the Fine Arts, studying there with HUGH H. BRECKENRIDGE, Daniel Garber (1880–1958), and PHILIP L. HALE. He traveled on scholarship to Europe in 1925 to study paintings by Ignacio Zuloaga (1870–1945) and the work of the old masters. He returned to Philadelphia and later established his studio in New York.

Kirk was instrumental in organizing exhibitions of works by Jewish artists on a local and then international level. In the late 1920s he painted murals for theaters. His frequent travels throughout the United States, Europe, Russia, and the Holy Land provided him with diverse subjects for his art. In 1927 he visited the coal-mining area of Pennsylvania and produced powerfully moving paintings of miners. He became best known for his figure paintings dignifying laborers and the common man. He also often exhibited still lifes, floral arrangements, and landscapes. Kirk showed extensively throughout New England and the Mid-Atlantic seaboard and was a member of numerous associations, such as the Brooklyn Society of Artists, the Copley Society, Grand Central Art Galleries, the National Academy of Design, the Philadelphia Art Alliance, and the Society of Independent Artists. His art was conservative, never diverging far from his academic training.

BIBLIOGRAPHY
Boston Art Club, *Exhibition of Paintings by Frank C. Kirk*, exh. cat., 1934, with introduction by A. J. Philpott and excerpts from newspapers § *Who's Who in American Art*, 1940–41, s.v. "Kirk, Frank C." § Z. Weinper, *Frank C. Kirk: His Life and Work* (New York: Ykuf, 1956), with introduction by A. J. Philpott (reprinted from 1934 cat.), in English and Yiddish § Obituary, *New York Times*, October 31, 1963, p. 39.

Kirk, *Rhapsody*.

Rhapsody, c. early 1940s
(*Tropical Leaves*)
Oil on canvas
34³/₁₆ x 34¹/₈ in (86.8 x 86.6 cm)
Signed lower left: FRANK C. KIRK
Inscribed verso, upper right: FCK (monogram)
Gift of Mr. and Mrs. Duncan MacPherson
M.81.198

Although his figure paintings often focused on the common laborer, Kirk's still lifes presented a more refined world, usually depicting works of art, oriental porcelains, and textiles arranged around large floral bouquets. In *Rhapsody* the artist included a print, a covered lacquer dish, a book, and a large arrangement of dried flowers and leaves in a gleaming copper pitcher.

The highly varied palette of deep hues contributes to the painting's rich elegance. Kirk's tabletop arrangements were in the tradition of the work of Paul Cézanne (1839–1906) but took on a rigidly standardized format. He repeatedly used the same objects, viewed them from an elevated viewpoint, and only slightly varied their positions within a triangular arrangement before a wall. For example, the same arrangement and bouquet in *Rhapsody* are found in *Tropical Leaves*, n.d. (unlocated, reproduced in Weinper, *Kirk*, p. 59). It is primarily his use of texture and color that distinguishes one still-life painting from another.

According to labels on the back of the canvas and stretchers, the painting was widely exhibited under the titles *Rhapsody* and *Tropical Leaves*, but attempts to verify these exhibitions have been futile or resulted in contradictory information.

PROVENANCE
Mollie E. Traibusch, New York § Mr. and Mrs. Duncan MacPherson (by descent), El Segundo, Calif., to 1981.

EXHIBITIONS
Probably Copley Society of Boston, *Members Exhibition*, date unknown § Probably New York, National Arts Club, *Exhibition of Paintings by Nonmembers*, date unknown, as *Tropical Leaves* § Probably Springville (Utah) High School Art Association, *National April Salon*, date unknown § Probably Washington, D.C., Society of Washington Artists, [exhibition title unknown], 1946, no cat. traced.

Robert Gwathmey

Born January 24, 1903,
Richmond, Virginia
Died September 24, 1988,
Southampton, New York

Robert Gwathmey was known for his paintings of southern blacks. He studied at the Maryland Institute of Design in Baltimore for a year in 1925 and then for four years in Philadelphia at the Pennsylvania Academy of the Fine Arts with Franklin Watkins (1894–1972), winning two Cresson European Traveling Scholarships there. In the 1930s he taught art in Pennsylvania at Beaver College, Glenside, and the Carnegie Institute of Technology, Pittsburgh. His work of that decade was still immature, largely studio pictures reflecting the influence of Watkins. Gwathmey later destroyed most of these works. In 1942 he began teaching in New York City at the Cooper Union.

It was in the mid-1930s that his mature themes first emerged with *The Hitchhiker*, c. 1936 (Brooklyn Museum). During summer visits home in the early 1940s Gwathmey became aware of the plight of the southern black, and he began to portray them. Although Gwathmey did not overlook the harsh realities of their rural life, he always presented them with dignity. Despite this basis in social commentary, Gwathmey developed a somewhat decorative, abstracted style influenced by Pablo Picasso (1881–1973), Henri Matisse (1869–1954), MARSDEN HARTLEY, José Orozco (1883–1949), and African art. In the early 1940s he painted his images in bright, matte, and often sweet colors, outlined in black and simplified into multifaceted forms by cubist fracturing, with an overall, flat, patterning effect. According to the artist the images are simplified so that their con-

tent can be clearly understood. While his paintings appear naïve, they are actually quite sophisticated. Varying his style little after the 1940s—his later paintings have more the appearance of drawings and stained-glass windows—Gwathmey did expand his themes to include urban life, the aged, and flowers. Gwathmey also worked in the serigraph medium.

BIBLIOGRAPHY
Harry Salpeter, "Gwathmey's Editorial Art," *Esquire* 21 (June 1944): 82–83, 131–32 § New York, A.C.A. Gallery, *Robert Gwathmey*, exh. cat., 1946, with essay by Paul Robeson § Elizabeth McCausland, "Robert Gwathmey," *Magazine of Art* 39 (April 1946): 148–52, with interview with the artist § Saint Mary's City, Md., Saint Mary's College of Maryland, and New York, Terry Dintenfass, Inc., *Robert Gwathmey*, exh. cat., 1976, with introduction by Jonathan Ingersoll, chronology, list of exhibitions § Judd Tully, "Robert Gwathmey," *American Artist* 49 (June 1985): 46–50, 88, 90–92.

Tobacco, 1946

Oil on canvas
44⅛ x 35⅛ in (112.1 x 89.2 cm)
Signed lower left: Gwathmey
Mira Hershey Memorial Collection
47.9.3

Sharecroppers were the subject of the majority of works exhibited in Gwathmey's solo exhibition in 1946 at the A.C.A. Gallery, New York. The tobacco industry was a major source of employment for blacks in the South, and Gwathmey knew the industry firsthand, for he won a Rosenwald Fellowship, which permitted him to live and work on a tobacco farm in 1944 and 1945. He usually singled out a particular aspect of farming, but in *Tobacco* he incorporated into one scene the different stages of tobacco processing. The painting is meant to be read clockwise, beginning in the lower left with the stooping man picking leaves off the stalk of a tobacco plant. The leaves are then tied together into bundles, as the women behind him are doing, and hung in heated tobacco barns for curing. This process is dramatically alluded to by the barn burning in the distance, which has been ignited by the fire used to heat it. After curing, the leaves are sorted by color. This process, known as grading, usually takes place indoors; Gwathmey showed the barn in the lower-right corner with the wall removed so that the women who are grading tobacco can be seen.

Despite the number of activities depicted, Gwathmey created a tightly knit composition. Although seemingly haphazard in arrangement, the scene is organized around several large buildings with pitched roofs and a triangular-shaped tobacco patch, which acts as a counterpoint to the roofs. The palette is intense, almost unreal: the foreground field is somber purple, the mid-distance rose, and the far distance forest green; the sky is a strong blue punctuated by the neon orange of the flames. The figures repeat the major color chords of the fields with greater variation.

PROVENANCE
The artist § With A.C.A. Gallery, New York, 1947.

EXHIBITION
Long Beach (Calif.) Municipal Art Center, *Contemporary American Painting,* 1952, no cat. traced.

LITERATURE
Arthur Millier, "Enriched by Hearst," *Art Digest* 21 (March 15, 1947): 20 § LACMA, American Art department files, the artist to Ilene Susan Fort, April 3, 1986, dates painting.

Gwathmey, *Tobacco.*

Grigory Gluckmann

Born October 25, 1898,
Vitebsk Province, Russia
To United States 1941
Died July 25, 1973, Los
Angeles, California

Grigory Gluckmann's studio subjects and scenes from modern life were distinguished by their rich color and sensuous technique. In 1917 he entered the Art Academy at Moscow. From 1920 to 1923 he worked as an illustrator in Berlin. In January 1924 he spent nine months in Italy, working in a studio in Florence. His encounter with the Italian old masters was to be an important influence on his art. In October he moved to Paris, where he had an exhibition at Galerie Druet; his second exhibition, at Galerie Charpentier in 1934, established his success. He had other shows in Paris and London and in 1937 for the first time in New York, where he moved in June 1941. Gluckmann came to Los Angeles for his first exhibition at Dalzell Hatfield Galleries in December 1941. He had a second exhibition there in 1944, and he moved his residence to Los Angeles in 1945. He had regular, very successful exhibitions at Dalzell Hatfield Galleries while also exhibiting at galleries in New York, which he frequently visited. He had a show at the Santa Barbara (Calif.) Museum of Art in 1946, the Charles and Emma Frye Museum in Seattle in 1956, and the Palm Springs (Calif.) Desert Museum in 1972.

BIBLIOGRAPHY
Ernest W. Watson, "Grigory Gluckmann: Contemporary 'Old Master,'" *American Artist* 12 (March 1948): 20–25 § Rose Henderson, "Grigory Gluckmann," *Studio* 138 (December 1949): 86–87 § Arthur Millier, *Grigory Gluckmann* (Los Angeles: Dalzell Hatfield Galleries, 1956), with lists of collections, awards, exhibitions, and publications § Palm Springs (Calif.) Desert Museum, *Grigory Gluckmann: Contemporary Classicist,* exh. cat., 1972, with essay by Ruth Dalzell Hatfield.

Gluckmann, *The Confidantes.*

The Confidantes, by 1947
(Confidences)
Oil on wood panel
23⅝ x 28¹¹/₁₆ in (60 x 72.8 cm)
Signed lower left: GLUCKMANN.
Gift of Mrs. June Braun Pike in memory
of her father
56.23

Although he also painted imaginative landscapes and somewhat satirical scenes of the city and society, Gluckmann's perennial subject was women, portrayed either singly or silently seated together, as though dreamily absorbed in their interior life. *The Confidantes* shows the artist's feeling for the large design and opulent forms. Critics have always marveled at his technique and sensuous paint surfaces, which seem almost Venetian. However, Gluckmann's mature images of women are modern in spirit. The confidantes are unmistakably working-class women, as shown by their clothes and slick, red-polished fingernails and lipstick. Consequently, despite his old master painting style, Gluckmann, in subject matter, paralleled East Coast realist artists.

PROVENANCE
June Braun Pike, Los Angeles, to 1956.

ON DEPOSIT
June Braun Pike, Los Angeles, 1961–67.

EXHIBITIONS
Pittsburgh, Carnegie Institute, *Painting in the United States, 1947,* 1947, no. 129 § Dalzell Hatfield Galleries, *Grigory Gluckmann: Recent Paintings,* 1948, entries not numbered, repro., unpaginated, as *Confidences* § Washington, D.C., Corcoran Gallery of Art, *Twenty-first Biennial Exhibition of Contemporary American Oil Paintings,* 1949, no. 63, repro., p. 24 § Los Angeles, Ohrbach's, Inc., [exhibition title unknown], 1956, no cat. traced § Palm Springs (Calif.) Desert Museum, *Gluckmann,* entries not numbered.

LITERATURE
Judy Owyang, "Art: Tribute to a Russian Artist," *Evening Outlook* (Santa Monica, Calif.), August 11, 1973, pt. A, p. 16, repro., dated 1948.

Philip Evergood

Born October 26, 1901,
New York, New York
Died March 11, 1973,
Bridgewater, Connecticut

Philip Howard Francis Dixon Evergood was an important socially concerned artist of the 1930s and 1940s and one of the few who painted in a strong, expressionist style. The son of a Jewish immigrant artist from Australia and a wealthy English mother, he was educated at Eton and Cambridge. His family name was changed from Blashki to Evergood in 1914.

In 1921 he began an extended period of study and travel in the United States and abroad, during which time he was a student at the Slade School in London, 1921–23, and in New York at the Art Students League with GEORGE LUKS and at the Educational Alliance School of Art. During his early years he also studied etching with Philip Reisman (born 1904) and Harry Sternberg (born 1904). In 1931 Evergood settled in New York and became friends with other artists concerned with social issues. He participated in the federal art projects and was appointed managing supervisor of the New York easel-painting division of the Works Progress Administration Federal Art Project in 1938. He joined the American Artists Congress and served as president of the Artists Union, 1937–38. Realizing the potential of the artist as propagandist and social innovator, Evergood during the 1930s established his reputation with social realist paintings that underscored the plight of the common man. His most controversial paintings of this period were *American Tragedy,* 1936 (private collection, New York), and the mural *The Story of Richmond Hill,* completed 1937, for a public library in Queens, New York.

His themes took on a more universal, humanist tone as political conditions changed in the late thirties and forties. While retaining the brilliant hues and expressionist black line of his early works, his style likewise was transformed, becoming increasingly fantastic, almost surreal at times. His socialist leanings led to his joining in 1938 those of like mind in the American Contemporary Artists Gallery (better known as A.C.A. Gallery), an association which lasted more than twenty years. Although he participated in the Whitney biennial and major annual exhibitions, he did not attract patronage until 1943, when Joseph Hirshhorn's generous support enabled Evergood to devote his time solely to painting.

The importance of the graphic line can be seen not only in his paintings but in his prints, which he produced throughout his career.

BIBLIOGRAPHY
Archiv. Am. Art, Philip Evergood Papers; Oral History Collection, interviews with the artist, 1938–75 § Whitney Museum of American Art, New York, and others, *Philip Evergood,* exh. cat., 1960 (enl. ed., New York: Harry N. Abrams, 1975), with text by John I. H. Baur, bibliography and chronology by Rosalind Irvine § Lucy R. Lippard, *The Graphic Work of Philip Evergood: Selected Drawings and Complete Prints* (New York: Crown, 1966), with chronology, bibliography § Patricia Hills, "Philip Evergood's 'American Tragedy': The Poetics of Ugliness, the Politics of Anger," *Arts* 54 (February 1980): 138–42 § Kendall Taylor, *Philip Evergood: Never Separate from the Heart,* A Center Gallery Publication (Lewisberg, Pa., and London: Bucknell University Press and Associated University Presses, 1986), with chronology, bibliography, lists of exhibitions and museum collections, checklist of exhibition held at Center Gallery, Bucknell University, and others, 1986–87.

Everybody Wants to Live, 1947

Oil on canvas
33⅝ x 21¹³/₁₆ in (85.5 x 55.4 cm)
Signed and dated lower right: Philip Evergood / 47
Inscribed verso lower right: THE TWINS.
Inscribed on top stretcher bar: NOBODY WANTS TO DIE.
Inscribed on left stretcher bar: PHIL EVERGOOD
Mira Hershey Memorial Collection
47.94

Evergood was moved by the violence and destruction of World War II to create a number of paintings on the theme of war. His concern did not end with the Allied victory. In July 1946 he wrote to Herman Baron of the A.C.A. Gallery, "What with the Bikini fiasco and OPA [Office of Price Administration]

this has been a pretty unsteading [sic] week" (Archiv. Am. Art, American Contemporary Artists Gallery Papers, microfilm roll D304, fr. 58). During 1946 and 1947 he created images such as *New Death,* 1947 (Terry Dintenfass, New York), which conveyed his anxiety about the new atomic age. *Everybody Wants to Live,* probably painted in the winter of 1946–47, demonstrates his skepticism over the ability of the victors to ensure a safe world.

He depicted a narrow city street, typical of the area where he lived in lower Manhattan. During 1946 the house in which he lived was the scene of a murder and drug dealings, events that heightened his general state of anxiety. In the painting the pedestrians' attention is drawn toward the fantastic objects floating in the sky. The image of a sky chaotically filled with

Evergood, *Everybody Wants to Live*.

seems innocent enough; their shape, however, recalls the airships that crowded the skies of Europe during the war. The other floating objects resemble underwater mines. The onlookers' expressions range from wonder and excitement to apprehension, suggesting that the ordinary citizen did not fully comprehend the ramifications of these war machines. Another ominous note to this bizarre scene is the sinister presence of the fat twins in the foreground, whose hats and cloaks may be military uniforms.

Evergood realized the expressive potential of color and manipulated it to the fullest in this painting, presenting the flying objects in cheerful hues while the overall image is pervaded by a monochromatic gray. Not only does that color have a negative connotation, it is also the color of airplanes and other machines of war. Much of the scene is suffused by a soft haze, which may have been meant to be radioactive dust, for it appears in some of his other antiatomic images. Evergood was in Santa Fe when an atomic bomb was tested and recorded how he "was sickened physically and mentally by these preparations for human destruction" (Kendall F. Taylor, "Philip Evergood and the Humanist Tradition," Ph.D. diss., Syracuse University, 1979, p. 106).

The title *Everybody Wants to Live* is a plea for the future of mankind, but even this plea has its ironic twist. Evergood may have originally entitled the painting less positively, for "nobody wants to die" was written on the back of the canvas and then covered over with white paint.

PROVENANCE
With A.C.A. Gallery, New York, 1947.

EXHIBITION
Pasadena (Calif.) Art Institute, Junior Museum, *Carnival of Kites and Toys*, 1950, no cat.

strange objects or birds was typical of Evergood's postwar paintings. The appearance of the colorful, striped flying machines at first

LITERATURE
LACMA, *Thirty-five Paintings from the Collection of Los Angeles County Museum*, Picture-Book Number One, 1950, pl. 35, unpaginated.

Norman Rockwell

Born February 3, 1894,
New York, New York
Died November 8, 1978,
Stockbridge, Massachusetts

Norman Percevel Rockwell was America's most beloved illustrator, renowned for his all-American, folksy images that appeared on the covers of the *Saturday Evening Post*. As a teenager he attended the Chase School and the Art Students League, studying with George Bridgman (1864–1943). In 1911 he began his career as a book illustrator for Condé Nast, and during his early years illustrations for children's magazines constituted his greatest source of income. His work appeared in *Youth's Companion, Everyland,* and *Boy's Life,* and he served as art director for the last named. In 1916 he began a forty-seven-year association with the *Saturday Evening Post,* and his covers for that magazine brought him a national reputation. Rockwell also received commissions from other popular magazines such as *Judge, Ladies' Home Journal, Life,* and *McCall's.* In 1923 he visited France

and as a result briefly flirted with modernism. He soon returned to the representational, story-telling compositions on which his reputation was established. He painted a few murals—*The Land of Enchantment,* 1934, for the New Rochelle (N.Y.) Public Library and *Yankee Doodle,* 1935, for a New Jersey tavern—and designed posters for commercial enterprises, the War Department, and the motion-picture industry.

BIBLIOGRAPHY
Arthur L. Guptill, *Norman Rockwell: Illustrator* (New York: Watson-Guptill, 1946), with biographical note by Jack Alexander, illustrated catalogue of *Post* covers, discussion of procedures § Norman Rockwell, *Norman Rockwell: My Adventures as an Illustrator* (Garden City, N.J.: Doubleday, 1960) § Thomas S. Buechner, *Norman Rockwell: Artist and Illustrator* (New York: Harry N. Abrams, [c. 1970]) § Donald Walton, *A Rockwell Portrait* (Kansas City, Kans.: Sheed Andrews & McMeel, 1978) § Mary Moline, *Norman Rockwell Encyclopedia: A Chronological Catalog of the Artist's Work, 1910–1978* (Indianapolis: Curtis, 1979), with chronology.

Rockwell, *The New Television Set.*

The New Television Set, 1949

Oil on canvas
46¹/₁₆ x 43³/₈ in (117.1 x 109.5 cm)
Signed and inscribed lower right: To my friends,
Ned and Louise / NORMAN / ROCKWELL
Gift of Mrs. Ned Crowell
55.42

The mid-1940s through the 1950s marked the period of Rockwell's most important paintings, when he transcended pure illustration without relinquishing a clearly understood, often humorous narrative. The transformation was apparent in the paintings he made for the *Saturday Evening Post* covers beginning around the mid-1940s. The change was encouraged by a new layout of the cover that separated the

title from the illustration and the appointment of Ken Stuart as art editor in 1944. Stuart wanted the covers to be portraits of a nation in change. The subject of this painting could not have been more topical, since the general public only started purchasing televisions during the late 1940s.

During the decade Rockwell increasingly used photographs in his preparatory work so that he could pay more attention to the setting, rather than the figures, as he had earlier. Consequently a new concern for architectural subjects, seen most often in detailed interiors, appeared in his art. He depicted architectural exteriors less frequently. By setting *The New Television Set* on the roof of a house, Rockwell used architecture not only to structure the composition but also to convey the contrast of the old, the house, with the new, the television. The scene epitomizes the rapid modernization of America, for the house was one of many large Victorian structures characteristic of the district around Adams Street in Los Angeles, where it was painted.

Rockwell's association with Los Angeles was long and close, beginning in 1930, when he met his wife, Mary Barstow, on his first trip to the city. During the 1940s he wintered here and was artist-in-residence at Otis Art Institute (Los Angeles County Art Institute). He became friendly with his students and asked some of them to serve as his models. For *The New Television Set* Robert H. Horton, at the time an architecture student, posed as the television serviceman, and Jack Farman, another student, served as the model for the elderly customer.

The painting was reproduced on the cover of the November 5, 1949, issue of the *Saturday Evening Post.* Rockwell presented the painting to Ned Crowell, a close friend who was West Coast district manager for the Curtis Publishing Company, among whose many publications was the *Saturday Evening Post.*

RELATED WORK
Cover, *Saturday Evening Post* 222 (November 5, 1949).

PROVENANCE
The artist § Mr. and Mrs. Ned Crowell, Los Angeles, c. 1950–55.

EXHIBITIONS
Los Angeles, Ohrbach's, Inc., [exhibition title unknown], 1956, no cat. traced § Long Beach (Calif.) Museum of Art, *The Figure: Past and Present,* 1961, no cat. traced § Fort Lauderdale (Fla.) Museum of the Arts and others, *Norman Rockwell: A Sixty-Year Retrospective,* 1972–73, entries not numbered, repro., p. 100 § Daytona Beach, Fla., Museum of Arts and Sciences, and West Palm Beach, Fla., Norton Gallery of Art, *Norman Rockwell's America,* 1976, entries not numbered, repro., p. 48 § Columbus (Ohio) Gallery of Fine Arts and Allentown (Penn.) Art Museum, *Salute to Norman Rockwell,* 1976–77, no. 32, repro., unpaginated.

LITERATURE
LACMA, Registrar's files, Mrs. Ned Crowell to Richard S. Brown, January 24, 1955, explains Crowell association and identifies setting § Rockwell, *My Adventures,* with repro. of November 5, 1949, *Post* cover, p. 441 § Thomas S. Buechner, *The Norman Rockwell Album* (Garden City, N.Y.: Doubleday, 1961), repro., p. 48, with quote from Rockwell § Buechner, *Rockwell: Artist and Illustrator,* p. 165, discussed in context of architectural emphasis, p. 205, *Post* cover listed as no. 459, repro. of *Post* cover § Gerald F. Broomer, *Movement and Rhythm* (Worcester, Mass.: Davis, 1975), repro., p. 67 § Mary Jarrett, *The Otis Story of Otis Art Institute since 1918* (Los Angeles: Alumni Association of Otis Art Institute, 1975), p. 56, discusses Los Angeles association and identifies models, repro. and photo of the artist and one model, p. 43 § Christopher Finch, *Norman Rockwell's America* (New York: Harry N. Abrams, [c. 1975]), p. 40, discusses theme and inaccurately places scene in a small town, repro. of painting as no. 27, p. 38, repro. of *Post* cover, p. 299 § Moline, *Rockwell,* listed, p. 77, repro., as no. 1-371, p. 76.

Walter Stuempfig

Born January 26, 1914,
Philadelphia, Pennsylvania
Died November 29, 1970,
Ocean City, New Jersey

Walter Stuempfig, Jr., was a highly esteemed painter of landscapes and figurative compositions working in the Philadelphia area during the third quarter of this century. He grew up in Germantown, a residential section of Philadelphia. He attended the Pennsylvania Academy of the Fine Arts from 1931 to 1935 and won its Cresson European Traveling Scholarship in 1934. His first solo exhibition was held at the Philadelphia Art Alliance in 1942. Solo exhibitions of his work were also organized by Durlacher Brothers Gallery, New York, from 1943 to 1961, encountering immediate success. Beginning in the late 1940s he received numerous honors for his work. Stuempfig was a faculty member of the Pennsylvania Academy from 1948 until his death in 1970. He often summered in Europe. He was equally successful with his still-life, landscape, and figure paintings.

BIBLIOGRAPHY
Archiv. Am. Art, Durlacher Brothers Papers § Rosamund Frost, "Stuempfig Remakes Nature," *Art News* 44 (December 15–31, 1945): 20 § Harry Salpeter, "Stuempfig: An Interview," *American Artist* 12 (November 1948): 52–55, 74–76 § Barbara Moore, "Stuempfig," in *Art U.S.A. Now,* ed. Lee Nordness (New York: Viking, 1963), 2: 276–78 § Philadelphia, Pennsylvania Academy of the Fine Arts, *Walter Stuempfig: Memorial Exhibition,* exh. cat., 1972, with essays by R. Sturgis Ingersoll and James Fosburgh, chronology.

Desolation: Boy in Empty Room, c. 1949
Oil on canvas
25³/₁₆ x 30⁵/₁₆ in (64.0 x 76.7 cm)
Signed lower right: Stuempfig
Clifton Webb Estate
M.68.19

Although figures in landscapes are more common in Stuempfig's work than figures in interiors, this painting's imagery of loneliness and enigmatic suspense are central to his art.

Stuempfig's themes and many of his formal devices are derived from surrealism and particularly from the variation of that movement most widely joined in the United Sates, magic realism. Like the work of this period by ANDREW WYETH, an artist living nearby in the Philadelphia area, Stuempfig's paintings appear to be realistic but depict the world of dreams and fantasy. The objective of both painters was to evoke in the viewer a certain mood from that realm. Stuempfig freely manipulated formal devices to undercut the seeming realism of his paintings, subtly suggesting a haunting strangeness. Strong frameworks of verticals and horizontals make the space in his paintings seem clear and organized, but large, central, empty spaces and conspicuously large separations between presumably related elements give the space a dreamlike quality. Strong effects of light and shadow, often from a raking light, enhance the impression of realism by bringing out the texture of surfaces, but the overly strong contrast of light and shadow in the modeling of the figures, recalling the early baroque period, injects a note of drama and menace.

In this painting the extreme contrast in the modeling of the figure is particularly puzzling because the direct light from the window

is shown to be striking the wall. A further quality of disquietude and unreality comes from the difficulty the viewer experiences in seeking to identify the subject of Stuempfig's paintings. Almost always there are figures, typically tough, adolescent males, who stand about idly, lost in their own troubling thoughts, without a relationship of position or action to any other figure or object in the paint-

ing. In the museum's painting this sense of thematic ambiguity is heightened by the familiar surrealist device of the juxtaposition of two conceivably related objects. The viewer must wonder about the relationship between the youth and the empty birdcage resting on an upturned music stand in this painting just as one wonders about the relationship between the similarly posed young man and the isolated houses in Stuempfig's painting, *Two Houses,* c. 1940s (Corcoran Gallery of Art, Washington, D.C.). The stiles of the antique chair, behind which the boy stands, establish a visual metaphor for the bars of the birdcage, perhaps hinting at the youth's spiritual captivity.

The settings of most of Stuempfig's paintings are entirely imaginary or greatly transformed, but the titles of a certain number of them acknowledge that he has painted his studio, as he may have done in the present case. The same chair and a similarly spare interior are seen in his painting *Solitary Figure,* 1948 (Fine Arts Museums of San Francisco). The same model may be portrayed in Stuempfig's painting *Portrait of Charles,* 1949 (art market, 1974).

PROVENANCE
Clifton Webb, 1966 § Estate of Clifton Webb, 1966–68.

LITERATURE
Jack Selleck, *Contrast* (Worcester, Mass.: Davis, 1975), repro., p. 9.

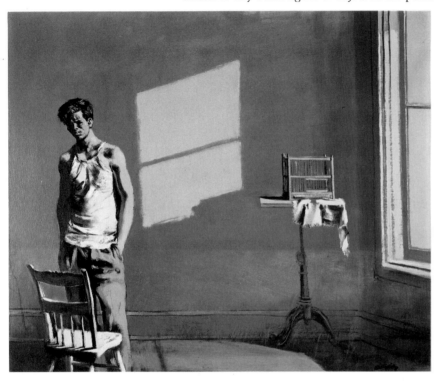

Stuempfig, *Desolation: Boy in Empty Room.*

Streeter Blair

Born July 16, 1888,
Cadmus, Kansas
Died November 3, 1966,
Los Angeles, California

Streeter Blair was "the West Coast Grandma Moses." He came late to art, after a varied and highly successful career as a teacher, an editor, in advertising, as a clothier, and an antique dealer. His frequent travels throughout the United States during his years in advertising acquainted him with early Americana and different areas of the country, knowledge which would later be utilized for the settings of some of his paintings. In late 1929 he moved to Los Angeles but during the following two decades he lived in several different areas of Southern California. About 1948 he turned to painting, at first as a hobby until he realized that customers in his antique shop wanted to buy his pictures. He began by depicting life in the Midwestern farming town where he grew up, hoping to record how things were before the era of the automobile. He later expanded his repertoire to include historical subjects, landscapes, and, in the 1960s, still lifes. Although his paintings reflected the revival of interest in Americana and naïve art during the 1940s and 1950s, his work was highly regarded among Southern California modernists. His charmingly nostalgic images reveal Blair's innate color sense and extraordinary talent for design. He was given his first solo exhibition in 1951 at the Carlbach Gallery in New York and thereafter had several exhibitions on both coasts. Vincent Price bought out his entire 1964 exhibition at the Ferus Gallery in Los Angeles, which was then circulated under the auspices of Sears Roebuck and Co.

BIBLIOGRAPHY
"Streeter Blair," *Look* 18 (May 18, 1954): 126–27, 129 § University of California, Los Angeles, Oral History Program, "Primitive Painter of the West," interview with Streeter Blair by Elizabeth I. Dixon and Donald J. Schippers, 1965, with incomplete list of paintings § *Who's Who in American Art,* 1966, s.v. "Blair, Streeter" § "Painting: Late Starter," *Time* 93 (March 21, 1969): 80–83 § Beverly Hills, Calif., Sári Heller Gallery,

Streeter Blair's America, 1886–1966: A Retrospective Exhibition, exh. cat., 1970, with essay by Frank R. Heller, list of museum collections, bibliography.

Meadow Lark Ranch—San Diego County, 1951

(Meadowlark Brahman Farm, Calif.)
Oil on canvas
34⅛ x 28½ in (86.7 x 72.4 cm)
Signed, dated, and inscribed lower right: MEADOW LARK / BRAHMAN FARM. Calif. / © STREETER BLAIR, '51
Gift of Mr. and Mrs. Ozzie Nelson
M.61.57

In the late 1930s Blair bought a ranch in San Diego County where he raised thoroughbred horses, cows, and pigs. During World War II one of his prizewinning stallions, El Ganito, was used to guard the mountainous area near San Diego. Meadow Lark, a farm about thirty miles from San Diego, was the first night's destination on the guard's circuit. Blair explained that "being interested in the spot where our horse spent the night, we made trips to the place, and being intrigued with its unusual character and beauty, the painting was the result." Life on the farm is rendered with all the ideal, pleasant activities typical of this naïve artist's work: a man fishes in a stream while cows graze nearby and a dog chases a rabbit.

In such early work Blair painted with pure color but faithfully rendered what he saw: bright green grassy fields subdivided by a meandering white picket fence and dotted with houses and barns with red and black roofs. Although the absence of atmospheric perspective is typical of primitive artists, Blair's handling of the composition, particularly the manner in which the delicate trees frame the flat image, is sophisticated.

Ozzie and Harriet Nelson, who donated the painting to the museum, were among the many actors who collected Blair's art. Not only did his paintings decorate their house and office, one of his early works was used in the living-room set of their popular television series.

PROVENANCE
The artist, 1951–61.

ON DEPOSIT
Los Angeles mayor's residence, 1977–79, 1980–81.

EXHIBITIONS
Sacramento, sponsored by California Arts Commission, *Horizons: A Century of California Landscape Painting,* 1970–71, entries not numbered, repro., p. 31 § Beverly Hills, Calif., Sári Heller Gallery, *Streeter Blair's America: A Retrospective Exhibition,* 1974, entries not numbered, repro., unpaginated.

LITERATURE
LACMA, Registrar's files, the artist to LACMA, November 1, 1961, explains what the painting represents § UCLA, Oral History Program, Blair interview, 1965, p. 551, notes Nelsons' purchase of painting § Carol N. Stallone, "California Horizons," *Art in America* 58 (November–December 1970): repro., 125 § Judy Van der Veer, "Autumn Thunder," *Christian Science Monitor,* October 1, 1974, p. HF1, repro., as *Meadowlark Brahman Farm, Calif.*

Blair, *Meadow Lark Ranch—San Diego County.*

Blair often set his historical farming scenes in a specific season of the year. In *Windham, Connecticut, 1815* Blair depicted a typical small New England town with its houses clustered around a simple, white clapboard church. Fascinated with the color white, the artist painted many such winter scenes. After he had been painting a few years, Blair realized that colors could be effectively rendered not only as pure hues but also in tonal gradations, which increased the apparent depth of a scene. Despite the overall soft focus, the black roofs dramatically contrast with the delicate white and gray of the snow and the houses stand out as bright geometric spots of color.

Windham, Connecticut, 1815, 1957
Oil on canvas
26¼ x 32³⁄₁₆ in (66.6 x 81.8 cm)
Signed, dated, and inscribed lower right: WiNDHAM
CONN. 1815 / © STREETER BLAIR '57
Gift of Mr. and Mrs. John Dodds
M.70.80.2

PROVENANCE
Mr. and Mrs. John Dodds, to 1970.

EXHIBITION
Beverly Hills, Calif., Sári Heller Gallery, *Streeter Blair's America: A Retrospective Exhibition,* 1974, entries not numbered, repro., unpaginated.

After the Cows, with a boy chasing two animals, is probably the artist's fond and rather "rose-colored" recollection of his youth in rural Cadmus, Kansas.

The painting is dominated by a brilliant pink sky and intensely green fields, with secondary colors of yellow, white, lavender, and brown. In the 1960s Blair began to use more pastel colors. The decorative quality and color of his late work accords with his nostalgic subject matter and may actually have been based on reality. Blair recalled that the Kansas grangers decorated their buildings in the colors of this painting: pink, green, and yellow.

After the Cows, 1964
Oil on canvas
26⅛ x 36⅛ in (66.4 x 91.8 cm)
Signed, dated, and inscribed lower right: AFTER THE
COWS / '64 © STREETER BLAIR
Gift of Mr. and Mrs. John Dodds
M.70.80.1

PROVENANCE
Mr. and Mrs. John Dodds, to 1970.

EXHIBITION
Beverly Hills, Calif., Sári Heller Gallery, *Streeter Blair's America: A Retrospective Exhibition,* 1974, entries not numbered, repro., unpaginated.

Moses Soyer

Born December 25, 1899,
Borisoglebsk, Russia
To United States 1912
Died September 2, 1974,
New York, New York

Moses Soyer's reputation was established during the 1930s with his social realist paintings. He and his two brothers, RAPHAEL, Moses's identical twin, and Isaac (1902–1981), learned to draw at an early age in Russia. Moses studied at several art schools in New York, including the Educational Alliance School of Art, the Ferrer School of Art with ROBERT HENRI, and the National Academy of Design. Henri had the most lasting effect on his art. In 1926 Soyer traveled to Europe on a scholarship and worked in Paris for two years. After he returned to New York he began supporting himself by teaching at the Educational Alliance and other local art schools. His first solo exhibition was at J. B.

Neumann's New Art Circle Gallery in 1929, and he continued to be given numerous exhibitions, especially after 1944, when he became associated with A.C.A. Gallery. During the Great Depression Soyer worked on government projects, producing easel paintings and murals for Greenpoint Hospital in Brooklyn and the Kingessing Station post office in Philadelphia. In the 1940s he turned away from sociopolitical issues and painted dancers in a manner reminiscent of the work of Edgar Degas (1834–1917), whom he admired. During the rest of his career he created studio productions, often of single figures, using professional models or his friends, capturing in these paintings the spirit of his sitters, their dreams or disillusionment. He also painted numerous portraits and self-portraits. He is best known for his introspective figure paintings of weary, melancholy women. Although his subject matter did not change after the 1940s, his painting style continued to evolve, and because of his increasing concern for formal elements his color became more resonant and brushwork more expressionist.

BIBLIOGRAPHY
Archiv. Am. Art, Moses Soyer Papers § Moses Soyer, "Three Brothers," *Magazine of Art* 32 (April 1939): 201–7, 254 § Charlotte Willard and Philip Evergood, *Moses Soyer* (Cleveland: World, 1962) § Alfred Werner and David Soyer, *Moses Soyer* (South Brunswick, N.J.: Barnes, 1970) § Syracuse (N.Y.) University and others, organized by ACA Galleries, New York, *Moses Soyer: A Human Approach,* exh. cat., 1972–73, with foreword by Martin H. Bush, statements by the artist, chronology, bibliography, lists of collections and awards.

Soyer, *Cynthia with Hands on Breast.*

Cynthia with Hands on Breast, c. 1955
Oil on canvas
25¹/₁₆ x 20 in (63.6 x 50.9 cm)
Signed lower right: MSOYER
Gift of Peg and Bud Yorkin
M.81.103

Cynthia Brown was a favorite model of both Moses and Raphael Soyer, posing often for them for more than twenty years. During this time she matured under the artists' eyes, as is demonstrated by the museum's two paintings of her by Moses, created years apart. In this painting Cynthia is young, her angular face full. Moses no doubt painted her so often because she epitomized the type of woman to whom he was attracted. He even married such a woman, describing his wife, Ida Chassner (d. 1970), as "tall, angular, . . . with wide-apart blue eyes, curly hair, and high cheekbones."

While Soyer usually portrayed his figures dressed, he occasionally painted full and partially draped nudes. In this painting Cynthia covers her breasts with her hands. The modesty of the gesture accentuates her vulnerability. The artist's portrayal of this wide-eyed, doleful woman is very poignant.

PROVENANCE
The artist, to 1974 § Estate of the artist, 1974–77 § With ACA Galleries, New York, 1977 § Peg and Bud Yorkin, Los Angeles, 1977–81.

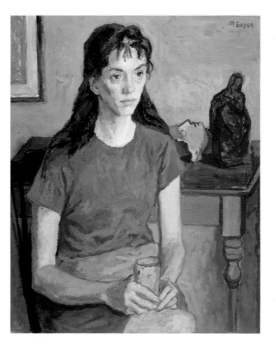

Soyer, *Cynthia with Glass.*

Soyer even followed the nineteenth-century artists' practice of cropping the painting hanging on the wall in the background. Like them, Soyer arranged the composition so that the art objects are essential to the balance and harmony of the composition but do not distract from the figure. The artist conceived his studio paintings as arrangements, avoiding details to present large, colorful areas. By the 1960s Soyer's palette had lightened and intensified. *Cynthia with Glass* has a carefully orchestrated, limited chromatic scheme established by the lavender wall and cool, sweet blue and green of Cynthia's attire. Her skin reflects these colors in the shadows. Consequently, despite Cynthia's weary, drawn face, the painting does not convey a spirit of defeat but rather of introspection.

PROVENANCE
The artist, 1969–74 § Estate of the artist, 1974–84.

Cynthia with Glass, 1969
(*Cynthia with Wine Glass; Girl with Glass*)
Oil on canvas
36¹/₁₆ x 30⅛ in (91.7 x 76.6 cm)
Signed upper right: MSOYER
Gift of David and Jane Soyer
M.84.115

Soyer usually posed his models in his studio or home. Many of his paintings, such as *Cynthia with Glass,* show the figure surrounded by works of art. Such a presentation of a figure in an interior dates from the late nineteenth century, when James McNeill Whistler (1834–1903) and Edgar Degas started a vogue for including a painting or print in their scenes.

EXHIBITIONS
ACA Galleries, New York, and others, *Moses Soyer: A Selection of Paintings, 1960–1970,* 1970–71, no. 47, repro., unpaginated, as *Girl with Glass* § ACA Galleries, *Moses Soyer: Selected Works,* 1980, no cat., repro., on announcement, as *Cynthia with Wine Glass* § Community Gallery of Lancaster, Pa., and others, *Moses Soyer: Oil Paintings and Works on Paper,* 1982, no. 7, repro., unpaginated.

LITERATURE
Werner and Soyer, *Moses Soyer,* pls. 120, 121 § "Art across the U.S.A.: Good-bye, Union Square," *Apollo* n.s. 93 (February 1971): fig. 9, 144, as *Girl with a Glass* § LACMA, American Art department files, David Soyer to Dana L. Sebrée, September 30, 1984, dates painting and identifies model § "American Art," *LACMA Report 1983–1985* (1985), p. 16.

Raphael Soyer

Born December 25, 1899,
Borisoglebsk, Russia
To United States 1912
Died November 4, 1987,
New York, New York

Raphael Soyer was one of the most respected figure painters in America during the years between the two world wars, best known for his depression-period scenes of life in New York and his figure studies of friends, dancers, and actors posed in his studio. The Soyer family—which included Raphel's twin brother MOSES and younger brother Isaac (1902–1981), both of whom became artists—immigrated to the United States in 1912 and settled in the New York borough of the Bronx. While working to help support them, Raphael studied at various art schools: for three years at the Cooper Union, then from 1917 to 1922 at the National Academy of Design, and occasionally during the early 1920s at the Art Students League, studying there with both GUY PÈNE DU BOIS and Boardman Robinson (1876–1952). He first exhibited at the Salon of America in 1926 and soon became a frequent contributor to the Whitney Studio Club, receiving the patronage of its director, Juliana Force. In 1929 his first solo exhibition at the Daniel Gallery met with much success.

In the 1930s and 1940s Soyer was very active, exhibiting regularly in the major museum annuals and in solo shows at a variety of New York galleries as well as working on the graphic arts and mural divisions of the Works Progress Administration/Federal Art Project. In 1930 he also began his career as a teacher, which lasted more than thirty years and included positions at the Art Students League, the New School for Social Research, and the National Academy of Design, all in New York.

Although identified with New York City art circles, Soyer summered in the country: in the late 1920s and early 1930s in Gloucester and Provincetown, Massachusetts, and Ogunquit, Maine; during the 1940s in Croton-on-Hudson, New York; and from 1957 in Vinalhaven, Maine. In later years he also traveled frequently, visiting Europe and Russia and publishing three books inspired by what he saw: *A Painter's Pilgrimage* (1962), *Homage to Thomas Eakins, Etc.* (1966), and *Self-Revealment* (1969). He continued to paint until the end of his life but never substantially altered his style formed during the 1930s. Always maintaining his desire "to be a realist and a humanist in art," Raphael Soyer was instrumental in organizing a group of like-minded artists who published the annual *Reality,* 1953–55.

BIBLIOGRAPHY
Archiv. Am. Art, Raphael Soyer Papers § Harry Salpeter, "Raphael Soyer: East Side Degas," *Esquire* 9 (May 1938): 58–61, 155–58 § Lloyd Goodrich, *Raphael Soyer* (New York: Harry N. Abrams, [c. 1972]), with statements by the artist, biographical note, list of solo exhibitions, bibliography § Raphael Soyer, *Diary of An Artist* (Washington, D.C.: New Republic Books, 1977), compilation from previous publications, *A Painter's Pilgrimage* (1962), *Homage to Thomas Eakins, Etc.* (1966), and *Self-Revealment* (1969) § Washington, D.C., Smithsonian Institution, Hirshhorn Museum and Sculpture Garden, *Soyer Since 1960,* exh. cat., 1982, published by Smithsonian Institution Press, with essay by Abram Lerner.

Portrait of Moses Soyer, c. 1962

Oil on canvas
36 in. x 30¹/₁₆ in (91.5 x 76.4 cm)
Signed lower right: RAPHAEL SOYER
Presented in honor of Professor Frederick Sethur
M.86.309

Raphael Soyer painted members of his family often and throughout his career. Painting Moses, his identical twin, was in many ways creating a self-portrait, for the two not only shared a common profession, they even worked in similar styles. During the decade this portrait was painted, Raphael also created *Double Portrait,* 1963 (Mrs. George H. Boynton, Tuxedo Park, N.Y.), which depicts the two sitting in a studio with easels cluttering the background.

The quiet, tired poignance of his brother is the sole theme of the painting. Moses's mood might have been the result of his advanced age, but it might just as readily be explained by the preferences of both brother-painters for models who expressed a silent and somewhat resigned sadness. In Raphael's case this tendency first appeared in the pathos of his scenes of the depression. Raphael often focused on his model's face as an expression of this mood, and here placed his brother's relatively small head in the center of a large composition. A cool palette of somber mauves, blue greens, and grays intensifies the mood. The emptiness of the room, with only a drawing tacked to a door in the background, emphasizes Moses's solitary bearing. Moses is similarly depicted in Raphael's most famous late work, *Homage to Thomas Eakins,* 1963–65 (Hirshhorn Museum and Sculpture Garden, Smithsonian Institution, Washington, D.C.), a large, crowded group portrait in which all the artists included appear to be en-tranced and in their own worlds despite the crowded nature of the composition.

Raphael always demonstrated a strong sense of design, shown here by his strategic placement of the figure. The fluid application of pigment in almost abstract terms is characteristic of his late, more painterly handling.

PROVENANCE
The artist, to 1986.

EXHIBITIONS
New York, Whitney Museum of American Art, *Annual Exhibition, 1963: Contemporary American Painting,* 1963–64, no. 129 § Youngstown, Ohio, Butler Institute of American Art, *Thirty-fourth Annual Midyear Show,* 1969, no. 171.

LITERATURE
Goodrich, *Soyer,* repro., p. 305, incorrectly dated 1965–66.

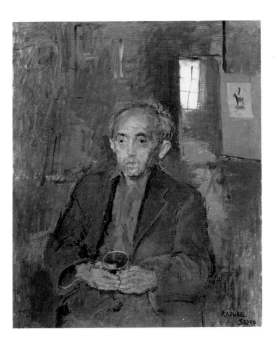

Soyer, *Portrait of Moses Soyer.*

Ben Abril

Born April 11, 1923,
Los Angeles, California
Lives in La Cañada,
California

Benjamin Abril's reputation is based on his picturesque scenes of old Los Angeles and the California countryside. After serving in the air force during World War II, Abril studied briefly at the Glendale School of Allied Arts with Arthur Beaumont (1890–1973). He then worked on the night shift at the post office in order to paint during the day. During these years he painted the circus and became interested in the Chinatown area of Los Angeles. He returned to school in the late 1940s to study art at Glendale College and landscape painting at the Art Center School of Design with Trude Hanscom (born 1898). He studied architectural rendering at Chouinard Art Institute and took watercolor classes at the Los Angeles County Art Institute (Otis Art Institute). Abril also studied privately with landscape painter ORRIN A. WHITE and painted with members of the California Water Color Society. The County of Los Angeles hired him in 1955 as a cartographer and architectural draftsman, a position he held for some twenty years. He also worked for architectural firms and briefly as a scenic designer for Desi-Lu Productions.

In 1962 Cowie Galleries began to represent Abril, and from then on his reputation grew; two years later actor Vincent Price bought out his entire studio. Around this time he began to depict the Victorian mansions in the Bunker Hill area of downtown Los Angeles. The fame of these paintings led to a commission from the United States Navy to paint a series on Japan and later one of the Mekong Delta in Vietnam for their collection. In 1972 President Nixon acquired one of his Northern California seascapes.

BIBLIOGRAPHY
Who's Who in American Art, 1980, 1986, s.v. "Abril, Ben (Benjamin)" § Janice Lovoos, "Ben Abril: The Ambience of the City," *Southwest Art* 11 (September 1981): 90–95 § Ann Bini, "Ben Abril: Capturing [the] Old West with Heart, Soul, and Brush," *Verdugo Newspaper Group,* December 11, 1983, pt. A, p. 7 § LACMA, American Art department files, Ben Abril, "My Life as an Artist: Ben Abril—Autobiography," 1985, typescript § Ben Abril, *Images of a Golden Era: Paintings of Historical California* (Glendale, Calif.: Arthur H. Clark, 1987), with introduction by Leon G. Arnold and biography by Jean Napier Neely, published in conjunction with an exhibition held at the Los Angeles County Museum of Natural History and San Bernardino County Museum, 1987.

The Old Hall of Records, 1966
Oil on canvas
48³/₁₆ x 60¹/₁₆ in (122.4 x 152.6 cm)
Signed lower right: BEN ABRIL
Inscribed and dated lower left: OLD HALL OF RECORDS / LOS ANGELES CALIF. 1966
Museum Associates Acquisition Fund
M.67.89

Abril has always been interested in historic buildings and has often depicted them as contrasting with the newer structures in his native city. This painting was completed after he had finished a series of thirty-six paintings of the old buildings in the Bunker Hill area of down-

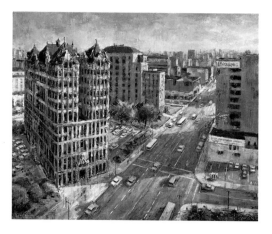

Abril, *The Old Hall of Records.*

town, 1959–63 (LACMNH).

The Old Hall of Records was demolished in 1973 in the course of an urban renewal project. Designed by the firm of Hudson and Munsel, the building was erected in 1909 on Pound Cake Hill at Temple and Broadway streets. It remained in use until after the new Hall of Records was built across the street. In 1966, as part of his preparation for this painting, Abril photographed and drew sketches of the old building from the fifteenth floor of the recently completed Hall of Records. Such a close, yet high vantage point enabled him to delineate the massive, turreted old hall in all its dignity. Abril painted the canvas in his characteristically bright, contemporary version of the impressionist style.

PROVENANCE
The artist, 1966–67 § With Cowie Galleries, Los Angeles, 1967.

ON DEPOSIT
Los Angeles County Chief Administrative Office, since 1969.

LITERATURE
LACMA, American Art department files, the artist to Ilene Susan Fort, August 15, 1985, discusses history of the painting.

Sculptures

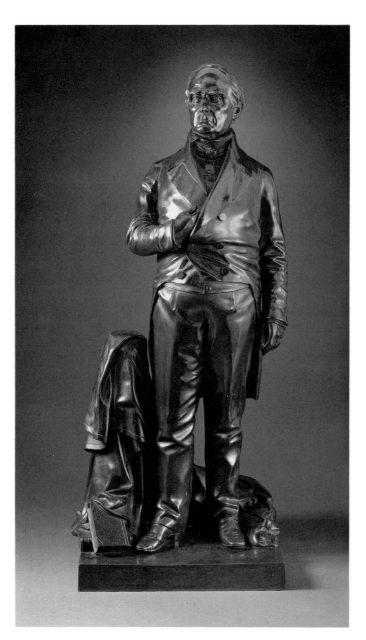

Ball, *Daniel Webster.*

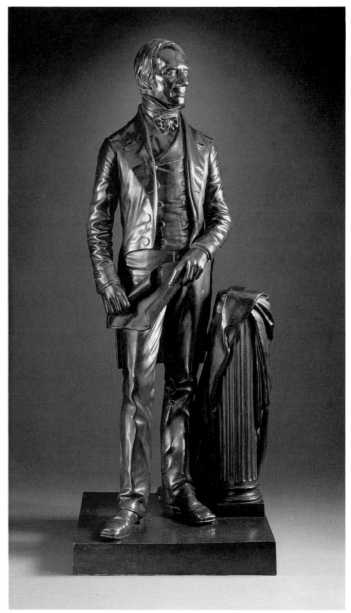

Ball, *Henry Clay.*

Thomas Ball

Born June 3, 1819,
Charlestown, Massachusetts
Died December 11, 1911,
Montclair, New Jersey

Thomas Ball was a leading sculptor of realist bronzes in Boston during the second half of the nineteenth century. The death of his father, a sign painter, caused him to quit school at the age of twelve to help support the family. One of his jobs was in a museum, where he began to cut silhouettes and paint miniature portraits. In 1840 he exhibited two miniature portraits at the annual exhibition of the Boston Athenaeum. He went on to paint life-size portraits and even exhibited history paintings at the American Art-Union in 1848 and 1849. He also supported himself as a singer, winning leading roles.

Some experiments with modeling clay in 1850 launched Ball's career as a sculptor. He modeled small-scale portrait busts until 1852, achieving a considerable local reputation. He was in Florence from 1854 to 1857, then in Boston, and after 1865 more or less permanently in Florence. From 1858 to 1861 he worked on his most famous sculpture, the heroic equestrian statue of Washington for the Boston Public Garden. Throughout his career, Ball was in demand both as a carver of portrait busts and a modeler of heroic public portrait sculptures. He also executed several ideal sculptures. In 1897 he retired and moved to Montclair, New Jersey.

BIBLIOGRAPHY
Thomas Ball, My Threescore Years and Ten: An Autobiography (1891; reprint of 2d ed. in The Art Experience in Late Nineteenth-Century America Series, ed. H. Barbara Weinberg, New York: Garland, 1977) § William Ordway Partridge, "Thomas Ball," New England Magazine n.s. 12 (May 1895): 291–304 § Taft 1930, pp. 141–49, with bibliography § Wayne Craven, "The Early Sculptures of Thomas Ball," North Carolina Museum of Art Bulletin 5 (Fall 1964–Winter 1965): 2–12 § Craven 1968, pp. 219–28, 258–61, with bibliography.

Daniel Webster,
modeled 1853
Bronze
29¾ in (75.6 cm) with base
Signed, inscribed, and dated on back, on drapery:
T BALL Sculp. / Boston Mass / 1853
Foundry mark with stamped number on back, on
base center: J. T. AMES / FOUNDER / CHICOPEE /
MASS / 23
Inscribed on back, on drapery: Patent Assigned to /
C. W. Nichols
Purchased with funds provided by
Dr. and Mrs. Matthew S. Mickiewicz
M.86.117.2

Henry Clay, modeled 1858
Bronze
30 in (76.2 cm) with base
Signed, inscribed, and dated on back, along edge of
drapery: T. BALL Sculp. Boston 1858
Foundry mark on back, on base right: Ames Mfg.
Co. Saunders. / Chicopee Mass.
Inscribed on back, on base left: PATENT assigned to /
C. W. Nichols
Purchased with funds provided by
Dr. and Mrs. Matthew S. Mickiewicz
M.86.117.1

Thomas Ball's first success as a sculptor was his cabinet-sized bust of the "Swedish Nightingale," Jenny Lind, which he modeled in 1851. He was overwhelmed by the demand for plaster copies of his bust. Although he had procured a patent for his design, eventually it was pirated and the market flooded with replicas. This was the period when American artists began to exploit the expanding middle-class market for inexpensively reproduced images that absorbed the lithographs from the firm of Currier and Ives, for instance, and the plaster sculptures of JOHN ROGERS. Early in this trend and at the upper end of quality, Thomas Ball's Daniel Webster and Henry Clay have the distinction of having been the first volume-cast art bronzes produced in this country.

Their large editions and their medium of bronze both reflect the towering stature of the two great statesmen, Webster, the Yankee orator of legendary ability, and Clay, the idolized senator, secretary of state, and three-time presidential candidate. Both of the great men died in 1852. Since childhood, Ball had been resolved to one day paint a portrait of Webster. He tried to model a cabinet-size bust but considered it a failure and destroyed it. It was Webster whom he took as the subject of his first life-size bust in 1852. He must have worked from prints or photographs, because, with the bust already in progress, he had only a brief glimpse of the man as a procession escorted him through Boston. As it happened, Ball finished that bust (Boston Athenaeum) just two days before Webster's death on October 24, 1852. It naturally attracted considerable attention, and Ball soon had orders for nearly a hundred casts of it. Declared to be a faithful likeness, it was the model for all of Ball's subsequent sculptures of Webster. His next project was a small full-length sculpture of the same subject, his first attempt at the full figure. His inexperience with armatures caused the first to tip over and crash to the floor. Managing to salvage the figure's head, he began again. The resulting sculpture was an immediate success. On the first day Ball exhibited it, he received an offer of five hundred dollars for the sculp-

ture and the right to reproduce it. Ball later remarked that the shrewd art dealer, C. W. Nichols, must have made five thousand dollars out of it.

Presumably Ball received a more appropriate sum from Nichols when he also assigned to him the patent for the companion figure of Henry Clay that the artist completed in 1858, shortly after returning to Boston from his Italian sojourn. Ball felt it was not as successful as his statuette of Webster, but Senator Edward Everett wrote a letter in praise of its fidelity, both in likeness and the carriage of the figure, and most today would find the statuette produced by the more experienced sculptor to have a greater delicacy of line and a more convincing sense of life in the figure. Nichols produced plaster copies of both sculptures (example of *Webster* in New Hampshire Historical Society, Concord; example of *Clay* in Rhode Island Historical Society, Providence) and examples in Parian ware are known (one of *Webster* in Chicago Historical Society and of *Clay* in Yale University Art Gallery, New Haven, Conn.). The bronze casts of *Daniel Webster* and *Henry Clay* are inscribed with the name of the Ames Manufacturing Company as founders. A long-established cannon and ironwork foundry, the Ames Manufacturing Company in 1851, at the urging of the sculptor Henry Kirk Brown (1814–1886), made its first attempts at casting works of sculpture. The firm enjoyed a prominent role as an art bronze foundry over the next half-century. One of the first works not by Brown to be cast by the Ames foundry, *Daniel Webster* was offered both in a model with drapery and in one without (proof cast, Malcom Stearns, Jr.; see *American Figure Sculpture in the Museum of Fine Arts, Boston* [Boston: Museum of Fine Arts, 1986], p. 96 for listing of examples in public collections). It was the first sculpture to be not only cast but also patinated by the foundry. The quality of its chasing indicates how thoroughly professional the foundry had become in just two years. In 1874–76 Ball created an heroic-sized enlargement of his statuette of Webster for New York's Central Park.

Although they were among the very first sculptures to be cast in bronze in this country, *Daniel Webster* and *Henry Clay* (example in Newark [N.J.] Museum) belong in style to the neoclassical movement that dominated American sculpture until well past the middle of the last century. Like the white marbles or plasters of that movement, they are compact, with simple, polished surfaces. They even retain the truncated pillar brought next to a marble figure to help support the weight of the stone but which is not necessary with highly ductile

bronze and in these cases was cast separately. Their classicism, though, is the more detailed and realistic later phase of the style.

Daniel Webster

RELATED WORK
Patent drawing, 1853, medium and dimensions unknown. Polar Archives Division, National Archives, Washington, D.C.

PROVENANCE
Private collection, to 1986.

LITERATURE (GENERAL)
Ball, *My Threescore Years*, pp. 141–42 § Taft 1930, p. 142 § Craven, "Early Sculptures of Ball," pp. 6–7, discusses modeling and casting, figs. 4–6, pp. 2, 7–8, with details of head and foundry mark § John Stephens Crawford, "The Classical Orator in Nineteenth Century American Sculpture," *American Art Journal* 6 (November 1974): 67–68, discusses in context of iconography of classical sculptures of orators, specifically the gesture of the right hand and contemporary dress, and compares with statue *Emperor Hadrian* of A.D. 117–38 in the British Museum, London, fig. 20, p. 68 § Michael Edward Shapiro, *Bronze Casting and American Sculpture, 1850–1900* (Newark: University of Delaware Press, 1985), pp. 55–56, 158, discusses history of casting at Ames Foundry and variations of size, patina, chasing, and drapery, lists foundry's costs for statuette, figs. 46–48, pp. 55–56.

LITERATURE (SPECIFIC)
Sotheby Parke Bernet, New York, *Important American Nineteenth- and Twentieth-Century Paintings, Drawings, and Sculpture*, May 30, 1985, offered for sale, lot 76, did not sell.

Henry Clay

PROVENANCE
Private collection, to 1986.

LITERATURE (GENERAL)
Ball, *My Threescore Years*, pp. 209–10 § William H. Gerdts, "Sculpture by Nineteenth-Century American Artists in the Collection of the Newark Museum," *The Museum* (Newark) n.s. 14 (Fall 1962): repro., 13 § Craven, "Early Sculptures of Ball," pp. 7–8, 10–11, discusses casting and opinion of Edward Everett, repros., cover, fig. 10, p. 11, with detail of head § Craven 1968, p. 223, fig. 7.3, p. 259 § Michael Edward Shapiro, *Bronze Casting and American Sculpture, 1850–1900* (Newark: University of Delaware Press, 1985), p. 158, lists foundry's costs for statuette.

LITERATURE (SPECIFIC)
Sotheby Parke Bernet, New York, *Important American Nineteenth- and Twentieth-Century Paintings, Drawings, and Sculpture*, May 30, 1985, offered for sale, lot 75, did not sell.

Randolph Rogers

Born July 8, 1825,
Waterloo, New York
Died January 15, 1892,
Rome, Italy

Randolph Rogers was a prominent member of the second generation of American neoclassical sculptors working in Rome. He spent most of his youth in Ann Arbor, Michigan. While working in a dry goods store in New York City he so impressed his employers with his self-taught efforts at portrait sculpture that they enabled him to study sculpture in Italy. In 1848 he began studying at the Academy of Saint Mark in Florence with the leading neoclassical sculptor Lorenzo Bartolini (1777–1850). In 1851 Rogers established a studio in Rome, where he would work for the rest of his life except for business visits to the United States. His ideal bust of *Night*, c. 1852 (unlocated), was well received when exhibited at the National Academy of Design in New York in 1852. The great success of his *Ruth Gleaning*, modeled in 1853 (example in Newark [N.J.] Museum), led to his receiving the commission for the Columbus Doors for the United States Capitol. On a trip to the United States between 1853 and 1855 he also received the commission for a statue of John Adams for Mount Auburn Cemetery in Cambridge, Massachusetts (now in Memorial Hall at Harvard University, Cambridge). Immediately after returning to Rome late in 1855, he modeled his most famous sculpture, *Nydia: The Blind Flower Girl of Pompeii* (example in LACMA; q.v.). He was married in Richmond, Virginia, in 1857, when he also was chosen to complete Thomas Crawford's Washington Monument for that city. During the late 1850s and early 1860s his studio was occupied with these major projects and beginning in 1863 carried out numerous Civil War memorials into the 1870s. Rogers continued to execute portrait busts and ideal sculptures in addition to these and other monumental projects. In 1873 he was chosen professor of sculpture at the Academy of Saint Luke in Rome, the first American to be elected. In 1884 he was awarded the order of Cavaliere della Corona d'Italia. After 1882 he was unable to work because of paralysis resulting from a stroke.

BIBLIOGRAPHY
Ann Arbor, University of Michigan, Bentley Historical Library, Michigan Historical Collections, Randolph Rogers Papers § Henry S. Frieze, "Randolph Rogers," *Michigan Alumnus* 4 (December 1897): 59–63 § Millard F. Rogers, Jr., *Randolph Rogers: American Sculptor in Rome* (Amherst: University of Massachusetts Press, 1971), with catalogue raisonné, bibliography, chronology § Horst W. Janson, "Daphnis and Chloe in the American Wilderness," in *Ars Auro Prior: Studia Ioanni Białostocki Sexagenario Dicata* (Warsaw: Państwowe Wydawnictwo Naukowe, 1981), pp. 683–86 § Vivien Green Fryd, "Randolph Rogers' Indian Hunter Boy: Allegory of Innocence," in Elvehjem Museum of Art, University of Wisconsin, Madison, *Bulletin/ Annual Report* (1984–85): 29–35.

Nydia: The Blind Flower Girl of Pompeii, modeled 1855, carved c. 1888

Marble
55 in (139.7 cm) with base
Signed on right, on bottom of overturned capital:
Randolph Rogers / Rome,
Museum purchase with Los Angeles County funds
78.4

Nydia was the most famous of Rogers's sculptures as well as the most popular, to judge from the fact that the artist sold at least fifty-two examples (see Rogers, *Rogers*, pp. 200–203 for lists of locations of life-size and half-life-size examples). It is just as remarkable that, having modeled *Nydia* in 1855–56, Rogers would sell the present example as late as 1888. Although it had still been much admired at the Centennial Exposition in Philadelphia in 1876, only a work of wide reputation and classic status would have survived the changes of taste and style that swept American sculpture during that interval.

Its subject is Nydia, the virtuous, blind flower girl in Edward Bulwer-Lytton's novel *The Last Days of Pompeii*, published in 1834.

The sculpture recreates a moment in the story when she became separated from some friends she was attempting to lead to safety on the seashore, since in the general darkness that followed the eruption of Vesuvius her developed sense of hearing was an advantage in trying to escape the doomed city. Those familiar with the novel saw her situation in a broader sense of brave struggle against impossible odds (1835 edition, 2: 189):

> Poor girl! her courage was beautiful to behold! and Fate seemed to favor one so helpless. The boiling torrents touched her not, save by the general rain which accompanied them, the huge fragments of scoria shivered the pavement before and beside her, but spared the frail form. . . .
>
> Weak, exposed, yet fearless, supported by one wish, she was the very emblem of Psyche in her wanderings; —of Hope, walking through the Valley of the Shadow; a very emblem of the Soul itself—lone but comforted, amid the dangers and the snares of life!

In the best tradition of neoclassical sculpture Rogers sought inspiration for his subject among

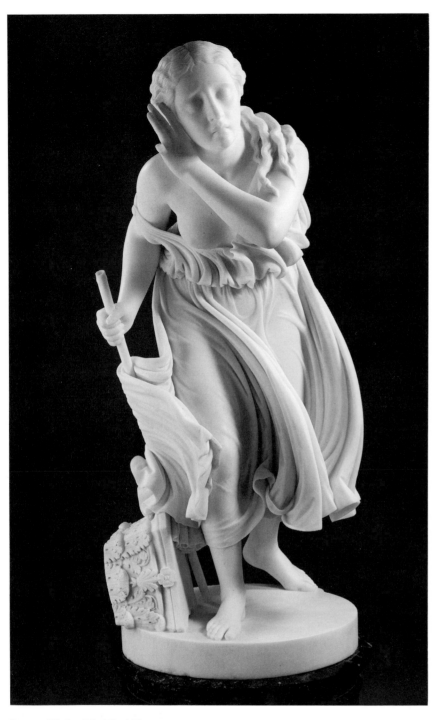

Rogers, *Nydia: The Blind Flower Girl of Pompeii.*

ancient marbles. Nydia's bent and tentative pose may have been based on a Hellenistic copy of the *Old Market Woman* (example in Vatican Museum) or the group of *Niobe and Her Daughters* in the Uffizi in Florence. The latter may have been the source of the baroque forms of *Nydia's* clinging, yet flying drapery, which, more than the fallen capital at her feet, suggests the danger faced by the helpless, wet, and wind-tossed young woman. Although *Nydia's* regular facial features and the sculpture's sources in antique art are in the tradition of neoclassical sculpture, its formal extravagance, drama, and excessively sentimental literary source are departures from that tradition that, nevertheless, made it the most popular American neoclassical sculpture ever.

The inscription does not include a date, but centered under the artist's name is the word *Rome* followed by a comma, as if the date were to be added when the piece was sold. The reason for its omission is unknown.

PROVENANCE
Probably Frank J. Baird, Kansas City, Mo., 1888 § Kansas City Museum and Kansas City Public Library § Kansas City Public Schools § U.S. Trade Schools, Kansas City (sale, Sotheby Parke Bernet, New York, *American Nineteenth- and Twentieth-Century Paintings, Drawings, Watercolors, and Sculpture,* April 21, 1978, no. 102, repro.).

ON DEPOSIT
Sotheby Parke Bernet, New York, 1978.

LITERATURE (GENERAL)
Ann Arbor, University of Michigan, Bentley Historical Library, Randolph Rogers Papers, the artist to Henry Frieze, April 3, 1859, discusses difficulties in producing the piece: "The *Nydia* is a very expensive statue to execute in marble, on account of the position of the figure. Then the flying drapery, deep cutting, and undercutting make it a very laborious undertaking." § Tuckerman 1867, p. 591, describes and opines "it is an effective work, though the main idea is not new" § Maitland Armstrong, *Day Before Yesterday* (New York: Scribner's, 1920), p. 194, discusses visiting Rogers's studio, where seven Italian stonecarvers were cutting seven examples of *Nydia:* "a gruesome sight" § Millard F. Rogers, Jr., "Nydia, Popular Victorian Image," *Antiques* 97 (March 1970): 374–77 § Rogers, *Rogers,* pp. 33–41, 96, discusses literary and classical statuary sources, pp. 200–203, lists examples and locations, figs. 10, 11, pp. 34–35.

LITERATURE (SPECIFIC)
Ann Arbor, University of Michigan, Bentley Historical Library, Randolph Rogers Papers, Sales Journal of the artist, entry for May 22, 1888, states sold to Frank J. Baird for two thousand dollars § Rogers, *Rogers,* p. 202, listed as no. 14, *Nydia* (first version), owned by Baird § "New Acquisition: American Art," *LACMA Members' Calendar* 16 (October 1978): 4 § "American Art," *LACMA Report 1977–1979* (1980), p. 13.

William Wetmore Story

Born February 12, 1819,
Salem, Massachusetts
Died October 7, 1895,
Vallombrosa, Italy

William Wetmore Story was one of the leading members of the American expatriate colony in Rome during the second half of the nineteenth century and a major proponent of the second, more naturalistic and detailed phase of neoclassical sculpture. The son of Supreme Court Justice Joseph Story, William was trained as a lawyer; after receiving degrees from Harvard College in 1838 and 1840, he practiced law for a few years and wrote several legal textbooks. Upon the death of his father in 1845, he was commissioned to execute a memorial statue, and in preparation he traveled to Italy in 1847 to study sculpture. He became immersed in the artistic and literary community of Rome, becoming an intimate of Robert and Elizabeth Barrett Browning. By 1851 he decided to abandon law for art, and in 1856 he settled permanently in Italy. His father's memorial, 1852 (Mount Auburn Cemetery, Cambridge, Mass.), was the first of numerous commissions for portrait and memorial statues Story received during his long career. He made statues of Edward Everett, 1867 (Richardson Park, Boston), and Chief Justice John Marshall, 1884 (United States Supreme Court, Washington, D.C.), and busts of English poets, among them Elizabeth Barrett Browning, 1861 (example of 1866, Boston Athenaeum).

Story's international reputation arose from his dramatic, full-length figures of tragic women from history and mythology. He was praised for the accuracy of the narrative details of costume and accessories in these marble statues.

A highly erudite man, Story was also an accomplished poet and essayist and published poems as early as 1842; among his books is *Excursions in Art and Letters* (1891). Story was a close friend of Henry James, his first biographer, and Nathaniel Hawthorne, whose stories popularized his early sculptures. Story also wrote a practical canon on the drawing of the human figure, which was published about 1866.

BIBLIOGRAPHY
University of Texas at Austin, Harry E. Ransom Humanities Research Center, William Wetmore Story Papers § William Wetmore Story, *Conversations in a Studio*, 2 vols. (Boston: Houghton, Mifflin, 1890) § Mary E. Phillips, *Reminiscences of William Wetmore Story, The American Sculptor and Author* (Chicago: Rand McNally, 1897), with lists of literary works, statues, and busts § Henry James, *William Wetmore Story and His Friends*, 2 vols. (1903; reprint, New York: Kennedy Galleries and Da Capo Press, 1969) § Jan M. Seidler, "A Critical Reappraisal of the Career of William Wetmore Story (1819–1895), American Sculptor and Man of Letters," 2 vols., Ph.D. diss., Boston University, 1985, with reprint of Story's poem "Cleopatra," transcript of "List of Sculpture Compiled by Story for Eliza Allen Starr's Lecture on Living Artists," bibliography.

Cleopatra, modeled 1858, carved 1860
(*Cleopatra Poisoning Herself; Cleopatra Seated*)
Marble on polychrome wood platform
55 in (139.7 cm) with base, on 9¾ in (24.8 cm) platform
Signed and dated on back, underneath chair:
W W STORY / ROME / 1858
Gift of Mr. and Mrs. Henry M. Bateman
78.3

Cleopatra made Story's reputation and set the standards for the second phase of American neoclassical sculpture. Story had planned to begin a compositional study for it during the winter of 1856–57 but only started the clay model during the winter of 1858. The carving of *Cleopatra* in marble was not completed until December 1860, but the statue was inscribed with only an 1858 date to commemorate the commencement of work.

When he could had not attract any buyers for the work over the next several years, Story contemplated abandoning the profession. Pope Pius IX sent, at his expense, *Cleopatra* and

Story's *Libyan Sibyl*, 1860 (Metropolitan Museum of Art, New York) to the 1862 *International Exhibition* in London along with several other sculptures by artists residing in Italy. *Cleopatra* was an immediate success, receiving favorable reviews from several newspapers and periodicals, including the London *Athenaeum*, which rated it, along with the *Libyan Sibyl*, as the most important sculpture in the exhibition. As a result, Story found a buyer for *Cleopatra*, a Mr. Morrison, a wealthy, provincial Englishman, who paid him three thousand pounds for it. The sculpture remained in the family, lost to public attention until 1978, when it was bought by the museum.

The museum's marble is the only example of the first of three versions created by the sculptor. About 1863–64 Story created a second version by slightly altering details of the original design. Four marble examples of this second version were made in life size, each dated at the time of its sale (Daniel Grossman, Inc., New York, 1865; Metropolitan Museum of

Art, New York, 1869; unlocated, formerly collection of Count Palffy, Paris, 1877; High Museum of Art, Atlanta, 1878). The one in the Metropolitan Museum of Art is the best-known example of this second version. Later, in 1884, Story revised his idea a third time to design a reclining Cleopatra; it is not known if this version was ever realized in marble.

The fame of *Cleopatra* is due not only to its reception in 1862 but also to the frequency with which the Metropolitan Museum's sculpture has been discussed and reproduced in the literature on Story; the best-known example, it has often been mistaken for the first version. The difference between the Los Angeles Museum's and the Metropolitan Museum's sculptures are subtle yet significant. They

represent the sculptor's reinterpretation of the theme and his turn to a more naturalistic style, one that was favored by the second generation of neoclassical sculptors. Julian Hawthorne discussed the artist's quandary over the gesture of Cleopatra's left hand:

> I remember very well the statue of Cleopatra while yet in clay. . . . Cleopatra was substantially finished, but Story was unwilling to let her go, and had no end of doubts as to the handling of minor details. The hand that rests on her knee—should the forefinger and thumb meet or be separated? If they were separated, it meant the relaxation of despair; if they met, she was still meditating defiance or revenge. After canvassing the question at great length

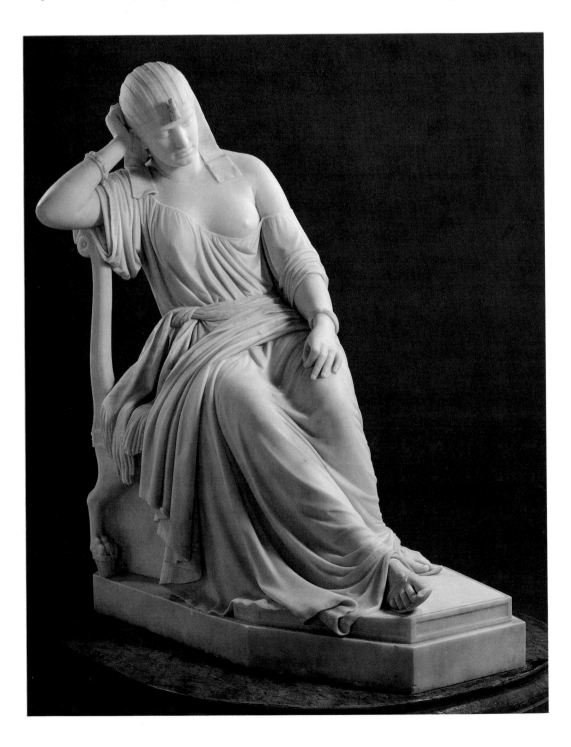

Story, *Cleopatra.*

with my father [Nathaniel Hawthorne], he decided that they should meet; but when I saw the marble statue in the Metropolitan Museum the other day I noticed that they were separated.

Hawthorne obviously saw the model for the first version in the studio: in the Los Angeles marble the thumb and forefinger are touching.

Story exaggerated the relaxed posture of the figure and changed the drapery in the second version. In the Los Angeles *Cleopatra* the left breast is partially exposed, with the drapery hanging in an unnatural but decorous manner; in the Metropolitan Museum's example Cleopatra's left breast is fully exposed, her garment falling from her shoulder more naturally.

Other differences in the details between the two versions might be attributed to the growing interest in the Near East that took place in Europe and America during the second half of the nineteenth century. In the Metropolitan Museum's figure Story gave the Egyptian queen a slightly more African physiognomy, perhaps to suggest an Eastern sensuality. Story also changed the details of the base from a simple, classical, rectangular design to one with Eastern arches.

The exoticism of *Cleopatra* is most obvious in the figure's jewelry and demonstrates just how typical of the nineteenth century the sculpture is. During the mid-1860s the artist had the opportunity of visiting in Paris an exhibition of ancient Egyptian jewelry and other artifacts. Although Story was praised for the authenticity of the Eastern jewelry, Cleopatra's accoutrements were a modern fabrication based on some familiarity with, but not an accurate understanding of, ancient artifacts. While Story's figure wears the Egyptian *nemes* (headcloth), the cloth is not flat as in those worn by the Ptolemaic pharaohs nor is the *uraeus* (cobra headdress) positioned correctly. Story's Cleopatra wears two bracelets, a snake band whose ends do not spiral in the same configuration as ancient jewelry, and a bracelet of authentic scarabs in a Victorian setting. The reworking of ancient motifs is also apparent in the chair. In his fascination with the decorative detail of other eras Story was a typically Victorian artist.

Nathaniel Hawthorne's *The Marble Faun* (1860) was a fictionalized account of Story's creation of the first version of *Cleopatra*. It and the later publication of the writer's journals were partly responsible for the sculpture's reputation. Hawthorne, who was a friend of Story's in Rome, witnessed the creation of the statue almost from the start. Visiting Story on February 12, 1858, only fourteen days after he had commenced work on the sculpture, Hawthorne wrote in his journal, "The statue of Cleopatra . . . is a grand subject, and he is conceiving it with depth and power. . . . He certainly is sensible of something deeper in his art than merely to make nudities and baptize them by classic names." The type of subject matter Story preferred might have been encouraged by his friendship with Hawthorne, for like the author, Story was intrigued by heroes caught in intense psychological drama. Unlike other American neoclassical sculptors, Story was fascinated with mythical and historical heroines, such as Medea and Delilah, whose fates were determined by their personalities. Cleopatra was the first of several statues he made of such women. Story often depicted his heroines seated and brooding, inspired by the powerful seated prophet figures of Michelangelo, whom he greatly admired.

Hawthorne's admiration of Story's abandonment of the classicized representation in favor of a more real, even "terribly dangerous woman," led him to the story of the sculptor Kenyon in *The Marble Faun* ([Chicago: Homewood, 1861], pp. 101–3):

"My new statue!" said Kenyon. . . .

He drew away the cloth that had served to keep the moisture of his clay model from being exhaled. The sitting figure of a woman was seen. She was draped from head to foot in a costume minutely and scrupulously studied from that of ancient Egypt, as revealed by the strange sculpture of that country, its coins, drawings, painted mummy-cases, and whatever other tokens had been dug out of its pyramids, graves, and catacombs. Even the stiff Egyptian head-dress was adhered to, but had been softened into a rich feminine adornment. . . . Cleopatra sat attired in a garb proper to her historic and queenly state

A marvelous repose—that rare merit in statuary . . . was diffused throughout the figure. The spectator felt that Cleopatra had sunk down out of the fever and turmoil of her life, and for one instant . . . had relinquished all activity. . . . It was the repose of despair.

The face was a miraculous success. The sculptor had not shunned to give the full, Nubian lips, and other characteristics of the Egyptian physiognomy. His courage and integrity had been abundantly rewarded; for Cleopatra's beauty shone out richer, warmer, more triumphantly beyond comparison, than if, shrinking timidly from the truth, he had chosen the tame Grecian type. The expression was of profound, gloomy, heavily revolving thought.

In a word, all Cleopatra—fierce, voluptuous, passionate, tender, wicked, terrible, and full of poisonous and rapturous enchantment—was kneaded into what, only

a week or two before, had been a lump of wet clay from the Tiber.

"What a woman is this!" exclaimed Miriam.

PROVENANCE
The artist, to 1862 § Mr. Morrison, Basildon Parke, Berkshire, England, 1862 § Baron Iliffe (by descent), Basildon Parke, to 1978 (sale, Sotheby Parke Bernet, New York, *American Nineteenth- and Twentieth-Century Paintings, Drawings, Watercolors, and Sculpture,* April 21, 1978, no. 100, repro.).

ON DEPOSIT
Sotheby Parke Bernet, New York, 1978.

EXHIBITION
London, *International Exhibition,* Fine Art Department, Foreign Division, Roman School, 1862, no. 2691, as *Cleopatra Seated.*

LITERATURE (SPECIFIC)
Cambridge, Mass., Harvard University, Houghton Library, Charles Eliot Norton Papers, the artist to Norton, August 1857–December 6, 1860 § Nathaniel Hawthorne, diary entry for October 4, 1858, in *Notes of Travel* (Boston: Houghton, Mifflin, 1900), pp. 260–61 § Christopher Cranch to his wife, November 18, 1858, in *Letters of Christopher Pearse Cranch,* ed. Leonora Cranch Scott (Cambridge, Mass.: Houghton, Mifflin, 1917), pp. 234–35 § Hiram Fuller, *Sparks from a Locomotive* (New York: Derby and Jackson, 1859), p. 270 § Henry Adams to Charles Francis Adams, May 17, 1860, in *The Letters of Henry Adams,* eds. J. C. Levinson et al. (Cambridge, Mass.: Harvard University Press, 1982), 1: 143 § "William Wetmore Story and His Cleopatra," *Dwight's Journal of Music* 17 (July 1860): 141, comments on the sculpture in progress § Edward Everett Hale, *Ninety Days Worth of Europe* (Boston: Walker, Wise, 1861), pp. 141–48, praises historical accuracy of attire § Robert Browning to Mr. and Mrs. William W. Story, November 10, 1861, and April 10, 1862, in *Browning to His American Friends,* ed. Gertrude R. Hudson (New York: Barnes & Noble, [1965]), pp. 85, 106 § University of Texas at Austin, Ransom Humanities Research Center, William Wetmore Story Papers, "Statues by W. W. Story"; William Wetmore Story, "Wise Saws and Modern Instances" § "International Exhibition," *London Athenaeum* no. 1802 (May 10, 1862): 631 § "Taste at South Kensington," *Temple Bar* 5 (July 1862): 478–79, praises Story's use of a delicate tint § Harriet Beecher Stowe, "Sojourner Truth: The Libyan Sibyl," *Atlantic Monthly* 12 (April 1863): 473 § University of Texas at Austin, Ransom Humanities Research Center, William Wetmore Story Papers, the artist to "Dear Sir," October 12, 1863, defends his interpretation of Cleopatra as Egyptian rather than classicized based on his genealogical research § James Jackson Jarves, *The Art-Idea,* ed. Benjamin Rowland, Jr. (1864; reprint, Cambridge, Mass.: Harvard University Press, 1960), p. 224 § "Miss Hosmer's Statue of Zenobia," *New Path* 2 (April 1865): 49–50, favorably compares with Harriet Hosmer's *Zenobia,* finding Story's *Cleopatra* to demonstrate "independence and freshness" §

Tuckerman 1867, p. 577 § Nathaniel Hawthorne, *Passages from the French and Italian Notebooks,* vol. 10 of *The Complete Works* (1871; Riverside ed., Boston: Houghton, Mifflin, 1882), pp. 71–72, 171, praises statue in early stages and after completion § James Jackson Jarves, *Art Thoughts* (New York: Hurd & Houghton, 1871), pp. 311–12, changes his position in *Art-Idea* of 1864 and considers the pose awkward and the subject sensational, as *Cleopatra Poisoning Herself* § William J. Clark, *Great American Sculptures* (Philadelphia: Gebbie & Barrie, 1877), pp. 91–92, discusses issue of accuracy of Story portraying Cleopatra as African § New York Public Library, Berg collection, William Wetmore Story to Enrico Nencioni, n.d., recounts history of the sculpture and how he first heard of *The Marble Faun* from visitors admiring *Cleopatra* in his studio § Obituary, *Harvard Graduates Magazine* 4 (December 1895): 288 § Phillips, *Reminiscences of Story,* pp. 131–35, 229, 295, discusses her impression of the work, quotes Hawthorne, mentions second version and related poem, lists with 1860 date § Julian Hawthorne, *Hawthorne and His Circle* (New York: Harper & Brothers, 1903), pp. 289–90, describes clay model and Story's problem with the gesture of the left hand § James, *Story and His Friends,* 1: 32–33, 358; 2: 72, 76, 79–80, 85, 217 § Homer Saint-Gaudens, ed., *The Reminiscences of Augustus Saint-Gaudens* (1913; reprint, New York: Garland, 1976), 1: 58, ranks it Story's chief work § Taft 1930, pp. 150–56, disagrees with Hawthorne's claim that it has "regal beauty" and states that it suffers from an "avid treatment" § Albert T. Gardner, "William Story and Cleopatra," *Metropolitan Museum of Art Bulletin* n.s. 2 (December 1943): 147, 150–51 § Margaret Farrand Thorp, *The Literary Sculptors* (Durham, N.C.: Duke University Press, 1965), pp. 18, 45–46, gives history and implies that the version as in the Metropolitan Museum is the one described by Hawthorne § William H. Gerdts, "Egyptian Motifs in Nineteenth-Century American Painting and Sculpture," *Antiques* 90 (October 1966): 497–98 § Craven 1968, pp. 277–79, states that the original is in Goldsmith's Company Hall, London [now in High Museum of Art, Atlanta] § Frank R. DiFederico and Julia Markus, "The Influence of Robert Browning on the Art of William Wetmore Story," *Browning Institute Studies* 1 (1973): 67–68, 72, discusses *Cleopatra* as an example of Story's interest in psychological content as a response to Browning's poetic technique of dramatic monologue § New York, Whitney Museum of American Art, *Two Hundred Years of American Sculpture,* exh. cat., 1976, p. 43, essay by Wayne Craven, p. 314, biographical entry by Libby Seaberg § Michael Quick, "Homer in Virginia," *LACMA Bulletin* 24 (1978): 61, 80 n. 7, comments on Cleopatra's Negroid physiognomy and links sculpture to Story's abolitionist sentiments, fig. 1, 63 § "New Acquisition: American Art," *LACMA Members' Calendar* 16 (October 1978): repro., p. 4 § "La Chronique des arts: principales acquisitions des musées en 1978," *Gazette des Beaux-Arts,* 6th ser., 93 (April 1979): repro., supp. 46 § "American Art," *LACMA Report 1977–1979* (1980), p. 13, repro., p. 12 § Patricia Dawes Pierce, "Deciphering Egypt: Four Studies in the American

Sublime," Ph.D. diss., Yale University, 1980, pp. 4–5, 32–33, 35–41, 46, 111–14, incorrectly states 1858 version is unlocated, discusses classical and neoclassical antecedents, literary associations, and sexual theme § *LACMA Members' Calendar* 19 (September 1981): repro., cover § Jan Seidler Ramirez, "William Wetmore Story's *Venus Anadyomene* and *Bacchus:* A Context for Reevaluation," *American Art Journal* 14 (Winter 1982): 33 § Jerry E. Patterson, "Three Marble Ladies in the Saleroom," *Maine Antique Digest* 11 (February 1983): 1b § Jan Seidler Ramirez, "The 'Lovelorn Lady': A New Look at William Wetmore Story's *Sappho*," *American Art Journal* 15 (Summer 1983): 81 § LACMA, American Art department files, Jan Seidler Ramirez to William Gerdts, April 30, [no year] (photocopy), discusses differences between first and second versions § Seidler, "Critical Reappraisal of Story," 2: 407–14, 448, 453–503, 507, 517, 521–57, 561–65, contains most extensive analysis of sculpture vis-a-vis the standard Story literature and unpublished letters: considers circumstances of its London exhibition, publicity through Hawthorne's writings, Egyptian theme in context of midcentury orientalism, and other versions, 2: 719, listed as "1st Cleopatra" in transcript of Story list for Starr, fig. 29, 2: 779, detail as fig. 31, 2: 781 § LACMA 1988, p. 16, repro.

John Quincy Adams Ward

Born June 29, 1830,
near Urbana, Ohio
Died May 1, 1910,
New York, New York

John Quincy Adams Ward was the foremost American proponent of realism in bronze sculpture during the third quarter of the nineteenth century. In 1849 he became the student of the prominent sculptor Henry Kirke Brown (1814–1886). Ward remained with Brown for seven years and eventually worked as his studio assistant on such projects as Brown's equestrian sculpture of George Washington, 1853–56 (Union Square, New York). He worked in Washington, D.C., sculpting portrait busts of politicians and visited Ohio before opening his own studio in New York in 1860. Although he established his reputation with *The Indian Hunter*, 1858 (example in LACMA; q.v.), and made several other ideal figures, such as *Freedman*, 1863 (example in American Academy and Institute of Arts and Letters, New York), he abandoned such subjects for portraiture. He was frequently commissioned to make both small portrait busts and public monuments. He executed major full-length statues and equestrian and other complex monuments, memorializing, among others, President James Garfield, Major General George H. Thomas, Horace Greeley, and Henry Ward Beecher.

By the early 1870s he was considered among the preeminent American sculptors. He also began to be active in art organizations: he participated in the formation of the Metropolitan Museum of Art and served as president of the National Academy of Design in 1874 and president of the National Sculpture Society from its inception in 1893 to 1904. In 1872 Ward visited Europe, obtaining the advice of sculptor Frédéric-Auguste Bartholdi (1834–1904) regarding the purchase of plaster casts for the National Academy of Design. The literal naturalism of his work was transformed somewhat by his response to French art. Although he never relinquished naturalism, his surfaces became increasingly invigorated and his figures expressed greater movement. In his late, multifigured monuments the more complex relationship between the figure and their base reflects the influence of Beaux-Arts aesthetics. At the end of his life Ward was involved in planning the sculptural ornamentation of the Library of Congress, contributed to the triumphal arch erected for Admiral George Dewey in New York in 1899, and four years later collaborated with the young Paul W. Bartlett (1865–1925) on the pediment of the New York Stock Exchange Building.

BIBLIOGRAPHY
Albany (N.Y.) Institute of History and Art and New-York Historical Society, John Quincy Adams Ward Papers (those in New-York Historical Society on microfilm, Archiv. Am. Art) § New York, National Sculpture Society, *Memorial Exhibition of Works by the Late John Quincy Adams Ward, N.A.,* exh. cat., 1911 § George W. Sheldon, "An American Sculptor," *Harper's New Monthly Magazine* 57 (June 1878): 62–68 § Adeline Adams, *John Quincy Adams Ward: An Appreciation* (New York: National Sculpture Society, 1912), with chronological list of major statues § Lewis Inman Sharp, *John Quincy Adams Ward: Dean of American Sculptors,* An American Art Journal/Kennedy Galleries Book (Newark: University of Delaware Press, 1985), with catalogue raisonné, bibliography.

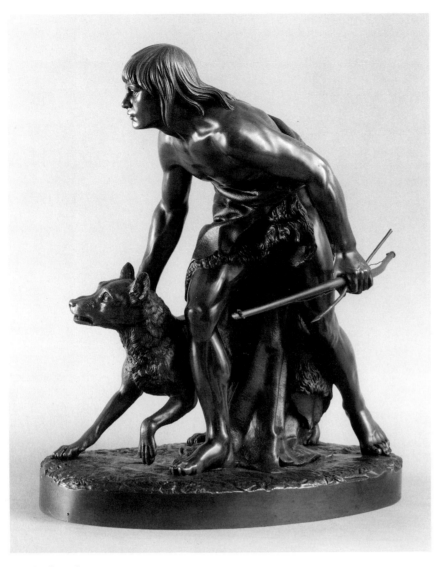

Ward, *The Indian Hunter.*

The Indian Hunter, modeled 1858, cast 1860

Bronze
16 in (40.6 cm) with base
Signed and dated on top of base, under dog: J. Q. A. Ward / 1860
Gift of Dart Industries, Inc., and Jo Ann and Julian Ganz, Jr.
M.77.38

Ward's reputation was established with his large cast of *The Indian Hunter,* 1866, the first statue to be placed in Central Park. That statue was modeled after a smaller bronze, of which the museum's sculpture is one of about fifteen known examples, all dated 1860. They are among the earliest American bronzes.

Although Ward traveled to the Dakotas to study Native American life and physiognomy between his creation of the half-life-size stat-uette and the statue in Central Park, the differences between the two sculptures are minor: in the outdoor *Indian Hunter* the arm holding the bow is slightly raised, the aborigi-

nal quality of the face emphasized, the animal skin reduced, and shape of the base made rectangular rather than oval. Ward based the general pose of *The Indian Hunter* on the famous classical *Borghese Gladiator* (Musée du Louvre, Paris), which he may have known from a plaster cast.

This bronze demonstrates Ward's skill at infusing a figure with an animated realism that was new to American sculpture. The surface of the man's body is highly polished, and exten-sive chasing developed texture in other areas. Ward contrasts the textures of the man's smooth skin, the coarse, thick hair of the pelt, and the soft, curly fur of the dog. Moreover, the poses are those of suspended animation as the hunter stalks his prey, momentarily holding back his dog to concentrate on the quarry.

Ward's choice of subject matter was impor-tant to the work's success. Mid-nineteenth-century artists had only recently turned to the Native American as a subject. Articles such as "The Indian in American Art" in the 1856 issue of *The Crayon* encouraged them to depict his character before he disappeared. Ward's teacher, Henry Kirke Brown, had been the first to do so in bronze, and Ward first modeled this figure while still in Brown's studio.

Some of the approximately fifteen known casts of the statuette of *The Indian Hunter* bear the mark of the Henry-Bonnard Bronze Company, New York, and others that of the Gorham Company, Providence, R.I.; yet others were cast by unknown foundries. Three larger than life-size casts are recorded (see Sharp, *Ward,* pp. 147–49 for list of known examples).

RELATED WORKS
Eight studies for figure's head, c. 1857–64, wax, each approximately 3 to 5 in (7.6 to 12.7 cm). American Academy and Institute of Arts and Letters, New York § Study for dog, c. 1857–64, wax, approx. 2 in (5.0 cm). American Academy and Institute of Arts and Letters, New York § *Study of Indian Hunter,* c. 1857–64, pencil on paper, dimensions unknown, Albany Institute of History and Art § Preliminary sketch model, plaster, 16½ in (41.9 cm). Erving and Joyce Wolf, New York § Original "pin model" (for casting additional examples), bronze, 16 in (40.6 cm). American Academy and Institute of Arts and Letters, New York.

PROVENANCE
Private collection (sale, C. G. Sloan & Co., Wash-ington, D.C., *Public Auction,* February 6, 1977, no. 1305, repro., p. 98).

ON DEPOSIT
National Collection of Fine Arts, Smithsonian Institution, Washington, D.C., 1977.

LITERATURE (GENERAL)
"Sketchings," *The Crayon* 6 (June 1859): 193, reviews

Indian and Dog on view at Pennsylvania Academy of the Fine Arts and urges someone to commission a larger bronze or marble § Tuckerman 1867, pp. 581–82, discusses small bronzes and lists J. C. McGuire, Washington, D.C., as owner of one § Craven 1968, p. 247 § Lewis Inman Sharp, "A Catalogue of the Works of the American Sculptor John Quincy Adams Ward, 1830–1910," Ph.D. diss., University of Delaware, 1980, pp. 14–15, 17, 117–22 § Sharp, *Ward*, pp. 37–38, 146–50, listed in cat. raisonné as no. 12, fig. 18, p. 38, pls. 2, 4, pp. 98, 100, repro., p. 148.

LITERATURE (SPECIFIC)
Advertisement, *Antiques* 110 (December 1976): repro., 1165 § "New Acquisition: American Sculpture," *LACMA Members' Calendar* 15 (August 1977): unpaginated, repro. § "American Art Department," *LACMA Report 1975–1977* (1978), p. 14, repro., p. 12 § Lewis Inman Sharp, "A Catalogue of the Works of the American Sculptor John Quincy Adams Ward, 1830–1910," Ph.D. diss., University of Delaware, 1980, p. 122, listed as no. 9 of *The Indian Hunter* statuettes § Sharp, *Ward*, p. 148, listed as no. 12.8.

Augustus Saint-Gaudens

Born March 1, 1848,
Dublin, Ireland
To United States 1848
Died August 3, 1907,
Cornish, New Hampshire

Augustus Saint-Gaudens is considered to be among the greatest of American sculptors. He grew up in New York City. In 1861, at age thirteen, he was apprenticed to Louis Avet (active mid-nineteenth century), a French cameo cutter. From 1864 to 1867 Saint-Gaudens worked in New York as a cameo cutter, attending drawing classes at the Cooper Union and later at the National Academy of Design. In Paris in 1867 he studied drawing in preparation for his admission the following year to the studio of François Jouffroy (1806–1882) in the Ecole des Beaux-Arts. With the outbreak of the Franco-Prussian War in 1870 he went to Rome and worked as a sculptor, very gradually obtaining patronage. In September 1872 he visited New York, returning to Rome early the following year. From 1875 to 1877 he was involved in decorative sculptural projects in New York but also received other important commissions. In 1877 he married and returned to Europe.

Saint-Gaudens was among the founders of the Society of American Artists in New York in 1877. Beginning in 1880 he worked almost continuously in New York and after 1891 also at his summer home and studio at Cornish, New Hampshire. During this period he was widely recognized as the greatest living American sculptor and received many of his most important commissions. A retrospective memorial exhibition was held at the Metropolitan Museum of Art, New York, the year after his death.

BIBLIOGRAPHY
Royal Cortissoz, *Augustus Saint-Gaudens* (Boston: Houghton Mifflin, 1907) § Homer Saint-Gaudens, ed., *The Reminiscences of Augustus Saint-Gaudens*, 2 vols. (1913; reprint, in The Art Experience in Late Nineteenth-Century America Series, ed. H. Barbara Weinberg, New York: Garland, 1976), with chronological list of works by the artist § Louise Hall Tharp, *Saint-Gaudens and the Gilded Age* (Boston: Little, Brown, 1969) § John H. Dryfhout, *The Work of Augustus Saint-Gaudens* (Hanover, N.H.: University Press of New England, 1982), with catalogue raisonné, bibliography, appendixes listing studio assistants, works by Louis Saint-Gaudens, works in public collections, and works misattributed to Saint-Gaudens, discussion of Saint-Gaudens Memorial in Cornish, N.H. § New York, Metropolitan Museum of Art, and Boston, Museum of Fine Arts, *Augustus Saint-Gaudens: Master Sculptor*, exh. cat., 1985, text by Kathryn Greenthal, with bibliography.

Florence Gibbs, 1872
Marble
21⁹/₁₆ in (54.8 cm)
Signed, inscribed, and dated under right breast on socle: Aug St Gaudens / Fecit Roma 1872
Los Angeles County Fund
24.5

Although Saint-Gaudens is known for his bronze sculptures, virtually all his work before 1877 that was not in cameos was carved in marble. His heads of two sisters, *Florence Gibbs* and *Belle Gibbs*, 1872 (Museum of Fine Arts, Houston, Tex.), were significant early efforts at portraiture, which was to remain an important part of the sculptor's work throughout his career.

As a young sculptor working in Rome in the early 1870s Saint-Gaudens depended on the patronage of Americans visiting the city. Montgomery Gibbs, father of Belle and Florence, a successful New York lawyer and writer, visited Saint-Gaudens's studio in January 1872 to order a cameo for his wife. He was so impressed by Saint-Gaudens's work that on a second visit to the studio, when he met the ailing sculptor, he offered him several commissions. Gibbs was Saint-Gaudens's first major patron and extended the struggling young artist financial support at a critical time in his career. While the family was in Rome, Saint-Gaudens began the busts of Belle and Florence that Montgomery Gibbs commissioned as part of his agreement to support the sculptor. He

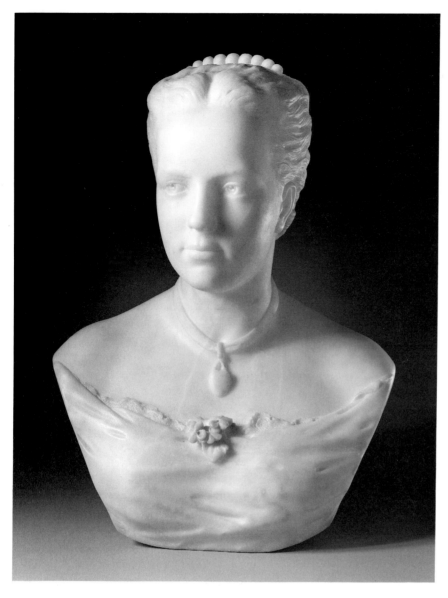

Saint-Gaudens, *Florence Gibbs.*

Saint-Gaudens, *Belle Gibbs,* 1872, marble, 26¾ in (67.9 cm). Museum of Fine Arts, Houston, gift of the family of Joseph S. Cullinan.

must be added the forty francs for what work the buffator had done on it. This of course makes it impossible to have it finished for my [proposed] departure [in July]. The features will be finished, but the hair and the accessories will take some time after my departure.

In a letter to the father on July 18, 1872, he reported on the progress of the busts: "Miss Belle's portrait has also been even a greater success than I expected on the marble. The marble on Miss Florence's is one of the finest pieces I have yet met with and if the accessories come out as well as Miss Belle's—and there is no reason for the contrary—it will be finer, *if anything* than Miss Belle's." There were additional delays before the Gibbs family received the finished busts, but a letter from Florence Gibbs in September 1874 reports the family's satisfaction with both.

Despite Saint-Gaudens's expressed satisfaction with the marble, it should be noted that compared with the flawless marble Hiram Powers (1805–1873) and other neoclassical sculptors insisted upon, the marble in the bust of Florence Gibbs is less than perfect, with some soft rust-colored areas, veins of pure white in the warmer stone, and one open crack on the right shoulder.

The bust came to the museum identified as Belle Gibbs, but a letter to Saint-Gaudens from Florence Gibbs in April 1872 refers to the locket: "I forgot to give you the heart locket to copy, but perhaps you remember it," indicating that Florence is the subject of the museum's bust.

Saint-Gaudens recalled the sisters as "both young and attractive" and also recalled having a "soft spot" for Florence. Mrs. Thomas Ridgeway Gould, wife of the sculptor and a host to Americans in Rome, noted Saint-Gaudens's interest in the younger sister, although she felt Florence was coquettish. In one of her several letters to Saint-Gaudens, Florence wrote, "You are bound that my features, including the purely Grecian nose shall go down to posterity in correct shape." The sculptor saw the girls socially on several occasions when they were in Rome. Some association may have continued afterward, to judge from the fact that Belle, then Mrs. John Merrylees, sent the sculptor an announcement of the marriage of her daughter in 1905. Nothing is known of the later life of Florence.

The busts were conceived as a pair and are very similar in format and attire but not in interpretation. Belle's (see illustration) is a more animated likeness. She looks forward with her lips slightly parted in a slight smile, whereas Florence turns slightly to the right and looks to the right and has a quieter, more thoughtful expression. Although executed

needed photographs to complete the likenesses, however; Gibbs wrote from Naples in February that Florence had been too busy to have her photograph taken but that Belle was then at the photographer's studio. In April Florence wrote from Venice that she had not yet had the photograph taken but would have it done when the family was in Vienna.

In a letter of May 1872 to Montgomery Gibbs, Saint-Gaudens wrote of the busts:

Miss Belle's bust will be finished in two or three days and I am highly satisfied. I cannot say the same though of Miss Florence's bust. It has been quite unfortunate. After having the rest of the bust roughed out and commencing to work on the features, a spot in the marble appeared over the left eye, so of course cutting could not go on. I have been obliged to buy another piece, this time not so cheaply. It cost fifty francs. I have had it commenced immediately and now I am sure we shall not be so unfortunate. The misfortune takes back the economies I had made on the first two pieces, because to the sum

in white marble, they are not neoclassical in feeling. Their naturalism and strong sense of personality recall the French portrait sculpture of the late eighteenth century, especially that of Jean-Antoine Houdon (1741–1828), as well as the work of contemporary French sculptors working in a rococo style. Specific stylistic features of *Florence Gibbs* may have been derived from the work of Houdon, particularly the hollow carving of the pupils, the line of lace edging that vaguely resembles the loose drapery of Houdon, and especially the turning of the head and the glance away that in the work of Houdon suggest an animated but elusive personality glimpsed in an unguarded moment.

PROVENANCE
Montgomery Gibbs, New York, 1872–81 § Probably Florence Gibbs (by descent) § With J. F. McCarthy, New York, as of 1924.

EXHIBITION
Library of the Boston Athenaeum, *Touched with Nobility: Portrait Sculpture of American Women by Augustus Saint-Gaudens (1848–1907),* 1984, no. 4, essay by Kathryn Greenthal, unpaginated.

LITERATURE
Hanover, N.H., Dartmouth College, Library Archives, Saint-Gaudens Collection, Saint-Gaudens–Gibbs family correspondence, February 26, 1872, to 1874; the artist's account book,

Rome, c. 1872–75, lists cost of bust as ninety-seven dollars § New York, Metropolitan Museum of Art, Archives, Mrs. John Merrylees (Belle Gibbs) to H. W. Kent [1908], inaccurately states that the Gibbs busts were destroyed in a fire § Saint-Gaudens, *Reminiscences,* 1: 112–13, 123–24, 134; 2: 361; dated 1870 § "Recent Acquisitions," *LA Museum Art Dept. Bull.* 6 (October 1924): 163 § *For Arts Sake* 2 (November 1, 1924): 3 § *Index 20th Cent. Artists* 1 (May 1934): 114; reprint, p. 162; listed, as *Miss Belle Gibbs* § Margaret Bouton, "The Early Works of Augustus Saint-Gaudens," Ph.D. diss., Radcliffe College, 1946, pp. 145–48, 451 § Craven 1968, p. 375 § Washington, D.C., National Park Service, Office of Archaeology and Historic Preservation, John W. Bond, "Augustus Saint-Gaudens: The Man and His Art," manuscript, 1968, pp. 25, 27 § Tharp, *Saint-Gaudens,* pp. 50–51, 53–57, 64–65, repro., p. 66, as *Belle Gibbs* § John Dryfhout, "A Portrait Bust of Belle Gibbs," *Houston Museum of Fine Arts Bulletin* n.s. 4 (Summer 1973): 34–37, fig. 11, p. 35, clarifies identity of sitter § Louis Goldreich Marcus, "Studies in Nineteenth-Century American Sculpture: Augustus Saint-Gaudens (1848–1907)," Ph.D. diss., City University of New York, 1979, p. 28 n. 65 § Dryfhout, *Saint-Gaudens,* pp. 4, 58–59, 73, listed in cat. raisonné as no. 26, with literature references, repro., p. 59 § Burke Wilkinson, *Uncommon Clay: The Life and Works of Augustus Saint-Gaudens* (San Diego, Calif.: Harcourt Brace Jovanovich, 1985), pp. 49, 51 § Metropolitan Museum of Art, *Saint-Gaudens,* pp. 69–70, relates to rococo style of Augustin Pajou and Jean Carpeaux, fig. 49, p. 68.

The Victory Gold Piece, modeled 1905–7, struck 1907
Gold
Diameter, 1¹⁵/₁₆ in (3.3 cm)
Gift of Virginia Hobbs Carpenter in memory of Virginia Loop Hobbs
M.83.233

In 1905, soon after they met, President Theodore Roosevelt commissioned Saint-Gaudens to redesign the ten-dollar, twenty-dollar, and one-cent coins. They agreed that ancient Greek coins, as the most artistic ever made, should serve as the standard for the new American ones. It was the president's suggestion that

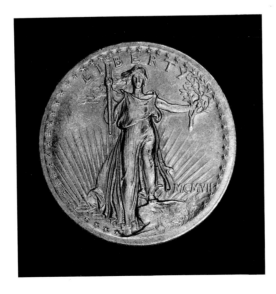

Saint-Gaudens, *The Victory Gold Piece.*

Saint-Gaudens should adopt in his designs the exceptionally high relief and raised rims of the ancient models. He corresponded with the sculptor frequently during the fall of that year to review design details. The design for the twenty-dollar gold piece was revised three times. Although the position of the eagle on the reverse changed from standing to flying, the obverse remained close to Saint-Gaudens's original concept of a figure "striding forward as if on a mountaintop," a "*living* thing and typical of progress."

Differences of opinion with the mint officials regarding the practicality of the high relief delayed the minting until after the sculptor's death. At the president's insistence a small number of experimental, extra-high-relief versions of the twenty-dollar coin were struck, and then an edition of high-relief coins was minted. Because these high-relief coins had to be struck on a medal press, rather than a regular coin press, and because they would not stack, Charles E. Barber (1842–1917), the mint engraver, then modeled a coin in flat relief and changed the date from Roman numerals to the Arabic 1907. The museum's coin is part of the regular issue in high relief, put into circulation in December 1907, before the Barber-modified final issue.

Saint-Gaudens's ten- and twenty-dollar coins generally have been considered the most artistic ever produced in the United States. President Roosevelt felt the issuance of these coins to have been one of the important accomplishments of his term in office.

PROVENANCE
Virginia Loop Hobbs, San Francisco, to 1983 § Mrs. William (Virginia Hobbs) Carpenter (by descent), Los Angeles, 1983.

LITERATURE (GENERAL)
The artist to President Roosevelt, November 11, 1905, quoted in Dryfhout, *Saint-Gaudens*, p. 35, describes figure on obverse § Homer Saint-Gaudens, "Roosevelt and Our Coin Designs: Letters between Theodore Roosevelt and Augustus Saint-Gaudens," *Century Illustrated Monthly Magazine* 99 (April 1920): 721–36 § Dryfhout, *Saint-Gaudens*, pp. 283–87, listed in cat. raisonné as no. 204c, repros. § Burke Wilkinson, *Uncommon Clay: The Life and Works of Augustus Saint-Gaudens* (San Diego, Calif.: Harcourt Brace Jovanovich, 1985), pp. 351–53 § Metropolitan Museum of Art, *Saint-Gaudens*, pp. 164–66.

Charles Henry Niehaus

Born January 24, 1855,
Cincinnati, Ohio
Died June 19, 1935,
Cliffside, New Jersey

Charles Henry Niehaus was among the foremost monumental sculptors of his generation. As a youth he worked as a stonecutter and a carver before studying at the McMicken School of Design in Cincinnati. Using his savings, in 1877 he went to Munich, where he studied for three and a half years at the Royal Academy of the Fine Arts, winning a gold medal for a sculptural composition. After visiting art collections in Italy, France, and England, he located in Manchester, England, where he executed several busts. He returned to Cincinnati in 1881. Niehaus received two important commissions for statues of the recently assassinated President Garfield, one to be erected in Cincinnati and the other, commissioned by the state of Ohio, intended for the Capitol in Washington. Shortly afterward the state awarded him a second commission, for a statue of former governor William Allen, also for the Capitol. To carve the two marble sculptures for the state, he went to Rome, remaining for two years. After returning to America in 1885, he opened a studio in New York, after that his home.

Niehaus was active as both a portrait sculptor and monumental sculptor, winning numerous national competitions and many honors. His practice increased greatly after the success of his monument to Doctor Samuel Hahnemann in Scott Circle, Washington, unveiled in 1900.

BIBLIOGRAPHY
Rufus R. Wilson, "Eminent American Artists, V—Charles Henry Niehaus," *Monthly Illustrator and Home and Country* 12 (June 1896): 390–400 § Regina Armstrong, *The Sculpture of Charles Henry Niehaus* (New York: De Vinne Press, 1902) § Charles H. Caffin, *American Masters of Sculpture* (New York: Doubleday, Page, 1903), pp. 119–28 § "Charles Henry Niehaus A.N.A., American Sculptor," *International Studio* 29 (August 1906): 104–11 § Taft 1930, pp. 394–404, with bibliography.

Silenus, modeled c. 1883, cast c. 1901
Bronze
36¹³/₁₆ in (93.6 cm) with base
Signed on left, on top of pedestal: C. H. NIEHAVS
Foundry mark on back, on base left: ROMAN
BRONZE WORKS N.Y.
Gift of Mr. and Mrs. John M. Liebes
M.87.143

Niehaus had used his savings from his work as a stonecarver to go to Munich to study and similarly used the proceeds of his first impor-

tant commissions to return to Europe, to spend two years in Rome, perhaps executing the commissions there and pursuing further his studies of the nude and the antique. He had a studio in the Villa Strohl-Fern, next to the Palazzo Borghese, where he modeled numerous figure studies in the manner of the antique. Of these apparently experimental works, only three survived: *Caestus,* modeled c. 1883–85 (casts of 1901, Metropolitan Museum of Art, New York, and National Museum of American Art, Smithsonian Institution, Washington, D.C.),

Niehaus, *Silenus.*

The Scraper (Greek Athlete Using a Strigil), modeled c. 1883–85 (a cast at Brookgreen Gardens, Murrell's Inlet, S.C.), and the museum's *Silenus.*

Niehaus's study of the ideal figure in light of the antique calls to mind the work of Adolf von Hildebrand (1847–1921) in Florence during these years, although Hildebrand's influence among Munich-trained artists is thought to date from the exhibition of his work there in 1891. Until that decisive event, sculpture in Munich was shaped by an advanced, naturalistic movement with a somewhat rococo flavor. Niehaus's early statues of Garfield and Allen are in this highly detailed, slightly agitated style. In the course of the 1880s this naturalistic trend culminated in such extreme manifestations as casts from life and tinted sculptures. A reaction among the younger artists led them to the simpler, stronger sculpture of antiquity, which they felt was animated by its coherent expression of the mechanism of movement.

The three surviving antique figures from Niehaus's years in Rome show that he sought a simpler, more powerful style in which organic movement and balance informed every part of the figure. When compared with the noble, somewhat abstracted figures of Hildebrand, those of Niehaus seem highly naturalistic; *The Scraper*'s great success at the World's Columbian Exposition in Chicago in 1893 was due to what was regarded as its unconventional realism. At the same time, one can discern in all three sculptures a shift to the more compact sense of form and more disciplined reserve in modeling that were to characterize Niehaus's subsequent work, suiting him particularly for monumental sculpture.

Sileni were Panlike woodland spirits resembling the satyrs. In Greek mythology, Silenus was the foster father and tutor of Dionysus and leader of the satyrs. He is traditionally depicted as a fat, drunken, old man, usually without the goat's legs and tail but with the pointed ears, upturned nose, and full beard of a satyr, and with heavy brows and high, full cheeks. An earlier, probably original version of *Silenus* (unlocated, illustrated in Armstrong, *Sculpture of Niehaus,* p. 60) has these traditional features, derived from ancient prototypes, that are absent from the museum's cast, except for the pointed ears. The earlier version differs in a few other details and in a finer, more naturalistic overall modeling. The pose, recalling the famous *Dancing Faun* from Pompeii (Museo Nazionale, Naples), remained the same. What appears to be a cast of this earlier version appears in a painting *Inquisitive,* 1893 (New York art market as of 1989), by Louis Charles Moeller (1855–1930).

Casts of *Caestus* bear the date 1901, and it seems likely that *The Scraper* and *Silenus* also were cast about that time, although each bears the mark of a different foundry and thus they were not from a single campaign of casting. They represented Niehaus in important exhibitions early in the century.

PROVENANCE
With private dealer, 1981–83 § With Steve Newman, New York, 1983–87.

LITERATURE (GENERAL)
Armstrong, *Sculpture of Niehaus,* p. 60, reproduces another version of *Silenus* with different base § Caffin, *American Masters,* pp. 121–22 § "Charles Henry Niehaus A.N.A.," p. 110 § Taft 1930, p. 400 § Beatrice Gilman Proske, *Brookgreen Gardens Sculpture* (Brookgreen Gardens, S.C.: Brookgreen Gardens, rev. enl. ed., 1968), p. 21.

John Rogers

Born October 30, 1829,
Salem, Massachusetts
Died July 26, 1904,
New Canaan, Connecticut

Using Yankee ingenuity, John Rogers, Jr., mass-produced plaster statuettes inexpensively and sold them to the general public. After attending college, Rogers worked for nine years as a machinist and draftsman in New England and a master railroad mechanic in Missouri. Although he had modeled clay figures for his own pleasure since 1849, he did not consider becoming a professional sculptor until he lost his job as a result of the Panic of 1857. In 1858 he traveled to Paris, where he modeled anatomical figures under the supervision of Antoine-Laurent Dantan (1798–1878), then to Rome, where he studied sculpture briefly with the English neoclassicist Benjamin Spence (1822–1866). Rogers returned home within the year and after the enthusiastic reception of his *Checker Players,* 1860, at a Chicago bazaar, decided to move to New York. There *The Slave Auction,* 1860, and later other Civil War subjects aroused much attention and initiated his long and successful career. The popularity of *Union Refugees* in 1863 resulted in his election to the National Academy of Design.

Between 1859 and 1893, when he gave up art due to ill health, Rogers sold some eighty thousand painted plaster reproductions, using commercial advertising to make his wares known to the general public. Rogers emphasized the narrative aspect of his figure groupings and was a master of pathos and humor, employing expressive gestures and theatrical

poses to convey sentiment. The realistic Rogers Groups, as they were called, depict American historical themes, American and English literary and theatrical illustrations, and American contemporary scenes. The last were his most popular and can be considered the three-dimensional equivalent of Currier and Ives prints. Rogers also created a large-scale equestrian bronze monument of General John Reynolds for Philadelphia City Hall, 1884, and a heroic-size seated Abraham Lincoln for Manchester, New Hampshire, 1892.

BIBLIOGRAPHY
William O. Partridge, "John Rogers: The People's Sculptor," *New England Magazine* n.s. 13 (February 1896): 705–21 § Dorothy C. Barck, "Rogers Groups in the Museum of the New-York Historical Society," *New-York Historical Society Quarterly Bulletin* 16 (October 1932): 67–86, with list of works in the society's Rogers collection § Mr. and Mrs. Chetwood Smith, *Rogers Groups: Thought and Wrought by John Rogers* (Boston: Goodspeed, 1934), with catalogue of published and unpublished works, family genealogy § David H. Wallace, *John Rogers: The People's Sculptor* (Middletown, Conn.: Wesleyan University Press, 1967), with catalogue raisonné, appendixes concerning the production of the plaster groupings from the initial design to the packing of the plaster casts § Paul Bleier and Meta Bleier, *John Rogers' Groups of Statuary: A Pictorial and Annotated Guide for the Collector* (North Woodmere, N.Y.: Privately printed, 1971), with extensive discussion of Rogers's production and sales methods, annotated list of works.

Rogers, *A Matter of Opinion.*

tised in the *Medical Record* as suitable for a physician's office.

A Matter of Opinion is a standard Rogers composition: three figures are arranged symmetrically and convey the story through their poses and expressions. The sculptor described his humorous representation as "a consultation of physicians over an invalid lady—which results in an evident disagreement." One physician, taking the woman's pulse, gives his opinion, while the other, obviously indignant over the diagnosis, reacts by glaring at his opponent and buttoning his coat to leave. Typical of Rogers's late groupings are the wealth of detailed accessory objects, close placement of the figures, and sense of movement.

About sixteen to twenty examples of the work are known (see Wallace, *People's Sculptor*, p. 251, for partial listing of collections).

A Matter of Opinion, modeled 1884, patented 1884
Painted buff plaster
21 in (53.3 cm) with base
Signed and dated left, on top of base: JOHN ROGERS / NEW YORK / 1884
Inscribed on front, on base: A MATTER OF OPINION
Inscribed on back, on top of base: PATENTED·Dec. 9. 1884
Gift of Pearl Field in memory of Isidor Tumarkin
M.81.231

This is one of five sculptures Rogers made of physicians. He began *A Matter of Opinion* early in 1884, after devoting his time to the equestrian statue of General Reynolds, and finished it by April 23, although he did not issue it for sale until the Christmas season. It was adver-

RELATED WORK
A Matter of Opinion, 1884, bronze master model, 21 in (53.3 cm). New-York Historical Society, New York.

PROVENANCE
Anna Tumarkin, early 1940s–80 § Pearl Field (by descent), Los Angeles, 1980–81.

LITERATURE (GENERAL)
Barck, "Rogers Groups in the New-York Historical Society," pp. 72, 76, lists, repro., 77 § Smith, *Rogers Groups,* p. 90, listed as no. 59, repro., p. 91, inaccurately dated November 1881 § David H. Wallace, "John Rogers: The People's Sculptor," Ph.D. diss., Columbia University, 1961, p. 149, inaccurately dated 1881 § Wallace, *People's Sculptor,* p. 251, listed in cat. raisonné as no. 167, describes, quotes Rogers's description, discusses date, repros., pp. 251, 294 § Bleier and Bleier, *Rogers' Groups,* pp. 45, 117, gives Rogers's description from patent application, repro., facing p. 117.

Frederick MacMonnies

Born September 28, 1863,
Brooklyn, New York
Died March 22, 1937,
New York, New York

At the turn of the century Frederick William MacMonnies was considered to be one of the country's three leading sculptors. The collapse of his father's business made it necessary for him to seek employment at the age of twelve. By his seventeenth birthday he had become an apprentice in the studio of AUGUSTUS SAINT-GAUDENS; he took evening classes in drawing at the Cooper Union and later at the National Academy of Design. In time, Saint-Gaudens recognized his abilities and promoted him to the position of assistant. In September 1884 MacMonnies left for Paris, where he began the study of drawing at the Académie Colarossi and drew from the antique at the Ecole des Beaux-Arts. When cholera broke out in Paris, MacMonnies went to Munich, where for five months he received instruction in drawing and sculpture at the Royal Academy of the Fine Arts. In the spring of 1885 he resumed his studies at Colarossi's but in the summer returned to New York at Saint-Gaudens's request to again assist him in his studio. Between 1886 and 1888 he studied sculpture with Jean-Alexandre-Joseph Falguière (1831–1900) at the Ecole des Beaux-Arts, twice winning the Prix d'Atelier, and with Marius-Jean-Antonin Mercié (1845–1916) in private classes. He then opened his own atelier in Paris. MacMonnies's sculptures won an honorable mention at the Salon of 1889 and a gold medal of the second class at the Salon of 1891, an unprecedented honor for an American sculptor. His large *Barge of State (Triumph of Columbia),* a decoration for the World's Columbian Exposition in Chicago in 1893 (destroyed), established his reputation. He received numerous public commissions. In 1898 he moved to Giverny, where numerous painters had gathered around Claude Monet. In 1901 he announced that he was giving up sculpture and turned to painting, at which he achieved a certain success. However, he continued to execute public sculpture commissions. In 1915 he moved back to New York.

BIBLIOGRAPHY
Avalon, Calif., Mrs. Henry VenderVelde Collection, Frederick MacMonnies Papers (on microfilm, Archiv. Am. Art) § Royal Cortissoz, "An American Sculptor: Frederick MacMonnies," *Studio* 6 (October 1895): 17–26 § French Strother, "Frederick MacMonnies, Sculptor," *World's Work* 11 (December 1905): 6965–81 § Taft 1930, pp. 332–55, 609, 615, with bibliography § Paula M. Kozol, "Frederick William MacMonnies (1863–1937)," in *American Figurative Sculpture in the Museum of Fine Arts, Boston* (Boston: Museum of Fine Arts, 1986), pp. 293–95, with bibliography.

Young Faun and Heron, modeled 1890, copyrighted 1894

(Boy and Heron; Boy with Heron; Faun with Heron; Young Faun with Heron)
Bronze
26⅝ in (67.7 cm) with base
Signed, inscribed, and dated on left, on top of base: Frederick. MacMonnies / copyright 1894. / Paris 1890
Foundry mark in circular cachet on back, on top of base: Jaboeuf & Rouard / Fondeurs à Paris
Purchased with funds provided by Phyllis J. Ruttenberg, Gary and Brenda Ruttenberg, and members of the American Art Council fall 1986 trip
M.86.227

According to a handwritten list of MacMonnies's sculptures in the artist's papers, he originally modeled this group in 1890 as a life-size statue for a fountain for a country house in Massachusetts. This commission for the garden of Joseph Hodges Choate's home, Naumkeag, in Stockbridge was obtained through the architect Sanford White. The statue was to be set into an exterior niche, the shape of the niche determining the curve of the bird's wings.

MacMonnies's lively imagination invented numerous such unusual subjects, although this one at least recalls traditional images such as Ganymede and the eagle and the youthful Hannibal fighting with the eagle. The figure, both in its realistic representation of a nude adolescent and in its general pose, recalls that of Mercié's *David,* 1878 in bronze (Musée d'Orsay, Paris) and, of course, that sculpture's source in Donatello's famous bronze of the same subject in the Bargello, Florence. The intensity with which the details of the bird's feathers are observed might seem to reflect further study of the character of quattrocento sculpture. At the same time, the sense of a specific model's unidealized face and anatomy and of almost excessive liveliness are characteristics of the nudes of MacMonnies's other master, Falguière. Cortissoz's characterization of MacMonnies and his circle as "Neo-Renaissance temperaments strengthened through appreciation of modern French craftsmanship" ("An American Sculptor," p. 18) captures the spirit of this sculpture.

The inventive subject provided material for a richly organized play of positive and negative

forms and of curves and countercurves. The forms of boy and bird, distinct in the lower part of the sculpture, are brought into close combination by the way the boy's proper left arm follows the curve of the wing and his other arm is entwined with the bird's curving neck. The large curve of his arms is set in equilibrium to the curve of the wings. The play of forms and sense of movement contribute to the sense of liveliness that was characteristic of MacMonnies's sculptures of the early 1890s.

The *Young Faun and Heron* exhibited in Paris at the 1890 Salon was in plaster and was probably for the life-size fountain statue. It and another 1890 fountain commission, *Pan of Rohallion* (formerly home of Edward D. Adams, Sea Bright, N.J.), contributed to MacMonnies's early reputation and led to the important commission of the colossal figures for the *Barge of State* at the 1893 World's Columbian Exposition.

Examples of the half-life-size statuette were favorably received when exhibited in 1891 at the annual exhibition of the Society of American Artists in New York, in 1892 in Saint Louis, and later in 1895 and 1896 in Boston, Philadelphia, and New York. Little of the casting history of the statuette is known. It seems to have been cast, in unknown numbers, by at least two foundries: a proof cast in the Metropolitan Museum of Art, New York, and a finished cast in the Cleveland Museum of Art were by Gruet Fondeur, Paris, while the museum's example was made by Jaboeuf & Rouard, also of Paris.

PROVENANCE
Probably private collection, to 1986 § With Conner-Rosenkranz, New York, 1986.

LITERATURE (GENERAL)
Avalon, Calif., Mrs. Henry VenderVelde Collection, Frederick MacMonnies Papers, the artist's scrapbook for early 1890s, "Works—MacMonnies," handwritten list, undated (microfilm roll D245, fr. 170) lists the fountain under 1890 as *Faun with Heron;* newspaper clipping, *Republic* (Saint Louis), January 8, 1892 (ibid., fr. 177), notes exhibition at the Saint Louis Art Museum, as *Faun with Heron;* newspaper clipping, *Boston Advertiser,* January 26, 1895 (ibid., fr. 146), mentions as in Boston Art Club exhibition, criticizes the chasing; newspaper clipping, *Boston Herald,* January 27, 1895 (ibid.), notes that it won first prize at Boston Art Club, with line drawing, as *Boy with Heron;* newspaper clipping, "The Fine Arts: New Works by MacMonnies," *Critic* (New York), February 16, 1895 (ibid.), on view at Starr's jewelry store on Fifth Avenue, repro., as *Boy with Heron;* newspaper clipping, "Won Fame Abroad, and More Waits for MacMonnies," *New York Commercial Advertiser,* January 18, 1896 (ibid., fr. 158), with line drawing, as *Boy and Heron* § Cortissoz, "An American Sculptor," p. 22, considers composition and movement to be convincing and charming, repro., p. 23, as *Boy and Heron* § Will H. Low, "Frederick MacMonnies," *Scribner's Magazine* 18 (November 1895): 620, refers to fountain statue as an essay *in petto,* as *Faun with Heron* § New-York Historical Society, De Witt McClellan Lockman Papers, Lockman interview with the artist, January 29, 1927, transcript, p. 26, discusses Stanford White's role in the artist's obtaining two fountain commissions in 1890, one of which was from Choate (on microfilm, Archiv. Am. Art, roll 503, fr. 898) § Fletcher Steele, "The Temple Garden: The Garden of Miss Mabel Choate, Stockbridge, Massachusetts," *House Beautiful* 74 (July 1933): 21–23, discusses changes in sculpture's placement and conception of garden setting.

LITERATURE (SPECIFIC)
Janis Conner and Joel Rosenkranz, *Rediscoveries in American Sculpture: Studio Works, 1893–1939* (Austin: University of Texas Press, 1989), repro., p. 127.

MacMonnies, *Young Faun and Heron.*

Frederic Remington

Born October 1, 1861,
Canton, New York
Died December 26, 1909,
Ridgefield, Connecticut

Frederic Sackrider Remington achieved a classic status as the foremost artist of the American West. He was born in Canton, New York, but after the age of eleven was raised in nearby Ogdensburg. Deciding to become an artist, he enrolled in the Yale School of Fine Arts, where he studied drawing until the death of his father cut short his college career after a year and a half. He worked at a number of jobs in Ogdensburg and Albany, made a brief trip to Montana Territory, and worked as a clerk in Albany. Coming into an inheritance at the age of twenty-one, he went to Kansas, purchased a sheep ranch, which he sold in less than a year, and then invested in a hardware store and later a saloon, both of which failed. While in Kansas City in 1884 he began to support himself with the sale of paintings locally and of illustrations to publishers in New York City. He traveled through New Mexico and Arizona Territories before moving in 1885 to New York, where he worked as an illustrator specializing in Western subjects. In 1886 he studied for one term at the Art Students League. He achieved success and wide reputation as an illustrator in just a few years. He also began to write about the West. In 1889 he was able to buy a large suburban house. Already an accomplished painter, the following year he had his first solo show of his paintings of life and adventure in the American West.

Remington frequently returned to the West to sketch and report, sometimes traveling with cavalry troops as he sought the flavor of the lives of the soldiers and cowboys. In 1892 he traveled to Europe and North Africa. He generally summered in the Adirondacks. In 1895, the same year that the first collection of his magazine articles was published, he began to work as a sculptor, attaining immediate acclaim. Remington visited Cuba in 1897 and as an illustrator and correspondent during the Spanish-American War. After 1900 he did much of his painting during summers on Inglenuek, a small island in the Saint Lawrence River near Ogdensburg. During this period he enjoyed even greater success and recognition. After 1905 he frequently abandoned the highly realistic, action-filled painting style that had won him this renown, preferring a softer, more atmospheric rendering of more imaginative themes. In 1909 he completed construction of a large house in Ridgefield, Connecticut. He died suddenly at the age of forty-eight following an unsuccessful appendectomy.

BIBLIOGRAPHY
Harold McCracken, *Frederic Remington: Artist of the Old West* (Philadelphia: Lippincott, 1947), with bibliographic checklist of Remingtoniana (including chronological list of works illustrated in periodicals and books) § Ben Merchant Vorphal, *My Dear Wister! The Frederic Remington-Owen Wister Letters* (Palo Alto, Calif.: American West, 1972) § Washington, D.C., Smithsonian Institution, National Museum of American Art, and others, *Cast and Recast: The Sculpture of Frederic Remington,* exh. cat., 1981, published by Smithsonian Institution Press, by Michael Edward Shapiro, with bibliography, lists of bronzes and Roman Bronze Works castings § Peggy Samuels and Harold Samuels, *Frederic Remington: A Biography* (1982; reprint, Austin: University of Texas Press, 1985), with bibliography § Michael Edward Shapiro and Peter H. Hassrick, *Frederic Remington: The Masterworks* (Saint Louis: Saint Louis Art Museum in conjunction with Buffalo Bill Historical Center, Cody, Wyo., and Harry N. Abrams, New York, 1988), with essays by David McCullough, Doreen Bolger Burke, and Joseph Seelye, lists of Henry-Bonnard Bronze Co. casts of *The Bronco Buster* and bronze edition sizes as of 1907, published in conjunction with an exhibition at the Saint Louis Art Museum and others, 1988–89.

The Bronco Buster, modeled 1894–95, copyrighted 1895, reworked by the artist 1903–7, cast c. 1907
Bronze
22 in (55.9 cm) with base
Signed on left, on top of base: Copyright by / Frederic Remington
Foundry mark on right, on top of base along edge:
ROMAN BRONZE WORKS N.Y.
Gift of Mrs. Gladys Letts Pollock
43.11.2

Remington was the first artist to specialize in Western sculpture. With the encouragement of the sculptor Frederick Wellington Ruckstull (1853–1942), who was then working on an equestrian monument, in the late fall of 1894 Remington set to work on his first sculpture, *The Bronco Buster.* He took his subject from *A Pitching Bronco,* one of his illustrations that had been published in the April 30, 1892, issue of *Harper's Weekly.* He completed the sculpture by the third week of August 1895.

Remington's direction in sculpture was probably inspired by his admiration for the animal bronzes of the great French sculptor Antoine-Louis Barye (1796–1875) and of the bronzes of the numerous French animal sculptors Barye inspired. Remington also had some contact with Augustus Saint-Gaudens, Frederick MacMonnies, the *animalier* Edward Kemeys (1843–1907), and other leading American sculptors. In the most important respects, however, Remington's bronzes are distinctly his own. Especially characteristic is the almost photographic quality of suspended, violent movement and his interest in freeing the figure from the support of the base so that the work truly seems to be in motion.

The Bronco Buster was the most popular of Remington's sculptures and had a long and active casting history. Because of the technical aspects of the sand-casting technique used by the Henry-Bonnard Bronze Company, the approximately seventy casts of the first edition were identical. Around 1900 Remington began to use Roman Bronze Works to cast sculpture. The lost-wax method used by this foundry permitted Remington to modify the model of *The*

Bronco Buster to bring it closer to his evolving objectives. Between 1903 and 1907 he made numerous individual and permanent adjustments both in the plaster model and in the wax models used for each cast to give the sculpture a greater unity and more vivid sense of motion. Remington reached the final, perfected version of the model in 1907, in about cast number sixty, which all subsequent casts resemble. The museum's cast is number sixty-nine, recorded with nine other numbers in the firm's ledger on December 31, 1907. Roman Bronze Works cast about 307 examples of the statuette. The foundry also produced approximately twenty-two casts of a larger statue (see National Museum of American Art, *Cast and Recast,* pp. 92–99 for casting history and ownership of both sizes).

PROVENANCE
Mr. Letts, Beverly Hills, Calif. § Mrs. Gladys Letts Pollock (by descent), Beverly Hills, to 1943.

ON DEPOSIT
Western White House, San Clemente, Calif., 1969–73.

EXHIBITIONS
Claremont, Calif., Scripps College, Art Department, [sculpture exhibition], 1955, no cat. traced § San Jose (Calif.) Museum of Art, *America IV: The West-ward Expansion,* 1975, entries not numbered, repro., unpaginated.

LITERATURE (GENERAL)
McCracken, *Remington: Old West,* pp. 92–94 § Vorphal, *My Dear Wister,* pp. 70, 74, 155, 158, 162–67, 170, 219, 237, 256, 259 § National Museum of American Art, *Cast and Recast,* pp. 37–46, 60–69, 91–99, discusses casting and transcribes ledgers of Roman Bronze casting lists; figs. 21, 42–54, pp. 41, 61, 64–68, of different casts, details, underside of base § Samuels and Samuels, *Remington: Biography,* pp. 222–29, 240–41, 288–89, 318, 341, 347, 367, 383, 432–33, 435, 442 § Shapiro and Hassrick, *Remington: Masterworks,* p. 13, preface by Shapiro and Hassrick, pp. 28, 66, essay by Burke, pp. 183, 186–87, 191–92, 194–95, 206–7, 210–11, 214, 223, 232, essay by Shapiro, pp. 266–67, lists casting history, pls. 47–49, pp. 172–75, 233, of different casts and details thereof.

LITERATURE (SPECIFIC)
"Recent Acquisitions, Fall 1969–Spring 1973," *LACMA Bulletin* 19 (1973): repro., 43 § National Museum of American Art, *Cast and Recast,* p. 94, listed as no. 69 of Roman Bronze casts with date of December 31, 1907.

Remington, *The Bronco Buster.*

The Outlaw, modeled and copyrighted 1906, cast posthumously 1913
Bronze
22¾ in (57.8 cm) with base
Signed on right, on top of base below horse's head: Copyright by / Frederic Remington
Foundry mark on back, on base left corner: Roman Bronze Works N·Y·
William Randolph Hearst Collection
50.9.51

The title refers to the untamable horse. With its two forefeet descending onto a clump of sagebrush, this horse with rider has the least connection with the base of any of Remington's sculptures and is seemingly caught in midair. The work may have been the greatest challenge ever presented by Remington to his founder, Riccardo Bertelli (1870–1955) of Roman Bronze Works, who worked with Remington to exploit the tensile strength of bronze and the advantages of the lost-wax process. Like most of Remington's sculptures, its conception is basically two-dimensional with a strong silhouette.

Remington modeled *The Outlaw* in 1906. The museum's cast is number twelve of the total edition of approximately fifty and was cast in 1913 after the sculptor's death, when Roman Bronze Works continued to cast models under authority of Remington's widow (see National Museum of American Art, *Cast and Recast,* pp. 107–8, for casting history).

PROVENANCE
Mrs. George A. Martin, Cleveland, to 1946 (sale, New York, Parke-Bernet Galleries, *Georgian Silver, Paintings and Drawings . . . Property of Mrs. George A. Martin,* October 1946, no. 83) § William Randolph Hearst, San Simeon, Calif., to 1950.

LITERATURE (GENERAL)
National Museum of American Art, *Cast and Recast,* p. 54, 60, 107–8, transcribes ledgers of Roman Bronze casting lists, fig. 36, p. 55 § Samuels and Samuels, *Remington: Biography,* p. 377 § Shapiro and Hassrick, *Remington: Masterworks,* p. 231, essay by Shapiro, p. 267, lists edition size as of 1907, pl. 61 and detail thereof, pp. 216, 220.

LITERATURE (SPECIFIC)
National Museum of American Art, *Cast and Recast,* p. 107, listed as no. 12 with date of June 1, 1913.

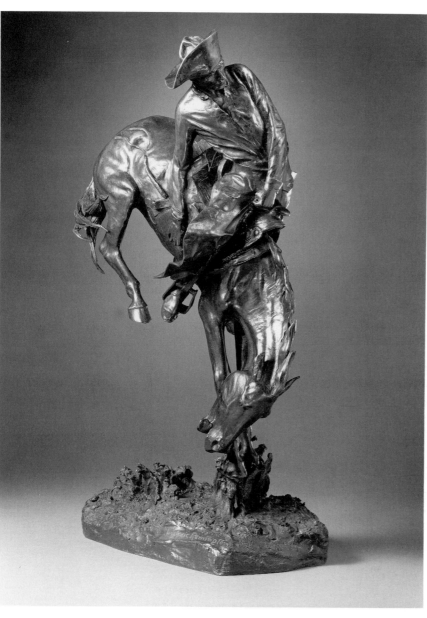

Remington, *The Outlaw.*

Arthur Putnam

Born September 6, 1873,
Waveland, Mississippi
Died May 27, 1930,
Ville D'Avray, France

Arthur Putnam appears to have been one of California's most talented sculptors, his promising career cut short by illness. After his birth the Putnam family lived in Omaha and then San Francisco, returning to Omaha after Mr. Putnam's death in 1880. In the early 1890s Arthur lived on his mother's lemon ranch near La Mesa in San Diego County, California. At one point he had his own ranch near where the sculptor Gutzon Borglum (1867–1941) happened to have his studio, and the two became close friends. Among other jobs, Putnam worked as a land surveyor. In 1894 he went to San Francisco to study drawing, attending the Art Students League there and briefly studying with the sculptor Rupert Schmid (1864–1932). In 1895 he returned to La Mesa and then in 1897–98 he assisted in the Chicago studio of the animal sculptor Edward Kemeys (1843–1907). After his return to California Putnam was employed as a modeler in a terra-cotta works in Lincoln.

In 1899 he married and moved permanently to San Francisco, where he worked primarily as a sculptor of architectural commissions. In 1905 a patron enabled Putnam to go to Europe, where he spent about a year and a half, mainly in Rome and Paris. While abroad he mastered the craft of bronze casting, which he later practiced in his own foundry in San Francisco. The five years after his return to that city were his most productive of both architectural sculptures and the small bronzes of wild animals for which he is known.

Neurological problems that began in 1909 led to an operation for the removal of a brain tumor in 1911. As a result, Putnam was paralyzed on his left side and his formal perceptions were impaired. He never modeled again. From 1921 until his death he lived abroad.

Putnam's bronzes were accorded recognition during his lifetime, including the praise of Rodin and a gold medal at the Panama-Pacific International Exposition in San Francisco in 1915.

BIBLIOGRAPHY
Archiv. Am. Art, Macbeth Gallery Papers (portions on microfilm) § Rose V. S. Berry, "Arthur Putnam: California Sculptor," *American Magazine of Art* 20 (May 1929): 276–82 § Julie Helen Heyneman, *Arthur Putnam: Sculptor* (San Francisco: Johnck & Seeger, 1932), with list of works § *California Art Research* (San Francisco: Works Progress Administration Project, 1937), 6: 1–59, with bibliography, lists of works in California Palace of the Legion of Honor, works in Panama-Pacific International Exposition, and medals § Carol M. Osborne, "Arthur Putnam: Animal Sculptor," *American Art Review* 3 (September–October 1976): 71–81.

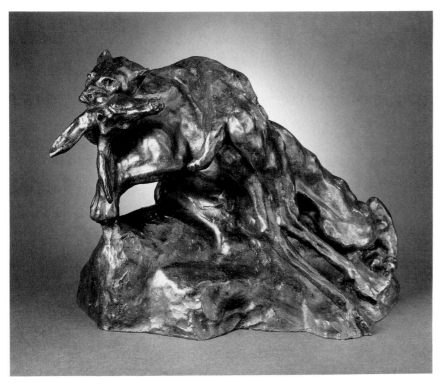

Putnam, *Puma and Deer.*

Puma and Deer, modeled 1902, copyrighted 1912
(*Cougar with Doe*)
Bronze
11¼ in (28.5 cm) with base
Signed and dated on left, on base under tail of puma: APutnam / 1902 (AP in monogram)
Inscribed on back, on base center: © 1912 A.P.
Museum purchase with funds provided by Clifton Webb Bequest, Felicia Meyer Marsh Bequest, Blanche and George Jones Fund, Inc., and Mrs. Stevenson Scott
84.38

Several influences combined in Putnam's distinctive work: the powerful animal subject matter of Antoine-Louis Barye (1796–1875), the fluid modeling of Auguste Rodin (1840–1917), and the artist's own knowledge of California wildlife. Pumas and other large cats were Putnam's favorite subjects, usually rendered, as here, as immensely powerful creatures with heavy, muscular limbs. In *Puma and Deer* the surging form of the puma is contrasted with that of the limp, lifeless deer carried across its back. Because of their vig-

orous modeling and lack of finish, Putnam's works greatly appealed to modernists.

Little information concerning the bronzes cast by the different foundries used by Putnam is available. The museum's cast has no foundry mark, but it does bear a copyright date of 1912. Putnam was associated with Macbeth Gallery in New York from 1908 to 1917 (Archiv. Am. Art, Macbeth Gallery Papers, Putnam-Gallery Correspondence, 1908–13, and Artists' Credit Books, 1910–18, not on microfilm), and for part of that time, from at least 1911 to 1914, used Roman Bronze Works to cast his bronzes (New York, Roman Bronze Works, Ledgers, unpaginated). A cast of *Puma and Deer* in the Oakland Museum bears a Roman Bronze foundry mark and a different version of the copyright inscription, so it would appear the museum's cast does not belong to the same edition. In 1913 Putnam induced his brother-in-law, Frederick Storey, to resume casting in their own foundry, with Putnam helping with the retouching and patination of the bronzes. Apparently with an interruption during the First World War, they continued to produce bronzes until early in 1918. Bronzes marked with the name "Putnam and Storey Foundry" are known, but it is not known whether all were so marked. During the war Rodin arranged for a foundry in Paris to make casts from Putnam's plasters for exhi-

bition at the Panama-Pacific International Exposition in 1915, but these casts have not been identified. In 1921 Mrs. Adolph Spreckels, who with her husband helped found the California Palace of the Legion of Honor in San Francisco, bought fifty-five plasters from the artist for the express purpose of having them cast by Alexis Rudier in his Paris foundry, whose mark they bear. Two sets were made, and Mrs. Spreckels gave one to the California Palace of the Legion of Honor (now part of the Fine Arts Museums of San Francisco) and the other to the Fine Arts Gallery of San Diego (now the San Diego [Calif.] Museum of Art).

PROVENANCE
Alexander MacNichol, San Francisco, to 1981 § Howland Wilson Smith, Houston, Tex., 1981–82 § Robert Bruce Johnson, Pasadena, Calif., 1982–84.

LITERATURE (GENERAL)
Berry, "Putnam: California Sculptor," repro., p. 277 § Osborne, "Putnam: Animal Sculptor," p. 76, repro., p. 80.

LITERATURE (SPECIFIC)
Butterfield & Butterfield, San Francisco, *American and European Pictures,* March 17, 1982, offered for sale, lot 485, did not sell, as *Cougar with Doe,* repro. § "American Art," *LACMA Report 1983–1985* (1985), p. 16, repro., p. 19.

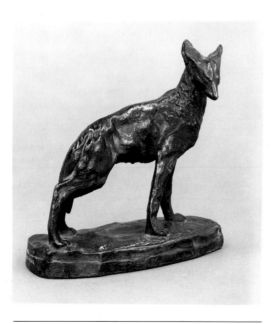

Putnam, *Coyote.*

Coyote, modeled c. 1911–14, cast c. 1911–14
Bronze
7⅝ in (19.4 cm) with base
Signed on back, on top of base: APUTNAM (encircled; AP in monogram)
Foundry mark on right, on base: ROMAN BRONZE WORKS N·Y·
Mr. and Mrs. Allan C. Balch Collection
M.45.3.467

In addition to his larger tabletop bronzes, such as *Puma and Deer,* which attain a certain monumentality, Putnam modeled numerous smaller, more whimsical bronzes. The public seems to have found these charming, small sculptures irresistible. The dealer R. W. Macbeth wrote to Mrs. Putnam on August 29, 1913, that the small animal figures were what people wanted to buy, and "it is upon those that his fame will very likely depend" (Archiv. Am. Art, Macbeth Gallery Papers, microfilm roll 2622, frs. 1386–87).

Putnam characteristically depicted the animal in an undramatic, habitual stance. The head of the sculpture is somewhat foxlike because of the size of the ears in relation to the width of the rostrum, but the length and thickness of the legs, the stance, the size and position of the tail, and the heaviness of the body are all characteristic of the coyote and not of the fox. Putnam's intimate knowledge of the animals is sometimes obscured in his smaller bronzes, which were more freely and expressively modeled than many of the larger ones.

The museum's cast of *Coyote* bears the foundry mark of Roman Bronze Works. Roman Bronze's association with Putnam and Macbeth, who may have sold the piece, lasted from

at least late 1911 until mid-1914 (examples from 1921 bearing the mark of Rudier, Paris, in the Fine Arts Museums of San Francisco and the San Diego [Calif.] Museum of Art).

PROVENANCE
Mr. and Mrs. Allan C. Balch, Los Angeles, to 1943 § Estate of Mr. and Mrs. Balch, 1943–45.

LITERATURE (GENERAL)
Phyllis Ackerman, "France Discovers a Great American Sculptor," *Arts and Decoration* 19 (September 1923): 15, repro.

LITERATURE (SPECIFIC)
LACMA, Registrar's files, "Los Angeles County Museum, The Balch Collection Inventory," [1944–45], typescript, p. 3, as *Bronze of a Fox* by R. J. Wam [*sic*], no. 1688 § LACMA, American Art department files, memo from Michael Quick, July 1, 1989, discusses identification of the animal and opinion of LACMNH curatorial staff.

Mahonri Young

Born August 9, 1877,
Salt Lake City, Utah
Died November 2, 1957,
Norwalk, Connecticut

Although he was an accomplished painter, etcher, and draftsman, Mahonri Mackintosh Young is best known for his small bronze genre figures of laborers and boxers. The monument erected in Salt Lake City to his grandfather Brigham Young, 1892, sculpted by Cyrus E. Dallin (1861–1944), inspired Young's interest in sculpture. In 1899 he studied briefly at the Art Students League in New York and in 1901 settled in Paris, where he attended the Académie Julian, where he studied modeling with Charles Raoul Verlet (1857–1923), and became close friends with Leo Stein and ALFRED MAURER. After painting canvases of French peasant figures, he turned to modeling modern-day men at work—digging, wielding sledges, carrying huge burdens—always stressing the dignity of their labor. When exhibited in the United States during the next decade, these small bronzes were compared with the work of the Belgian sculptor Constantin Meunier (1831–1905) and considered the sculptural counterpart of Ash Can school painting. In 1905 Young returned to Salt Lake City, where he received commissions from the Mormon Church. In 1910 he settled in New York.

His interest in capturing the human form in motion led Young to create a series of bronzes of boxers in the 1920s. During his career he created many bas-reliefs, including several monumental public projects commissioned by Salt Lake City and the American Church of the Holy Trinity in Paris. Commissions from Winfield R. Sheehan, manager of Fox Studios, brought him to Hollywood in 1929 and included relief panels for the studio's building and a statue of the boxer Joe Ganz. Young also produced landscape etchings, taught at the Art Students League, and wrote articles on sculpture for the *Dictionary of American Biography* and *Encyclopaedia Britannica*.

BIBLIOGRAPHY
Provo, Utah, Brigham Young University, Harold B. Lee Library Archives, Mahonri Young Papers § J. Lester Lewine, "The Bronzes of Mahonri Young," *International Studio* 47 (October 1912): LV–LVIII § Andover, Mass., Phillips Academy, Addison Gallery of American Art, *Mahonri M. Young: Retrospective Exhibition,* exh. cat., 1940, with essay by Frank Jewett Mather, Jr., excerpts from artist's autobiography, chronology § Wayne K. Hinton, "A Biographical History of Mahonri M. Young: A Western American Artist," Ph.D. diss., Brigham Young University, 1974, with bibliography, list of significant sculptures § Thomas E. Toone, "Mahonri Young: His Life and Sculpture," Ph.D. diss., Pennsylvania State University, 1982, with bibliography.

Tired Out, modeled 1903, cast by 1905
(*Fatigue; Man Tired; Rest*)
Bronze
9 in (23.0 cm) with base
Signed and dated on top of base, behind left foot:
YOUNG / 03.
Foundry mark in rectangular cachet on back, on top of base left: CIRE / PERD[U]E / A.A. HÉBRARD.
Mr. and Mrs. Allan C. Balch Collection
M.45.3.471

In the spring of 1903 Young modeled his first original works, *Tired Out* and *Laborer (The Shoveler III)* (cast of 1908, Sheldon Memorial Art Gallery, University of Nebraska, Lincoln) based on sketches he had made while wandering through the streets of Paris. When the plaster models of the two small pieces were exhibited at the 1903–4 winter exhibition of the American Art Association in Paris, they were enthusiastically noted by the press. This critical attention launched Young's career.

According to the artist *Tired Out* was modeled from memory and from small life drawings. It may have been first conceived as part of a larger project, since the figure appears as the top center component in the drawing *Monument to Labor,* c. 1902–3 (Provo, Utah, Harris Fine Arts Center, Brigham Young University). Young's allegorical design was no doubt inspired by the *Gates of Hell,* begun 1880, by Auguste Rodin (1840–1917); also, the pose

of *Tired Out* was most likely derived from *The Thinker,* the main figure of Rodin's *Gates.* Young transformed Rodin's contemplative into a man of physical endeavor. The change is most evident in the context of Young's allegorical design, which is devoted to the theme of labor. As both *Tired Out* and *Laborer* appeared in *Monument to Labor* (the latter as the large, lower-central motif) and were first exhibited together, Young no doubt originally conceived of them as companion pieces. In fact, when they were reproduced in 1904 in the *New York Herald* (Paris edition) and the *Salt Lake Tribune,* the figures were given the titles *Toil* and *Rest.*

The surface of *Tired Out* ripples softly throughout, giving an amorphous feeling to the solid mass. Young's sketchy handling was probably inspired by Rodin. The toiler is dressed in rough, loose, work clothes, his strength conveyed by his oversized hands. Exhausted, and perhaps asleep, his head and shoulders droop down toward his knees. Although at rest, he conveys a power comparable with that of Young's active laborers, who strain under their physical exertion. Despite its small size, the figure is monumental in conception.

Young's practice was to cast only one bronze at first and later to cast two or three at a time if needed. Although the sculpture was extensively exhibited in the United States during the first two decades of the century after its showing in the Paris Salon of 1904, the museum's cast is the only located bronze example of *Tired Out.* It was cast in Paris, probably sometime between the successful exhibition of the plaster model and Young's permanent return to the United States in 1905. The casting was done by A. A. Hébrard, a small foundry specializing in the lost-wax technique active around 1900.

Young, *Tired Out.*

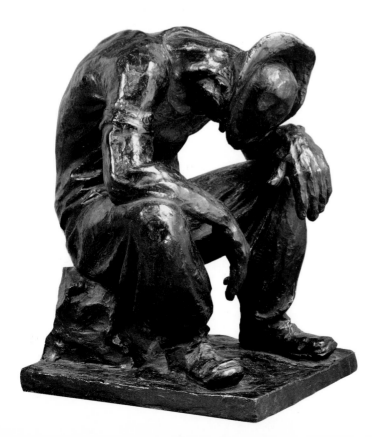

The bronze was originally named *Tired Out.* When the son of Young's friend Al Wright called it "man tired," the artist decided that the new title better expressed the sentiment he intended.

RELATED WORKS
Monument to Labor, c. 1902–3, drawing, 7³/₈ x 8¹/₄ in (18.9 x 21.4 cm), mounted in MS 4, bk. 28, unpaginated. Archives, Harold B. Lee Library, Brigham Young University § *Man Tired,* 1903, plaster, 9¹/₄ in (23.5 cm). Harris Fine Arts Center, Brigham Young University (studio inventory no. 164).

COMPANION PIECE
Laborer (The Shoveler III), 1908, bronze, 10¹/₄ in (26 cm), University of Nebraska, Lincoln, F. M. Hall Collection, Sheldon Memorial Art Gallery.

PROVENANCE
Mr. and Mrs. Allan C. Balch, Los Angeles, by 1921 to 1943 § Estate of Mr. and Mrs. Balch, 1943–45.

EXHIBITIONS
Possibly Paris, Société Nationale des Beaux-Arts, *Salon* (Champs de Mars), 1904, no. 2132 § Possibly Philadelphia, Pennsylvania Academy of the Fine Arts, *101st Annual Exhibition,* 1906, no. 975, as *Fatigue* § Possibly New York, National Academy of Design, *Winter Exhibition,* 1910–11, no. 15 § Possibly Art Institute of Chicago, *Twenty-fifth Annual American Oil Paintings and Sculpture,* 1912, no. 454, as *Fatigue* § Possibly New York, Berlin Photographic Co., *Catalogue of an Exhibition of Bronzes and Drawings by Mahonri Young,* [1912], no. 8, as *Fatigue* § Possibly New York, Macbeth Gallery, *Exhibition of Sculpture by Chester Beach, Abastenia St. L. Eberle, Mahonri Young,* 1914, no. 28 § Probably San Francisco, *Panama-Pacific International Exposition, Department of Fine Arts, Official Catalogue (Illustrated),* 1915, no. 3358 § Possibly New York, The Sculptors' Gallery, *Sculpture, Drawings, and Paintings by Mahonri Young,* 1918, no. 17 § LAMHSA, *Summer Exhibition,* 1921, no. 61 § Los Angeles, Barnsdall Park, Municipal Art Gallery, *Form in Time,* 1955, no cat. traced.

LITERATURE (GENERAL)
"American Art Association: Winter Exhibition," *New York Herald* [Paris ed.], January 31, 1904, pt. 2, p. 1, repro. of plaster model, as *Rest* § Addison Gallery of American Art, *Young Retrospective,* p. 53, in Mahonri Young, "Notes at the Beginning," as *Man Tired* § Hinton, "Biographical History of Young," pp. 80–84, 249, discusses sketches, theme, and reception, as *Man Tired* § Toone, "Young: Life and Sculpture," pp. 23, 61–63, 132, fig. 2 § Janis Conner and Joel Rosenkranz, *Rediscoveries in American Sculpture: Studio Works, 1893–1939* (Austin: University of Texas Press, 1989), p. 179.

LITERATURE (SPECIFIC)
LACMA, American Art department files, Daniel S. Hodgson to Ilene Susan Fort, March 6, 1984, discusses the museum's cast in context of history of sculpture, Young's practice of exhibiting plasters, bronze editions § Janis Conner and Joel Rosenkranz, *Rediscoveries in American Sculpture: Studio Works, 1893–1939* (Austin: University of Texas Press, 1989), repro., p. 178.

Eli Harvey

Born September 23, 1860,
Clinton County, near
Wilmington, Ohio
Died February 10, 1957,
Alhambra, California

After the death of Edward Kemeys (1843–1907), Eli Harvey was considered the leading animal sculptor in the country. He attended the Art Academy of Cincinnati from 1884 to 1888, studying drawing with Thomas S. Noble (1835–1907) and sculpture with Louis T. Rebisso (1837–1899). In 1889 he went to Paris, where he studied at the Académie Julian and Académie Delecluse, and later at the Jardin des Plantes with Emmanuel Frémiet (1824–1910). He originally studied to be a painter but in 1897 exhibited his first animal sculpture at the Paris Salon. He returned to the United States in 1900, fully committed to animal sculpture. Beginning with his sculptural decorations for the lion house at the New York Zoological Park, 1902–3, he received numerous commissions for public sculptures. In 1921 he married Grace Harvey, a photographer also from Ohio. In 1929 Harvey retired to Alhambra, California, and the following year was accorded a solo exhibition at the Los Angeles Museum.

BIBLIOGRAPHY
Wilmington, Ohio, Clinton County Historical Society, Eli Harvey Scrapbooks § R. G. McIntyre, "Eli Harvey: Sculptor," *Arts and Decoration* 3 (December 1912): 58–59, 74 § Jessie Lamont, "Impressions in the Studio of an Animal Sculptor," *International Studio* 51 (November 1913): CVI–CVIII, supp. § Murrells Inlet, S.C., Brookgreen Gardens, *Sculpture by Eli Harvey,* 1937 (folder) § Dorothy Z. Bicker, Jane Z. Vail, and Vernon G. Wills, eds., *The Autobiography of Eli Harvey: Quaker Sculptor from Ohio* (Wilmington, Ohio: Clinton County Historical Society, 2d ed., 1966).

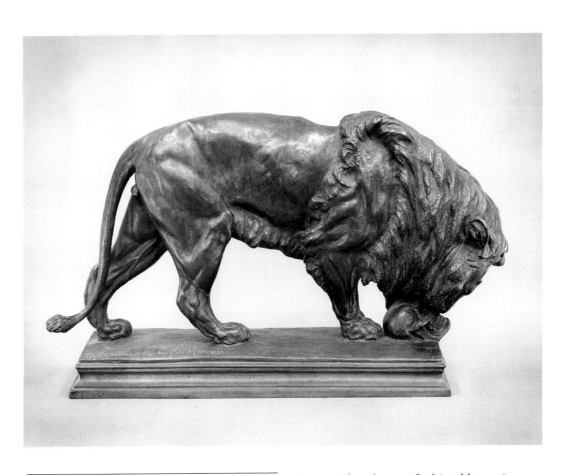

Harvey, *Lion of the Desert.*

Lion of the Desert, modeled and copyrighted 1904

Bronze
8⅞ in (22.5 cm) with base
Signed and dated on front, on top of base left:
Eli·Harvey·Sc·1904·
Inscribed on back, on top of base left:
Copyright·1904·by Eli·Harvey·
Inscribed on left, on base edge: Roman Bronze Works N.Y. 1904.
Gift of Eli Harvey
43.17.6

Harvey is best known for his tabletop-size bronzes issued in large editions. *Lion of the Desert* is one such bronze, and it displays Harvey's essentially naturalistic approach, although the skull adds an uncharacteristic narrative element. He favored wild over domestic animals and exotic over native. Felines, often lions, were his principal subject.

According to Roman Bronze Works's records for 1904 to 1916 the foundry cast only one *Lion of the Desert,* on October 5, 1904, so the museum's bronze may be a unique cast. The

number two is, however, stamped into the underside of the base.

PROVENANCE
The artist, c. 1904–43.

LITERATURE (GENERAL)
New York, Roman Bronze Works, *Ledger 1904–15,* unpaginated, lists cast no. 1, October 5, 1904, for forty dollars.

Paul Manship

Born December 24, 1885,
Saint Paul, Minnesota
Died January 31, 1966,
New York, New York

During the thirty years between 1915 and 1945 many considered Paul Howard Manship to be the nation's greatest sculptor. He studied painting and sculpture at the Saint Paul Institute of Art before going in 1905 to New York, where he attended the Art Students League. He spent a year as assistant to the sculptor Solon H. Borglum (1868–1922) in Mamaroneck, New York. He next studied at the Pennsylvania Academy of the Fine Arts in Philadelphia with Charles Grafly (1862–1929) and assisted Isidore Konti (1862–1938). In 1909 Manship won a three-year scholarship to the American Academy in Rome. His introduction there to ancient art, particularly archaic Greek sculpture, profoundly influenced his mature style. He returned to New York late in 1912 and married early the following year. He almost immediately encountered success. Election to the National Academy of Design in 1916 was only one of many honors that came to Manship early.

During World War I he served with the Red Cross in Italy and afterward lived in London and then in Paris. In 1927 he established his permanent residence and studio in New York, although he also maintained a studio in Paris until 1937. During World War II he built a summer home and studio in Gloucester, Massachusetts. Although after the war he continued to receive important civic commissions, he increasingly was regarded as an arch-conservative.

BIBLIOGRAPHY
Archiv. Am. Art, Paul Manship Papers § Paul Vitry, *Paul Manship: Sculpteur américain,* Artistes étrangères contemporaines Series (Paris: Editions de la Gazette des Beaux-Arts, 1927), with catalogue of principle works § Edwin Murtha, *Paul Manship* (New York: Macmillan, 1957), with catalogue raisonné, chronology, bibliography § Saint Paul, Minnesota Museum of Art, and others, *Paul Manship: Changing Taste in America,* exh. cat., 1985, with essays by Harry Rand, Frederick D. Leach, Susan Rather, and others, bibliography § Harry Rand, *Paul Manship* (Washington, D.C.: Smithsonian Institution Press, 1989), with bibliography, published in conjunction with an exhibition held at the National Museum of American Art, Smithsonian Institution, Washington, D.C., and others, 1989–91.

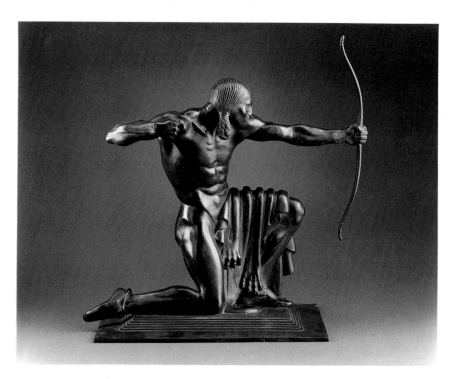

Manship, *Indian.*

Indian, modeled and copyrighted 1914
(*Indian Hunter; Kneeling Indian; Kneeling Indian with Bow*)
Bronze
12¹³/₁₆ in (32.6 cm) with base
Signed and dated on back, on top of base: PAVL MANSHIP / ©1914
Foundry mark on right, on side of base: ROMAN BRONZE WORKS N.Y.
Paul Rodman Mabury Collection
39.12.30

Although *Indian* apparently was sold separately, it and *Pronghorn Antelope,* 1914 (see illustration), were designed as companion pieces (examples of both in Saint Louis Art Museum and National Museum of American Art, Smithsonian Institution, Washington, D.C.). Manship originally created the pair of sculptures for his own use, to occupy places at either end of a mantlepiece in his apartment in New York.

The antelope's side is pierced by the arrow, in low relief, that has just left the Indian's bow. The release of tension in the bow is answered by the tensing of the animal's body in pain and surprise; the pair of sculptures relate to each other across distance in terms of sequence and cause-and-effect. Formally they offer a contrast between the heavy, stable, and angular body of the Indian and the light, unstable, and curving form of the antelope.

Like the antelope and like many of Manship's earlier sculptures, *Indian* is relatively flat and meant to be viewed principally from one side. The sculptor stated that his primary objective was to create decorative arrangements of form. The strong silhouette allowed him to develop long, elegant contour lines and to achieve contrast and balance of form and space, both within each figure and between the two. While at the American Academy in Rome he had developed a great admiration for the formal qualities of archaic Greek sculpture, as well as Gothic and East Indian sculpture. Although his subject is a Native American, Manship developed it in terms of Greek models in the way the simple, clear form of the man's body is set off by the areas of stylized, decorative detail in the hair and in the drapery. Although it must be the skin of a wild beast, the flat folds and meandering edge of the drapery emulate Greek examples. The essential quality of Manship's sculpture is that it formalizes nature to achieve a pleasing, decorative effect in which rich patterns balance austere purity of outline. Manship was one of the first American sculptors to reject the Rodinesque style of conspicuous modeling, seen in the work of ARTHUR PUTNAM, for example. There are no accidents of modeling in his smooth, compact, very carefully calculated, and exquisitely adjusted forms.

The statuette was cast by Roman Bronze Works, New York, in an edition of fifteen (see

Murtha, *Manship*, p. 152, for partial list of locations), and a unique example of heroic size was made in 1917, originally for the garden of Herbert Pratt, Glen Cove, N.Y.

COMPANION PIECE
Pronghorn Antelope, 1914, bronze, 12⅛ in (30.8 cm), see Murtha, *Manship*, p. 152, for partial list of collections.

PROVENANCE
Paul Rodman Mabury, Los Angeles, to 1939.

EXHIBITIONS
Los Angeles Art Association, *Loan Exhibition of International Art*, 1937, exhibited but not listed § Pomona, Calif., Los Angeles County Fair, *Masters of Art from 1790 to 1950*, 1950, entries not numbered, repro., unpaginated, as *Kneeling Indian with Bow* § Claremont, Calif., Scripps College, Art Department, [sculpture exhibition], 1955, no cat. traced § Los Angeles, Barnsdall Park, Municipal Art Gallery, *Form in Time*, 1955, no cat. traced § Los Angeles Municipal Art Department, *Artmobile for L.A. Elementary Schools*, 1968–70, no cat. traced.

LITERATURE (GENERAL)
"Paul H. Manship," *Art and Progress* 6 (November 1914): 21, reprints letter by Herbert Adams, who praises Manship's skill in design and execution, repro., p. 20 § Murtha, *Manship*, p. 152, listed in cat. raisonné as no. 51, with description and selected list of collections, pl. 12, p. 36 § Minnesota Museum of Art, *Manship: Changing Taste*, no. 97, p. 136, entry by Jean F. Hunter, fig. 97, p. 136 § Susan Rather, "The Origin of Archaism and the Early Sculpture of Paul Manship," Ph.D. diss., University of Delaware, 1986, pp. 283–84, discusses circumstances of creation, issue of size, and opinions of Charles Caffin and Royal Cortissoz § Rand, *Manship*, p. 36, describes the interaction between the two pieces, fig. 26, p. 40, as *Indian Hunter*.

LITERATURE (SPECIFIC)
Higgins 1963, p. 128, no. 29 in checklist of Paul Rodman Mabury collection, as *Kneeling Indian*.

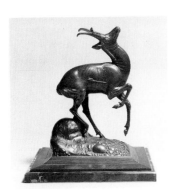

Manship, *Pronghorn Antelope*, 1914, see Companion Piece. Saint Louis Art Museum, Museum Purchase.

Malvina Hoffman

Born June 15, 1885,
New York, New York
Died July 10, 1966,
New York, New York

Malvina Cornell Hoffman was renowned for her figurative sculptures of non-Western racial types. She first studied painting with JOHN W. ALEXANDER and received advice from her cousin, sculptor Herbert Haseltine (1877–1962). At the age of twenty-two she decided to become a sculptor and began studying with Herbert Adams (1858–1945) and George Grey Barnard (1863–1938) at the Veltin School in New York. Later she studied anatomy and dissection at Columbia University in New York. From 1910 to 1914 Hoffman lived in France, where she received criticism from Auguste Rodin (1840–1917), who permitted her to draw with him and to watch him carve. This experience was to have an important effect on her art, determining her early romantic-symbolist themes and sketchy, fluid approach to surface.

During the 1910s Hoffman achieved international success with sculptures devoted to the dance, including figures of the famed Anna Pavlova; a large example of her *Russian Bacchanale*, modeled 1912, was installed in the Luxembourg Gardens in Paris. During the late 1910s and 1920s she received major commissions for fountains and monuments, including the war memorial, *The Sacrifice*, 1920, in the Harvard Memorial Chapel in

Cambridge, Massachusetts. In 1927 she studied with Ivan Meštrović in Zagreb, Yugoslavia.

In 1929 the Field Museum of Natural History in Chicago asked Hoffman to participate in an ethnographic endeavor to document the different races of mankind. Traveling throughout Africa, Asia, and Australia and assisted by her husband Samuel B. Grimson, who took charge of measuring and photographing the people, she studied different physiognomies and created more than one hundred bronze and stone heads, busts, and full-length figures. The project was completed in time to be a central feature of the 1933 Chicago World's Fair. When the series was later put on permanent display in the Hall of Man in the Field Museum, Hoffman was praised for her dramatic realism and faithfulness to racial types. She wrote about her experiences during this project in her first book, *Heads and Tales* (1936).

Hoffman continued to work for another thirty years, applying her detailed, realistic style to portraits of notables, among them Ignacy Paderewski and Wendell Wilkie. She also received several architectural commissions. She wrote two other books, *Sculpture Inside and Out* (1939) and an autobiography, *Yesterday Is Tomorrow* (1965).

BIBLIOGRAPHY
Los Angeles, Getty Center for the History of Art and Humanities, Archives of the History of Art, Malvina Hoffman Papers § Arsène Alexandre, *Malvina Hoffman* (Paris: J. E. Pouterman, 1930), with chronological list of principal works § Malvina Hoffman, *Heads and Tales* (New York: Scribner's, 1936) § Malvina Hoffman, *Yesterday Is Tomorrow, A Personal History* (New York: Crown Publishers, 1965), with chronological list of works § Linda Nochlin, "Malvina Hoffman: A Life in Sculpture," *Arts* 59 (November 1984): 106–10.

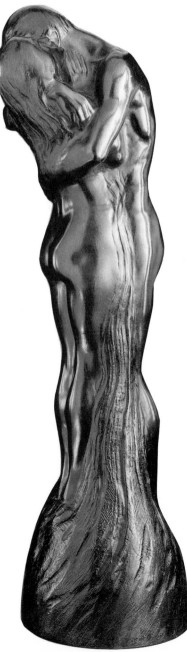

Hoffman, *Column of Life.*

Column of Life, modeled in small scale 1912, modeled at 26 inches 1917, cast 1966

Bronze
26 in (66.2 cm)
Inscribed around lower edge: M. HOFFMAN © BEDI-RASSY N.Y.
Gift of the B. Gerald Cantor Art Foundation
M.86.261

In her autobiography, *Heads and Tales*, Hoffman recounted the genesis of *Column of Life* (pp. 43–44):

> I was kept waiting a long time for Rodin to arrive. I took two small bits of clay and rolled them absent-mindedly into two pieces about five inches long. These I pressed together in my closed hand, and studying the result was amazed to find that the pressure of my fingers had clearly suggested the forms of two standing figures. I added the two heads and was tapping the base on the stone step to make it stand up, when Rodin appeared. He asked me what I was doing and I showed him the little group. "Just an accident," I said, "made while I was waiting for you."
>
> After carefully examining it from all sides, he said very seriously, "There is more in this than you understand at present. . . . You will keep this, and model this group one-half life-size and cut it in marble—but before you do it, you must study for five years."

In 1912 the clay model was made into a seal five inches high and cast in bronze, with approximately 128 lifetime casts and five posthumous ones.

Following Rodin's advice, Hoffman did not translate the idea of the lovers into a larger scale until about 1917, when she carved two marble examples (private collections). Bronzes of *Column of Life* were not produced until even later, and their casting history is somewhat complex. The dating of a single bronze cast by Cellini Bronze Works Company, Brooklyn (Art Institute of Chicago), is problematic; it may have been cast as early as 1928 although records in the Hoffman papers list it under 1937. This Cellini bronze is unique in its inclusion of a separately cast, forty-two-inch pedestal with oriental motifs: elaborate low reliefs of six centers of kundalini (*chakras*) connected by a serpentine form. Not until more than two decades later was another edition cast by Bedi-Rassy Art Foundry, Brooklyn. According to the artist's account ledgers and foundry receipts, a plaster cast was made in 1959, probably from the marble sold that year to Huntington Hartford. The following year Bedi-Rassy cast a bronze, probably from the 1959 plaster, and it was sold (Glenbow Foundation, Calgary, Alberta, Canada). The foundry also produced a second cast three months before Hoffman's death, the museum's cast.

Column of Life exemplifies the strong influence of Rodin on Hoffman during her early years as a sculptor. Rodin created many marbles of lovers embracing, usually presenting the

couples as if their bodies were melted together and they had just emerged from the roughly hewn block of stone. Hoffman treated her lovers in a similar manner, also modeling the surface in soft, flowing passages in a manner similar to the sketchy surfaces of Rodin's sculptures. Such a handling intensified the sensual quality of the theme.

RELATED WORK
Plaster cast of marble example, 1959, dimensions unknown. Estate of the artist.

PROVENANCE
Estate of the artist, New York, 1966–79 §
B. Gerald Cantor Art Foundation, New York, 1979–86.

LITERATURE (GENERAL)
Los Angeles, Getty Center, Archives of History of Art, Malvina Hoffman Papers, "Bronzes made for Malvina Hoffman by Cellini Bronze Foundry," typed list, n.d., under 1937 lists "Pedestal for Column of Life $135[,] Column of Life, statuette 2 figs $85"; account ledgers, February 10, 1959–May 1960, pp. 118–48, lists information about plaster cast, foundry,

and sale of *Column of Life*; "Bedi-Rassy for Malvina Hoffman," typed list, n.d., lists 1960 casting for $280 § Pauline Carrington Bouvé, "The Two Foremost Women Sculptors in America: Anna Vaughn Hyatt and Malvina Hoffman," *Art and Archaeology* 26 (September 1928): 78, recounts circumstances of *Column of Life*'s creation, repro. of marble, p. 77 § Alexandre, *Hoffman*, pp. 13, 38, no. 13 in list of works, dates marble 1917 and refers to a bronze example, repro. of marble, p. 55 § *Index 20th Cent. Artists* 2 (October 1934): 9; reprint, p. 255; mentions in biography § Hoffman, *Heads and Tales*, pp. 43–44, details first modeling of sculpture in Rodin's studio, repros., p. 40, of three-foot marble and photograph of Hoffman examining the small model in her studio § Hoffman, *Yesterday Is Tomorrow*, p. 374, listed under 1917 and refers to a 1939 bronze example with "Oriental Pedestal" § Nochlin, "Hoffman," p. 108, refers to 1928 cast as "a kind of vertical version of Rodin's famous *The Kiss*."

LITERATURE (SPECIFIC)
LACMA, American Art department files, Janis Conner to Ilene Susan Fort, December 12, 1986, discusses carving of marble examples and history of bronze castings.

Gaston Lachaise

Born March 19, 1882,
Paris, France
To United States 1906
Died October 18, 1935,
New York, New York

One of America's most significant modernist sculptors, Gaston Lachaise is known for his female nudes. The son of a cabinetmaker, at the age of thirteen he began traditional academic studies in Paris with the sculptors Jean-Paul Aube (1837–1916) and Alphonse Emmanuel Monçel (born 1866) at the Ecole Bernard Palissy, and in 1898 with Gabriel Jules Thomas (1824–1905) at the Académie Nationale des Beaux-Arts. Early in the next decade, sometime between 1901 and 1903, he met and fell in love with Isabel Dutaud Nagle, a married American woman. Although he would not be able to marry her until 1917, their love determined the course of his life and art.

Lachaise immigrated to the United States in 1906 and settled first in the Boston area to be close to Isabel. From 1906 to 1912 he worked in the studio of the sculptor Henry Hudson Kitson (1865–1947) and then moved to New York, where he did carving for PAUL MANSHIP. In 1916 he became an American citizen. The year of his marriage, he met E. E. Cummings, Scofield Thayer, and James Sibley Watson, Jr., three men who would be significant in promoting Lachaise's career through the literary magazine *The Dial*. In 1921 he began to receive commissions for architectural reliefs, including the American Telephone and Telegraph Building (destroyed), and the R.C.A. and International Buildings in Rockefeller Center, all in New York. His first solo exhibition in New York at the Stephan Bourgeois Gallery in February 1918 received critical praise. He was given other exhibitions by progressive New York dealers, again at the Bourgeois Gallery in 1920, at the Intimate Gallery in 1927, and at the Brummer Gallery in 1928. The year of his death he was accorded his first museum exhibition by the Museum of Modern Art, New York.

Isabel served as the spiritual and physical model for the buxom nudes Lachaise began to sculpt around 1910. During the next two decades he presented his idealized conception of the eternal woman in standing, lounging, and floating single figures, and in body fragments (torsos, breasts, and knees). In his statues and relief panels Lachaise's ever-changing style developed from his early, sketchy and rippling surfaces to a more streamlined and crisp interpretation of form and line. Through his simplification of surfaces and shapes he achieved some of the most modern interpretations of three-dimensional form by an American.

BIBLIOGRAPHY
Boston, Lachaise Foundation, Gaston and Isabel Lachaise Papers, and New Haven, Conn., Yale University, Beinecke Rare Book and Manuscript Library, Collection of American Literature, Lachaise Archive (papers in Lachaise Foundation on microfilm, Archiv. Am. Art) § A. E. Gallatin, *Gaston Lachaise* (New York: E. P. Dutton, 1924), with list of works § Hilton Kramer, *The Sculpture of Gaston Lachaise* (New York: Eakins Press, 1967), with reprints of essays by Hart Crane, E. E. Cummings, Marsden Hartley, and others, chronology, bibliography, list of public collections § Gerald Nordland, *Gaston Lachaise: The Man and His Work* (New York: George Braziller, 1974), with bibliography, published in conjunction with an exhibition held at the Herbert F. Johnson Museum of Art, Cornell University, Ithaca, N.Y., and others § Washington, D.C., Smithsonian Institution, National Portrait Gallery, *Gaston Lachaise: Portrait Sculpture*, exh. cat., 1985 (copublished with Smithsonian Institution Press), with essay by Carolyn Kinder Carr, entries by Margaret C. S. Christman, bibliography.

Lachaise, *Sea Lion.*

Sea Lion, modeled by early 1918, copyrighted 1921, probably cast 1921
Bronze
11 in. (27.9 cm) with base
Signed and dated on back, on base left: G. LACHAISE © / 1921
Gift of Mr. and Mrs. Alexander R. Brandner
M.83.175.2

Lachaise's art is not usually identified with animals, but all his life he was devoted to visiting zoos and the circus. His first solo exhibition in New York at the Bourgeois Gallery during February 1918 included not only female nudes but animals as well, and in the 1920s animals supplied Lachaise with the subject for several commissioned fountains.

Early on, A. E. Gallatin commended the animal studies, saying, "Lachaise's genius in many instances has soared to its greatest heights in his studies of animals. In these creations his love of voluptuous and swelling forms has found full play. Possessed of great style and highly decorative are both of his interpretations of peacocks. . . . Also a masterpiece of stylistic animal interpretation is Lachaise's imposing sea-lion, seen raising his head with a superb gesture above his massive body, the thick folds of fat quivering with life." Whereas his group of three bronze peacocks, 1918 (Metropolitan Museum of Art, New York), was inspired by Manship's work of the same period, Lachaise's sea lion is in his own mature style. Lachaise's conception of the sea lion's body as a pyramid, the corpulent solidity of the animal, and the suggestion of the soft, swelling nature of its skin make it analogous to his interpretation of the reclining female nude in the series *The Mountain*, begun in 1913. This interpretation might have been encouraged by Lachaise's interest in Eskimo art, which his friend E. E. Cummings explained was related to the sculptor's desire to "experience the bigness and whiteness and silences of the polar regions" ("Gaston Lachaise," *The Dial* 68 [February 1920]: 197).

Little is known about the casting histories of Lachaise's bronzes. *Sea Lion* seems to have been cast on at least two different occasions by unidentified foundries: an example with the date 1917 is owned by the Phillips Collection, Washington, D.C., while the museum's cast is dated 1921, as is the example in the Whitney Museum of American Art, New York (as *Seal*).

PROVENANCE
Mrs. Alexander R. Brandner, Laguna Hills, Calif., to 1982 § Estate of Mrs. Alexander Brandner, 1982–83.

ON DEPOSIT
LACMA, 1982–83.

LITERATURE (GENERAL)
Gallatin, *Lachaise*, pp. 13–14, describes animal sculptures, p. 51, cited under 1918 in list of works, pl. 16, p. 48.

Elie Nadelman

Born February 20, 1882,
Warsaw, Polish Russia
To United States 1914
Died December 28, 1946,
New York, New York

Elie Nadelman was a successful sculptor working in an original and highly influential modernist style. He received a high school education in Warsaw and briefly attended the art academy there before beginning a year's service in the Russian Imperial Army in 1900. He then returned to the academy for a year. In 1904 he spent six months in Munich before settling in Paris, where he remained until 1914. He briefly drew at the Atelier Colarossi. In Paris Nadelman pursued theoretical studies of form and evolved a greatly simplified style of sculpture inspired by Renaissance, classical, and archaic models. While in Paris he was a prominent figure in the most avant-garde circles. He is thought to have influenced Picasso's development of analytical cubism in 1909. An exhibition in a gallery in London in 1911 won Nadelman the patronage of Helena Rubenstein and the wide exposure of his works in her beauty establishments.

Unable to return to Russia to serve in the Imperial Army at the outbreak of the First World War, he moved to New York, where he lived until 1929. Exhibitions at the "291" gallery in late 1915–early 1916 and at Scott & Fowles Gallery in 1917 launched his successful American career. He received numerous private commissions for portraits and decorative work. His satiric figures in plaster and wood were not as well received. His marriage in 1920 to a wealthy widow enabled his purchase of an estate in Riverdale, New York, where he established a studio. The couple lived a fashionable and extravagant life in their mansion in New York. They also amassed an early collection of American folk art. The financial crash of 1929 brought bankruptcy upon them. Nadelman at first sought architectural commissions. Having removed to the estate in Riverdale, he worked primarily in ceramics during the early 1930s and in plaster after 1935, modeling mainly small classical figures.

BIBLIOGRAPHY
New York, Museum of Modern Art, and others, *The Sculpture of Elie Nadelman*, exh. cat., 1948, with text by Lincoln Kirstein, bibliography by Bernard Karpel § Athena T. Spear, "Elie Nadelman's Early Heads (1905–1911)," *Allen Memorial Art Museum Bulletin* 28 (Spring 1971): 201–22 § Lincoln Kirstein, *Elie Nadelman* (New York: Eakins Press, 1973), with statements by the artist, catalogue raisonné, bibliography, list of exhibitions compiled by Ellen Grand § New York, Whitney Museum of American Art, and Washington, D.C., Smithsonian Institution, Hirshhorn Museum and Sculpture Garden, *The Sculpture and Drawings of Elie Nadelman, 1882–1946*, exh. cat., 1975, with text by John I. H. Baur, chronology by Hayden Herrera § I. E. Ouvaroff, "Homage to Elie Nadelman," *Yale Literary Magazine* 150, no. 3 (1983): 1–6, 13–25, with quotes by the artist.

Nadelman, *Marie Scott.*

Marie Scott, carved 1919
Marble with three bronze reliefs attached to base
20¼ in (51.5 cm) with base; relief panels: front, 2⅞ x 4⅝ in (7.3 x 11.7 cm); right, 2⅞ x 2¹⁵⁄₁₆ in (7.3 x 7.4 cm); left, 2⅞ x 3¹¹⁄₁₆ (7.3 x 9.3 cm)
Signed on back, on neck: ELIE NADELMAN
Gift of Mrs. Stevenson Scott
58.25

Nadelman's introduction to New York was largely through Martin Birnbaum, a junior partner at the firm of Scott & Fowles, the artist's dealers from 1915 to 1925, who organized two successful exhibitions of his work in 1917 and 1925. In about 1916 Nadelman carved a marble bust of the firm's senior partner, Stevenson Scott (Joslyn Art Museum, Omaha). In 1915 Nadelman began studies for *Portrait of a Little Girl*, 1916 (Metropolitan Museum of Art, New York), a three-quarter-length marble sculpture of Scott's daughter. Nadelman completed portraits of the family with this head of Mrs. Stevenson Scott, Marie, carved in 1919.

Seldom attempted before by Nadelman, portraiture became a significant part of his output

during his New York period, coming to about two dozen examples. Most are in white marble and similar to *Marie Scott* in their balance of accurate representation and stylization. Nadelman sought pure forms within the specific, slightly abstracting and softening the portrait. In 1910 Nadelman explained, "I employ no other line than the curve, which possesses freshness and force. I compose these curves so as to bring them in accord or opposition to one another. In that way I obtain the life form, i.e. harmony" ("Photo-Secession Notes," *Camera Work* no. 32 [October 1910]: 41). One finds in *Marie Scott* this balanced, rhythmic, flowing movement of simplified, swelling volumes. This fluid quality is enhanced by Nadelman's rejection of the conventional opaque marble surface, which gives a hard, firm appearance. He polished his marbles to the point that they have a soft, waxlike surface. This allowed planes to merge imperceptibly, while also giving the sculpture an indefiniteness that enhances its ideal quality.

Nadelman was one of numerous sculptors who found in early Greek sculpture the strength and purity of simplified naturalism. If the frontal, regular, ideal marble bust of Marie Scott, seemingly broken from a larger work, recalls ancient sculpture, the decoration of its base does so even more, both in its theme and stylization that recall gem carving. According to Lincoln Kirstein, an early photograph shows the model on a plain onyx base. It is not known when the present bronze base with its three reliefs was substituted. In several instances Nadelman used relief sculptures on his bases. The three reliefs here appear to be softer, less-detailed versions of parts of the bronze relief *Autumn*, c. 1912 (Hirshhorn Museum and Sculpture Garden, Smithsonian Institution, Washington D.C.), but are too much reduced in scale to have been taken from it by *surmoulage*. The original design for the reliefs may have been provided by the now-lost terra-cotta relief *L'Automne* that Nadelman made for Helena Rubenstein's London house in 1912.

The relief on the front of the base repeats almost the entire composition of the bronze *Autumn* of c. 1912. The relief on the proper right is just of the horse and rider, and the relief on the other side is of the grouping of three figures. Although themes of this kind are common in Greek art, it is possible to find here the example of the Elgin marbles in the British Museum, which Nadelman may have seen in London while working on the Rubenstein commission for *L'Automne*. The reclining woman with a younger figure clutching her leg may recall the figures of Aphrodite and Eros, and the position of Nadelman's horsewoman recalls the rider on the Parthenon frieze who leans back to speak to the rider behind him.

RELATED WORK
Autumn, c. 1912, bronze relief, 9 x 18¼ in (22.9 x 46.3 cm). Hirshhorn Museum and Sculpture Garden, Smithsonian Institution, Washington, D.C.

PROVENANCE
Mr. and Mrs. Stevenson Scott, New York, 1919–58.

EXHIBITIONS
Santa Barbara (Calif.) Museum of Art and others, organized by California Arts Commission, *Perception: An Exhibition of Sculpture for the Sighted and Blind,* 1971–72, entries not numbered, p. 45, repro., p. 44 § Los Angeles, Black Arts Council for the Blind, Children's Center, *Tactile Sculpture Exhibition,* 1972, no cat. traced.

LITERATURE
LACMA, Registrar's files, Mrs. Stevenson Scott to Jean Delacour, June 30, 1958, identifies sitter, gives date and circumstances of sculpture's creation § "Painting and Sculpture," *LA Museum Art Div. Bull.* 10 (1958): repro., unpaginated § Kirstein, *Nadelman,* p. 303, listed in cat. raisonné as no. 171, incorrectly identifies sitter as the Scotts' daughter, incorrectly dates 1925, discusses base § LACMA, American Art department files, Zabriskie Gallery to Ilene Susan Fort, May 31–November 1, 1985, discuss various versions of *L'Automne* and *Autumn;* Zabriskie Gallery to Michael Quick, November 28, 1988, discusses the possibility of Hirshhorn Museum's *Autumn* relating to the museum's reliefs.

Nadelman, *Autumn,* c. 1912, see Related Work.

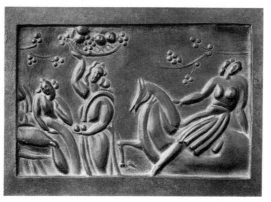
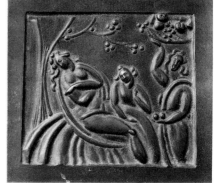

Nadelman, *Marie Scott,* reliefs on the base's proper right, front, and proper left.

Jo Davidson

Born March 30, 1883,
New York, New York
Died January 3, 1952,
near Tours, France

Jo Davidson, born Joseph, was the most famous American portrait sculptor of the mid-twentieth century. After studying at the Art Students League with George de Forest Brush (1855–1941), he studied medicine at Yale University. From around 1901 to 1904 he worked as a studio assistant to sculptor Hermon Atkins MacNeil (1866–1947). In 1907 Davidson went to Paris to study at the Ecole des Beaux-Arts and while there met Gertrude Stein and acquired the patronage of Gertrude Vanderbilt Whitney. After his return to the United States in 1910 his first solo exhibition was held at the New York Cooperative Society. He thereafter exhibited his sculptures and drawings widely, in the Armory Show of 1913 and in other major exhibitions of modernist art.

Firsthand exposure to the fighting during World War I as an artist-correspondent turned Davidson's attention to contemporary politics. For his busts of the Allied leaders made during the late 1910s and early 1920s he attained an international reputation as a "plastic historian." During the next several decades he made portrait sculptures of individuals who had made notable contributions to literature, art, and politics. Although Davidson's portraits are realistic, they also reflect his training, grounded in the turn-of-the-century beaux-arts style, especially in the invigorated, sketchy surfaces of his portraits. Not as well known are his ideal subjects, which he began to make early in his career and never totally abandoned. His evocative nudes, carved in marble or bronze, reflect the influence of symbolism and Auguste Rodin (1840–1917).

BIBLIOGRAPHY
Washington, D.C., Library of Congress, Jo Davidson Papers § Raymond Wyer, "A New Message in Sculpture: The Art of Jo Davidson," *Fine Arts Journal* 26 (April 1912): 262–70 § *Index 20th Cent. Artists* 2 (August 1935): 157–59; 2 (September 1935): I; 3 (August–September 1936): III; reprint, pp. 447–49, 457, 459 § Jo Davidson, *Between Sittings: An Informal Autobiography of Jo Davidson* (New York: Dial, 1951) § Washington, D.C., Smithsonian Institution, National Portrait Gallery, *Jo Davidson: Portrait Sculpture*, exh. cat., 1978, with foreword by Marvin Sadik, entries by Marc Pachter and Amy E. Henderson, checklist of Davidson sculptures in the collection.

Davidson, *Lord Balfour.*

Lord Balfour, modeled 1920
Bronze
14⅞ in (37.8 cm)
Signed and dated on back, on right shoulder: JO DAVIDSON / MODELED 8 RUE FRANKLIN PARIS / JAN 1920
Inscribed on front: [indecipherable]
Foundry mark in rectangular cachet on back, center: CIRE / VALSUANI / PERDUE
Gift of Maury P. Leibovitz
M.83.206.10

Arthur James, the first Earl of Balfour (1848–1930), was prime minister of the United Kingdom, 1902–5. During World War I he served as minister of foreign affairs and in 1917 issued a declaration favoring the establishment in Palestine of a national Jewish homeland.

Davidson modeled this sculpture as part of a series of Allied leaders. It was done from life while Balfour was attending the Paris Peace Conference in 1920. The broad planes of the head are typical of Davidson's early portraits.

PROVENANCE
Maury P. Leibovitz, New York, to 1983.

LITERATURE (GENERAL)
Eulalia Anderson, "Jo Davidson's Portrait Busts," *American Magazine of Art* 11 (November 1920): repro., 471 § Davidson, *Between Sittings,* pp. 146, 367.

Gertrude Stein, modeled c. 1920–23, possibly cast posthumously
Bronze
32 in (81.3 cm)
Signed and dated on right side, on leg: JO DAVIDSON / PARIS 1920[?]
Signed by Stein on right side, on leg: Gertrude Stein
Gift of Maury P. Leibovitz
M.83.206.3

The figure of Gertrude Stein (1874–1946) is Davidson's best-known sculpture due to the reputation of the sitter and modernity of the work itself. Stein was a champion of the avant-garde in both her writings and patronage of early twentieth-century modernist art. She collected the works of Paul Cézanne (1839–1906), Pablo Picasso (1881–1973), and Henri Matisse (1869–1954), and in her Paris salon numerous American artists were exposed to radical European trends.

As he explained, Davidson chose not to sculpt just a head of Stein because "there was so much more to her than that." He faithfully conveyed the massiveness of Stein's figure as an immobile, pyramidal form with the weight massed at the base. He did not allow the surface treatment to weaken the primary effect of bulk and limited the linear markings to a few details—the collar, cuffs, and pin—and suggested texture only in the clothing. This "modern Buddha," as Davidson called it, suggests the eternal quality that the sculptor thought Stein possessed.

Although Davidson wrote that he modeled Stein's portrait in 1923 and the National Portrait Gallery, Smithsonian Institution, Washington, D.C., dates its terra-cotta to that year, the most famous bronze cast of the sculpture, owned by the Whitney Museum of American Art, New York, is dated 1920, and the work was mentioned in periodicals in 1922.

PROVENANCE
Maury P. Leibovitz, New York, to 1983.

LITERATURE (GENERAL)
Guy Pène du Bois, "Art by the Way," *International Studio* 76 (November 1922): 180–81, discusses vis-a-vis Stein's personality, repro., 179 § Gertrude Stein, "A Portrait of Jo Davidson," *Vanity Fair* 19 (February 1923): 48, 90, repro., 48 § Davidson, *Between Sittings,* pp. 174–75, discusses the statue and his opinion of Stein, gives 1923 date, repro. of plaster, opposite p. 118.

Davidson, *Gertrude Stein.*

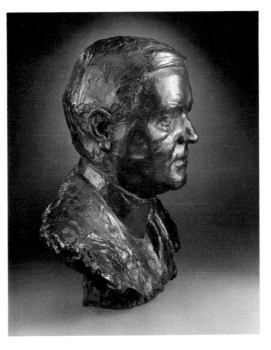

Davidson, *Herbert Hoover.*

Herbert Clark Hoover (1874–1964) was the thirty-first president of the United States, serving during the early years of the Great Depression. He began his career as an engineer and was known for his relief work, the feeding of millions of needy people after World War I.

This portrait was modeled when Hoover was secretary of commerce as part of Davidson's project to sculpt the notable Allied military and civil figures of World War I. The bust has a relatively smooth surface, which is typical of Davidson's early portraits.

The bronze carries a foundry mark of the Chicago firm of A. C. Rehberger, one of the foundries the artist used in the United States. There is also a cast in the National Portrait Gallery, Smithsonian Institution, Washington, D.C.

PROVENANCE
Maury P. Leibovitz, New York, to 1983.

LITERATURE (SPECIFIC)
LACMA, American Art department files, Jacques Davidson to Ilene Susan Fort, September 17, 1985, states that his father used Rehberger foundry.

Herbert Hoover, modeled 1921, possibly cast posthumously
Bronze
16³/₁₆ in (41.1 cm) with socle
Signed and dated on back, on collar right: JO DAVIDSON / N.Y. 1921
Signed by Hoover on front, center: Herbert Hoover
Foundry mark of A. C. Rehberger in circular cachet on back, on base lower right
Gift of Maury P. Leibovitz
M.83.206.6

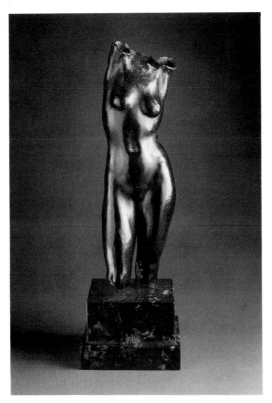

Davidson, *Female Torso.*

Female Torso, modeled 1929
Bronze
10³/₄ in (27.3 cm)
Signed and dated on back, on left leg: JO DAVIDSON / 1929 PARIS
Foundry mark in rectangular cachet on back, on left leg: CIRE / VALSUANI / PERDUE
Gift of B. Gerald Cantor Art Foundation
M.85.313

Davidson's ideal figures were usually female nudes sitting quietly or in motion. The slight contrapposto of *Female Torso* suggests that the figure is slowly turning and stretching. It differs from most of the artist's nudes in that it is not a whole figure but rather a headless torso that is reminiscent of a classical fragment. This tie with classical art is strengthened by Davidson's idealization of the figure as a perfect female body. The crisp delineation and smooth surface of the bronze further align it with classical marble statuary rather than the work of Rodin, whose softer treatment of surfaces influenced many of Davidson's later portraits.

In the tradition of late nineteenth-century symbolists Davidson intended his ideal figures to evoke an idea or feeling rather than something physical. Because he believed that the meaning of the sculptures was clearly conveyed by their gestures, he usually did not give them descriptive titles but "opus" numbers instead.

PROVENANCE
New York, Christie's, *American Paintings, Drawings, and Sculpture of the Eighteenth, Nineteenth, and Twentieth Centuries*, October 24, 1979, no. 272, repro. § B. Gerald Cantor Art Foundation, New York, 1979–85.

ON DEPOSIT
Cornell University, Ithaca, N.Y., 1980–82.

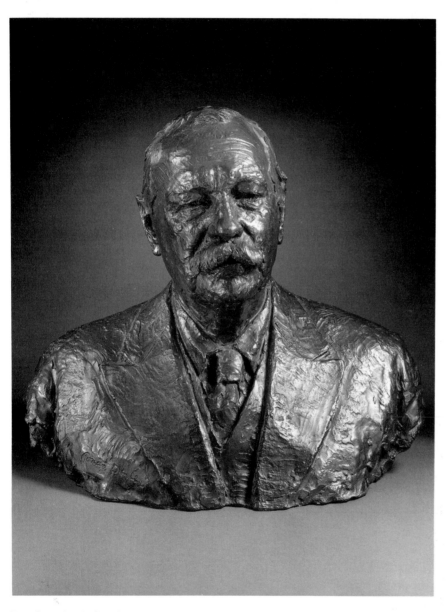

Davidson, *Sir Arthur Conan Doyle*.

Sir Arthur Conan Doyle, modeled 1930, possibly cast posthumously
Bronze
18³/₄ in (47.6 cm)
Signed and dated back on back, below collar right:
JO DAVIDSON / LONDON 1930
Signed by Conan Doyle on front, right: Conan Doyle
Foundry mark of A. C. Rehberger in circular cachet on back, on socle lower left
Gift of Maury P. Leibovitz
M.83.206.8

Best known for his detective stories featuring Sherlock Holmes, Sir Arthur Conan Doyle (1859–1930) also wrote romances, historical novels, and books on spiritualism.

Davidson modeled the elderly author as part of his project to document the most distinguished contemporary men of letters. The idea for such a series was suggested in 1930 by George Doran, whose publishing firm issued many books by the authors selected. At first Davidson was surprised by Conan Doyle's appearance but soon decided that his round face and drooping moustache reminded him of the fictional character, Dr. Watson.

PROVENANCE
Maury P. Leibovitz, New York, to 1983.

LITERATURE (GENERAL)
F. G. R., "Men of Letters," *Connoisseur* 88 (August 1931): 126, describes as an "almost speaking likeness" § Davidson, *Between Sittings,* p. 247, describes his reaction to sitter's appearance, repro., opposite p. 215.

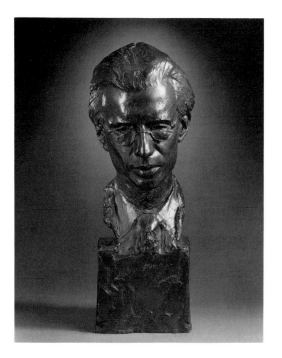

Davidson, *Aldous Huxley.*

Aldous Huxley, modeled 1930, possibly cast posthumously

Bronze
22½ in (57.1 cm) with base
Signed and dated back, on collar left: JO DAVIDSON /
PARIS 1930
Signed by Huxley on base: Aldous Huxley
Foundry mark of A. C. Rehberger in circular cachet
on back, on base lower right
Gift of Maury P. Leibovitz
M.83.206.13

Aldous Leonard Huxley (1894–1963), one of the foremost English novelists of the twentieth century, is now usually identified with the book *Brave New World* (1932).

Davidson sculpted this bust before Huxley had written his most famous novel. He was impressed with Huxley's appearance, writing that "genius was the word that came to your mind the moment you saw him." Although accurate in such details as the inclusion of Huxley's glasses, Davidson's depiction of the author's large, powerful head can also be identified with nineteenth-century romantic interpretations of creative genius.

There is an example of the head in terra-cotta in the National Portrait Gallery, Smithsonian Institution, Washington, D.C.

PROVENANCE
Maury P. Leibovitz, New York, to 1983.

LITERATURE (GENERAL)
F. G. R., "Men of Letters," *Connoisseur* 88 (August 1931): 126, discusses innovative treatment of spectacles § Davidson, *Between Sittings,* pp. 243, 248, describes Huxley's appearance.

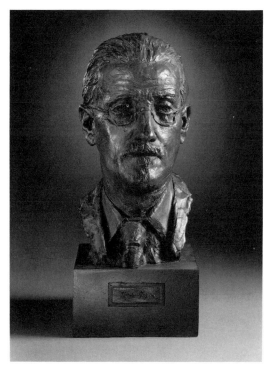

Davidson, *James Joyce.*

James Joyce, modeled 1930, possibly cast posthumously

Bronze
17⅛ in (43.5 cm) with base
Signed and dated on back, below collar: JO
DAVIDSON / 1930
Signed by Joyce on base: James Joyce
Gift of Maury P. Leibovitz
M.83.206.4

James Augustine Joyce (1882–1941) is best known for his novels *Portrait of an Artist as a Young Man* (1916), *Ulysses* (1922), and *Finnegans Wake* (1939).

Davidson first met Joyce in 1919 and had long wanted to sculpt him, for he found the author "frail, detached and the essence of sensitivity." Davidson aptly captured the intellectual aspect of Joyce, and when the bust was exhibited in 1933 a critic wrote that it "bespeaks the restraint of the ascetic mingled with perplexity common to the brow of the

philosopher." Although Davidson had difficulty rendering Joyce's eyeglasses, he successfully indicated them with delicately incised lines and ridges. Joyce often shaved off his goatee, so Davidson made two versions of his head, one with and one without it.

The Metropolitan Museum of Art, New York, has a terra-cotta example of the head.

PROVENANCE
Maury P. Leibovitz, New York, to 1983.

LITERATURE (GENERAL)
"Jo Davidson, Knoedler Galleries," *Art News* 32 (December 23 1933): 5 § Davidson, *Between Sittings*, pp. 241–43, describes Joyce.

Davidson, *Rudyard Kipling*.

Rudyard Kipling, modeled 1930

Bronze
15¹⁄₈ in (38.4 cm)
Signed and dated on back, on left shoulder: PIMA REON [?] / JAN. 8 1930 JO DAVIDSON
Foundry mark in rectangular cachet on back, on right shoulder: CIRE / VALSUANI / PERDUE
Gift of Maury P. Leibovitz
M.83.206.7

The career of Joseph Rudyard Kipling (1865–1936) as a short-story writer and journalist is associated with late nineteenth-century British India.

Kipling's inclusion in Davidson's series of notable writers was deemed essential by George Doran of Doubleday, Doran & Co., but the author refused to sit for the portrait. Eventually Davidson resorted to sketching Kipling surreptitiously during a formal dinner. The head was shown as a sketch from memory at Davidson's Knoedler exhibition in London.

PROVENANCE
Maury P. Leibovitz, New York, to 1983.

LITERATURE (GENERAL)
F. G. R., "Men of Letters," *Connoisseur* 88 (August 1931): 126, describes as "memory sketch" § Davidson, *Between Sittings*, pp. 243, 245–46, recounts making of head.

Davidson, *Somerset Maugham.*

Somerset Maugham, modeled 1930, possibly cast posthumously

Bronze
14 in (35.6 cm) with base
Signed and dated on back, on neck: JO DAVIDSON / CORF [?] 1930
Foundry mark of A. C. Rehberger in circular cachet on back, on base right
Gift of Maury P. Leibovitz
M.83.206.15

The British novelist and playwright William Somerset Maugham (1874–1965) gained an international reputation for his stories based on an insightful analysis of human frailties.

Maugham agreed to sit for Davidson and invited him to visit him in his villa on Cape Ferrat, near Nice, France. Davidson found Maugham very gracious and portrayed him as a benign gentleman.

PROVENANCE
Maury P. Leibovitz, New York, to 1983.

LITERATURE (GENERAL)
F. G. R., "Men of Letters," *Connoisseur* 88 (August 1931): 126, repro. § Davidson, *Between Sittings,* pp. 244, 249–51, 262.

Davidson, *George Bernard Shaw.*

George Bernard Shaw, modeled 1930

Ivory terra-cotta
16 in (40.6 cm)
Signed and dated on back, on collar right: JO DAVIDSON / LONDON / 1930
Gift of Maury P. Leibovitz
M.83.206.1

George Bernard Shaw (1856–1950), an Irish-born dramatist, critic, and wit, is best known for his comedies and satires, including *Man and Superman* (1903), *Major Barbara* (1905), and *Pygmalion* (1913).

Davidson first met Shaw in 1914 and was much impressed by his humor and intelligence. The dramatist, however, refused to sit for him. Years later, when Shaw finally agreed to pose, Davidson portrayed him as a genial, elderly gentleman. The dramatist himself noted that Davidson was the only artist to capture his sense of humor.

There is also an example in terra-cotta in the estate of the artist.

PROVENANCE
The artist § Estate of the artist, 1952–77 § Maury P. Leibovitz, New York, 1977–83.

LITERATURE (GENERAL)
Davidson, *Between Sittings,* pp. 99–100, 253, 261, recounts Shaw's observation on the portrait, repro., opposite p. 214 § LACMA, American Art department files, Jacques Davidson to Ilene Susan Fort, April 3, 1990, discusses the varous versions in different mediums.

Davidson, *John Galsworthy.*

An Edwardian novelist, poet, and playwright, John Galsworthy (1867–1933) is best known for his series of novels, The Forsyte Saga, in which he portrayed the fortunes of a moneyed, upper-class English family.

Galsworthy was one of the last to be modeled in Davidson's series of notable living authors. Davidson had met the author earlier and had hoped that Galsworthy would open up to him, but he did not. Nevertheless, Davidson was able to capture what he considered Galsworthy's "austere beauty."

This is believed to be a unique example in terra-cotta.

PROVENANCE
The artist § Estate of the artist, 1952–77 Maury P. Leibovitz, New York, 1977–83.

LITERATURE (GENERAL)
Davidson, *Between Sittings,* pp. 243, 261, 262, comments on the sitter § LACMA, American Art department files, Jacques Davidson to Ilene Susan Fort, April 3, 1990, discusses the various versions in different mediums.

John Galsworthy, modeled 1931
Terra-cotta
12⅛ in (30.8 cm)
Signed and dated on back, on neck: JO DAVIDSON / LONDON 1931
Gift of Maury P. Leibovitz
M.83.206.2

Davidson, *Sinclair Lewis.*

Sinclair Lewis, modeled 1937, possibly cast posthumously
Bronze
18⅞ in (48.0 cm) with base
Signed and dated on back, on collar: JO DAVIDSON 193[?]
Foundry mark of A. C. Rehberger in circular cachet on back, on base right
Gift of Maury P. Leibovitz
M.83.206.18

Harry Sinclair Lewis (1885–1951) established an international reputation with two of his earliest novels, *Main Street* (1920) and *Babbitt* (1922). In 1930 he became the first American to receive the Nobel prize in literature.

Davidson sympathetically portrayed his friend. The bust is full of energy, suggested by the turn and slight tilt of Lewis's head and the light-dark patterns formed by the deep undercutting of his attire.

The Metropolitan Museum of Art, New York, has a terra-cotta example of the head of Lewis dated 1937, and a polychrome terra-cotta

of the head with the same date was included in the first retrospective exhibition of Davidson's sculpture, held in 1947 at the American Academy of Arts and Letters, New York. The National Portrait Gallery, Smithsonian Institution, Washington, D.C., dates its bronze cast to 1937.

PROVENANCE
Maury P. Leibovitz, New York, to 1983.

LITERATURE (GENERAL)
Davidson, *Between Sittings,* p. 302, repro. of 1937 head, opposite p. 311.

Davidson, *Enrique Lister.*

Enrique Lister, modeled 1938

Bronze
14 in (35.6 cm)
Signed and dated on back, on collar left: DAVIDSON G.R.O. in [indecipherable]
Signed by Lister on front, on insert in base: List[er]
Foundry mark in rectangular cachet on right, on collar: CIRE / VALSUANI / PERDUE
Gift of Maury P. Leibovitz
M.83.206.11

Enrique Lister gained renown during his lifetime as the commander of the Spanish Fifth Army Corps, loyalist soldiers who repeatedly resisted the Fascists.

Davidson loved Spain and the Spanish people, and when the country was in turmoil during the Civil War he determined to record the faces of resistance leaders. On a visit to the country in 1938 he modeled a bust of Lister and two other military figures, all of whom were heroes of the recent Ebro Front campaign. He captured Lister's peasant heritage and forceful character by emphasizing the Spaniard's large, round head and strongly set jaw.

PROVENANCE
Maury P. Leibovitz, New York, to 1983.

LITERATURE (GENERAL)
Jo Davidson: Spanish Portraits (New York: Georgian Press, [1938?]), repro., unpaginated.

Davidson, *Charles Lindbergh.*

Charles Lindbergh, modeled 1939,
possibly cast posthumously
Bronze
20⅝ in (52.4 cm) with base
Signed and dated back on neck. JO DAVIDSON /
PARIS 1939
Signed by Lindbergh on base: Charles A. Lindbergh
Gift of Maury P. Leibovitz
M.83.206.5

Charles Augustus Lindbergh (1902–1974)
made the first solo nonstop trans-Atlantic flight
from New York to Paris in 1927. Although this
deed established his reputation, the aviator
became equally famous as a result of the pub-
licity related to the kidnapping of his son in
1932.

Davidson modeled the bust in Paris shortly
before World War II began. The National
Portrait Gallery, Smithsonian Institution,
Washington, D.C., owns a cast from an earlier
edition and dates it 1937.

PROVENANCE
Maury P. Leibovitz, New York, to 1983.

LITERATURE (GENERAL)
Davidson, *Between Sittings,* p. 317.

Davidson, *Henry Wallace.*

Henry Agard Wallace (1888–1965) was an edi-
tor and agriculturist before becoming engaged
with politics during the New Deal. Davidson
met Wallace when he was the secretary of
agriculture and modeled his portrait several
years later when he was vice president (1941–
45). Davidson believed Wallace projected a
"feeling of wide open spaces, a clean beauty,
and of strong healthy optimism." His positive
idealism is here conveyed by the tilt of the
head and distant gaze. Three years later David-
son modeled a more formal, fuller bust for the
United States Senate chambers.

A cast of the head from an earlier edition
and originally owned by the sitter is in the
National Portrait Gallery, Smithsonian Insti-
tution, Washington, D.C.

PROVENANCE
Maury P. Leibovitz, New York, to 1983.

LITERATURE (GENERAL)
Davidson, *Between Sittings,* pp. 336–37, describes the
sitter, repro. of clay model, opposite p. 311.

Henry Wallace, modeled 1942, possibly
cast posthumously
Bronze
12⅞ in (32.7 cm)
Signed and dated on back, on neck: JO DAVIDSON
WASH 1942
Signed by Wallace on front, on insert in base:
Henry A. Wallace
Gift of Maury P. Leibovitz
M.83.206.12

Davidson, *Self-Portrait.*

Self-Portrait, modeled 1946, possibly cast posthumously
Bronze
19¼ in (49.0 cm) with socle
Signed and dated on back, on right shoulder: JO DAVIDSON / SEPT 1946
Foundry mark of A. C. Rehberger in circular cachet on back, on socle lower left
Gift of Maury P. Leibovitz
M.83.206.9

The sculptor was a powerful and commanding figure. For his self-portrait he modeled his massive head in large, solid forms. His innate energy is conveyed through the turn of the head, a device not typical of Davidson's portraits.

The National Portrait Gallery, Smithsonian Institution, Washington, D.C., owns a cast of this self-portrait, as does the Metropolitan Museum of Art, New York (also possibly posthumous).

PROVENANCE
Maury P. Leibovitz, New York, to 1983.

Davidson, *Walt Whitman.*

Walt Whitman, modeled 1949
Bronze
17⅜ in (44.2 cm)
Signed and dated on back, on collar right: JO DAVIDSON / BECHERON / 1949
Foundry mark in rectangular cachet on back, on collar left: CIRE / VALSUANI / PERDUE
Gift of Maury P. Leibovitz
M.83.206.17

Walt Whitman (1819–1892) considered himself a poet of democracy and achieved a reputation of mythical proportions during his own lifetime. Best known for his volume of verse *Leaves of Grass* (1855), in which he extolled America, Whitman agreeably sat for numerous artists who immortalized his appearance in paintings and photographs.

This portrait of Whitman was one of the few Davidson did not model from life. The sculptor had long been a devotee of Whitman, and in 1925, although opposed to competitions, he submitted a design for a proposed Whitman memorial to be placed in a New York park. The project was never realized, and a decade later Averell Harriman suggested that Davidson complete the full-length statue for Bear Mountain Park near West Point, New York. It is not known if the museum's head was taken by *surmoulage* from the head of the Bear Mountain Park statue of 1939, or was reworked and then cast, or is an entirely different head. The inscribed date of 1949 suggests that Davidson revised his earlier conception. The specific impetus for making the 1949 head is unknown. Davidson presented the poet with his full beard, combining a rippling surface with deep undercutting, which was unusual for the sculptor.

PROVENANCE
Maury P. Leibovitz, New York, to 1983.

Davidson, *David Ben-Gurion.*

David Ben-Gurion, modeled 1951,
possibly cast posthumously
Bronze
17⅝ in (44.7 cm) with base
Signed and dated on back, on collar: JO DAVIDSON
[indecipherable] 1951.
Signed by Ben-Gurion in Hebrew on base
Inscribed on base: D. Ben-Gurion
Gift of Maury P. Leibovitz
M.83.206.16

David Ben-Gurion (1886–1973) served as
the first and third prime minister of Israel,
1949–53, 1955–63.

Davidson visited Israel in 1951, eager to meet
the people who had played a crucial role in the
creation of the new nation, among them Ben-
Gurion. The prime minister cooperated in
providing the sculptor several hours from his
busy schedule. Davidson was much impressed
and described Ben-Gurion's head as "beauti-
ful . . . with an aureole of white hair, with
blue eyes set deep under bushy eyebrows and a
powerful jaw." He portrayed Ben-Gurion as a
kindly, but determined elderly man, his open
collar typical of the informal dress of Israeli
statesmen.

There is a cast in the Jewish Museum,
New York.

PROVENANCE
Maury P. Leibovitz, New York, to 1983.

LITERATURE (GENERAL)
Davidson, *Between Sittings,* pp. 368–69, describes
Ben-Gurion, repro., opposite p. 311.

Davidson, *Chaim Weizman.*

Chaim Weizman, modeled 1951,
possibly cast posthumously
Bronze
17⅝ in (44.8 cm) with base
Signed and dated back on collar: JO DAVIDSON
ISRAEL 1951
Signed by Weizman in Hebrew on base
Inscribed on base: Ch. Weizman
Gift of Maury P. Leibovitz
M.83.206.14

Trained as a chemist, Chaim Azriel Weizman
(1874–1952) contributed significantly to the
creation of the state of Israel and was the first
president of the newly formed country,
1949–52.

Davidson modeled Weizman during his visit
to Israel in 1951, the year before the president
died. The surface treatment, particularly of
Weizman's wrinkled cheeks and breast, is
exceptionally sketchy.

PROVENANCE
Maury P. Leibovitz, New York, to 1983.

LITERATURE (GENERAL)
Davidson, *Between Sittings,* pp. 367–68.

Karoly Fulop

Born 1893 Czabadka,
Austria-Hungary
(now Hungary)
To United States by 1921
Died April 7, 1963,
Los Angeles County,
California

Károly Fülöp's highly spiritual vision found expression in both the fine and decorative arts as well as in interesting combinations of the two. As a young boy Fulop had a monastic education in his home town, and the medieval art he saw around him left a lasting impression. He studied art in Budapest, Munich, and Paris and may have maintained a winter studio in Europe at least through 1930.

Fulop had settled in New York by 1921, when he was given an exhibition with William Grimm (1883–1950) at the Whitney Studio Club. Seventeen canvases, mostly decorative port scenes painted with rich colors, were shown. In the summer of 1923 an exhibition of his seascapes and figure compositions inspired by music, with gold and silver leaf, was held at Gallery on the Moors, Gloucester, Massachusetts. In early 1924 he exhibited decorative paintings on canvas and silk at the Babcock Galleries, New York. Most were on religious themes. From 1925 to 1931 and again in 1937 he exhibited his watercolors and paintings on canvas and silk at Doll and Richards, Boston. By 1927 he was showing his sculptures and by 1930 his carved panels. Sometime during the 1920s he was commissioned to paint a mural for the Philadelphia Public Library. He exhibited at Grand Central Art Galleries, New York, in March 1930 and at the Los Angeles Museum in September 1930, courtesy of the Stendahl Art Galleries, Los Angeles, where he exhibited in December 1931. Fulop opened a school of decorative arts in his studio in Los Angeles in 1931 and taught at the Plaza Art Center in 1932. He also made ceramic sculptures during the 1930s. Fulop continued to participate in local and national exhibitions, winning first prize for sculpture at the Los Angeles Museum's *Eighteenth Annual Exhibition of Painting and Sculpture* in 1937, an award at the New York World's Fair in 1939, and the Mr. and Mrs. Irving T. Snyder Prize from the San Diego (Calif.) Museum in 1940. The Los Angeles Museum organized a second solo exhibition of his work in December 1940. Little is known about his later life.

BIBLIOGRAPHY
Archiv. Am. Art, Stendahl Art Galleries Papers, artist's file § New York, Babcock Galleries, *Decorative Paintings by Károly Fülöp* exh. cat., [1924], with foreword by Josef Stransky § "Karoly Fulop: Grand Central Galleries," *Art News* 28 (March 29, 1930): 13 § "Art Calendar: Karoly Fulop," *California Arts and Architecture* 40 (December 1931): 6, repro., cover § LACMA 1980, pp. 70, 97.

Fulop, *The Hymn.*

The Hymn, c. 1929–31
Wood panel with gilt, polychrome, and ivory
Signed lower right: KÁROLY / FÜLÖP
51⅛ x 36¹/₁₆ in (129.8 x 91.6 cm)
Given anonymously
38.1
Color plate, page 70

The use of stylized, attenuated figures arranged rhythmically and decoratively was developed in Fulop's paintings and watercolors by at least 1924. His sources probably include the Byzantine art of the Hungarian church, the decorative characteristics of the country's folk styles, the art of Gustav Klimt (1862–1918) and the Vienna Sezession, and aspects of early twentieth-century French modernism. The fantastic quality, obscure symbolism, and religious nature of his works—meant to be the externalizations of mystical visions—seem to come out of the period before the First World War. Fulop spoke of his designs in terms of music, a concept of synesthesia embodied in his carved panels with their combination of design and sculpture and mixture of materials, bridging the separation between the fine and decorative arts.

The panel is in low relief, with very smooth surfaces. Ivory has been inlaid for the face and

hands of the large female figure at the right and for the entire figures of the woman and baby at the lower left. The wood is gilded in places, such as the throne, swords, and trumpet banners, and in other places apparently painted in mostly muted colors over gilding. The effect is rich, but dusky and mysterious.

PROVENANCE
Private collection, to 1938.

EXHIBITIONS
Possibly Boston, Doll and Richards, *Exhibition and Sale of the Recent Works of Karoly Fulop,* 1931, no. 11, unpaginated, listed under carved and painted wood panels, as *Hymnus* § Los Angeles, Stendahl Art Galleries, *Exhibition by Karoly Fulop,* 1931, no. 4.

LITERATURE
"A Recent Acquisition," *LA Museum Bulletin* 2 (April–June 1938): repro., unpaginated.

Isamu Noguchi

Born November 17, 1904,
Los Angeles, California
Died December 30, 1988,
New York, New York

Isamu Noguchi was one of the most significant sculptors to emerge in the period between the two world wars. The son of a Japanese poet and an American writer, Noguchi spent most of his early years in Japan. After returning to the United States in 1918, he was apprenticed briefly to the sculptor Gutzon Borglum (1867–1941) and then studied with Onorio Ruotolo (1888–1966) at the Leonardo da Vinci School of Art in New York. A Guggenheim Fellowship enabled Noguchi to travel in 1927 to Paris, where he served as a studio apprentice to Constantin Brancusi (1876–1957). In the early 1930s he visited Paris; Peking, where he studied brush drawing with Qi Baishi (1863–1957); and Japan, where he learned ceramics from Uno Jinmatsu. In the mid-1940s he began creating marble slab constructions, using abstracted biomorphic shapes, and associating his sculptures with myths. He also continued to sculpt in terra-cotta and ceramic. In the late 1950s he reintroduced into his art more angular, geometric shapes, and he also worked in metal, particularly aluminum.

Noguchi extended the boundaries of sculpture to include its use in the theater and as environmental works. The stage offered him a place to realize his imaginary environments. Best known for his collaborations with Martha Graham, which began in 1926, he continued to be involved in the theater until the early 1970s. His first designs for public spaces date from the mid-1930s and his landscape reliefs from the early 1940s, but none was realized until the early 1950s. The gardens and playgrounds enable people to experience sculpture directly as part of their everyday life. Self-illuminating sculpture, furniture, lamps, and interiors also occupied the artist as early as the 1940s.

In 1929 the Eugene Schoen Gallery in New York gave Noguchi his first solo exhibition. He had his first exhibition in London in 1934, in Japan in 1950, and in France in 1964. In 1942 the San Francisco Museum of Art organized his first museum exhibition, and in 1968 the Whitney Museum of Art gave him his first retrospective.

Noguchi established a studio in Japan in 1952 and commuted between there and New York. In the 1960s he established a studio in Long Island City, now the Isamu Noguchi Garden Museum. He remained productive, attracting many large-scale, private and public commissions, until his death.

BIBLIOGRAPHY
New York, Whitney Museum of American Art, *Isamu Noguchi,* exh. cat., 1968, published by Frederick A. Praeger, text by John Gordon, chronology, bibliography, lists of collections and exhibitions § Isamu Noguchi, *A Sculptor's World* (New York: Harper & Row, 1968), with foreword by R. Buckminster Fuller § Sam Hunter, *Isamu Noguchi* (New York: Abbeville Press, 1978), with chronology, lists of exhibitions and awards, bibliography § Nancy Grove and Diane Botnick, *The Sculpture of Isamu Noguchi, 1924–1979: A Catalogue* (New York: Garland, 1980), with foreword by the artist, chronology, bibliography § Nancy Grove, "Isamu Noguchi: A Study of the Sculpture," Ph.D. diss., City University of New York, 1983, with bibliography.

Portrait Head (Fernand Leger), 1941
Plaster, painted
22⅝ in (57.5 cm) with base
Signed on back, on base lower right: NOGUCHI
Gift of Mrs. Oscar Homolka
42.3.13

Figural elements have informed approximately one-third of Noguchi's art. Inspired by the example of his teacher, the academic sculptor Onorio Ruotolo, Noguchi began making portrait heads in the late 1920s and immediately won critical praise for the strength of his por-

trayals of the sitters' personalities. Although portrait commissions supported his more progressive work and financed his travels, many of the heads were of friends and fellow artists, among them Berenice Abbott, 1929 (National Portrait Gallery, Smithsonian Institution, Washington, D.C.), R. Buckminster Fuller, 1929 (Buckminster Fuller Institute, Los Angeles), Martha Graham, 1929 (Honolulu Academy of Arts), and José Clemente Orozco, 1931 (San Francisco Museum of Modern Art).

On a trip west with Arshile Gorky (1904–1948) in 1941 Noguchi visited Los Angeles, where he modeled a few portrait heads, among them Leger's. The two artists may have met earlier in Paris or during one of Leger's visits to New York. In November 1940, after France fell to the Nazis, Leger set up a studio in New York, and the following year he taught summer classes at Mills College in Oakland, California.

Noguchi used a variety of materials and styles for his heads, but they have strict frontal poses and somber gazes in common. Leger's head differs from many in that it does not have a long, tubular neck. Like Noguchi's head of Orozco, that of Leger is quite realistic and vigorously modeled, with a rough, unfinished, claylike surface. The head was tinted pink while the base was left unpainted.

PROVENANCE
National Art Week Committee, Los Angeles, 1941.

EXHIBITIONS
Los Angeles, Biltmore Salon, *National Art Week Exhibition,* 1941, no cat. traced § Los Angeles, Eastside Jewish Community Center, *America's All Festival Week,* 1953, no cat. traced § Washington, D.C., Smithsonian Institution, National Portrait Gallery, *Isamu Noguchi: Portrait Sculpture,* 1989, published by Smithsonian Institution Press, no. 34, pp. 22, 98, Nancy Grove discusses in context of other portrait work and Noguchi's visit to Los Angeles, p. 108, listed in checklist of all portraits, repro., p. 99.

LITERATURE
LACMA, Registrar files, typed note, n.d., mentions a now-lost letter by James Byrnes, curator of art, LACMHSA, dated September 2, 1953, identifying the model as Leger § Noguchi, *A Sculptor's World,* p. 25, mentions sculpting Leger's head on trip west § Grove and Botnick, *Sculpture of Noguchi,* p. 30, lists as no. 173, fig. 173, illustrations unpaginated, as *Fernand Leger* § Michael Kimmelman, "Forgotten Noguchi: Portrait Sculpture of His First Fame," *New York Times,* May 17, 1989, pt. B, p. 1, describes as "a rough, vigorously molded bust . . . [that] echoes the boldness of his [Leger's] designs."

Noguchi, *Portrait Head (Fernand Leger).*

Donal Hord

Born February 26, 1902, Prentice, Wisconsin
Died June 30, 1966, San Diego, California

Donal Hord, born Donald Albert Hord, was San Diego's most famous sculptor, celebrated for his direct-carving technique and public monuments in stone and wood. Raised in Seattle, Hord moved to San Diego at the age of fourteen. His first sculpture teacher was Anna M. Valentien (1862–1947), a pupil of Auguste Rodin's (1840–1917). During his late teens he developed a strong interest in oriental art and began his lifelong association with Homer Dana (born 1900), who assisted him in the more physically demanding aspects of his studio work, such as carving. From 1926 to 1928 Hord studied bronze casting and the lost-wax technique at the Santa Barbara School of the Arts with Archibald Dawson (died 1938), who emphasized the importance of a meticulous finish. He also studied the direct-carving process. A Gould Memorial Fellowship allowed Hord to study in Mexico for eleven months in 1928–29. In Mexico he studied pre-Columbian art, the styles of Diego Rivera (1886–1957) and Jean Charlot (1898–1979), and learned much about the folklore and ceremonies of the indigenous villagers. He briefly attended the Pennsylvania Academy of the Fine Arts in Philadelphia and the Beaux-Arts Institute of Design in New York during 1929–30. Around 1928 Hord turned increasingly to direct carving, and his fame rests largely for his work in that technique; he is also known for his highly polished finishes. During the 1930s he also experimented with polychromed wood.

In 1931 he received his first award at the annual exhibition of Southern California art at the Los Angeles Museum for *Culua,* 1930 (San Diego Historical Society). After 1931 he resided permanently in San Diego, producing his most notable public sculpture there—including *Aztec,* 1936–37 (San Diego State University) and *Guardian of Water,* 1937–39 (San Diego County Administrative Building)—under the auspices of the Federal Art Project, for which he was sculpture supervisor. In the 1940s Hord's powerful carvings received national attention: he was included in the Museum of Modern Art's exhibition *Americans 1942: Eighteen Artists from Nine States,* elected a fellow of the National Sculpture Society, and twice awarded a Guggenheim Fellowship. In 1936 Hord began to teach sculpture at San Diego State College, and he subsequently taught at the Coronado School of Fine Arts, Coronado (San Diego), and Art Center in La Jolla.

BIBLIOGRAPHY
Catherine Sullivan, "Donal Hord," *American Artist* 14 (October 1950): 49–52, 63, based on an interview with the artist § Janice Lovoos, "The Sculpture of Donal Hord," *American Artist* 23 (September 1959): 42–47, 67–69 § La Jolla, Calif., California First Bank, *A Donal Hord Retrospective,* exh. cat., 1976, with statement by the artist, essay by Homer Dana § Helen Ellsberg, "Donal Hord: Interpreter of the Southwest," *American Art Review* 4 (December 1977): 76–83, 126–30 § Bruce Kamerling, "Like the Ancients: The Art of Donal Hord," *Journal of San Diego History* 31 (Summer 1985): 164–209, with catalogue raisonné, chronology, bibliography.

The Corn Goddess, by 1942
(*Corn Woman*)
Wood
39½ in (100.3 cm)
Signed on back, on base center: DH (monogram)
Given anonymously
M.55.4

Hord was an amateur archaeologist and was fascinated with the indigenous culture of the Southwest. In his art he attempted to represent in human form the forces of nature that the Native Americans believed controlled their lives, such as corn, their basic food staple, which they deified. Hord carved *Young Maize,* 1931 (San Diego Museum of Art), as a powerful young man symbolizing the sturdy stalk of a new plant. In *The Corn Goddess* Hord presents a strong, voluptuous figure to suggest the fecundity of the earth. The waves of her elaborate hair arrangement form a soft bed from which two ears of corn emerge, and two small figures representing sprouting corn grow upwards on stalks from her back. This swirling arrangement of hair, an essential, symbolic element, is present in many of Hord's carvings of the early 1940s, as are figures depicted with the broad, flat facial features of the Native American.

Hord preferred the harder types of stone and wood for his sculpture. During World War II he could not obtain rosewood, so he used lignum vitae, which takes a beautiful polish, and he used it for *Corn Goddess.* Hord worked on his wood objects himself, without the aid of his assistant, Homer Dana, and this piece required three months to complete. Although he had been taught to leave the chisel marks showing, in the early 1930s Hord began the practice for which he became famous: polishing a piece to a high gloss to expose the wood's grain.

PROVENANCE
With Dalzell Hatfield Galleries, Los Angeles, 1945 § Private collection, Los Angeles, to 1955.

EXHIBITIONS
New York, Metropolitan Museum of Art, sponsored by Artists for Victory, Inc., *Artists for Victory: An Exhibition of Contemporary American Art,* 1942–43, entries not numbered, p. 26, as *Corn Woman* § Los Angeles 1945, repro. of detail, unpaginated § University of Redlands (Calif.) Art Department, *Sculpture Exhibition,* 1981, no cat. traced § California First Bank, *Hord Retrospective,* entries not numbered, repro., unpaginated.

LITERATURE
Rosamund Frost, "Artists for Victory: Sculpture," *Art News* 41 (January 1, 1943): 14 § Virginia Stewart, "Southern California," *Art News* 45 (June 1946): repro. of detail, 23 § "Recent Acquisitions," *LA Museum Art Div. Bull.* 7 (Summer 1955): repro., 25 § Loovos, "Sculpture of Hord," p. 69, repro., p. 44 § "Male and Female Figures," *National Sculpture Review* 18 (Fall 1969): 11, repro., 10 § Ellsberg, "Hord: Interpreter," p. 126, fig. 2, p. 82 § Kamerling, "Like the Ancients," p. 204, listed in cat. raisonné as no. 91 § LACMA, American Art department files, Bruce Kamerling to Ilene Susan Fort, October 2, 1985, discusses Hord's working method and gives date and provenance.

Hord, *The Corn Goddess.*

Thomas Hart Benton

Born April 15, 1889,
Neosho, Missouri
Died January 19, 1975,
Kansas City, Missouri

See biography in oil paintings section.

Indian and Frenchman, modeled and cast c. 1956–57

Bronze mounted on wood
14¾ in (37.5 cm)
Gift of Dr. and Mrs. Franklin D. Murphy
M.80.143

Benton, *Indian and Frenchman*.

One of Thomas Hart Benton's late mural commissions was *Jacques Cartier Discovers the Indians*, 1956–57, for the Power Authority of the State of New York at Massena near Niagara Falls. In this painting Benton described the moment when the sixteenth-century French discover of the Saint Lawrence River, Jacques Cartier, is presented with gifts by people from the Seneca nation.

Around 1919 Benton began to make it a practice to construct three-dimensional clay models of scenes he intended to paint. The bronze *Indian and Frenchman* was cast from the clay models of the mural's central figures.

Dr. Franklin Murphy, a friend of Benton's and former chancellor of the University of Kansas, was instrumental in having the bronze cast. During a visit to Benton's studio in the mid-1950s Murphy came across the clay models for the two figures, which Benton reluctantly allowed Murphy to have cast. The clay model was destroyed after an edition of three was cast by Eldon Teft, University of Kansas.

RELATED WORK
Jacques Cartier Discovers the Indians, 1956–57, egg tempera on canvas mounted on panel, 90 x 78 in (228.6 x 198.1 cm). Power Authority of the State of New York, Massena.

PROVENANCE
Dr. and Mrs. Franklin D. Murphy, Beverly Hills, Calif., c. 1956–80.

LITERATURE (GENERAL)
LACMA, American Art department files, Franklin D. Murphy to Michael Quick, October 17, 1980, discusses circumstances of casting.

Watercolors

Watercolors

The distinctive character of the museum's holdings of American watercolors reflects the trends in art and art collecting in Southern California. The collection includes fine examples by such outstanding watercolorists as Winslow Homer, John S. Sargent, Maurice Prendergast, Charles Demuth, John Marin, Millard Sheets, and Andrew Wyeth.

The core of the collection was donated by Mr. and Mrs. William Preston Harrison. Harrison amassed most of the watercolors after his collection of American oil paintings was essentially complete. An important consideration in his shift to the medium was cost. Aspiring to assemble a group of American watercolors comparable to his oil paintings, Harrison began acquiring works on paper during the late 1920s, and by 1929 critics had acknowledged the importance of the collection. The watercolors were more modernist than the oils due to changes in style that had occurred during the decade and the broadening of Harrison's interests as he began to collect French art on his 1926 trip to Paris. Although his watercolor collection contained a substantial number of works by such traditional artists as George Overbury "Pop" Hart and Joseph Pennell, also included were examples by some of the most important progressive artists of the period, including Charles Demuth, Maurice Prendergast, Max Weber, and William Zorach.

The second large group of watercolors donated to the museum came fifteen years after William Preston Harrison's death, when, in 1955, a selection of the California Water Color Society's prizewinning paintings was received. Founded in 1921 by a group of Southern California artists, the society grew in size and importance during the next two decades. In 1925 the society initiated a purchase prize collection of the top prizewinners from each of its annual exhibitions. That year it also began circulating exhibitions throughout the West. By 1940 the society had gained widespread prominence as the annuals received coverage in national art magazines, and that year the society held an exhibition in

New York at the Riverside Museum. The Los Angeles Museum's holdings date from 1930 to 1954 and constitute a survey of the type of art espoused by the society's members during the group's heyday as a major school of landscape painting, during the 1930s and early 1940s through the postwar years, when its members developed styles analogous to abstract expressionism. Characteristic of the California watercolor style are vigorous brushwork, a bold palette, a large format, and references to oriental painting. The museum's holdings include examples by some of the school's most prominent members: Rex Brandt, Phil Dike, Barse Miller, and Millard Sheets.

In addition, the museum's collection of California watercolors includes paintings by artists who were active before the founding of the California Water Color Society or who were not affiliated with it. Represented by two or more works are Christian A. Jörgensen, a Northern California artist; Paul de Longpré, the most important watercolorist in Los Angeles at the turn of the century; and Nick Brigante, among the earliest and one of the more independent of Los Angeles's abstractionists.

The collection has been augmented by several donations of nineteenth-century watercolors. In 1939 an important Adirondack watercolor by Winslow Homer was part of the bequest of one of the museum's foremost patrons, Paul Rodman Mabury, and more recently Dr. and Mrs. Jacob Terner donated an interesting group of nineteenth-century works on paper. Probably the most important single acquisition was the impressive watercolor by John S. Sargent donated by the Art Museum Council.

All watercolors in the collection are listed and illustrated here, and for the notable works style and subject are analyzed and biographical information on the artist, provenance, exhibitions, and literature references are provided. Watercolors receiving this treatment were painted by artists highly regarded for their work in the medium or by artists who devoted a large portion of their output to watercolor.

Unknown Artist

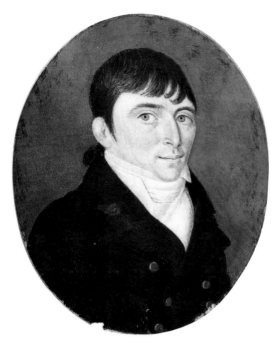

Portrait of an Unidentified Sitter,
c. 1808–15
Watercolor on paper
2³⁄₄ x 2¹⁄₄ in (7.0 x 5.7 cm), oval
Gift of Pauline Haden Van Noy
M.76.34

Robert W. Weir

Born June 18, 1803,
New York, New York
Died May 1, 1889, New York,
New York

Italian Landscape, possibly c. 1825–27
Watercolor on paper
8¹⁵⁄₁₆ x 6¹¹⁄₁₆ in (22.5 x 17.0 cm)
Signed lower right: Robt. W Weir
Gift of Sandra and Jacob Terner
M.76.167.18

View of West Point, 1834 or later
Watercolor on paper
2³⁄₄ x 4³⁄₁₆ in (7.0 x 10.6 cm)
Signed lower left: R.W.W.
Gift of Sandra and Jacob Terner
M.76.167.20

Knight's Encounter, 1855
Wash and ink with white on dark beige paper
14¹⁵⁄₁₆ x 19⁷⁄₁₆ in (37.8 x 49.4 cm)
Signed and dated lower right: Robt. W. Weir / 1855
Gift of Sandra and Jacob Terner
M.76.167.19

Family Group, 1863
Wash with gouache and graphite on paper
16⅛ x 21¾ in (41.0 x 55.3 cm)
Signed and dated lower right: Robt. W. Weir. / 1863
Gift of Sandra and Jacob Terner
M.76.167.17

Thomas Campbell and others

Thomas Campbell
Born c. 1810, Scotland
To United States by 1832
Died September 17, 1847,
Louisville, Kentucky

Thomas Campbell painted the portraits of John and Eliza Griffin in this group of minia-tures of the Griffin family. Nothing is known of the artist's life before 1832, when he advertised in a Baltimore newspaper as a "painter from Edinburgh."

In 1834 Campbell and Colin R. Milne (1813–1897) established in Baltimore a lithographic printing firm with Campbell as artist and Milne as printer. They published lithographs after William Hogarth (1697–1764), portraits of leading clergymen, genre subjects for the peddlers' trade, and frontispiece designs for magazines. Eventually Camp-bell moved west, first to Cincinnati before settling in Louisville in June 1835. He found immediate success as a portrait painter and miniaturist, painting portraits of notable Ohio Valley families and Louisiana planters who came north for the summer. Within a year of his arrival in Louisville he had arranged for his Baltimore partner to join him, and in 1836 they established T. Campbell & Co., the first lithographic press in the West. They published a variety of commercial items—portraits of statesmen, maps, and music sheets—but their greatest single endeavor was the publication of the *Kentucky Stock Book*, an undertaking they never completed. Except for a three-year residence in Cincin-nati during the early 1840s Campbell remained in Louisville for the rest of his life, often traveling to Frankfort, Lexington, and other towns in Kentucky. His latest attributed works date from 1845.

BIBLIOGRAPHY
Edna Talbott Whitley, *Kentucky Ante-Bellum Portraiture* (Paris, Ky.: National Society of Colonial Dames in America in the Commonwealth of Kentucky, 1956), pp. 639–40 § Donald R. MacKenzie, "Painters in Ohio, 1788–1860," Ph.D. diss., Ohio State University, 1960, p. 180 § Martin F. Schmidt, "The Artist and the Artisan: Two Men of Early Louisville," *Filson Club History Quarterly* (Louisville, Ky.) 62, no. 1 (1988): 32–51.

Four miniatures mounted together, clockwise from lower center: *John Caswell Griffin; Lieutenant William Preston Griffin, U.S.N.; Eliza Croghan Griffin; Captain George Hancock Griffin, U.S.A.*

John Caswell Griffin, c. 1839–40
Watercolor on ivory
1½ x 1³⁄₁₆ in (3.81 x 3.0 cm), octagon
Colonel and Mrs. George J. Denis Collection
26.1.154

John Caswell Griffin (birthdate unknown) of Fincastle, Virginia, married Mary Hancock, daughter of Colonel George Hancock and Margaret Strother Hancock, in 1806. They had six children, four of whom lived to adulthood. Griffin and his wife died three months apart in 1826.

According to family tradition the miniature was painted by Thomas Campbell around 1840 from a portrait that has since disappeared. Griffin is shown as a young man, and the original may have been completed at the time of his wedding. The miniature is mounted with those of three of Griffin's children.

PROVENANCE
Griffin family (by descent?) § Colonel and Mrs. George J. Denis, to 1926.

Lieutenant William Preston Griffin, U.S.N., c. 1833–38
Watercolor on ivory
2¾ x 2¼ in (7.0 x 5.7 cm), oval
Signed upper left: E. Toci F.
Colonel and Mrs. George J. Denis Collection
26.1.152

According to the signature and family tradition an artist by the name of E. Toci (dates unknown) painted this portrait of William Griffin (1810–1851). Attempts to verify the artist's name have proven fruitless.

Second son of Mary and John Griffin, William Griffin became a lieutenant in early 1838. In this portrait he is depicted wearing the uniform of a passed midshipman, a status he achieved in 1833. The miniature may have been painted in Italy during Griffin's year-long tour of Europe.

PROVENANCE
Griffin family (by descent?) § Colonel and Mrs. George J. Denis, to 1926.

Eliza Croghan Griffin, c. 1839–43
Watercolor on ivory
2¾ x 2⅛ in (7.0 x 5.4 cm), oval
Colonel and Mrs. George J. Denis Collection
26.1.151

Eliza Griffin (1821–1896) was the only daughter of Mary and John Griffin to survive to adulthood. In this miniature Campbell captures her youth and innocence, depicting her softly rounded face with feathery brush strokes. The miniature may have been painted in 1843 at the time of her marriage to General Albert Sidney Johnston. General Johnston was also painted by Campbell, and his miniature was exhibited along with twenty-six others in 1839 at the Cincinnati Academy. Campbell's portraits of the Griffins may have been shown on that occasion or in an exhibition the following year, when the artist again displayed a large number of miniatures. Johnston took his family to San Francisco during the Civil War, and after his death in 1862 Eliza Griffin remained in California with her children, looked after by her brother Dr. John Strother Griffin. She died in Los Angeles on September 25, 1896.

PROVENANCE
Griffin family (by descent?) § Colonel and Mrs. George J. Denis, to 1926.

Captain George Hancock Griffin, U.S.A., c. 1834
Watercolor on ivory
2¼ x 1⅞ in (5.7 x 4.8 cm), oval
Colonel and Mrs. George J. Denis Collection
26.1.153

Captain George Griffin (1808–1838) was the oldest child of Mary and John Griffin. He served as an aide to General Zachary Taylor during the Seminole War, dying in service at age thirty. The portrait of the captain in military dress has been dated to a few years before his death.

The miniaturist is unknown.

PROVENANCE
Griffin family (by descent?) § Colonel and Mrs. George J. Denis, to 1926.

John O'Brien Inman

Born June 10, 1828, New York, New York
Died May 28, 1896, Fordham (now New York), New York

Conch Shell, 1846
Watercolor and graphite on paper
5 x 7¹⁄₁₆ in (12.7 x 17.9 cm)
Signed, dated, and inscribed lower right: Shell Jno: O'B. Inman. / Jan 22d 1846 / First attempt in water colour
Gift of Sandra and Jacob Terner
M.76.167.10

Albert Bierstadt

Born January 7, 1830,
Solingen, Germany
To United States 1832
Died February 18, 1902,
New York, New York

See biography in oil paintings section.

Woodland Sunset, n.d.
Watercolor on paper
7¹⁵/₁₆ x 3⁵/₁₆ in (20.2 x 8.3 cm)
Signed lower left: ABierstadt (AB in monogram)
Gift of Sandra and Jacob Terner
M.76.167.3

Winslow Homer

Born February 24, 1836,
Boston, Massachusetts
Died September 29, 1910,
Prout's Neck, Maine

See biography in oil paintings section.

After the Hunt, 1892
(*Hunting Scene; Return from the Hunt*)
Watercolor, gouache, and graphite underdrawing on
off-white paper
13¹⁵/₁₆ x 19¹⁵/₁₆ in (35.3 x 50.5 cm)
Signed and dated upper right: HOMER / 1892
Paul Rodman Mabury Collection
39.12.11
Color plate, page 50

After the Hunt is one of twenty-six watercolors
made by Winslow Homer in the early autumn
of 1892 while he was vacationing in the
Adirondacks. Homer first visited this wilder-
ness area near Minerva in upstate New York in
1870 and returned there often to fish with his
brother Charles, eventually becoming a charter
member of the sportsmen's North Woods Club.

Along with his watercolors of the tropics,
Homer's images of the Adirondacks constitute
his most outstanding work in the medium. In
theme and composition *After the Hunt* is a clas-
sic example of his Adirondack scenes. Homer's
love of nature and respect for the rugged life of
the hunters and fishermen are here clearly
conveyed.

Adirondack hunters often pursued their
quarry into a lake, where a deer would drown
or be cornered by the hounds. In *After the Hunt*
the pursuit is over, the deer has been hauled
into the boat, and the old hunter is taking care
of his dog. The bearded man appears in many
Homer images and was first identified by art
historian Ashton Sanborn as the guide Henry
Holt. Another Homer scholar, Philip C. Beam,
suggests that Homer used models of similar
appearance and that John Gatchell and his son
Wiley, residents of Scarboro, Maine, may have

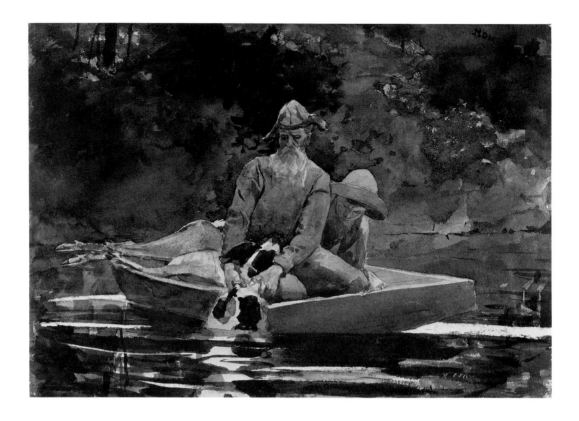

Homer, *After the Hunt.*

posed for some of the Adirondack scenes, especially those completed after Holt's death in 1893 or those finished in Homer's studio in Prout's Neck. Although Homer painted some watercolors outdoors, many were completed or executed entirely in the studio. *After the Hunt* was probably a studio production.

Homer was one of many late nineteenth-century artists to consider watercolor painting an independent art form worthy of exhibition rather than merely a preparatory medium. With his watercolors of the 1890s Homer matured and found his true medium. Indeed, Homer believed that he would be most remembered for his watercolors. Moving away from the soft, tinted drawings of the British watercolor tradition, Homer became a master of rich colors and textures, creating direct, sensuous paintings. The Adirondack images have the deepest color schemes of his watercolors; the purples, greens, dark blues, russets, and yellow-greens of the foliage and water convey a full range of autumnal hues. The clarity of the mountain air is fully described by the bold handling of the reflections on the water, which Homer created by lightly scraping the paper with a knife while it was still wet with pigment. Homer boldly brushed on one transparent layer of color over another so that the water shimmers with multiple reflections and colors. In the thicket behind the figures Homer applied the pigment very broadly, bleeding one wash into another. The bushes do not distract from the figures but instead form a soft screen behind them.

In the more panoramic watercolor *The End of the Hunt,* 1892 (Bowdoin College Museum of Art, Brunswick, Maine; see illustration), Homer depicted the same subject with identical hunters. In the Los Angeles painting he made a much more powerful statement by moving closer into the scene and creating with the figures and boat a monumental triangle in which verticals and horizontals are counterpoised.

PROVENANCE
The artist, 1892–1900 § With Doll and Richards, Boston, 1900–1902 § George (or Gustav) H. Buek, Brooklyn, 1902–11 § With Moulton & Ricketts Galleries, Chicago and New York, 1911–16 § Paul Rodman Mabury, Los Angeles, 1916–39.

EXHIBITIONS
Saint Louis, City Art Museum, *An Historical Collection of Pictures in Water Color by American Artists, Assembled by George H. Buek, Esq., of Brooklyn, N.Y., and by Him Lent for Exhibition,* 1909, no. 68 § Art Institute of Chicago, *A Collection of Paintings in Water Color by American Artists Lent by Gustav H. Buek of Brooklyn, New York,* 1910, no. 77 § Chicago, Moulton & Ricketts Galleries, [Buek Collection], 1911, no cat. traced § Muskegon, Mich., Hackley Art Gallery, *Catalogue of the Inaugural Exhibition,* 1912, no. 31, repro., facing p. 38 § LAMHSA, *Summer Exhibition of Paintings,* 1919, no. 22, as *Hunting Scene* § LACMHSA, *Temporary Installation and Catalogue of the Paul Rodman Mabury Collection,* 1939, no. 12, as *Return from the Hunt* § Los Angeles, University of Southern California, Elizabeth H. Fisher Gallery of Fine Arts, *American Painting of the Eighteenth and Nineteenth Centuries,* 1940, no. 16, as

Homer, *The End of the Hunt,* 1892, watercolor on paper, 15⅛ x 21⅜ in (21.4 x 38.4 cm). Bowdoin College Museum of Art, Gift of the Misses Harriet and Sophia Walker.

Return from the Hunt § Pomona, Calif., Los Angeles County Fair Association, *Painting in the U.S.A., 1721–1953,* 1953, no. 69, repro., p. 26, as *Return from the Hunt* § Boston, Museum of Fine Arts, and others, organized by American Federation of Arts and presented by *Sports Illustrated, Sport in Art,* 1955–56, no. 51, repro., unpaginated, as *Return from the Hunt* § Washington, D.C., National Gallery of Art, and New York, Metropolitan Museum of Art, *Winslow Homer: A Retrospective Exhibition,* 1959, no. 147, repro., p. 86 § Tucson, University of Arizona Art Gallery, *Yankee Painter: A Retrospective Exhibition of Oils, Water Colors, and Graphics by Winslow Homer,* 1963, unnumbered, repro., cover § LACMA and others, *Eight American Masters of Watercolor,* 1968, no. 6 § New York, Whitney Museum of American Art, and others, *Winslow Homer,* 1973, no. 124, repro., p. 101 § Evanston, Ill., Terra Museum of American Art, *Five American Masters of Watercolor,* 1981, entries not numbered, repro., p. 7 § Washington, D.C., National Gallery of Art, and others, *Winslow Homer Watercolors,* exh. cat., 1986 (copublished with Yale University Press, New Haven), entries not numbered, pp. 177–79, text by Helen A. Cooper, fig. 168, p. 179.

LITERATURE
James William Pattison, "Buek Collection of Water Colors: Historic, Artistic, Complete," *Fine Arts Journal* 24 (June 1911): 369, described and praised for its "direct forceful treatment," and as "possibly the noblest piece" in the Buek collection bought by Moulton & Ricketts and exhibited in Chicago,

repro., 375 § Archiv. Am. Art, Macbeth Gallery Papers, Macbeth Gallery to Paul Rodman Mabury, September 25, 1937; Mabury to Robert W. Macbeth, October 8, 1937; gallery to Mabury, October 14, 1937; Mabury to Macbeth, October 18, 1937 (microfilm roll 2608, frs. 528–32) § LACMHSA, *The Paul Rodman Mabury Collection of Paintings,* c. 1940, p. 22, repro., p. 23, as *Return from the Hunt* § "At the Los Angeles Museum," *Los Angeles Times,* September 1, 1940, rotogravure section, repro., p. 2, as *Return from the Hunt* § Forbes Watson, *Winslow Homer* (New York: Crown, 1942), repro., p. 36 § Lloyd Goodrich, *Winslow Homer* (New York: Macmillan for the Whitney Museum of American Art, 1944), pl. 33 § Ashton Sanborn, "Winslow Homer's Adirondack Guide," *Bulletin of the Museum of Fine Arts* (Boston) 46 (June 1948): 49, fig. 4, 50, as *Return from the Hunt* § Alexander Eliot, *Three Hundred Years of American Painting* (New York: Time, 1957), p. 300, listed § Blue Mountain Lake, N.Y., Adirondack Museum, *Winslow Homer in the Adirondacks,* exh. cat., 1959, p. 25, in list of Adirondack works compiled by Lloyd Goodrich and Edith Havens Goodrich § Albert Ten Eyck Gardner, *Winslow Homer—American Artist: His World and Work* (New York: Potter, 1961), repro., p. 187 § Higgins 1963, p. 127, no. 11 in checklist of Paul Rodman Mabury collection § Philip C. Beam, *Winslow Homer at Prout's Neck* (Boston: Little, Brown, 1966), pp. 106, 259, identifies the figures § *LACMA Members' Calendar* (June 1973): repro., detail as back cover § LACMA 1977, p. 142, repro. § LACMA 1988, p. 131, repro.

Joseph Pennell

Born July 4, 1857,
Philadelphia, Pennsylvania
Died April 23, 1926,
New York, New York

Blue Night, London, c. 1894–1909
Watercolor on light blue paper
10 x 13¹³⁄₁₆ in (25.4 x 35.2 cm)
Signed lower right: Pennell
Mr. and Mrs. William Preston Harrison Collection
31.12.18

Sunset, Acapulco, c. 1912
Watercolor and pastel on paper
10¹³⁄₁₆ x 13³⁄₄ in (27.5 x 34.9 cm)
Inscribed on mat lower center: Sunset Pacific
Inscribed verso lower left: Sunset Point
Mr. and Mrs. William Preston Harrison Collection
31.12.20

The Schooner, c. 1921–24
Watercolor and gouache with charcoal on
light blue paper
9³⁄₄ x 13¹³⁄₁₆ in (24.7 x 50.4 cm)
Signed lower right: J. Pennell
Mr. and Mrs. William Preston Harrison Collection
31.12.17

Sunset, New York Harbor, c. 1921–26
Watercolor and gouache on paper
10³⁄₁₆ x 13¹⁄₈ in (26.0 x 33.3 cm)
Signed lower center: J Pennell
Signed upper right: Pennell
Inscribed on attached mat lower right:
Winter Sunset
Gift of Mrs. Lottie V. Behrens
57.16.20

Martha Wheeler Baxter

Born 1869, Castleton,
Vermont
Died September 2, 1955,
Los Angeles, California

Portrait of a Girl with a Black Hat, 1898
Watercolor on ivory
3¹⁄₁₆ x 2⁵⁄₈ in (7.8 x 6.7 cm), oval, sight
Signed and dated along right edge: M. W. Baxter. /
1898.
Gift of Martha W. Baxter
23.4

Paul de Longpré

Born April 18, 1855,
Lyons, France
To United States 1890
Died June 29, 1911,
Hollywood, California

Known as the "king of flowers," Paul de Longpré was the son of a designer. At an early age he began decorating silks and fans but soon turned to watercolor painting. He exhibited at the Paris Salon only once, in 1880; many articles published after his arrival in this country in 1890 erroneously reported that de Longpré won a medal at the Paris Salon.

Although known primarily as a California artist, de Longpré first lived for nine years in New York, where he was given two successful exhibitions at the American Art Galleries, in 1895 and 1896. Reproductions of his paintings in national art magazines also

garnered him wide recognition. De Longpré spent part of each year in the New Jersey countryside, where he visited local greenhouses. Sometime during the late 1890s he moved to Southern California to recuperate from a serious operation, and in 1901 he built a house in Hollywood that during his lifetime was known for its art galleries and elaborate gardens. Although he occasionally painted oils, he became famous for his mastery of the watercolor medium.

BIBLIOGRAPHY
"America's Foremost Flower Painter," *Art Interchange* 35 (November 1895): 118 § Pierre N. Beringer, "Le Roi des Fleurs: A Citizen of the Republic," *Overland Monthly* n.s. 35 (March 1900): 193, 234–36 § Louis N. Richards, "The King of the Flower Painters in His California Home," *Overland Monthly* n.s. 43 (May 1904): 395–402 § Addison E. Avery, "Paul de Longpre: Painter of Roses," *American Rose Annual* (1948): 72–76 § Moure with Smith 1975, pp. 66–67, with bibliography.

De Longpré, *Study of a Rose.*

Study of a Rose, c. 1898
Watercolor and graphite on paper
6½ x 6⅜ in (16.6 x 16.1 cm), irregular
Inscription in another hand on verso upper right: by Paul De Longpré / given me by Mrs. Gertrude Hameis / who had his house 1924 / Maude Gray Best
Gift of Mrs. Maude Gray Best
M.73.136

De Longpré, *Poppies and Bees.*

Poppies and Bees, 1906
Watercolor on paper mounted on cardboard
25¹⁵/₁₆ x 16⅛ in (65.9 x 41.0 cm)
Signed and dated lower right: Paul de Longpré / ·Los Angeles 1906.
Charles H. Quinn Bequest
75.4.9

This watercolor is characteristic of de Longpré's mature flower paintings. Focusing on one or two stalks with buds and flowers, de Longpré isolated the arrangement by leaving the background white. Such a treatment and use of watercolor as a drawing medium relate to traditional botanical renderings (which de Longpré studied while working with a French horticulturist named Paillet). The poppy, the state flower of California, shares with the rose, for which de Longpré is better known, many characteristics that appealed to the artist, namely its large, sensuous petals and brilliant hues.

PROVENANCE
Charles H. Quinn, to 1975.

LITERATURE
James J. White, "Raoul M. de Longpré's fils, Elusive Painter of Lilacs and Roses," *Huntia* 6, no. 2 (1986): fig. 8, 145.

Charles Nicolas Sarka

Born December 6, 1879,
Chicago, Illinois
Died 1960

Sister Julia, late 1890s
Watercolor and graphite on paper
9¹¹/₁₆ x 6 in (24.5 x 15.2 cm)
Signed lower right: SARKA
Gift of Sandra and Jacob Terner
M.76.167.13

Walter Shirlaw

Born August 6, 1838,
Paisley, Scotland
To United States 1841
Died December 26, 1909,
Madrid, Spain

Landscape, n.d.
Charcoal and watercolor on paper
11¹⁵/₁₆ x 17¹¹/₁₆ in (27.8 x 45.0 cm)
Signed lower right: WS (monogram)
Gift of Mr. and Mrs. Arthur Herschensohn
M.74.62.1

Turkey, n.d.
Watercolor and graphite on paper
7⁵/₈ x 10 in (19.3 x 25.3 cm)
Signed lower right: W Shirlaw
Gift of Mr. and Mrs. Arthur Herschensohn
M.74.62.3

John La Farge

Born March 31, 1835,
New York, New York
Died November 14, 1910,
Providence, Rhode Island

An important figure in the late nineteenth century, John Lewis Frederick Joseph La Farge was respected not only for his paintings and work in the decorative arts but also for his writings on art and aesthetics. Raised in a prosperous French Catholic family in New York, La Farge first studied law. Not until after a trip to France in 1856, where he associated with notable writers and artists, did he decide to become an artist. Although he only briefly studied painting formally, with Thomas Couture (1815–1879), he spent hours drawing from old master paintings in the Louvre. On his return to America in 1857 he stopped in England, where he first saw the work of the English Pre-Raphaelites then on display at the Art Treasures Exhibition in Manchester. He became familiar with oriental art and in 1886 traveled to the Far East with historian Henry Adams; four years later they visited the South Sea Islands together.

La Farge's association with WILLIAM MORRIS HUNT in Newport, Rhode Island, was crucial to his early development. Hunt encouraged La Farge to explore and synthesize a number of interests. In his landscapes and floral still-life compositions of the 1860s La Farge experimentally combined concepts borrowed from the Pre-Raphaelite and Barbizon painters with contemporary theories of optics and color. Extremely erudite, he produced art that often alluded to earlier literary and artistic sources. During the 1860s he also illustrated books and magazines, including an edition of Alfred Tennyson's *Enoch Arden* (1865) and *Riverside Magazine for Young People.*

La Farge developed a new method to produce a pearly, opalescent glass, and with the commission in 1876 to decorate Trinity Church in Boston he became the most prominent muralist and designer of stained-glass windows in the United States. Among his many religious and civic projects were the Church of Saint Paul the Apostle in New York, 1884–99, and the Baltimore Court House, 1905–7. His imagery for public buildings usually was based on allegories and religious iconography. For the private homes of Cornelius and William Vanderbilt he designed floral windows that are among the most outstanding examples of the turn-of-the-century Aesthetic Movement in the United States. Among his numerous publications are *Consideration on Painting* (1895), *An Artist's Letters from Japan* (1897), and *The Higher Life in Art* (1908).

BIBLIOGRAPHY
Cecilia Waern, *John La Farge: Artist and Writer* (New York: Macmillan, 1896) § Royal Cortissoz, *John La Farge: A Memoir and a Study* (Boston: Houghton Mifflin, 1911) § Helene Barbara Weinberg, *The Decorative Work of John La Farge* (New York: Garland, 1977), with bibliography § Henry Adams, "John La Farge, 1830–1870: From Amateur to Artist," Ph.D. diss., Yale University, 1980, with bibliography § Pittsburgh, Carnegie Museum of Art, and others, *John La Farge,* exh. cat., 1987 (copublished with National Museum of American Art, Smithsonian Institution, Washington, D.C., and Abbeville Press, New York), with essays by Henry Adams, James L. Yarnall, Kathleen A. Foster, H. Barbara Weinberg, and others, chronology by Yarnall and Mary A. La Farge, and lists of exhibitions, sales, and locations of decorative works by Yarnall, Amy B. Werbel, and Henry A. La Farge.

Wisdom, c. 1900–1901
(*Colour Sketch for Ames Memorial Window, North Easton, Mass.*)
Watercolor on paper
17⅝ x 11¾ in (44.8 x 30.0 cm), arched top
Mr. and Mrs. William Preston Harrison Collection
33.11.5

This watercolor was the final preparatory work for one of La Farge's finest late stained-glass windows, *Wisdom,* 1901 (see illustration), in the east transept of Unity Church in North Easton, Massachusetts. The window, a memorial to Oakes Ames and his sons Oakes Angier Ames and Oliver Ames, was commissioned by the grandchildren of Oakes Ames. Designed by John Ames Mitchell, the church itself had been a gift of the Ames family, and most of the memorials in the church were dedicated to members of the family. Earlier, in 1887, La Farge had designed for the family the *Angel of Help* window in the west transept, a memorial to Helen Angier Ames.

Depicted as a lovely woman, Wisdom is enthroned and surrounded by an elaborate architectural structure. She thoughtfully touches her right hand to her cheek; her right elbow rests on a globe. To her left stands Youth, a handsome man dressed in Renaissance military garb, and to her right, Old Age, a bearded man clothed in classical attire. The differences between this window and the earlier *Angel of Help* reveal the impact of La Farge's visit to Italy in 1894. While both have allegorical figures and a similarly symmetrical arrangement, *Wisdom* is more structured with an emphatic architectural perspective.

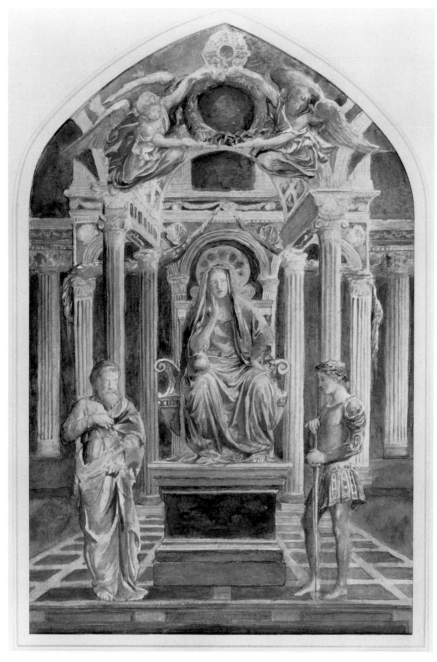

La Farge, *Wisdom.*

La Farge, *Wisdom,* 1901, see
Related Works.

such an image for the grave monument for
Henry Adams's wife, 1886–91 (Rock Creek
Cemetery, Washington, D.C.), for which La
Farge was Saint-Gaudens's advisor, indicating
the degree to which La Farge absorbed Far
Eastern philosophy. Such an amalgamation of
sources not only reflects La Farge's eclectic
learning but also is in keeping with the Ameri-
can Renaissance aesthetic. La Farge's late
windows, such as *Wisdom,* reveal a greater pic-
torialism, possibly as much in response to
patronage demands as to his own preferences.

The watercolor probably was executed
between 1900 and 1901 since a sketch of the
central figure (Toledo Museum of Art) is
inscribed August 1900, and the finished win-
dow was exhibited in the autumn of 1901
and installed on December 17 of that year.

RELATED WORKS
Youth, 1900, watercolor, gouache, and graphite on
paper, 11¼ x 4⅝ in (28.6 x 11.7 cm). Unlocated
§ *First Study for Oakes Ames Window,* 1900, crayon,
9⁹/₁₆ x 7¹/₁₆ in (24.3 x 17.9 cm). Toledo Museum of
Art § *Study of Wisdom for Oakes Ames Window,*
1900, crayon, 11 x 7¹¹/₁₆ in (27.9 x 19.5 cm). Toledo
Museum of Art § *Youth,* c. 1900–1901, graphite
and black chalk or charcoal on paper mounted on
cardboard, 9 x 3⁹/₁₆ in (22.9 x 9.0 cm). Museum of
Fine Arts, Boston. § *Wisdom,* 1901, stained glass,
144 x 84 in (365.8 x 213.7 cm). Unity Church, North
Easton, Mass.

PROVENANCE
The artist, 1900–1910 § Estate of the artist, 1910–
11 (sale, American Art Galleries, New York, *Art-
Property and Other Objects Belonging to the Estate
of the Late John La Farge, N.A.,* March 31, 1911,
no. 664) § With C. W. Kraushaar Galleries,
New York, 1911–33 § Mr. and Mrs. William
Preston Harrison, Los Angeles, 1933.

EXHIBITIONS
Boston, Doll and Richards, *Exhibition and Private
Sale of Pictures, Drawings, and Sketches by Mr. John
La Farge,* 1904, no. 78, as *Colour Sketch for Ames
Memorial Window, North Easton, Mass.* § Boston,
Doll and Richards, *Catalogue of Works by John La
Farge,* 1907, no. 301 § New York, Ferargil Galleries,
*Watercolors, Stained Glass, and Oil Paintings by John
La Farge,* 1923, no. 31, no cat. traced § New York,
Milch Gallery, *19th and 20th Century American
Watercolors,* 1933, no. 5 § LACMA, *American Pas-
tels and Watercolors: Selections from the Mr. and Mrs.
William Preston Harrison Collection,* 1969, no. 10.

LITERATURE
"The Fine Arts: Exhibition of La Farge's Pictures,
Drawings and Sketches," *Boston Evening Transcript,*
February 26, 1904, p. 10 § "La Farge Exhibits
Many Paintings," *Boston Herald,* February 29, 1904,
p. 5 § "The Fine Arts: The La Farge Exhibition,"
Boston Evening Transcript, February 21, 1907, p. 12
§ New Haven, Conn., Yale University, Sterling
Memorial Library, Department of Manuscripts and

Art historian Henry La Farge has suggested
that the window relates to decorations in the
Villa of Mysteries in Pompeii. The overall for-
mat, however, is that of a late-fifteenth century
Italian *sacra conversazione* image. The Ionic
baldachin under which Wisdom sits is
reminiscent of fifteenth-century Italian tomb
monuments, while inlaid checkered marble
floors appear in countless Renaissance paint-
ings. La Farge derived the figure of Old Age
from a relief by Donatello (1386?–1466). The
angels holding a wreath above the figure may
have been derived from terra-cotta bas-reliefs
by Andrea del Verrocchio (1435–1488) for the
Forteguerra monument. The image of a seated,
hooded figure in meditation appeared in orien-
tal art as Kannon (Kwannon), Buddhist deity
of mercy. AUGUSTUS SAINT-GAUDENS used

Archives, La Farge Family Papers, Grace Edith Barnes to J. W. Beatty, January 11, 1911 § Guy Pène du Bois, "The Case of John La Farge," *Arts* 17 (January 1931): repro., 276, incorrectly identified as Saint Elizabeth § Harrison 1934, p. 64, repro. § LACMA, Registrar's files, William Preston Harrison to Louise Upton, February 3, 1935, refers to a lost letter from Royal Cortissoz in which the critic complimented Harrison on his acquisition of such a fine example of the artist's work § Higgins 1963, p. 62, no. 127 in checklist of Mr. and Mrs. William Preston Harrison collection § Susan Hobbs, "John La Farge and the Genteel Tradition in American Art, 1875–1910," Ph.D. diss., Cornell University, 1974, p. 121 n. 218 § Weinberg, *The Decorative Work*, fig. 300, p. 672 § Henry A. La Farge, James L. Yarnall, and Mary A. La Farge, *Catalogue Raisonné of the Works of John La Farge, Vol. 1: Oils and Watercolors* (forthcoming, Yale University Press, New Haven), listed as no. W1900.9.

Christian A. Jörgensen

Born 1859 or 1860,
Oslo, Norway
To United States 1869
Died June 9, 1935,
Piedmont, California

Mission, c. 1901–6
Watercolor on paper
15¹/₁₆ x 12¹³/₁₆ in (38.1 x 29.9 cm)
Signed lower left: Chris Jörgensen
Bequest of Mildred and Irving Shepard
M.79.109.2

Harbor Scene, 1916
Watercolor on paper
Signed and dated lower right: chris Jörgensen / 1916
15¹/₁₆ x 10⁹/₁₆ in (36.8 x 26.7 cm)
Bequest of Mildred and Irving Shepard
M.79.109.1

John S. Sargent

Born January 12, 1856,
Florence, Italy, to
American parents
Died April 15, 1925,
London, England

See biography in oil paintings section.

Rose-Marie Ormond Reading in a Cashmere Shawl, c. 1908–12
(*Reading; Study of a Lady Reading*)
Watercolor, gouache, and charcoal on paper
14¹/₁₆ x 20¹/₁₆ in (35.7 x 50.9 cm)
Inscribed upper right: To my friend Pegram—John
S. Sargent
Gift of the Art Museum Council
M.72.52

—which would have come from Kashmir or have been derived from Kashmiri prototypes—may have been an allusion to Rose-Marie's fondness for reading Mughal poetry, Sargent no doubt included the wrap because of its decorative character, and in this watercolor the drape's ornamental design becomes a maze of loose brush strokes surrounding the figure.

Sargent found that sketching in watercolor enabled him to combine drawing with painting. A virtuoso of bravura brushwork, Sargent here used techniques ranging from dry brush

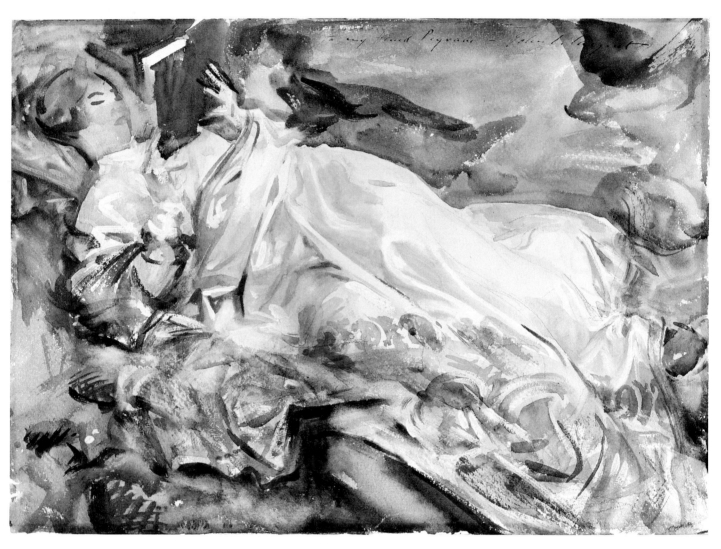

Sargent, *Rose-Marie Ormond Reading in a Cashmere Shawl.*

Rose-Marie Ormond (1893–1918), daughter of John Singer Sargent's sister, Violet Sargent Ormond, was one of the artist's favorite models during his later years. Weary of portrait painting, around 1908 Sargent turned increasingly to more informal figurative paintings in oil and watercolor. At about the same time he also began summering with the Ormond family in the Alps, near Val d'Aosta and Simplon. During these vacations he painted many compositions of young women reclining in open landscapes. Often they are draped in elegant cashmere shawls, as is Rose-Marie in this watercolor. Although the shawl

in the shawl to wet-into-wet strokes in the foreground. Utilizing transparent washes, gouaches, and the white of the paper, Sargent captured the brilliance of reflected sunlight. Rose-Marie's white dress picks up the blues and browns cast by her surroundings. The colors, flickering sunlight, and mass of zigzag and circular strokes contribute to an active optical impression, which at first hinders the reading of the image. In his Alpine watercolors Sargent moved a step closer to abstraction as color and brushwork assumed precedence over narration.

Sargent gave the painting to Henry Alfred Pegram (1862–1937), a minor English sculptor,

and it remained in his family's possession until acquired by the museum.

PROVENANCE
The artist § Henry Alfred Pegram, London, to 1937 § P. G. Browne (by descent), London, to 1972 (sale, Sotheby & Co., London, *Modern British Paintings, Drawings, and Sculpture,* April 26, 1972, no. 20, repro., unpaginated, as *The Reading,* dated c. 1909) § With M. R. Schweitzer Gallery, New York, 1972.

EXHIBITIONS
London, Royal Academy of Arts, *Exhibition of Works by the Late John S. Sargent, R.A.,* 1926, no. 112, as *Study of a Lady Reading* § New York, Brooklyn Museum, *Sargent Watercolors from the Brooklyn Museum and the Metropolitan Museum of Art,* 1972, exhibited but not listed § LACMA, *Two Decades of Art Museum Council Gifts,* 1973, listed under 1972 gifts.

LITERATURE
Advertisement, *Apollo* 95 (April 1972): repro., 138 of advertisements, as *Reading* § Advertisement, *Burlington Magazine* 114 (April 1972): repro., x, as *Reading* § "Recent Acquisitions, Fall 1969–Spring 1973," *LACMA Bulletin* 19, no. 2 (1973): fig. 19, 42 § "La Chronique des arts," *Gazette des Beaux-Arts,* 6th ser. 81 (February 1973): fig. 576, supp. 164 § "Recent Accessions of American and Canadian Museums," *Art Quarterly* 36 (Spring–Summer 1973): repro., 128 § "Permanent Collection," *LACMA Report 1969–1973* (as *LACMA Bulletin* 20, no. 1 [1974]), p. 19 § Donelson F. Hoopes, *American Watercolor Painting* (New York: Watson-Guptill, 1977), p. 66, pl. 26, p. 122 § New York, Coe Kerr Gallery, *John Singer Sargent, His Own Work,* exh. cat., 1980 (copublished with Wittenborn, New York), unpaginated, cited in list of works in American public collections.

Mary Cassatt

Born May 22, 1844,
Allegheny City,
Pennsylvania
Died June 14, 1926,
Mesnil-Théribus, France

See biography in oil paintings section.

Augusta and Her Daughter Seated near a River Bank, c. 1910
(*Two Women in a Garden*)
Watercolor on paper
19⁵⁄₁₆ x 13³⁄₈ in (49.1 x 34.0 cm)
Stamp lower right: COLLECTION / MARY CASSATT / MATHILDE X
Mr. and Mrs. William Preston Harrison Collection
39.9.4

Maurice Prendergast

Born October 10, 1858,
Saint John's, Newfoundland,
Canada
To United States 1861
Died February 1, 1924,
New York, New York

Often referred to as America's first postimpressionist, Maurice Brazil Prendergast developed his own modern idiom. During the 1890s he achieved recognition for his watercolors and monotypes. Working in Boston, he developed a watercolor style in which color and light vibrate and dance over the paper. Around 1903–4 Prendergast increasingly painted in oils. His dominant theme remained constant: figures parading along a beach or a city street or in a park. Only in the twentieth century did Prendergast occasionally paint still-life compositions.

His first documented trip to Europe was undertaken with his lifelong companion, his brother Charles (1868–1948), in 1891. Maurice studied intermittently at the Académie Julian and Atelier Colarossi in Paris, but his most important teachers were his friends the painters James Wilson Morrice (1865–1924) and Charles Conder (1868–1909). The

paintings of the impressionists, neoimpressionists, and symbolists, which he saw in Paris, also influenced his artistic development.

Returning to Boston in 1895, Prendergast supported himself by illustrating books and with the assistance of his brother. At this time he began exhibiting outside Boston. From 1898 to 1900 he lived in Europe, both in France and in Italy, where he created his well-known, brilliantly luminous watercolors of Venice. In early 1900 the Macbeth Gallery, New York, began selling his work, and in 1908 he participated in the gallery's landmark exhibition of The Eight. In 1914 he moved to New York. His third trip to Paris, taken after the exhibition of The Eight, exposed him to more modern art, in particular the late work of Paul Cézanne (1839–1906) and the art of the fauves. In late 1911 and 1914 he again traveled abroad.

Although his early watercolors have often been referred to as impressionist, Prendergast abandoned the concern with nature to concentrate on the pictorial design of a painting. His art became nonreferential as he began to create a personal language. By using a limited range of subjects in serial fashion, he focused exclusively on formal elements of line and color. He also became more aware of the sensuous qualities of paint. Colors are juxtaposed and brush strokes broken to create perfectly harmonious, rhythmic arrangements.

BIBLIOGRAPHY

Margaret Breuning, *Maurice Prendergast,* American Artists Series (New York: Whitney Museum of American Art, 1931), with biographical note by Edmund Archer, bibliography § Boston, Museum of Fine Arts, and others, *Maurice Prendergast, 1859–1924,* exh. cat., 1960, published by Harvard University Press, Cambridge, Mass., by Hedley Howell Rhys, with catalogue by Peter A. Wick, chronology, bibliography § College Park, University of Maryland Art Gallery, and others, *Maurice Prendergast,* exh. cat., 1976, with essay by Eleanor Green, chronology by Green and Ellen Glavin, catalogue by Green and Jeffrey R. Hayes § Cecily Langdale, *Monotypes by Maurice Prendergast in the Terra Museum of American Art* (Evanston, Ill.: Terra Museum of American Art, 1984), with bibliography § Carol Clark, Nancy Mowll Mathews, and Wendy Owens, *Maurice and Charles Prendergast: A Systematic Catalogue,* ed. Milton W. Brown (forthcoming, Prestel-Verlag, Munich), with bibliography, list of exhibitions.

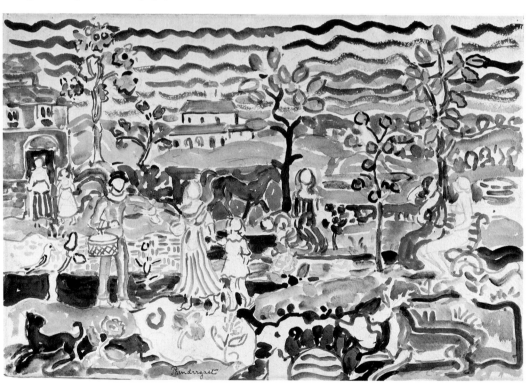

Prendergast, *Decorative Composition.*

Decorative Composition, c. 1914
Watercolor with graphite underdrawing on paper
13½ x 20 in (34.3 x 50.8 cm)
Signed center lower left: Prendergast
Mr. and Mrs. William Preston Harrison Collection
31.12.1
Color plate, page 57

Decorative Composition is characteristic of Prendergast's theme of promenades but atypical stylistically. It was painted during an experimental period in the artist's career. While earlier watercolors reveal Prendergast's increasing use of individualized brush strokes as abstract, notational elements, he usually

painted with short strokes rather than long lines. In this composition the wavy lines in the sky are especially unusual, as is the formation of white lines by leaving the paper exposed. The effect is fauvist, like the art of Henri Matisse (1869–1954), and recalls the arabesque linearity of the decorative, incised and painted panels his brother Charles began creating around the same time.

Art historian Eleanor Green suggests that the unusual style and period costumes worn by the figures may have been stimulated by the Prendergast brothers' set designs for the King-Coit Children's Theater group in New York. Unfortunately the designs for these sets are lost. Soon after completing this watercolor, Prendergast created two mural-size canvases that also reveal experimental brushwork with shorter, more mosaiclike strokes and a similar exploitation of the white of unpainted areas (*Picnic*, 1914–15, Carnegie Museum of Art, Pittsburgh; *Promenade*, 1914–15, Detroit Institute of Art).

Decorative Composition was admired and bought by two of the most important early twentieth-century collectors of American art. John Quinn, who owned one of the finest private collections of Prendergast works,

that her father, C. W. Kraushaar, sold the Quinn painting to Harrison and not to Hirshhorn.

On the verso is an unfinished sketch, not unlike studies of the sea that Prendergast did in Saint Malo, France, around 1909.

PROVENANCE
With Carroll Galleries, New York, 1915 § John Quinn, New York, 1915–24 § Estate of John Quinn, 1924–27 (sale, American Art Association Galleries, New York, *Paintings and Sculptures: The Renowned Collection of Modern and Ultra-Modern Art Formed by the Late John Quinn*, February 11, 1927, no. 433) § With C. W. Kraushaar Galleries, New York, 1927 § Mr. and Mrs. William Preston Harrison, Los Angeles, 1927–31.

EXHIBITIONS
New York, Carroll Galleries, *Maurice B. Prendergast: Paintings in Oil and Water Colors*, 1915, no. 55, dated 1914 § LACMA, *American Pastels and Watercolors: Selections from the Mr. and Mrs. William Preston Harrison Collection*, 1969, no. 12 § Pasadena (Calif.) Pacificulture Foundation, [calligraphy and the arts exhibition], 1972, no cat. traced § University of Maryland Art Gallery, and New York, Davis and Long, *Prendergast*, 1976–77, no. 70, p. 26, essay by Green, p. 70, chronology by Green and Glavin, pp. 136–38, entry by Green, repro., p. 137 § Fresno (Calif.) Arts Center, *Two Hundred Years of American Painting*, 1977, no. 39, repro., p. 32.

LITERATURE
"Prendergast's Paintings," *New York Times*, March 4, 1915, p. 8 § Collection of Thomas F. Conroy, "Art Ledgers of John Quinn," 1: 141, lists purchase § New York Public Library, John Quinn Memorial Collection, "Catalogue of the Art Collection Belonging to Mr. Quinn," July 28, 1924 § *John Quinn, 1870–1925: Collection of Paintings, Water Colors, Drawings, and Sculpture* (Huntington, N.Y.: Pidgeon Hill, 1926), p. 25, listed § "Sale of the Quinn Collection Is Completed," *Art News* 25 (February 19, 1927): 11, lists § Harrison 1934, p. 66, repro., p. 65 § *Index 20th Cent. Artists* 2 (March 1935): 93; reprint, p. 358; listed in colls. as an oil § Higgins 1963, p. 61, no. 114 in checklist of Mr. and Mrs. William Preston Harrison collection § LACMA, American Art department files, Eleanor Green to Nancy Dustin Wall Moure, April 22, 1975, tells of Antoinette Kraushaar identifying the LACMA painting as having been in the Quinn collection § Washington, D.C., Smithsonian Institution, Hirshhorn Museum and Sculpture Garden, *"The Noble Buyer": John Quinn, Patron of the Avant-Garde*, exh. cat., 1978, published by Smithsonian Institution Press, p. 179, "Appendix: Partial Checklist of the Quinn Collection," by Judith Zilczer and Ruth Ginsburg, includes pre-1928 provenance and references and cites listing in Quinn's ledger § LACMA, American Art department files, Carol Clark to Ilene Susan Fort, January 23, 1986, compares sketch on verso to Saint Malo sea studies § Clark, Mathews, and Owens, *Maurice and Charles Prendergast*, listed in cat. raisonné as no. 117, dated 1913–15.

Verso of Prendergast, *Decorative Composition*.

bought *Decorative Composition* in 1915 out of the Carroll Galleries exhibition. The painting remained in his possession until his death in 1924, after which it was acquired by William Preston Harrison. The oil painting *Decorative Composition* now in the Hirshhorn Museum and Sculpture Garden (Smithsonian Institution, Washington, D.C.) was once believed to have been the one owned by Quinn. However, dealer Antoinette Kraushaar recently recalled

Childe Hassam

Born October 17, 1859,
Dorchester (now Boston),
Massachusetts
Died August 27, 1935,
East Hampton, New York

See biography in oil paintings section.

Castle Island, Boston Harbor, 1916
Watercolor, gouache, and graphite on paper
9 x 12⅞ in (22.8 x 35.7 cm)
Signed lower right: Childe Hassam
Inscribed and dated lower left: Castle Island,
Boston. May 15 1916
Mr. and Mrs. William Preston Harrison Collection
31.12.9

Charles Demuth

Born November 8, 1883,
Lancaster, Pennsylvania
Died October 23, 1935,
Lancaster, Pennsylvania

Charles Henry Buckius Demuth was among the most important early American modernists. He was equally adept as a painter in watercolor and oil and is considered one of the twentieth century's preeminent watercolorists. Demuth studied in Philadelphia at Drexel Institute from 1901 to 1905 and from 1905 to 1911 at the Pennsylvania Academy of Fine Arts with Thomas P. Anshutz (1851–1912), Henry McCarter (1866–1942), and HUGH H. BRECKENRIDGE. Between 1904 and 1921 he made several visits to Europe, where he met and associated with major figures of the avant-garde. During his stay in Paris from 1912 to 1914 he enrolled in various art academies and met Gertrude and Leo Stein and MARSDEN HARTLEY. Demuth had hoped to pursue a literary career, and in 1914 wrote a one-act play, *The Azure Adder.* His first solo exhibition was held in 1914 at Daniel Gallery in New York, where he maintained a studio (while frequently commuting between the city and his hometown of Lancaster in rural Pennsylvania). He was often invited to the soirees held in the apartment of collector Walter Arensberg, meeting Marcel Duchamp (1887–1968), Francis Picabia (1879–1953), and other European and American modernists there. By 1915 Demuth had become enamored of New York café society and vaudeville and began depicting them. In the late 1910s for his own enjoyment he began making watercolors inspired by literary works such as Emil Zola's *Nana* and Henry James's *Turn of the Screw.*

By the 1920s he developed an aesthetic of precisionism out of the series of cubist-influenced architectural views he had painted in Provincetown and Bermuda during the late 1910s. In addition to painting oils of Lancaster buildings, Demuth devoted considerable time during the last decade of his life to watercolor still lifes and floral studies. In the latter he combined the control and precision of his architectural images with the richness and organic quality of the line and color in his vaudeville watercolors, adding to his art a greater sensuosity than previously seen. During the twenties he became a close friend of Georgia O'Keeffe (1887–1986) and Alfred Stieglitz (1864–1946), and when Stieglitz opened his Intimate Gallery, Demuth became one of the regular exhibitors. Always neglecting his health for his art—he was a diabetic—Demuth died at the height of his career in 1935.

BIBLIOGRAPHY
Albert E. Gallatin, *Charles Demuth* (New York: Rudge, 1927) § Emily Farnham, *Charles Demuth: Behind a Laughing Mask* (Norman: University of Oklahoma Press, 1971), with chronology, bibliography § Alvord L. Eiseman, "A Study of the Development of an Artist: Charles Demuth," 2 vols., Ph.D. diss., New York University, 1975, with bibliography § Thomas E. Norton, ed., *Homage to Charles Demuth: Still Life Painter of Lancaster,* with essays by Norton, Alvord L. Eiseman, Sherman Lee, and others (Ephrata, Pa.: Science Press, 1978) § New York, Whitney Museum of American Art, and others, *Charles Demuth,* exh. cat., 1987 (co-published with Harry N. Abrams, New York), by Barbara Haskell, with exhibition history and bibliography by Marilyn Kushner.

Old Houses, 1917
(Old House)
Watercolor on paper
9¹⁵/₁₆ x 14 in (25.2 x 35.6 cm)
Signed and dated center left: C. Demuth / 1917
Mr. and Mrs. William Preston Harrison Collection
29.18.7

In the autumn of 1916 Demuth joined Marsden Hartley in Bermuda and while there produced a group of cubist watercolors that marked a crucial change in his work as he moved closer toward an intellectual, abstract art. Demuth

Demuth presents the buildings as a cluster of geometric shapes with nature limited to a few trees and the distant mountains represented by diagonals.

In the Bermuda watercolors Demuth for the first time controlled his previously rhythmic line, limited his forms to geometric shapes, and faceted objects into overlapping planes and directional lines. The landscape becomes a carefully composed arrangement of prismatic light and darker geometric areas. His new classicism of line and image usually is accompanied by a soft, hushed palette. *Old Houses* is more

Demuth, *Old Houses.*

had had ample opportunity to become acquainted with cubism during his stay in Paris and as a member of the Arensberg circle in New York. Moreover, the second-generation cubist Albert Gleizes (1881–1953) was in Bermuda during Demuth's visit there. While on the island Demuth painted landscapes and the picturesque buildings in the town of Saint George. A classic example of Demuth's Bermuda landscapes, *Old Houses* features the tower structure often included in the center of these paintings. Perhaps following the example of early cubist landscapes by Pablo Picasso (1881–1973) and Georges Braque (1882–1963),

vivid than other Bermuda watercolors, its color restricted to earth tones with a strong orange rectangle in the center. Demuth took advantage of the white of the paper by allowing the colored planes to fade into the background and blotted the watercolor to achieve a mottled effect.

The Bermuda series resembles the late landscape watercolors of Paul Cézanne (1839–1906), whose work Demuth could easily have seen in New York or Paris. Cézanne also allowed the white of the paper to show through delicately applied, pale colors. Both artists shared a concern for abstract form,

which may have determined their controlled approaches. Demuth, however, more actively manipulated the paper surface by contrasting not only light and dark planes but also textured and smooth surfaces.

PROVENANCE
The artist § With Edith Gregor Halpert, New York § Mr. and Mrs. William Preston Harrison, Los Angeles, 1927–29.

EXHIBITIONS
Possibly New York, Daniel Gallery, *Demuth and Fisk Exhibition,* 1917, no cat. traced § Santa Barbara, Calif., Faulkner Memorial Art Gallery, *American Water Colors,* 1935, no. 22 § American Federation of Arts, *Watercolors for Asia,* traveling exhibition, 1955; *American Watercolor Exhibition,* exh. cat., Indian ed.; *American Watercolor Exhibition,* exh. cat., Japanese ed., p. 16 § Albuquerque, University of New Mexico Art Museum, and others, *Cubism: Its Impact in the USA, 1910–1930,* 1967, no. 20, repro., p. 27 § LACMA and others, *Eight American Masters of Watercolor,* 1968, no. 72, repro. § LACMA, *American Pastels and Watercolors: Selections from the Mr. and Mrs. William Preston Harrison Collection,*

1969, no. 2 § Santa Barbara, University of California, Art Galleries, and others, *Charles Demuth: The Mechanical Encrusted on the Living,* 1971–72, no. 41 § Minneapolis Institute of Arts and others, *American Master Drawings and Watercolors: Works on Paper from Colonial Times to the Present,* 1977, entries not numbered, pp. 314–15, repro., p. 316 § LACMA, *Charles Demuth,* 1988, exhibited but not listed.

LITERATURE
Harrison 1934, p. 62 § LACMA, Registrar's files, William Preston Harrison to Louise Upton, November 8, 1935, refers to painting as "a universally superb abstraction—about his best type and this is early enough to have unusual interest" § Emily Farnham, "Charles Demuth: His Life, Psychology, and Works," Ph.D. diss., Ohio State University, 1959, 2: 517, listed in cat. of works as no. 278, cites its listing as no. 485 in now untraced Richard Weyand Scrapbooks, fig. 49, 2: 802 § Higgins 1963, p. 59, no. 74 in checklist of Mr. and Mrs. William Preston Harrison collection, as *Old House* § Emily Farnham, "Charles Demuth's Bermuda Landscapes," *Art Journal* 25 (Winter 1965–66): fig. 4, 132 § Farnham, *Demuth: Laughing Mask,* pp. 88–89, pl. 17, facing p. 110.

George Overbury "Pop" Hart

Born May 10, 1868,
Cairo, Illinois
Died September 9, 1933,
New York, New York

Market Place, San Fernando, Trinidad,
1917
Watercolor and gouache with charcoal underdrawing on buff-colored paper
11⅝ x 19¹⁵⁄₁₆ in (29.6 x 50.7 cm)
Signed, dated, and inscribed lower right: Hart '17 / MARKET PLACE / SAN FERNANDO / TRINIDAD
Mr. and Mrs. William Preston Harrison Collection
29.18.10

Carnival Scene, Dominica, West Indies,
c. 1921
Watercolor, gouache, ink, and charcoal on buff-colored paper
17⅞ x 23⅞ in (45.4 x 60.6 cm)
Signed and inscribed lower left: Hart / Dominica W.I. / Carnival
Mr. and Mrs. William Preston Harrison Collection
29.18.11

Market Plaza, c. 1923
Watercolor and pastel on paper
17$^{15}/_{16}$ x 24 in (45.6 x 61.0 cm)
Signed and inscribed lower right: Hart / Jalapa MEX
Inscribed lower center: The original drawing for
Aquatint Market Plaza
Gift of Irving Stone
M.70.77.1

Landscape with Goats, Mexico, 1926
Watercolor, gouache, and graphite on
dark cream paper
17$^7/_8$ x 23$^{13}/_{16}$ in (45.4 x 60.4 cm)
Signed, dated, and inscribed lower left: Hart 26 /
MEXICO
Mr. and Mrs. William Preston Harrison Collection
29.18.9

Nick Brigante

Born June 29, 1895,
Padulla, Italy
To United States 1897
Died May 6, 1989,
Los Angeles, California

Nicholas P. Brigante was one of the earliest and foremost modernists in Los Angeles. Although he used a variety of mediums, he worked primarily with watercolor or ink. Brigante studied at the Art Students League of Los Angeles in 1913 with Rex Slinkard (1887–1918), who became his close friend and mentor. Slinkard encouraged him in his interest in classical art, Chinese landscape painting, and oriental philosophy, all of which were to help determine the spirit of Brigante's art.

Brigante fought in World War I and on his return to Los Angeles became an active, independent artist. From 1923 to 1924 he undertook his only major excursion to the East Coast, living in New York and immersing himself in modernist circles. During the 1930s he produced several figurative series based on the theme of workers and the West; interiors with nudes; and, for a proposed federally sponsored project, a nine-panel mural on the struggle of mankind (LACMA; q.v.). Although during the 1940s he composed allegorical and figurative scenes inspired by automatic drawing, Brigante increasingly moved from figuration toward a spiritual abstraction based on his response to nature.

Around 1957 he began the series Cloud Lands of Abstraction, in which he combined the refined calligraphy of his automatic drawings with atmospheric washes suggested by Southern Song-period Chinese painting. After the Los Angeles Art Association gave him a retrospective exhibition in 1963, Brigante added a new element to his art, brilliant color, and turned to oils. He continued to create abstracted imagery inspired by his personal response to nature, working on an ever-increasing scale and often utilizing a multiple-panel format. His works continued to appear in exhibitions of contemporary art as well as in historical surveys, and Brigante was given solo exhibitions by Loyola-Marymount University, Los Angeles, in 1973 and the Long Beach Art Association in 1975.

BIBLIOGRAPHY
Archiv. Am. Art, Nick Brigante Papers § Los Angeles, Stendahl Galleries, *Nicholas Brigante,* exh. cat., 1937, with foreword by Arthur Millier and essay by Earl L. Stendahl § John Alan Walker, "Nick Brigante," *Fine Art Source Material Newsletter* 1 (April 1971): 73–88 § Joseph E. Young, "Nicholas Brigante: An Elegant Timelessness," *Art News* 74 (January 1975): 44–46 § *Nicholas Brigante* (Los Angeles: Privately printed by American Art Review Press, 1975), with reprints of major early solo exhibition catalogues and Young's 1975 article, chronological list of exhibitions, bibliography.

At Camp Kearny—World War I, 1918
Watercolor and graphite on paper
4¹³/₁₆ x 7³/₄ in (12.2 x 19.7 cm)
Signed and dated lower center: N.B. 1918
Inscription on mat: At Camp Kearny W.W. I
Gift of Dr. Robert E. Barela
M.72.122.78

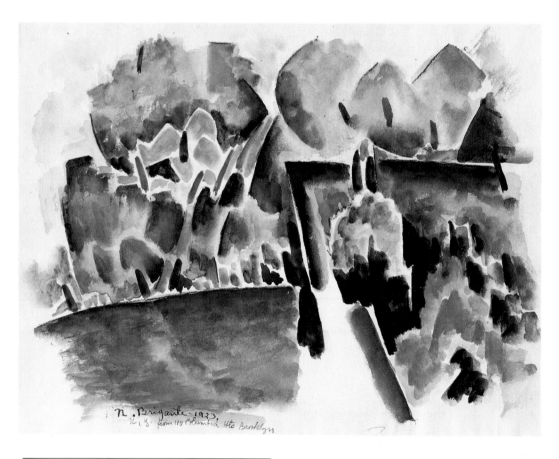

Brigante, *New York from 110 Columbia Heights, Brooklyn.*

New York from 110 Columbia Heights, Brooklyn, 1923
Watercolor with black crayon on paper
10¹⁵/₁₆ x 14 in (27.8 x 35.6 cm)
Signed and dated lower left: N. Brigante 1923.
Inscribed lower left below signature: N.Y. from 110 Columbia Hts Brooklyn
Gift of Dr. Robert E. Barela
M.72.122.29

In April 1923 Brigante left Los Angeles for New York. The year he spent there was of seminal importance to his artistic development. He lived in a house on Columbia Heights in Brooklyn rented to him by the modernist sculptor Robert Laurent (1890–1970). Brigante, anxious to learn all he could, visited Alfred Stieglitz (1864–1946) in his gallery and became better acquainted with modern American

trends, and he began exhibiting at the progressive Daniel Gallery. A devoted watercolorist, Brigante admired the art of JOHN MARIN and Charles Sheeler (1883–1965) but was most influenced by the work of CHARLES DEMUTH.

Although Brigante was living in a major metropolis and admired artists famous for depicting it, he still sought out nature. In this cityscape he moved toward abstraction, flattening, simplifying, and streamlining natural forms to narrow shapes, and presenting the scene as an arrangement of angular, overlapping planes.

The smooth paper further enhances the two-dimensionality of the composition. As did Demuth, Brigante preferred to leave parts of the watercolor unfinished to stimulate the viewer's imagination. Brigante's palette is expressionistic, with vivid purples, deep blues, and oranges as well as black outlines. This watercolor and the stylistically related oil painting *Landscape Abstraction, 1923–24* (private collection), would be the closest Brigante came to cubism.

PROVENANCE
Dr. Robert E. Barela, Los Angeles.

Brigante, *Elysian Park, L.A., Road with Bordering Trees.*

Brigante, *Elysian Park, L.A., Trees and Clearing.*

Elysian Park, L.A., Road with Bordering Trees, 1924
Watercolor and charcoal on paper
13³/₈ x 19³/₄ in (34.0 x 50.1 cm)
Signed and dated lower right: N. Brigante 1924 /
Dedicated to my Francisca
Inscribed lower right below signature: ELYSIAN P.K.
L.A. CALIF.
Gift of Dr. Robert E. Barela
M.72.122.15

Elysian Park, L.A., Trees and Clearing, 1924
Watercolor and charcoal on paper
13³/₈ x 19³/₄ in (34.0 x 50.1 cm)
Signed and dated lower right: N. Brigante 1924. /
Dedicated to my Francisca
Inscribed lower right below signature: ELYSIAN P.K.
L.A.
Gift of Dr. Robert E. Barela
M.72.122.13

Elysian Park, L.A., Trees without Foliage, 1924
Watercolor and charcoal on paper
13³/₈ x 19³/₄ in (34.0 x 50.1 cm)
Signed and dated lower right: N. Brigante 1924 /
Dedicatedto my Francisca
Inscribed lower right below signature: ELYSIAN P.K.
L.A.
Gift of Dr. Robert E. Barela
M.72.122.14

Returning in 1924 from New York, Brigante settled in the Hollywood hills, at that time still a rural area. He often went to nearby Elysian Park to draw and paint.

Brigante's art after his New York visit exhibits a more sophisticated treatment of nature, a more facile use of the watercolor medium, and a less-radical approach to abstraction. He did not allow his knowledge of

Brigante, *Elysian Park, L.A., Trees without Foliage.*

modernism to distract him from conveying the spirit of a scene. In these three watercolors, completed shortly after his return, he described the essence of natural growth by using short brush strokes and arcing lines for twisted trunks and limbs. He painted the scene in bright, warm peaches, pinks, and roses and complementary purples and greens in thin, delicate washes shimmering with light. The pigments were applied somewhat dryly on a rough paper so that bits of it are exposed. In these respects Brigante followed the practices of Paul Cézanne (1839–1906), whom he admired. One of these watercolors may have been exhibited during the 1920s in New York at the New Gallery.

PROVENANCE
Dr. Robert E. Barela, Los Angeles.

Brigante, *Nature and Struggling Imperious Man.*

Nature and Struggling Imperious Man, 1935–37
(*Implacable Nature and Elemental Imperious Man*)
Watercolor on paper
Nine panels, each 38 x 27 in (96.5 x 68.9 cm)
Gift of the artist
M.87.98a–c
Color plate, page 75

In 1934 Brigante was injured in an industrial accident and prevented from working directly from nature for several years. During his convalescence he produced thousands of sketches of the figure and used them, along with earlier landscape studies, as the basis for two large works, the museum's *Nature and Struggling Imperious Man* and the smaller *Early Western Activities,* 1937 (private collection). In both Brigante used his favorite medium of watercolor for a purpose that differed from that of his earlier, small-scale works. No doubt inspired by mural painting, which experienced a

revival in the late 1920s and was further encouraged by the federal art projects of the 1930s, Brigante viewed his multi-paneled, large-scale watercolors as murals and consequently intended them to convey a more elaborate story or theme than was possible in a single image.

Nature and Struggling Imperious Man is the grandest and the most significant painting of Brigante's early decades. In its philosophic view of nature and calligraphic composition the mural foreshadows his multi-paneled, oriental-inspired ink landscapes of the 1970s. In 1942 Stanton Macdonald-Wright compared this nine-panel work with the long handscroll format of Chinese Song dynasty painting. Brigante's work shares with much of Song painting a "high distance" viewpoint and also interprets the mountain formations as twisting linear rocky outcroppings, which the Chinese refer to as "dragon veins." However, while Brigante's later works are devoid of man, here the human

figures are crucial. In his two murals from the 1930s Brigante returned to the figure for the first time in several years, and there are so many figures in this painting—more than two hundred—that they seem to swarm over the landscape. The subject of *Nature and Struggling Imperious Man* is primitive man's constant struggle to dominate or at least find some harmonious existence with implacable nature and his fellow man, so Brigante set the tiny figures in an almost overwhelming landscape of mountains, valleys, and desert.

Unlike typical murals of the period, this painting is not a simple narrative of consecutive scenes but instead consists of vignettes set in a single panoramic landscape, which obscures somewhat the episodic nature of the work. Read from left to right, the scene shows: a primitive village of tipis, the inhabitants of which are going about their daily search for food; a group of figures setting out from a village into the mountains, where they are ambushed by members of their own tribe; and a lone figure emerging from the savage fight to

entries not numbered, unpaginated, foreword by Arthur Millier, essay by Earl L. Stendahl, both discuss the work at length § Seattle Art Museum and others, organized by Western Association of Art Museum Directors, Seattle, *Nicholas Brigante, 1938–39*, no cat. traced § New York and San Francisco 1940, no. 35, panel one only § Los Angeles, Occidental College, Thorne Hall, *Nicholas Brigante, 1940*, no cat. traced § Santa Barbara (Calif.) Museum of Art, *Nicholas Brigante, 1942*, no cat. traced, as *Implacable Nature and Elemental Imperious Man* § Los Angeles, Loyola University-Marymount College, Malone Art Gallery, *Nick Brigante, 1973*, entries not numbered, as *Implacable Nature and Elemental Imperious Man.*

LITERATURE
Archiv. Am. Art, Nick Brigante Papers, Correspondence of the artist, November 13, 1937–December 19, 1942, (microfilm roll 1357, frs. 105–8, 112–13, 660, 662–63, 667–68, 679, 682, 684–85, 687–92, 694–95, 697, 699) § "Nick Brigante's Watercolor Epic," *Pacific Saturday Night* 45 (November 27, 1937): 13, repro., 12 § Seattle Art Museum files, newspaper clipping, Kenneth Callahan, "The Art Museum," *Seattle Times*, July 17, 1938, discusses in terms of

ride quietly through an idyllic valley and then come upon a fortress village under attack.

Brigante's employment of watercolor for a mural painting was likely unique, for such large-scale work is usually the domain of the less fragile mediums of oil and fresco. The artist desired to invest watercolor with a new importance and dignity. To this end he experimented with glazing and repeated tonal applications of the medium to achieve a greater luminosity and depth of color. His success was attested by critics of the day, who repeatedly praised his brilliant coloring. As one stated, the cycle is a tour-de-force of watercolor painting (Archiv. Am. Art, Nick Brigante Papers, microfilm roll 1357, fr. 111).

PROVENANCE
The artist, to 1987.

EXHIBITIONS
Los Angeles, Stendahl Galleries, and Fine Arts Gallery of San Diego, Calif., *Nicholas Brigante, 1937–38*,

Song landscape painting § Archiv. Am. Art, Nick Brigante Papers, newspaper clipping, Page Homer, "Many at Preview," *Tacoma News Tribune*, November 8, 1938 (microfilm roll 1357, fr. 686); newspaper clipping, "Occidental Participates in National Art Week," *Occidental* [college newspaper], November 20, 1940 (ibid., fr. 698); newspaper clipping, Donald Bear, "Watercolors Depict Development of Man," *Santa Barbara News Press*, November 15, 1942 (ibid., fr. 111), discusses, as *Implacable Nature and Elemental Imperious Man* § Stanton Macdonald-Wright, "Art Stuff," *Rob Wagner's Script* 27 (November 21, 1942): 14, praises Brigante's inventiveness and classical order, compares work to a *makimono*, inspiration from Song masters § John Alan Walker, "The Summer Landscapes of Nick Brigante," *Southwest Art Gallery Magazine* 2 (Summer 1972): 43, dates and relates to other large series § *Nicholas Brigante*, unpaginated, reprints 1937 Stendahl Galleries brochure and quotes Stanton Macdonald-Wright's 1942 review, repro. § Gordon T. McClelland and Jay T. Last, *The California Style: California Watercolor Artists, 1925–1955* (Beverly Hills: Hillcrest Press, 1985), p. 38.

Lorser Feitelson

Born February 11, 1898,
Savannah, Georgia
Died May 24, 1978, Los
Angeles, California

See biography in oil paintings section.

Max Weber

Born April 18, 1881,
Bialystok, Russia
To United States 1891
Died October 4, 1961,
Great Neck, New York

See biography in oil paintings section.

Frederic Schiller Cozzens

Born October 11, 1846,
Livingston, Staten Island
(now New York), New York
Died August 29, 1928,
New York, New York

Untitled Marine, 1924
Watercolor and graphite on cream paper
8¼ x 12¼ in (20.9 x 31.1 cm)
Signed and dated lower left: Fred. S. Cozzens. / .24
Gift of Mrs. Annie Michael
M.81.149

Ernest Fiene

Born November 2, 1894,
Elberfeld, Germany
To United States 1912
Died August 10, 1965,
Paris, France

Brick Factories, 1924
Watercolor and graphite on paper
Signed and dated lower right: Ernest Fiene 1924
17¾ x 21⅝ in (45.2 x 55.6 cm)
Mr. and Mrs. William Preston Harrison Collection
37.18.17

George Luks

Born August 13, 1866,
Williamsport, Pennsylvania
Died October 29, 1933,
New York, New York

See biography in oil paintings section.

Girl in Checkered Dress, by 1925
Watercolor and graphite on paper
10 x 7³⁄₁₆ in (25.2 x 18.1 cm)
Signed lower left: George Luks
Mr. and Mrs. William Preston Harrison Collection
34.12.7

Jack Dempsey in Training, by 1925
Wash on brown paper
13 x 14³/₁₆ in (33.1 x 36.0 cm)
Signed lower right: George Luks—
Inscribed below image: "The secret layer beyond the moat" / Flynn: "Now listen Jack & Co."
Mr. and Mrs. William Preston Harrison Collection
34.12.6

George C. Ault

Born October 11, 1891,
Cleveland, Ohio
Died December 30, 1948,
Woodstock, New York

Jefferson Gate, New York, 1927
Watercolor on paper
19¹¹/₁₆ x 13¹³/₁₆ in (50.0 x 35.1 cm)
Signed and dated lower left: G. C. Ault, 27.
Inscribed verso: Title: Jefferson Gate / BY: Geo. C. Ault. / Price: $40.00
Mr. and Mrs. William Preston Harrison Collection
37.18.1

William Zorach

Born February 28, 1889,
Eurburg, Lithuania
To United States 1892
Died November 15, 1966,
Bath, Maine

Rainy Day, 1927
Watercolor and charcoal on paper
15⁷/₁₆ x 22³/₈ in (39.3 x 56.7 cm)
Signed and dated lower right: Zorach 1927
Inscribed lower left: Rainy Day Robinhood—Maine
Mr. and Mrs. William Preston Harrison Collection
36.20.7

Reginald Marsh

Born March 14, 1898, Paris,
France, to American parents
Died July 3, 1954, Dorset,
Vermont

See biography in oil paintings section.

Locomotive, n.d.

Watercolor with traces of graphite on paper
13³/₈ x 19³/₄ in (34.1 x 50.0 cm)
Stamped lower right: F. MARSH COLLECTION
Inscribed over stamp lower right: WC NO 242
Felicia Meyer Marsh Bequest
M.79.143.3

Seascape, 1927

Watercolor with traces of graphite on paper
13 x 20 in (35.5 x 50.8 cm)
Signed and dated lower right: Reginald Marsh 1927
Stamped lower right: F. MARSH COLLECTION
Inscribed beneath stamp lower right: CAT # WC 27-2
Felicia Meyer Marsh Bequest
M.79.143.4

On the Ferry, 1945

Watercolor, ink, and graphite on paper
22¹/₁₆ x 30⁵/₁₆ in (56.0 x 76.9 cm)
Signed and dated lower right: Reginald / Marsh
1945
Inscribed verso upper left: Lower Deck
Felicia Meyer Marsh Bequest
M.79.143.1

Eugene Savage

Born March 29, 1883,
Covington, Indiana
Died October 19, 1978,
Waterbury, Connecticut

See biography in oil paintings section.

Five Studies for Mural, Elks National
Memorial, Chicago, 1927
Watercolor and graphite on dark beige paper

*"Blessed Are Those Who Mourn, for They
Shall be Comforted" (Matthew 5:4)*
44⅞ x 23 in (113.9 x 58.4 cm), sight
Signed lower right: EVGENE FR SAVAGE
Given anonymously
M.78.6.2

*"Blessed Are the Meek, for They Shall
Inherit the Earth" (Matthew 5:5)*
45³/₁₆ x 23 in (114.8 x 58.4 cm), sight
Signed lower right: EVGENE FR·SAVAGE
Given anonymously
M.78.6.1

"Blessed Are the Pure in Heart, for They Shall See God" (Matthew 5:8)
45¹/₁₆ x 22⁷/₈ in (114.5 x 58.1 cm), sight
Gift of Mrs. Kathryn Leighton
46.6.2

Symbol Bearers: Charity
44⁷/₈ x 23 in (113.9 x 58.4 cm), sight
Signed lower right: EVGENE FR·SAVAGE·
Given anonymously
M.78.6.4

Symbol Bearers: Justice
45 x 23 in (114.3 x 58.4 cm), sight
Given anonymously
M.78.6.3

Abraham Walkowitz

Born March 28, 1878,
Tyumen, Russia
To United States 1893
Died January 26, 1965,
New York, New York

Man and Woman, c. 1927
Watercolor, charcoal, and graphite on paper
22 x 15¹⁄₁₆ in (56.0 x 38.2 cm)
Signed lower center: A. WALKOWITZ
Mr. and Mrs. William Preston Harrison Collection
36.20.6

William S. Horton

Born November 16, 1865,
Grand Rapids, Michigan
Died October 1936,
London, England

Village Landscape, 1928
Watercolor on paper
19¹⁄₈ x 23⁵⁄₈ in (45.6 x 60.0 cm)
Signed and dated lower right: W. S. HORTON /
10/24/28
Gift of Dr. and Mrs. Ronald M. Lawrence
M.86.308.3

Leon Kroll

Born December 6, 1884,
New York, New York
Died October 25, 1974
Gloucester, Massachusetts

See biography in oil paintings section.

Nude in Red Chair, by 1929
Oil, charcoal, and clear glaze on cream paper
12 x 19⁵⁄₁₆ in (30.6 x 49.1 cm)
Signed lower right: Leon Kroll
Mr. and Mrs. William Preston Harrison Collection
34.12.4

John Marin

Born December 23, 1870,
Rutherford, New Jersey
Died October 1, 1953,
Cape Split, Maine

John Marin was one of America's foremost early modernists, renowned for his images of Maine, the Atlantic coast, and New York. He grew up in New Jersey, attended Stevens Institute in Hoboken, and worked briefly as an architect. From 1899 to 1901 Marin studied in Philadelphia at the Pennsylvania Academy of the Fine Arts with Thomas P. Anshutz (1851–1912) and HUGH H. BRECKENRIDGE. For five years, until 1910, he traveled and studied throughout Europe, producing etchings of city views. On his return to the United States he began a long association with Alfred Stieglitz (1864–1946). Many solo exhibitions of Marin's work were held in New York at Stieglitz's galleries, and in 1920 Marin was given a retrospective at Daniel Gallery, which resulted in his gaining his first important patron, Ferdinand Howald. In 1922 he was given another large exhibition, at Montross Gallery, which brought him major critical recognition. Marin was also honored with a large retrospective in 1936 at the Museum of Modern Art, a rare honor at that time for an American artist.

Marin led a somewhat peripatetic life, traveling throughout New Jersey, upstate New York, New England, and New Mexico. The drama of nature and dynamism of the city were his chief concerns throughout his career. He first became known as a master watercolorist, and although he had painted in oils in the early 1900s, it was not until the 1930s that he began to work primarily in that medium. Marin used colored planes and lines of directional force, fracturing objects to record the energy of the scene. By the mid-1920s his compositions began to push and pull apart, the painted borders shattering under the tension of the lines of force. In the 1930s Marin added the figure to his scenes, and during the last two decades of his life his work became increasingly expressionistic.

BIBLIOGRAPHY
Herbert J. Seligmann, ed., *Letters of John Marin* (New York: Privately printed for An American Place, 1931) § Mackinley Helm, *John Marin* (Boston: Pellegrini & Cudahy with Institute of Contemporary Art, [1948]), with foreword by John Marin § Dorothy Norman, ed., *The Selected Writings of John Marin* (New York: Pellegrini & Cudahy, 1949) § Sheldon Reich, *John Marin, A Stylistic Analysis and Catalogue Raisonné*, 2 vols. (Tucson: University of Arizona Press, [1970]), with chronology, bibliography, list of exhibitions § Cleve Gray, ed., *John Marin by John Marin* (New York: Holt, Rinehart, & Winston, 1977).

New Mexico, near Taos, 1929
Watercolor with gouache and charcoal
underdrawing on paper
14¹/₁₆ x 21¹/₁₆ in (35.7 x 53.5 cm)
Signed and dated lower right: Marin 29
Mira Hershey Memorial Collection
47.9.2

Marin spent the summers of 1929 and 1930 in New Mexico after Georgia O'Keeffe (1887–1986) and Rebecca Strand, wife of photographer Paul Strand, urged Mabel Dodge Luhan to extend an invitation to him. Marin was eager to leave the city and visit the Southwest, having become tired of "living in herds." He immediately responded to the expansive, wide-open land. While maintaining an allegiance to nature, Marin distilled the elements of the desert and mountains, coming close to abstraction.

According to art historian Van Deren Coke the setting for this watercolor is the area north of the Arroyo Seco, looking northeast toward the entrance of Hondo Canyon. Marin exaggerated the angularity and sharpness of the mountain slopes and peaks and flattened, simplified, and tilted up the foreground plain.

With horizontal stripes of gray, black, brilliant yellow, and bright green he succinctly summarized the flat, open spaces of the plateau. In few New Mexican watercolors of 1929 was Marin so extreme in his synthesis of visual elements, for he usually delineated the sagebrush more literally with swirling brushwork. Marin contrasts the angularity and grayness of the stormy sky and mountains with the plains, creating a visual tension analogous to the sensation felt as a storm approaches.

New Mexico, near Taos was one of the first of Marin's New Mexico watercolors to be acquired by a public institution when it was bought by the Los Angeles Museum in 1947.

PROVENANCE
Probably with An American Place, New York, 1930 § With Downtown Gallery, New York, by 1934 to 1947.

EXHIBITIONS
New York, An American Place, *John Marin: Recent Watercolors—New Mexico and New York*, 1930, one of nos. 1–32 of New Mexico paintings § Claremont, Calif., Pomona College Galleries, *Stieglitz Circle*, 1958, no. 38, repro., unpaginated §

Marin, *New Mexico, near Taos.*

La Jolla (Calif.) Museum of Art, *Marsden Hartley, John Marin,* 1964, no. 19 § LACMA and others, *Eight American Masters of Watercolor,* 1968, no. 54 § Albuquerque, University of New Mexico Art Museum, and others, *Marin in New Mexico, 1929 and 1930,* 1968–69, no. 17, p. 29, text by Van Deren Coke identifies the site, repro., p. 19 § Houston, Tex., Museum of Fine Arts, *Days on the Range: Artists in the American West,* 1972, no. 15, fig. 29, p. 67.

LITERATURE
Archiv. Am. Art, Downtown Gallery Papers, Correspondence, "List of Paintings on Consignment to Mrs. Halpert from Stieglitz," October 25, 1934,

typed (microfilm roll 1342, fr. 64), a *New Mexico, near Taos,* 1929, which may be the museum's watercolor, is listed as no. 3 of watercolors; Photograph Album of Marin Paintings, "Photographs: Watercolors Sold, 1917–1952" (roll 1839, fr. 1136), listed but photograph missing § *Los Angeles Times,* March 2, 1947, pt. 3, p. 4, repro. § Arthur Millier, "Enriched by Hearst," *Art Digest* 21 (March 15, 1947): 20, incorrectly implies that painting was purchased with Hearst funds § Henry J. Seldis, "The Stieglitz Circle Show at Pomona College," *Art in America* 46 (Winter 1958–59): repro., 62 § Reich, *Marin,* 2: 610, listed in cat. raisonné as no. 2940, repro. § Gerald F. Brommer, *Landscapes* (Worcester, Mass.: Davis, 1977), repro., p. 25.

Movement—Cape Split, Maine, 1936
(Sailboat)
Watercolor with charcoal underdrawing on off-white paper
15 ³/₈ x 20⁵/₁₆ in (39.0 x 51.6 cm)
Signed and dated lower right: Marin 36
Gift of Robert H. Ginter
M.81.160

In 1933 Marin discovered Cape Split and the next year purchased property and a house overlooking Pleasant Bay, where he would summer for the rest of his life. The artist loved Maine, and its hills and shoreline became one of the main themes of his work. Cape Split, between Mount Desert and Eastport, was at that time not well known. Its isolation and rugged terrain may have been what initially attracted the

Marin, *Movement—Cape Split, Maine.*

artist to the site. Marin frequently painted the craggy shoreline of the Cape Split area during the mid-1930s, often, as in this scene, including a view of the bay and a sailboat.

During the 1930s Marin's palette changed from the bright primary hues he used during the 1920s to somber tones. The almost monochromatic black and blue-gray palette in this watercolor brings to mind the cold and dampness of a storm at sea. Marin's brushwork conveys the power of nature. While the thick line around the boat describes the force and movement of a wave, the equally thick, but crisper, black line of the shore establishes the barrier between land and sea. Marin utilized different techniques for different effects: the water was painted very wet, but the shoreline was described with a greater variety of dry brush strokes.

PROVENANCE
With An American Place, New York § With Downtown Gallery, New York, c. 1947–as of 1958 § Anne Porter, as of 1976 to 1977 § With ACA Galleries, New York § Robert H. Ginter, Los Angeles, to 1981.

LITERATURE
Archiv. Am. Art, Downtown Gallery Papers, Photograph Album of Marin Paintings, "Photographs: Unsold Watercolors as of 1958" (microfilm roll ND33, fr. 391; roll 1840, fr. 295), photograph of the museum's painting, as untitled § Reich, *Marin*, 2: 681, no. 36.30 in cat. raisonné, *Sailboat*, with location unknown, corresponds to the museum's painting.

Arthur H. T. Millier

Born October 19, 1893,
Weston-super-Mare,
Somersetshire, England
To United States c. 1908
Died March 30, 1975,
Hackensack, New Jersey

Street Scene, c. 1920s
Watercolor and graphite on paper
8³/₈ x 9¹¹/₁₆ in (21.3 x 24.5 cm)
Signed lower right: Arthur H. Millier
Paul Rodman Mabury Collection
39.12.69

Phil Dike

Born April 6, 1906,
Redlands, California
Died February 4, 1990,
Claremont, California

Long a prominent watercolorist, Philip Latimer Dike was instrumental in establishing the California watercolor style. He was also one of the first West Coast artists to achieve national recognition. After attending Chouinard Art Institute, Los Angeles, 1924–27, where he was influenced by Clarence Hinkle (1880–1960), Dike went to New York to study at the Art Students League with Frank Vincent DuMond (1865–1951) and George Bridgman (1864–1943). He took private lessons with GEORGE LUKS. Dike also studied fresco painting at the American Academy in Fontainebleau and lithography in Paris and visited Spain, Italy, and North Africa. Back in the United States in 1931, he became known for his depictions of the sea and coast. Late in life his work became increasingly abstract.

Beginning in 1935 Dike worked for Walt Disney Productions for ten years, contributing art to *Snow White and the Seven Dwarfs* (1937) and *Fantasia* (1940). He also served as president of the California Water Color Society, 1938–39. He became one of the most influential teachers in Southern California, first at Chouinard, then in 1946 establishing his own summer school with REX BRANDT at Corona del Mar. In 1950 Dike began his long association with the Claremont Colleges, which in 1971 honored him with the title of professor emeritus.

BIBLIOGRAPHY
Who's Who in American Art, 1936–37, 1986, s.v. "Dike, Philip Latimer" § "Phil Dike: He Captures the Scale of the West," *American Artist* 4 (November 1940): 19–23 § Moure 1975, pp. 12–13, with bibliography § Janice Lovoos, "Phil Dike: The Poetry of Painting," *American Artist* 43 (December 1979): 34–37, 88–89 § Janice Lovoos and Gordon T. McClelland, *Phil Dike* (Beverly Hills: Hillcrest Press, 1988), with chronology.

Dike, *Sicilian Houses.*

Sicilian Houses, 1930
Watercolor on paper
13 x 16¹⁄₁₆ in (33.1 x 40.8 cm)
Signed lower left: Phil Dike
Inscription on mat: Taormina Sicily 1930
California Water Color Society Collection of Water Color Paintings
55.34.7

Dike painted *Sicilian Houses* while in Taormina on a sketching trip through Sicily. The island is known for its bright sunshine, yet Dike chose to paint the scene in a dark, somewhat harsh palette of greens, browns, and blue-grays as if to underscore the severity of the people's lives.

The watercolor exhibits the bold execution that would become a hallmark of the California watercolor school. Indeed it is even more rugged and experimental than Dike's later watercolors. In *Sicilian Houses* he vigorously applied the pigment, leaving small bits of white paper exposed. The overall impression is of almost chaotic agitation despite the generally calm mood of the subject. Dike gave texture to the tree limbs and hillside on the left by lightly rubbing a dry brush over the paper; such textural effects would later disappear from his work.

PROVENANCE
California Water Color Society, 1930–55.

ON DEPOSIT
LACMHSA, 1946–47 § Los Angeles County Sheriff's Office, Hall of Justice, 1967–72 § Los Angeles mayor's residence, 1977–78.

EXHIBITIONS
LACMHSA, *California Water Color Society Eleventh Annual Exhibition,* 1931, no. 25, awarded purchase prize § Oakland Art Gallery, *Annual Exhibition of the Works of Western Artists,* 1933, no. 54 § Claremont, Calif., Scripps College, Contemporary Galleries, *An Exhibition of Drawings, Lithographs,*

Paintings by Phil Dike, 1950–51, no. 1 § LA 1951 § Pasadena 1957 § Long Beach 1959–62 § LACMA 1973, no. 8 § Fullerton 1976 § Sylmar 1978.

LITERATURE
Arthur Millier, "Water Colors Exhibited," *Los Angeles Times,* October 18, 1931, pt. 3, p. 18 § "California Water Color Society," *Christian Science Monitor,* October 24, 1931, p. 6 § Henri De Kruif, "California Water Color Society Shows Great Progress," *California Art Club Bulletin* 6 (November 1931): unpaginated § "California Water Color Jury Is 'Hard Boiled,' " *Art Digest* 6 (November 1, 1931): 16, repro. § Moure 1975, pp. 2, 6, 40, lists, repro., p. 83.

Dike, *Victorian Tapestry.*

Victorian Tapestry, 1946
Watercolor and ink on paper
22¼ x 30 in (56.5 x 76.2 cm)
Signed and dated lower right: Phil Dike '46
California Water Color Society Collection of
Water Color Paintings
55.34.8

The Riverside-Redlands area of Southern California is noted for its turn-of-the-century houses. Dike was fascinated by this particular Victorian structure and painted it at least twice, in 1946 in watercolor and later in oil. Perhaps an interest in architecture was innate, since the artist's father had been a well-known real-estate developer in Redlands and owned a similar late-nineteenth-century Victorian house.

Most of Dike's images, whether representational or abstract, display a sensitivity to structure and design. This old, picturesque house with its various shingles, gables, turret, and gingerbread decoration provides an array of patterns that dominates the composition. Although basically dark and somber, the image is not ominous. Rather, the architectural details and arabesques of the foliage convey a sense of life and energy.

PROVENANCE
California Water Color Society, 1946–55.

ON DEPOSIT
LACMNH, 1975–present.

EXHIBITIONS
Pasadena (Calif.) Art Institute, *California Water Color Society Twenty-sixth Annual Exhibit,* 1946, no. 1, awarded Dalzell Hatfield Galleries Purchase Prize § Long Beach 1959–62 § Pomona 1964 § San Diego State College, *American Water Color Exhibition,* 1964, no cat. traced.

LITERATURE
Arthur Millier, "West Coast Artists Present Strong Front," *Art Digest* 21 (November 1, 1946): 15 § Moure 1975, pp. 6, 40, lists, repro., p. 82 § LACMA, American Art department files, the artist to Ilene Susan Fort, January 9, 1986, discusses painting.

Thomas Hart Benton

Born April 15, 1889,
Neosho, Missouri
Died January 19, 1975,
Kansas City, Missouri

See biography in oil paintings section.

Cotton Pickers, 1931
(*Cotton Pickers No. 3*)
Watercolor, ink, and graphite on cream paper
21¹/₁₆ x 26³/₁₆ in (53.6 x 66.4 cm)
Signed and dated lower left: Benton / '31
Gift of Anatole Litvak
53.55.2

Thomas Hart Benton first visited the South in the summer of 1928 while on a sketching trip and chose to record the life of rural blacks because he considered the subject quintessentially American yet often overlooked. He sought to document a way of life that would soon succumb to mechanization, and in numerous drawings and watercolors he showed the manual laborers in the cotton

industry. Although the picking of cotton may have been one of Benton's favorite subjects, he depicted other activities as well: cotton being weighed, loaded into bins, and transported onto boats.

Cotton Pickers was probably made in the fields. Many of Benton's Southern plein-air sketches are on the same cream paper used here. According to art historian Karal Marling, Benton would first lightly sketch a

PROVENANCE
Possibly with Associated American Artists, New York, as of 1940 § Possibly with Frank Perls Gallery, Los Angeles § Anatole Litvak, Los Angeles, to 1953.

EXHIBITIONS
Art Institute of Chicago, *Fourteenth International Exhibition [of] Water Colors, Pastels, Drawings, and Monotypes,* 1935, no. 241, repro., unpaginated § New York, Walker Galleries, *Group Show of Watercolors*

Benton, *Cotton Pickers.*

scene, draw over the main lines with India ink, and then add a tone of watercolor to preserve the sketch. With a wiry ink line Benton captured the shapes, outlines, and details and then modeled the forms with a very thin, delicately tinted wash.

In the 1930s Associated American Artists reproduced this watercolor as a gelatone print entitled *Cotton Pickers: Georgia.* The edition of this inexpensive, popular print numbered in the thousands.

RELATED WORKS
Georgia Cotton Pickers, c. 1931, oil on panel, 11½ x 15 in (29.2 x 38.1 cm). Museum of Modern Art, New York § *Cotton Pickers: Georgia,* 1930s, gelatone print, 20 x 16 in (50.8 x 40.6 cm).

by Benton, Grosz, and Others, 1936, no cat. traced § Chicago, R. R. Donnelly & Sons Co., *A Loan Exhibition of Drawings and Paintings by Thomas Hart Benton, with an Evaluation of His Work,* 1937, no. 70, as *Cotton Pickers No. 3* § Pomona 1964 § Santa Cruz, University of California, Mary Porter Sesnon Gallery, *American Art of the Twenties and Thirties,* 1973, exhibited but not listed.

LITERATURE
" 'Cotton Pickers—Georgia,' by Thomas Hart Benton," advertising flyer, undated, concerning watercolor and gelatone print § "International Art News: New York," *Studio* 112 (December 1936): repro., 348 § "Three Paintings by Contemporary American Masters," *Coronet* 8 (September 1940): repro., 19 § LACMA, Registrar's files, J. B. Byrnes to Anatole Litvak, October 6, 1953, discusses gelatone reproduction § "Recent Acquisitions," *LA Museum Art Div. Bull.* 6 (Spring 1954): repro., 30.

Rene H. Lopez

Active 1930–1940

Little is known about Rene H. Lopez. He is believed to have been born in Mexico. By the early 1930s he was enrolled in the Los Angeles County Art Institute (Otis Art Institute), where he studied life drawing, portrait painting, and decorative design until the spring of 1932. From 1938 to 1940 he exhibited in Los Angeles and New York and participated in the California Water Color Society annuals. The titles of his exhibited work suggest that he also may have painted in San Francisco. In 1940 a solo exhibition of his views of New York was held at the Vendome Galleries in that city. His whereabouts after that show, which received favorable notices, remain unknown.

BIBLIOGRAPHY
Moure 1975, pp. 19, 55, with bibliography.

Lopez, *Sunday at the Plaza.*

Sunday at the Plaza, 1934
Watercolor and graphite on paper
18¹/₁₆ x 24 in (45.8 x 60.8 cm)
Signed and dated lower right: Rene H Lopez 34.
California Water Color Society Collection of
Water Color Paintings
55.34.22

Lopez often painted city views with masses of figures. In this delicately tinted watercolor hundreds of people are gathered in a city plaza, perhaps for a religious festival. The large expanse of open land and distant oil tanks suggest that the event is taking place in a large industrial center, perhaps Los Angeles. Completed only a few years after Lopez was a student, the watercolor is quite sophisticated, displaying an assured control of the fluid medium and a mastery of abstract shapes. The cool hues dominating the scene suggest a cold, wintry day. Lopez employed a similar blue tonality for his New York cityscapes.

PROVENANCE
California Water Color Society, 1934–55.

ON DEPOSIT
LACMHSA, 1936–47.

EXHIBITIONS
LACMHSA and others, *California Water Color Society Fourteenth Annual Exhibition*, 1934, no. 43, awarded purchase prize § LA 1951 § Long Beach 1959–62 § LACMA 1973, no. 17 § Sylmar 1978.

LITERATURE
Arthur Millier, "Southland Watercolorists Challenge East's Big Shots," *Los Angeles Times*, October 21, 1934, pt. 2, p. 6 § LACMNH, Archives, Museum Scrapbook, unidentified newspaper clipping, "Water Color Exhibit at Museum Wins Plaudits," October 27, 1934 § Moure 1975, pp. 3, 6, 55, lists, repro., p. 83.

Barse Miller

Born January 24, 1904,
New York, New York
Died January 21, 1973,
near Mazatlán, Mexico

Barse Miller was one of Southern California's most important artists, contributing significantly to the development of the California watercolor school. At age eleven he began his studies at the National Academy of Design in New York, and during summers in the late 1910s he attended classes under Henry B. Snell (1858–1943) and HUGH H. BRECKENRIDGE in East Gloucester, Massachusetts. From Breckenridge he learned color theory and later, while attending the Pennsylvania Academy of the Fine Arts in Philadelphia, he studied with Breckenridge's friend Arthur B. Carles (1882–1952). The Pennsylvania Academy twice awarded him traveling scholarships to Paris, where he was much impressed by the work of the French impressionists, in particular Edgar Degas (1834–1917), and of Henri Matisse (1860–1954). In 1923 Miller exhibited at the Salon d'Automne.

On his return to the United States he settled in California. Before World War II he taught at various schools, including the Art Center of Los Angeles; the Harwood Foundation in Taos, New Mexico, summers 1938–40; the University of Vermont at Burlington, summers 1939–40; and the Chester Springs School of the Pennsylvania Academy, summers 1940–41. He also executed murals, including ones for Sommer and Kaufmann's Modern Store in San Francisco and for post offices in Island Point, Vermont, and Burbank, California. His first solo exhibition in the West was organized by the Los Angeles Museum in 1928, and his first in the East by the Ferargil Galleries in New York in 1936.

During the war *Life* magazine hired Miller to document the training of the armed forces, and his illustrations first appeared in the May 12, 1942, issue. During the war he served as chief of the Combat Art Section in the Pacific. His paintings and drawings of combat, later exhibited and reproduced, earned him the Legion of Merit. After the war he settled in New York, and in 1946 won a Guggenheim Fellowship. He taught at the Art Students League from 1947 to his death and at Queens College, serving as chairman of the art department, 1947–53. He continued to exhibit at Cowie Gallery in Los Angeles until 1967.

Since he was the son of a writer on outdoors subjects and of an artist, it is perhaps not surprising that Miller's art was devoted to landscape painting. He also depicted figures in the American scene tradition, humorously at first. His views of the California country-side, coast, and cities set an example for generations of students before World War II. After his move east his images of Long Island took on a romantic mood. He worked in both oil and watercolor until 1948 and thereafter turned exclusively to watercolor.

BIBLIOGRAPHY
Archiv. Am. Art, Ferargil Galleries Papers, Barse Miller Scrapbook § Ernest W. Watson, "Barse Miller, Painter at the Crossroads: Interview," *American Artist* 10 (June 1946): 20–25 § Los Angeles, Cowie Wilshire Galleries, *Barse Miller, N.A.*, exh. cat., 1961, with essays by Rex Brandt and Alexander S. Cowie, biographical note, list of awards and collections § Moure 1975, pp. 20–22, 58, with bibliography § Moure with Smith 1975, pp. 168–69, with bibliography.

Miller, *Stockton Street.*

Stockton Street, by 1935
Watercolor on paper
21⅞ x 29⅜ in (55.5 x 74.6 cm)
Signed lower right: Barse Miller
California Water Color Society Collection of
Water Color Paintings
55.34.9

Stockton Street is a classic example of the early California watercolor style. It is also characteristic of the regionalist subject matter that interested Miller in the 1930s. During the mid-1930s Miller often included images of old buildings and automobiles in his work.

Painted on a large sheet, this watercolor depicts an ordinary street in a small California town on a sunny day. Despite the delicacy of the transparent, thin wash, Miller was able to record the dramatic contrast of cast shadows and brilliant daylight as sunlight filtered through the trees. His short, almost calligraphic strokes aptly convey the flickering light. Equally bold and modern was Miller's color, complementary hues of intense orange-ochers and browns for the lighted objects and deep purples and bluish purples for the shadows. Of this painting Miller later noted, "It is very linear, joyous in the use of the medium but less concerned with the abstract qualities of design and color than my work following World War II."

PROVENANCE
California Water Color Society, 1935–55.

ON DEPOSIT
LACMHSA, 1935–47 § Los Angeles County Data Processing Department, 1970–72.

EXHIBITIONS
LACMHSA, *California Water Color Society Fifteenth Annual Exhibition,* 1935, no. 42, awarded purchase prize § New York and San Francisco 1940, no. 134 § LA 1951 § Pasadena 1957 § Long Beach 1959–62 § LACMA 1973, no. 22 § Fullerton 1976, repro., p. 23 § Sylmar 1978 § LACMA 1980, no. 24, pp. 61–62, repro., p. 60 § Santa Barbara (Calif.) Museum of Art, *Regionalism, The California View: Watercolors, 1929–1945,* 1988, entries not numbered.

LITERATURE
Alma May Cook, "Water Colors on Display at L.A. Museum," *Los Angeles Evening Herald and Express,* October 9, 1935, pt. 2, p. 9 § "Art and Artists: Water Color Group Holds High Level, Exhibit Proves," *Los Angeles Times,* October 13, 1935, pt. 2, p. 9 § "Jury Picks 'Conservative Best in Modernism,'" *Art Digest* 10 (November 1, 1935): repro., 9 § LACMA, Registrar's files, the artist to Nancy Dustin Wall Moure, October 1972, describes painting § Moure 1975, pp. 2, 7, 58, lists, repro., p. 81.

East River Drive, 1941
Watercolor on paper
15 9/16 x 21 11/16 in (39.9 x 55.1 cm)
Signed lower center: Barse Miller—
Inscribed and dated lower right: East River Drive / New York City 1941
Gift of Helen Gahagen Douglas
42.3.4

Tom E. Lewis

Born February 22, 1909,
Los Angeles, California
Died August 2, 1979,
San Francisco, California

Thomas E. Lewis studied architecture at the University of Southern California. He began painting during the late 1920s, winning an award in 1928 at the first exhibition in which he participated. From 1920 to 1935 he maintained a studio in Laguna Beach, California, and was active as an exhibitor and arts organizer, helping form the Progressive Painters of Southern California. Although in 1935 he moved permanently to San Francisco, Lewis continued to exhibit frequently in Southern California. In 1937 he lived in Hawaii, and in 1941, after receiving the James D. Phelan Award given to young native-Californian artists, he traveled throughout New England. Before World War II he painted murals under the auspices of the Treasury Section of Painting and Sculpture and the Works Progress Administration. Lewis's first solo museum exhibition was organized by the San Diego

Fine Arts Gallery in 1935; his first major exhibition in Northern California was held in 1940 at the San Francisco Museum of Art.

Lewis was especially fond of landscapes, cityscapes, and floral still lifes. Although his reputation was established as a watercolorist, during the early 1940s he increasingly painted in oil. A trip to Mexico in 1947 inspired him to paint fauvist landscapes. Lewis later turned to mysterious, almost magic-realist paintings of architecture.

BIBLIOGRAPHY
Tom E. Lewis (San Francisco: Privately printed, [1940]), with comments by Ted Cook and Grace McCann Morley, list of collections § Moure 1975, pp. 18–19, 55, with bibliography § Nancy Dustin Wall Moure and Phyllis Moure, *Artists' Clubs and Exhibitions in Los Angeles Before 1930,* Publications in Southern California Art, no. 3 (Los Angeles, Privately printed, 1975), s.v. "Lewis, Tom E."

Lewis, *To San Francisco.*

To San Francisco, by 1936
(*Morning Route; San Francisco Landscape*)
Watercolor and graphite on off-white paper
21⅞ x 29¹⁵/₁₆ in (55.5 x 76.0 cm)
Signed lower center: Tom E Lewis
California Water Color Society Collection of
Water Color Paintings
55.34.14

During the 1930s Lewis painted several Victorian houses in California settings. His fascination with picturesque buildings stemmed no doubt from his early aspirations to be an architect. The crowded San Francisco streets with rows of houses with steep front steps were particularly appealing and might have been one reason for his move to that city, where he lived on Telegraph Hill. In this watercolor Lewis utilized an open view, painting from high atop a hill, looking down toward the bay and Alcatraz Island. From this position

he was able to dwell on more than just the houses, handsomely capturing the character of the Bay Area. The entire composition is presented in cool colors with large amounts of white paper exposed or luminously appearing through thin washes. Lewis painted the scene very wet, applying one pigment over a wet wash, so that the overall effect becomes extremely soft, suggesting the hazy light and overcast skies of San Francisco.

PROVENANCE
California Water Color Society, 1936–55.

ON DEPOSIT
LACMHSA, 1936–55 § Los Angeles County Counsel, 1977–78.

EXHIBITIONS
LACMHSA, *California Water Color Society Sixteenth Annual Exhibition,* 1936, no. 38, awarded

purchase prize § New York and San Francisco 1940, no. 119 § LA 1951 § Long Beach 1959–62 § LACMA 1973, no. 16, as *San Francisco Landscape* § Fullerton 1976, as *San Francisco Landscape* § Sylmar 1978, as *San Francisco Landscape.*

LITERATURE
Arthur Millier, "Water Colors, Glass, Prints on View," *Los Angeles Times,* October 4, 1936, pt. 3, p. 4 § LACMNH, Archives, Museum Scrapbook, newspaper clipping, Alma May Cook, "Interesting Studies Exhibited," *Los Angeles Evening Herald and Express,* October 6, 1936, repro. § Herman Reuter, "Small Picture Singled Out for Praise," *Hollywood Citizen-News,* October 10, 1936, p. 12 § *Tom E. Lewis,* repro., unpaginated, as *Morning Route* § Grace McCann Morley, "Tom Lewis," *California Arts and Architecture* 57 (February 1940): repro., 3, as *Morning Route* § "Tom E. Lewis," *Coast* 3 (November 1940): repro., 34, as *Morning Route* § Moure 1975, pp. 2, 6, 55, lists, repro., p. 82, as *San Francisco Landscape.*

Lewis, *Three Fish in a Pan.*

Three Fish in a Pan, 1940
(Fish in Pan; Three Fish in a Dish)
Watercolor on paper
22³⁄₈ x 30½ in (56.8 x 77.6 cm)
Signed and dated lower right: Tom E Lewis / '40
California Water Color Society Collection of Water Color Paintings
55.34.13

In this painting Lewis took full advantage of the effects that could be achieved by the wet-into-wet watercolor technique. No element is

sharply defined, not even the heavy dark lines of the plate or the outline of the tabletop; instead, lines bleed into washes. The painting cannot be clearly read and must be appreciated as a composition of abstract lines and colors.

In the late nineteenth century WILLIAM M. CHASE glorified the glistening, pearly scales of fish in numerous still-life paintings. In this watercolor Lewis likewise extols the moist, opalescent surface of the fish by introducing different colors into small areas so that the fish seem to sparkle iridescently.

PROVENANCE
The artist, 1940–42 § California Water Color Society, 1942–55.

ON DEPOSIT
LACMHSA, 1942–47 § Los Angeles mayor's residence, 1977–78.

EXHIBITIONS
New York and San Francisco 1940, no. 120 § Oakland Art Gallery, *Eighth Annual Exhibition: Water Colors, Pastels, Drawings, and Prints,* 1940, no. 103, as *Three Fish in a Dish* § Arts Club of Chicago, *American Prize Winners,* 1942, no. 19 § LACMHSA, *California Water Color Society Twenty-first Annual Exhibition,* 1942, no. 71, as *Fish in Pan,* awarded purchase prize § LA 1951 § Pasadena 1957 § Long Beach 1959–62 § LACMA 1973, no. 15 § Fullerton 1976 § Sylmar 1978.

LITERATURE
Rex Brandt, *The Winning Ways of Watercolor* (New York: Van Nostrand, 1973), repro., p. 71, incorrectly cited as being owned by the San Francisco Museum of Art § Moure 1975, pp. 6, 55, lists, repro., p. 91.

James Couper Wright

Born March 21, 1906,
Kirkwall, Orkney Islands,
Scotland
To United States 1930
Died December 25, 1969,
Los Angeles, California

After being graduated from Edinburgh College of Art in 1928, James Couper Wright received scholarships enabling him to study in London. He also was awarded a traveling scholarship to study at the Académie moderne in France and in Belgium, Germany, and Switzerland, where he furthered his knowledge of the watercolor medium, learned the art of stained glass, and was introduced to the avant-garde.

In 1930 Wright moved to Santa Barbara, California, where he taught private classes in design and painting. During the summer of 1933 he studied with Alexander Archipenko (1887–1964) at Mills College in Oakland. He moved to Hollywood in 1937 to paint murals for private homes and remained in the Los Angeles area for the rest of his life, except from 1939 to 1941, when he taught at the University of Georgia and traveled throughout the South and New England. He taught at numerous schools in Southern California, among them the Coronado School of Fine Arts, Los Angeles County Art Institute (Otis Art Institute), and Occidental College, Los Angeles. He was also elected vice-president of the California Water Color Society.

BIBLIOGRAPHY
Private collection, James Couper Wright Papers (on microfilm, Archiv. Am. Art) § *Who's Who in American Art*, 1941, 1947, s.v. "Wright, James Couper" § Janice Lovoos, "The Watercolors of James Couper Wright," *American Artist* 29 (October 1965): 52–57, 74–77 § Moure 1975, pp. 26, 75, with bibliography § Moure with Smith 1975, p. 281, with bibliography.

Wright, *Still Life with Brown Pears.*

Still Life with Brown Pears, 1937
Watercolor and charcoal on paper
18³/₄ x 24¹³/₁₆ in (47.6 x 63.0 cm)
Signed and dated lower right: J.C. Wright / 1937
California Water Color Society Collection of
Water Color Paintings
55.34.2

Wright was fascinated with California's indigenous vegetation. He studied the shape, color, and texture of what he called "inexpensive objects of beauty" and learned to capture in his art the subtle golds and tans of the California countryside.

In this still life pears are presented in all their chromatic glory of muted oranges, reds, browns, yellows, and greens and are contrasted with the darker, black eggplants and delicate green and terra-cotta colored grapes. The subject and the treatment of the fruit as simple geometric shapes reveal Wright's familiarity with the work of Paul Cézanne (1839–1906).

Wright luxuriated in the wetness and transparency of the watercolor medium and worked quickly with very wet pigment. The vigorous black strokes outlining the objects are typical of his watercolors of this period, inspired by the paintings of Georges Rouault (1871–1958) and Wright's own work in stained glass. He considered line to be a means to organize a composition by fitting together the shapes of objects as if they were pieces of stained glass. He thought that these lines would not be solid or static because "there was nothing static in the brilliant light of California." As did JOHN MARIN, whom he greatly admired, Wright framed his composition with strong, broken lines.

PROVENANCE
California Water Color Society, 1937–55.

ON DEPOSIT
LACMHSA, 1937–57 § Los Angeles County Building Service, Hall of Administration, 1970–72.

EXHIBITIONS
LACMHSA, *California Water Color Society Seven-teenth Annual Exhibition,* 1937, no. 82, awarded purchase prize § Santa Barbara, Calif., Faulkner Memorial Art Gallery, *Oils by Clarence Hinkle, Watercolors by James Couper Wright,* 1937, no. 8 of Wright entries § Long Beach 1959–72 § LACMA 1973, no. 29 § Fullerton 1976 § Sylmar 1978 § Laguna 1979, repro., p. 205.

LITERATURE
Private collection, James Couper Wright Papers, Scrapbook, unidentified clipping, "J. C. Wright Wins Water Color Prize" (Archiv. Am. Art microfilm roll LA9, fr. 75) § Alma May Cook, "California Water Color Society Awards Prizes in Its Seventeenth Exhibition," *Los Angeles Evening Herald and Express,* October 2, 1937, pt. B, p. 3 § Moure 1975, pp. 2, 7, 75, lists, repro., p. 79 § LACMA, Research Library, artist's file, artist's statement, n.d., associates fruit still life with his initial reaction to California light and nature.

Rex Brandt

Born September 12, 1914, San Diego, California
Lives in Corona del Mar, California

Rexford Elson Brandt contributed significantly to the midcentury resurgence of the watercolor medium in America. As a teenager he enrolled in Saturday classes at Chouinard Art Institute in Los Angeles and by 1930 was experimenting with printmaking and watercolor painting. After being graduated from Riverside (Calif.) Junior College in 1934, he spent two years at the University of California, Berkeley, assimilating the ideas of Hans Hofmann (1880–1966) and other modernists as well as studying Byzantine and Chinese art. His return to Southern California in 1936 marked the beginning of his career as a professional artist. During the late 1930s he achieved regional and national prominence, serving as director of the Works Progress Administration for Riverside and San Bernardino counties and establishing the Riverside College Art Center. Brandt also taught at Chouinard from 1947 to 1950. He and PHIL DIKE formed their own summer art school at Brandt's studio in Corona del Mar, California, in 1947. During the 1960s Brandt and a group of artists in Newport Harbor, California, became known as the "Balboa Bay Byzantines."

Brandt's numerous books on technique, beginning with *Watercolor with Rex Brandt* (1949), contributed to his national reputation. He was elected an associate of the National Academy of Design in 1955 and an academician in 1974. He has served as president of the California Water Color Society, 1948–49, and vice-president of the American Water Color Society, 1965–69. Although Brandt has worked in a variety of mediums, it is his large, boldly painted, transparent watercolors that have earned him much acclaim.

BIBLIOGRAPHY
Jerome K. Muller, ed., *Rex Brandt: A Portfolio of Recent Works Commemorating the First Twenty-five Years of the Brandt Workshop at Corona del Mar* (Santa Ana, Calif.: Unicorn, 1972), with essays by Rex Brandt and Joan Brandt, chronology, lists of awards and exhibitions, bibliography § Moure 1975, pp. 10, 33 § Corona del Mar, Calif., Sherman Library and Gardens, Rex Brandt, "Balboa Bay Byzantine," transcript of lecture, February 19, 1982 § Riverside (Calif.) Art Center and Museum, *Two from California: Joan Irving and Rex Brandt,* exh. cat., 1984, with essays by Janice Lovoos, biographical note, lists of exhibitions and awards, bibliography § LACMA, Research Library, "Four Decades of Alfresco Painting, with Rex Brandt, Joan Irving, and other Californians," brochure, c. 1986, with chronology of Rex Brandt–Phil Dike and Brandt painting workshops 1941–1986, statements and quotes by Brandt, Dike, and others, Brandt chronology and bibliography.

South San Diego, by 1938
Watercolor and graphite on paper
21¹⁵/₁₆ x 28⁷/₈ in (55.7 x 73.4 cm)
Inscribed on mat: South San Diego
California Water Color Society Collection of Water Color Paintings
55.34.18

In this romantic representation of the Cudahy Packing Plant in north San Diego (the inscription "South San Diego" on the original mat is incorrect), a group of industrial buildings dominates the crest of a rolling hill along the San Diego River. Brandt painted the watercolor in the early morning hours after a sleepless night camping in the sand dunes of Mission Bay with his friend, sculptor DONAL HORD. The smell and sounds of the slaughter-house disturbed Brandt: "[While] the pigs were mostly inside the plant becoming bacon, [I] visualized them in a happier relationship [grazing outside]." The cool palette aptly conveys the damp morning air felt by Brandt while he painted the scene.

When exhibited at the 1938 California Water Color Society annual, the painting's large size drew attention. Phil Dike, then president of the society, believed that the heroic size of the composition demonstrated the effect of

Brandt, *South San Diego.*

Brandt's mural painting on his watercolors. Such large-scale images became typical of paintings produced by many members of the California Water Color Society beginning in the mid-1930s.

PROVENANCE
California Water Color Society, 1938–55.

ON DEPOSIT
LACMHSA, 1938–47 § Los Angeles County Board of Supervisors, 1973–78.

EXHIBITIONS
Los Angeles, *California Water Color Society Eighteenth Annual Exhibition,* 1938, no. 15, awarded purchase prize § New York and San Francisco, 1940, no. 33 § Los Angeles, Foundation of Western Art, *Fourth Annual Review of California Art,* 1941, no cat. traced § LACMHSA and others, *Rex Brandt Paintings,* 1943, entries not numbered § LA 1951 § Pasadena 1957 § Long Beach 1959–62 § LACMA 1973, no. 3 § Sylmar 1978 § San Diego Museum of Art, *The Golden Land,* 1986–87, entries not numbered § Santa Barbara (Calif.) Museum of Art, *Regionalism, The California View: Watercolors, 1929–1945,* 1988, entries not numbered.

LITERATURE
Arthur Millier, "Exhibition Shows Some Fine Pieces," *Los Angeles Times,* October 9, 1938, pt. 3, p. 7 § "California Watercolors High in Competence," *Art Digest* 13 (November 1, 1938): 21, repro. § Moure 1975, pp. 2, 6, 33, lists, repro., p. 78 § LACMA, American Art department files, artist's statement, August 2, 1985, describes the circumstance of its creation.

Brandt, *Summer at 29th Street.*

Summer at 29th Street, 1945

Watercolor and gouache with graphite on paper
22⅝ x 30¼ in (57.6 x 76.9 cm)
Signed and dated lower right above embossment:
Rex Brandt / 1945
Inscribed lower left: Summer at 29th Street
California Water Color Society Collection of
Water Color Paintings
55.34.19

The Pacific Ocean is a recurring subject in Brandt's work, usually in images contrasting the sea and shore. *Summer at 29th Street* is somewhat different. For Brandt "the first glimpse of the sea and the smell and sound [of it] are so important to an inland-raised boy." *Summer at 29th Street* is the view of the ocean first seen by the artist as he walked down the street from the railroad tracks in Newport Beach, California. A restricted palette of blues and browns evokes the scent and sound of the ocean. The serene composition is disturbed by the ominous shape of a patrol blimp, a reminder of the threat of attack during World War II, when the scene was painted.

While studying at Berkeley, Brandt became interested in Chinese landscape painting and the watercolors of Paul Cézanne (1839–1906). In *Summer at 29th Street* the thin washes and exposed paper owe a debt to Cézanne while the shorthand use of light and dark to delineate the buildings and automobiles recalls the abbreviated brushwork of oriental landscape painting. Brandt considers the wet-into-wet method, which produces a slightly out-of-focus effect, the most exciting watercolor technique. He used it here in the sky and the railroad tracks in the foreground, which is most unusual since the technique is rarely used in detailed, descriptive passages.

PROVENANCE
California Water Color Society, 1945–55.

ON DEPOSIT
LACMHSA, 1946–47 § Los Angeles County Department of Parks and Recreation, Education Building, 1965–68 § Los Angeles County Data Processing Department, 1970–73 (?) § Los Angeles County Counsel, 1977–79.

EXHIBITIONS
LACMHSA 1945, no. 13, awarded Museum Association Purchase Award § San Francisco 1946 § LA 1951 § Long Beach 1959–62 § Pomona 1964 § LACMA 1973, no. 4 § Fullerton 1976 § Sylmar 1978.

LITERATURE
Arthur Millier, "Los Angeles: Watercolor Prizes," *Art News* 44 (November 1–14, 1945): 25 § Moure 1975, pp. 6, 33, lists, repro., p. 89 § LACMA, American Art department files, artist's statement, August 2, 1985, describes effect of ocean on him § Santa Barbara (Calif.) Museum of Art, *Regionalism, The California View: Watercolors, 1929–1945*, 1988, entries not numbered, p. 38.

Thomas Craig

Born June 16, 1907,
Upland, California
Died February 8, 1969,
San Diego County, California

Thomas Theodore Craig earned a bachelor's degree in botany from Pomona College; he also studied with the historian José Pijón y Soteras, who awakened in him an interest in the arts. Craig later studied in Los Angeles with Frank Tolles Chamberlin (1873–1961), whom he considered his principal teacher, and Clarence Hinkle (1880–1960) as well as with ANDREW DASBURG in Taos, New Mexico. For a short time Craig worked as a scientific illustrator but soon switched to the fine arts, teaching in the Los Angeles area at Occidental College, 1937–39, the University of Southern California, 1939, and Chouinard Art Institute, 1946–50. He was most identified with the medium of watercolor and become an active member of the California Water Color Society. He first specialized in landscapes of the Northern California coast and mountains, but during the late 1930s, with his adoption of oils, he expanded his repertoire to include figure painting and portraiture. He painted until 1950.

Solo exhibitions of his work were organized by the San Francisco Art Association in 1937, the Los Angeles Museum in 1940, and the Frank K. M. Rehn Galleries in New York in 1942. During World War II Craig recorded battle scenes in Italy for *Life* magazine.

BIBLIOGRAPHY
Thomas Craig, "Thomas Craig," *San Francisco Art Association Bulletin* 4 (May–July 1938): 3 § Alfred Frankenstein, "Tom Craig's Water Colors," *Magazine of Art* 31 (October 1938): 576–78, 604–5 § "Thomas Craig Discusses His Painting," *American Artist* 5 (June 1941): 20–23 § Arthur Millier, "Our Artists in Person, no. 40: Thomas Craig," *Los Angeles Times*, June 7, 1942, pt. 3, p. 5 § Moure 1975, pp. 11, 37, with bibliography.

Craig, *The Lorenzetti Grave.*

For Craig "a landscape is not so much a place as a moment of time in a place." Craig used his art not to tell a story but rather to suggest a mood, in this case a romantic, contemplative one of quiet solitude. In *The Lorenzetti Grave* Craig used a controlled, very wet wash to create the soft, blurry effects of impending rain. Windswept trees are a characteristic element in Craig's landscapes, and he often presented them against a sweeping, open sky to suggest changeable weather conditions. Despite the delicacy of his technique, Craig painted the composition on a full sheet, the large size—a feature that became characteristic of the California watercolorists in the midthirties—demonstrating the expansive vision of the California Water Color Society painters.

PROVENANCE
California Water Color Society, 1939–55.

ON DEPOSIT
LACMHSA, 1939–55.

EXHIBITIONS
LACMHSA, *California Water Color Society Nineteenth Annual Exhibition,* 1939, no. 45, awarded purchase prize § New York and San Francisco 1940, no. 50 § LA 1951 § Long Beach 1959–62 § Pomona 1964 § LACMA 1973, no. 5 § Fullerton 1976 § Sylmar 1978.

LITERATURE
Pictures on Exhibit 3 (November 1939): repro., 22 § "Los Angeles Host to Nation's Watercolorists," *Art Digest* 14 (November 1, 1939): 12, repro. § Moure 1975, pp. 6, 37, lists, repro., p. 80.

The Lorenzetti Grave, by 1939
Watercolor on paper
23¹¹⁄₁₆ x 30¹⁵⁄₁₆ in (57.4 x 78.0 cm)
Signed lower left: T. CRAIg—
California Water Color Society Collection of Water Color Paintings
55.34.12

This solitary scene of an oceanside graveyard poignantly illustrates art critic Alfred Frankenstein's description of Craig as a "master of mist and water."

Craig, *Mining Town I.*

In 1941 Craig was awarded a Guggenheim Fellowship, enabling him to travel throughout Texas and the Far West. His wanderings through Nevada were recorded in a series of images of mining towns. This watercolor is the first in the series. By depicting a deserted town Craig may have intended to suggest the boom-and-bust fortune of many mining towns. Reflecting his preference for the mundane, Craig focused on a dirt road rather than on some dramatic aspect of the mining industry. Also typical of the artist is the evocative treatment of the subject: the sky is overcast and a soft, gray-white mist pervades the distant hills. Craig orchestrated the scene of rambling road, cottages, and various shrubs and trees by repeatedly using browns, greens, and bluegrays. While he painted the scene loosely with washes, he also used a small amount of dry brush for the foreground details of foliage and fence.

Mining Town I, 1941
Watercolor on paper
15¹⁄₁₆ x 22³⁄₈ in (38.2 x 56.8 cm)
Signed and dated lower right: T. CRAIG '41
Gift of National Art Week
42.3.1

Clarence Arthur Ellsworth

Born September 23, 1885,
Holdredge, Nebraska
Died February 17, 1961,
Los Angeles, California

Four Ponies, 1939
Watercolor, gouache, and graphite on pebble board
10 x 15¹/₁₆ in (25.5 x 38.2 cm)
Signed lower right: CLARENCE / ELLSWORTH / 1939.
Given in memory of Dr. Carl S. Dentzel
M.80.193.1

Standish Backus, Jr.

Born April 5, 1910,
Detroit, Michigan
Lives in Santa Barbara,
California

After being graduated in 1933 from Princeton University, where he studied architecture, Standish Backus, Jr., spent a year in Munich. On his return to the United States he began his career as a commercial artist, settling in Santa Barbara, California. During World War II he served in the navy as a combat artist and in 1955–56 joined Admiral Richard Byrd's expedition to the South Pole as the party's official artist. Backus has been especially active in the Santa Barbara art community, serving as a trustee of and chairman of the acquisitions committee of the Santa Barbara Museum of Art since 1948 and a trustee of the University Art Museum, University of California, Santa Barbara, for the past twenty years. In the 1950s and 1960s he received two mural commissions, one for a war memorial on the island of Corregidor in the Philippines.

BIBLIOGRAPHY
Who's Who on the Pacific Coast, 1951, s.v. "Backus, Standish, Jr." § Moure 1975, pp. 9, 29, with bibliography § *Who's Who in American Art*, 1984, s.v. "Backus, Standish, Jr."

Backus, *Uninhabited.*

Uninhabited, 1940
Watercolor and gouache on paper
15³/₈ x 22¹/₄ in (39.0 x 56.5 cm)
Signed and dated lower right: Backus '40
California Water Color Society Collection of Water Color Paintings
55.34.21
Color plate, page 77

Uninhabited typifies landscapes created by members of the California Water Color Society at the time. Painted on a large sheet, a solitary shack sits high on a sandy hill near the ocean far above a few other cabins. This image of isolation is painted in a limited palette of somber browns, yellow ochers, and grays, accented by the brilliant white of the paper. Applying the paint in broad, fluid washes with

touches of dry brush limited to the foreground vegetation, Backus skillfully controlled the medium to retain a clean crispness.

PROVENANCE
California Water Color Society, 1940–55.

ON DEPOSIT
LACMHSA, 1940–47 § Los Angeles County Medical Examiner, 1965–68 § Los Angeles County Hall of Administration, Clerk of the Board, 1968–72.

EXHIBITIONS
LACMHSA, *Twentieth Annual California Water*

Color Society Exhibition, 1940, no. 4, awarded purchase prize § Los Angeles, Foundation of Western Art, *Fourth Annual Review of California Art,* 1941, no. 1 § LA 1951 § Long Beach 1959–62 § LACMA 1973, no. 1, repro., cover § Sylmar 1978 § Santa Barbara (Calif.) Museum of Art, *Regionalism, The California View: Watercolors, 1929–1945,* 1988, entries not numbered.

LITERATURE
"Art: Los Angeles," *California Arts and Architecture* 57 (November 1940): 6 § "Watercolors Even a Critic Yens to Purchase," *Art Digest* 15 (November 1, 1940): 21, repro. § Moure 1975, pp. 2, 6, 29, lists, repro., p. 77.

Emil Kosa, Jr.

Born November 28, 1903,
Paris, France
To United States 1907
Died November 4, 1968,
Los Angeles, California

See biography in oil paintings section.

Back Yards, by 1940
(*My Back Yard*)
Watercolor and graphite on paper
17 x 22¹/₁₆ in (43.1 x 56.0 cm)
Signed lower right: Emil Kosa Jr
Gift of Alexander Cowie
42.3.2

Kosa, *The First Overcast.*

The First Overcast, by 1945
Watercolor and graphite on drawing board
19¹¹/₁₆ x 25³/₄ in (49.9 x 65.3 cm)
Signed lower right: E J Kosa Jr.
California Water Color Society Collection of Water Color Paintings
55.34.20
Color plate, page 79

Emil Jean Kosa, Jr., contributed to the formation of a California watercolor style that gained national recognition during the 1930s. Kosa preferred the wet-into-wet technique, applying pigment to his large sheets in broad strokes. Many of his prizewinning watercolors were of the Southern California countryside, as is *The First Overcast.* A master of shadowy effect, Kosa captures the moment before a storm by softening the forms and limiting the palette mostly to grays and olive greens. His fluid manner gives breadth and power to the expansive landscape.

PROVENANCE
California Water Color Society, 1945–55.

Jules Eugene Pages

Born May 16, 1867,
San Francisco, California
Died May 22, 1946,
San Francisco, California

War Scene—Depart de Taul, 1940
Watercolor, gouache, and ink on drawing board
20½ x 29½ in (51.8 x 74.5 cm)
Inscribed, signed, and dated lower right: Depart de
Taul / Juin 40 / J. PAGES 40
Gift of Emil Hilb
54.118.4

Bendor Mark

Born June 5, 1912,
New York, New York
Lives in La Jolla, California

See biography in oil paintings section.

The Family, 1941
Gouache and graphite on paper
30 x 22⅜ in (76.2 x 57.0 cm)
Signed lower right: Bendor Mark
Signed and dated verso lower left: Bendor Mark '41
Given anonymously
M.80.194.2

Dan Lutz

Born July 7, 1906,
Decatur, Illinois
Died November 10, 1978,
Santa Barbara, California

Daniel S. Lutz was a venerable figure in Los Angeles art circles, noted primarily for his highly expressionist, emotive paintings. After briefly attending James Millikin University in Decatur, Illinois, Lutz enrolled in the School of the Art Institute of Chicago, where from 1928 to 1931 he studied sculpture with John Norton (1876–1934) and painting with Boris Anisfeld (1879–1973). Awarded a traveling scholarship, he spent a year visiting museums in Europe. Then in 1932 he and his wife settled permanently on the West Coast. During the late 1930s Lutz served as vice-president of the California Water Color Society for two years. He also taught at many local schools, including the University of Southern California, 1933–44, and Chouinard Art Institute, 1944–52, and was visiting professor at schools in Athens, Georgia; Chicago; San Antonio; and Saugatuck, Michigan. In 1954 he established his own summer school of painting. During the 1950s he traveled frequently, to Mexico, Canada, Europe, and New Zealand. In 1960 he moved permanently to Santa Barbara.

Lutz painted in both oil and watercolor. His early works were mostly genre scenes and views of the places where he lived. In the mid-1940s Lutz turned increasingly toward more expressionist abstraction. He returned to representation in the mid-1950s, and his style did not change substantially thereafter.

BIBLIOGRAPHY
Archiv. Am. Art, Dan Lutz Papers (not on microfilm) § Donald Bear, "Recent Pictures by Dan Lutz," *Magazine of Art* 36 (December 1943): 304–7 § Arthur Millier, "Dan Lutz," *American Artist* 15 (December 1951): 34–37, 87–89 § Rose Henderson, "The New Dan Lutz," *Studio* 156 (October 1958): 114–17 § Moure 1975, pp. 19–20, 55–56, with bibliography.

Lutz, *Rehearsal*.

Rehearsal, 1942
Watercolor on paper
23 x 28¹⁵/₁₆ in (58.3 x 73.3 cm)
Signed lower right: DAN LUTZ 42
California Water Color Society Collection of
Water Color Paintings
55.34.6

Lutz's art demonstrates the changes that occurred during the late 1940s among California watercolor painters as the use of more opaque pigment and expressionist handling

became popular. Lutz painted *Rehearsal* in somber blacks and grays—a palette common to his paintings of the period—that do not distract from the power of his brush. With heavy, gestural strokes he captured the outlines of the musicians.

Lutz stated, "Music has always been a great love—possibly as great to me as is painting." His father was a choral director, and Lutz enjoyed playing the bassoon, often accompanying his wife, who was a professional musician, and friends in impromptu concerts. The traveling fellowship Lutz won in 1932 was for a painting he made of the Chicago Symphony, entitled *The Orchestra*, 1931 (unlocated). During the early 1940s he often painted musical subjects, many inspired by Negro spirituals and jazz, such as *The Gospel Train*, by 1940 (formerly collection of Aline Barnsdall), and *Jam Session*, by 1945 (formerly collection of Artie Shaw). Lutz was praised for his ability to capture in paint the feeling of different types of music ("Art," *California Arts and Architecture* 57 [November 1940]: 6). In *Rehearsal* he clearly conveys the seriousness and deep resonance of the music.

PROVENANCE
The artist, 1942 § California Water Color Society, 1942–55

ON DEPOSIT
LACMHSA, 1943–47 § Los Angeles County Northeast Health Center, 1970–71.

EXHIBITIONS
New York, National Academy of Design, *Seventy-*

fifth *Annual Exhibition of the American Water Color Society,* 1942, no. 358 § LACMHSA and others, *California Water Color Society Twenty-second Annual,* 1942–43, no. 75, awarded War Bond Purchase Prize § LA 1951 § Long Beach 1959–62 § LACMA 1973, no. 20.

LITERATURE
"California Watercolorists Open Annual Show," *Art Digest* 17 (November 1, 1942): 19 § LACMA, Registrar's files, the artist to Nancy Dustin Wall Moure, October 1972, refers to his love of music § Moure 1975, pp. 7, 56, lists, repro., p. 86.

Lutz, *Green Trees and Blue Lagoon.*

Green Trees and Blue Lagoon, 1944
Watercolor and graphite on paper
11 x 28⅜ in (27.9 x 72.1 cm)
Signed and dated lower right: DAN LUTZ 44
California Water Color Society Collection of Water Color Paintings
55.34.4
Color plate, page 78

The subject matter of *Green Trees and Blue Lagoon* is of secondary importance, for Lutz was moving away from the specificity of time and place. He stated that this painting "marks the beginning of my dedication to the use of lush color and free brushwork." Anisfeld, his teacher in Chicago, had stressed the primary importance of color. In this painting the blues and greens are spirited and, although based on reality, assume an expressionist, nonreferential dimension. With an almost opaque medium, Lutz dashed the pigment onto the paper with short, swirling movements. The calligraphic touch enhances the soft quality of the foliage and atmosphere enveloping the trees. The brushwork and landscape subject, combined with the extremely horizontal format, are reminiscent of oriental screens.

PROVENANCE
California Water Color Society, 1945–55.

ON DEPOSIT
LACMHSA, 1946–47 § Los Angeles County Citizens Economy and Efficiency Committee, Hall of Administration, 1969–72 § Los Angeles County Counsel, 1977–78.

EXHIBITIONS
LACMHSA 1945, no. 52, awarded Dalzell Hatfield Gallery Purchase Award § San Francisco 1946 § Los Angeles 1945, repro., unpaginated § LA 1951 § Long Beach 1959–62 § LACMA 1973, no. 18 § Fullerton 1976 § Sylmar 1978.

LITERATURE
Arthur Millier, "Los Angeles: Watercolor Prizes," *Art News* 44 (November 1–14, 1945): 25 § LACMA, Registrar's files, the artist to Nancy Dustin Wall Moure, October 1972, describes the color and brushwork § Moure 1975, pp. 7, 56, lists, repro., p. 90.

Kalamazoo Lake, by 1951
Opaque watercolor on paper
20⅜ x 27¹/₁₆ in (51.8 x 68.5 cm)
Signed lower right: DAN LUTZ
California Water Color Society Collection of Water Color Paintings
55.34.5

In 1940 Lutz taught at the Summer School of Painting in Saugatuck, Michigan, and returned there each summer until 1945 and then again from 1951 to 1953. Despite the identification of the locale in the title, it is insignificant, for by 1951 Lutz had all but relinquished representational subject matter. In *Kalamazoo Lake* Lutz

Lutz, *Kalamazoo Lake.*

moved closer to pure abstraction than he would ever again. At first glance the painting might be categorized as abstract expressionist. A house and lake become discernible only after long and careful observation. Lutz's brush, filled with opaque paint, charged the painting with an organic vitality. The highly potent palette of blacks, bluish grays, white, greens, and yellows—almost garish in effect—was essential to the artist's enthusiastic response to nature.

PROVENANCE
California Water Color Society, 1951–55.

ON DEPOSIT
Los Angeles County Sheriff's Office, Hall of Justice, 1967–72.

EXHIBITIONS
Santa Barbara (Calif.) Museum of Art, *California Water Color Society Thirty-first Annual Exhibition,* 1951, no. 60, repro., cover, awarded purchase prize § Pasadena 1957 § Long Beach 1959–62 § LACMA 1973, no. 19 § Los Angeles, Occidental College, Thorne Hall, *Los Angeles: A Continuing Frontier, 1940–1961,* 1976, no cat. traced § Fullerton 1976.

LITERATURE
Arthur Millier, "Los Angeles Events: Society Goes 'Modern,'" *Art Digest* 26 (January 1, 1952): 14, repro. § Moure 1975, pp. 7, 56, lists, repro., 90.

Ejnar Hansen

Born January 9, 1884,
Copenhagen, Denmark
To United States 1914
Died September 26, 1965,
Pasadena, California

See biography in oil paintings section.

One of Us, c. 1944
Gouache and watercolor on paper
22¹¹/₁₆ x 15¹/₈ in (57.5 x 38.3 cm)
Signed lower right: EHANSEN (EH in monogram)
California Water Color Society Collection of
Water Color Paintings
55.34.11

Although figure painting was not the most popular genre exhibited at California Water Color Society annuals, this portrait by Ejnar Hansen was awarded the society's purchase prize in 1944.

The head and shoulders of an elderly man are incisively modeled with full and vigorous brush strokes. All that is known of the sitter is

486

Hansen, *One of Us.*

gaze, Hansen portrayed the turmoil and sorrow of the subject's life. This poignant image, one of Hansen's favorite works, is one of several paintings he made on the theme of men near death.

PROVENANCE
California Water Color Society, 1944–55.

ON DEPOSIT
LACMHSA, 1945–55.

EXHIBITIONS
LACMHSA and Santa Barbara (Calif.) Museum of Art, *California Water Color Society Twenty-fourth Annual Exhibition,* 1944, no. 34, awarded purchase prize § Pasadena Art Museum, *Ejnar Hansen: Fifty Years of His Art,* 1956, entries not numbered, p. 21, dated 1941 § Pasadena 1957 § Long Beach 1959–62 § LACMA 1973, no. 13 § Glendale, Calif., Brand Library, *National Watercolor Society Past Presidents Invitational,* 1987, catalogue published as *The California Romantics: Harbingers of Watercolorism,* by Robert Perine (Encinitas, Calif.: Artra Publishing, 1986), entries not numbered.

LITERATURE
Art Digest 19 (December 15, 1944): repro., 12 § Arthur Millier, "Ejnar Hansen Interviewed," *American Artist* 14 (October 1950): 29, 32, repro., 30 § Moure 1975, pp. 6, 46, lists, repro., p. 85.

that he committed suicide shortly after this portrait was completed. In the man's tired face, etched with deep creases, and dazed, far-off

Loren Barton

Born November 16, 1893, Oxford, Massachusetts
Died May 27, 1975, Pomona, California

Known primarily for her picturesque scenes of the San Pedro waterfront, the Mexican quarter of Los Angeles, and San Francisco's Chinatown, Loren Roberta Barton studied with William L. Judson (1842–1928) at the University of Southern California and with Rex Slinkard (1887–1918) at the Art Students League of Los Angeles. In 1920 she had her first solo exhibition at the Los Angeles Museum and later in the decade began winning awards throughout the country. At that time she was the only Los Angeles member of the National Association of Women Painters and Sculptors. Until 1930 Barton was primarily involved with printmaking, although she had first experimented with oil painting around 1915 and with watercolor in 1920.

Throughout her career she painted genre scenes, landscapes, figure studies, and occasionally portraits. From 1929 until the mid-1930s Barton lived in Europe, spending much of her time in Italy, where she married Perez Babcock in 1930. During this period she received commissions to illustrate books from New York publishers. After her return to Los Angeles she exhibited regularly in the California Water Color Society annuals and in 1944 began a seven-year association with Chouinard Art Institute, where she taught watercolor painting. She remained in Southern California for the rest of her life, marrying Russell Miller in 1951, and continued to paint and make prints.

BIBLIOGRAPHY
Arthur Millier, "Our Artists in Person, no. 20: Loren Barton," *Los Angeles Times,* November 30, 1930, pt. 3, pp. 15, 18 § *Who's Who in American Art,* 1947, s.v. "Barton, Loren" § Moure 1975, pp. 9, 30, with bibliography § Moure with Smith 1975, pp. 13–14, with bibliography § Laguna 1979, pp. 22–23, with bibliography.

Barton, *Sunny Day at Balboa.*

By using vivid blues and purples and exposing large areas of white paper, in *Sunny Day at Balboa* Barton conveys a typical California scene of bathers relaxing at the beach in the blazing sun and fresh air. In this painting her vigorous brushwork—which has been compared with that of Edouard Manet (1832–1883) in its directness—was applied dryly, and the strokes appear almost opaque.

PROVENANCE
California Water Color Society, 1945–55.

ON DEPOSIT
LACMHSA, 1946–47.

EXHIBITIONS
LACMHSA 1945, no. 4, awarded Silver Jubilee Purchase Award § Los Angeles 1945, repro., unpaginated § San Francisco 1946 § Los Angeles, Dalzell Hatfield Galleries, *Loren Barton Exhibition,* 1947, no cat. traced § LA 1951 § Pasadena 1957 § Long Beach 1959–62 § LACMA 1973, no. 2.

LITERATURE
Arthur Millier, "Los Angeles: Watercolor Prizes," *Art News* 44 (November 1–14, 1945): 25, repro. § Moure 1975, pp. 6, 30, lists, repro., p. 80.

Sunny Day at Balboa, by 1945
Watercolor and graphite on paper
24⅛ x 30¼ in (61.3 x 77.0 cm)
Signed lower left: Loren Barton
California Water Color Society Collection of Water Color Paintings
55.34.17

Pauline Polk

Born June 27, 1896, New York, New York
Died February 25, 1986, Pomona, California

Pauline Polk began her career as an actress and in 1920 appeared in *The Dance of Death* at the Garrick Theater in New York. In the 1920s she married concert violinist Rudolph Polk and spent several years abroad. After her return to New York she studied art with George Grosz (1893–1959) in 1933 and, after moving to Southern California in the mid-1930s, continued her art instruction with MILLARD SHEETS at Scripps College in Claremont. For three years she assisted Sheets with paintings, murals, and mosaics.

Polk specialized in floral still life and landscape painting, and solo exhibitions of her art were held at the Santa Barbara (Calif.) Museum of Art in 1945, Dalzell Hatfield Galleries in Los Angeles in 1946 and 1948, and O'Brien Galleries in Phoenix in 1953. Beginning in the 1950s she became more involved in art administration as a member of the board of the Los Angeles Municipal Art Commission.

BIBLIOGRAPHY
Arthur Millier, "Hawaiian Scenes, Florals Shown by Two Women," *Los Angeles Times,* July 25, 1948, pt. 3, p. 8 § Moure 1975, pp. 22, 63, with bibliography.

Summer Time, by 1945
Watercolor on paper
22⅝ x 30¹⁵⁄₁₆ in (57.5 x 78.5 cm)
Signed lower right: Pauline Polk
California Water Color Society Collection of Water Color Paintings
55.34.27

Although still lifes were not often entered in the California Water Color Society annuals, one of the society's purchase prizes of the 1945 exhibition was awarded to *Summer Time,* Polk's first contribution to the annuals. A vase of flowers is placed directly on a carpet, quite out of scale with the stool, fruit compote, and

Polk, *Summer Time.*

other objects in the room. The fluid, yet controlled handling of the transparent washes of bright red and green reveals Polk's mastery of the medium.

PROVENANCE
California Water Color Society, 1945–55.

ON DEPOSIT
LACMHSA, 1946–47 § Los Angeles County Data Processing Department, 1970–72.

EXHIBITIONS
LACMHSA 1945, no. 61, awarded Brugger Fine Arts Forwarding Service Purchase Award § Los Angeles 1945, repro., unpaginated § San Francisco 1946 § Pasadena 1957 § Long Beach 1959–62 § LACMA 1973, no. 24 § Sylmar 1978.

LITERATURE
Arthur Millier, "Los Angeles: Watercolor Prizes," *Art News* 44 (November 1–14, 1945): 25 § Moure 1975, pp. 7, 63, lists, repro., p. 79.

Millard Sheets

Born June 24, 1907,
Pomona, California
Died March 31, 1989,
Gualala, California

See biography in oil paintings section.

Head of Christ, 1945

(*Head*)
Opaque watercolor on paper on Masonite panel
47⅝ x 29¹³/₁₆ in (121.0 x 75.7 cm)
Signed upper right: Millard Sheets
California Water Color Society Collection of
Water Color Paintings
55.34.28

During the last year of World War II Millard Sheets worked as an artist-correspondent in Asia for *Life* magazine. Not only did he record the horrors of battle but he witnessed the perseverance of the Indian people during one of the worst famines in history. This deepened his social awareness. When he returned to the United States in 1944 he was haunted by the harshness of what he had seen and turned to his painting for catharsis. Sheets's postwar works were less documentary and more religious in spirit than the countless drawings of the dead and dying famine victims he had drawn in India.

Painted shortly after Sheets he came back to the United States, *Head of Christ* is the most traditional in iconography of these religious works. He says that the depiction of the angular figure may have been based on a late nineteenth-century New Mexican Cristo carving. In a later oil painting, *Bombed Christ*, 1946 (estate of the artist), the Christ figure is saved by a native, and in *Day of the Cross*, 1949 (estate of the artist), it is venerated during a religious festival.

Through the formal devices of dark, oppressive colors and heavy brushwork in paintings such as *Head of Christ* Sheets expressed the horrors of death and his bitterness about the effects of war. His macabre, angular figures are similar to images of Christ by Georges Rouault (1871–1958). To give the watercolor the appearance of an oil painting, Sheets vigorously applied thick pigment to a rough paper. Despite its being water based, because of the paint's opacity *Head of Christ* must have seemed an anomaly to members of the California Water Color Society when it was exhibited in 1945. Nonetheless the painting was awarded a purchase prize.

PROVENANCE
California Water Color Society, 1945–55.

ON DEPOSIT
LACMHSA, 1946–55.

EXHIBITIONS
LACMHSA 1945, no. 73, awarded Museum Association Purchase Award, as *Head* § Los Angeles 1945, repro., unpaginated, as *Head* § San Francisco 1946 § LA 1951 § Pasadena 1957 § Long Beach 1959–62 § Pomona 1964 § LACMA 1973, no. 26 § Claremont, Calif., Scripps College, Lang Art Gallery, *Millard Sheets,* 1976, no. 7, p. 10, essay by David W. Steadman discusses in context of 1930s and post-World War II years, repro., p. 11 § Sylmar 1978 § Los Angeles, Loyola Marymount University Art Gallery, *Faces of Jesus,* 1978, no. 44, repro., unpaginated § Laguna Beach (Calif.) Museum of Art and others, *Millard Sheets: Six Decades of Painting,* 1983, no. 45, repro., p. 38.

Sheets, *Head of Christ.*

LITERATURE

Arthur Millier, "Los Angeles: Watercolor Prizes," *Art News* 44 (November 1–14, 1945): 25, as *Head* § Rose Henderson, "The Paintings of Millard Sheets," *Studio* 137 (January 1949): repro., 17, as *Head* § Arthur Millier, "The Fabulous Mr. Sheets," *American Artist* 15 (May 1951): 32 § Moure 1975, pp. 7, 67, lists, repro., p. 92 § LACMA, American Art department files, the artist to Ilene Susan Fort, August 6, 1985, discusses possible source of the image § Robert Perine, *The California Romantics: Harbingers of Watercolorism* (Encinitas, Calif.: Artra Publishing, 1986), repro., p. 21, as *Head.*

J. Jay McVicker

Born October 18, 1911,
Vici, Oklahoma
Lives in Stillwater, Oklahoma

Although he has worked primarily in Oklahoma, Jesse Jay McVicker participated in the California Water Color Society annuals for a decade beginning in 1942. He paints in a variety of mediums—acrylic, casein, oil, and watercolor—as well as making prints and sculpture.

McVicker took undergraduate and graduate degrees at Oklahoma State University and was a faculty member there for more than thirty years. During the 1940s his art was regionalist in character but at the end of the decade he abandoned representation. Influenced by Paul Klee (1879–1940) and Juan Gris (1887–1927), he painted increasingly abstract works during the 1950s as he began to create colorful, constructivist arrangements. By the 1970s he had developed a spare, hard-edge, geometric style.

BIBLIOGRAPHY
Who's Who in American Art, 1947, 1984, s.v. "McVicker, J. Jay" § "J. Jay McVicker," *La Revue moderne des arts et de la vie* (June 1, 1948): 14–15 § Moure 1975, pp. 20, 56, with bibliography § Bethesda (Md.) Art Gallery, *J. Jay McVicker: Four Decades of Printmaking*, exh. brochure, 1983.

McVicker, *Payne County Road*.

Payne County Road, 1946
Watercolor on paper
22¾ x 31⅜ in (57.7 x 79.7 cm)
Signed and dated lower right: J Jay McVicker '46
California Water Color Society Collection of Water Color Paintings
55.34.16

McVicker has lived most of his adult life in Stillwater, Oklahoma. This landscape depicts a rural road northeast of Stillwater, in Payne County. The artist acknowledges that "this particular road . . . is not of any great significance other than the fact that I continue to find it an exciting subject in its rich earth colors and its undulating forms."

McVicker's landscape is more forcefully painted than most of the works by members of the California Water Color Society. His dark, heavy palette of blacks, greens, and browns may be a reference to the rich Oklahoma humus. McVicker's blackish coloration and heavy brushwork also reflect his admiration for Georges Rouault (1871–1958). *Payne County Road* reveals McVicker as a master of technique; he added dark, black, opaque lines over large wet-into-wet passages to delineate the road and houses while applying fuzzy touches of dry brush to suggest plowed fields.

PROVENANCE
California Water Color Society, 1946–55.

ON DEPOSIT
Los Angeles County Counsel, 1977–78.

EXHIBITIONS
Pasadena (Calif.) Art Institute, *California Water Color Society Twenty-sixth Annual Exhibition*, 1946, no. 36, awarded purchase prize § Pasadena 1957 § Long Beach 1959–62 § LACMA 1973, no. 21 § Sylmar 1978.

LITERATURE
Arthur Millier, "West Coast Artists Present Strong Front," *Art Digest* 21 (November 1, 1946): 15 § Moure 1975, pp. 7, 56, lists, repro., p. 86 § LACMA, Registrar's files, artist's statement, n.d.

Jan Stussy

Born August 13, 1921,
Benton County, Missouri
Died July 31, 1990, Los
Angeles, California

Jan Frederick Stussy was a significant artist and teacher in Los Angeles. Born in the Midwest, he came to Southern California as a small child and remained here for his schooling, studying at Long Beach City College, at the Art Center School in Pasadena with BARSE MILLER, and at the University of California, Los Angeles, where he took his bachelor's degree and studied anatomy with George J. Cox (1884–1946). After serving in the navy, in 1953 Stussy earned a master's degree from the University of Southern California, where he was a student of FRANCIS DE ERDELY. Stussy became a close friend of STANTON MACDONALD-WRIGHT, studying privately with him for several years. Stussy's travels throughout Europe, Mexico, South America, and Japan beginning in the 1950s afforded him further periods of study. In 1950 he was elected vice-president of the California Water Color Society. His teaching career began in 1947 with his appointment to the faculty of UCLA, where he taught until 1989. He also taught at the University of California, Santa Barbara. Solo exhibitions of his work were held throughout Southern California and the Southwest, and he received many awards, including a grant to work at the Tamarind Lithography Workshop in 1970.

In his imaginative work Stussy symbolically presented various images, including human and animal figures and flowers. Often his subjects are distorted and inside boxes, circles, or other geometric shapes. He best described his own intent: "As a painter I am interested in various aspects of abstraction, allegory, transfiguration, codes, analogies, metaphors, equivocation, and ambiguity as they relate to art."

BIBLIOGRAPHY
Archiv. Am. Art, Jan Stussy Papers § University of California, Los Angeles, Art Galleries, and Santiago, Chile, Carmen Waugh Gallery, organized by Chile/California Program, *Jan Stussy Paintings,* exh. cat., 1967, with essay by Jorge Elliott § LACMA, Research Library, artist's file, artist's statement, n.d., and biographical data, c. 1971 § Moure 1975, pp. 24–25, 70, with bibliography § *Stussy Drawings* (Los Angeles and New York: University of California, Los Angeles, and Technological Investors Management Corp., 1984), with introduction by Robert H. Gray, comments by the artist, biographical note, lists of awards and exhibitions.

Stussy, *Hurt Bird.*

Hurt Bird, 1947
Watercolor, tempera, and ink on paper
18¹/₁₆ x 23¹⁵/₁₆ in (45.8 x 60.8 cm)
Signed and dated lower right: Stussy 8–47
Inscribed lower left: HURT BIRD
California Water Color Society Collection of
Water Color Paintings
55.34.3

Hurt Bird was part of Stussy's master's degree project, which was based on the subject of the bird catcher. An injured bird flaps its wings and screams for help, to no avail. The lines and washes enveloping the bird isolate and confine him. The story of Icarus and the image of men and animals constrained in boxes continued to fascinate Stussy, whose mature images are often distorted or disquieting. Even an early work such as *Hurt Bird* reveals a striving for a transcendental quality: "Painting for me is the slow unraveling of an endless mystery," explained the artist.

Hurt Bird recalls the art of ALBERT PINKHAM RYDER and Morris Graves (born 1910), two romantic artists, who, like Stussy, painted dead or dying birds and used the evocative formal elements of line and color. Stussy was as much a draftsman as a painter, having become interested in calligraphy as early as 1947, and line dominates many of his paintings. Moreover, when he used color, as in *Hurt Bird,* it is secondary to the graphic elements. In this watercolor the palette is limited and was applied in delicate tints, the lines and washes forming transparent, intersecting planes. Stussy's fractured planes and use of color tints were influenced by Macdonald-Wright, who also probably introduced Stussy to oriental mysticism.

PROVENANCE
California Water Color Society, 1947–55.

EXHIBITIONS
Pasadena Art Institute, *California Water Color Society Twenty-seventh Annual Exhibition*, 1947, no. 8, repro., unpaginated, awarded purchase prize § New York, Grand Central Art Galleries, *California Water-color Society Artists Exhibition*, 1948, no. 3 § Pasadena 1957 § Long Beach 1959–62 § LACMA 1973, no. 27 § Sylmar 1978, exhibited but not listed.

LITERATURE
Moure 1975, pp. 3, 7, 70, lists § LACMA, American Art department files, the artist to Ilene Susan Fort, November 11, 1985, discusses the theme and technique of watercolor in context of his early and mature work.

Richard Haines

Born December 29, 1906,
Marion, Iowa
Died October 9, 1984,
Santa Monica, California

Richard Carver Haines was a respected figure in Southern California art circles following World War II. He began his career in the Midwest, studying at the Chicago Academy of Fine Arts with John Morton (1876–1934) and at the Minneapolis School of Art. In 1934 he won a scholarship enabling him to study at the Ecole des Beaux-Arts in Fontainebleau and visit England, Germany, Italy, Spain, and North Africa.

Haines first worked as a commercial artist, designing greeting cards and calendars. During the depression he was active in the Works Progress Administration and was awarded several mural commissions from the Treasury Section of Painting and Sculpture to decorate post offices in the Midwest. In 1941 he settled permanently in Santa Monica. After World War II Haines devoted much of his time to teaching, first at Chouinard Art Institute for five years and then at the Los Angeles County Art Institute (Otis Art Institute) until 1974, heading the department from 1952 to 1964. In 1950 he was elected president of the California Water Color Society. He served as a combat artist in Vietnam for the United States Navy in 1967.

His paintings, watercolors, prints, tapestries, and murals reveal a strong sense of abstract design, line, and color. Primarily a figure painter, he also painted landscapes, and over the years his subjects changed from the specific to the universal. A poetic, almost magical mood pervades many of his late works.

BIBLIOGRAPHY
Private collection, Richard Haines Papers (on microfilm, Archiv. Am. Art) § Janice Lovoos, "The Paintings of Richard Haines," *American Artist* 27 (April 1963): 50–57, 84–86 § Moure 1975, pp. 16, 45, with bibliography § Los Angeles, Dalzell Hatfield Galleries, *Richard Haines: "El Desierto y la Mar,"* exh. cat., 1977, with lists of awards, teaching positions, and murals § Abraxas Gallery, Newport Beach, Calif., *Richard Haines: A Selection of Paintings from 1947–1979*, exh. cat., 1979, with statement by the artist, bibliography, lists of exhibitions, awards, teaching positions, collections, murals, and architectural designs.

Winter Rain, by 1948
Watercolor and charcoal on paper
19¼ x 26⁷⁄₁₆ in (48.7 x 67.0 cm)
Signed lower right: Haines
California Water Color Society Collection of
Water Color Paintings
55.34.1

Haines sought to express in his art the essence of an experience. In this silvery watercolor he captured the feel of cold, wet rain falling on a crowded city street. In broad sweeps of fluid, overlapping washes, Haines applied a rainbow of cool blues, purples, grays, and greens to suggest a downpour. Sharper vertical black accents describe the quick movement of the mass of figures scurrying for shelter. This emphasis on abstract patterning, while retaining representational elements, reflects the general trend in the paintings exhibited at the California Water Color Society annuals after the war.

Haines was extremely imaginative in his technique, experimenting with combinations of mediums. He described how he created *Winter Rain*: "I used charcoal lines to indicate the large color planes. Next a few sweeps of wax across the paper at the angle of falling rain. Then I dampened the paper and applied the color in large washes, darkening it here, intensifying an area there using the line to suggest form and motion. As the paper became less moist, the darker, sharper lines were added."

Haines later removed the excess wax to achieve a soft, almost pastel effect.

PROVENANCE
California Water Color Society, 1948–55.

EXHIBITIONS
Pasadena 1948, no. 38, repro., unpaginated, awarded purchase prize § Pasadena 1957 § Long Beach 1959–62 § Pasadena, Calif., Pacificulture Foundation, [calligraphy and art exhibition], 1972, no cat. traced § LACMA 1973, no. 12 § Fullerton 1976 § Sylmar 1978 § Glendale, Calif., Brand Library,

Haines, *Winter Rain.*

National Watercolor Society Past Presidents Invitational, 1987, catalogue published as *The California Romantics: Harbingers of Watercolorism,* by Robert Perine (Encinitas, Calif.: Artra Publishing, 1986), entries not numbered.

LITERATURE
Arthur Millier, "Activities in California: Winners at the Los Angeles Fair," *Art Digest* 23 (October 1, 1948): repro., 12 § Alice M. Goudy, "This Month in California," *Art News* 47 (November 1948): 50, repro. § Richard Haines, "The Watercolor Series," *American Artist* 13 (November 1949): 48, describes technique used in painting the work, repro., 49 § Norman Kent, *One Hundred Watercolor Techniques* (New York: Watson-Guptill, 1968), p. 87, details technical procedure, repro., p. 86 § Moure 1975, p. 45, lists, repro., p. 87.

Francis de Erdely

Born May 3, 1904,
Budapest, Hungary
To United States 1939
Died November 28, 1959,
Los Angeles, California

Francis de Erdely (born Ferenc de Erdély) was renowned in Europe and the United States for his powerful figure paintings and drawings as well as for his teaching abilities. He studied at the Royal Academy of Art in Budapest, from 1919 to 1923, and later attended the Royal Academy of Fine Arts of San Fernando in Madrid and the Sorbonne in Paris. He first exhibited in 1924 in Madrid and Barcelona. De Erdely was commissioned to paint a portrait of María Cristina, who had been queen regent of Spain until 1902, and for that painting was awarded the Színyei-Merse Grand Prize in Budapest in 1925.

In the 1930s his art changed as he became increasingly troubled by the effect of war on humanity, a subject that would dominate much of his art for the rest of his life. His anti-Nazi paintings eventually made it necessary for him to flee Europe. He arrived in the United States in 1939 and after a year in the East settled in Detroit. His solo exhibitions in New York and Detroit drew favorable comments from leading newspaper critics who extolled the vitality of his drawing and his ability to probe the depths of human experi-

ence. Although he painted landscapes, still lifes, and portraits, he became best known for his figure compositions.

In 1944 he moved to California and exhibited his war paintings and drawings, which were favorably compared with the *Disasters of War* etchings by Francisco Goya (1746–1828). In these poignant works de Erdely expressed emotion through meticulously refined, anatomical drawing.

De Erdely was dean of the Pasadena Art Institute School for two years, 1944–46. His longest and most influential academic affiliation was with the University of Southern California, where he taught from 1945 until his death in 1959.

BIBLIOGRAPHY
Ernest W. Watson, "The Art of Francis de Erdely," *American Artist* 12 (May 1948): 22–27, 59–61 § Obituary, *Los Angeles Times,* November 29, 1959, pt. 1, p. 39 § Pasadena (Calif.) Art Museum, *Francis de Erdely, 1904–1959,* exh. cat., 1960, with essay by Arthur Millier § Beverly E. Johnson, "De Erdely: The Master Draftsman," *Los Angeles Times,* May 22, 1960, Home Magazine, pp. 20–21, 84 § Moure 1975, pp. 12, 39, with bibliography.

De Erdley, *Mexican Dance.*

Mexican Dance, by 1949
Gouache and ink on board
28¹⁵/₁₆ x 21¹⁵/₁₆ in (73.5 x 55.7 cm)
Signed lower right: de erdely
California Water Color Society Collection of
Water Color Paintings
55.34.10

De Erdely encouraged his students to develop their awareness of anatomy, and in his own work his extensive knowledge of the human form is apparent. He had studied anatomy and performed dissections, and his brief career as a professional boxer undoubtedly increased his awareness of the human body. De Erdely always drew his figures as well formed and substantial, and often in mature drawings, as in *Mexican Dance,* he made sculptural masses of the figures, breaking up the head, limbs, and torso into massive, blocklike forms with faceted surfaces. De Erdely constructed *Mexican Dance* as a drawing, modeling the figures with a heavy black line and applying an overlay of pale washes of naturalistic pink, aqua, and yellow.

Among de Erdely's favorite subjects in his late years were Mexicans and Spaniards dressed in folk costumes. He often depicted

dancers—at rest and in motion—and typically focused on one or two individuals. In *Mexican Dance* the couple's gestures suggest that they are performing a folk dance, and yet their poses appear somewhat contrived. This composed quality, commented on when the watercolor was first exhibited, may be merely decorative. It also may have derived from de Erdely's preference for studying one model at a time rather than the ensemble of figures and his wish to describe the individual's solitary alienation.

PROVENANCE
California Water Color Society, 1949–55.

EXHIBITIONS
Beverly Hills, Calif., Associated American Artists Galleries, and Pasadena (Calif.) Art Institute, *California Water Color Society Twenty-ninth Annual Exhibition,* 1949, no. 15, repro., unpaginated, awarded purchase prize § LA 1951 § Pasadena 1957 § Long Beach 1959–62 § Pasadena Art Museum, *de Erdely,* no. 29, dated 1949 § Norwalk, Calif., Cerritos College Art Gallery, *Francis de Erdely Memorial Exhibition,* 1965, no. 16 § LACMA 1973, no. 6.

LITERATURE
Arthur Millier, "Los Angeles Events," *Art Digest* 24 (October 1, 1949): 14, repro. § Moure 1975, pp. 6, 39, lists, repro., p. 84.

Ogden Minton Pleissner

Born April 29, 1905,
New York, New York
Died October 24, 1983,
London, England

Along the Arno, c. late 1940s
Ink and watercolor on paper
11 x 16¹/₁₆ in (28.0 x 40.7 cm)
Inscribed and signed lower right: Florence / Ogden
M. Pleissner
Gift of American Academy of Arts and Letters
55.58

Neil Fujita

Born May 16, 1921, Waimea,
Hawaii
Lives in New York, New York

Sadamitsu Neil Fujita is known primarily as a graphic designer. In 1939 he moved to Los Angeles, where he studied at Chouinard Art Institute. During World War II he served in the infantry in Europe and worked with army intelligence in Japan, where he was introduced to traditional Japanese art, which would later influence his work. Returning to Chouinard to study graphic design, Fujita was graduated in 1949 and joined the staff of the Philadelphia advertising agency N. W. Ayer & Son. In the early 1950s he became director of design and packaging for Columbia Records. He settled in New York in 1954. In 1958 he helped establish the design firm of Ruder, Finn, and Fujita, Inc., and later formed his own company, Fujita Design, Inc.

Fujita has created designs and logos for many large corporations, including General Foods Corporation, Random House, and Standard Oil of New Jersey, and for government agencies. His graphics have also been used in magazines, books, and billboards. He has taught design at the Philadelphia Museum College of Art, Pratt Institute in Brooklyn, and in New York at the New School for Social Research and Parsons School of Design. He was an early member of the executive committee of the National Academy of Recording Arts and Sciences.

Since early in his career as a graphic designer Fujita has also shown his noncommercial art in group exhibitions held in California, New York, and Philadelphia. Solo exhibitions of his work were organized by the Philadelphia Art Alliance in 1953 and the Wellon Gallery, New York, in 1956. His association with the California Water Color Society was brief, from his last years at Chouinard to 1951.

BIBLIOGRAPHY
"Caseins and Drawings by Sadamitsu Neil Fujita," *Art Alliance Bulletin* (Philadelphia) 31 (April 1953): 7 § S. Neil Fujita, *Aim for a Job in Graphic Design/Art* (New York: Richards Rosen Press, 1968), with biographical note § "Neil Fujita," *Idea* 18 (May 1970): 42–43 § Moure 1975, pp. 14, 43, with bibliography § "Fujita Design, Inc.: They Know What They Are Doing and Why," *Idea* 23 (May 1975): 10–21.

Fujita, *Harbor Living.*

Harbor Living, 1950
Tempera on cardboard
18¹/₁₆ x 22 in (45.9 x 55.8 cm)
Signed and dated lower left: Fujita '50
California Water Color Society Collection of Water Color Paintings
55.34.25

Harbor Living exemplifies the stylistic and technical changes that occurred in paintings exhibited in the California Water Color Society annuals during the late 1940s and early 1950s. Pure watercolor was sometimes replaced by more opaque mediums such as gouache and, as in this instance, tempera. No longer was the luminosity of the aquarelle desired, especially when the artist was concerned with design rather than representation.

Fujita presents a man and child looking out over a pier in a cluttered harbor. The viewpoint is high, the entire scene tilted up as if composed by a naïve painter, so that the essential shape of each object is easily discerned. *Harbor Living* is much more than a charming scene. The geometric shapes and lines are arranged with the same sophistication that marks Fujita's book and graphic designs. The limited hues and values of the dull reds, terracottas, and gray-blues do not distract from the composition. The matte flatness of the tempera paint emphasizes two-dimensionality, and the brushwork activates the surface, enhancing the overall sense of liveliness.

PROVENANCE
California Water Color Society, 1950–55.

ON DEPOSIT
Los Angeles County Board of Supervisors, 1973–78.

EXHIBITIONS
Pasadena (Calif.) Art Institute, *California Water Color Society Thirtieth Annual Exhibition*, 1950, no. 33, repro., unpaginated, awarded purchase prize § LA 1951 § Pasadena 1957 § Long Beach 1959–62 § LACMA 1973, no. 10 § Sylmar 1978.

LITERATURE
"The Honor Roll," *Art Digest* 25 (December 15, 1950): repro., 23 § Moure 1975, pp. 3, 6, 43, lists, repro., p. 88.

George Gibson

Born October 16, 1904,
Edinburgh, Scotland
To United States 1930
Lives in Los Osos, California

George Gibson has led a dual career as a motion picture set designer and watercolor artist. He attended Edinburgh College of Art and Glasgow School of Art. In 1930 he moved to the United States and settled in California, where he studied at Chouinard Art Institute from 1931 to 1933, and later with F. Tolles Chamberlin (1873–1961). Since Gibson had worked as a set designer in Scotland, he turned to the motion-picture industry for employment and in 1931 worked as a storyboard illustrator for Fox Studio. From 1934 to 1969 he was employed by Metro-Goldwyn-Mayer Studios, where he designed sets for such movies as *The Wizard of Oz* (1939), *Oklahoma!* (1955), *The Prodigal* (1955), and *Ice Station Zebra* (1968), and became head of the set department.

During the early 1940s Gibson increasingly painted watercolors, and after the war began exhibiting them as an active member of the California Water Color Society, serving as the organization's secretary, 1947–48, vice-president, 1949–50, and president, 1950–51. During this period he became close friends with EMIL KOSA, JR., often accompanying him on sketching trips. In his watercolors Gibson combines the traditional English aquarelle technique with the vigor and boldness of the California watercolor school.

BIBLIOGRAPHY
LACMA, Research Library, artist's file, interview with the artist by Nancy Dustin Wall Moure, n.d. § Vic Heutschy, "From Any Angle," *International Photographer* 26 (October 1954): 16–17 § Moure 1975, pp. 15, 43, with bibliography § *Who's Who in American Art,* 1984, s.v. "Gibson, George" § Gordon T. McClelland and Jay T. Last, *The California Style: California Watercolor Artists, 1923–1955* (Beverly Hills, Calif.: Hillcrest, 1985), pp. 62–63.

Gibson, *Near the Point.*

Near the Point, 1952
Watercolor on paper
22⁹/₁₆ x 30¹/₁₆ in (57.3 x 76.4 cm)
Signed and dated lower right: Gibson 52
California Water Color Society Collection of
Water Color Paintings
55.34.15

Although Gibson has devoted much of his painting career to creating dramatic vistas of California, *Near the Point* is an intimate scene. Gibson stepped close to the fishermen on the beach yet was able to retain a sense of the largeness and drama of the rocky shore. To convey the ruggedness of the area, a dry brush was applied over thin washes of color. The actual locale is just south of Malibu, in an area now largely developed.

Gibson works on location and allows the mood of the day to dictate the character of the scene. Describing the cool palette and wetness of this watercolor, Gibson commented, "It was a rather cold day, as the warmly clothed fishermen would indicate, and the tonal quality of the painting was pretty much influenced by the weather conditions . . . hence the violet-grays and blues."

Gibson drew on the verso an uncompleted pencil sketch for another coastal landscape.

PROVENANCE
California Water Color Society, 1952–55.

ON DEPOSIT
Los Angeles County Medical Examiner, 1965–66 § Los Angeles County Health Center, Compton, 1970–72 § Los Angeles County Board of Supervisors, 1973–78.

EXHIBITIONS
San Francisco, M. H. De Young Memorial Museum, and Pasadena (Calif.) Art Institute, *California Water Color Society Thirty-second Annual Exhibition,* 1952–53, no. 39, repro., unpaginated, awarded purchase prize § Pasadena 1957 § Long Beach 1959–62 § LACMA 1973, no. 11 § Sylmar 1978.

LITERATURE
"Coast-to-Coast Notes," *Art Digest* 27 (December 15, 1952): repro., 15 § Moure 1975, pp. 6, 43, lists, repro., p. 78 § LACMA, American Art department files, the artist to Ilene Susan Fort, July 29, 1985, describes the weather and palette.

Leonard Edmondson

Born June 12, 1916,
Sacramento, California
Lives in Los Angeles,
California

Leonard Edmondson earned undergraduate and graduate degrees in art from the University of California, Berkeley, in 1940 and 1942, respectively, and independently studied Japanese brush painting and calligraphy with Chiura Obata. After serving in the army during World War II, he settled in Southern California, establishing himself as an abstract painter and printmaker. Initially a nonobjective artist inspired by abstract surrealism, he eventually developed his own muscular version of abstract expressionism. Working in New York during the early 1960s and again in the 1970s, he turned to representational art, first to the figure and then to landscape, although formal design always remained his primary concern.

Edmondson was awarded Tiffany grants in graphic art in 1952 and 1955 and was a Guggenheim Fellow in 1960. Major exhibitions of his work were held at the M. H. de Young Museum, San Francisco, in 1952, and the Philadelphia Art Alliance in 1958. An active teacher since 1947, he has served on the faculties of Pasadena City College, the Los Angeles County Art Institute (Otis Art Institute), and California State University, Los Angeles. He has been president of the California Water Color Society, 1955, secretary of Artists Equity, and president of the Los Angeles Printmaking Society, 1966.

BIBLIOGRAPHY
San Francisco Museum of Art, *Leonard Edmondson: Color Etchings, 1951–1967,* exh. cat., 1967, with essay by the artist, biographical note § *Who's Who in American Art,* 1970, 1984, s.v. "Edmondson, Leonard" § Moure 1975, pp. 14, 41, with bibliography § Los Angeles, University of California, Oral History Program, "Los Angeles Art Community: Leonard Edmondson," interview with the artist by Merle S. Schipper, 1976.

Edmondson, *Ascendant Number.*

Edmondson's palette consists of limpid hues of translucent rose, terra-cotta, pink, gray-blue, and yellow. The impression of constant movement through the composition is important, but its course is controlled. Edmondson's art is concerned with cognition, and titles such as *Interdependencies, Equivalent Restraint,* and *Ascendant Number* demonstrate his interest in relationships, both conceptual and formal (the latter comprising space and color). His paintings and prints share a delicate line, a concern with the tonal gradations of textured backgrounds, and a refined elegance. In paintings exhibited at the California Water Color Society annuals beginning in the late 1940s, such as *Ascendant Number,* California artists abandoned the regional style for which they had become known and adopted an international aesthetic to which they brought their own interpretations.

Ascendant Number, 1953

Tempera, ink, silver paint, graphite, and possibly gouache on paper
19¹/₁₆ x 27 in (48.5 x 68.4)
Signed and dated lower left: EDMONDSON 1953
California Water Color Society Collection of Water Color Paintings
55.34.26

Influenced by Joan Miró (1893–1983) and Paul Klee (1879–1940), Edmondson's abstract paintings of the early 1950s are allover compositions in which biomorphic shapes float through an atmosphere of soft color. The slender jawbone element used throughout *Ascendant Number* was a favorite shape.

PROVENANCE
California Water Color Society, 1953–55.

EXHIBITIONS
Long Beach (Calif.) Municipal Art Center and Claremont, Calif., Scripps College, *California Water Color Society Thirty-third National Exhibition,* 1953–54, no. 19, repro., unpaginated, awarded purchase prize § Cleveland Museum of Art and others, *California Water Color Society: 1954 Traveling Exhibition,* 1954, no. 7 § Pasadena 1957 § Long Beach 1959–62 § LACMA 1973, no. 9 § Sylmar 1978.

LITERATURE
Leonard Edmondson, brochure, 1954 or later, repro., back cover § Moure 1975, pp. 3, 6, 41, lists, repro., p. 88.

Richards Ruben

Born November 29, 1925,
Los Angeles, California
Lives in New York, New York

During the 1950s Richards Ruben was a major exponent of abstract expressionism in California. After serving in the army during World War II, he studied in Los Angeles at Chouinard Art Institute, in Santa Monica with RICHARD HAINES, and in Pittsburgh with Samuel Rosenberg (1896–1972). Ruben began teaching in 1948, first in Pennsylvania and from the 1950s in Southern California, at Chouinard, 1954–61, the University of California, Los Angeles, 1958–62, and other institutions. After moving to New York in the early 1960s, he taught at the Cooper Union, Columbia University, and New York University. Solo exhibitions of Ruben's work have been organized in California by the Oakland Art Museum, 1957, and the San Francisco Museum of Art, 1970, and by the Herbert F. Johnson Museum of Art, Cornell University, Ithaca, New York, in 1974 and 1976. He has received many awards, including a Tiffany grant and fellowships from the Tamarind Lithography Workshop, the Ford Foundation, and the National Endowment for the Arts.

Ruben's first mature paintings of the 1950s, often derived from landscape and twisting body forms, exhibit a muscularity of shape and a sensuosity of paint as well as an interest in calligraphic line. In the next decade Ruben began to incorporate symmetry and eventually a geometric order into his art and became increasingly concerned with the interrelationship of pure paint and perception; by the 1970s his paintings consisted of lightly colored, highly impastoed surfaces into which linear configurations were etched.

BIBLIOGRAPHY
Beverly Hills, Calif., Paul Kantor Gallery, *Richards Ruben,* exh. cat., 1958, with essay by Peter Selz, biographical note, lists of exhibitions and collections § *Who's Who in American Art,* 1959, 1984, s.v. "Ruben, Richards" § Pasadena (Calif.) Art Museum, *Richards Ruben: A Selection of Paintings and Drawings—Claremont Series, 1958–1961,* exh. cat., 1961, with introduction by Bates Lowry § Gerald Nordland, "West Coast in Review," *Arts Magazine* 36 (December 1961): 64 § Ithaca, N.Y., Cornell University, Herbert F. Johnson Museum of Art, *Richards Ruben,* exh. cat., 1976, with introduction by Thomas W. Leavitt, biographical note, lists of exhibitions and collections.

Rubens, *Circumstance at Meridian II.*

Circumstance at Meridian II, 1953

Gouache, watercolor, and ink on paper
22³/₈ x 29¹³/₁₆ in (56.9 x 75.8 cm)
Signed lower left: Richards Ruben
California Water Color Society Collection of
Water Color Paintings
55.34.29

This watercolor reveals the degree to which many of the exhibitors at the California Water Color Society annuals during the postwar years embraced abstract expressionism, a style generally associated with East Coast artists. *Circumstance at Meridian II* was created at the height of the first generation of abstract expressionism and demonstrates Ruben's somewhat brooding explorations of the energy and calligraphy of that postwar aesthetic. The surface is heavily encrusted with many layers of pigment of varying thickness and opacity. Ruben brushed the paint on in wide expanses and thin strokes; he even used a sponge to apply the pigment in some passages. His paint almost appears alive, its slow movement causing ripples, crevices, and irregularly shaped concretions. On the right, wiry lines merge to form a spidery web caught on the surface of the paper. While Ruben spared nothing in his rich surfaces, he limited his palette to organic colors: white, cream, flesh, and black, with touches of reddish orange for some of the delicate linear passages.

This was one of a series of paintings similar in formal terms and in their power and refinement.

PROVENANCE
California Water Color Society, 1955.

EXHIBITIONS
Fine Arts Gallery of San Diego, Calif., and Pasadena (Calif.) Art Museum, *Thirty-fourth National Exhibition of the California Watercolor Society*, 1954–55, no. 81, repro., unpaginated, awarded purchase prize § Pasadena 1957 § Long Beach 1959–62 § LACMA 1973, no. 25.

LITERATURE
Jules Langsner, "Art News from Los Angeles: Watercolor Revival," *Art News* 53 (December 1954): repro., 39 § Moure 1975, pp. 3, 65, lists, repro., p. 87 § LACMA, American Art department files, the artist to Ilene Susan Fort, [July 1989], states that it was painted in 1953.

Andrew Wyeth

Born July 12, 1917,
Chadds Ford, Pennsylvania
Lives in Chadds Ford,
Pennsylvania

Andrew Wyeth is one of the most popular twentieth-century American painters. The son of painter and illustrator N. C. Wyeth (1882–1945), Andrew grew up in an environment devoted to art. His father was his only teacher. With his first solo exhibition at the Macbeth Gallery, New York, in 1937 he established his preference for subject matter derived from his own surroundings. During the first fifteen years of his career he had frequent exhibitions at the Macbeth Gallery and at Doll and Richards, Boston, and in 1962 was accorded the first of several major museum retrospectives at the Albright-Knox Art Gallery, Buffalo.

Unlike most artists working in the 1930s and early 1940s who extolled a regionalist aesthetic, Wyeth never abandoned representation nor his ties to his immediate surroundings. The subject of his art is the people and countryside of Chadds Ford, Pennsylvania, and his summer home in Cushing, Maine. Wyeth goes beyond mere reportage, infusing his landscapes, architectural studies, interiors (which are almost still-life compositions), portraits, and figure paintings with a transcendental quality. Wyeth has been lauded for his exceptional technique and personal subject matter. His early watercolors are in the tradition of WINSLOW HOMER. The meticulous realism of his subsequent work was first achieved in the late 1940s with his adoption of tempera, a medium introduced to him by his brother-in-law, artist Peter Hurd (1904–1984).

BIBLIOGRAPHY
George Plimpton and Donald Stewart, "An Interview with Andrew Wyeth," *Horizon* 4 (September 1961): 88–101 § Wanda Corn, *The Art of Andrew Wyeth* (Greenwich, Conn.: New York Graphic Society for M. H. de Young Memorial Museum, San Francisco, 1973), with reprints of articles by Brian O'Doherty and E. P. Richardson and of an interview with the artist by Richard Meryman, bibliography by Deborah H. Loft, list of exhibitions, served as a catalogue of an exhibition held at the M. H. de Young Memorial Museum, 1973 § Betsy Wyeth, *Wyeth at Kuerners* (Boston: Houghton Mifflin, 1976) § Thomas Hoving, *Two Worlds of Andrew Wyeth: A Conversation with Andrew Wyeth* (Boston: Houghton Mifflin, 1978) § Betsy J. Wyeth, *Christina's World: Paintings and Pre-studies of Andrew Wyeth* (Boston: Houghton Mifflin, 1982).

Portrait of Dwight Eisenhower, 1959
(*General Eisenhower*)
Gouache, watercolor, and graphite on natural
colored vellum
12⁵/₁₆ x 10¹⁵/₁₆ in (31.3 x 27.8 cm)
Signed lower right: AW
Gift of Dwight D. Eisenhower
M.64.67
Color plate, page 80

sitter to wear his favorite clothes—Eisenhower chose a straw-colored, nubby silk jacket—and placed him before an empty background. Wyeth presented the president as a strong-minded individual with the quiet strength of a dedicated public servant. These characteristics are similarly captured in Wyeth's *The Patriot,* 1964 (private collection), a bust portrait of an elderly soldier.

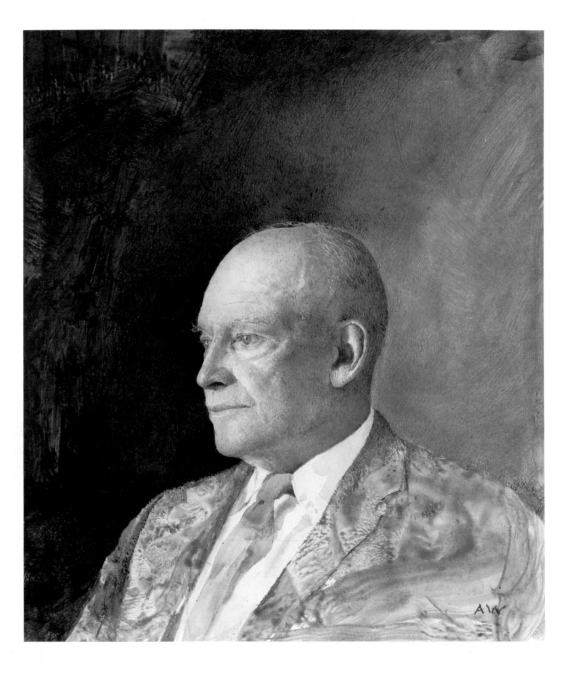

Wyeth, *Portrait of Dwight Eisenhower.*

Wyeth has always been reluctant to accept commissions, and his most famous portraits are of his friends and neighbors. Nevertheless, he accepted the commission to paint the portrait of President Eisenhower for the cover illustration of the September 7, 1959, issue of *Time* magazine. Eisenhower sat for the portrait at his home in Gettysburg, Pennsylvania, for short periods over the course of five days in August 1959. In characteristic fashion Wyeth asked his

The response to the portrait was divided. In letters printed in successive issues of *Time,* members of the public characterized it as both undistinguished and striking. Recalling that his staff had criticized it, Eisenhower remarked that he was one of the few people in the White House who liked the portrait.

The portrait is painted in several techniques typical of Wyeth. He blocked out the basic forms in a wet, very transparent watercolor,

leaving the background unfinished. In the jacket the paint was vigorously applied to convey the rough texture of the material. Only the face is carefully delineated, with many tiny strokes of opaque pigment applied to model the head.

Richard Nixon admired the portrait very much and borrowed it for an extended period during his presidency.

RELATED WORKS
Cover, *Time* 74 (September 7, 1959) § *Eisenhower,* print, published by Haddads Fine Prints, Buena Park, Calif., c. 1969.

PROVENANCE
Time, Inc., New York, 1959–60 § Dwight D. Eisenhower, Gettysburg, Pa., 1960–64.

ON DEPOSIT
LACMA, 1964 § Western White House, San Clemente, Calif., 1969–74.

EXHIBITIONS
Buffalo, Albright-Knox Art Gallery, *Andrew Wyeth: Temperas, Watercolors, and Drawings,* 1962, no. 127, repro., p. 70, as *General Eisenhower* § Tucson, University of Arizona Art Gallery, *Andrew Wyeth: An Exhibition of Watercolors, Temperas, and Drawings,* 1963, no. 73.

LITERATURE
James A. Linen, "A Letter from the Publisher," *Time* 74 (September 7, 1959): 5, repro., cover § "Letters [to the Editor]," *Time* 74 (September 28, 1959): 2; (October 5, 1959): 9; show the different opinions of portrait § Bernhard M. Auer, "A Letter from the Publisher," *Time* 76 (October 24, 1960): 21, recounts Eisenhower's opinion, repro. § Plimpton and Stewart, "Andrew Wyeth," p. 100, the artist describes Eisenhower sittings § *Time* 82 (December 27, 1963): 52, repro. § LACMA, Registrar's files, Dwight D. Eisenhower to Richard F. Brown, December 28, 1964.

Wyeth, *Cider Apples.*

Wyeth, *Early Spring.*

Cider Apples, c. 1962
Watercolor and drybrush on paper attached to stretcher
19³⁄₁₆ x 24¹⁄₈ in (48.7 x 61.4 cm)
Signed lower right: Andrew Wyeth
Gift of Maurine Church Coburn
M.64.12.1

Early Spring, c. 1963
Watercolor and drybrush on paper
29⁷⁄₈ x 21⁷⁄₁₆ in (76.0 x 55.3 cm)
Signed lower left: Andrew Wyeth
Gift of Maurine Church Coburn
M.64.12.2

During the late 1950s Wyeth began painting watercolors of the family apple orchard planted by his father and maintained by his sister. In these paintings he often combined the fluid watercolor and drybrush techniques to utilize the medium effectively. Thus these mature paintings differ from his early watercolors in which, in the tradition of Homer, Wyeth applied the paint in bold, vigorous strokes, often manipulating its bleeding. The drybrush enabled him to suggest texture, as in the rough bark of the tree in *Cider Apples,* and to delineate details, such as the grass blowing in the wind in *Early Spring.* In neither painting, however, did Wyeth relinquish the fluid brush.

Some of his studies of trees contain genre details that introduce narrative elements to the scene, but most are pure painting. Thus despite Wyeth's reputation as a realist, these watercolors reveal the strong abstract quality beneath his detailed specificity. Wyeth usually focuses on a single tree and only on part of that tree's trunk and limb structure. The Y configuration of the tree in *Cider Apples* appears in several other paintings, the most famous being *Frosted Apples,* 1967 (M. H. de Young Memorial Museum, San Francisco). The irregularity of a tree's limbs is emphasized in *Early Spring* and other studies, such as *Fungus,* 1959 (private collection), by the artist's placement of the limbs against a light background. *Early Spring* is not read so much as the trunk and branches of a tree as an abstract angular form.

Although Wyeth's realistic approach reveals an almost cold, analytic mood, a sense of mystery still pervades these watercolors. Wyeth permits the viewer to glimpse his private world but does not allow us to comprehend his enigmatic personality.

Cider Apples

PROVENANCE
With M. Knoedler & Co., New York, to 1964 § Mr. and Mrs. Samuel F. B. Morse, Pebble Beach, Calif., 1964 § Maurine Church Coburn, Pebble Beach, 1964.

ON DEPOSIT
The Honorable Leonard K. Firestone, American Embassy, Brussels, 1974–77.

EXHIBITION
LACMA and others, *Eight American Masters of Watercolor,* 1968, no. 103, repro., unpaginated.

Early Spring

PROVENANCE
With M. Knoedler & Co., New York, to 1963 § Mr. and Mrs. Samuel F. B. Morse, Pebble Beach, Calif., 1963 § Maurine Church Coburn, Pebble Beach, 1964.

EXHIBITIONS
Philadelphia, Pennsylvania Academy of the Fine Arts, and others, *Andrew Wyeth: Temperas, Watercolor, Dry Brush, Drawings, 1938 into 1966,* 1966–67, no. 192 § LACMA and others, *Eight American Masters of Watercolor,* 1968, no. 105.

LITERATURE
Gerald F. Brommer, *Landscapes* (Worcester, Mass.: Davis, 1977), repro., p. 31.

Index of Donors

Index of Artists and Titles